JOURNAL
of the
American Research Center in Egypt

VOLUME 53

2017

Published by

THE AMERICAN RESEARCH CENTER IN EGYPT

Contents

* * *

Book Reviews

The Lost Throne of Queen Hetepheres from Giza:
An Archaeological Experiment in Visualization and Fabrication

PETER DER MANUELIAN

Abstract

In 1925, one of the greatest discoveries made at Giza revealed a small, unfinished chamber (labeled "G 7000 X") more than twenty-seven meters underground, just east of the Great Pyramid. The Harvard University–Boston Museum of Fine Arts Expedition found there the deteriorated burial equipment, sarcophagus, and other objects belonging to Queen Hetepheres I, presumed consort of Snefru and mother of Khufu. Since the discovery of this rare Old Kingdom royal assemblage, the thousands of small fragments have remained in storage in the Egyptian Museum, Cairo. Meticulous documentation allowed the excavators to reconstruct some of the queen's furniture. However, the most exquisite piece, her "second" chair or throne, made of cedar with hundreds of faience inlays and completely gilded, was never reconstructed. This paper describes an interdisciplinary collaboration initiated by the Giza Project at Harvard University to create a full-scale reproduction of Hetepheres's second chair in modern cedar, faience, gold, gesso, and copper. The goals for this visualization experiment were to reconstruct the excavation history, the iconography, and to document, insofar as possible, the ancient workflow the Egyptians used to construct this Old Kingdom masterpiece. The final results produced a new museum display object and research/teaching tool.

Two significant features of Hetepheres's tomb complex stand out today. One consists of the anomalies: the lack of a (surviving?) superstructure, along with the empty sarcophagus and missing body, despite the presence of a canopic chest most likely packed with the queen's viscera.[1] And the second feature is the spectacular, albeit thoroughly deteriorated, royal furniture, among the oldest from the ancient Mediterranean world.[2] This paper will not focus on the enigma of the burial itself, a subject I hope to revisit elsewhere, but instead on "chair ii," one particular piece of Hetepheres's furniture that has until now never been restored or reconstructed.

[1] For a different interpretation of the canopic chest, see T. Rzeuska, "And where are the viscera…? Reassessing the function of Old Kingdom canopic recesses and pits," in N. Strudwick and H. Strudwick, eds., *Old Kingdom, New Perspectives. Egyptian Art and Archaeology 2750–2150 BC* (Oxford and Oakville, 2011), 244–55. Compare this interpretation to the one in P. Der Manuelian, "Harvard University–Boston Museum of Fine Arts Expedition Contributions to Old Kingdom History at Giza: Some Rights and Wrongs," in P. Der Manuelian and T. Schneider, eds., *Towards a New History for the Egyptian Old Kingdom: Perspectives on the Pyramid Age. Papers from a Symposium at Harvard University, April 26, 2012,* Harvard Egyptological Studies 1 (Leiden/Boston, 2015), 328.

[2] For reference, I provide here a concordance list of the accession numbers of the Egyptian Museum, Cairo, restored furniture and the reproductions created for the Museum of Fine Arts, Boston: chair i (reconstruction = Cairo JE 53263; reproduction = MFA 38.957); canopy (reconstruction = Cairo JE 57711; reproduction = MFA 38.873); curtain box (reconstruction = Cairo JE 72030, reproduction = MFA 39.746); bed (reconstruction = Cairo JE 53261; reproduction = MFA 29.1858); headrest (reconstruction = Cairo JE 53262; reproduction = MFA 29.1859); bracelet box (reconstruction = Cairo JE 53265); carrying chair (reconstruction = Cairo JE 52372, reproduction = MFA 38.874).

Journal of the American Research Center in Egypt 53 (2017), 1–46
doi: http://dx.doi.org/10.5913/jarce.53.2017.a001

1. Excavation History of G 7000 X

On Saturday evening, March 7, 1925, the day of the first modern-era glimpse into Queen Hetepheres's subterranean burial chamber, key members of the Harvard University–Boston Museum of Fine Arts Expedition could hardly have been further apart from one another. George Reisner was in Boston, preparing for his Monday morning 9:00 am Harvard class, "Egyptology 3: History of Egypt," with a total of sixteen undergraduates. Dows Dunham, rather unceremoniously "fired" by Reisner back in the fall of 1923, was living in Maadi, working for the Egyptian Government under Cecil Firth at Saqqara, and occasionally at the Mastabat el-Faraon with G. Jéquier. (Dunham was among the first to see the *heb sed* statue of Djoser on the north side of the Step Pyramid.) William Stevenson Smith was studying as an undergraduate at the University of Chicago. The following year he transferred to the Harvard class of 1928, and only joined Reisner as a graduate student in 1929. Alan Rowe, T. R. Duncan Greenlees, and *reis* Said Ahmed Said were the men supervising the HU-MFA Expedition's relocation over to the Eastern Cemetery at Giza.

Expedition photographer Mohammedani Ibrahim's tripod had slipped on "Queens Street," which runs north–south between the three queen's pyramids GI-a through c, and the westernmost row of great twin mastabas, to reveal the plaster covering and limestone fill blocks beneath it (fig. 1). This accidental discovery took place on either February 2 or 9, 1925, depending on which account one reads.[3] Ibrahim was slightly west of shaft P of mastaba G 7101, belonging to the Sixth Dynasty official named Qar (figs. 2–3).[4]

On Sunday, Feb. 22, 1925, word was sent to inspector James Quibell to inform him of the find. By Saturday, March 7, 1925, the burial chamber south of the shaft finally appeared (fig. 4), as described in the Expedition Diary kept by T. R. D. Greenlees:[5]

> At the depth of 2550 at 3:30 p.m. it was observed that the rock surface on the south, here extremely good, fell away at an angle, and immediately afterwards the top of the door to a chamber was revealed. One limestone block was loosened and removed in order to see in. A large chamber is visible extending up a little to east and west of the door. It is possible to see what appears to be a sarcophagus in the foreground upon which are several staves or maces with gilded tops. A good deal of gilding appears on other objects upon the ground. It is certain that the burial is intact.
>
> Work was now diverted towards re-blocking this small hole lest dust should trickle in to the damage of objects unseen and near the door.

Five days later, on March 12, 1925, Reisner ordered the tomb closed and sealed.

There was a back-story here. Alan Rowe was keen on continuing the excavation and clearing the burial chamber despite Reisner's absence. Reis Said Ahmed Said felt that the complex nature of the deposit required far more expertise than Rowe or Greenlees possessed, and he favored waiting for Reisner's return from America. While the Expedition workmen slaughtered a bull and celebrated the discovery with a "fantasia," Said Ahmed telegraphed Reisner. This resulted in Reisner wiring Cecil Firth with a request to investigate the situation. Firth and Dows Dunham visited the site, and Firth agreed with reis Said Ahmed. Firth wired back to Reisner that both he and Pierre Lacau felt the tomb should be closed. So Reisner wired Rowe asking him to obtain Lacau's permission to shut down the operation.[6]

[3] For the earlier February 2, 1925 date: G. Reisner and W. Stevenson Smith. *A History of the Giza Necropolis* 2, *The Tomb of Hetep-Heres the Mother of Cheops: A Study of Egyptian Civilization in the Old Kingdom* (Cambridge, Mass., 1955), xxiii, xxv ("first record" made February 19, but see below); W. Stewart, "Tomb of Hetepheres. Mother of Cheops," unpublished manuscript in the Giffith Institute, Oxford, 7 (ms. p. 2). For the later February 9, 1925 date: G. Reisner, "Hetep-Heres, Mother of Cheops," *BMFA* 25, Supplement (May 1927), 1–36, esp. 6. The Arabic Expedition diary, kept by Said Ahmed Said, mentions on February 9, 1925 the "layer of plaster that was photographed and drawn recently…".

[4] W. Simpson, *The Mastabas of Qar and Idu*, Giza Mastabas 2 (Boston, 1976).

[5] HU-MFA Expedition Diary vol. 13, 279 (English version).

[6] This account derives from Said Ahmed Said's Arabic diary, 5–6, as translated with annotations, by Reisner himself. The account differs extensively from the Arabic diary account acquired from the descendants of Said Ahmed in 2006, and from the English diary kept by the Expedition staff. It is part of the HU-MFA Expedition archives; see P. Der Manuelian, *Digital Giza. Visualizing the Pyramids* (Cambridge-London, 2017), 117–18, fig. 3.15.

Reisner was not only concerned about utilizing proper excavation methodology (and, one assumes, about being personally present to enjoy the discovery), but also about controlling the publicity coverage. Having seen Snefru's name on fragments of the bed canopy lying on top of the sarcophagus on March 8, 1925, Alan Rowe apparently went to the press. Local US papers as well as the London Times bear press dates as early as March 9, 1925. Reisner did all he could to argue against G 7000 X being the tomb of Snefru, and while he had Alan Gardiner on his side, Wallis Budge and H. R. Hall in England felt otherwise. This cast a pall over Reisner's relationship with Alan Rowe that would only worsen with time.

Rowe apparently caught malaria after a meal downtown with General Allenby. After many days in bed, Rowe was back at work in mid-March, 1925. At this time, a Fox news cameraman named Ben Miggins had been lurking around Giza for three days trying to cover the story. The notes accompanying the movie footage he eventually shot record the events:

> "I had to steal this with the aide of Mr. Rowe who is unable to help me because Dr. Ressner [sic] has issued an order that no photographs be made. I worked around the pyramids for three days waiting for Mr. Rowe has been sick in bed two weeks and this is his first day up. He could not connect himself with me so I had to wait until he was around."

Figure 5 shows Rowe and no doubt a coerced Said Ahmed preening before Miggins's camera; being the "first day back" for Rowe, a corroboration with Said Ahmed's diary fixes figure 5 at March 21, 1925.[7] As a result of these and other events, Rowe's departure on August 1 to direct the University of Pennsylvania Expedition was a great relief to Reisner.[8]

On March 16, 1925, Said Ahmed and Greenlees blocked up the entrance to the burial chamber.[9] Reisner himself jumped into the PR business with a note in the *Harvard Alumni Bulletin*, dated March 19, 1925. From Boston, Reisner, who had yet to see the tomb with his own eyes, reported that on the coffin "lay an elaborate, woven-gold mat with a line of incised hieroglyphics, giving the name Nebti-Sneferuw, which is apparently the name of the person buried in the coffin. The name indicates that the person was a woman, probably a princess."[10] On April 4, Quibell sent word that Antiquities Service director Pierre Lacau did not wish the tomb reopened.

With the spring semester finished at Harvard, Reisner booked passage back to Egypt, leaving from New York on June 13, 1925, and reaching Giza on July 22.[11] In the wake of Alan Rowe's looming departure (August 1),[12] Reisner ordered Duncan Greenlees to cancel his planned trip to Boston, where he had just been named assistant curator of Egyptian Art at the MFA, and return to Cairo from London. Reisner also hired Lt. Commander Noel F. Wheeler as surveyor; Wheeler would remain with the HU-MFA Expedition until September, 1933. Reisner had also brought a young Alexander Boyd Hawes, son of Cretan archaeologist Harriet Boyd Hawes and MFA associate director Charles Henry Hawes, to Giza with him.[13] Other changes included the sudden departure of Duncan Greenlees for India (Dec. 8, 1925), and the rehiring of Dows Dunham to take his place.

The excavations in G 7000 X should then have continued promptly after the preparation work was completed, but Reisner came down with a case of shingles (herpes). By September 6 he was ordered to the Anglo-American Hospital. He returned on Sept. 14; November 18, 1925 was the first official day of the 1925–26 season, and work finally commenced in the burial chamber of G 7000 X on January 21, 1926.[14] The real "all-clear" came three days later when acting director C. C. Edgar descended with Reisner into the tomb to examine the

[7] I am grateful to Benjamin Singleton of the Moving Image Research Collections, University of South Carolina, for his help in procuring this image and Ben Miggins's log. Miggins had filmed "The Shepherd King" two years earlier.

[8] I hope to detail Reisner's interactions with Rowe further in a forthcoming biograpy of Reisner's life and career.

[9] Diary of Said Ahmed, p. 6: A much shorter entry is given in the official Arabic Diary, 337 (Book 5).

[10] G. Reisner, "A New Discovery in Egypt," *Harvard Alumni Bulletin* (March 19, 1925), 737.

[11] Reisner letter of June 5, 1925; HU-MFA Expedition Archives.

[12] See *Expedition Magazine* (University of Pennsylvania Museum, Winter 1979), 26–29; and J. Copland Thorn, "Alan Rowe: Archaeologist and Excavator in Egypt, Palestine and Cyrenaica," *Libyan Studies* 37 (January 2006), 71–83.

[13] M. Allsebrook, *Born to Rebel: The Life of Harriet Boyd Hawes* (Oxford, 1992), esp. 182–83; V. Fotou and A. Brown, "Harriet Boyd Hawes (1871–1945)," in G. Cohen and M. Sharp Joukowsky, eds., *Breaking Ground: Pioneering Women Archaeologists* (Ann Arbor, 2004), 198–273.

[14] Reisner and Smith, *Giza Necropolis* 2, xxv.

burial chamber. He compared the appearance of the deposit before his eyes, on January 24, 1926, with prints of HU-MFA Expedition Photos A 3598 and A 3606, both from March 9, 1925, and concluded that there had been no changes to the tomb's condition since the previous year. The final delay was the wait for artist and conservator William A. Stewart to paint a watercolor rendering of the untouched burial chamber (January 29 to February 3, 1926). Stewart was to receive no credit for this work, however, for the Boston painter Joseph Lindon Smith later arrived and created his own oil painting at Harvard Camp (color fig. 6), based on Stewart's *Vorlage*. Stewart's illustration has apparently not survived or still remains to be located.[15]

Clearance of the armchairs "i" and "ii," along with the carrying chair, ointment vessels, bed, inlays of chair ii, and some ceramics, all took place between January and July 15, 1926. Before we leave this excavation history summary, just a few more key dates are worth summarizing. The first was the tragic loss of the truly unique *reis* (since 1909) Said Ahmed Said to pneumonia on February 14–15, 1926.[16] The queen's name was finally read, and noted in the Expedition's Communiqué no. 4, on April 14, 1926 as "Hetepet-heres" (from inscriptions on the back of the carrying chair). There were to be twelve public communiqués in all. By December 23, 1927, Dunham had secured W. A. Stewart's help in restoring the furniture, a "two-year task and to be paid for by Harvard Research Fund."[17] Two years was a low estimate.

Figure 7 shows much of the contents of G 7000 X already cleared, and figure 8 presents a completely cleared floor, with the sarcophagus and niche alone remaining. The opening ceremony, revealing what turned out to be an empty sarcophagus, took place on March 3, 1927. The canopic chest from the blocked and plastered eastern niche, was removed on May 23, 1927. In all, the project had taken up approximiately 1,701 pages of plans, notes, and drawings; 1,057 photographs on glass plate negatives; and 321 working days.

2. Chair ii of Queen Hetepheres

The restored furniture of Queen Hetepheres I is now justly famous, both in Cairo and Boston (figs. 9–10).[18] "The furniture of Hetep-heres shows that by the early part of the third millennium B.C. accurate joinery had already a long tradition. Its simple and elegant proportions accord with the restrained taste of this classic period of Egyptian art."[19] Indeed, Hetepheres's sitting chair (as opposed to the carrying or sedan chair), so-called chair i, with arms composed of three bound papyrus plants in open-work decoration, is almost emblematic among Egyptologists and others for the tomb today (fig. 36). But for almost three decades since the original discovery, the second of the two armchairs, which Reisner labeled "chair ii," continued to plague the original Expedition staff members regarding its original design. The problem outlasted Reisner himself; witness his remarks in his Report no. 4 where he notes that chair ii "seemed of simpler form" than chair i. In fact, the exact opposite was true.

Extracting the thousands of tiny fragments of chair ii from the surrounding items on the chamber floor was a daunting task. That a second chair existed was proven by the four gilded lion legs found in addition to those belonging to chair i. In the *Bulletin of the Museum of Fine Arts, Boston* from 1927, Reisner described this area of the burial chamber: "In the course of time the debris in the pit itself had settled about 15 cm., enough to expose the southern side of the pit for about half its length from the east; and this settlement had brought about the collapse towards the north of a chair which stood partly over the southern part of the pit. This was the area on which

[15] Joseph Lindon Smith (1863–1950); oil on canvas, 38.5 × 64 cm (15 3/16 × 25 3/16 in.); Anonymous gift; courtesy of the descendants of Joseph Lindon Smith, MFA 27.388; published in Reisner, "Hetep-Heres, Mother of Cheops," 11; D. Dunham, *Recollections of an Egyptologist* (Boston, 1972), 31; G. Johnson, "The Mysterious Cache-Tomb of Fourth Dynasty Queen Hetepheres," *Kmt* 6:1 (spring 1995), 37, and Manuelian, *Digital Giza*, 167, fig. 5.5 (middle).

[16] Reisner, "Hetep-Heres, Mother of Cheops," 11.

[17] Dows Dunham to the MFA Director's office, December 23, 1927; archives of the Museum of Fine Arts, Boston.

[18] Z. Hawass, "The Mystery of Hetepheres," in Z. Hawass, ed., *Treasures of the Pyramids* (Vercelli, 2003), 152–55; idem, *Inside the Egyptian Museum with Zahi Hawass* (Cairo, 2010), 96–99; G. Reisner, "The Household Furniture of Queen Hetep-heres I," *BMFA* 27, no. 164 (December 1929), 83–90.

[19] C. Aldred, "Fine Wood-work," in C. Singer, E. Holmyard, and A. Hall, eds., *A History of Technology I: From Early Times to Fall of Ancient Empires* (Oxford, 1954), 699.

we were forced to begin."[20] In the drawings for each layer, Dunham represented the gold in red ink, wood and other types of objects using purple, and the stones and walls in black (fig. 11). Fragments were numbered (from 1 to over 1600) on photographs and on Dunham's drawings, removed individually to trays, then examined and recorded in the Object Register with all relevant metadata.

To explain the disappearance of the wood, Reisner wrote: "Fungus generally flourishes in a moist atmosphere, and there are stains of copper and wood on the coffin which prove that at some time rainwater had worked its way down from the surface, probably through the natural fissures of the rock and in particular through that fissure which formed the southern wall of the shaft."[21]

In one of his work reports, Reisner described the extraction process for the area where chair ii had collapsed, running from about mid-February to mid-April, 1926:

(1) A large scale photograph is prepared of the area in hand.[22]
(2) A drawing is made to about 1:2 of the same inlays.
(3) After examination, Dunham and I agree as the first inlay to be moved and the order in which the following inlays are to be taken so as to enable us to reconstruct the original setting.
(4) The selected inlay is numbered on the photographic print and drawing.
(5) Dunham then lifts it without disturbing anything else—an act which requires great steadiness of hand and skill (the game of *spillikins*, we call it).
(6) We both examine it. In the list which I keep in ink on a sheet of paper of the size and quality of the sheets used in this report, I make a sketch of the object opposite its No. and write down the measurements taken by Dunham.
(7) We have thin boards with raised edges and covered with cotton cloth (to keep the inlays from slipping. On this the inlay in question is laid in its proper position.
(8) The same process is followed with each succeeding inlay which after recording is laid on the board in its proper relation to those already taken up.[23]

Even an earthquake of February, 1926 failed to jostle the tomb's contents, and Reisner and Dunham only learned of the event by subsequent consultation of the newspapers.[24] A selection from Reisner's report follows (fig. 12):

> On Feb. 27 we began to remove chair No. ii which seemed of simpler form than chair No. i. It had stood west of chair i with its front towards the south[25] and had decayed in place with a slight pitch towards the southeast. Across the back part lay a board decorated with inlays and gold (X). The elements of the decoration were of two types,—a row of 7 vertical feathers and a gold rectangle cut out in a flower pattern and inlaid with colored faience pieces. The flower element also consisted of faience inlays (blue with black tips) in a gold frame-work. The two types of elements alternated. By March 2nd, we had worked out mostly in the original order, eleven of these elements [see fig. 13].
>
> At this point, further progress was impeded by inlays and fragments of gold sheet which lay dislocated. By the 6th, we had cleared these away, carefully recorded and also the two hind legs and some other parts of the chair ii. It was then apparent that another decorated board (Z) similar to the first ran about at right angles to it and that the whole area was underlaid by a great sheet of gold decorated with large flowers inlaid with blue faience. This great sheet (Y) ran under the bird's wing visible on the east and lying over the gold-cased bars of the bed (iii). It was therefore necessary to begin removing the bird's

[20] Reisner, "Hetep-Heres, Mother of Cheops," 10.

[21] Reisner, "Hetep-Heres, Mother of Cheops," 36.

[22] By "large scale" Reisner means an "A"-sized negative, 8×10 inches, or 20×25 cm; see P. Der Manuelian, "George Andrew Reisner on Archaeological Photography," *JARCE* 29 (1992), 1–34.

[23] G. Reisner, unpublished "Report" No. 4, March 28, 1926, 5 (HU-MFA Expedition archives).

[24] Reisner, "Hetep-Heres, Mother of Cheops," 9 with n. 1.

[25] Actually the front of the chair faced north, according to the Expedition's reconstruction drawings; see Reisner and Smith, *Giza Necropolis* 2, fig. 20.

wing. This wing consisted of feathers of blue faience with black tips separated by strips of gold,—the whole set in gesso (carbonate of lime). No. 208 was a group from the tip of the wing which had fallen apart and lay against the southwest leg (left foreleg) of chair i. These were removed and then this leg of chair i and some scattered inlays fallen down from the first decorated board (X). Then on March 8th, we began clearing away the second decorated board (Z) which was not finished until March 16. It was a board 22 cm. high, four cm. thick and of a width not yet exactly determined, inlaid on one side and edges with black-tipped blue faience elements in regular rows set in a gold frame….”

…Then we were obliged to clear away various parts of the arm of a chair apparently belonging to chair ii. This gave us access to further parts of the board Z which we removed by the [sic] March 16th and further parts of (X)…

… On the 18th of March we attacked the main part of the wing which lay face up and by the 21st had pieced it together. Under this was a layer of crumbled plaster, a layer of wood, a second layer of crumbled plaster, and then a layer of inlays face <u>down</u>.[26]

After Reisner's death in 1942, and owing to the challenges of the Second World War, much miscellaneous material remained at Harvard Camp, on the Giza Plateau, for decades after the excavation of G 7000 X. It was not until early 1947, when William Stevenson Smith and Dows Dunham returned to Giza to assess, and eventually to close down, the HU-MFA Expedition, that this material came once more under scrutiny.

Another task, done partly by me and partly by Bill Smith, was the final study of the Hetep-heres material before its delivery to Cairo. First we went through the many boxes and threw away a large quantity of decayed wood, cloth, and miscellaneous rubbish which could have no usefulness. Then a good deal of time was spent by Bill Smith in re-arranging and adding to the various groups of inlays, so as to get them consolidated and easier to deal with….[27]

An Egyptian Museum photographer came to document the material, and in the end Smith and Dunham personally drove thirty boxes to the Museum in downtown Cairo in their car. "There, they were placed in a special room in the basement for future study and reconstruction. We do not know whether they stood the journey without damage."[28] The Museum authorities assigned the Temporary Registration Number of April 18, 1947, No. 5 (fig. 14).

The greatest achievement of the HU-MFA Expedition in G 7000 X was the meticulous documentation that allowed the staff to reconstruct many objects, some physically, some on paper. George Reisner, Dows Dunham, Noel F. Wheeler, Hagg Ahmed Youssef, William A. Stewart, Bernard Rice, Marion Thompson (Mrs. Dows Dunham), and woodworker Said Halaby were all integral to the success of the reconstructions.[29] New wood had to replace completely disintegrated beams, planks, and legs, while intricate inlay patterns and sophisticated joinery had to be recreated, always after countless hours of painstaking research. In fact, it was only in late 1949 and early 1950 that William Stevenson Smith, back in Boston, felt he had finally deciphered the original look of Hetepheres's second chair.[30] He reproduced the results in fig. 32 of the primary source publication of the tomb, *Giza Necropolis* 2, which I have modified with labels on the individual elements (fig. 15).[31] The volume was

[26] G. Reisner, unpublished "Report" No. 4, March 28, 1926, 2–3 (HU-MFA Expedition archives). Additional photographs of the area where chair ii had collapsed may be found in Reisner and Smith, *Giza Necropolis* 2, pls. 17a-b, 19c-d, 20a-b, 21b, and 23b.

[27] D. Dunham, unpublished report on the closing of Harvard Camp, 1947 (HU–MFA Expedition archives), 7.

[28] Dunham, unpublished report on the closing of Harvard Camp, 8.

[29] Hagg Ahmed Youssef inscribed the copy of the curtain box that now resides in the Museum of Fine Arts, Boston (MFA 39.746) in Arabic: "Exact replica model of Hetepheres box. Made by me, Ahmed Yousef Mostafa -1939. Technical assistant at the casting molds manufactury of the Egyptian Museum."

[30] W.S. Smith to W.A. Stewart, February 23, 1950; Griffith Institute, University of Oxford.

[31] Reisner and Smith, *Giza Necropolis* 2, pls. 17–24. This illustration, or portions thereof, has been reproduced in W. Stevenson Smith, *History of Egyptian Sculpture and Painting in the Old Kingdom* (London, 1949), 147–48, figs. 58–59 (hereafter *HESPOK*); S. Hendrickx, "Two Protodynastic Objects in Brussels and the Origin of the Bilobate Cult-Sign of Neith," *JEA* 82 (1996), 34, fig. 8; H. Baker, *Furniture in the Ancient World Furniture in the Ancient World* (New York, 1966), 40 fig. 30; R. el-Sayed, *La déesse Neith de Sais* II (Cairo, 1982), pl. IV, doc. 191; W. Stevenson Smith, "The Tomb of Hetep-heres I," *BMFA* 51, No. 284 (June 1953), 28, fig. 7; n.a., "A Queen's Furniture of 5000 Years ago: Final Reconstructions for the unique Treasures from the Tomb of Hetep-heres, Mother of Cheops," *Illustrated London News*, May 8 (1954), 764,

based on Reisner's earlier manuscripts, but did not appear until 1955, thirteen years after his death at Harvard Camp, Giza. In 1953, Smith wrote: "It is to be hoped that the Cairo Museum may eventually find it possible to reconstitute the armchair and inlaid box from the very fragile elements which are at present arranged in trays, according to their various patterns and packed away in storage."[32]

3. Summary Description of the Chair ii Elements

Chair ii of Queen Hetepheres outstrips its simpler and better-known counterpart—chair i with its three papyrus flower arms—by virtue of its exquisite craftsmanship. In fact, there is probably no reason to avoid referring to it as a throne in the wider sense of the word.[33] A (most likely) woven seat probably appeared in the center of four rails that once interlocked by means of mortise and tenon joints (fig. 15). The seat was supported by four feet carved in imitation of lion's legs (among the earliest examples known) and likewise connected with mortise and tenons, and reinforcing leather bands. The front legs are taller by 2.54 cm, giving the chair a gentle backwards slope of three degrees.[34] A cushion or cushions would have rendered the dimensions more comfortable. Beneath the feet are the ribbed drums or supports customarily found on theriomorphic furniture; in this case, the drums were of rilled copper. We will return to the topic of possible limestone cone supports further below.

The arms consist of four primary elements on each side. One rail runs from the back of the chair forward, resting on the seat and connecting at a right angle to an armchair support rail placed vertically. Both rails are inlaid on multiple sides with an alternating pattern of vertical feathers and rosettes.[35] The vertical rail is capped by a horizontal armrest rail with a semicircular top that is not inlaid but rilled with a pattern of intersecting lines. (These appear on chair i as well.) Hidden leather ties passing diagonally through the front and back mortises and tenons of the armrest helped to secure the ensemble. Filling the square "window" produced by these elements is a Horus falcon resting on a palm column, with outstretched wings adorned with numerous faience inlays (figs. 16–17). The Horus motif with outstretched wings also occurs six times in raised relief in exquisitely detailed hieroglyphs on the queen's gilded canopy inscriptions (fig. 18); it appears with furled wings an additional six times.[36] This open-work motif must have attached for stability to the chair rails at the head of the falcon, the

fig. 4; A. Pepler-Harcombe, *Ancient Egyptian Furniture in Context: From Ancient Production, Preservation to Modern-Day Reconstruction and Conservation* (Unpublished MA dissertation, University of South Africa, 2011), 166, image 61; and Manuelian, *Digital Giza*, 200, fig. 6.6. For a similarly annotated chair drawing, see M. Eaton-Krauss, *The Thrones, Chairs, Stools, and Footstools from the Tomb of Tutankhamun* (Oxford, 2008), 149, fig. 1.

[32] Reisner and Smith, *Giza Necropolis* 2, xxiii. A similar anonymous statement appeared in the *Illustrated London News:* n.a., "A Queen's Furniture of 5000 Years Ago," 764–65. This issue also notes the magazine's previous coverage of tomb G 7000 X: first notice on March 12, 1927; on November 24, 1928, photographs of the carrying-chair; on August 24, 1929, her bed and Chair i; on May 7, 1932, the bed canopy and a "jewel box;" and on November 18, 1939, the curtain box.

[33] Eaton-Krauss, *The Thrones, Chairs, Stools, and Footstools from the Tomb of Tutankhamun*, 21, n. 3, citing K. Kuhlmann, *Der Thron im alten Ägypten: Untersuchungen zu Semantik, Ikonographie und Symbolik eines Herrschaftszeichens* (Glückstadt, 1977), esp. 3–7.

[34] G. Killen, *Ancient Egyptian Furniture* I, *4000–1300 BC* (Warminster, 1980), 59, notes for chair i (Cairo JE 53263) that "the back legs would have to be slightly raised in order to keep the seat horizontal," but why assume that this was the ancient Egyptians' goal? See J. Panero and M. Zelnik, *Human Dimension & Interior Space. A Source Book of Design Reference Standards* (New York, 1979), 129: "The angle formed by thighs and trunk should not be less than 105°...." "A seat angle of about 15° should be adequate." For roughly contemporary furniture representations at Giza, only three of the surviving Giza slab stelae show leonine legs on their owner's stools, instead of bull's legs: Khufunakht (G 1205), Nefer (G 1207), and Seshat-sekhentiu (G 2120); see P. Der Manuelian, *Slab Stelae of the Giza Necropolis*, PPYE 7 (New Haven-Philadelphia, 2003), pls. 5–8, 17–18.

[35] Concerning the decoration on the inside of the chair arms, note that Reisner and Smith, *Giza Necropolis* 2, 30, state: "There were no inlays which could be assigned to the inner surface of the frame of the arm, although the hawks and the plants on which they are poised were inlaid on both the outer and inner faces. Perhaps the frame on the inside was covered with gold which has not been identified, like the frame of the chair seat." In our modern fabrication, we opted to inlay the interior and exterior of the chair arms identically.

[36] The canopy's top left side falcon drawing reproduced in fig. 18 is by Harvard student Vera Jin, but I would also like to thank Harvard graduate students Hilo Sugita, Inês Torres, and Sara Zaia, all of whom likewise produced publishable (uncollated) drawings of selected Hetepheres falcons as part of a digital epigraphy class during the fall semester of 2016. For the canopy's right side, compare the montaged photograph in Reisner and Smith, *Giza Necropolis* 2, pl. 8.

base of the palm column, and perhaps also the tips of the wings.[37] A similar system may be observed with the papyrus umbels of chair i.

The front-facing decoration of the chair's back contains four emblems of the goddess Neith, each on its own standard, and each pair of standards facing inwards towards the center (fig. 15). Above the Neith emblems is a frieze of sixteen braided and inlaid sidelocks, very similar to royal or divine beards, and the entire ensemble is framed by additional feather and rosette patterns.[38] On the rear-facing back of the chair, the feather and rosette pattern frame continues, with the addition of a central vertical slat. On either side of this vertical piece is an additional, larger Neith emblem on a standard, this time with two platforms and two streaming pennants each, almost resembling a diadem viewed from behind. Surrounding the emblems is an intricate zigzagging or basket-weave pattern of rectangular faience tiles. The overall dimensions of the chair, as collected from our modern reproduction, are listed as follows:

Width: 64.135 cm = 25 1/4 inches
Depth: 66.04 cm = 26 inches
Height of chair minus the legs: 63.5 cm = 25 inches
Height of front legs: 26.67 cm = 10.5 inches
Height of rear legs: 24.13 cm = 9.5 inches

4. Modern Fabrication of Hetepheres's Chair ii

The Giza Project, first at the Museum of Fine Arts, Boston, and more recently based at Harvard University, began a collaboration in 2008 with 3D modeling company Dassault Systèmes of Paris. The goals included creating an immersive 3D visualization of the entire Giza Plateau, as an aid to academic teaching and scholarly research.[39] By 2014, the Giza Project at Harvard had built an interactive 3D computer model of the tomb of Hetepheres and its contents (figs. 19–20). This included a 3D rendering of the queen's second chair (fig. 21), and since computer-driven additive (3D printing) and subtractive (3D milling) machines had come of age, Giza Project lead technical artist Rus Gant explored whether we might move in a reverse direction: from the virtual back to the physical worlds. That is, we hoped that by using digital tools we might be able physically to fabricate the second chair of Queen Hetepheres, based on the archaeological record that the original excavators had felt was too poorly preserved, too complex and confusing to restore or reconstruct. Sources for this initiative included the HU-MFA Expedition photography, pages of notes on the individual fragments, English and Arabic Expedition diaries, a conservation manuscript at the Griffith Institute, University of Oxford, comparative study and new photography of the (modern) companion pieces in the Museum of Fine Arts, Boston, and new photography of the Hetepheres fragments generously supplied by our Egyptian colleagues at the Egyptian Museum, Cairo

[37] For another intricately patterned open-work sidearm design, see the recumbent lion on the south wall of the tomb of Meresankh: D. Dunham and W. K. Simpson, *The Mastaba of Queen Mersyankh III* Giza Mastabas 1 (Boston, 1974), 16 (register 4), pl. 9b, fig. 8. The palm column may be seen in other contemporary contexts in the slab stela of Setji-hekenet (G 1227), Manuelian, *Slab Stelae*, pls. 13–14; the end poles of the carrying chair of Hetepheres (Egyptian Museum, Cairo JE 52372, reproduction MFA 38.874), M. Saleh and H. Sourouzian, *Egyptian Museum Cairo. Official Catalogue* (Mainz, 1987), cat. 29; Hawass, *Inside the Egyptian Museum*, 96–97; Reisner and Smith, *Giza Necropolis* 2, pls. 27a, 28c; Metropolitan Museum of Art, *Egyptian Art in the Age of the Pyramids* (New York, 1999), 218–19, cat. 33; Yvonne Markowitz, J. Haynes, and R. Freed, *Egypt in the Age of the Pyramids. Highlights from the Harvard University-Museum of Fine Arts Boston Expedition* (Boston, 2002), 50(f); N. Cherpion, *Mastabas et Hypogées d'Ancien Empire* (Brussels, 1989), 32–33, fig. 13, who also notes a two-dimensional example from the tomb of Kapunisut Kai (G 4651), ibid, pl. 30; and the column inside the Khufu boat, N. Jenkins, *The Boat Beneath the Pyramid* (New York, 1980), 15, fig. 5, 105, fig. 90.

[38] Through misadventure, our fabricated chair ended up with just thirteen sidelocks, but they show the correct size and proportions. The original sixteen must have been more tightly grouped side by side.

[39] Manuelian, *Digital Giza*, chapter 4, 124–53. I thank my friend and colleague, Mehdi Tayoubi, of Dassault Systèmes, Paris, for many years of fruitful collaboration, encouragement, and support. I thank his colleagues in Paris as well: Karine Guilbert, Richard Breitner, Nicholas Serikoff, Emmanuel Guerrero, Fabien Barati, and Pierre Gable. Bob Brier was also instrumental in helping us forge this partnership. Dassault Systèmes's interest in the Giza Pyramids began with the pyramid construction theories of Jean-Pierre Houdin.

(figs. 22–23).[40] We hoped to learn more about Fourth Dynasty woodworking, and specifically the construction sequence for the individual elements of the chair. Wherever possible, we wanted to use the same materials as the ancient Egyptians, although clearly our digital tools precluded a complete correspondence between our methodology and that used in antiquity. (If the Giza Project staff had included or could have afforded the services of high-end woodworking craftsmen, we might have opted to follow the ancient routine with human labor more closely.) A completed chair would give us the opportunity to study the iconography in greater detail, and take a closer look at the significance of the goddess Neith's dominating presence in its decoration program. The deliverable, we hoped, would be a museum-quality object that would serve as both a teaching and a research tool.

Working with Giza Project digital artist David Hopkins, and supported by the Giza Project's Egyptological staff members Nicholas Picardo, Rachel Aronin, and Jeremy Kisala, Rus Gant began the project in earnest in 2015. It had taken Reisner's team ten months to empty the contents of G 7000 X. It took the Giza Project team eighteen months, amongst much other work, to recreate the lost chair of Queen Hetepheres. We believe the results represent fairly accurately the original chair's appearance, but one should bear in mind the derivative nature of our archaeological experiment. William Stevenson Smith was not present at the original excavation of G 7000 X in 1925–27, although he must have consulted Dows Dunham, who was directly involved in the tomb's clearance, during his (Smith's) reconstruction efforts in the late 1940s. Our reconstruction is based in turn on Smith's, and so any errors of his may be perpetuated in our results.

4.1 Wood

As noted above, lacking master woodworkers on the Giza Project staff, and restricted by a limited budget, we obtained a CNC (computer numeric control) 3-axis milling machine, generously loaned by ShopBot Tools, Inc., and controlled by our 3D model to carve all the individual pieces of cedar wood.[41] We are especially grateful to Neil Gershenfeld, Director of the Center for Bits and Atoms at MIT, for putting us in contact with representatives from ShopBot, and for allowing us to 3D-print some small resin and plastic examples of both of Hetepheres's chairs i and ii (fig. 24). The ShopBot router cut all the intricate patterns from the digital file of the chair created by David Hopkins in 3D Studio Max (figs. 25). Additional "human" touches (see below) were necessary to achieve the final effect, but overall the device quite successfully produced everything: the theriomorphic chair legs, the seat and back, rilled armrests, and even elaborate Horus falcon arm elements, including the numerous cut-out areas in the feathers to hold to the faience inlays.[42]

Figure 26 displays one of the legs in both rough and fine cut, using a rough drill bit first, then a 1/16 inch drill bit for finer detail. The speed of the carving process was managed carefully so as to avoid breaking drill bits, or starting a fire by igniting the resulting dust. The average carving time on one side was 8–10 hours, a time-intensive process. Detailing work remained to be completed by hand with other tools, such as a hammer and chisel to carve out mortise and tenons; and rounding, sanding and gluing. Simple mortise and tenons were used for the seat base. Leather ties would have secured these mortise and tenons for the chair's upper arm, bottom arm, and vertical support. The falcon's wing tips and the top of the head would have locked themselves in

[40] I would like to express my gratitude to colleagues in the Ministry of State for Antiquities, and the Egyptian Museum, Cairo: Minister of Antiquities Dr. Khaled el-Enany, Egyptian Museum, Cairo, Director General Sabah Abdel Razek, Assistant to the Minister for Museum Affairs Yasmin el-Shazly, conservator Dr. Nadia Lokma, and Eman Amin of the Museum's Registration, Collections Management and Documentation Department. We must also acknowledge here the countless hours of research and conservation that Dr. Lokma had already invested in the chair's ancient fragments long before we undertook this fabrication initiative.

[41] Cedar was not the only wood used for Hetepheres's furniture; see the ebony mentioned in relation to the carrying chair, Reisner and Smith, *Giza Necropolis* 2, 33–34.

[42] For more on Egyptian woodworking, see Baker, *Furniture in the Ancient World*, esp. 39–49, drawing on 40, fig. 30; short discussion on 42; H. Fischer, "Möbel," in *LdÄ* IV, 180–89; Killen, *Ancient Egyptian Furniture* I, esp. 59–61 with fig. 31; idem, *Egyptian Woodworking and Furniture* (Buckinghamshire, 1994); A. Wenzel, *Die Formen der altägyptischen Liege- und Sitzmöbel und ihre Entwicklung bis zum Ende des Alten Reiches*, PhD dissertation, Munich (Heidelberg, 1939); R. Gale, P. Gasson, N. Hepper, and G. Killen, "Wood," in P. Nicholson and I. Shaw, eds., *Ancient Egyptian Materials and Technology* (Cambridge, 2000), 334–71; E. Leospo, "Woodworking, Furniture and Cabinetry," in A. Roveri, ed., *Egyptian Civilization: Daily Life* (Milan, 1987), 136–61: 93–161; and D. El Gary, *Chairs, Stools and Footstools in the New Kingdom: Production Typology, and Social Analysis* (Oxford, 2014).

place within the frame of the chair's arms. A dry test assembly proved that all the wooden elements fit together as originally envisaged (figs. 27–28).

4.2 Gilding

We received expert advice from conservator Christine Thomson and her assistant Wenda Kochanowski, who served as consultants for the gilding process. We wanted to recreate as much as was possible the original appearance of gold leaf on a wood substrate. To achieve this, it was necessary to research Egyptian gilding processes and understand the types of materials that were available in antiquity and how they might have been used.

The goal of the gilding process in general is to give the illusion that an object is made of solid gold when it is actually made of wood, stone or other less valuable material. Applying a thin veneer of gold onto the surface can create this illusion convincingly. The Egyptians were among the first to devise methods of beating gold with a hammer into thin sheets or "leaves" then applying the leaves onto a surface using some sort of adhesive.[43] Before the application of gold leaf, the surface was prepared by brushing on thin layers of gesso (chalk and animal glue mixed together with water) that helped to fill holes, dents and imperfections in the wood. It could be sanded very smooth, thereby obliterating all evidence of wood grain or tool marks. The smoother the preparation surface underneath, the brighter and more metallic-looking gilding will be the result. The process of gilding today uses nearly identical materials and techniques to those used in Fourth Dynasty Egypt. This includes the use of gesso, gold pounded into thin layers, an adhesive to adhere the gold to the wood, and burnishing with a polished stone (traditionally an agate) to remove wrinkles and imperfections in the gold.

A close examination of photographs of gold surviving from the original Hetepheres chair ii showed that the gold used then was much thicker (like foil) than the typical gold leaf used today for gilding. When considering the results of applying modern gold leaf versus gold foil onto the wood, we felt that the appearance of gold foil would be more in keeping with the look of Egyptian-produced gilding. Unfortunately, the cost of using real gold foil to gild the chair would have been prohibitive, so alternatives had to be considered. We consulted with Epner Technology of Brooklyn, NY, who provided us with samples of copper foil electroplated with 24K gold. This gave the appearance of solid gold foil at a lower cost and turned out to be an excellent alternative to using gold only (figs. 29–30).

Traditionally, the Egyptians would have adhered the gold foil to a prepared surface with animal hide glue, but in this case we found that the hide glue did not produce a sufficiently strong bond between the gold plated foil and the substrate. Instead, we turned to a synthetic adhesive, a polyvinyl acetate resin-based glue (Jade 403, from Talas, New York, NY), and found it better for attaching the gold plated copper to the prepared wood.[44] It will also hold up longer against the effects of the environment than traditional hide glue. The only difficulty with the gilded copper was that it was not as malleable as pure gold, and therefore could not be as easily burnished to eliminate wrinkles. Its use, however, did give the chair the appearance of an object made of solid gold. It was then relatively easy to "punch" out holes in the gilding over the carved depressions and inset in the wood where the faience inlays belonged.

[43] On ancient gilding in general, see P. Hatchfield and R. Newman, "Ancient Egyptian Gilding Methods," in D. Bigelow, ed., *Gilded Wood: Conservation and History* (Madison, 1991), 27–47; E. Figueiredo, R. Silva, M. Fátima Araújo, and J. Senna-Martinez, "Identification of ancient gilding technology and Late Bronze Age metallurgy by EDXRF, Micro-EDXRF, SEM-EDS and metallographic techniques," *Microchim Acta* 168 (2010), 283–291 (doi: 10.1007/s00604-009-0284-6). In 2000, microscopic analysis was conducted on the (modern) reproduction furniture in the MFA, Boston, by Robert Mussey Associates, Inc. The goal was to understand the layer structure of each gilded object in order to devise the best strategy for stabilization. In the case of the papyrus-armed chair i (MFA 38.957), "the preparatory layers on the chair consist of two to three layers of red bole or paint, but no gray layer. The red layer has the same fluorescence in ultraviolet light and the same uneven chunky red and black pigments as the red layer on the canopy and bed. There is no evidence of any toner or coating over the gold layer. The white-fluorescing chunks in the red layer are either a reisnous material or animal hide glue." Christine Thomson, "Microscopy Report, October 23, 2000," on file in the MFA, Boston, 4.

[44] Cf. R. Newman and M. Serpico, "Adhesives and Binders," in *Ancient Egyptian Materials and Technology*, 475–94.

4.3 Faience

Perhaps the greatest challenge to the entire project was the production of faience inlay tiles: the manufacture method, the color, the best procedure for cutting to the desired shapes, and the insertion of the pieces into the gilded wooden sections of the newly fabricated Hetepheres chair. Once fired, faience reacts like glass, with a factor of 7 on the hardness scale. It is difficult to cut to shape without fracturing. It can be sanded from the sides but is resistant, and in fact, using modern tools we discovered that a belt sander belt wears out after shaping about five pieces.

We had the good fortune to collaborate on faience production with Kathryn King, Director of Education, Ceramics Program, Office for the Arts at Harvard. Along with her Ceramics Associate Darrah Bowden, she performed countless tests on chemical composition and hue, and supervised the faience fabrication process from start to finish. Intensive study of the Egyptian Museum fragments also helped us in our research, even as they raised new questions about color fidelity, and the mutability of faience inlays over time and resulting from long contact with metals or other materials. To put it bluntly: Was Hetepheres's chair gilded with green or with blue faience inlays? The surviving faience inlays show wide-ranging color shifts between various tiles. As a first caveat, we should note that it was not always easy to discern whether a given faience inlay actually belonged to chair ii, or to another one of the queen's furniture items.[45] Secondly, the color range could have resulted from "fading" in some instances, but in others from contiguous proximity to copper elements over several millennia. Analysis of the Djoser tiles from the Step Pyramid complex has revealed that

> … the faience tiles suffered from high degradation because of rising damp in the supported walls and crystallization of soluble salts. Failure of faience tiles is most commonly water related, where the units are highly susceptible to glaze cracking, spilling and material loosing …. Also when a glass or glaze is subjected to weathering by the action of water, the alkali ions (Na+ and K+) are replaced by hydrogen ions (H+) and the glass network progressively breaks up. Thus, the silica glass structure is lost and replaced by amorphous layer so-called silica gel. In addition to leaching out of the alkalis, there are also some leaching out of the colorants which will no longer be present as ions but will have been deposited as fine amorphous or poorly crystalline compounds resulted in the change the chemical composition of faience surfaces.[46]

Most of our faience consulting experts, such as Paul Nicholson of Cardiff University, to whom we are very grateful, agreed that the Hetepheres faience fragments had undergone significant change over time. It is also possible that the original color scheme for the chair may have lacked a uniform faience appearance. The rosettes differed from the feathers, and the papyrus column on which the falcons stand differs from everything else.[47]

For our faience production work we were interested in limiting the amount of customized hand labor for each individual inlay. We tested several technologies, including producing squares of faience that were subsequently carved to shape using a water-jet cutter. We ultimately concluded that producing the inlays with molds made the best sense. We practiced with some terracotta mold tests to see if the Egyptians might have worked this way. But to save time and meet our deadlines, we opted for a 50/50 mix of plaster and silica (fig. 31). Such molds, used in glass slumping, can be placed in the kiln and fired, whereas standard plaster molds cannot. We were in essence treating the faience as glass, a relationship possibly seen by the Egyptians as well. Our workflow involved settling

[45] Reisner and Smith, *Giza Necropolis* 2, 29.

[46] F. Madkour, M. Khallaf, "Degradation Processes of Egyptian Faience Tiles in the Step Pyramid at Saqqara," *Procedia - Social and Behavioral Sciences* 68 (2012), 73 (§ 5.5). For a study of multicolored faience techniques, based on New Kingdom samples, see C. Riccardelli, J. Mass, and J. Thornton, "Egyptian Faience Inlay Techniques: a process for obtaining detail and clarity by refiring," *Materials Research Society Online Proceeding Library* 712 (October 2002), 1–26. And on faience in general see F. Friedman, et al., *Gifts of the Nile: Ancient Egyptian Faience* (New York, 1998), esp. 66, 72–73, and P. Nicholson and E. Peltenburg, "Egyptian Faience," in *Ancient Egyptian Materials and Technology*, 177–94. The Djoser tiles also appear in D. Patch, *Dawn of Egyptian Art* (New York, 2011), 205, fig. 49.

[47] It was inevitable that in ancient times small workshops must have used slightly different chemical compositions for their faience. The purity of the main ingredients would have impacted the texture and color of the final product. Evidence from the Cairo fragments suggests that some faience inlays consisted of individual sections, some blue, some black, while others were larger pieces overpainted to show multiple colors; Paul Nicholson, personal communication, April 29, 2015.

the faience paste into the plaster/silica mold, firing it, and then breaking away the brittle mold to free the faience tiles. The falcon-shaped arms of the chair required replacing the preliminary clay molds with modern rubber ones to create the resulting plaster/silica mold (fig. 32). Thicker faience tiles for the arms and legs were easier to produce; in these cases we returned to the ShopBot router, using the same computer model data we employed for carving the wood to produce molds for the faience. Except for some of the modern tools, we believed that this system may mirror at least portions of the ancient workflow.

Our faience paste took the following chemical composition:

Cone 010 - 06 (Tested to 09)
Gram Batch Amounts:
Soda Feldspar (Minspar) 39.0
Silica 39.0
Ball Clay (Old Mine 4) 12.0
Soda Ash 6.0
Sodium Bicarbonate 6.0

With efflorescence, the metal and silica content created a glass coating towards the top; when we altered the percentages of materials, the colors changed wildly from light to dark blues, greens, and even into black. While we were able to produce a color range from blue to green, the color that was always the most stable with the hardest surface turned out to be blue. The final faience color that worked successfully contained 3% copper (fig. 33, color fig. 34). Reisner's statement on observing blue faience tiles (see above) further encouraged us to stay with blue as the dominant color for the chair's decorative program. The firing temperature was to approximately 900 C.

In creating the faience tiles, we failed to factor in the addition of the thin gilding layers in the side walls of the inlays holes. The gold created 1/100th of an inch difference, but this nevertheless required much hand sanding to reduce and fit the faience tiles in. A tile cutter proved the best tool for cutting the faience into smaller forms.

In the case of the Horus falcons, the contents of Hetepheres's burial chamber revealed two strips of metal on one of the falcon arms, ranging from gold to black. It is possible that these could represent an intentional ancient color scheme. Perhaps silver was used on one side of the lower wing of each falcon, while gold was chosen for the other side. Over the millennia, the silver oxidized to black, while the gold retained its hue. Due to the uncertain nature of the original composition of the falcons, we opted to use gold for both sides and wings of the falcons.

Once the faience falcon wing feather inlays were complete,[48] we turned to the back of the chair with its intricate basket-weave pattern surrounding the Neith emblems. The faience was rolled into thin slabs and then cut into strips. It was then easy to break them off cleanly to create the desired length in the basket weave pattern. Towards the end of our layout preparations, we realized we had to double the size of the individual faience pieces. This larger tile size resulted from study of one of the Reisner notebook drawings, which showed the width of the bottom of the large Neith streamer relative to the faience inlays. With the completion of the Neith emblem we could determine that bottom of her streamer was the width of two faience inlay pieces, instead of three, as we had previously estimated. This reduced considerably the number of individual pieces required for the back (fig. 35).

4.4 Seating Cordage

Decades ago, both the Cairo conservators and the Boston furniture maker Joseph Gerte reconstructed their versions of the better-known chair i of Hetepheres with a simple flat wood board for a seat (fig. 36). The assumption was that a cushion would have rendered the chair more comfortable. But after closer inspection of ancient Egyptian furniture parallels, we began to suspect that this reconstruction was too simplistic, and that most Egyptian chairs displayed cordage or thatching of one form or another. Stools could show solid wood seats in panels,

[48] A useful parallel for the faience inlays on the outstretched wings is provided by the arms with winged cobras on the gold throne of Tutankhamun: M. Eaton-Krauss, "Seats of Power. The Thrones of Tutankhamun," *Kmt* 19:2 (Summer 2008), 29 = *Amarna Letters* 5 (2015), 176.

but the chair seats were most often woven. We selected a tabby (as opposed to a diagonal twill) pattern, using a \4/3\\4 open formula (fig. 37).[49]

4.5 Copper and Chair Supports

Rilled bands of copper beneath the leonine legs complete the composition of the Hetepheres chair. Limestone chair supports, in the form of truncated pyramids, would have served to raise the height of both Hetepheres chairs. Eight of these supports, four per chair, were discovered in the fill of the tomb shaft, between 22 and 24.5 m. deep. Each contained a hole about 6 cm in diameter at the top, along with a hieroglyph which, Smith believed, related to positioning of a canopy (figs. 38–39).[50] The excavators assigned the object register numbers 25-3-232, 233, 234, 235, and 236 to these limestone supports, but they never reached Boston, and have so far not been located in the Egyptian Museum, Cairo.[51] Since the diameter of the legs of chair ii measures about 5 cm, there should be a snug fit of the chair's legs into the limestone supports.

With the completion of the fabricated chair ii of Queen Hetepheres (shown in figs. 40–41), we can summarize the various elements:

19 major wood elements, each sheathed in 1–5 pieces of gold (about 57 separate pieces)
403 inlays for the flowers
414 inlays in the falcon wing feathers
376 inlays in the falcons
about 1,000 inlays in the basket weave faience pattern on the back
13 sidelock pieces
16 pieces for the Neith emblems
12 wood pieces for the back Neith
2 1/4 inch pieces of plywood for the back
2 100-foot spools of hemp
8 wood pegs
2 leather ties
black paint
Jade glue
4 pieces of copper wrap

Total: approx. 2,330 elements

1,000 person-hours, spread over 18 months

5. Iconography of Chair ii

Overall, the chair shows some affinities with other pieces of Hetepheres's furniture, indicating that they may all derive from the same (royal) workshop, despite the presence of Snefru's name on certain pieces and its absence elsewhere (more on this below). Perhaps the most eye-catching and significant elements of the chair are the six emblems (four to the front, two to the back) of the goddes Neith, and the ornate images of the falcon god Horus

[49] W. Wendrich, "Basketry," in *Ancient Egyptian Materials and Technology*, esp. 258 and fig. 10.4.

[50] Reisner and Smith, *Giza Necropolis* 2, figs. 17–18, pl. 3; M. Lehner, *The Pyramid Tomb of Hetep-heres and the Satellite Pyramid of Khufu*, SDAIK 19 (Mainz, 1985), 32 with n. 12.

[51] For a recent comparable discovery of three additional truncated supports in a non-funerary context see M. Lehner, "Discovery 2015: House of a High Official," *Aeragram* 16.1 (Spring 2015), 6, and idem, "Supporting Egypt's Archaeologists: Field Training in the Heit el-Ghurab Settlement of the Giza Pyramids," *BARCE* 207 (Winter 2015/2016), 10, fig. 10a-c. See also J. Vercoutter, "Supports de meubles, éléments architectoniques, ou 'établis'?" *BIFAO* 78.1 (1978), 81–102.

with outstretched wings, adorning both arms. The following remarks briefly touch on some of the iconographic elements of Hetepheres's second chair.

5.1 Neith (and her Arrows and Beetles)

The goddess Neith, of northern origin (Sais, red crown), was one of the most revered deities at the outset of Egyptian history. Numerous Early Dynastic queens bear names compounded with that of Neith.[52] In fact, she was so important in the Old Kingdom that the claim has been made that 40% of all names compounded with that of a deity use Neith's name.[53] (Hathor's popularity rises during and after Dynasty 4; whether we have a parallelism between Hathor and Neith in Hetepheres's two chairs will be touched upon below). Eventually, Neith comes to play many roles in the Egyptian pantheon. A cursory glance at Christian Leitz's *Lexikon der ägyptischen Götter und Götterbezeichnungen* reveals her association with a stunning array of powers, concepts, deities, and locations. In connection with the cosmos, she has affiliations with the heavens, sun, moon, stars, wind, water, earth, and the netherworld.[54] Neith is the *nbt-nt-mḥtyt*, the "mistress of the northern (fifth Lower Egyptian) Neith nome," but other epithets link her to place names in both Upper and Lower Egypt, as well as the Fayum and even Punt.[55] Along with the numerous localities to which she is attached, she is *ḥryt jb tꜣ ḏsr* "who dwells in the Necropolis," and *ḥryt tp smyt* "chief of the desert," which could apply to Giza.[56] Neith oversees aspects of the inundation,[57] and has creator god and mothering/nurturing and resurrection abilities.[58] The Neith hieroglyph is written for *ḥmswt* (*Wb.* III, 95), which Faulkner calls the "feminine counterpart of the ka" in the Pyramid Texts,[59] and James P. Allen translates as "guardian forces."[60] Neith's warfare and hunting associations such as *nbt pḏwt psḏt* "mistress of the Nine Bows,"[61] and *ḳnt m swn=s,* "brave one with her arrow" are also well documented.[62] The epithet *wpt wꜣwt* "opener of the ways," may have more to do with leading the king into battle than assisting with the opening of the mouth ceremony.[63] Neith even incorporates some androgynous elements (*ḥmt jrt ṯꜣy,* "the woman who is a man;" *ṯꜣy jr ḥmt,* "the man who is a woman;" *ṯꜣy jr ṯꜣyw,* "the man who creates men."[64] Of potential relevance to G 7000 X, she is associated on a few epithets with thrones,[65] and in a funerary context, Neith is *nbt ḳrst,* "mistress of the burial."[66]

The standard upon which the Neith symbol rests displays nothing unusual on our chair. Sheets of gold foil with cutouts, and faience inlay elements, have both survived from the tomb to indicate the form of the Neith

[52] B. Lesko, *The Great Goddesses of Egypt* (Norman, 1999), 45–63, esp 48–49; B. Begelsbacher-Fischer, *Untersuchungen zur Götterwelt des Alten Reiches* (Göttingen, 1981), 111–20 (117, source list no. 641 for Hetepheres); C. Graves-Brown, *Dancing with Hathor. Women in Ancient Egypt* (London, 2010), 163–64.

[53] Graves-Brown, *Dancing with Hathor,* 164.

[54] C. Leitz, ed., *Lexikon der ägyptischen Götter und Götterbezeichnungen* (Leuven/Paris/Dudley, 2002/2003), vol. III, 510–17, and VIII, 265–74.

[55] W. Helck, *Die altägyptischen Gaue* (Wiesbaden, 1974), 158–63.

[56] For Neith at Giza in the Old Kingdom, see el-Sayed, *La déesse Neith de Sais,* 239–51; Hetepheres is Doc. 191, 266 and pl. IV.

[57] Leitz, *LGG* VIII, 268, D1.

[58] Leitz, *LGG* III, 511, function D (28= Merneptah sarcophagus, see *KRI* IV, 68–70, and J. Assmann, "Neith spricht als Mutter und Sarg (Interpretation und metrische Analyse der Sargdeckelinschrift des Merenptah)," *MDAIK* 28 (1972), 115–39; and Leitz, *LGG* VIII, E2.

[59] Utterance 273–74, §396; R. Faulkner, *Pyr.,* 80, 83 n. 6. I am grateful to Cynthia May Sheikholeslami for bringing the *ḥmswt* to my attention in this context.

[60] J. Allen, *The Ancient Egyptian Pyramid Texts* (Atlanta, 2005), 51 (180a): "… for Unis's kas are about him, his guardian forces are under his feet…;" see also Lesko, *The Great Goddesses,* 57–58.

[61] Leitz, *LGG* VIII, 267 and 270, I.1.

[62] Leitz, *LGG* VIII, 269, H1.

[63] Begelsbacher-Fischer, *Untersuchungung zur Götterwelt des Alten Reiches,* 112.

[64] Leitz, *LGG* VIII, 269, H5.

[65] Leitz, *LGG* III, 271, O8. *ḥmst ḥr nst=s m tꜣ-šmʿw,* "who sits on her throne in Esna in Upper Egypt;" *ḥryt ḥndw m wsb n pt,* "who is upon the throne of the breadth of heaven;" *ḥryt st wrt,* "who is upon the great seat;" *ḏsrt st,* "whose seat is sacred;" *ḏsrt st m Jwnyt,* "whose seat is sacred in Esna." On comparisons between Hathor and Neith, see also el-Sayed, *La déesse Neith de Sais,* 142–43, Doc. 981, 607–608, with bibliography: "Hathor … mistress of the two seats of Neith."

[66] Leitz, *LGG* VIII, 273, U.2.

emblems (figs. 42–43).[67] The tall processional poll extends upward to end in a horizontal cross-piece, with a thicker, striated front section or platform, while a streamer billows off of it.[68] When the queen sat in the chair, her torso would have blocked the view of the Neith emblems on the front-facing side of the chair's back; and most likely few elites would have had a direct view of the additional Neith emblems on the back (assuming the chair was actually used at court during formal events, and was not constructed solely as a piece of funerary equipment). As noted above, either a horizontal cushion, a vertical one, or perhaps more likely both, seem required to offset the deep, square area of the seat, thereby forcing the queen's figure forward so that her knees might bend over the front edge of the chair. To quote today's furniture designers, admittedly regarding modern, not ancient (smaller), bodies: "The buttock-popliteal length governs the seat depth. This length, for 95 percent of both men and women, is 17 in. or 43.2 cm, or more. A seat depth not exceeding that should, therefore, accommodate a large majority of users." Note that by comparison the Hetepheres chair shows a whopping 66 cm or 26 inches in depth.[69]

On the back of the chair, the two Neith emblems are larger, and the most unusual elements are the double platforms on the standards, facing both inward and outward, along with the double streamers.[70] The pairs of arrows each face inwards, towards the center of the chair and each other, while the fletchings face outwards.

5.2 Beetles

We turn now to the actual items perched atop the divine standard. Over time, a striking evolution has taken place with these elements. In an excellent 1982 article, Stan Hendrickx argued that the Neith emblem was never associated with shields; and it is indeed true that holding a shield and bow and arrows simultaneously makes for a very unwieldy amount of weaponry.[71] Three different objects relate to Neith: the oldest is the crossed arrows, followed by the so-called bilobate object consisting of two ovals, and lastly the tied pair of bows (fig. 44). For our purposes, the two ovals are the key, as they appear on all six examples of the emblem on the Hetepheres chair. Rather than shields,[72] most scholars agree today that these grooved, connecting ovals represent the backs of the bilobate click beetles (*Agrypnus notodonta Latr*).[73] The shape devolves over time, losing its internal grooves in the Fifth Dynasty and becoming a broad oval in later periods.[74] We can find parallel examples as early as an Early Dynastic small gold beetle-shaped capsule with the Neith emblem inlaid in a "dark blue paste," from Reisner's excavations at Naga ed-Deir,[75] from the Abydos stela of Merneith, and also from the tag of Horus Aha showing

[67] For a line drawing of the front of the chair back, with the four Neith emblems and surrounding ornamentation, see Smith, *HESPOK*, 147, fig. 58.

[68] See W. Simpson, "A Horus-of-Nekhen Statue of Amunhotpe III from Soleb," *BMFA* 69, no. 358 (1971), 160–61. For a Middle Kingdom parallel, a mirror handle showing the same form, see MFA 72.4470 (provenance not known), Manuelian, *Slab Stelae*, 155, fig. 229.

[69] See Panero and Zelnik, *Human Dimension & Interior Space. A Source Book of Design Reference Standards*, 57–67, 128.

[70] The standard hieroglyph (Gardiner R12, R13 with the Horus falcon, G26 with Thoth) is called by F. Griffith, *Hieroglyphs* (London, 1898), 58, with figs. 168, 175, a "hawk-perch, with two ornamental straight plumes at the back; at the end of the horizontal bar a peg passed through it, holding a food trough," For various discussions of aspects of the standard, see H. Fischer, *Varia Nova*, Egyptian Studies III (New York, 1996), 201–3, with fig. 13; R. Shalomi-Hen, *The Writing of the Gods. The Evolution of Divine Classifiers in the Old Kingdom* (Wiesbaden, 2006), 11–38.

[71] Hendrickx, "Two Protodynastic Objects in Brussels," 23–42.

[72] Helck, *Die altägyptischen Gaue*, 158.

[73] Hendrickx, "Two Protodynastic Objects in Brussels," 26, fig. 3; L. Keimer, "Pendeloques en forme d'insectes faisant partie de colliers égyptiens," *ASAE* 31 (1931), 150, pl. 3. For a look at beetles as a clue to Old Kingdom climate change (at Abusir), see M. Bárta and A. Bezdek, "Beetles and the Decline of the Old Kingdom: Climate Change in Ancient Egypt," in H. Vymazalová and M. Bárta, eds., *Chronology and Archaeology in Ancient Egypt (The Third Millennium B.C.). Proceedings of the Conference Held in Prague June 11–14, 2007* (Prague, 2008), 215–24.

[74] Hendrickx, "Two Protodynastic Objects in Brussels," 40.

[75] G. Reisner, *The Early Dynastic Cemeteries of Naga-ed-Dêr* I (Leipzig, 1908), 31, 143–44, pl. 6 no. 1, and pl. 9a. This object derives from Dyn. 1–2 tomb N 1532 (Cairo JE 35706 = CG 53821–2); see also E. Brovarski, "Naga ed-Deir," in *LdÄ* IV, 302 with n. 40l; A. Wilkinson, *Ancient Egyptian Jewellery* (London, 1971), 14, fig. 5. The other two gold amulets from this tomb, a bull and an oryx, are illustrated in color, ibid., 15, figs. 6–7; C. Aldred, *Jewels of the Pharaohs* (London, 1971), pl. 2.

a temple dedicated to the goddess.[76] An excellent example is found on the schist plaque or temple enclosure fragment in Brussels (E 6261) discussed by Hendrickx (fig. 45).[77] This piece shows not only the Neith emblems in the same form as on the Hetepheres chair, but additional oval click beetles immediately adjacent to them. From Giza, Selim Hassan discovered a Fourth Dynasty gold necklace composed of fifty beetles that was wrapped around the neck of the deceased.[78]

The question is, What is the relationship between the click beetles and the goddess Neith? Many scholars believed there was no clear solution here,[79] but Hendrickx has followed Kaplony's and el-Sayed's focus on Neith's important association with the inundation (*srnpt wḥm ꜥnḫ r tr=f*, "who replenishes/rejuvenates the inundation waters in their time"[80]) as the connection between the goddess and the click beetle. Specifically, Hendrickx suggested that the beetle jumps to avoid the rising waters of the Nile. To connect the goddess further with sound, he has also called attention to the click or twang of arrows flying off the bow.[81]

I would like to take the Neith/beetle sound association one step further, to relate to concepts of clicking, locking, and sealing. The iconography of the click beetle appears in locations we might otherwise not expect, some of them even in Hetepheres's tomb, and on other contemporary royal monuments. For example, the beetle appears as a door latch in the cabin of the first Khufu boat, found in 1954.[82] It also forms the head of copper bolts or pins on Hetepheres's "bedroom" canopy, intended to lock the corner posts together. There are three beetle pins on each of the two front sides: one at the bottom, a second in the middle, and a third towards the top (fig. 46) All of these elements utilizing the beetle are related to clicking shut, or sealing.

This association might even bring us to a better understanding of door bolt *z/s* hieroglyph (Gardiner O34).[83] To my knowledge, the bulbous forms in the middle of the sign have yet to be explained. The more detailed versions of the hierogyph show the same grooves that we find on the Hetepheres chair Neith emblems, the bed canopy beetle pins, the Brussels shrine, and other examples (fig. 47).[84]

5.3 Sidelocks

It may be tempting to interpret the frieze of thirteen vertical elements above the four Neith emblems on the front of the chair back as royal or divine beards (fig. 48).[85] They show the same braiding and curled end as are found, for example, on the mask of Tutankhamun, right down to the color scheme.[86] Now it is true that one of

[76] For the stela of Merneith, Egyptian Museum, Cairo JE 34450 see el-Sayed, *La déesse Neith de Sais*, 236, Doc. 108, pl. 3; for Horus Aha: Hendrickx, "Two Protodynastic Objects in Brussels," 31, fig. 6; W. Petrie, *Royal Tombs of the Earliest Dynasties* II (London, 1901), pl. X.2, and el-Sayed, *La déesse Neith de Sais*, 225–26, Doc. 73, pl. 1.

[77] Patch, *Dawn of Egyptian Art*, 150, cat. 124, Naqada III–Dynasty 1 (3300–2900 BC), graywacke, Brussels E 6261; Hendrickx, "Two Protodynastic Objects in Brussels," 28–32, pl. III.2; See also Patch, *Dawn of Egyptian Art*, 151, cat. 125, beetle-shaped beads, probably Naqada III–Dynasty 1 (3300–2900 BC), mineralized bone; MMA 16.7.59; 199, cat. 180, bowl with carved relief of an anthropomorphized beetle, Dyn. 1, reign of Den.

[78] Hassan, *Gîza 2: 1930–1931*, 149, pls. 49–50, 52 (G 8887 = mastaba of shaft 294, discovered in 1930; Egyptian Museum, Cairo, GEM 6184); Aldred, *Jewels of the Pharaohs*, pl. 5; Vilímková, *Egyptian Jewellery*, 17, pl. 6.

[79] Keimer, "Pendeloques en forme d'insectes," 173; Reisner and Smith, *Giza Necropolis* 2, 31: "…there is still a curious relationship, difficult to express, between these representations of the beetle and the Goddess of Sais," citing M. Murray, *The Museums Journal, London* 47 (1947), 37 (not seen).

[80] Leitz, *LGG* III, 269, (F2); Hendrickx, "Two Protodynastic Objects in Brussels," 41–42. See also S. Quirke, *Ancient Egyptian Religion* (New York, 1992), 51: "Still another expression of the waters out of which land emerged was Neit, a goddess whose main temple stood at Sais and whose role included the masculine territory of hunt and warfare; Neit as aggressive water formed the natural mother, in Egyptian expression, to the crocodile Sobek, a god revered particularly at dangerous riverbanks where the threat of crocodiles loomed especially large…."

[81] Hendrickx, "Two Protodynastic Objects in Brussels," 42.

[82] Jenkins, *The Boat beneath the Pyramid*, 15, fig. 6.

[83] Griffith, *Hieroglyphs*, 38–39, fig. 139.

[84] See the false doors with carved doorbolts from the Giza mastaba of Seshemnefer II (G 5080 = 2200): Tübingen Inv. Nr. 4, E. Brunner-Traut, *Die Grabkammer Seschemnofers III.* (Mainz, 1977), pl. 32, and N. Kanawati, *Tombs at Giza* II (Warminster, 2002), pl. 32; Hildesheim Inv. Nr. 1540, M. von Falck and B. Schmitz, *Das Alte Reich, Ägypten von den Anfängen zur Hochkultur* (Hildesheim, 2009), 74–75, cat. 14.

[85] See the beard on the creator god (Geb?) on a fragment from a Third Dynasty Djoser shrine at Heliopolis: *Egyptian Art in the Age of the Pyramids*, 175, cat. no. 7c. For this reference I am grateful to Florence Friedman.

[86] For the beard on the Tutankhamun mask, see I. Edwards, *Treasures of Tutankhamun* (New York, 1976), 134 and pl. 12; and Hawass,

Neith's epithets was *rwy=s m ṯꜣy rꜣ ḥmt=s m ḥmt* "whose 2/3 are masculine and whose 1/3 is feminine,[87] But why would we find male beards on a chair designed for a queen and adorned with emblems of a goddess? Even the god Horus, whose falcons adorn the chair's arms, never appears in his mature form with a beard. Far more likely, then, these elements represent sidelocks associated with children and appearing most frequently in the wigs on coffins and statues of Middle Kingdom women. The feature that seems to clinch this argument is the circular element in the center of the curl at the bottom of each sidelock; this represents a spool, possibly of carnelian, around which the hair of the wig could be wound. It is not found on beards. Smith has gathered several parallels, and even speculates on a possible connection to a Libyan origin of the goddess Neith.[88] Should one want to associate the sidelocks with the Horus falcons on the Hetepheres chair arms, it is true that this deity sports a sidelock when represented as a youth, such as on cippi.[89]

5.4 Feathers and Floral Rosettes

The original excavators of G 7000 X deemed much of the ornamental decoration of the Hetepheres furniture to be "new" in the Egyptian repertoire.[90] This is not the case, however, with the flower pattern that appears on several pieces. Other scholars have already drawn connections between the "strongly stylized"[91] Hetepheres rosettes and the flowers appearing on diadems and fillets from the Old and Middle Kingdoms, among them the statue of Nofret from Meidum, diadems from Giza now in Cairo and Leipzig, and the exquisite diadem of Sit-hathor-iunet from Lahun.[92] With the Hetepheres rosettes, the four large, diagonal teardrop-shaped negative spaces between the four curving inlays seem to recall the cut-out spaces on Giza diadems that separate papyrus flowers.[93] There are either twenty-four or eighteen rosettes on Hetepheres's chair ii, depending on whether the interiors of the chair arms were actually decorated or not (we assumed that they were for our modern reproduction).[94] These appear between rows of vertical feathers, colored blue, with black midsection and black tip at the bottom, at regular intervals. Three rows of eight vertical feathers separate the three rosettes on the exterior horizontal pieces (see fig. 15 N) of the arm frames. The vertical arm rest supports (see fig. 15 K) have rows of five feathers (no rosettes). On the front-facing side of the chair's back (fig. 15 F), two groups of eleven feathers make up the outside left and right; then two groups of eight feathers separate the three rosettes. The top rail of the rear-facing side of the chair's back (fig. 15 M) shows four sections of ten feathers each between five floral rosettes. The vertical back rails (fig. 15 L) have five feathers in each row, and two rosettes each. It is interesting that the bottoms of all three back rails end, not in a rosette, but in a second row of five feathers.

Inside the Egyptian Museum, 240–41, 244.

[87] Leitz, *LGG* VIII, 269, H5.

[88] Smith, *HESPOK*, 147–48, fig. 58; Lesko, *The Great Goddesses of Egypt*, 47, 58; E. Terrace and H. Fischer, *Treasures of Egyptian Art from the Cairo Museum* (Boston, 1970), 73–76, cat. 14 (Queen Nofret); R. Freed, L. Berman, and D. Doxey, *Arts of Ancient Egypt* (Boston, 2003), 173 Hathor/Bat capital (MFA 89.555).

[89] See, for example, the Thirtieth Dynasty Metternich stela (MMA 50.85), Metropolitan Museum of Art, *The Metropolitan Museum of Art Guide* (New Haven, 2012), 57.

[90] Reisner and Smith, *Giza Necropolis* 2, 30.

[91] Smith, *HESPOK*, 146.

[92] Hawass, *Inside the Egyptian Museum*, 281, 284; Aldred, *Jewels of the Pharaohs*, 33–34, pls. 4 and 20; I fail to see the connection of Aldred's roundel drawing on p. 34 to the decorative elements from Hetepheres's tomb. See also Vilímková, *Egyptian Jewellery*, 16–17, pls. 5 and 14; D. Dunham, "An Egyptian Diadem of the Old Kingdom," *BMFA* 44, No. 255 (February 1946), 23–29. The MFA diadem, accession number 37.606a–b, from G 7143 at Giza, bears less of a relation to the Hetepheres rosettes since it contains a rising ankh sign flanked by two ibis birds. A color painting of this diadem appears in Dunham, "An Egyptian Diadem," 24, fig. 1; and see L. Keimer, "Interprétation de plusieurs représentations anciennes d'ibis," *CdE* 29, no. 58 (1954), 237–50; addendum in: *CdE* 30, no. 59 (1955), 46.

[93] Dunham, "An Egyptian Diadem," 27, figs. 7–8. S. Hassan, *Excavations at Gîza* 2: *1930–1931* (Cairo, 1936), 149, pls. 49–51 (G 8887 = mastaba of shaft 294, discovered in 1930; Egyptian Museum, Cairo SR1 4873 = GEM 6184); M. Gauthier-Laurent, "Couronnes d'orfèvrerie à bandeau de soutien de l'Ancien Empire," *RdE* 8 (1951), 79–90; R. Krauspe, ed., *Das Ägyptische Museum der Universität Leipzig* (= Zaberns Bildbände zur Archäologie, Sonderhefte der Antiken Welt) (Mainz am Rhein, 1997), 47 (D 208, shaft 9, discovered in 1903; Leipzig ÄMU 2500).

[94] Reisner and Smith, *Giza Necropolis* 2, 30.

The patterns employ groups of five, eight, ten, and eleven feathers. We can contrast this with the footboard of Hetepheres's bed, which uses nine feathers in between each of three rosettes (fig. 49),[95] and the inlaid box, which uses seven feathers in between seven rosettes.[96] Both the curtain box and the walking stick case show feathers but no rosettes.[97]

6. Conclusions

We have summarized above the excavation history of tomb G 7000 X, and the meticulous recording that allowed us in recent years to explore fabricating the second chair of Queen Hetepheres. The experimentation and discovery process, from traditional archaeology to digital archaeology to a fabricated, real-world object, provided several benefits, not least of which was the opportunity to follow the ancient Egyptian construction methodology and to gain a closer look at the decorative iconography.

There are several ways to contextualize the corpus of Hetepheres's furniture. Questions include

- Did the queen use the furniture in daily life or commission them as part of her burial assemblage?
- Were some items made during the reign of Snefru and others under Khufu?
- Is there is a symbolic comparative significance to the iconography of the different pieces of Hetepheres's furniture?

For all these questions, the fact that we are dealing with thousands of tiny fragments and modern restorations hardly simplifies our interpretation. This is especially true for the daily life versus funerary equipment question, for the disintegration of the wood has obliterated any evidence of wear and tear from repeated use.

On the dating from one reign to the next, clearly several motifs recur across different pieces of furniture, such as the feather and rosette pattern on our chair ii, on the bed footboard, and on the inlaid box, although in different number sequences. These would seem to link all the furniture to the same royal workshop. We could look to the presence or absence of royal names on certain pieces. Snefru's name appears on the bed canopy and the curtain box. Khufu's name explicitly appears only on mud seal impressions from inside decayed wooden boxes and at the bottom of the pit.[98] Are we then to infer that items lacking the name of Snefru must date to Khufu's reign? This category would include the carrying chair, the inlaid box, the bracelet box, and our chair ii. But the ornament and decorative scheme selected for an object might take precedence over the presence or absence of a royal name, so this is a dangerous interpretation at best. In fact, we seek in vain for even a specific mention of Hetepheres I as the wife of Snefru. The only title naming Hetepheres as a *ḥmt nswt* comes from a sacred oil vessel lid in a private collection, a context unrelated to G 7000 X, and that could even refer to a different Hetepheres.[99] Vivienne Gae Callender has recently taken a very cautious approach to the genealogy:

> "It is quite certain that Hetep-heres I was buried near her son *after* the death of Sneferu (as the title of *king's mother* in her tomb demonstrates) and this may have taken place a number of years after the death of Sneferu. Whether or not she was ever married to him is an unknown factor; we must not automatically assume that she was. Not one item from that tomb links the names of King Sneferu and Hetep-heres I.

[95] G. Reisner, "The Household Furniture of Queen Hetep-heres I," *BMFA* 27, no. 164 (December 1929), 88, fig. 9. Note that Reisner and Smith, *Giza Necropolis* 2, fig. 33, lower left, shows an irregular pattern of nine, then ten feathers, but this must be a modern drawing error. For a line drawing, see Smith, *HESPOK*, 147, fig. 57.

[96] Reisner and Smith, *Giza Necropolis* 2, fig. 40.

[97] Reisner and Smith, *Giza Necropolis* 2, figs. 28a–b and 46.

[98] Reisner and Smith, *Giza Necropolis* 2, 48–59, fig. 47, pl. 43c; see also Reisner, "Hetep-Heres, Mother of Cheops," 31.

[99] P. Kaplony, *Kleine Beiträge zu den Inschriften der ägyptischen Frühzeit* (Wiesbaden, 1966), 21, 272, fig. 1114. Kaplony notes that Hetepheres is the earliest example of oils labeled on vessel lids; Reisner and Smith, *Giza Necropolis* 2, fig. 41. In fact, Peter Jánosi doubts Khufu was a son of Snefru: *Giza in der 4. Dynastie* (Vienna, 2005), 62, with reference to S. Roth, *Die Königsmütter des Alten Ägypten* (Wiesbaden, 2001), 69–81, esp. 72, and additional bibliography.

Those few items of hers that are named do not mention Sneferu, even if Sneferu's name is present in her tomb."[100]

If the significant relationship was between Hetepheres and her son Khufu, rather than between Hetepheres and Snefru, then this would explain the proximity of G 7000 X to Khufu's pyramid complex, instead of an original location at Dahshur, as Reisner originally surmised.[101] And yet, the quality of the furniture is so exquisite that I find it difficult to follow Callender's suggestion that the "majority of the funerary equipment and the unwanted bric a brac of the previous reign would have been used in the burial."[102]

How should we parse the furniture items in a comparative schema in order to assess the iconography? Are there Upper Egyptian and Lower Egyptian elements to consider? Under the category of furniture representing the south we might list our chair ii (with the Horus falcons and their palmiform columns), the carrying chair (likewise with palmiform columns on the ends of the poles), and the inlaid box (with Min emblems). But here the pattern breaks down if we factor in the Neith emblems, most likely a northern feature, for chair ii. Northern elements may be found on chair i (with the three papyrus flower arms). Perhaps the two chairs should be seen in juxtaposition, with chair i emblematic of Hathor and our chair ii representative of the goddess Neith. Chair i places the queen between (arms of) papyrus, just as the Hathor cow was often traditionally portrayed."[103]

If Hetepheres's two chairs really were meant to stand in contrast with each other, despite the relative simplicity of one and the complex ornamentation of the other (as restored, of course), then we must take a closer look at the iconography of the queen's other pieces of furniture. Among them is the yet-to-be-fabricated elaborate inlaid box, with emblems of the god Min, rosettes and additional inscriptions (fig. 50).[104] The remarks above will hopefully serve as guideposts for future research that will either confirm or overturn some of the suggestions and conclusions drawn here. The last word has yet to be written on the tomb, its discovery, unique material record (figs. 50–51), and the ancient motivation behind one of the most intriguing archaeologial finds from any Egyptian cemetery or era.

Acknowledgments

For both local and international collaboration in completing this project, I am grateful to the Egyptian Ministry of State for Antiquities, and the Egyptian Museum, Cairo: Minister of Antiquities Dr. Khaled el-Enany, Egyptian Museum, Cairo, Director General Sabah Abdel Razek, Assistant to the Minister for Museum Affairs Yasmin el-Shazly, conservator Nadia Lokma, and Eman Amin of the Museum's Registration, Collections Management and Documentation Department. Special thanks go to Rus Gant and David Hopkins of the Giza Project, Harvard University, for the realization of the Hetepheres chair. Rus Gant conceived of the concept, and David Hopkins carried out most of the computer work and physical construction. They were aided by Kathryn King, Director of Education, Ceramics Program, Office for the Arts at Harvard, and her Ceramics Associate, Darrah Bowden (faience production), and conservators Christine Thomson and her assistant, Wenda Kochanowski (gilding). Consulting help was also provided by Gordon Hanlon and Meredith Montague (both from the Museum of Fine Arts, Boston), Susanne Gänsicke, from the J. Paul Getty Museum, and Egyptologists Florence Friedman (Brown University), Paul Nicholson (Cardiff University), and Marianne Eaton-Krauss (Berlin). And as always, for fruitful Giza collaboration, I thank my curatorial colleagues from the Department of Art of the Ancient World at the Museum of Fine Arts, Boston: Rita Freed, Larry Berman, and Denise Doxey. For archival

[100] Callender, *In Hathor's Image* I, 62–63.

[101] Reisner, "Hetep-Heres, Mother of Cheops," 31.

[102] Callender, *In Hathor's Image* I, 65: "All we can honestly say about her relationships is that she was the mother of Khufu, the grandmother of Hetep-heres II and Djedefre—and probably of Kawab, Khafukhufu I, Horbaf and Meresankh II and great-grandmother of Queen Meresankh III, but other relationships are uncertain."

[103] Lesko, *The Great Goddesses*, 85. For a suggestion that the seated image of Hetepheres sniffing a blossom could have adorned the back of Hetepheres's simpler chair I (see our color fig. 51), see Johnson, "The Mysterious Cache-Tomb of Fourth Dynasty Queen Hetepheres," 40, 49–50, cited by Eaton-Krauss, "Seats of Power. The Thrones of Tutankhamun," 31 = *Amarna Letters* 5 (2015), 175.

[104] Reisner and Smith, *Giza Necropolis* 2, 36–40, figs. 38, 40.

assistance with documents and footage relating to G 7000 X I am also indebted to Cat Warsi of the Griffith Institute, University of Oxford, and Benjamin Singleton, Moving Image Research Collections, University of South Carolina.

Research and Egyptological support came from the Giza Project staff at Harvard University: Rachel Aronin, Nicholas Picardo, and Jeremy Kisala. The installation of the chair exhibit in the Harvard Semitic Museum took place with assistance from Museum staff Joseph Greene, Adam Aja, Kristen Vagliardo, and Adam Middleton, and the design and exhibition expertise of staff from the Harvard Museums of Science and Culture: Jane Pickering (director), Janis Sacco, Sam Tager, and Tristan Rocher. The installation video was created by the author and Jennifer Berglund (Harvard Semitic Museum: http://bit.ly/2g89K9I, Youtube: http://bit.ly/2g89K9I). An educational video was also produced, in collaboration with our partners at Dassault Systèmes (http://bit.ly/2frzSe2). I thank Peter Lu for photographing the chair in the Harvard Semitic Museum with a PhaseOne IQ3 100-megapixel medium format back on an Arca Swiss technical camera (see fig. 40).

The 3D models rely in part on our collaboration with Dassault Systèmes, and I am particularly grateful to Mehdi Tayoubi, and his colleagues Karine Guilbert, Richard Breitner, Nicholas Serikoff, Emmanuel Guerriero, Fabien Barati, and Pierre Gable. ShopBot Tools generously provided us with the loan of a 3-axis CNC milling machine. Gold sheets were purchased from Epner Technology, Brooklyn, NY. Additional 3D modeling expertise, and the use of larger format ShopBot routers was provided by Neil Gershenfeld, director of the Center for Bits and Atoms, MIT.

I am grateful for two different grants from Harvard University that made the construction of the Hetepheres chair possible; these came from the Anne and Jim Rothenberg Fund for Humanities Research (2013), and the Provostial Fund for Arts and Humanities (2015). A third grant, from the Publications Fund for Tenured Faculty, provided the subvention for printing images in color in this journal.

Harvard University

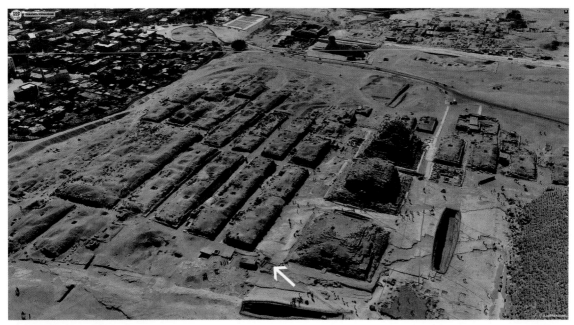

Fig. 1. Aerial view of the Eastern Cemetery, looking southeast, with the location of G 7000 X indicated by white arrow. 10/7/2011. Courtesy of AirPano.com.

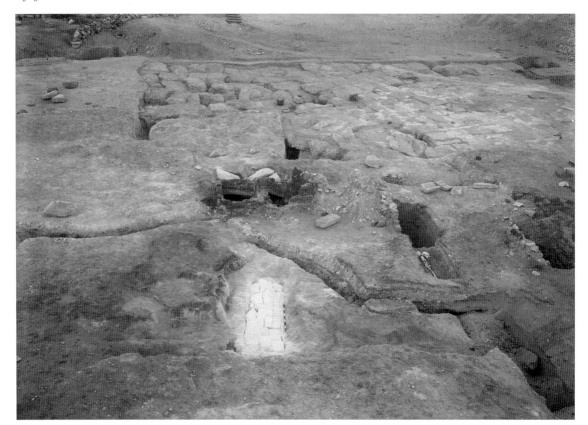

Fig. 2. G 7000 X, course I in stairway after removal of plaster fill, looking north. 02/20/1925, Photograph by Mohammedani Ibrahim (B5632). HU-MFA Expedition, courtesy MFA, Boston.

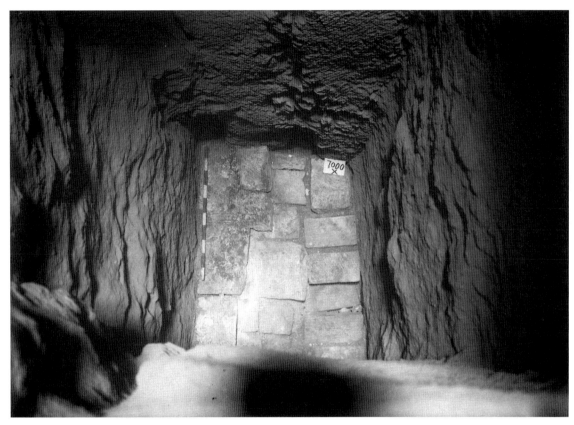

Fig. 3. G 7000 X, pit blocks at 24.8 meters from mouth, looking north. 03/07/1925. Photograph by Mohammedani Ibrahim (B5671A). HU-MFA Expedition, courtesy MFA, Boston.

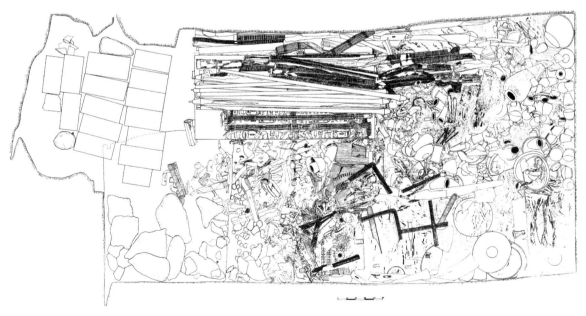

Fig. 4. G 7000 X, plan of chamber as found. Reisner and Smith, Giza Necropolis 2, fig. 19.

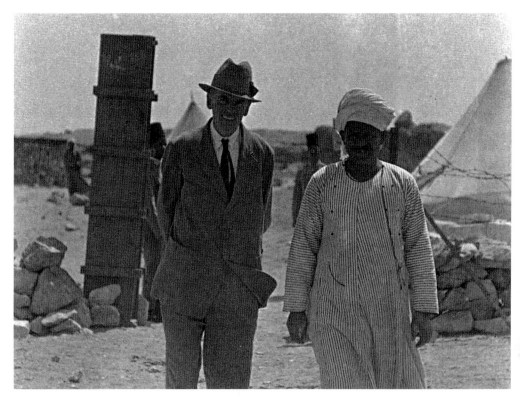

Fig. 5. Alan Rowe and Said Ahmed Said, in front of G 7000 X, pose for Fox news cameraman Ben Miggins, probably March 21, 1925, looking south. Courtesy Moving Image Research Collections, University of South Carolina.

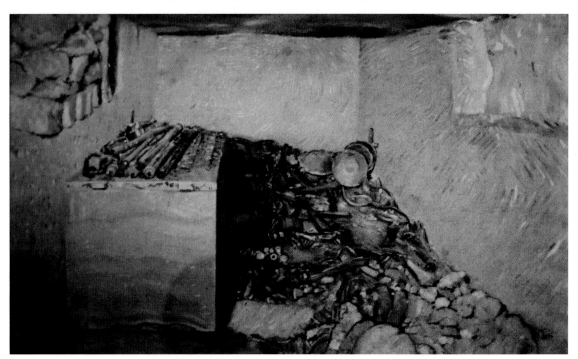

Fig. 6. G 7000 X, plan of chamber as found; oil on canvas painting by Joseph Lindon Smith (1863–1950), 38.5 x 64 cm (15 3/16 × 25 3/16 in.). Anonymous gift; courtesy of the descendants of Joseph Lindon Smith, MFA 27.388. Photograph by the author.

Fig. 7. G 7000 X, general view of south deposit, looking northeast, before work commenced; fifth photo of the day, 09/25/1926. Photograph by Mustapha Abu el-Hamd (A4231). HU-MFA Expedition, courtesy MFA, Boston.

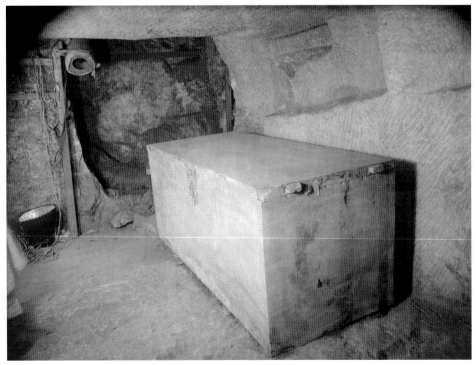

Fig. 8. G 7000 X, sealed sarcophagus (Cairo JE 51899) in cleared chamber, looking northeast, 02/27/1927. Photograph by Mohammedani Ibrahim (A4587). HU-MFA Expedition, courtesy MFA, Boston.

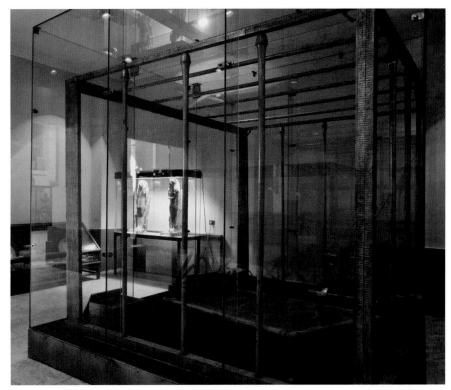

Fig. 9. Restored furniture of Queen Hetepheres, Egyptian Museum, Cairo. Photograph by Sandro Vannini.

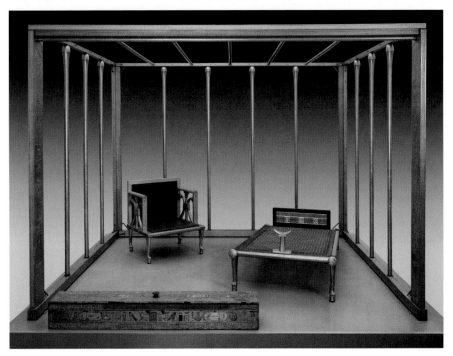

Fig. 10. Modern reproductions of Hetepheres's furniture in the MFA, Boston: canopy (38.873), headrest (29.1859), chair i (38.957), curtain box (39.746), bed (29.1858) (SC63207). Courtesy MFA, Boston.

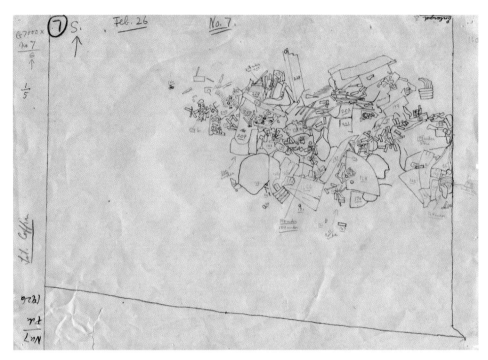

Fig. 11. G 7000 X, sample drawing of contents of the deposit, with gold objects in red ink, wood and other types of objects in purple, and stones and walls in black, 2/26/1926. HU-MFA Expedition Archives.

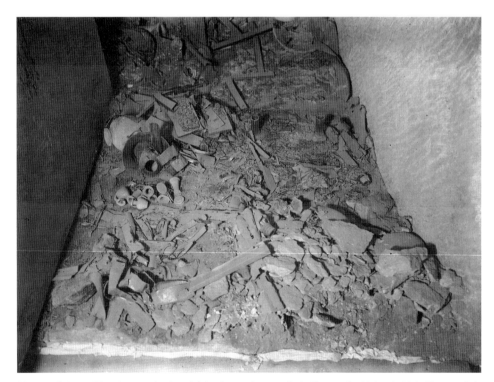

Fig. 12. G 7000 X, "view c" of strip adjoining lower pit on south, looking south, 02/15/1926. Photograph by Mustapha Abu el-Hamd (A3693). HU-MFA Expedition, courtesy MFA, Boston.

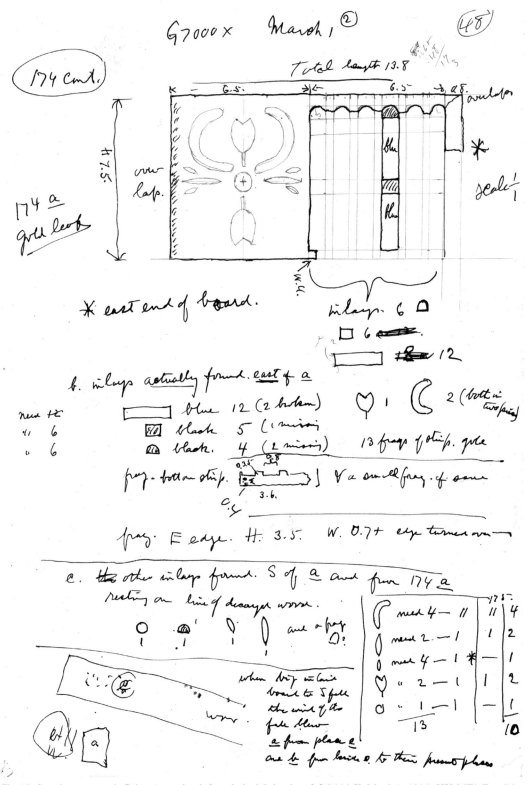

Fig. 13. Sample notes page, in Reisner's own hand, from the burial chamber of G 7000 X, March 1, 1926. HU-MFA Expedition Archives.

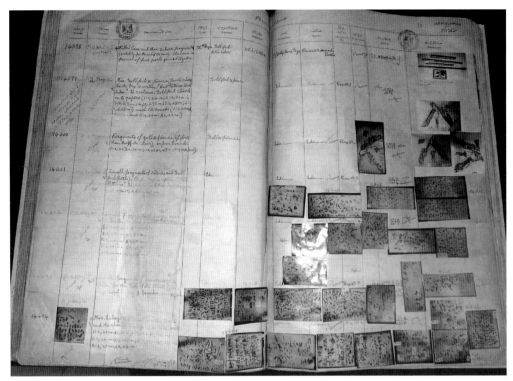

Fig. 14. Egyptian Museum, Cairo, sample view of Journal d'Entrée containing objects and photographs from G 7000 X. Courtesy Egyptian Museum, Cairo.

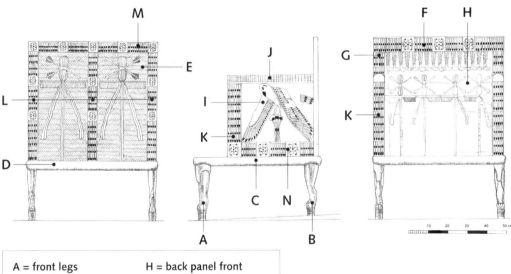

A = front legs	H = back panel front
B = rear legs	I = arm decoration
C = seat rails	J = arm rest
D = cross rails	K = arm rest support
E = back panel rear	L = vertical back rails
F = top rail front	M = top rail rear
G = vertical front rails	N = bottom rail of arm rest

Fig. 15. Reconstruction scale drawing of chair ii of Hetepheres, with annotations by the author; after Reisner and Smith, Giza Necropolis 2, fig. 32.

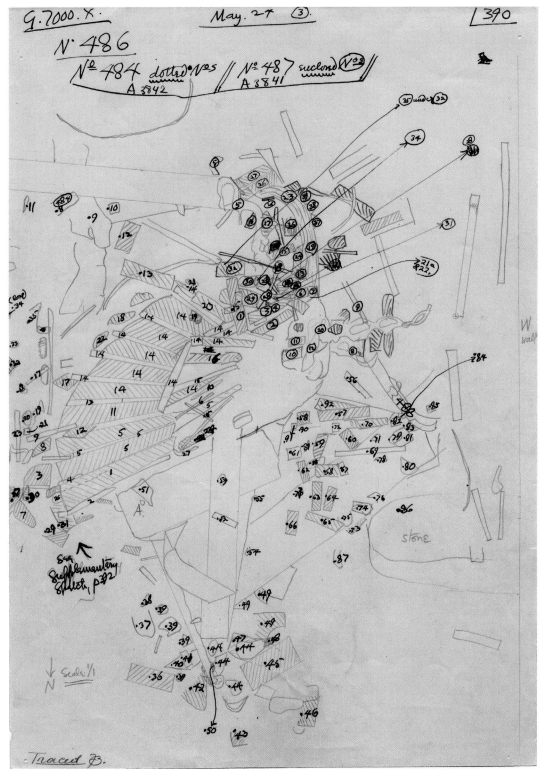

Fig 16. G 7000 X, sketch plan by Noel Wheeler of burial chamber deposit, showing wing fragments of the chair ü falcon arms; HU-MFA Expedition notes, 390, May 24, 1926.

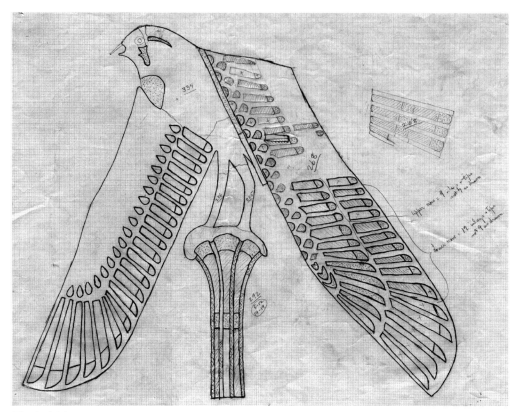

Fig 17. Original reconstruction drawing by Reisner's expedition staff of one of the falcon arms. HU-MFA Expedition Archives.

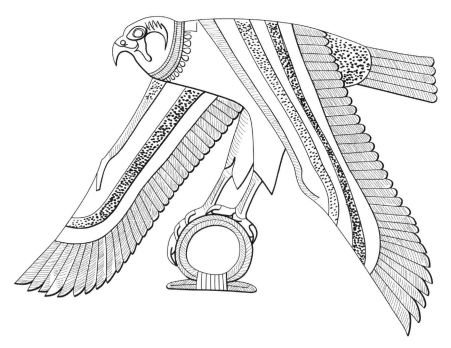

Fig. 18. Digital epigraphy of one of six falcons on the bed canopy of Hetepheres, top left side; Egyptian Museum, Cairo JE 57711. Uncollated drawing by Vera Jin, Harvard University.

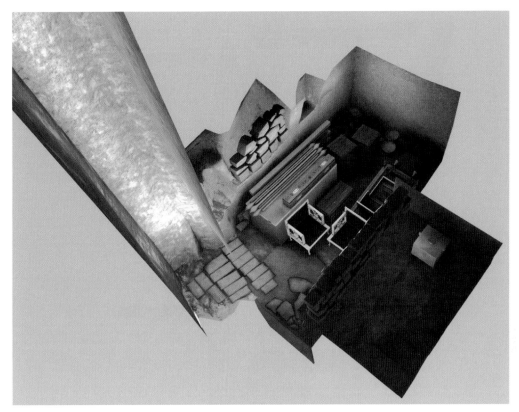

Fig. 19. 3D model view down the shaft of G 7000 X and into the reconstructed burial chamber. Image by David Hopkins and Rus Gant. Courtesy the Giza Project, Harvard University, and Dassault Systèmes.

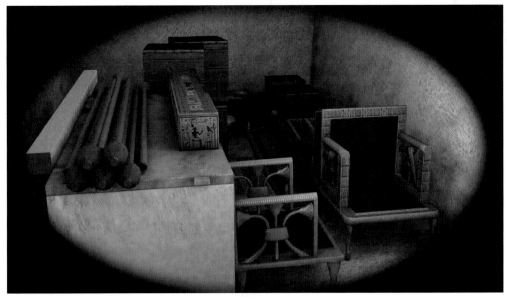

Fig. 20. 3D model view into the reconstructed burial chamber of G 7000 X. Image by David Hopkins and Rus Gant. Courtesy the Giza Project, Harvard University, and Dassault Systèmes.

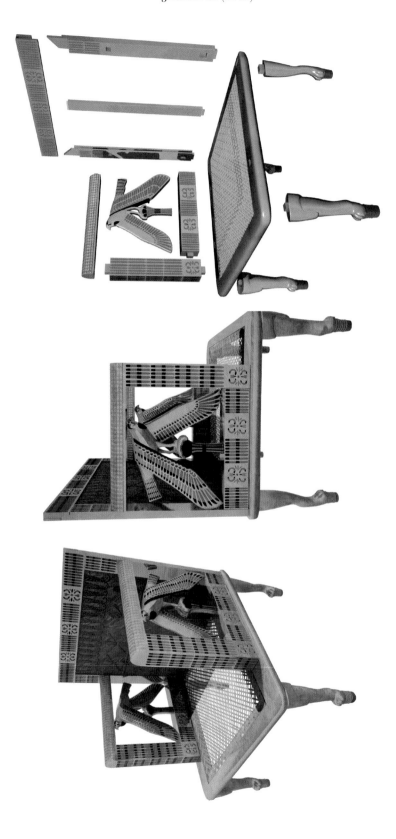

Fig. 21. Chair ii of Hetepheres, 3D model and exploded view. Image by David Hopkins. Courtesy the Giza Project, Harvard University.

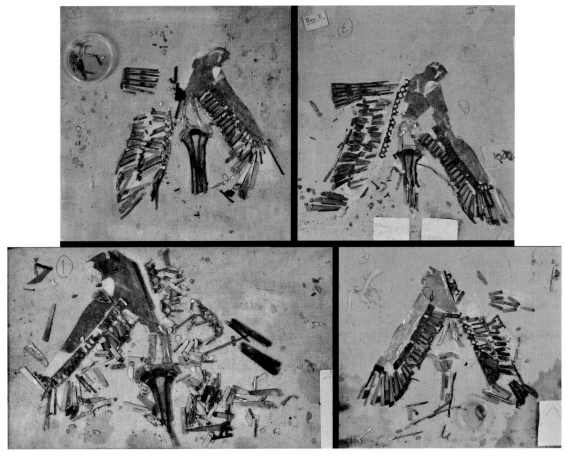

Fig. 22. *Original ancient fragments of the falcons from the arms of Hetepheres's chair ii, Egyptian Museum, Cairo, part of SR 1/16599 to SR1/16610. Courtesy Egyptian Museum, Cairo.*

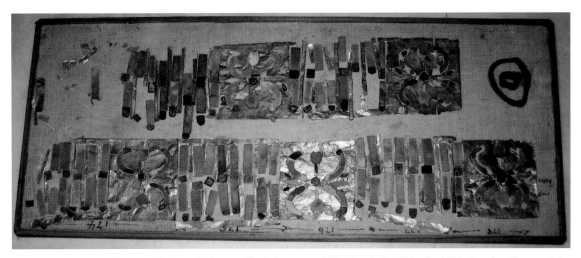

Fig. 23. *Original ancient fragments of the exterior bottom rails of the armrest of Hetepheres's chair ii (see fig. 15 N), Egyptian Museum, Cairo, part of SR 1/16599 to SR1/16610. Courtesy Egyptian Museum, Cairo.*

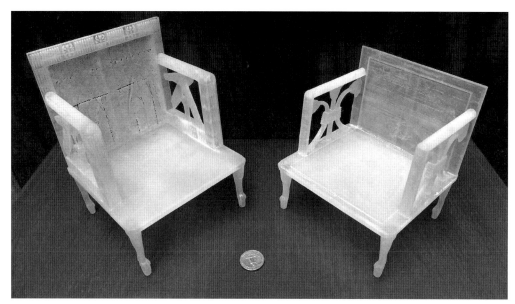

Fig. 24. Small-scale 3D prints of both chairs i and ii from G 7000 X, prepared by Rus Gant and David Hopkins, Giza Project, Harvard University. Photograph by Rus Gant. Courtesy the Giza Project, Harvard University.

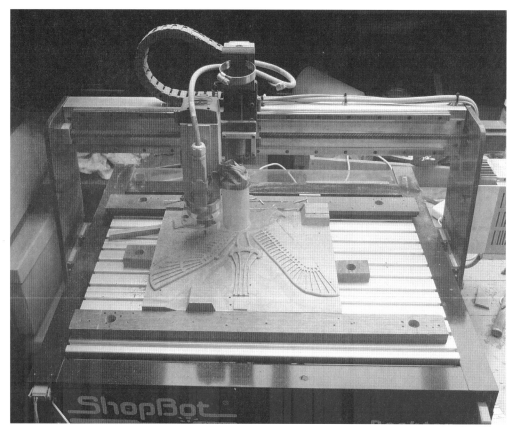

Fig. 25. Computer-controlled ShopBot Tools CNC router carving one of the modern falcon arms for Hetepheres's chair ii. Photograph by the author.

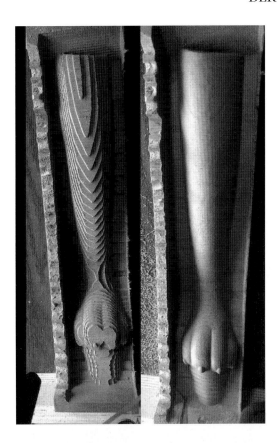

Fig. 26. *Modern leonine legs from Hetepheres's chair ii at various stages of carving by the computer-controlled ShopBot Tools CNC router. Photo by Rus Gant.*

Fig. 27. *General view of all the modern wooden elements of Hetepheres's chair ii, prior to assembly. Photograph by the author.*

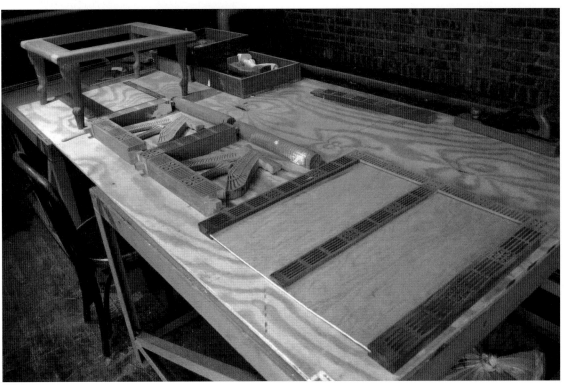

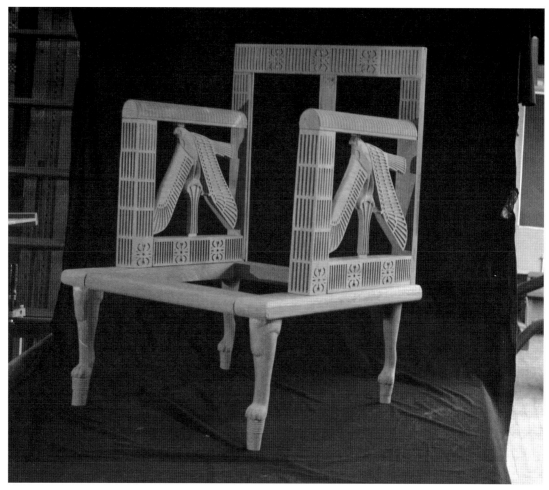

Fig. 28. Dry mount test assembly of all the modern wooden elements of Hetepheres's chair ii. Photograph by Rus Gant.

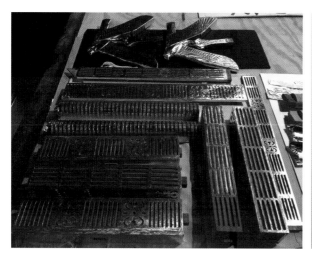

Fig. 29. Modern gilded wooden elements of Hetepheres's chair ii. Photograph by the author.

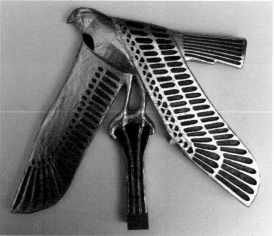

Fig. 30. Modern gilded falcon wing from one of the chair arms, prior to the inlay of faïence tiles. Photograph by Rus Gant.

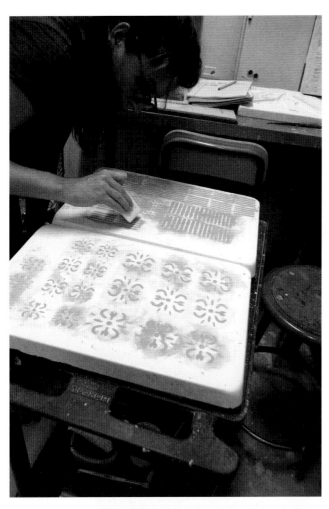

Fig. 31. Modern plaster-silica molds carved by computer-controlled ShopBot CNC router, filled with faience paste. Photograph by Rus Gant.

Fig. 32. Modern rubber and plaster-silica falcon arm molds for the chair. Photograph by Rus Gant.

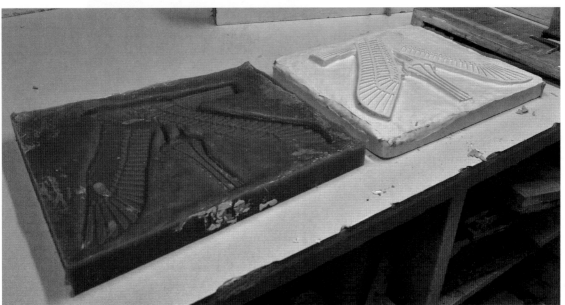

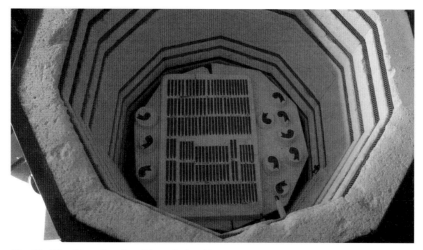

Fig. 33. Kiln firing of modern faience feather tiles, and sidelock elements for the back of the chair. Photograph by Rus Gant.

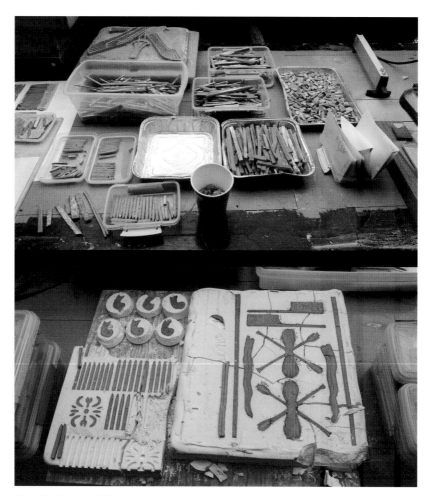

Fig. 34. Modern fired faience elements, both in their plaster-silica molds and after removal. Photographs by Rus Gant.

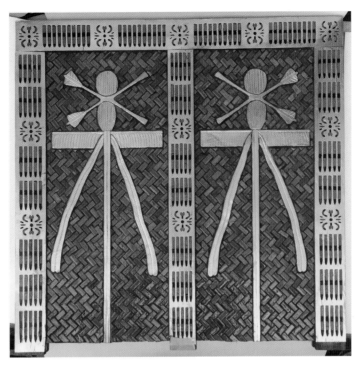

Fig. 35. Detail of the exterior side of the back of Hetepheres's modern chair ii with faience and Neith emblems. Photograph by the author.

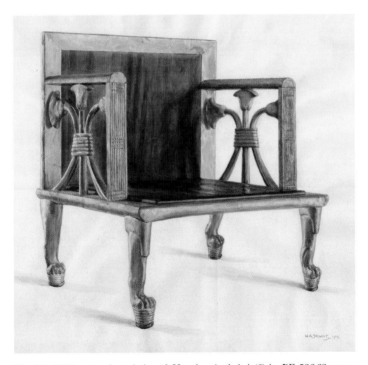

Fig. 36. 1929 watercolor painting of Hetepheres's chair i (Cairo JE 53263; reproduction = MFA 38.957) by William A. Stewart. HU-MFA Expedition Archives (EG021372).

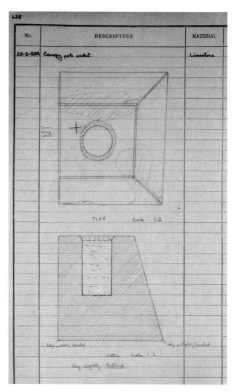

Fig. 37. Detail of seating cordage for Hetepheres's modern chair ii fabrication. Photograph by the author.

Fig. 39. HU-MFA Expedition Object Register 12, page 638, with drawing of limestone cone support 25-3-232 (mislabeled as canopy pole socket).

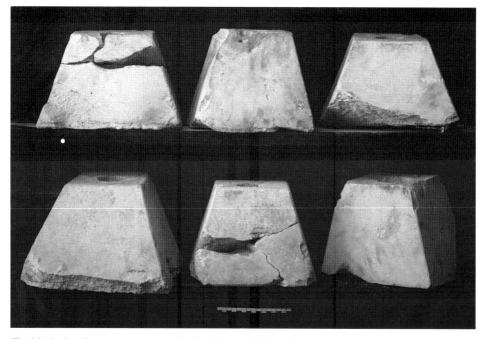

Fig. 38. Ancient limestone cone supports for Hetepheres's chair legs, from the shaft of G 7000 X, 06/27/1925. Photograph by Mohammedani Ibrahim (C10960). HU-MFA Expedition, courtesy MFA, Boston.

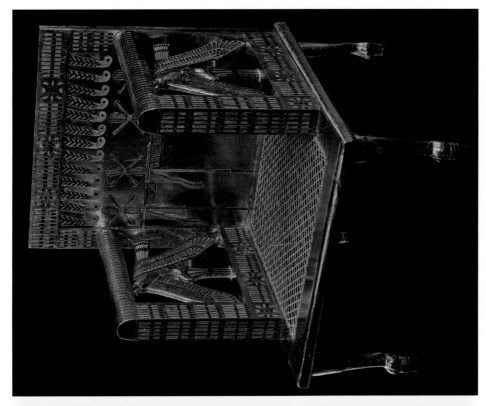

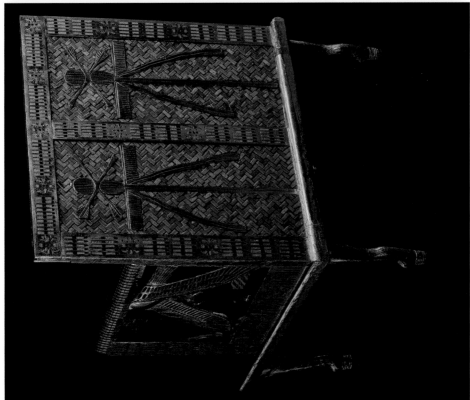

Figs. 40a–b. Two views of modern fabrication of chair ii of Hetepheres (Harvard Semitic Museum 2015.2.1); cedar, faience, gold foil, copper, and cordage. Photographs by Peter Lu, using a PhaseOne IQ3 100-megapixel medium format back on an Arca Swiss technical camera.

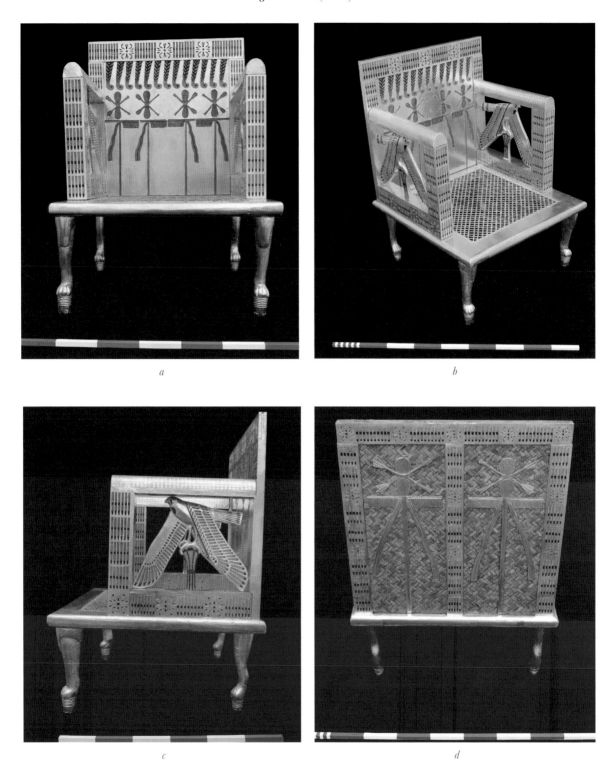

a

b

c

d

Figs. 41a–d. Four views of modern fabrication of chair ii of Hetepheres (Harvard Semitic Museum 2015.2.1). Photographs by Rus Gant.

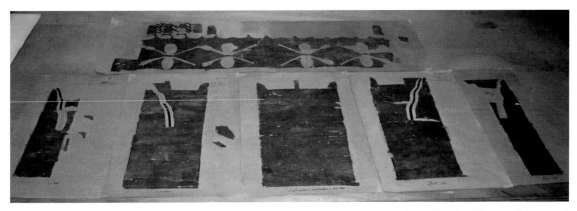

Fig. 42. Ancient gold foil "cut-outs" from the back of Hetepheres's chair ii, showing the Neith emblems. Egyptian Museum, Cairo, part of SR 1/16599 to SR1/16610. Photograph courtesy Egyptian Museum, Cairo.

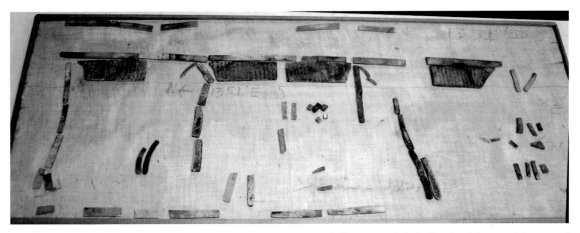

Fig. 43. Ancient faience platforms from the Neith emblems, from the back of Hetepheres's chair ii. Egyptian Museum, Cairo, part of SR 1/16599 to SR1/16610. Photograph courtesy Egyptian Museum, Cairo.

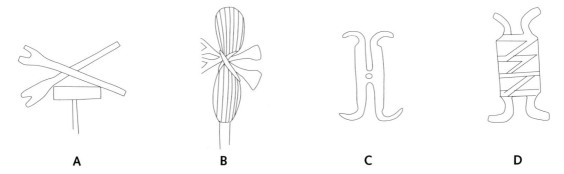

A **B** **C** **D**

Fig. 44. Evolution of the Neith emblem, from the Protodynastic period to the Old Kingdom, after Hendrickx, "Two Protodynastic Objects in Brussels," 39, fig. 11. A = F. von Bissing, Re-Heiligtum, 7, no. 17. B = Brussels E.6261. C = W. Emery, Great Tombs of the First Dynasty III (London 1958), pl. 39. D = H. Wild, Ti 3, La chapelle, 2ᵉ partie, pl. 164. Schematic redrawing by the author (not true facsimiles).

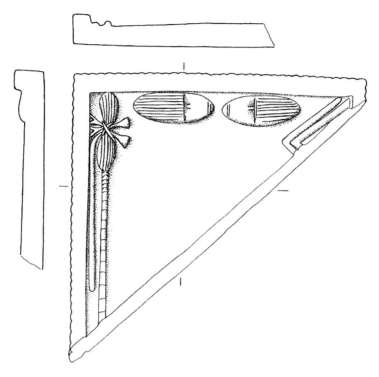

Fig. 45. Fragment of a rectangular palette, adorned with beetles and Neith emblems (Brussels E.6261), after Hendrickx, "Two Protodynastic Objects in Brussels," 28, fig. 5.

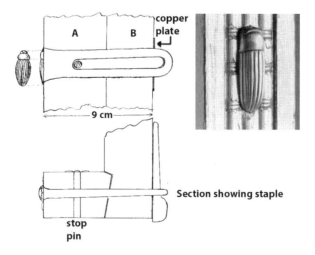

Fig. 46. Beetle-shaped pin, one of three on each side of Hetepheres's bed canopy; line drawing by W. Stewart, courtesy Griffith Institute, University of Oxford. Photograph detail by the author from modern reproduction in Boston (MFA 38.873).

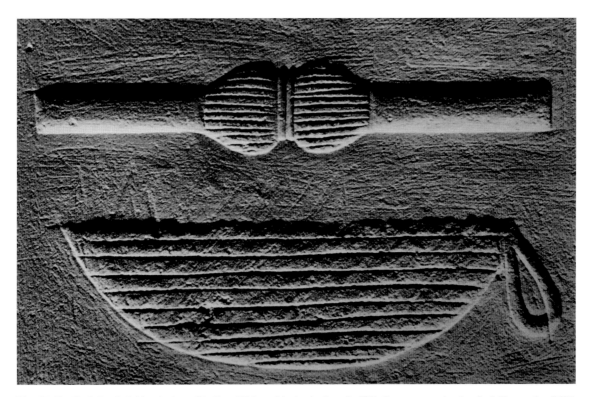

Fig. 47. Detail of door bolt hieroglyphs z (Gardiner O34) and basket k, from the Fifth Dynasty mastaba chapel of Kayemnefret (MFA 04.1761). Photograph by Rus Gant.

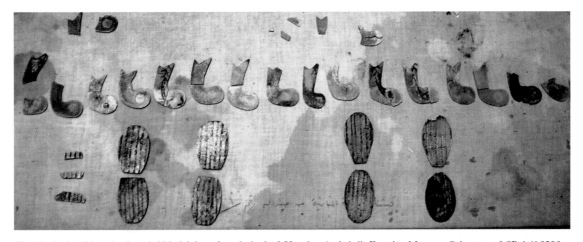

Fig. 48. Ancient faience beetle and sidelock inlays, from the back of Hetepheres's chair ii, Egyptian Museum, Cairo, part of SR 1/16599 to SR1/16610. Photograph courtesy Egyptian Museum, Cairo.

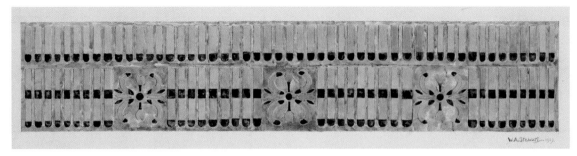

Fig. 49. 1929 modern watercolor painting by William A. Stewart of footboard from Hetepheres's bed (reconstruction = Cairo JE 53261; reproduction = MFA 29.1858), showing the color scheme for the feathers and floral rosettes. HU-MFA Expedition Archives (EG023583).

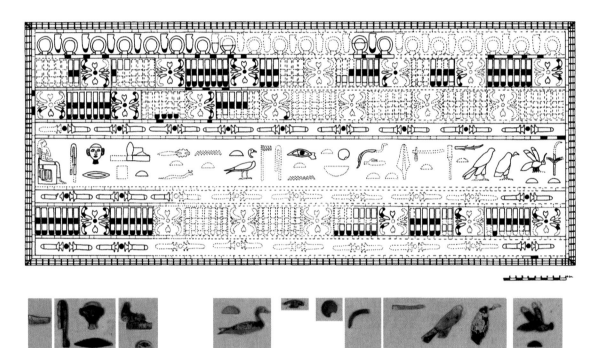

Fig. 50. Line drawing of the inlaid box from G 7000 X with a selection of the surviving ancient fragmentary hieroglyphs of Hetepheres, montaged by the author; Egyptian Museum, Cairo, part of SR 1/16599 to SR1/16610. Photograph courtesy Egyptian Museum, Cairo; compare Reisner and Smith, Giza Necropolis 2, fig. 40 and pl. 35b.

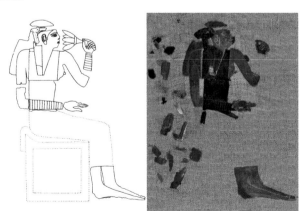

Fig. 51. Ancient seated figure of Hetepheres, Egyptian Museum, Cairo, SR 1/14609 = GEM 6191; Reisner and Smith, Giza Necropolis 2, fig. 30 and pl. 14a, and photo courtesy Egyptian Museum, Cairo; montage by the author.

An Unpublished Lintel of Ahmose-Nebpehtyre from El-Atâwla

Abdalla Abdel-Raziq

Abstract

Publication of a rectangular slab of sandstone once formed the right part of a lintel of unknown dimensions that still preserved areas of the original paint, most probably of a doorway or entrance of the lost temple (or a chapel) of the god Nemty at Per-Nemty, from the time of king Ahmose-Nebpehtyre the founder of the Eighteenth Dynasty.

In August 1988,[1] staff members of the Egyptian Antiquities Organization in Assiut at that time, received word that during the digging of a vertical sewage well in the court of the house of a local named Abdel-Aziz Mahmoud Ali Diab, of ʿArab El-Atâwla village,[2] Al-Fatḥ District at Assiut (Asyut) Governorate, the owner stumbled, approximately at a depth of five meters, on a rectangular slab of sandstone of particular interest. The unearthed object was recorded then moved immediately by the Authorities of the EAO to Al-Ashmunein Antiquities Storeroom, Gallery no. 4, the place where it is still stored. According to the register of seizures of Antiquities for the Assiut region (north and south) kept now in the magazine of Shutb (a small village situated about seven kilometers south of the city of Assiut), the slab bears the identification number 317. Although the slab was discovered in 1988, it was not published. This article aims to shed light on an important piece that could provide new evidence that helps in the localization of the temple of Nemty and therefore of the capital of the Upper Egyptian Twelfth Nome.

Description

The object, which forms the subject of this article, is a slab of poor-quality sandstone, measuring (maximum) 68 cm high, 122 cm wide and 15 cm thick. It is worked on one face only, decorated with figures and hieroglyphs

[1] Thanks are due to the Director General of Asyut, Mr. Abd El-Satar Ahmed Mohamed, to the Director of the magazine at Shutb, Mrs. Nadia Naguib, to the inspector Mr. Medhat Fayez and to the inspector of the magazine at Shutb Mr. Tarek Hassan for the full cooperation and encouragement that I received from them during the fieldwork. I also wish to acknowledge the assistance provided by the anonymous reviewers of *JARCE* for numerous helpful and valuable comments at different stages of writing.

[2] El- Atâwla or ʿArab El-Atawla (also known as Al Atawilah, Al Atawila, Al Aṭāwilah, El Aṭaula, El Atawla and El-Atayla) is a modern-day village, situated on the right bank of the Nile barely 5 km northeast of Asyut/Assiut city, derived its modern (or recent) name from the family of Tayel (Taïl) who established or dwelled it. This village was also known at first as El-Kanaïs (namely, churches), because of the existence of the ancient ruins of temples or churches. According to Kamal the remains of the capital of the Twelfth Upper Egyptian Nome are here. From the Old Kingdom onward the dead from this old settlement were buried in the tombs of an old necropolis located to the south east of the modern-day village ʿArab Mieteir (also known before as ʿArabe-el-Borg). The distance between the two villages is only about 3.5 km. Both places are new establishments with a "Bedouin" population, who have taken the place on the land of two different older communities, namely, the municipalities of al-Hammam for ʿArab Hetam> ʿArab-el-Borg> ʿArab Mieteir. And Bani ʿlieg for (ʿArab) El-Atâwla. A. Kamal, "Rapport sur la nécropole d'Arabe-el-Borg," *ASAE* 3 (1902), 80–81; Muḥammad Ramzī, *Al-Qāmūs al-Jughrāfī lil-Bilād al-Misriya min ʿahd Qudamāʾ al-misriyyīn ilā Sanat 1945*, Abt. (*qism*) II Teil (*guz2*) 4 (Cairo, 1994), 11–12; N. Alexanian, "Die provinziellen Mastabagräber und Friedhöfe im Alten Reich," Bd. I, PhD diss., Heidelberg University, 2016, 203–5; J. Horn, "Einleitung: Zu Topographie und Archäologie des Gebietes des 12. oberägyptischen Gaues," in D. Kurth and U. Rößler-Köhler, eds., *Zur Archäologie des 12. oberägyptischen Gaues. Bericht über zwei Surveys der Jahre 1980 und 1981, GOF* IV.16 (Wiesbaden, 1987), 26, 29–30.

Journal of the American Research Center in Egypt 53 (2017), 47–55
doi: http://dx.doi.org/10.5913/jarce.53.2017.a002

executed in sunk-relief (figs. 1–2). The back face is rough and full of chisel marks. The piece seems to be the lintel of a doorway or entrance of a temple (or a small shrine) of the god Nemty at Per-Nemty, from the time of king Ahmose-Nebpehtyre (Ahmose I)[3] dated to the beginning of the Eighteenth Dynasty. At first glance, however, it is clear that this slab formerly was a part of a panel, perfectly divided into two symmetrical or parallel parts, that the existence of two representations of the seated god, back to back, allow the conclusion that the slab originally consisted of two symmetrical offering scenes of king Ahmose-Nebpehtyre, founder of the Eighteenth Dynasty, offering to the god *Nemty*, separated by a vertical line of carved hieroglyphs, runs from right to left and reads:

ḏd mdw di.n(.i) n(.k) ꜥnḫ wꜣs nb ḏdt nb snb nb ꜣwt-ib mi Rꜥ nb

Words spoken, I have given to (you)[a] all life and dominion, all stability, all health, and all joy like Re.

The upper part of the lintel under discussion is covered by a single line of horizontal inscription, which runs in two opposite directions and identifies the king Ahmose-Nebpehtyre; each one of them starts from the same participated word (sign) Ankh except the Birth name (also called the Nomen) of king Ahmose-Nebpehtyre which is incised vertically, irregularly without cartouche, due to lack of space. The first line runs horizontally from left to right and reads:

ꜥnḫ nṯr nfr nb tꜣwy nb irt-ḫt (Nb-pḥty-Rꜥ)| sꜣ Rꜥ Tꜥḥ-ms

May the good god live, the Lord of the Two Lands, Lord of Doing Effective Things,[4] Nebpehtyre, Son of Re, Ahmose.

Notably, only the right register of the lintel is complete while a large part of the left one is missing. It shows king Ahmose-Nebpehtyre standing facing left, wearing the royal circlet or diadem with uraeus, named the *Seshed* (*sšd*) or *Medjeh* (*mdḥ*)[5] headdress,[6] fixed on a short wig, broad collar necklace, a short kilt with ceremonial bull tail. He is shown presenting two elegant globular or rounded jars (*nw*-pots) of wine (*irp*) closed by means of a conical lid, to a seated figure (image) of the falcon-headed god Nemty who was worshipped in the Tenth and Twelfth nomes of Upper Egypt, in the region of Asyut (Assiut). Opposite to the king, Nemty appears *seated* on his throne, his face is shown in profile turned to the right to face king Ahmose-Nebpehtyre, a longer over-skirt extending to his ankles. Nemty is depicted wearing a short kilt holding the *wꜣs*-scepter, diagonally across his body, with his

[3] H. Gauthier, *Le livre des rois d'Égypte: Recueil de titres et protocoles royaux*, Vol. 2, *De la XIIIᵉ dynastie à la fin de la XVIIIᵉ dynastie*, MIFAO 18 (Cairo, 1912), 175–96; J. von Beckerath, *Handbuch der ägyptischen Königsnamen*. 2nd ed., MÄS 49 (Mainz, 1999), 132–33. With the recent discovery of King Senakhtenre Ahmose I (Dynasty 17:26), the founder of the Eighteenth Dynasty must now be referred to as "Ahmose the Second." See S. Biston-Moulin, "Le roi Sénakht-en-Rê Ahmès de la XVIIᵉ dynastie," *ENIM* 5 (2012), 61–72; Ronald J. Leprohon, *The Great Name: Ancient Egyptian Royal Titulary*, Writings from the Ancient World 33 (Atlanta, 2013), 91, 95–96.

[4] However, Routledge points to frequent translations of the term as "lord of performing cultic rites," "lord of action," "action-meister," and "Cult-master." She suggests that such titles fail to adequately express the meaning of the title in question. After extensive discussion, Routledge in fact suggests that *nb irt-ḫt* might be translated as "Lord of Doing Effective Things" with the understanding that it refers to the duty of the king to perform physical actions that promote Maꜥat. For this title see. C. Routledge, *Ancient Egyptian Ritual Practice: ir-ḫt and nt-ꜥ*, PhD diss., University of Toronto, 2001; idem, "The Royal Title *nb irt-ḫt*," *JARCE* 43 (2007), 193–220.

[5] For the *seshed* headdress see. S. Collier, "The Crowns of Pharaoh: Their Development and Significance in Ancient Egyptian Kingship," PhD. diss., University of California, Los Angeles, 1996, 61–67; A. von Lieven, "Schlange, Auge, Göttin: Das Diadem aus der Sicht des alten Ägypten," in A. Lichtenberger, et al., eds., *Das Diadem der hellenistischen Herrscher*. Übernahme, Transformation oder Neuschöpfung eines Herrschaftszeichens, EUROS 1 (Bonn, 2012), 35–54; K. Goebs, "Crown (Egypt)," *Iconography of Deities and Demons: Electronic Pre-Publication, Last Revision*: 14 Apr (2015), 9–10.

[6] There is, however, no evidence to suggest a fixed relationship between the offering objects and the crowns that the king wears in the rituals. See Mu-chou Poo, *Wine and Wine Offering in the Religion of Ancient Egypt* (London-New York, 1995), 42.

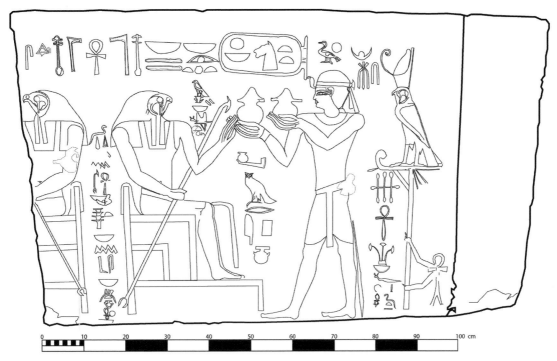

Fig. 1. The lintel of Ahmose-Nebpehtyre from El-Atâwla.

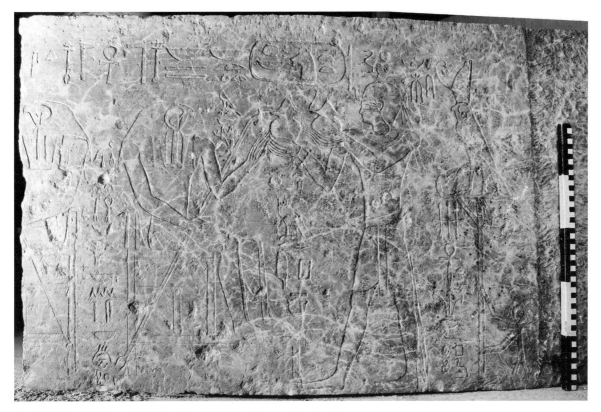

Fig. 2. The lintel of Ahmose-Nebpehtyre from El-Atâwla. Photograph by the author.

right hand whose forked tip is visible on the lower part of the throne while touching the king's right hand with his left hand. In front of him is a vertical line of carved hieroglyphs reads:

Nmty nb 3tft
Nemty[b], Lord of Atfet.[7(c)]

The title of the offering act is inscribed in a short form, in one vertical column between the two figures of the king and the god directly beneath their hands. The inscription reads:

ḥnk m irp
Offering[d] of wine.[e]

Behind the king's figure is a single vertical line of a formulaic inscription has been inserted and reads:

s3 ˁnḫ h3 nb.f mi Rˁ dt
Protection and life are behind his lord like Re,[f] eternally.

In the far right side of the scene is a standard of the god Horus.[8] The huge divine standard[9] (*i3t,*)[10] is fixed to the ground (without special base) and supported (or held) by the hieroglyphic sign *ankh* which is represented as a personification, decorated with ribbons bearing a long rod (or pole), with top mounted cross beam on which is the divine image of the god Horus. Interestingly, the front of the standard cross bar is incised in an unusual form which looks like an animal head, perhaps similar to a lioness head turned back; a form may be linked with the goddess Matit[11] who was worshipped along with the falcon god Nemty at the Twelfth Upper

[7] For the Twelfth Upper Egyptian Nome, see Gardiner, *AEO* 2, 68*–72*; Montet, *Géographie* 2, 129–34; Helck, *Gaue,* 100–102; idem, *LdÄ* 2, 389, *s.v.* "Gaue."

[8] Although the figure on the standard here is not named and Egypt had numerous falcon deities, this one is identifiable as Horus because he wears the double crown of Upper and Lower Egypt, which expresses the dual but unified aspect of Egyptian kingship, i.e., the rule over the united Upper and Lower Egypt, and it is hence the most typical crown of the royal god Horus, who is embodied in the living ruler. See Goebs, "Crown (Egypt)," 7/30.

[9] Three types of ancient Egyptian standards from historic times may be distinguished; Divine standards or god standards with images and symbols of individual deities. These played an important role in the royal cult and were carried by priests in procession. Nome standards consisting of portable support and the nome sign which usually represented the image of the Nome deity or, according to the beliefs of that time, an object imbued with power. The military standards which were likewise carried divine images as symbol of might and victory. For ancient Egyptian standards and their types see. A. Abdel-Raziq, "The Standards in Ancient Egypt," PhD. diss., Zagazig University, 2005 (in Arabic); idem, "A New Look at the Goddess Bastet Bronze Statue at Zagazig University Archaeological Museum," in *The 14th Conference of the General Union of Arab Archaeologists* (Cairo, 2011), 1–13. see also Bonnet, *RäRG,* 253–54, *s.v.* "Götterstandarte"; S. Curto, *LdÄ* 5, 1255–56, *s.v.* "Standarten"; D. Wildung, *LdÄ* 2, 713–14, *s.v.* "Götterstandarte"; M. Lurker, *The Gods and Symbols of Ancient Egypt* (London, 1982),116, *s.v.* "standards"; I. Shaw and P. Nicholson, *British Museum Dictionary of Ancient Egypt* (Cairo, 1995), 278, *s.v.* "standards"; G. Graham, "Insignias," in D. Redford, ed., *The Oxford Encyclopedia of Ancient Egypt,* 2 (2001), 163–67.

[10] In the Greco-Roman period these standards that were carried before the deities and kings for detaching evil away from them were also called *bḫnḫn* (var.). See. V. Loret, "Le mot " *RevEg* 10 (1902), 87–94; *Wb.* 1, 26, 480; Gardiner, *EG,* 502 (R12), 550; Faulkner, *CDME,* 7; R. Hannig, *Die Sprache der Pharaonen Großes Handwörterbuch Ägyptisch-Deutsch (2800–950 v. Chr.)* (Mainz, 1995), 22.

[11] For goddess Matit see: C. De Wit, *Le rôle et le sens du lion dans l'Égypte ancienne* (Leiden, 1951), 299–301; Davies, *Deir el Gebrâwi* 2, 43; Bonnet, *RäRG,* 444, *s.v.* "Matit"; Montet, *Geographie de l'Egypte ancienne* 2, 131; E. Graefe, "Matit" *LdÄ* 3, 1245–46; idem, *Studien zu den Göttern und Kulten im 12. und 10. oberägyptischen Gau (insbesondere in der Spät-und Griechisch-römischen Zeit)* (Freiburg, 1980), 10, 22–24; J. Osing and

Egyptian Nome. The image of Horus is shown as a falcon wearing the double crown. No doubt the lintel was originally painted. Traces of the original red painting are preserved on the bodies of the figures of the king Ahmose-Nebpehtyre and the god Nemty, the Ankh-sign holding the standard and on the double crown of Horus on the standard.

To the left, the rear part of a left-facing seated figure of a typical falcon-headed deity is preserved who can be easily identified as Nemty. In his left hand, he holds a scepter slants diagonally backward across his body whose forked tip can be seen behind his throne. The upper part is covered by the remains of a single line of a puzzling horizontal inscription, runs from right to left and reads:

ʿnḫ nṯr nfr sḏm s[bḥ-n-ʿš-nb]?

May the good god live, hearer [of the cry of everyone (?)][g]

In the far right hand side of this stone slab is a vertical unscribed rough area measuring (maximum) 20 × 68 cm. mostly indicated the end corner of the side wall and it would have been sunk inside the side wall slabs of the shrine for fixation.

Textual Commentary

a) Although omitting the second person indirect object (dative) suffix pronoun (.*k*) on the Ahmose-Nebpehtyre lintel is somewhat unusual, parallel examples were found more than once in the texts of the tomb of Queen Nefertari (QV 66) of which six examples were included in the two similar scenes decorating the north-east and south-east walls of the Vestibule starting with *ḏd mdw di n*(.*i*) *n*(.*ṯ*) "I have given to (you)"[12]

b) Nemty is a rather obscure falcon god, depicted as a diurnal bird of prey with long pointed wings and a notched beak, often perched on a crescent-shaped boat whose cult was assimilated from quite early times into that of the god Horus and was predominantly worshipped in the Tenth, Twelfth and Eighteenth Upper Egyptian nomes especially in Per-Nemty "the house of Nemty," the capital of the Twelfth Nome, which housed his main cult temple. Nemty was also of some importance in the regions between and adjacent to these Middle Egyptian provinces on the east bank of the Nile. However, the reading of the god's name is still doubtful[13]; according to the early generations of Egyptologists literature his name should be read ʿnty (Anty) meaning "the one who has claw" or "with claws,"[14] but the consensus leans now in favor of the reading *nmty* (Nemty), "the wanderer,"[15] which is by now generally accepted.

G. Rosati, *Papiri geroglifici e ieratici da Tebtynis* (Florence, 1998), 138; C. Leitz, ed., *Lexikon der ägyptischen Götter und Götterbezeichnungen* 3, *OLA* 112 (Leuven, 2002), 213, *s.v.* "*Mȝityt*"; M. Bunson, *Encyclopedia of Ancient Egypt* (New York-Oxford), 2002, *s.v.* "Matit"; J.-P. Corteggiani, *L'Egypte ancienne et ses dieux. Dictionnaire illustré* (Paris, 2007), 312.

[12] PM I2, 762–763 (7–10); C. Campbell, *Two Theban queens, Nefert-ari and Ty-ti, and their tombs*, (London, 1909), 33–37, pls. facing 33, 37; J. McDonald, *House of Eternity. The Tomb of Nefertari*, (Los Angeles, 1996), 67; H. McCarthy, "Queenship, Cosmography, and Regeneration: The Decorative Programs and Architecture of Ramesside Royal Women's Tombs," PhD diss., Institute of Fine Arts, New York University, 2011), pl. 95–96; idem, "The Osiris Nefertari: A Case Study of Decorum, Gender, and Regeneration," *JARCE* 39 (2002),181, fig. 5.

[13] E. Brovarski, "Two Old Kingdom Writing Boards from Giza," Extrait des *ASAE*, 71 (1987), 29–30; R. Wilkinson, *Complete Gods and Goddesses of Ancient Egypt* (Cairo, 2003), 204–5.

[14] K. Sethe and A. Gardiner, "Zur Vokalisation des Dualis im Ägyptischen: der Name von Gebelên und der Name des Gottes Antaios," *ZÄS* 47 (1910), 50–59; J. Vandier, *Le papyrus Jumilhac*, 337; G. Lefèbvre, dans son recueil de traduction *Romans et contes égyptiens*, (Paris, 1961), 189 et 192; H. Beinlich, *Studien zu den "geographischen Inschriften" (10.–14.o.äg. Gau)*, *TÄB* 2 (Bonn, 1976), 129–32; E. Otto, *LdÄ* 1, 318, s.v. "Anti."

[15] See O. Berlev, "Сокол, плывущий в ладье," Иероглиф и бог," ВДИ 1 (107), [= "*Falcon in boat*," a *hieroglyph and a god*," *VDI* 1 (107)], 3–30; idem, "Imja personaža "Povesti o krasnorečivom žitele oazisa' i ieratičeskij znak Möller I 270B," [= "The Name of a Personage in the "Story of the Eloquent Peasant' and the Hieratic Sign Möller I, 207B"], in: *Drevnij Vostok*, 15–24; D. Meeks, "Notes de lexicographie (§2–4)," *RdE* 28 (1977), 91, n. 32; Graefe, *Studien zu den Göttern und Kulten im 12. und 10. Oberägyptischen Gau*; idem, "Der Drogenname Swt-Nmty," *GM* 18 (1975), 15–20; W. Barta, *LdÄ* 4, 453, *s.v.* "Nemti"; K. Lembke, "Unter falschem Namen: Der sog. Chertihotep (Berlin ÄM 15700)," *GM* 150 (1996), 81–86; K. Koschel, "Ein altes Problem und ein Graffito im Wadi Hammamat: Antj oder Nemtj?," *GM* 174 (2000),

c) The Twelfth Upper Egyptian Nome (Atfet)[16] was located on the eastern bank of the Nile and ranged from the south, approximately from the height opposite Assiut, up to the Gebel Abu Fuda in the north.[17] On the other hand, the designation or the legend ʿntj/Nmtj nb ꜣtft, "Anty/Nemty, lord of Atfet," is very well attested on several finds and according to Gardiner, the town "Per-Anty" is presumably synonymous of "Dju-f(yet)" and it seems likely that wherever the designation "Anty, Lord of Djufet," is thus found, the town is meant.[18]

d) The wine-offering theme was so common that it is found on many parts of the temple, such as doorways, walls of the halls and chapels, and on columns. Wine-offering scenes are represented on doorways leading to various parts of the temple; these include the doorways of the sanctuary, the rooms of various cultic functions, and the gates and other entrances of the temple. The scene is found depicted on the lintel, the jamb, or the thickness of the doorway. Scenes on lintels are usually depicted in symmetrical pairs. Apart from the double scenes, in which two identical offering scenes are placed in parallel, wine offering is shown juxtaposed with the offering of incense, water, bread, milk, Maat, and food.[19] On the other hand, the style of the vessels (nw pots) as shown on the lintel is not that generally related to the rather "common" depiction of the wine offering motif that each one of them is closed by means of conical lid.

e) Throughout the Pharaonic period the generic term for wine was *irp*. It continued to be used in the Ptolemaic and Roman period, and survived in Demotic and in Coptic. There is no definite etymological explanation for *irp*.[20] The determinative 🏺 of the word *irp* here is not the normally attested sign, being rather a substitution of one liquid storage vessel for another. On the other hand, The *nw*-pot, is the conventional vessel employed in the offering of wine but in only a few cases the vessels used in wine offering are other kinds of jars, such as the *nmst*-jar.[21] Thus whenever a scene shows the king offering two *nw*-pots, even though no accompanying title of the act exists, the act most probably represents wine offering.[22]

f) The suffix of "his" lord here refers to the Follower of Horus figure, who carries the Falcon standard and stands protectively behind the king. Though a strange box or a square shape oddly appears following the sun disc, the word logically precedes the term *mi ḏt* should be read ☉ | *rʿ*, but it seems likely to be deformed later as well as it is also difficult to be read ◉ | |, *sp 2* because of *mi* appearing before *ḏt*.

g) The first sign of the title follows the royal title *nṯr nfr* is rather strange and not clear but it looks similar to the sign ⬭—compare for instance, the term *sḏm-ḥbt* in a scene in the temple of Ramesses III at Medinet Habu[23]—and could be also compared with the hieratic forms[24] of the same sign which then reads *sḏm, msḏr* or *idn* but here due to the sign (*s*) existence which comes after, I suggest the reading ʿnḫ nṯr nfr sḏm s[bḥ-n-ʿš-nb], but it is also still doubtful. However, the *sḏm sbḥ* [n ʿš nb] is an epithet of the god Amun dated to the New Kingdom (pChester Beatty IV, rto 9, 10–13,1).[25] The later epithet may be one of epithets which indicates that the king as the god listens to the cry or prayers in this sector or shrine of the temple complex.[26]

17–19; idem, "Ein altes Problem und ein Graffito im Wadi Hammamat: Antj oder Nemtj?," *GM* 175 (2000), 9–12; Leitz, *LGG* 4, 242–44; W. Grajetzki, "Qau el-Kebir," *UCLA Encyclopedia of Egyptology* (Los Angeles, 2012).

[16] The reading of the province name in the Old Kingdom as *Ḏw-f* or *Ḏw-ft* is uncertain, as evidence from later periods suggests *jꜣt-ft* or *ꜣt-ft*. For different readings of the name see Gardiner, *AEO* II, 69, n.1*; Montet, *Géographie* 2, 129; Helck, *Gaue*, 100–102; Beinlich, *Studien zu den "geographischen Inschriften" (10.-14.o.äg. Gau)*, 126.

[17] Horn, *Zu Topographie und Archäologie des Gebietes des 12. oberägyptischen Gaues*, 1–3.

[18] Gardiner, *AEO* 2, 69*.

[19] Poo, *Wine and Wine Offering in the Religion of Ancient Egypt*, 46.

[20] *Wb* I, 115; W. Erichson, *Demotisches Glossar* (Copenhagen, 1954), 39; Crum, *CD*, 66–67; Poo, *Wine and Wine Offering in the Religion of Ancient Egypt*, 21.

[21] For the *nw*-pot see. H. Balcz, "Die Gefassdarstellungen des Alten Reiches," *MDAIK* 4 (1933), 207–9; Gardiner, *EG*, sign list, W24; Do. Arnold, *LdÄ* 2, 483–501, Abb. 1, no. 29, *s.v.* "Gefäße, Gefäßformen (Gf.), Gefäßdekor."

[22] Poo, *Wine and Wine Offering in the Religion of Ancient Egypt*, 43.

[23] *Medinet Habu VIII*, pl. 609.

[24] Möller, *Paläographie*, no. 158–9.

[25] A. Gardiner, *Hieratic Papyri in the British Museum: Third Series: Chester Beatty Gift*, ed. Alan H. Gardiner I (London, 1935), 33; Leitz, *LGG* 6, 737.

[26] A type of chapel, called a "chapel of the hearing ear," referring to the ear of a god who hearkens to prayer was one of the structures which was devoted in and around temples specifically to enabling people to appeal to the god(s). These chapels are known from the Middle Kingdom and continued to be founded and patronized into the Roman period. Anyone hoping for divine assistance could approach the

Commentary

First of all, several places were located in the Twelfth Upper Egyptian Nome; of which Iakemet and *Pr.w nw M‘m* (the domains of Mam) are well known especially from the texts of the Old Kingdom,[27] but their location is uncertain. However, Iakemet, according to Zibelius,[28] is to be likely located in Deir el-Gabrawi and *Pr.w nw M‘m* in El-Atâwla. The *Pr.w nw M‘m*, mostly connected with *Pr-Ḥr-nbw*, "House of the Golden Horus" and *Njw.t n.t bjk*, "City of the Falcon" which are described in the great nome list at Edfu and Dendera Temples,[29] and probably goes back to Per-Nemty (previously read as Per-Anty), the main town or the capital of the Twelfth Upper Egyptian Nome, which was sometimes (wrongly) equated with Hieracon.[30]

However, according to an approach that consists of considering the cult of Nemty attested in the nome since the late Old Kingdom and the beginning of the Middle Kingdom and later, and that is supported by several monuments found at El-Atâwla that are thought to come from the temple of Nemty, known only from written sources,[31] Kamal, followed by Gardiner, Helck and Zibelius,[32] assumed that the place of the modern-day village called El-Atâwla is the location that contains the ruins of the temple of Nemty and thus is the capital of the nome.[33] On the other hand, Beinlich believes that the localization of the main town—the capital—of the Twelfth Upper Egyptian Nome, called "Per-Nemty," is uncertain, and has not been established archaeologically so far, and therefore its temple, which was called *ḫnm-ršwt* or *ḫnmwt-m-ršwt* (united of joy).[34]

Therefore, this interesting piece from El-Atâwla opens the debate, once again, about El-Atâwla as the site suggested for the old city "Per-Nemty" and its temple. However, the identification of the location of El-Atâwla as a site of the former main town (capital) of the Twelfth Upper Egyptian Nome was first suggested by Ahmed Kamal, but with insufficient basis of arguments based on finds, among which are two inscribed blocks of limestone found in 1893 by Muhammad effendi Ša‘bān (Mohammed Chabân), and cited at the same area, El-Atâwla; the first block bears the cartouches of king Senwosret I[35] while the second is a limestone lintel dated to the king

shrine and recite his or her petition. In most cases, the figure to whom the petitioner appealed was a god, but in some cases, the appeal was made to the god and the king or, in rare instances, to the divine king alone. Cf. C. Ausec, "Gods Who Hear Prayers: Popular Piety or Kingship in Three Theban Monuments of New Kingdom Egypt," PhD diss., University of California, Berkeley, 2010; E. Teeter, *Religion and Ritual in Ancient Egypt* (New York, 2011), 79–84; L. Gallet, "Karnak: the Temple of Amun-Ra-Who-Hears-Prayers," in W. Wendrich, ed., *UCLA Encyclopedia of Egyptology* (Los Angeles, 2013), http://digital2.library.ucla.edu/viewItem.do?ark=21198/zz002gw1j9.

[27] Davies, *Deir el Gebrâwi*, 1, pl. 23; 2, 44, pls. 7, 18, 21, 24, 28; Helck, *Gaue*, 101; idem, *LdÄ* 2, 389, s.v. "Gaue"; III, 113, s.v. "Iakemet"; N. Kanawati, *Deir el-Gabrawi. I, The northern cliff*, The Australian Center for Egyptology Reports 23 (Oxford, 2005), 70–71; J.-C. Moreno García, "Deir el-Gabrawi," in W. Wendrich, ed., *UCLA Encyclopedia of Egyptology*, (Los Angeles, 2012), 2.

[28] K. Zibelius, *Ägyptische Siedlungen nach Texten des Alten Reiches*, TAVO Beiheft 19 (Wiesbaden 1978), 15–17, 85–86.

[29] *Edfou* I, 340; J. Dümichen, *GI* 3, 82.

[30] Beinlich equated readily Per-Nemty (Per-Anty) with Hieracon based on the reading of the localities name *Pr-ḥrw-nbw* "House of gold Horus" and *Njw.t n.t bjk* "City of the Falcon," which were according to his view, other names for the same place, Per-Nemty, corresponding strikingly the location names to the Greek name Ἱεράκων πόλις. H. Beinlich, *LdÄ* 4, 929–30, s.v. "Per-Anti." See also Horn, *Einleitung: Zu Topographie und Archäologie des Gebietes des 12. oberägyptischen Gaues*, 20–23.

[31] See Gardiner, *AEO* II, 68*–73* ; Horn, *Einleitung: Zu Topographie und Archäologie des Gebietes des 12. oberägyptischen Gaues*, 22–23.

[32] Kamal, "Rapport sur la nécropole d'Arabe-el-Borg," 80; Gardiner, *AEO* 2, 68*–69*; Helck, *Gaue*, 101; idem, *LdÄ* 2, 389, s.v. "Gaue"; Zibelius, *Ägyptische Siedlungen nach Texten des Alten Reiches*, 15–17, 85–86.

[33] On the other hand, according to a recent survey carried out in the neighboring areas, but it must be stressed that it is also only circumstantial evidence, Kurth and Rössler-Köhler suggested the immediate vicinity of the Southern Necropolis of Deir el-Gabrawi where a late Roman locality called Hierakon and the quartering of a Roman cohort were built in its close vicinity, and the dead from these settlements were buried in the tombs of the old necropolis. Therefore the name of this camp could be derived from the nearby major Egyptian city (Hieracon). D. Kurth and U. Rößler-Köhler, *Zur Archäologie des 12. oberägyptischen Gaues. Bericht über zwei Surveys der Jahre 1980 und 1981*, GOF IV.16, (Wiesbaden 1987), 186–94. See Moreno García, "Deir el-Gabrawi."

[34] According to Horst Beinlich, the temple is considered the birthplace of Horus, and may be dedicated to Horus and Anty. Osiris and Isis-Matit probably had secondary cults here. The connection of this province temple with the Dendera temple become by a word play of *ḫnm-ršwt*, which formed a name of a temple or temple part in Dendera *pr-ršwt*. H. Beinlich, *Studien zu den „geographischen Inschriften" (10.–14.o.äg Gau)*, 135; idem, *LdÄ* 4, 929–30, s.v. "Per-Anti."

[35] The block is probably in the Egyptian Museum at Cairo but no more precise information is possible at the moment. G. Daressy, "Notes et remarques," *RecTrav* 16 (1894), 133; Kamal, "Rapport sur la nécropole d'Arabe-el-Borg," 80–81; Horn, *Einleitung: Zu Topographie und Archäologie des Gebietes des 12. oberägyptischen Gaues*, 26.

"Ḥetepibre" of the Thirteenth Dynasty.[36] The latest block bears two cartouches of the king Ḥotepibre *and most probably* used to form a part of the wall in a chapel erected by that king. The inscription on the block is well en-graved and shows that it should be dated not far from the Thirteenth Dynasty, thus the king was thought to have reigned towards the beginning of the Thirteenth Dynasty (the Egyptian Museum, Cairo, Temp. 24/4/22/3).[37] The designation "Nemty, Lord of Atfet," was also incised on the offering table of Teruru dated to the Saite period which was found at "Arabe-el-Borg/"Arab Mieteir, the necropolis of Per-Nemty according to Ahmed Kamal, now in the Egyptian Museum at Cairo (*CG* 23037).[38] Kamal supported his testimony, at that time (1902), concerning El-Atâwla as the site in which the temple of Nemty was located by saying that a remnant of the temple complex "still exist" and it can be seen in a lake in the center of the settlement complex.[39]

However Kamal,[40] in his article, mentioned very simply that the ancient name of El-Atâwla was "Duf" (*Dw-f*). He thus refers to the name of the nome's capital using the name of the province. Kamal, however, does not regard "Duf" as the main town of the Twelfth Upper Egyptian nome, but for the place of the Temple of Nemty (read by Kamal "Hor-Mehti"), whereas the capital of the nome, to him, is *Pr-Ḥrw-nbw* "Pa-har-Noub," which is to be distinguished from "Duf" and linked questioningly with Abnub. The separation of the two localities by Kamal is quite inaccurate, but his distinction between the capital and the place of the temple of the chief de-ity in the nome has not been taken up in the later references. Only his localization statement of El-Atâwla has found an echo—but now not only as a place of the Nemty-temple, but also for the capital of the Upper Egyp-tian Twelfth Nome. Gardiner[41] takes up the suggestion of Kamal, certainly, for the localization of "Per-Anty/ Per-Nemty," though he brings forward, on the other hand, arguments for the fact that one would expect that the principal town of the nome is to have been situated at no great distance from "Deir al-Gabrâwi," the main Old Kingdom necropolis of the Upper Egyptian Twelfth Nome.

The above-mentioned arguments presented by Kamal, followed by Gardiner and others, of which for ex-ample the finds discovered there and the existence of a remnant of a temple complex in a pool within the settle-ment complex as Kamal saw at that time, were considered insufficient to Jürgen Horn,[42] as the latest indication related to the temple of Nemty could not be verified on the site (El-Atâwla): although a survey of the houses of the village was observed by the "Göttinger Survey" of 1980 and 1981, nevertheless, there were no traces of antique architecture. Since blocks of relief were also observed in other parts of the area, Kamal's provenance is doubtful. These doubts also apply to all attempts to localize the capital of the nome and its temple to El-Atâwla. Therefore, Horn believes that the El-Atâwla site should be treated with great caution as the provenance for dis-coveries in the Twelfth Upper Egyptian Nome, divorcing the finds "allegedly" made there as practical indicators of the locality of Per-Nemty, and then the identification of Kamal is to be regarded as very doubtful, supporting finally Beinlich's view that the site of El-Atâwla has archaeologically not yet been established and still needs to be proved.[43]

In conclusion, I think due to the lintel slab of Ahmose-Nebpehtyre under discussion (most probably found *in situ*),[44] inscribed with the name, epithet, and figure of the god *Nemty*, and supported by the above-mentioned

[36] For this king see. K. Ryholt, *The Political Situation in Egypt during the Second Intermediate Period c. 1800–1550 B.C*, Carsten Niebuhr Institute Publications, vol. 20 (Copenhagen, 1997), 338; idem, "Hotepibre, a Supposed Asiatic King in Egypt with Relations to Ebla," *BASOR*, No. 311 (1998), 1–6; von Beckerath, *Handbuch der ägyptischen Königsnamen*, 90–91.

[37] On the second block is seen the king offering to the falcon-headed god Nemty above whom is an inscription reads: "Words spoken, I have given to you every provision (namely) Nemty lord of...." The king is styled "The good god, lord of ceremonies Ḥetepibre, Son of Re of his body Qemaw-Siharnedjheritef, given life, health, stability, prosperity and joy." PM IV, 246; Daressy, "Notes et remarques," 133; Kamal, "Rapport sur la nécropole d'Arabe-el-Borg," 80; L. Habachi, "Khatâ'na-Qantîr: Importance," *ASAE* 52 (1954), 461, pls. 10, 11*A*.

[38] Kamal, *CG*, 23001–23256, 30, pl. 15; Cf. idem, "Rapport sur la nécropole d'Arabe-el-Borg," 81; PM IV, 247.

[39] Kamal, "Rapport sur la nécropole d'Arabe-el-Borg," 80–81, and n.3.

[40] Kamal, "Rapport sur la nécropole d'Arabe-el-Borg," 80–81.

[41] Gardiner, *AEO* 2, 68*, 73*.

[42] For other arguments see Horn, *Einleitung: Zu Topographie und Archäologie des Gebietes des 12. oberägyptischen Gaues*, 29–31.

[43] H. Beinlich, *LdÄ* 4, 929–30, *s.v.* "Per-Anti"; Horn, *Einleitung: Zu Topographie und Archäologie des Gebietes des 12. oberägyptischen Gaues*, 22.

[44] Interestingly, the inspector Mr. Hani Sadek Metri, who supervised the extraction and transfer of this lintel in 1988, asked the EAO in his final report at that time, for providing him with three thousand Egyptian pounds for the completion of the excavation and exploration in that area, and that may indicate that he had probably seen an extension or the rest of this stone block or maybe other blocks.

finds, Kamal's view concerning El-Atâwla as the place in which the temple of Nemty existed or was erected, to returns strongly to the spotlight This piece also supports the idea that the other above-mentioned inscribed blocks were found at El-Atâwla itself and not outside, as Horn suspected or suggested, and it is possible now to rethink seriously identifying all of these finds as coming from the lost temple of the god *Nemty*, known only from written sources.

Assiut University

Untersuchungen zu den Totenbuchsprüchen 33, 34 und 35

Elena Mahlich

Abstract

The essay examines the spells 33, 34 and 35 from the Book of the Dead. The topic of these texts is the protection from snakes, which is a well known theme of Ancient Egyptian literature, especially from texts concerning the afterlife. From the Pyramid Texts onwards, snakes are known from various genres as a dangerous threat for the dead and also the living. The paper includes a synopsis and a commentary on the three spells, and concludes with a comparison of all texts.

Das Thema der vorliegenden Abhandlung stellen drei Sprüche des Totenbuches dar, denen trotz ihres aussagekräftigen Inhalts bisher keine Untersuchung zuteil wurde. Zwar wurden die Sprüche in gängigen Übersetzungen mit übernommen, doch wurde sich den Texten bisher noch nicht durch einen Kommentar oder eine Synopse genähert. Diese Situation kann allerdings auf große Teile des Totenbuches ausgeweitet werden: Zwar liegen zu einigen Sprüchen Texteditionen vor, doch ist ein recht großer Teil bisher unkommentiert geblieben wie auch ein hoher Prozentsatz der betreffenden Papyri bislang unpubliziert ist. Zwar existieren einige Synopsen zu verschiedenen Sprüchen, jedoch zumeist nur mit einer begrenzten Auswahl an Textzeugen.[1] Eine Synopse des gesamten Totenbuches fehlt derzeit, doch wäre eine solche Aufgabe durch die große Anzahl der Belege auch nicht mehr zu bewerkstelligen. Als einzige synoptische Textedition ist auch heute noch "Das aegyptische Todtenbuch der XVIII. bis XX. Dynastie," die 1886 von Edouard Naville publiziert wurde, zu nennen. Dabei lässt sich diese nicht als "richtige" Synopse verstehen, da sich der Herausgeber darauf beschränkte, die Unterschiede bei einigen Textzeugen hervorzuheben.[2] Die Datenbank des Totenbuchprojekts in Bonn schuf zumindest die Basis, sich mit allen Textzeugen befassen zu können. Es gibt im Bereich der Totenbuch-Forschung folglich einiges aufzuarbeiten.

Im Rahmen dieser Untersuchung soll sich mit den Sprüchen 33, 34 und 35, die das Abwehren einer Schlange als Motiv gemeinsam haben, beschäftigt werden. Neben diesen Sprüchen existieren im Totenbuch noch weitere, welche sich mit der Verteidigung gegen eine Schlange befassen. In Spruch 39 wird dies thematisiert, wobei in ihm speziell auf Apophis, der mit der *Rrk*-Schlange gleichgesetzt wird, Bezug genommen wird. Der Spruch "Gestalt anzunehmen als Sohn der Erde" (Tb 87) beschäftigt sich zwar ebenfalls mit einer Schlange, jedoch handelt es sich bei ihm um einen "Verwandlungsspruch," bei dem die Verwandlung des Verstorbenen in eine Schlange ("Sohn der Erde") das erklärte Ziel darstellt.

"Der Verstorbene identifiziert sich mit der Schlange als einem Bild ständiger Erneuerung und Verjüngung [...]."[3]

[1] Als Beispiele seien die Untersuchungen von Barbara Lüscher, *Die Sprüche vom Kennen der Seelen (Tb 107–109, 111–116). Synoptische Textausgabe nach Quellen des Neuen Reiches*, Totenbuchtexte 8 (Basel, 2012); und idem, *Die Mund- und Herzsprüche (Tb 21–30). Synoptische Textausgabe nach Quellen des Neuen Reiches*, Totenbuchtexte 9 (Basel, 2016), genannt, die nur Textträger bis zum Ende des Neuen Reiches einbeziehen. *Nota bene*: Alle in der Arbeit genannten Internetadressen wurden am 12. Januar 2016 zuletzt auf ihre Richtigkeit überprüft.

[2] Vgl. Barbara Lüscher, "Zu einer synoptischen Neu-Edition des Totenbuches des Neuen Reiches," in Burkhard Backes, et al., eds., *Totenbuchforschungen. Gesammelte Beiträge des 2. Internationalen Totenbuch-Symposiums 2005*, SAT 11 (Wiesbaden, 2006), 213–21, hier: 213.

[3] Erik Hornung, *Das Totenbuch der alten Ägypter* (Düsseldorf-Zurich, 1997), 469f.

Journal of the American Research Center in Egypt 53 (2017), 57–90
doi: http://dx.doi.org/10.5913/jarce.53.2017.a003

In diesem Spruch nimmt die Schlange also nicht die Rolle einer Bedrohung ein, sondern der Verstorbene bewundert die vorteilhaften Eigenschaften des Reptils und will von diesen im Jenseits profitieren. Dadurch nimmt der Spruch eine Sonderstellung ein, da Schlangen ansonsten in der Jenseitsliteratur sehr häufig eine Gefahr für den Toten darstellen, die es abzuwehren gilt. Allerdings muss gesagt werden, dass solcherlei gefährliche Gestalten durchaus auch positive Eigenschaften aufweisen können, da sie in der Lage sind, Feinde abzuschrecken und somit auch eine apotropäische Funktion innehaben, wie es auch für die Uräus-Schlange gelten kann,[4] auf die im Kommentar zu Spruch 34 näher eingegangen wird.

Die drei in diesem Rahmen behandelten Sprüche tauchen außerordentlich häufig gemeinsam auf,[5] was eine zusammenfassende Behandlung rechtfertigt. Aufgrund der großen Materialfülle – insgesamt sind die drei Sprüche derzeit 364 Mal belegt – sollen hier nur diejenigen Textzeugen berücksichtigt werden, die bis zum Ende des Neuen Reiches entstanden sind. Dabei stammen die Textzeugen aus dieser Periode gänzlich aus dem privaten Bereich und gehörten – abgesehen von der Ausnahme Pap. Kairo, TR 25/1/55/6 – durchgängig Männern. Spruch 33 ist indessen schon aus der 13. Dynastie bekannt: Er befindet sich auf dem Sarg der Königin *Mnṯw-ḥtp.w*, welcher "einen der frühsten Belege, wenn nicht bis jetzt frühsten, für die Tradierung des Totenbuches darstellt."[6] Die Mehrheit der Textzeugen ist auf Papyrus geschrieben, wobei der Erhaltungszustand zwischen sehr gut bis fragmentarisch variiert. Bei etwa 5% der Textzeugen ist zudem die Vignette des jeweiligen Spruches vorhanden.

Für jeden der Sprüche wird eine Textsynopse, eine Transliteration zuzüglich einer Übersetzung geboten. Darauf wird sich sowohl den einzelnen Textzeugen wie auch dem Textinhalt generell durch einen Kommentar angenähert, wodurch ein Vergleich der drei „Schlangensprüche" ermöglicht werden soll.

<div align="center">Totenbuchspruch 33[7]</div>

Die Textzeugen

[1] Sarg der Königin *Mnṯw-ḥtp*(.*w*);[8] Material: Holz; heutiger Standort: Unbekannt; Herkunft: Theben; Datierung: Ende 13. Dynastie; Literatur: Christina Geisen, *Die Totentexte des verschollenen Sarges der Königin Mentuhotep aus*

⁴ Vgl. Rita Lucarelli, "Demons in the Book of the Dead," in Backes, et al., *Totenbuchforschungen. Gesammelte Beiträge des 2. Internationalen Totenbuch-Symposiums 2005*, 203–13, hier: 203.

⁵ So ist nach der Auswertung der derzeit bekannten Textzeugen unter http://totenbuch.awk.nrw.de/spruch/34 in 44% der Fälle Spruch 33 und in 40% Spruch 35 der direkte Nachbar von Spruch 34. Andere Sprüche sind nur noch in wenigen Prozenten belegt.

⁶ Christina Geisen, *Die Totentexte des verschollenen Sarges der Königin Mentuhotep aus der 13. Dynastie. Ein Textzeuge aus der Übergangszeit von den Sargtexten zum Totenbuch*, SAT 8 (Wiesbaden, 2004), 2. Dabei ist diese Datierung allerdings nicht unumstritten, so datieren einige Forscher *Ḏḥwti*, den Gemahl der Königin in die 17. oder seltener auch in die 16. Dynastie; vgl. z.B. Detlef Franke, "Chronologie des Mittleren Reiches (12.-18. Dynastie, Teil II: Die sogenannte Zweite Zwischenzeit' Altägyptens," *OR* 57 (1988), 245–74, hier: 271; Jürgen von Beckerath, *Untersuchungen zur politischen Geschichte der Zweiten Zwischenzeit in Ägypten*, ÄF 23 (Glückstadt, 1964), 224; Kim Ryholt, *The Political Situation in Egypt during the Second Intermediate Period c. 1800–1550 B. C.*, CNIP 20 (Copenhagen, 1997), 158. In seiner Rezension zu Geisen spricht sich auch Stephen Quirke gegen die Datierung in die 13. Dynastie aus, da er dafür nicht ausreichend Belege sieht; vgl. Stephen Quirke, "Review: Christina Geisen, *Totentexte des verschollenen Sarges der Königin Mentuhotep aus der 13. Dynastie. Ein Textzeuge aus der Übergangszeit zum Totenbuch*," *JANES* 5 (2005), 228f. Hier wird sich einer Einordnung in die 13. Dynastie angeschlossen. Für diese Datierung sprach sich vor Geisen z.B. schon Claude Vandersleyen, "Brèves Communications," *RdE* 44 (1993), 189–91, aus. Für Argumente für diese Datierung vgl. Christina Geisen, "Zur zeitlichen Einordnung des Königs Djehuti an das Ende der 13. Dynastie," *SAK* 32 (2004), 149–57.

⁷ Symbolverzeichnis: || Abtrennung von Zeilen; | Abtrennung von Fehlern, Änderungen etc. innerhalb einer Zeile; Trennung von mehreren bekannten Lesungen oder Schreibungen; ° Das auf ° folgende Wort ist in den gebotenen Textzeugen ausgelassen; ⌐ Das nachfolgende Wort wird in den gebotenen Textzeugen durch ein oder mehrere andere ersetzt; ⊤ An der durch das Zeichen ⊤ markierten Stelle werden von den gebotenen Textzeugen ein oder mehrere Wörter eingefügt; ⌑ Zwischen den Zeichen ⌑ und ` fehlen in den gebotenen Textzeugen Wörter; ein ` markiert das Ende des Abschnitts; ⌐ ` Die auf ⌐ folgenden Wörter werden in den gebotenen Textzeugen durch andere ersetzt; ein ` markiert das Ende des Abschnitts; † Die gesamte Zeile fehlt; ⊤ ⊤⌐ Durch Punkte oder Exponenten nach den kritischen Zeichen werden mehrere Varianten der gleichen Art im selben Apparatabschnitt voneinander unterschieden.

⁸ Das Rubrum wurde in der Publikation von Geisen markiert, in der Umzeichnung der Texte wurde der Spruch aber einheitlich schwarz geschrieben.

[Editor's note: a separate file can be found in the online version that provides the hieroglyphs as found in red in the originals.]

der 13. Dynastie. Ein Textzeuge aus der Übergangszeit von Sargtexten zum Totenbuch, SAT 8 (Wiesbaden, 2004); *Totenbuchprojekt Bonn*, TM 135249, <totenbuch.awk.nrw.de/objekt/tm135249>.

[2] Pap. Paris, Louvre, E. 11085, ursprünglicher Besitzer: *Tꜥḥ-msi(.w)*; Material: Papyrus; Standort: Paris, Musée du Louvre; Herkunft: Theben; Datierung: Frühe 18. Dynastie; Literatur: Irmtraut Munro, *Das Totenbuch des Jah-Mes (p.Louvre E. 11085) aus der frühen 18. Dynastie*, HÄT 1 (Wiesbaden, 1995), Tf. 15; Totenbuchprojekt Bonn, TM 134310, <totenbuch.awk.nrw.de/objekt/tm134310>.

[3] Pap. Sydney R 375 (Pap. Sydney, R 94), ursprünglicher Besitzer: *Jmn-msi(.w)*; Standort: Sydney, University of Sydney, Nicholson Museum; Herkunft: Theben; Datierung: 18. Dynastie; Literatur: Totenbuchprojekt Bonn, TM 133521, <totenbuch.awk.nrw.de/objekt/tm133521>.

[4] Pap. Paris, Louvre, E. 21324 (SN 1), ursprünglicher Besitzer: *Msi-m-nṯr*; Standort: Paris, Musée du Louvre; Herkunft: Theben; Datierung: 18. Dynastie (Hatschepsut / Thutmosis III.); Literatur: Totenbuchprojekt Bonn, TM 134311, <totenbuch.awk.nrw.de/objekt/tm134311>.[9]

[5] Pap. Kairo, TR 25/1/55/6, ursprünglicher Besitzer: *Ḥꜣ.t-nfr.t*, heutiger Standort: Kairo, Ägyptisches Museum; Herkunft: Theben, Deir el-Bahari; Datierung: 18. Dynastie (Hatschepsut / Thutmosis III.); Literatur: Totenbuchprojekt Bonn, TM 134627,<totenbuch.awk.nrw.de/objekt/tm13462>.

[6] L. Grab TT 99, ursprünglicher Besitzer: *Sn-nfr*; Material: Leinen; heutiger Standort: Theben-West, Magazin; Herkunft: Theben; Datierung: 18. Dynastie (Hatschepsut / Thutmosis III.); Literatur: Totenbuchprojekt Bonn, TM 133692, <totenbuch.awk.nrw.de/objekt/tm133692>.[10]

[7] Pap. London, BM, EA 10477, ursprünglicher Besitzer: *Nw*; heutiger Standort: London, British Museum; Herkunft: Theben; Datierung: 18. Dynastie (Hatschepsut - Amenophis II.); Literatur: Totenbuchprojekt Bonn, TM 134299, <totenbuch.awk.nrw.de/objekt/tm134299>.

[8] Pap. London, U.C. 71000, ursprünglicher Besitzer: *Ḥp-rs*, heutiger Standort: London, University College, Petrie Museum; Herkunft: Unbekannt; Datierung: 18. Dynastie (Hatschepsut - Amenophis II.); Literatur: Totenbuchprojekt Bonn, TM 134705, <totenbuch.awk.nrw.de/objekt/tm134705>.

[9] Pap. Kairo (Grabung DAI / H. Guksch), ursprünglicher Besitzer: *Mn-ḫpr-(snb.w)*; heutiger Standort: Kairo, Ägyptisches Museum; Herkunft: Theben (TT 79); Datierung: 18. Dynastie (Amenophis II.); Literatur: Totenbuchprojekt Bonn, TM 134274, <totenbuch.awk.nrw.de/objekt/tm134274>.

[10] Pap. Kairo, Äg. Mus., CG 40003 (JdE 95834; S.R. IV 931), ursprünglicher Besitzer: *Jmn-ḥtp(.w)*; heutiger Standort: Kairo, Ägyptisches Museum; Herkunft: Theben; Datierung: 18. Dynastie (Amenophis II.); Literatur: Irmtraut Munro, *Die Totenbuch-Handschriften der 18. Dynastie im Ägyptischen Museum Cairo*, 2 Bde., ÄA 54 (Wiesbaden, 1994), 127–140, s/w-Tf. 46–53, Umschr.-Tf. 114; Totenbuchprojekt Bonn, TM 134272, <totenbuch.awk.nrw.de/objekt/tm134272>.

[11] Pap. Paris, Louvre, N. 3074, ursprünglicher Besitzer: *Ṯnn*; heutiger Standort: Paris, Musée du Louvre; Herkunft: Theben; Datierung: 18. Dynastie (Amenophis II.); Literatur: Totenbuchprojekt Bonn, TM 134307, <totenbuch.awk.nrw.de/objekt/tm134307>.[11]

[9] Leider fehlt in der Totenbuchdatenbank in Bonn das betreffende Foto mit diesem Spruch.

[10] Die Nennung des Spruchs auf dem Leichentuch aus Leinen vermag ich nicht nachzuvollziehen. Auf den gebotenen Photographien sind keine Reste zu erkennen, die zum Spruch passen würden.

[11] Leider sind einige der Bilder in der Datenbank des Totenbuchprojekts Bonn überbelichtet und lassen keine sichere Lesung des Spruchs zu. Manche der Umschrift als zerstört markierte Passagen könnten im Papyrus auch nur zu schwach mit Tinte geschrieben worden sein.

[12] Pap. Krakau MNK XI 746–751 (Pap. Czartoryski), ursprünglicher Besitzer: *Wȝ*; heutiger Standort: Krakau, Muzeum Narodowe; Herkunft: Theben; Datierung: 18. Dynastie (Amenophis III.); Literatur: Totenbuchprojekt Bonn, TM 134284, <totenbuch.awk.nrw.de/objekt/tm134284>.

[13] Pap. Turin 8438, ursprünglicher Besitzer: *Ḫꜥi(.w)*; heutiger Standort: Turin, Museo Egizio; Herkunft: Theben (TT 8); Datierung: 18. Dynastie (Amenophis III.); Literatur: Totenbuchprojekt Bonn, TM 134315, <totenbuch.awk.nrw.de/objekt/tm134315>.

[14] Pap. London, BM, EA 10471(Leder London, BM, EA 10473), ursprünglicher Besitzer: *Nḫt*; heutiger Standort: London, British Museum; Herkunft: Theben; Datierung: Ende der 18. oder Anfang der 19. Dynastie; Literatur: Totenbuchprojekt Bonn, TM 133529, <totenbuch.awk.nrw.de/objekt/tm133529>.

[15] Pap. Paris, Louvre, SN 2 (Pap. Krakau MNK IX-752 / 1–4.), ursprünglicher Besitzer: *Ptḥ-msi(.w)*; heutiger Standort: Krakau, Muzeum Narodowe / Paris, Musée du Louvre; Herkunft: Theben; Datierung: Frühe 19. Dynastie; Literatur: Ullrich Luft, "Das Totenbuch des Ptahmose. Papyrus Kraków MNK IX-752/1–4," *ZÄS 104* (1977), 46–75; Hildo van Es, "Das Totenbuch des Ptahmose. Ein Beitrag zur weiteren Diskussion," *ZÄS 109* (1982), 97–121; Totenbuchprojekt Bonn, TM 133557, <totenbuch.awk.nrw.de/objekt/tm133557>.[12]

[16] Pap. Graz 23.197 (Pap. Graz 23.202 / Pap. Wien KHM F 5 + F 6, Gruppe b.), ursprünglicher Besitzer: *Ḥnr*; heutiger Standort: Graz, Landesmuseum, Joanneum / Wien, Kunsthistorisches Museum; Herkunft: Unbekannt; Datierung: 19. Dynastie; Literatur: Totenbuchprojekt Bonn, TM 133590, <totenbuch.awk.nrw.de/objekt/tm133590>.

[17] Pap. Cambridge E2.a. 1922, ursprünglicher Besitzer: *Rꜥ-msi(.w)*; heutiger Standort: Cambridge, Fitzwilliam Museum; Herkunft: Sedment, Hill A, Grab 134; Datierung: 19. Dynastie (Sethos I.); Literatur: Totenbuchprojekt Bonn, TM 134358, <totenbuch.awk.nrw.de/objekt/tm134358>.

[18] Grab TT 183,[13] Material: Stein; ursprünglicher Besitzer: *Nb-sw-mn.w*; heutiger Standort: Theben-West; Herkunft: Theben; Datierung: 19. Dynastie (Ramses II.); Literatur: Mohamed Saleh, *Das Totenbuch in den thebanischen Beamtengräbern des Neuen Reiches* (Mainz, 1984), 26; Totenbuchprojekt Bonn, TM 135027, <totenbuch.awk.nrw.de/objekt/tm135027>.

[19] Pap. Leiden T 4 (AMS 14), ursprünglicher Besitzer: *Pȝ-qrr*; heutiger Standort: Leiden, Rijksmuseum van Oudheden; Herkunft: Saqqara; Datierung: 20. Dynastie; Literatur: Totenbuchprojekt Bonn, TM 134347, <totenbuch.awk.nrw.de/objekt/tm134347>.

Synopse

Spruchtitel:

1

[12] Leider findet sich in der Totenbuchdatenbank in Bonn kein Foto, welches sich eindeutig dem Spruch zuordnen lässt. Dabei ist auf dem Textzeugen eine Vignette vorhanden. Von dieser sind nur noch zwei von drei Schlangen erhalten, wobei *Ptḥ-msi(.w)* den Tieren ungewöhnlicherweise ohne Messer gegenübersteht; vgl. Hildo van Es, "Das Totenbuch des Ptahmose. Ein Beitrag zur weiteren Diskussion," *ZÄS* 109 (1982), 97–121, hier: 103.

[13] Am Ende des Spruchs wurde in TT 183 der folgende Passus angefügt:

Dieser Text ist in keinem anderen Schriftträger vorhanden und sollte somit nicht zu TB 33 gezählt werden.

2

3 ...

5

7

8

9

10 ...

11

12 ...

13

14

16

17 ...

18

19

Name und Titel:

1

2

3

5

6

8 nicht vorhanden

9 ...

10

11 ??? ??

12

13

14

16

17

18

19

Zeile 1:

1

2

3 ▨ … ▨

5

7

8 ▨ …

9 ▨ … ▨

10

11

12

13

14

16 ▨ …

17

18

19

Zeile 2:

1 [hieroglyphs]

2 [hieroglyphs]

3 [hieroglyphs] ...

5 [hieroglyphs]

7 [hieroglyphs]

8 [hieroglyphs] ...

9 ... [hieroglyphs]

10 ... [hieroglyphs]

11 [hieroglyphs]

12 ... [hieroglyphs]

13 [hieroglyphs]

14 [hieroglyphs]

16 [hieroglyphs] ...

17 ... [hieroglyphs]

18 [hieroglyphs]

19 [hieroglyphs]

Zeile 3:

1 [hieroglyphs]

2 [hieroglyphs] ... [hieroglyphs] ...

3 [hieroglyphs] ...

5 [hieroglyphs]

7 [hieroglyphs]

8 ... [hieroglyphs]

9 [hieroglyphs] ...

Zeile 4:

Übersetzung des Spruches

> *Spruch um jede Schlange zu vertreiben. (Worte zu sprechen) durch NN:*
> "Oh *Rrk*-Schlange, bewege dich nicht!
> Siehe, Geb und Schu haben sich gegen dich erhoben,
> weil du eine Maus, den Abscheu des Re, gefressen
> und an den Knochen einer verwesten Katze genagt hast."

Kommentar

Kritischer Kommentar zu den Textzeugen

Spruchtitel:

⌐*r* *n* ˋ *ḫśf* ⌐*ḫ*βw ⌐*nb* ⌐*ḏd mdw in*

|| | ⌐ᴰˋ *1, 2, 5, 7* | ⌐*ḫβ.t 1, 2, 11* | ⌐*1, 2, 8, 11, 13* | ⌐*ḏd mdw 7, 14, 16, 19; tm wnm 1* ||

Name und Titel:

|| † 8 ||

Text:

> 1 ⌐ᵒ*i rrk*ˋ ⌐*m šm*
> 2 ᵒ*m=k* ⌐ *Gb* ᵒ⌐*Šw* ⌐*ḥ*ᶜ *r=k*
> 3 *iw*⌐ ⌐*wnm.*ᵒ*n=k pnw bw.t R*ᶜ
> 4 ᵒ*iw* ⌐*wš*ᶜ*.n=k qś.w n(.i)w* ⌐*mii.t* ⌐ ⌐*ḥwβ.t*

|| 1 ⌐ ˋ*ii.n r=k ḫβw 14; i in=k 19* | ᵒ1 | ⌐*šm.t 19* || 2 ᵒ1 | ⌐*m 18 i*⌐*11* | ⌐*ḥβ 1* || 3 ⌐=*i 12* | *3* | ᵒ *13* ||
4 ᵒ *14* | ⌐*wnm.n=k 2* | ⌐*miβ.t 14; miw 1* | ⌐*R*ᶜ *tm 1* | ⌐ˋ*ḥdββ 11; pwtw=k r=i 18; ḥwrḏβtw 19* ||

Kommentar zu TB 33

Für Spruch 33 existiert eine direkte Parallele in den Sargtexten in CT V, 31 (Spruch 369). Dort heißt es:

> "Gehe heraus, *Rr*-Schlange, Wanderer des Schu! Du hast eine Maus gefressen, den Abscheu des Osiris.
> Du hast an den Knochen einer verwesten Katze genagt. 'Vertreiben einer Schlange im Reich der Toten'."[14]

Genau wie in TB 33 wird einer Schlange vorgeworfen, eine Maus gefressen und an einer verwesten Katze genagt zu haben, weswegen Geb und Schu sich gegen sie erhoben haben. Letzteres lässt sich auf die Tatsache zurück-

[14] Vgl. die Textedition von de Buck, *CT V*, 31. Bei der Übersetzung von Raymond O. Faulkner, *The Ancient Egyptian Coffin Texts II. Spells 355–787* (Warminster, 1977), 8, sind die Belege für Osiris (B²L, B¹C) außen vorgelassen worden und es wird lediglich der Gott Re (B²P) genannt.

führen, dass die Maus, wie es im ägyptischen Text ausgedrückt wird, der "Abscheu des Re" (*bw.t Rʿ*) ist.[15] Auch dem Gott Osiris ist das Tier laut dem Sargtextspruch verpönt. Eine eindeutige Erklärung hierfür kann leider nicht geboten werden, allerdings ist ein Zusammenhang zwischen dieser Aussage und dem Faktum möglich, dass die Maus im alten Ägypten sehr weit verbreitet war. Dadurch war sie eine regelrechte Plage und eine Bedrohung für Vorratskammern und Getreidesilos.[16] Das Tabu des Verzehrens einer Maus galt allerdings primär für Menschen, die das Tier wohl auch verzehrten,[17] und wird im Totenbuch auf die Schlange, zu deren natürlichen Beutetieren die Maus zählt, übertragen.[18] Im Übrigen ist TB 33 der einzige Spruch des Totenbuches, in dem die Maus anzutreffen ist. Eine religiöse Bedeutung der herkömmlichen Maus, die seit dem Mittleren Reich als *pnw* schriftlich belegt ist, lässt sich anders als bei der verwandten Spitzmaus (*ʿmʿm.w*) nur schwer feststellen. Besagte Spitzmaus profitierte von der Verehrung des Ichneumons – einem Tier, das dem Gott Horus als heilig galt; eine Eigenschaft, die auf sie ausgedehnt wurde.[19] Aus der Spätzeit sind zahlreiche mumifizierte Spitzmäuse belegt, die Gründe hierfür bleiben in Ermangelung erklärender schriftlicher Quellen jedoch unklar. Aber auch die 'gemeine' Maus spielt in der Literatur und Märchenwelt eine Rolle: Ein gutes Beispiel hierfür bietet der als solcher bezeichnete Katz-Mäuse-Krieg,[20] eine Erzählung in der die Mäuse die Herrschaft über die Katzen erlangen.

Das Erscheinungsbild der Katze im alten Ägypten ist vielseitig,[21] wobei sie häufig zum Jagen von schädlichen Nagetieren und Schlangen eingesetzt wurde. Im Alten Reich scheint die Katze eher von untergeordneter Bedeutung zu sein, da kaum Darstellungen des Tiers aus dieser Periode bekannt sind, erst ab ca. 2000 v. Chr. ist sie als Haustier ausreichend belegt.[22] Im Mittleren Reich taucht der Frauenname *Mi.t*[23] auf und die Darstellungen von Katzen beginnen sich stetig zu vermehren. Die Tiere werden für ihre Nützlichkeit bei der Jagd geschätzt und ab der 18. Dynastie werden zahlreiche Gottheiten mit der Katze assoziiert.[24] Hauptsächlich galt die Katze jedoch als das heilige Tier der Göttin Bastet, die eng mit den löwenköpfigen Göttinnen Sachmet, Pachet und Tefnut verbunden war.[25] Der Kater ist gleichfalls zahlreich in schriftlicher und bildlicher Form belegt und spielt im religiösen Kontext ebenfalls eine wichtige Rolle. So galt der Kater insbesondere ab dem Neuen Reich als eine Form des Sonnengottes Re, wobei dies die Vorstellung einer Katze als Sonnenauge[26] hervorbrachte.[27] Dadurch wird erklärbar, warum so viele dem Sonnengott nahe stehenden Göttinnen in Katzengestalt dargestellt wurden. Im Totenbuch ist der Kater in drei Sprüchen vertreten, wohingegen die Katze nur in TB 33 auftritt. In Spruch 17

[15] Eine Studie zum Ausdruck *bw.t* in den Sargtexten bereitet John Frandsen vor, vgl. id., "Faeces of the Creator or the Temptations of the Dead," in Panagiotis Kousoulis, ed., *Ancient Egyptian Demonology. Studies on the Boundaries between the Demonic and the Divine in Egytian Magic*, OLA 175 (Leuven-Paris-Walpole, 2011), 25–62; hier: 25, Anm. 1.

[16] Vgl. Emma Brunner-Traut, "Maus," in *LdÄ III*, 1250–52.

[17] So wird in einer Aufzählung von Nahrungsmitteln von der Lieferung von Mäusen berichtet: vgl. K*RI VI*, 629, 13. Im Tagewählkalender findet sich ein Gebot, dass Tier am 13. Tag des ersten Monats des *ȝḥ.t* nicht zu verzehren; vgl. Christian Leitz, *Tagewählerei. Das Buch ḥȝ.t nḥḥ pḥ wy ḏ.t und verwandte Texte*, 1. Bd., ÄA 55 (Wiesbaden, 1994), 436. Dies impliziert gleichzeitig, dass das Verspeisen des Nagers an anderen Tagen gestattet war.

[18] Vgl. Katharina Stegbauer, *Magie als Waffe gegen Schlangen in der ägyptischen Bronzezeit* (Borsdorf, 2015), 154.

[19] Vgl. Bonnet, *RÄRG*, 748f.

[20] S. hierzu Emma Brunner-Traut, *Altägyptische Märchen, Märchen der Weltliteratur* (Düsseldorf-Cologne 1963), 59–69 und Eric van Essche, "Le chat dans les fables et les contes: la guerre entre chats et souris, le monde retourné," in Luc Delvaux und Eugène Warmenbol, eds., *Les divins chats d'Égypte: un air subtil, un dangereux parfum* (Leuven, 1991), 69–83.

[21] Für Belege s. Christian Leitz, ed., *Lexikon der ägyptischen Götter und Götterbezeichnungen III*, OLA 112 (Leuven, 2002), 240c–241a. Der Beleg der "Katze in Karnak" auf Ostrakon Corteggiani 1, 3f., ist mit Joachim Quack, "Tier des Sonnengottes und Schlangenbekämpfer. Zur Theologie der Katze im Alten Ägypten," in Rainer Kampling, ed., *Eine seltsame Gefährtin. Katzen, Religion, Theologie und Theologen*, Apeliotes 1 (Frankfurt, 2007), 11–39, hier: 11, Anm. 3, allerdings in Zweifel zu ziehen.

[22] Vgl. Quack, "Tier des Sonnengottes und Schlangenbekämpfer," 11.

[23] Vgl. Ranke, *PN I*, 145, 25.

[24] Vgl. Lothar Störk, "Katze," in *LdÄ III*, 367–70, hier: 367f.

[25] Vgl. Bonnet, *RÄRG*, 371.

[26] Zum Mythos des Sonnenauges sei auf Antonio Loprieno, "Der demotische 'Mythos vom Sonnenauge'," in Otto Kaiser, ed., *Weisheitstexte, Mythen und Epen*, TUAT, Mythen und Epen III (Gütersloh, 1995), 1038–77; sowie auf Friedhelm Hoffmann und Joachim Quack, *Anthologie der demotischen Literatur*, Einführung und Quellentexte zur Ägyptologie 4 (Berlin, 2007), 195–229 verwiesen.

[27] Vgl. Bonnet, *RÄRG*, 372.

bezeichnet sich der Tote als „großer Kater" (*miw ʿȝ*).[28] wobei dieser als Re selbst aufgefasst werden kann.[29] In der zugehörigen Vignette ist ein Kater dargestellt, der dem schlangenköpfigen Apophis, welcher bekanntermaßen als Gegenspieler des Re agiert, den Kopf abschlägt.

Im Hintergrund der Vignette zu TB 17 ist der *Tšd*-Baum[30] zu sehen, welcher zumeist als "der prächtige *Tšd*-Baum" bezeichnet wird. Die Verehrung von heiligen Bäumen[31] beruht dabei auf alten religiösen Traditionen, so herrschte beispielsweise auch schon im Alten Reich die Vorstellung, dass auf bestimmten Bäumen[32] am Rande der Wüste eine Göttin – bei der es sich für gewöhnlich um Isis, Nut oder Hathor handelt – wohnt.[33] Allerdings taucht bisher zum ersten Mal im Grab von Thutmosis III. (KV 34) ein heiliger Baum in den Wandmalereien auf.[34] Der *Tšd*-Baum galt als Lebensbaum und ist eng mit dem Königtum verbunden; so werden die Annalen des Königs (durch die Götter Thot und Seschat) auf den *Tšd*-Baum in Heliopolis gesetzt.[35] Später verbreitete sich dieses Element auch im privaten Bereich: So behauptet in Totentexten der Spätzeit jeder Verstorbene von sich, dass seine Annalen von Thot selbst in Heliopolis festgelegt worden seien.[36] Der *Tšd*-Baum, bei dem es sich vermutlich um einen Perseabaum handelt, befand sich in Heliopolis im Obeliskensanktuar (*bnbn*)[37] und später behaupteten auch weitere Tempel (so z.B. der ptolemäische Tempel in Edfu),[38] einen solchen Baum zu besitzen. Diesem Motiv aus TB 17 liegt ein Vorläufer aus den Sargtexten in CT IV, 283–291 (Spruch 335) zu Grunde.[39] Des Weiteren ist der Kater in TB 125 und TB 145 zu finden. Im Falle des Totenbuchspruchs 33 dient die Erwähnung der Katze wohl hauptsächlich dazu, die Feindschaft zwischen den beiden Tieren Katze (bzw. Kater) und der Schlange hervorzuheben, während das Bild des Gefressenwerdens der Maus von der Schlange Beobachtungen der Natur entspricht.[40] Die Tatsache, dass der *Rrk*-Schlange explizit vorgeworfen wird, an einer "verwesten" Katze genagt zu haben, ist an dieser Stelle besonders hervorzuheben, denn das Verspeisen von verwestem, faulem Fleisch erscheint sowohl äußerst verachtenswert wie auch beunruhigend, was sich in TB 17 widerspiegelt:

> "Rette doch den NN vor jenem Gott, der die *Bas* raubt und das Verweste verschlingt, der von Fäulnis lebt […]."[41]

Bei der *Rrk*-Schlange (Varianten: *Rr*, *Rrr.w*, *Rkrk*, *Rdk*, und *Rfrf*), die im Mittelpunkt des Spruches steht und gemeinsam mit den beiden Göttern Geb und Schu als Akteur auftritt, handelt es sich um ein Wesen, das erstmals in den Sargtexten des Mittleren Reiches belegt ist. Eine zoologische Identifizierung ist schwierig, denn innerhalb der Totenliteratur lassen sich zahlreiche metaphorische Schlangennamen finden, die nicht eine bestimmte Gattung bezeichnen müssen, sondern dazu dienen, bestimmte Eigenschaften des betreffenden Tieres hervorzuheben. Allerdings findet sich auf einem Schrein aus dem Mittlerem Reich, welcher sich heute unter der Inv.-Nr. 25485 im Pariser Louvre befindet, ein Hinweis darauf, dass es sich bei der *Rrk*-Schlange um eine Hornviper handeln könnte: Dort werden dieser als Attribut zwei Hörner zugeschrieben.[42] Des Weiteren taucht sie in CT V,

[28] Für Belege s. Leitz, *LGG* III, 241a-b.

[29] Vgl. Hornung, *Das Totenbuch der alten Ägypter*, 68f.

[30] Zum *Tšd*-Baum sowie heiligen Bäumen und Sträuchern generell s. Nathalie Baum, *Arbres et Arbustes de l'Égypte Ancienne* (Leuven, 1988).

[31] Zu sakralen Bäumen im kulturellen Vergleich s. Georg Steiner, *Götterwohnungen. Eine Kulturgeschichte der sakralen Bäume und Haine aus fünf Jahrtausenden* (Basel, 2014).

[32] Vgl. die Baumliste auf Pap. Berlin P. 29027, publiziert von Alexandra von Lieven, "Das Göttliche in der Natur erkennen. Tiere, Pflanzen und Phänomene der unbelebten Natur als Manifestationen des Göttlichen. Mit einer Edition der Baumliste P. Berlin 29027," *ZÄS* 131 (2004), 156–72.

[33] Vgl. Adolf Erman, *Die Religion der Ägypter*, 2. Auflage (Berlin-New York, 2001), 153f.

[34] Vgl. z.B. Nicholas Reeves und Richard Wilkinson, *Complete Valley of the Kings. Tombs and Treasures of Egypt's Greatest Pharaos* (London, 1996), 97–99.

[35] So vermerkt auch im Tempel von Karnak, siehe die Publikation in K*RI* V, 241, 7.

[36] Vgl. Jens Lieblein, *Le Livre Égyptien. Que mon nom Fleurisse* (Leipzig, 1895), XLVII (Text); für die Übersetzung vgl. S. 30.

[37] Vgl. Dimitri Meeks, *Mythes et legends du Delta d'après le papyrus Brooklyn 47.218.84*, MIFAO 125 (Cairo, 2006), Tf. III 1.

[38] Vgl. Bonnet, *RÄRG*, 84.

[39] S. die Textedition von de Buck, *CT IV*, 33–42.

[40] Vgl. Quack, "Tier des Sonnengottes und Schlangenbekämpfer," 14.

[41] Übersetzung nach Hornung, *Das Totenbuch der Ägypter*, 73.

[42] Joris Borghouts, "The victorious eyes: A structural Analysis of two Egyptian mythologizing texts of the Middle Kingdom," in Fried-

41a.c; 42f; 44c.h; 283b; 286a; 287a; CT VI, 205h; 261a; 385k und CT VII, 94 auf. In TB 39 wird sie mit der zerstörerischen Schlangengottheit Apophis gleichgesetzt, die stets versucht, den Gott Re in seiner Sonnenbarke anzugreifen.[43] Ebenfalls tritt die *Rrk*-Schlange in TB 149 in Erscheinung. Ohne Ausnahme wird ihr Auftauchen mit Bedrohung und Gefahr gleichgesetzt, die es abzuwenden gilt, wobei sich ein derartiger Umgang mit Schlangen schon in den Pyramidentexten des Alten Reiches abzeichnet.[44] Die Sprüche, die sich mit dem Schutz vor Schlangen befassen, lassen sich in die von Hartwig Altenmüller geschaffene Kategorie der Schutzriten des "Heiligen Bezirks" einordnen.[45] In den Pyramiden widmet sich zumeist ein recht umfangreicher Spruchkorpus dem Schutz des Grabes vor Schlangen, wobei allerdings in keiner Pyramide der komplette Bestand an "Schlangensprüchen" angebracht wurde.[46] Im Totenbuch treten spezielle Schlangengattungen auf, so wird im Spruch 34 die Uräus-Schlange abgewehrt und in TB 37 erscheinen zwei gewisse *Mr.ti*-Schlangen, die gleichsam vertrieben werden sollen.[47]

Auch außerhalb des Totenbuches ist das Motiv der Schlange als Bedrohung für den Toten in der Jenseitsliteratur des Neuen Reiches von großer Bedeutung. So ist in diversen Unterweltsbüchern wie dem Pfortenbuch die Schlange unverzichtbar:

> "Im Pfortenbuch gehört zu jedem Tor ein schlangengestaltiger Wächter auf dem Türflügel, dazu zwei weitere Wächter mit bedrohlichen Namen und feuerspeiende Uräus-Schlangen."[48]

Es gab jedoch auch zahlreiche Kulte rund um Gottheiten in Schlangengestalt, so, um Beispiele zu nennen, die Göttinnen Wadjet und Renenutet. Dabei stellt sich die Frage nach den Beweggründen, solche als gefährlich anzusehende Geschöpfe zu verehren: Zum einen mag die Angst, welche zu Ehrfurcht führt, ein bedeutender Faktor gewesen sein.[49] Des Weiteren spielt die Vorstellung, dass man sich ein bedrohliches Wesen – erreicht man sein Wohlwollen – gegen potenzielle Feinde zu Nutze machen kann, eine wichtige Rolle. Jedoch verkörperten die meisten Raubtiere, die in Göttergestalt verehrt wurden, im alten Ägypten zumeist noch andere Aspekte: Das Krokodil wie auch das Nilpferd repräsentierten durch Assoziation mit dem Nil u.a. Fruchtbarkeit, der ʿʿꜣ-fressende Schakal galt als Wächter der Toten. Auch das Wesen der Schlange besaß verschiedene Facetten. Sie wurde für ihre lange Lebensdauer und der engen Beziehung zur Erde bewundert, die ihr als chthonisches Tier zugeschrieben wurde: Wohl deswegen gilt die Schlange als Urform vieler Gottheiten.[50]

Die beiden Götter, die sich die *Rrk*-Schlange mit ihrer Schandtat zum Feind gemacht hat, sind zum einen der Erdgott Geb und zum anderen der Luftgott Schu. Der heliopolitanischen Theologie nach trennte Schu auf Befehl des Urgottes Atum den Erdgott von der Himmelsgöttin Nut.[51] Auf diese Trennung von Himmel und Erde wird schon in den Pyramidentexten (PT 519 § 1208c) Bezug genommen.[52] Daraufhin wird es, ähnlich wie beim griechischen Atlas,[53] zur Aufgabe des Gottes, den Himmel in Gestalt der Göttin Nut oder auch der Himmelskuh

rich Junge, ed., *Studien zu Sprache und Religion Ägyptens, 2. Bd: Religion* (Göttingen, 1984), 703–16, hier: 704.

[43] Zum Kontext Alessandro Roccati, *Magica Taurinesia. Il grande papiro magico di Torino e i suoi duplicati*, AnOr 56 (Rome, 2011), 90f.

[44] Zu Schlangen in den Pyramidentexten sei hier auf Christian Leitz, "Die Schlangensprüche in den Pyramidentexten," *Or NS* 65 (1996), 381–427, und Christoffer Theis, *Magie und Raum. Der magische Schutz ausgewählter Räume im alten Ägypten nebst einem Vergleich zu angrenzenden Kulturbereichen*, ORA 13 (Tübingen, 2014), 736–47 und 802–4 verwiesen.

[45] Zur Kategorisierung der Pyramidentexte s. Hartwig Altenmüller, *Die Texte zum Begräbnisritual in den Pyramiden des Alten Reiches*, ÄA 24 (Wiesbaden, 1972); für die Schutzriten im Besonderen vgl. 212–72.

[46] Vgl. Theis, *Magie und Raum*, 461.

[47] Vgl. zu diesen Wesen Waltraud Gugliemi, *Die Göttin Mr.t. Entstehung und Verehrung einer Personifikation*, PÄ 7 (Leiden-New York-Copenhagen-Cologne, 1991), 153–73.

[48] Vgl. Erik Hornung, *Altägyptische Jenseitsbücher. Ein einführender Überblick* (Darmstadt, 1997), 59; zusammengefasst bei Theis, *Magie und Raum*, 804.

[49] Vgl. Erman, *Die Religion der Ägypter*, 45.

[50] Vgl. Bonnet, *RÄRG*, 682. So nennt Horapollon, *Hieroglyphica* I, 1, die Schlange auch als Abbild der Ewigkeit, s. George Boas, *The Hieroglyphics of Horapollo*, BS 23 (Princeton, 1993), 43, und Heinz Thissen, *Des Niloten Horapollon Hieroglyphenbuch, Bd. I: Text und Übersetzung*, AfP, Beiheft 6 (Munich-Leipzig, 2001), 1f.

[51] Vgl. Siegfried Morenz, *Ägyptische Religion* (Stuttgart, 1960), 182f.

[52] Belege bei P (C ant/W 32), M (C med/E 47f.) und N (C med/E 45f.).

[53] Des Weiteren übernimmt dessen Rolle auch der ägyptische Gott Heh, der primär als Himmelsträger gilt.

zu tragen.[54] Der Name Schu leitet sich von dem Verb *šw* "leer sein" ab, es handelt sich also um einen abstrahierten Namen.[55] Dadurch wird das Bild von Schu als Instanz zwischen Himmel und Erde leicht greifbar.[56] Laut der Überlieferung soll Atum ihn und die Göttin Tefnut ausgespien haben, nachdem er seinen eigenen Samen verschluckt hatte.[57] Er und seine Schwester nehmen in der Götterneunheit[58] von Heliopolis die Rolle des ersten Götterpaares ein, worauf hin die Götterpaare Geb, Nut und ihre Kinder Osiris, Seth, Isis und Nephthys folgen. Im Totenbuch ist Schu recht häufig belegt und tritt in verschiedenen Sprüchen auf.[59]

Der Gott Geb gilt als Erdgott; seine Gemahlin, die Himmelsgöttin Nut, ist ihm gegenübergestellt. Beide gehören zu der Kategorie der kosmischen Gottheiten. Bei den kosmischen Göttern fällt im alten Ägypten generell die fehlende Übereinstimmung zwischen ihren Namen und der Bezeichnung des ihnen zugehörigen Elements auf, was auf eine Vielschichtigkeit im Wesen jener Götter hindeutet.[60] Die Auffälligkeit in der Namensgebung trifft im Übrigen auch auf besagtes Götterpaar zu, denn die ägyptischen Wörter für Himmel und Erde sind *p.t* und *t3*. Den altägyptischen Vorstellungen nach handelt es sich bei Geb um einen jener Götter, die einst als Götterkönige das Land beherrschten.[61] Es besteht eine direkte Verbindung zwischen ihm und Schlangen, wodurch die Verbindung zu TB 33 erklärbar wird: Aufgrund ihres Lebensraumes werden Schlangen schon in den Pyramidentexten als die "Kinder des Geb" bezeichnet (PT 385 § 675a)[62] und auch im Totenbuch (TB 87) gilt die Schlange als "Sohn der Erde." Zudem soll Geb durch den Sonnengott Re zum Wächter über Schlangen und Skorpione ernannt worden sein und somit dafür verantwortlich, dass diese den Menschen nicht schaden, was er durch die Weitergabe von passenden Zaubersprüchen bewerkstelligen soll.[63] Diese Aufgabe kommt dem Erdgott zu, weil Re im Gegensatz zu ihm die Schlangen fürchtet und keine Kenntnis über ihre Zauberkraft besitzt.[64] Durch diesen Umstand wird verständlich, warum sich gerade Geb gegen die *Rrk*-Schlange erhebt: er ist für sie und ihre Schandtaten gewissermaßen verantwortlich.

Die Rolle, die der Gott Schu in TB 33 spielt, ist weniger offensichtlich; womöglich steht er als der göttliche Erzeuger von Geb diesem zur Seite. Eine andere Möglichkeit wäre, dass Schu – in der Vorstellung des antiken Betrachters – aus Erbostheit über die Kränkung des Gottes Re handelt, was allerdings aufgrund der Quellenlage Spekulation bleibt.

Zusammenfassend lässt sich über den Inhalt des Spruches folgendes sagen: TB 33 bezweckt wie viele andere "Schlangensprüche" auch das Abwehren einer Schlange im Totenreich, wobei in ihm explizit die *Rrk*-Schlange gemeint ist. Diese tritt häufig als Bedrohung für den Toten auf und kann wie beispielsweise in TB 39 mit dem bösartigen Gott Apophis, dem "Feind des Re" *par excellence*, gleichgesetzt werden. In TB 33 wird der Schlange vorgeworfen, eine Maus gefressen zu haben, obwohl dies ein Tabu in den Augen des Gottes Re darstellt. Dabei ist der Grund für besagtes Verbot nicht eindeutig zu identifizieren. Außerdem soll sie an den Knochen einer verwesten Katze genagt haben, wobei eine Analogie zwischen Re und der besagten Katze hergestellt werden kann. Aufgrund der fast gleichlautenden Parallele in den Sargtexten ist Totenbuchspruch 33 wohl direkt aus diesen entnommen worden, oder man nimmt eine gemeinsame Vorlage für beide Textgattungen an. Das Motiv der Schlangenabwehr ist wie gezeigt dezidiert älter und lässt sich bis in das Alte Reich zurückverfolgen. Dass ein so großes Korpus an Sprüchen wie die Schlangensprüche in ihren verschiedenen Textkorpora in den königlichen

[54] So in PT 571 § 1471; vgl. Sethe, *Pyr. II*, 304.

[55] Vgl. Erik Hornung, *Der Eine und die Vielen. Altägyptische Götterwelt* (Darmstadt, 2005, 6. Auflage), 76.

[56] Vgl. Harco Willems, *The Coffin of Heqata (Cairo JdE 36418). A Case Study of Egyptian Funerary Culture of the Early Middle Kingdom*, OLA 70 (Leuven, 1996), 271f.

[57] S. die Textedition von Sethe, *Pyr. II*, 203f.

[58] Zur Götterneunheit generell s. Winfried Barta, *Untersuchungen zum Goetterkreis der Neunheit*, MÄS 28 (Munich, 1973).

[59] Der Gott erscheint in TB 17, 18, 33, 35, 46, 55, 64, 67, 78, 90, 98, 110, 115, 125, 130, 131, 134, 149, 151, 153b, 154, 160, 171, 178, 183.

[60] Vgl. Hornung, *Der Eine und die Vielen*, 64.

[61] So ist der Gott auf der Turiner Königsliste genannt, vgl. K*RI II*, 827, 14.

[62] Belegt bei T (A/E 18).

[63] Vgl. Günther Roeder, *Urkunden zur Religion des alten Ägypten* (Jena, 1915), 89; 91; 147.

[64] Vgl. Erik Hornung, *Der ägyptische Mythos von der Himmelskuh. Eine Ätiologie des Unvollkommenen*, OBO 46 (Freiburg-Göttingen, 1982), 18, Verse 205–208.

Pyramiden angebracht wurde, bezeugt die immense Wichtigkeit, sich vor diesen Reptilien zu schützen – umso mehr wird verständlich, warum auch ein Privatmann sich dieses Schutzes bedienen wollte.

Totenbuchspruch 34

Die Textzeugen

[1] Pap. Paris, Louvre, E. 11085, ursprünglicher Besitzer: *Tꜥḥ-msi(.w)*; Material: Papyrus; Standort: Paris, Musée du Louvre; Herkunft: Theben; Datierung: Frühe 18. Dynastie; Literatur: Munro, *Das Totenbuch des Jah-Mes (p.Louvre E. 11085*, Tf. 15; Totenbuchprojekt Bonn, TM 134310, <totenbuch.awk.nrw.de/objekt/tm134310>.

[2] Pap. Kairo, TR 25/1/55/6, ursprünglicher Besitzer: *Ḥꜣt-nfr.t*, heutiger Standort: Kairo, Ägyptisches Museum; Herkunft: Theben, Deir el-Bahari; Datierung: 18. Dynastie (Hatschepsut / Thutmosis III.); Literatur: Totenbuchprojekt Bonn, TM 134627, <totenbuch.awk.nrw.de/objekt/tm13462

[3] Pap. Paris, Louvre, E. 21324 (SN 1), ursprünglicher Besitzer: *Msi-m-nṯr*; Standort: Paris, Musée du Louvre; Herkunft: Theben; Datierung: 18. Dynastie (Hatschepsut / Thutmosis III.); Literatur: Totenbuchprojekt Bonn, TM 134311, <totenbuch.awk.nrw.de/objekt/tm134311>.[65]

[4] Sarkophag New York MMA 31.3.95 + 65.274 + 1971.206, ursprünglicher Besitzer: *Sn-n-mw.t*; Material: Quarzit; heutiger Standort: New York, Metropolitan Museum of Art; Herkunft: Theben (TT 71); Datierung: 18. Dynastie (Hatschepsut / Thutmosis III.); Literatur: Peter Dorman, *The Tombs of Senenmut. The Architecture and Decoration of Tombs 71 and 353*, PMMA 24 (New York, 1991), Nr. 11, 70ff.; Totenbuchprojekt Bonn, TM 135260, <totenbuch.awk.nrw.de/objekt/tm135260>.

[5] L. Grab TT 99, ursprünglicher Besitzer: *Sn-nfr*; Material: Leinen; heutiger Standort: Theben-West, Magazin; Herkunft: Theben; Datierung: 18. Dynastie (Hatschepsut / Thutmosis III.); Literatur: Totenbuchprojekt Bonn, TM 133692, <totenbuch.awk.nrw.de/objekt/tm133692>.[66]

[6] Pap. London, BM, EA 10477, ursprünglicher Besitzer: *Nw*; heutiger Standort: London, British Museum; Herkunft: Theben; Datierung: 18. Dynastie (Hatschepsut – Amenophis II.); Literatur: Totenbuchprojekt Bonn, TM 134299, <totenbuch.awk.nrw.de/objekt/tm134299>.

[7] Pap. Paris, Louvre, N. 3074, ursprünglicher Besitzer: *Ṯnn*; heutiger Standort: Paris, Musée du Louvre; Herkunft: Theben; Datierung: 18. Dynastie (Amenophis II.); Literatur: Totenbuchprojekt Bonn, TM 134307, <totenbuch.awk.nrw.de/objekt/tm134307>.[67]

[8] Pap. Paris, Louvre, SN 2 (Pap. Krakau MNK IX-752 / 1–4.), ursprünglicher Besitzer: *Ptḥ-msi(.w)*; heutiger Standort: Krakau, Muzeum Narodowe / Paris, Musée du Louvre; Herkunft: Theben; Datierung: Frühe 19. Dynastie; Literatur: Luft, "Das Totenbuch des Ptahmose. Papyrus Kraków MNK IX-752/1–4," 46–75; van Es, "Das Totenbuch des Ptahmose," 97–121; Totenbuchprojekt Bonn, TM 133557, <totenbuch.awk.nrw.de/objekt/tm133557>.

[65] Leider fehlt in der Totenbuchdatenbank in Bonn das betreffende Foto mit diesem Spruch.

[66] Die Nennung des Spruchs auf dem Leichentuch aus Leinen vermag ich nicht nachzuvollziehen. Auf den gebotenen Photographien sind keine Reste zu erkennen, die zum Spruch passen würden.

[67] Leider sind einige der Bilder in der Datenbank des Totenbuchprojekts Bonn überbelichtet und lassen keine sichere Lesung des Spruchs zu. Manche in der Umschrift als zerstört markierte Passagen könnten im Papyrus auch nur zu schwach mit Tinte geschrieben worden sein.

Synopse

Spruchtitel:

1

2

4

6

7

8

1

2

4

6

7 *n.v.*

8

Zeile 1:

1

2

4

6

7

8 *n.v.*

Zeile 2:

1

2

4

6

7

8 *n.v.*

Zeile 3:

8 *n.v.*

Übersetzung des Spruches

> *Spruch um zu verhindern, dass ein Mann/dass NN im Totenreich von einer Schlange* ¹⁻⁴*gefressen/*⁶⁻⁸*gebissen wird.* ¹⁻⁴*Das Abwehren der Uräus-Schlange durch NN/* ⁶⁻⁸*Worte zu sprechen durch die Uräus-Schlange:*

"Ich bin das Licht der Flamme, die am Scheitel von Millionen/ (des Gottes) *Ḥḥ* leuchtet,
die Standarte der *Dnpw*-Götter; andere Lesung: die Standarte der frischen Pflanzen.
Sei fern von mir, denn ich bin *Mȝfd.t*!"

Kommentar

Kritischer Kommentar zu den Textzeugen

Spruchtitel:

ᵒr' n˅ tm ᵒrḏi̯.t ⸢wnm si̯/NN⸣² i̯n ⸢wnmy ⸢²dwȝ.t
†⸢ḫsf⸣ᶠᶜr⸢ᶜr.t i̯n NN

|| ᵒ˅ 1, 2, 4 | ᵒ˅² 7 | ᵒ 1, 6 | ⸢psḥ 6, 8 | ⸢ḥfȝw.t 6; wnmḫȝ.t 7 | ⸢²m ḥr.t-nṯr ||
|| † 7 | ⸢ḏd i̯n 6, 8 | ⸢i̯ᶜr.t 2; i̯ᶜr.t 4 ||

Text:

1 †i̯nk bi̯.t psd.t m wp.t Ḥḥ
2 †⸢ȝȝ.t dnp.w ky-ḏd ⸢ȝȝ.t ⸢dnp.w
3 †⸢ḥry.ti̯ r=i̯ i̯nk Mȝfd.t

|| 1 † 8 || 2 † 8 | ⸢ȝ.t 6 | ⸢rnpy.t 6, 7 || 3 † 8 | ⸢ḥr.ti̯ 6 ||

Kommentar zu TB 34

Im Gegensatz zu TB 33 gibt es für TB 34 weder in den Sarg- noch in den Pyramidentexten eine direkte Parallele, wobei das Motiv des Abwehrens einer Schlange jedoch aus verschiedenen Quellen bekannt ist. Besagtes Motiv wird in TB 34 weiter eingegrenzt, denn es soll in den früheren Textzeugen explizit das Gefressenwerden bzw. in den späteren der Biss der Schlange im Jenseits verhindert werden. Dabei unterscheidet sich der Umgang mit einem Schlangenbiss in Totentexten von denjenigen in medizinisch-magischen Abhandlungen[68] insofern,

[68] Als Beispiel seien die sog. Horus-Stelen genannt; s. hierzu z.B. das von Heike Sternberg el-Hotabi, *Untersuchungen zur Überlieferungsgeschichte der Horus-Stelen*, ÄA 62 (Wiesbaden, 1999) gesammelte Material.

dass das Augenmerk nicht auf die Behandlung von Symptomen und die Heilung, sondern vielmehr auf die prophylaktische Vermeidung des Bisses durch Magie gelegt wird.[69] TB 34 dient folglich als ein magisches Schutzschild, welches die Gefahr von vornherein fern halten soll.

Wie in TB 33 wird auch in TB 34 nicht von Schlangen generell gesprochen, sondern diese genauer definiert: Der Spruch nimmt explizit auf die Kobra oder die Uräus-Schlange, welche in allen das Jenseits betreffenden Textgattungen recht häufig auftritt, Bezug. Im Totenbuch erscheint dieser Schlangentypus in den Sprüchen 11, 34, 42, 71, 78, 83, 85, 95, 100, 124, 125, 136 B, 149, 172, 174 und 183, und kann somit als ein wiederkehrendes Motiv gelten.

Bei der Uräus-Schlange handelt es sich mit sehr großer Wahrscheinlichkeit um eine ägyptische Kobra (*Naje haje*), wobei außerdem drei weitere Kobraarten in Ägypten anzutreffen sind: Die Rote Speikobra (*Naja pallida*), die Nubische Speikobra (*Naja nubiae*) und die schwarze Wüstenkobra.[70] Nach Christian Leitz ist es die ägyptische Kobra, die in Pap. Brooklyn 47.218.48 und 85, § 15 (1, 16)[71] als *ḥf3.t ʿ3(.t) n ʿ3pp* "große Schlange des Apophis" angesprochen wird.[72] Dabei untermauert er diese These durch die Beschreibung des Tieres im Papyrus: Laut dieser ist die Schlange von brauner Farbe – womit die schwarze Wüstenkobra ausgeschlossen werden kann – und ihr Gift erwirkt den sofortigen Tod. Da die Speikobra im Vergleich zu der ihr verwandten ägyptischen Kobra als weniger giftig gilt, scheint letztere in der Tat angesprochen zu sein.[73]

Um einen allgemeinen Überblick zu geben, lässt sich sagen, dass Kobras der Familie der Giftnattern (*Elapidae*) angehören, wobei ihr Gift neurotoxisch wirkt und zum Tod führen kann. Die *Naja haje* wird der Gattung "echte Kobras," welche in afrikanische und asiatische Tiere unterteilt wird, zugeordnet. Sie gilt im Gegensatz zu vielen anderen Arten ihrer Gattung als scheu und wenig aggressiv, kann aber, wenn sie sich in die Enge gedrängt fühlt, auch zum Angriff übergehen. Zudem hält sie sich gerne in der Nähe menschlicher Siedlungen auf, da dies durch die hier vorkommenden Nutztiere sowie Mäuse und Ratten der Nahrungsbeschaffung zuträglich ist. Führt man sich die enorme Gefahr für Leib und Leben durch den Biss dieser Schlange vor Augen, erscheint es durchaus Sinn zu ergeben, sich auch auf magische Weise vor ihr schützen zu wollen.

Neben der potenziellen Gefahr, die es abzuwehren galt, hatte die Uräus-Schlange, deren ägyptischer Name *Tʿr.t* sich mit der "Aufgebäumten" übersetzen lässt, allerdings auch andere Funktionen inne. So erscheint Wadjet als Kronengöttin von Unterägypten in der Gestalt eines Uräus und ziert gemeinsam mit der geiergestaltigen Nechbet die Krone des Pharaos. Dazu ist mit Hans Bonnet hinzuzufügen, dass sich dieser Kronengottheit-Charakter erst ab dem Mittleren Reich entwickelte und die Uräus-Schlange zunächst ein eigenständiges Symbol darstellte.[74] Außerdem fungierte *Tʿr.t* als Bezeichnung zahlreicher Göttinnen, darunter sogar als solche ihres Gegenübers Nechbet.[75] Von sehr großer Bedeutung ist die Uräus-Schlange, insbesondere mit Hinblick auf TB 34, wo sich für die Aussage, dass sie "am Scheitel" sitzt, in den Pyramidentexten (PT 583 § 1568c)[76] eine Parallele findet, die sich auf den Sonnengott bezieht. Dort heißt es *Tʿr.t im.it wp.t Rʿ*,[77] wobei dies als eine eindeutige Anspielung auf die Kobra als Auge des Re zu werten ist, wie es auch z.B. im Tempel von Dendara der Fall ist.[78] Außerdem kann dieser Passus auch anders gedeutet werden, denn:

"Um die Sonnenscheibe, die der Gott auf dem Haupte trägt, ringelt sich […] die Schlange […]."[79]

[69] Vgl. Georg Meurer, *Die Feinde des Königs in den Pyramidentexten*, OBO 189 (Göttingen, 2002), 270.

[70] Vgl. Christian Leitz, *Die Schlangennamen in den ägyptischen und griechischen Giftbüchern*, Abhandlungen der Geistes- und Sozialwissenschaftlichen Klasse 6/1997 (Stuttgart, 1997), 52–54. Für die gebotene abweichende Unterscheidung zweier Speikobraarten vgl. Wolfgang Wüster und Donald Broadley, "A New Species of Spitting Cobra (*Naja*) from north-eastern Africa (Serpentes: Elapidea)," *Journal of Zoology* 259 (2003), 345–59.

[71] Publiziert von Serge Sauneron, *Un Traité Égyptien d'Ophologie. Papyrus du Brooklyn Museum Nos 47.218.48 et 85* (Cairo 1989), 9.

[72] Vgl. Leitz, *Die Schlangennamen in den ägyptischen und griechischen Giftbüchern*, 52.

[73] Vgl. Leitz, *Die Schlangennamen in den ägyptischen und griechischen Giftbüchern*, 54.

[74] Vgl. Bonnet, *RÄRG*, 846.

[75] Vgl. Sauneron, *Esna IV*, 426, 14; idem, *Esna VI*, 536 C, 6; Georges Bénédite, *Le temple de Philae*, MMAF 13 (Paris, 1893), 133, 14.

[76] Belegt bei P (V/W 84) und M (V/N w 1).

[77] Vgl. die Textedition von Sethe, *Pyr. II*, 339.

[78] Chassinat, *Dendara III*, 164, 16.

[79] Vgl. Erman, *Die Religion der Ägypter*, 19.

An anderer Stelle wird der Uräus als ꜥr.t im.it wp.t Stš (PT 478 § 979c) mit dem zwiespältigen Gott Seth as-soziiert.[80] Dabei ist anzumerken, dass der Gott sowohl in den Pyramidentexten wie auch in späterer Zeit auch durchaus positiv konnotiert sein kann.[81] Eine weitere Parallele findet sich im sog. "Kannibalenhymnus," welcher lediglich für zwei Königsgräber des Alten Reiches – der Pyramide des Unas und der des Teti – belegt ist. Eine Abschrift existiert des Weiteren in der Mastaba des S(i)-n(.i)-Wsr.t-ꜥnḥ aus dem Mittleren Reich.[82] Laut dem Hymnus zieren Uräen den Scheitel des verstorbenen Pharao: iw iꜥr.wt=f m wp.t=f (PT 273 § 396b).[83]

Im Gegensatz zu den Parallelen in den Pyramidentexten wird die Uräus-Schlange in TB 34 in den gängigen Übersetzungen weder mit einem Gott noch dem König in Verbindung gebracht, denn sie befindet sich statt-dessen "am Scheitel von Millionen." Die Deutung dieses Sachverhalts erweist sich als äußerst problematisch, denn der Ausdruck ist nur aus dem Totenbuch bekannt. Möglicherweise kann dies als eine Anspielung auf die Uräus-Schlange als Kronengottheit, die dem Pharao und damit dem ägyptischen Reich einen solch langen, womöglich ewig andauernden Bestand garantiert, gewertet werden. Allerdings fehlt dieser Deutung der Zusam-menhang mit der eigentlichen Thematik des Spruches, weswegen sie nur wenig plausibel erscheint. Im Übrigen kann die Übersetzung der Textstelle nicht als gesichert gelten, denn die Hieroglyphe 𓁨 kann neben der Zahl Millionen gleichfalls den Gott Heh bezeichnen. Hierfür sprächen die vorher genannten Parallelen in denen das Tier gleichfalls am Scheitel eines Gottes befindlich ist. Hinzukommt, dass – zumindest bei den behandelten Textzeugen aus dem Neuen Reich – das Wort stets nur im Singular anzutreffen ist. Dabei kann dies als mögli-ches Indiz für Ḥḥ als Gottesbezeichnung gesehen werden. Zudem erscheint der Gott auf einer Statue aus der Zeit Ramses III., welche sich heute in Kairo befindet (Äg. Mus., JdE 69771) und in Pap. Brooklyn 47.218.138 in einem Spruch gegen Schlangenbisse.[84] Dies spricht für die Identifikation von Ḥḥ mit dem Gott Heh. Die Tatsa-che, dass das Wort im Singular steht, kann allerdings nur schwer als Argument gegen das Zahlwort verwendet werden, denn es erscheint im Zusammenhang mit der Bezeichnung einer sehr großen Zahl sehr häufig in dieser Form.

Interessanterweise scheint sich der Verstorbene in TB 34 zunächst mit der Uräus-Schlange, die es abzuweh-ren gilt, zu identifizieren,[85] denn die Beschreibung des Toten als leuchtende Flamme steht in enger Verbindung zu deren Wesen. So ist auch in Pap. Turin, CGT 54050, rt. V, 2[86] vom Gluthauch, der dem Maul der Urä-us-Schlange (ḥḥ pri m rꜥ n ꜥrꜥr.t) entspringt, die Rede. Folglich wird also der Tote, welcher sich vor der Schlange schützen will, selbst zu dieser. Der Spruch besitzt somit zugleich den Charakter eines Verwandlungsspruches,[87] wobei eine derartige Metamorphose des Toten zur Schlange auch in TB 87 thematisiert wird. Allerdings soll dort die zerstörerische Kraft der Uräus-Schlange gegen diese selbst gewendet werden, was durchaus als Parado-xon zu bezeichnen ist.

Eine weitere mögliche Deutung von TB 34 wäre, dass sich der Verstorbene bereits am Anfang des Spruches mit der katzenartigen Göttin Mafdet identifiziert. Aufgrund von fehlenden Belegen für eine Beziehung zwischen der Göttin und dem Element Feuer ist dies als nur wenig wahrscheinlich zu betrachten. Zudem scheint neben der Identifikation als Uräus-Schlange und Mafdet noch eine weitere zu erfolgen: Der Verstorbene als "Standarte

[80] Belegt bei P (A/W 36), M (A/W s 9) und N (A/W inf 26).

[81] So in PT 534 § 1264b, belegt bei P (C ant/E 1); s. Sethe, *Pyr. II*, 214. Dort wird er als Schutzgott der Pyramide genannt. Zudem fun-giert er als Beschützer der Sonnenbarke, wie es in einigen Papyri wie z.B. bei Alexandre Piankoff und Natacha Rambova, *Mythological Papyri* (New York, 1957), Tf. 2 vorliegt, und er Apophis ersticht, was auch eine Stele aus der 19. Dynastie, heute Leiden, RMO, Inv.-Nr. AP60, zeigt, s. die Abbildung bei Philip Turner, *Seth - A Misrepresented God in the Ancient Egyptian Pantheon?*, BAR International Series 2473 (Oxford, 2013), 45, Abb. 16. Zu seiner Rolle während des Neuen Reiches speziell s. Turner, *Seth*, 28–46.

[82] Vgl. die Liste mit den dort verwendeten Paragraphen der PT bei William Hayes, *Texts in the Maṣṭabeh of Se`n-Wosret-ꜥankh at Lisht*, PMMA 12 (New York, 1937), 15.

[83] Vgl. die Textedition von Sethe, *Pyr.*, 207; vgl. die Übersetzung bei Christopher Eyre, *The Cannibal Hymn: a cultural and literary Study* (Liverpool, 2002), 7. Paragraph belegt bei W (A/E sup. 8–9); T (A/E 30) und Sen (F/E 16).

[84] Beide Textzeugen sind publiziert in K*RI V*, 261–68. Der Papyrus wurde von Jean-Claude Goyon, *Le recueil de prophylaxie contre les agres-sions des animaux venimeux du Musée de Brooklyn. Papyrus Wilbour 47.218.138*, SSR 5 (Wiesbaden, 2012) neu publiziert.

[85] Vgl. Hornung, *Das Totenbuch der Ägypter*, 437.

[86] Publiziert bei Roccati, *Magica Taurinensia*, 26.

[87] Als Verwandlungssprüche werden im Totenbuch generell die Sprüche 76 bis 88 bezeichnet; hierzu generell Barbara Lüscher, *Die Verwandlungssprüche (Tb 76–88)*, Totenbuchtexte 2 (Basel, 2006).

der *Dnpw*-Götter." Besagte Gottheiten sind ausschließlich in TB 34 belegt. Deswegen wurde in der Forschung vermutet, dass es sich dabei lediglich um eine Verschreibung von *rnp.wt* "frische Pflanzen" handelt.[88] Jedoch ist in den behandelten Textzeugen auch die Schreibung *rnpy.t* belegt, was gegen die Theorie eines Schreibfehlers spricht. Zudem erscheint *rnpy.t* in den verfügbaren Textzeugen des Neuen Reiches mindestens genauso häufig wie die Schreibung *dnpw*. Damit kann wohl von der "Standarte der Pflanzen" als Variante zur „Standarte der *Dnpw*-Götter" ausgegangen werden. Aber auch andere Lesungen für das ägyptische *rnpy.t* bzw. *rnp.wt* wurden erwogen; so schlägt Raymond Faulkner "the Standard of Years" als eine mögliche Übersetzung vor. Allerdings erscheint diese Variante m. E. nur wenig überzeugend, denn das Jahr, dessen Bezeichnung im Ägyptischen *rnp.t* lautet, wird doch stets mit der Rispe ⸢ geschrieben, wobei diese nur in einem einzigen Textzeugen des Neuen Reiches nämlich in Pap. Paris, Louvre, N. 3074 Verwendung findet. Deswegen erscheint die vorgeschlagene Lesung – zumindest für die ursprüngliche Spruchversion – äußerst fragwürdig. Anders verhält es sich bei der Annahme, statt den "*Dnpw*(-Göttern)," die "frischen Pflanzen" zu lesen, denn das in einigen Textzeugen verwendete Determinativ 𓏲𓏲 kann als Indiz für die vermutete Verschreibung betrachtet werden. Trotzdem ist es als problematisch anzusehen, allein aufgrund des Mangels an weiteren Belegen und einer Erklärung auf einen Fehler der ägyptischen Schreiber zu schließen, denn noch sind nicht alle Quellen erfasst worden. Auch erscheint es fragwürdig, dass über die Jahrhunderte hinweg, in denen TB 34 rezipiert wurde, ein Begriff, welcher auch in den Augen des altägyptischen Betrachters einen tieferen Sinn vermissen ließ, stets mit in den Spruch aufgenommen wurde. So schreibt Stephen Quirke über die Tradierung des Totenbuches:

> "Despite their many achievements over the past two centuries, the philological European tradition in Egypt, Europe and America often blocked understanding, by an almost pathological tendency to treat any variation as a mistake, in a philological quest for some mythical original version – as if the Book of the Dead was a modern printed book with a named author, rather than anonymous collective outcome of a millennial pre-printing writing tradition."[89]

Folglich bleibt die Lesung des Spruches an dieser Stelle unklar und es kann lediglich über die Deutung dieser Passage spekuliert werden. Des Weiteren scheint es für TB 34 innerhalb des Neuen Reiches zwei verschiedene Überlieferungstraditionen zu geben: So weisen die älteren Textzeugen nicht nur bezüglich der Schreibung *dnpw* eine Parallele auf, sondern in den Sprüchen ist zudem von einem "Gefressenwerden" (*wnm*) des Toten die Rede, wohingegen sich diese Parallelität mit der Nennung der *rnpy.t* und dem "Gebissenwerden" (*psḥ*) des Toten in den Textzeugen Pap. London, BM, EA 10477 (Nr. 6) und Pap. Paris, Louvre, N. 3074 (Nr. 7) nachweisen lässt. Dabei stört der Sarkophag aus dem MMA in New York (Textzeuge 4) diese Theorie, denn in ihm werden zwar die *rnpy.t*-Pflanzen erwähnt, allerdings wird auch das "Gebissenwerden" (*wnm*) im Gegensatz zum "Gefressenwerden" (*psḥ*) genannt, welches in den anderen Textzeugen in einem Überlieferungsstrang mit den *rnpy.t*-Pflanzen zusammen erscheint. Somit muss der Schreiber entweder Kenntnis von beiden Überlieferungstraditionen des Totenbuchspruches besessen haben oder man nimmt an, dass auch hier ursprünglich die *Dnpw*-Götter genannt wurden, da *r* und *d* im Hieratischen leicht verwechselt werden konnten.

Auf die diskutierte Passage folgt die Aufforderung des Verstorbenen an die Uräus-Schlange, ihm nicht zu nahe zu kommen. Um diese zu bekräftigen setzt er sich schließlich mit Mafdet, welche wohl als "Erzfeind aller Schlangen" gelten kann, gleich. Bei dieser handelt es sich um eine tiergestaltige Göttin, deren zoologische Einordnung noch nicht vollständig geklärt werden konnte. Hermann Kees schrieb hierzu:

> "Auf den Bildern des Papyrussumpfes in Gräbern des AR erscheint gern ein katzenartiges Tier, das an Papyrusstengeln den Vogelnestern nachsteigt. Da, wie die Zoologen versichern, das Ichneumon nicht klettert, scheint es sich um eine Ginsterkatzenart […] zu handeln."[90]

[88] Vgl. z.B. Raymond Faulkner, *The Ancient Egyptian Book of the Dead* (London, 1985, 2. Auflage), 58 und Hornung, *Das Totenbuch der Ägypter*, 437.

[89] Stephen Quirke, *Going out in Daylight – prt m hrw: the Ancient Egyptian Book of the Dead; translation, sources, meanings*, GHP Egyptology 20 (London, 2013), VII.

[90] Vgl. Kees, *Götterglaube*, 33.

Häufig wird die Göttin mit dem Panther assoziiert,[91] aber auch als Fabelwesen[92] wurde sie interpretiert. Des Weiteren wurde sie als Luchs[93] bzw. Rohrkatze,[94] Gepard und Löwe[95] bezeichnet. Dabei erscheinen die Beobachtungen Wolfgang Westendorfs sehr einleuchtend: Dieser verweist auf den übermäßig langen Hals mit dem die Göttin zumeist dargestellt wird. Er zeichnet sich dadurch durch eine große Ähnlichkeit zum "Schlangenhalspanther" sowie der Hieroglyphe F9 🐾 aus. Letztere fungierte wohl als Symbol für verschiede Pantherarten wie auch Gepard und Leopard.[96] Damit bietet Westendorf ein überzeugendes Argument für die Identifikation Mafdets mit einem Panther.

Belegt ist die Göttin in Darstellungen seit der Frühzeit und bereits in den Pyramidentexten taucht ihr Name, dessen Etymologie in der Forschung umstritten ist,[97] auf.[98] So gibt Kees das ägyptische *Mꜣfd.t* als "die Kletterin" wieder,[99] wobei diese Lesung nach Frank Kammerzell linguistisch jedoch nicht untermauert werden kann.[100]

In der religiösen Literatur tritt Mafdet zumeist als Schlangenfeindin auf, wobei sie die Verstorbenen vor den Tieren beschützt. In TB 39 und TB 149 wird über sie ausgesagt, dass sie die *Rrk*-Schlange bzw. Apophis getötet habe. Dies geschieht im ersten Spruch durch das Herausreißen des Herzens (*qd ḥꜣ.ti=k in Mꜣfd.t*),[101] wohingegen in TB 149 der Schlangenkopf abgeschlagen wird. Die schon im Alten Reich bekannte Gottheit taucht in den Pyramidentexten an folgenden Stellen auf: PT 295 § 438a; 298 § 442c; 385 § 677d; 390 §685c+d.[102] In PT 298 § 442c wird gesagt, dass der Kopf einer Schlange mit einem Messer abgetrennt wird, welches sich zuvor in der Hand der Mafdet befand: Ein Motiv, das aus zahlreichen bildlichen Darstellungen bekannt ist, wobei die Göttin zumeist auch mit der Tätigkeit an sich in Verbindung gebracht wird. Allerdings kann Mafdet als Schutzgöttin auch ohne abzuwehrende Schlangen auftreten: So kann sie gleichfalls die Funktion einer herkömmlichen Totengöttin übernehmen. Veranschaulichen lässt sich dies mit PT 390 § 685c+d:

> *rd pn n Tti dd.w=f ḥr=k rd n Mꜣfd.t ꜥ.t pf n Tti wꜣḥ=f ḥr=k ꜥ.t n Mꜣfd.t ḥr.t-ib pr-ꜥnḫ*[103]
> "Dieser Fuß des Teti, welchen er auf dich gestellt hat, ist der Fuß der Mafdet. Dieser Arm des Teti, welchen er auf dich gelegt hat, ist der Arm der Mafdet, die inmitten des Lebenshauses ist."

In den Sargtexten erscheint Mafdet wie in den Pyramidentexten in vier Sprüchen. Belegt ist die Göttin in CT V, 142a; VI, 39j, 289g; VII, 94p. Generell lässt sich sagen, dass Mafdet zwar nicht ausschließlich als Feindin von Schlangen fungierte, diese Funktion ihr Erscheinen im Totenbuch jedoch bestimmt. So wird in TB 34 versucht, die Schlange schon durch die bedrohliche Präsenz des Verstorbenen in Gestalt der Mafdet abzuwehren.

Insgesamt betrachtet gibt der Totenbuchspruch einige Rätsel auf, wobei an vielen Textstellen sowohl über die Übersetzung wie auch die Interpretation diskutiert werden kann. Sicher ist, dass sich der Verstorbene mit der Katzengöttin Mafdet identifiziert. Es bleibt unklar, warum dieser aber mit der Standarte der *Dnpw*-Götter oder

[91] Vgl. Bonnet, *RÄRG*, 58; Sethe, *Urgeschichte*, § 32.

[92] Vgl. Friedrich von Bissing, "Probleme ägyptischer Vorgeschichte I. Ägypten und Mesopotamien," *AfO* 5 (1928–1929), 49–81, hier: 73.

[93] Vgl. Constant de Wit, *Le rôle et le sens du lion dans l'Égypte ancienne* (Leiden, 1951), 390.

[94] Vgl. Leitz, "Die Schlangensprüche in den Pyramidentexten," 387.

[95] Vgl. Raymond Weill, *Recherches sur la Ire Dynastie*, BdE 38 (Cairo, 1961), 347.

[96] Vgl. Wolfgang Westendorf, "Beiträge aus und zu den medizinischen Texten," *ZÄS* 92 (1966), 128–54, hier: 132f.

[97] Zur Etymologie s. die Publikation von Frank Kammerzell, *Panther, Löwe und Sprachentwicklung im Neolithikum. Bemerkungen zur Etymologie des ägyptischen Theonyms Mꜣfd.t, zur Bildung einiger Raubtiernamen im Ägyptischen und zu einzelnen Großkatzenbezeichnungen indoeuropäischer Sprachen*, LingAeg, Studia monographia 1 (Göttingen, 1994).

[98] Ein Auflistung der Pyramidentextstellen in denen die Göttin belegt ist findet sich bei Harold Hays, *The Organization of the Pyramid Texts. Typologie and Disposition*, Vol. 1, PÄ 31 (Leiden-Boston 2012), 578. Zur Rolle der Göttin in den Pyramidentexten s. auch Wolfgang Westendorf, "Die geteilte Himmelsgöttin," in Ingrid Gamer-Wallert und Wolfgang Helck, eds., *Gegengabe. Festschrift für Emma Brunner-Traut* (Tübingen, 1992), 341–57, hier: 355–57.

[99] Vgl. Kees, *Götterglaube*, 33.

[100] Vgl. Kammerzell, *Panther, Löwe und Sprachentwicklung*, 14f.

[101] Das hier das *ḥꜣ.ti*-Herz genannt wird und nicht das *ib*-Herz ließe sich damit erklären, dass erstgenanntes metonymisch geistige Phänomene wie Bewusstsein und Erinnerung bezeichnet und somit der Mensch generell verschwindet, wenn dieses Herz gefressen wird; vgl. Jan Assmann, *Tod und Jenseits im alten Ägypten* (Munich, 2001), 38.

[102] Belege von PT 295 § 438a bei W (A/E inf 18), T (A/E 12), N (A/E inf 42), Nt (F/E sub 54) und Sen (F/E 36); 298 § 442c bei W (A/E inf 22f.), N (A/E inf 41), Nt (F/E sub 52f.) und Sen (F/E 38); 385 § 677d bei T (A/E 19); 390 §685c+d bei T (A/E 23f.).

[103] S. die Textedition von Sethe, *Pyr. I*, 372.

der der frischen Pflanzen in Verbindung steht. Da es sich bei den *Dnpw*-Götter um ein *Hapax legomenon* handelt, wird sich die genaue Bedeutung dieser Wesen wohl nur durch einen erläuternden Text erschließen lassen. Einigkeit herrscht wohl nur über die Funktion des Spruches: Dem Abwehren der Schlange.

Totenbuchspruch 35

Die Textzeugen

[1] Pap. Paris, Louvre, E. 11085, ursprünglicher Besitzer: *Tꜥḥ-msi*(*.w*); Material: Papyrus; Standort: Paris, Musée du Louvre; Herkunft: Theben; Datierung: Frühe 18. Dynastie; Literatur: Munro, *Das Totenbuch des Jah-Mes (p.Louvre E. 11085)*, Tf. 15; Totenbuchprojekt Bonn, TM 134310, <totenbuch.awk.nrw.de/objekt/tm134310>.

[2] Pap. Sydney R 375 (Pap. Sydney, R 94), ursprünglicher Besitzer: *Jmn-msi*(*.w*); Standort: Sydney, University of Sydney, Nicholson Museum; Herkunft: Theben; Datierung: 18. Dynastie; Literatur: Totenbuchprojekt Bonn, TM 133521, <totenbuch.awk.nrw.de/objekt/tm133521>.

[3] Pap. Berlin P. 23013, 23014, 23015+ 23075 1–4 (a–p), hier P. 23075–2f (Pap. Berlin P. 23012), ursprünglicher Besitzer: *Rꜥ-ꜥzš*; heutiger Standort: Berlin, Ägyptisches Museum und Papyrussammlung; Herkunft: Theben; Datierung: 18. Dynastie; Literatur: Günther Burkhard und Hans-Werner Fischer-Elfert, *Ägyptische Handschriften IV*, VOHD XIX (Stuttgart, 1994), 125–29 und 148; Werner Kaiser, ed., *Ägyptisches Museum Berlin* (Berlin, 1967), 121–22, Nr. 1106; Nr. 1107–1109; *Totenbuchprojekt Bonn, TM 133543, <totenbuch.awk.nrw.de/objekt/tm133543>*.

[4] Pap. Paris, Louvre, E. 21324 (SN 1), ursprünglicher Besitzer: *Msi-m-nṯr*; Standort: Paris, Musée du Louvre; Herkunft: Theben; Datierung: 18. Dynastie (Hatschepsut / Thutmosis III.); Literatur: Totenbuchprojekt Bonn, TM 134311, <totenbuch.awk.nrw.de/objekt/tm134311>.[104]

[5] Pap. Kairo, TR 25/1/55/6, ursprünglicher Besitzer: *Ḥꜣ.t-nfr.t*, heutiger Standort: Kairo, Ägyptisches Museum; Herkunft: Theben, Deir el-Bahari; Datierung: 18. Dynastie (Hatschepsut / Thutmosis III.); Literatur: Totenbuchprojekt Bonn, TM 134627, <totenbuch.awk.nrw.de/objekt/tm13462>.

[6] Pap. London, BM, EA 10477, ursprünglicher Besitzer: *Nw*; heutiger Standort: London, British Museum; Herkunft: Theben; Datierung: 18. Dynastie (Hatschepsut – Amenophis II.); Literatur: Totenbuchprojekt Bonn, TM 134299, <totenbuch.awk.nrw.de/objekt/tm134299>.

[7] Pap. Hannover 1970.37(Pap. Brocklehurst 2); ursprüngliche Besitzerin: *Bꜣk-sw*; heutiger Standort: Hannover, Museum August Kestner; Herkunft: Theben; Datierung: 18. Dynastie (Amenophis II.); Literatur: Burkhard und Fischer-Elfert, *Ägyptische Handschriften IV*, 212; Irmtraut Munro, *Das Totenbuch des Bak-su (p.KM 1970.37 / p.Brocklehurst) aus der Zeit Amenophis' II.*, HAT 2 (Wiesbaden, 1995); Peter Munro, *Brocklehurst-Papyrus im Kestner-Museum Hannover* (Hannover, 1970); Totenbuchprojekt Bonn, TM 134281, <totenbuch.awk.nrw.de/objekt/tm134281>.

[8] Pap. Kairo (Grabung DAI / H. Guksch), ursprünglicher Besitzer: *Mn-ḫpr-(snb.w)*; heutiger Standort: Kairo, Ägyptisches Museum; Herkunft: Theben (TT 79); Datierung: 18. Dynastie (Amenophis II.); Literatur: Totenbuchprojekt Bonn, TM 134274, <totenbuch.awk.nrw.de/objekt/tm134274>.

[9] Pap. Kairo, CG 40002 (JdE 21369; S.R. IV 935; S. R. IV 966; S.R. IV 1540; Pap. Triest 12089 a–d.), ursprünglicher Besitzer: *Jmn-ḥtp(.w)*, heutiger Standort: Triest, Civico Museo di Storia ed Arte di Trieste; Herkunft: Theben; Datierung: 18. Dynastie (Amenophis II.); Literatur: Auguste Mariette, *Les papyrus égyptiens du*

[104] Leider fehlt in der Totenbuchdatenbank in Bonn das betreffende Foto mit diesem Spruch.

Musée de Boulaq III, Papyrus Nos 21 & 22 (Paris, 1876), Taf. 1–11; Irmtraut Munro, *Die Totenbuch-Handschriften der 18. Dynastie im Ägyptischen Museum Cairo*, 2 Bde., ÄA 54 (Wiesbaden, 1994), 93–126, Farb-Taf. 1, s/w-Taf. 23–45, Umschr.: Taf. 74–99 und 93–126; Marzia Vidulli Torlo, *La collezione egizia del Civico museo di storia ed arte di Trieste VI. Quaderno didattico dei Civici musei di storia ed arte* (Triest 1994), 88–91; Totenbuchprojekt Bonn, TM 133589, <totenbuch.awk.nrw.de/objekt/tm133589>.

[10] Pap. Paris, Louvre, SN 2 (Pap. Krakau MNK IX-752 / 1–4.), ursprünglicher Besitzer: *Ptḥ-msi(.w)*; heutiger Standort: Krakau, Muzeum Narodowe / Paris, Musée du Louvre; Herkunft: Theben; Datierung: Frühe 19. Dynastie; Literatur: Luft, "Das Totenbuch des Ptahmose. Papyrus Kraków MNK IX-752/1–4," 46–75; van Es, "Das Totenbuch des Ptahmose," 97–121; Totenbuchprojekt Bonn, TM 133557, <totenbuch.awk.nrw.de/objekt/tm133557>.

[11] Pap. Privatsammlung Paris (Slg. Mallet), ursprünglicher Besitzer: *Bȝk-n-Ḫnsw*; heutiger Standort: Paris, Sammlung Mallet; Herkunft: Theben; Datierung: 19.-20. Dynastie; Literatur: Totenbuchprojekt Bonn, TM 134388, <totenbuch.awk.nrw.de/objekt/tm 13488>.[105]

Synopse

Titel und Eigentümer:

[105] Da zu dem Papyrus keine Fotos oder Umschriften zur Verfügung stehen, wird der Textzeuge in der Synopse außen vorgelassen.

1 ⸗

2 ...

3 ...

*5+s-i\57**n{{173,465,54}}:.-/*

6

7 *Spatium*

8 ...

9

10 ...

Spruch:

Zeile 1:

1

2 ...

3 ...

5

6

7

8 ...

9 ...

10 ...

Zeile 2:

1

2 ...

3 ...

5

6

7

8 ...

9 ...

10 ...

Zeile 3:

Zeile 4:

Zeile 5:

1

2

3

5

6

7

8

9

10

Zeile 6:

1

2

3

5

6

7

8

9

10

Zeile 7:

Übersetzung des Spruchs

Spruch um zu verhindern, dass ein Mann/NN, gerechtfertigt, im Totenreich von einer Schlange gefressen wird.
"Oh Schu, zu (sagen) von dem von Busiris und umgekehrt,
der Kopftuchträger (und) Hathor, sie erfreuen Osiris.
Gibt es jemanden, der mich fressen will?
Du, der zerstören will, was mich schützt, gehe an mir vorbei, *Sksk*-Schlange!
Es sind die *Sᶜm*-Pflanzen, die dich bewachen.
Sie sind jenes Kraut des Osiris, der seines Begräbnisses bedarf.
Die Augen des Großen, des ‚Wäschers' fielen auf dich,
der, der Maat verteilt beim Richten der Stehenden."

Kommentar

Kritischer Kommentar zu den Textzeugen

Titel und Eigentümer:

⸢rʾ⸣ °n tm wnm⸣ sⁱ/NN mꜣᶜ ḫrw
ⁱn ⸢ḥfꜣw m ẖr.t-nṯr⸣

|| ⸢ᶜ⸣ ⁱn Wsⁱr ḥr.ⁱ ⁱr.ⁱw ḫsbd n(.ⁱ) nb tꜣ.wⁱ 10 | °2
|| ⸢ḥfꜣ.t 5, 7, 9 | ⸢ḏd≈f 6; ḏd.ⁱn≈f ḏd≈f 7 ||

Text:

1 ⁱ Šw ⁱn Ḏdw(.ⁱ) ṯs-pẖr ḥr.ⁱ ᶜfn.t Ḥw.t-Ḥr ⸢ḥnm≈śn Wsⁱr
2 ⁱn wnm.tⁱ≈fⁱ wⁱ
3 ⸢sḫn nḫ wⁱ snⁱ wⁱ sksk
4 ⁱn ⸢sᶜm ⸢sꜣu̯ tw⸣

5 ⌜ꜣꜣq.t Wsỉr ⌜pwy nn dbḥ=f qrś(.t)=f

6 ḥr °n °²⌜ỉr.tỉ wr ⌜rḫt.ỉ=°³f r=k

7 ⌜pšn mꜣ°.t ⌐ wḏ° °ḥ°.wt

|| 1 ⌜nm=śn 10 || 3 ⌜snḫ 6 || 4 ⌜°m 6; °.w 7 | ⌐r 1, 2, 6, 10 | ⌜sꜣꜣ 9 || 5 ⌜°.w 7 | ⌜pw 7 | ⌐r 7 || 6 ° 9 | °² 10 | ⌜ỉr.t 9 | ⌜bꜣ.tỉ 5 | °³ 10 || 7 ⌜psš 6, 7 | ⌐m 6, 7 ||

Kommentar zu TB 35

Der Totenbuchspruch 35 dient wie die beiden vorhergehenden Texte dem Abwehren von Schlangen. Im Titel des Spruches wird dies expliziert, denn es soll insbesondere das Gefressenwerden von einer Schlange im Totenreich verhindert werden. Dies deutet darauf hin, dass es nicht zwangsläufig eine Giftschlange ist, die angesprochen wird. Stattdessen könnte es sich theoretisch bei dem als *Sksk*-Schlange bezeichneten Tier auch um eine Würgeschlange handeln. Gegen diese These spricht die Tatsache, dass innerhalb der ägyptischen Fauna meines Wissens keine Schlangen heimisch sind, die in der Lage wären einen Menschen zu verschlingen.

In den ägyptischen Quellen erscheint die *Sksk*-Schlange erstmals in den Pyramidentexten (PT 276 § 417a).[106] Schon dort wird sie dazu aufgefordert, am Verstorbenen – in diesem Fall dem König – vorbeizugehen: Eine Forderung, die gleichfalls in TB 35 formuliert wird. Die Verbindung der *Sksk*-Schlange zur *Sꜥm*-Pflanze findet schon in den Sargtexten des Mittleren Reiches Erwähnung, wobei CT V 32–33c (Spruch 370) und CT V, 38–39 (Sprüche 375–377) als Vorlagen für den Spruch zu nennen sind. Dabei weisen diese Vorläufer viele Gemeinsamkeiten mit TB 35 auf, jedoch existieren auch einige grundlegende Unterschiede. So wird die Kopftuchträgerin näher benannt: Es handelt sich dabei um die Göttin Neith, die unter ihrem Kopftuch ist. Damit wird auf die enge Bindung der Göttin zur Kobra angespielt, welche sich unter Anderem dadurch zeigt, dass der Nackenschild des Tieres durch das Emblem der Göttin geziert sein kann.[107] Hervorzuheben ist das Auftreten der *Rrk*-Schlange in CT V, 38f. In Pap. Tebtynis, Fr. Y 4, 9–14 spielt die *Sksk*-Schlange eine wichtige Rolle.[108] Dort wird sie als Mitglied der ersten Schutztruppe in Heliopolis geführt und tritt somit in einer positiven Funktion auf.

Die *Sksk*-Schlange als Widersacher des Verstorbenen erscheint nicht gleich zu Beginn des Spruches: Stattdessen wird zunächst der Luftgott Schu angesprochen und zwar durch "den von Busiris." Dabei erscheint diese Lesung unsicher, denn es wurde nur *Ḏdw* (Busiris) geschrieben, wohingegen für die Bezeichnung "der von Busiris" die Nisben-Schreibung *Ḏdw.i* zu erwarten wäre. Nichtsdestotrotz wird diese Phrase des Spruches in den gängigen Übersetzungen aus Sinngründen in personifizierter Form wiedergegeben. Eine Ausnahme bildet dabei die Übersetzung von Quirke, der die Phrase *Ḏd.w* als "Djedu city"[109] übersetzt. Eine Lesung die den ägyptischen Wortlaut zwar exakt wiedergibt, aber inhaltlich fragwürdig scheint. Zudem ist es keine Seltenheit, dass die Endung der Nisbe wie auch manche anderen Endungen entfallen kann,[110] ein weiteres Argument für die Lesung "der von Busiris."

Der Ort Busiris spielte im Totenkult des alten Ägypten eine herausragende Rolle, denn es handelt sich bei ihm um einen der Hauptkultorte des Osiris. Dabei ist die heute geläufige arabische Bezeichnung aus dem ägyptischen *Pr-Wsir* entstanden.[111] Busiris war Hauptstadt des neunten oberägyptischen Gaus und Schauplatz der

[106] S. die Textedition von Sethe, *Pyr.* I, 217. Die Angabe bei Christian Leitz, ed., *Lexikon der ägyptischen Götter und Götterbezeichnungen* VII, OLA 116 (Leuven, 2002), 676a, ist zu berichtigen.

[107] Vgl. Olga Tomashevich, "Uraeus, Neith and Goddesses of Lower Egypt," in Eleonora Kormyševa, ed., *Ancient Egypt and Kush. In memoriam Mikhail A. Korostovtsev* (Moskow, 1993), 373–92, hier: 375ff.

[108] Publiziert von Jürgen Osing, *The Carlsberg Papyri 2. Hieratische Papyri aus Tebtunis I. Text*, CNIP 17 (Copenhagen, 1998), 184.

[109] Quirke, *Going out in Daylight*, 108.

[110] Vgl. Werner Vycichl, "Bau und Ursprung der ägyptischen Nisbe," *WZKM* 46 (1939), 189–94; hier: 189. So wird z.B. für den Konsonanten t in wortfinaler Position als Marker des femininen Geschlechts ein Zeitpunkt spätestens zur Mitte des zweiten vorchristlichen Jahrtausends genannt, vgl. Carsten Peust, "Fälle von strukturellem Einfluss des Ägyptischen auf europäische Sprachen," *Göttinger Beiträge zur Sprachwissenschaft* 2 (1999), 99–120, hier: 106.

[111] Vgl. Jürgen von Beckerath, "Abusir," *LdÄ* I, 27f. und Carsten Peust, *Die Toponyme vorarabischen Ursprungs im modernen Ägypten. Ein Katalog*, GM.B 8 (Göttingen, 2010), 88.

berühmten Osirismysterien,[112] wobei das Symbol der Stadt der Ḏd-Pfeiler[113] als das Rückgrat des Osiris galt.[114] In TB 35 spricht also eher "der von Busiris" zu Schu. Die Beziehung zwischen dem aus Heliopolis stammenden Luftgott Schu und Busiris bleibt ungeklärt, wobei jedoch eine Verbindung über den in Busiris ansässigen Gott Osiris vermutet werden kann, entstammt dieser doch der gleichen Götterfamilie und ist als dessen Großvater zu bezeichnen. "Der von Busiris" ist folglich mit dem Verstorbenen gleichzusetzen, welcher nach seinem Tod zum "Osiris NN" geworden ist.

Im Folgenden wird ausgesagt, dass der "Kopftuchträger" sowie die Göttin Hathor Osiris erfreuen. Unter dem ersten Passus, der zunächst rätselhaft erscheint ist wohl ein Verstorbener zu verstehen, da die Kopfbedeckung im Neuen Reich insbesondere in diesem Bereich Verwendung fand. Dabei hatte sich die Bedeutung des ꜥfn.t-Kopftuches im Laufe der Zeit geändert, denn zunächst wurde es wohl von Muttergottheiten getragen, wohingegen es in Pap. Westcar X, 11.18.26 bei den drei vorkommenden Pharaonen Verwendung fand.[115] Im Kontext des Totenbuches dient das Kopftuch primär der "Umhüllung" des Verstorbenen.[116]

Die Aussage, dass Hathor den Gott erfreut, scheint dahingegen eindeutiger: In den Pyramidentexten (PT 303 § 466a)[117] taucht die Göttin als Gemahlin des Osiris und Mutter des Horus auf, weswegen die Freude des Gottes über Hathor, deren Name "Haus des Horus" bedeutet, offensichtlich ist. Allerdings ist sie der gängigen Forschungsmeinung nach schon früh durch die Göttin Isis aus dieser Rolle verdrängt worden, wobei die enge Verbindung zum Gott Horus jedoch bestehen blieb.[118] Zudem erscheint Hathor auch als Gattin des Falkengottes. Häufig tritt die Göttin auch als Königsmutter oder Königsgattin in Erscheinung, was auf die Rolle Hathors als Mutter bzw. Gattin Horus zurückgehen mag.[119] Passenderweise wird die Göttin in einer Inschrift im Sethos-Tempel in Abydos als Falkenweibchen (Bik.t) bezeichnet.[120] In griechisch-römischer Zeit kann Hathor zudem einen Synkretismus mit der Göttin Isis eingehen und als Hathor-Isis[121] auftreten. Allerdings lässt sich die Göttin Hathor nicht allein auf ihre Funktion als Königsgöttin in Verbindung mit dem Gott Horus beschränken: So hatte sie früh die Rolle einer Himmelsgöttin inne. In den Pyramidentexten wird in diesem Kontext vom "Haus des Horus am Firmament" gesprochen (PT 534 § 1278b: Ḥw.t-Ḥr m qbḥ; PT 539 § 1327b: Ḥw.t-Ḥr im.it qbḥ).[122] Hinzu kommt ihre Kuhgestalt, welche als Anspielung auf die Himmelskuh, der allerdings im Laufe der Zeit nur eine untergeordnete Rolle zukam, gewertet werden kann.[123] Nicht eindeutig klar scheint, ob Hathor tatsächlich mit der Himmelskuh identisch ist oder nur Attribute von ihr übernommen hat. Auch als Tochter oder "Auge des Re" galt Hathor. Eine Sage besagt, dass sie starb und vorher ihren Vater Re bat, sie einmal im Jahr die Sonne schauen zu lassen, weswegen man ihr Bildnis alljährlich auf das Tempeldach von Dendara trug, da sie so die Sonne erblicken konnte.[124] Ab dem Mittleren Reich befand sich – passend zur Lokalität der Sage – der Hauptkultort Hathors in Dendara. Dort galt sie als Göttin der Liebe, der Sexualität und der "schönen Künste."[125] Eine weitere Erscheinungsform Hathors war indessen die als Baumgöttin.[126] Die Funktion, die sie in

[112] Zu den Osirismysterien s. Hermann Junker, "Die Mysterien des Osiris," *Semaine d'Ethnologie Religieuse, compte-rendu analytique de la IIIe session tenue à Tilbourg (6–14 Sept. 1922)*, 414–26.

[113] Für Belege s. Leitz, *LGG* VII, 677c–678b

[114] Vgl. Jürgen von Beckerath, "Busiris," *LdÄ* I, 883f.

[115] Marianne Eaton-Krauß, "The *khat* headdress," *SAK* 5 (1977), 21–39, hier: 23.

[116] Jan Assmann, "Die Inschrift auf dem äußeren Sarkophagdeckel des Merenptah," *MDAIK* 28 (1972), 47–73, hier: 64; Mark Smith, *Papyrus Harkness (MMA 31.9.7)* (Oxford, 2005), 39; 206. Für anderen Aspekte des Kopftuches vgl. Dimitri Meeks, *Mythes et legends du Delta d'après le papyrus Brooklyn 47.218.84*, MIFAO 125 (Cairo, 2006), 312; Arno Egberts, *In Quest of Meaning. A Study of the Ancient Egyptian Rites of Consecrating the Mehret-Chests and Driving the Calves I*, Egyptologische Uitgaven 8 (Leiden, 1993), 136f.

[117] S. die Textedition von Sethe, *Pyr.* I, 240.

[118] Vgl. Bonnet, *RÄRG*, 277.

[119] Vgl. Richard Wilkinson, *The Complete Gods and Goddesses of Ancient Egypt* (London, 2003), 141.

[120] Publiziert bei Auguste Mariette-Bey, *Abydos: description des fouilles exécutées sur l'emplacement de cette ville* (Paris, 1869), Tf. 39b.

[121] Für Belege s. Leitz, *LGG* V, 80a.

[122] S. die Textedition von Sethe, *Pyr.* II, 219 & 236. Belege von PT 534 § 1278b bei P (C ant/E 24) und PT 539 § 1327b bei P (V/S 23).

[123] Vgl. Ermann, *Die Religion der Ägypter*, 30.

[124] Vgl. Ermann, *Die Religion der Ägypter*, 66.

[125] Vgl. François Daumas, "Hathor," *LdÄ* II, 1024–33, hier: 1024.

[126] Vgl. Kees, *Götterglaube*, 86.

Theben während des Neuen Reiches innehatte, war eine andere: Hathor war zur Göttin der Nekropole und der Toten geworden, eine Rolle in der sie es zu großer Bedeutung schaffte:

> "Women aspired to be assimilated with Hathor in the afterlife in the same manner that men desired to 'become' Osiris, but the goddess`s relationship to the deceased applied to men and women alike."[127]

In dieser Form erscheint die Göttin häufig mit der *Jmn.t*-Standarte auf dem Haupt.[128] Möglicherweise bezieht sich die Aussage des Spruches 35 somit nicht gar auf Hathor, die Gemahlin des Horus, sondern auf Hathor in ihrer Erscheinungsform als Totengöttin. Dafür spräche der funeräre Kontext sowie der Kopftuchträger, welcher sich als Verstorbener identifizieren lässt. Damit erfreuen sowohl der verklärte Tote wie auch die Göttin Hathor, welche diesen unterstützt, den Totengott. Leider lässt sich nicht eindeutig sagen, wie die Textpassage wirklich zu interpretieren ist, weswegen die verschiedenen, aufgezeigten Möglichkeiten in Betracht zu ziehen sind.

Die Ansprache des Verstorbenen an den Luftgott Schu endet mit der Frage, ob es denn jemand gäbe, der ihn fressen wolle. Dies wird nur indirekt beantwortet, indem sich der *Sksk*-Schlange, der böswillige Absichten vorgeworfen werden, zugewandt wird. So erscheint das Reptil gleichfalls wie in den vorherigen Sprüchen die *Rrk*- und die Uräus-Schlange als Übeltäter und Widersacher des Menschen, weswegen der Verstorbene es auffordert, von ihm fernzubleiben. Dabei wird das Annähern des gefährlichen Raubtieres durch eine bestimmte Pflanzengattung, der *Sᶜm*-Pflanze,[129] verhindert. Interessanterweise fand diese Pflanze auch Verwendung bei der Behandlung von Schlangenbissen, insbesondere den Bissen von Vipern.[130] Die Identität der *Sᶜm*-Pflanze ist noch strittig, wobei sie in der Forschung häufig als Beifußart gedeutet wurde. So ist die Pflanze von Sydney Aufrère als Beifuß bzw. Wermut identifiziert worden.[131] Dagegen spricht sich Renate Germer indirekt aus, indem sie darauf hinweist, dass diese "nicht zur ägyptischen Flora gehören."[132] Einigkeit herrscht bei beiden Wissenschaftlern darüber, dass die *Sᶜm*-Pflanze nicht mit der *Sᶜꜣm*-Pflanze gleichzusetzen sei,[133] eine Vermutung, die u. a. von Hildegard von Deines und Hermann Grapow geäußert wurde.[134] Diese geht darauf zurück, dass in Pap. Ebers § 593[135] in einem Rezept zum "Beseitigen eines Blutnestes" die *Sᶜm*-Pflanze durch die *Sᶜꜣm*-Pflanze ersetzt wurde, was als ausreichender Beweis für eine Gleichsetzung der beiden Wirkstoffe jedoch nicht vollständig zu überzeugen vermag: Germer verweist zu Recht auf die enormen Unterschiede in der Anwendung der beiden Pflanzen, denn die *Sᶜm* -Pflanze wird in 87% der Fälle äußerlich angewendet, wohingegen bei der *Sᶜꜣm*-Pflanze die innere

[127] Wilkinson, *The Complete Gods and Goddesses of Ancient Egypt*, 143.

[128] So bspw. auf einer Stele aus Abydos, die sich heute in Kairo, Äg. Mus., JdE 91274 befindet; publiziert von William Simpson, *Inscribed material from the Pennysylvania-Yale Excavations at Abydos*, PPYE 6 (New Haven, 1995), 59, Abb. 97. Hierbei kann es allerdings zu einer Verwechslung mit der Westgöttin kommen, deren markantes Zeichen ebenfalls die *Jmn.t*-Standarte auf dem Haupt ist; s. zu Belegen Christoffer Theis, *Deine Seele zum Himmel, dein Leichnam zur Erde. Zur idealtypischen Rekonstruktion eines altägyptischen Bestattungsrituals*, BSAK 12 (Hamburg, 2011), 100f, Abb. 3.

[129] Zu dieser Pflanze s. Renate Germer, *Handbuch der altägyptischen Heilpflanzen*, Phillipika, Marburger altertumskundliche Abhandlungen 21 (Wiesbaden, 2008), 110f.

[130] So in Pap. Brooklyn 47.218.48 und .85 § 51e (3, 24); § 73 (4, 23); §75b (4, 25–26). Als ein weiterer Schlangenbiss, der behandelt wird, ist in § 49b (3, 21) derjenige der *gꜣrw*-Schlange angesprochen. Dabei kann es sich möglicherweise um eine Verschreibung für *gꜣny*, die mutmaßliche Bezeichnung für die Schwarze Wüstenkobra (*Walterinnesia aegyptia*) handeln; vgl. Leitz, *Die Schlangennamen in den ägyptischen und griechischen Giftbüchern*, 46f. Damit würde das Rezept eine Ausnahme darstellen, denn die *Sᶜm*-Pflanze wurde in allen anderen Fällen gegen Schlangenbisse aus der Familie der Vipern angewendet, wohingegen die Schwarze Wüstenkobra der Familie der Giftnattern angehört. Allerdings entstammen alle genannten Schlangen der Überfamilie der Nattern- und Vipernartige (*Colubroidea*) und sind so auf einen gemeinsamen Nenner zu bringen.

[131] Vgl. Sydney Aufrère, "Études de lexicologie et d'histoire naturelle VIII-XVII: remarques au sujet des végétaux interdits dans le temple d'Isis á Philae," *BIFAO* 86 (1986), 1–32, hier: 13.

[132] Vgl. Germer, *Handbuch der altägyptischen Heilpflanzen*, 111.

[133] Vgl. Germer, *Handbuch der altägyptischen Heilpflanzen*, 111; Renate Germer, *Untersuchung über Arzneimittelpflanzen im Alten Ägypten* (Hamburg, 1979), 303; Sydney Aufrère, "Études de lexicologie et d'histoire Naturelle XVIII-XXVI," 21–45, hier: 26f.

[134] Vgl. Westendorf, *Grundriss der Medizin* 6, 426f.; vgl. auch François Daumas, "Remarques sur l'absinthe et le gattilier dans l'Egypte antique," in Manfred Görg und Edgar Pusch, eds., *Festschrift Elmar Edel*, ÄAT 1 (Bamberg, 1979), 66–90, hier: 86.

[135] Publiziert von Georg Ebers, *Papyros Ebers: Das hermetische Buch über die Arzneimittel der alten Ägypter in hieratischer Schrift*, 2 Bde. (Leipzig, 1875).

Anwendung überwiegt.[136] Damit ist wohl von einem Unterschied der beiden Arzneimittel auszugehen, wobei sich in beiden Fällen eine eindeutige Identifikation nicht ermitteln lässt. Da die Erwähnung der Sᶜm-Pflanze in TB 35 innerhalb des religiösen Kontextes einzigartig ist, ist es schwierig, eine Verbindung zu Osiris herzustellen, als dessen Kraut die Pflanze bezeichnet wird. Eine mögliche Erklärung für das Vorkommen der Arzneipflanze im Totenbuch wäre die linguistische Ähnlichkeit mit 'Im.i-smȝ=f[137], wodurch es zu einem Austausch des Begriffs gekommen sein könnte. Letztere Pflanze findet sich in den Sargtexten neben der bereits zitierten Passage CT V, 39d auch in CT V, 40f & h, womit alle Belege aus Spruch 377 stammen.[138] Dort wird erläutert, dass sich die Sksk-Schlange in ihrem Pflanzengestrüpp befände. Dabei stellt der Spruch zwar eine Verbindung zwischen der Pflanze und der Sksk-Schlange her, es bleibt jedoch ungeklärt, inwiefern die Sᶜm-Pflanze bzw. Smᶜ-Pflanze die Funktion des Osiriskrauts innehatte. Vermutlich wurde, berücksichtigt man den Mangel an Belegen, der Pflanze diese Funktion in TB 35 erst zugeschrieben. Es stellt sich die Frage, wer mit der Bezeichnung "Osiris" angesprochen wird, denn abgesehen von der Gottesbezeichnung lässt sich der Begriff gleichfalls auf den Verstorbenen beziehen, der im Jenseits als Osiris NN in Erscheinung tritt. Dies wäre sehr passend, denn es wird von "Osiris, der seines Begräbnisses bedarf" gesprochen, was schließlich auch auf den Toten zutrifft. Zudem dient die Sᶜm-Pflanze laut dem Spruch der Bewachung der Schlange und somit dem Schutz des Verstorbenen, wodurch es nahe liegend erscheint, diesem die Pflanze zuzuschreiben. Trotzdem lässt sich ein Bezug des Spruches zum Totengott Osiris nicht vollständig ausschließen.

Weiter wird ausgesagt, dass die Augen des "Großen" (wr), dessen Identität nicht klar zuzuordnen ist, auf die Schlange gefallen seien. Leider kann auch diese Lesung nicht als gesichert gelten, denn die in den meisten Textzeugen vorkommende Schreibung mit der Hieroglyphe A 19 𓀀 kann sowohl wr "Großer," wie auch iȝw "Alter" und smsw "Ältester" gelesen werden. Damit ist die häufigste Lesung und Übersetzung nur eine der möglichen Varianten. So transliteriert dahingegen z.B. Quirke an dieser Stelle smsw, wodurch er auch zu seiner abweichenden Übersetzung kommt.[139]

Bei dem im Textzeugen Pap. Kairo, TR 25/1/55/6 folgend erscheinenden Passus bȝ.ti handelt es sich um einen im Neuen Reich erscheinenden Beinamen des Gottes Osiris, was einen Bezug zu diesem herstellt. In den anderen Textzeugen taucht – soweit erhalten – dahingegen der Begriff rḫt.i auf, welcher mit "Wäscher" übersetzt werden kann. Aus dem königlichen Kontext sind die Titel "Wäscher des Pharao" (rḫt.i n Pr-ᶜȝ) und "Oberster Wäscher des Pharaos" (ḥr.i rḫt.i n Pr-ᶜȝ),[140] sowie "Oberster der Wäscher des Harems" (ḥr.i pd.t n rḫt.iw n pr ḥnr)[141] bekannt; im Tempelkontext ist sind die Titel "Wäscher des Tempels des Min" (rḫt.i n ḥw.t-nṯr n.t Mnw)[142] und "Wäscher des Gottes" (rḫt.i nṯr)[143] belegt. Aber auch im funerären Bereich ist der Wäschertitel zu finden: So existieren mehrere Nennungen der "Wäscher des Hauses der Ewigkeit" (rḫt.i(w) n.w pr-ḏt)[144], wobei es sich bei dem Haus der Ewigkeit um einen Euphemismus für das Grab bzw. den Friedhof handelt. Passend hierzu findet sich einer der Belege in einem Grab (S8),[145] dessen Besitzer den Namen 'Ibi trägt. Dort wird der Wäscher als eine Berufsbezeichnung unter anderen genannt, was sich laut Jurij Perepelkin folgendermaßen begründen lässt:

> "Hier war die Bezeichnung von bestimmten Arbeitern als zum Haus des Gauherren gehörig besonders sinnvoll, weil es sich bei solchen Handwerkern nicht nur um eigene handeln konnte, sondern auch um solche, die den Fürsten […] unterstellt waren."[146]

[136] Vgl. Germer, *Untersuchung über Arzneimittelpflanzen im Alten Ägypten*, 303f.

[137] S. den Beleg bei Leitz, *LGG* I, 251a.

[138] S. die Textedition von de Buck, *CT V*, 39d; 40f & h.

[139] Vgl. Quirke, *Going out in Daylight*, 108.

[140] Beide Titel sind im "Zwei-Brüder-Märchen" belegt; publiziert von Gardiner, *LESt*, 9–30. Für die Belege s. 20; 10; 14.

[141] Vgl. Christiane Zivie, "À propos de quelques reliefs du Nouvel Empire au Musée du Caire," *BIFAO* 75 (1975), 285–310, hier: 306f.

[142] S. die Verweise bei Dilwyn Jones, *An Index of Ancient Egyptian Titles, Epithets and Phrases of the Old Kingdom I* (Oxford, 2000), 493, Nr. 1845.

[143] S. die Verweise bei Jones, *An Index of Ancient Egyptian Titles I*, 493, Nr. 1843.

[144] S. die Verweise bei Jones, *An Index of Ancient Egyptian Titles I*, 493, Nr. 1844.

[145] Publiziert von Davies, *Deir el-Gebrâwi I*; für den "Wäscher" s. Tf. 6.

[146] Perepelkin, *Privateigentum*, 171.

Damit findet der Beruf des Wäschers zwar im Kontext des Grabes Erwähnung, aber in einer rein trivialen Funktion. Zudem liegt zwischen dem Grab des *Ibi* aus dem Alten Reich und der Entstehung des Spruches ein zu großer Zeitraum, um klare Schlüsse zuzulassen. Somit bleibt das Erscheinen des Wäschers unverständlich. Hornung setzt in seinem kurzen Kommentar "den Großen, den Wäscher" mit Osiris gleich, ohne jedoch eine Erklärung für die Bezeichnung des Osiris als Wäscher zu bieten.[147] Durch die Tatsache, dass in der vorhergehenden Passage vom "Kraut des Osiris" die Rede ist, wäre durchaus die Möglichkeit gegeben, dass sich weiterhin auf den Gott bezogen wird. Folgend wird der Genannte als derjenige bezeichnet, der die Maat zuteilt und die Stehenden (*ʿḥʿ.w*)[148] richtet, ein weiteres Indiz, welches auf den Totengott und -Richter hindeutet.[149] So wird Osiris im Totenbuch als der große Richter der Toten beschrieben, wobei sich der Spruch TB 125 intensiv mit dem Jenseitsgericht auseinandersetzt. Dieses findet in der "Halle der Vollständigen Wahrheit" statt und wird bezeichnet als "jenem Tag, an dem Rechenschaft abgelegt wird vor *Wnn-nfr*."[150] Dabei stehen dem Gott 42 Wesen als Totenrichter zur Seite, die mit ihm gemeinsam über den Verstorbenen urteilen.

> "Der Tote begrüßt zunächst den Osiris und versichert seine Reinheit, indem er eine lange Zahl von Sünden aufzählt, die er nicht getan habe. Dann wendet er sich mit dem gleichen negativen Bekenntnis, wie man es zu bezeichnen pflegt, an jene Dämonen; denn jeder Dämon wacht über eine besondere Sünde."[151]

Neben den Sünden, die der Verstorbene nicht begangen hatte, berichtet er zudem von seinen guten Taten: So soll er dem Hungrigen Brot gegeben, dem Durstigen Wasser, dem Nackten Kleider, ein Fährboot dem Schifflosen und den Göttern und Toten geopfert haben. Solcherlei Tugenden traten schon in der älteren Literatur und Grabschriften Ägyptens in Erscheinung.[152] Allerdings ist letztendlich nicht die "Beichte" des Verstorbenen vor dem Gericht ausschlaggebend, sondern das Gewicht seines Herzens, welches gegen die Feder der Maat aufgewogen wird. Nach Jan Assmann handelt es sich folglich um die Berechnung der Differenz zwischen der Lebensführung des Verstorbenen und der gerechten Ordnung.[153] Hat sich der Verstorbene zu Lebzeiten versündigt, so wird sein Herz der "Großen Fresserin" (*ʿmmy.t*) zum Fraß vorgeworfen. Das erste Mal erscheint diese im Neuen Reich und verbreitete zumeist als Mischwesen mit Krokodilkopf, dem Vorderleib eines Löwen und dem Hinterleib eines Nilpferdes Angst und Schrecken. Jedoch scheint den bisher bekannten Belegen nach nicht nur das Auftreten der *ʿmmy.t* eine Neuerung des Neuen Reiches zu sein, sondern die gesamte Ausarbeitung des Jenseitsgerichtes, wie es in TB 125 überliefert ist. Zwar ist schon im Alten Reich die Idee eines jenseitigen Gerichts nachzuweisen, aber dieses richtete sich nach dem Vorbild eines irdischen Gerichthofes, welcher nur dann tagt, wenn ein Ankläger existiert.[154] Damit betraf das Jenseitsgericht vor allem Feinden der Verstorbenen. In Gräbern des Alten Reiches wurden Grabräuber mit diesem bedroht,[155] wobei solcherlei Drohungen sich auch im Mittleren Reich fortsetzten.[156] Im Alten Reich trat der Sonnengott Re als Hüter und Bewahrer der Ordnung sowie Richter auf. Dies zeigt sich insbesondere in PT 524 § 1238b:

> *ꜣw mdw pw pn ḏr ḥr=k Rʿ*
> "Weit ist dieses Wort in deinem Angesicht, oh Re!"[157]

[147] Vgl. Hornung, *Das Totenbuch der Ägypter*, 437.

[148] Für Belege s. Leitz, *LGG* II, 194c.

[149] Vgl. Hornung, *Das Totenbuch der Ägypter*, 437.

[150] TB 125, 8f., s. die Übersetzung von Hornung, *Das Totenbuch der Ägypter*, 233.

[151] Bonnet, *RÄRG*, 339.

[152] Vgl. Erman, *Die Religion der Ägypter*, 158f.

[153] Vgl. Jan Assmann, *Maʿat. Gerechtigkeit und Unsterblichkeit im Alten Ägypten* (Munich, 1990), 133.

[154] Vgl. Assmann, *Tod und Jenseits im Alten Ägypten*, 100f.

[155] So z.b. auch im Grab des Ibi, s. die Publikation von Davies, *Deir el-Gebrâwi I*, pl. 23.

[156] So z.B. in CT II 227–254 (Spruch 149), s. die Textedition von de Buck, *CT II*, 227–54.

[157] S. die Textedition von Sethe, *Pyr. II*, 198; belegt bei P (C ant/W 66).

Der Sonnengott war es auch, der laut dem Osirismythos beim Göttergericht von Heliopolis über Osiris und Seth Recht gesprochen hatte und ersteren damit erst zum "Gerechtfertigten" gemacht hatte. Dies wird in PT 477 § 956–962 zum Ausdruck gebracht.[158] Im Mittleren Reich ist eine Wandlung der Unterweltsvorstellungen zu erkennen. Nun strebt der Tote nicht mehr nur gen Himmel, sondern auch in die Unterwelt, in der er sich eine Vereinigung mit dem Gott Osiris zum Ziel setzt. Ein Wunsch, der auch im Totenbuch anklingt. In den Sargtexten wird die Reise des Toten zu Osiris ausführlich behandelt. Hierfür lässt sich CT IV, 68–87 (Spruch 312), "Spruch um zum göttlichen Falken zu werden" (*ḫpr m bik nṯr.i*), als Beispiel nennen. Im Mittelpunkt steht dieses Verlangen im als solchen bezeichneten Zweiwegebuch.[159] Dieses setzt sich aus CT VII 252–521 (Sprüche 1029–1185) zusammen und ist damit ein integraler Bestandteil der Sargtexte.[160] Der Verstorbene des Mittleren Reiches muss zahlreichen Gefahren trotzen, wobei er diese nur wenn er reinen Herzens ist überstehen kann, um so zu einem verklärten Geist (*3ḫ*)[161] zu werden. Somit finden sich bereits vor dem Neuen Reich einige Elemente, welche später in die Konzeption des Jenseitsgerichts wie es aus TB 125 bekannt ist, einflossen.

Dort soll Osiris über die "Stehenden" richten. Diese Bezeichnung ist unter anderem im Höhlenbuch 64, 6 belegt.[162] Dort werden sie als zwei Götter, die den Gott Tatenen stützen, dargestellt und mit den Leichnamen der Götter Chepri und Atum assoziiert. Der Gott Tatenen ist schon aus dem Mittleren Reich bekannt, wobei die ersten Belege ausschließlich auf Särgen aus der Nekropole von Assiut zu finden sind.[163] Zu diesem Zeitpunkt galt er als Erdgott, wohingegen er ab dem Neuen Reich mit dem Urhügel in Verbindung stand und so zum Ur- und Schöpfergott wurde. Die "Stehenden" treten in den Sargtexten (CT I, 93b und CT II, 111f)[164] in Erscheinung. In CT I, 93b fungieren sie als eine Bezeichnung der Westlichen (*imn.tiw*), was sich sehr gut mit der betreffenden Textpassage des Totenbuches in Einklang bringen klingen lässt, da zumeist die Verstorbenen euphemistisch als "die Westlichen" bezeichnet werden.[165] An anderer Stelle (CT II, 111f) heißt es, dass die *ʿḥʿ.w* vor dem Verstorbenen auf ihr Gesicht fallen sollen. Dabei stellt sich die Frage, ob *ʿḥʿ.w* an dieser Stelle gleichfalls als Bezeichnung der Westlichen Verwendung findet. Wäre dies zutreffend, so sollen die bereits verklärten Toten möglicherweise dadurch dem soeben Verstorbenen ihre Ehrerbietung zu Teil werden lassen. Leider kann sich hiermit an dieser Stelle nicht weiter auseinandergesetzt werden, weswegen diese Passage rätselhaft bleibt. Neben der Interpretation von *ʿḥʿ.w* als die "Stehenden" wird von Burkhard Backes in der Totenbuchdatenbank für den Textzeugen Pap. London, BM, EA 10477 die Übersetzung die "Aufgebäumten," welche er als Wächterschlangen identifiziert, vorgeschlagen.[166] Zwar gibt es Belege für die *ʿḥʿ.w* als Wächterschlangen,[167] jedoch datieren diese allesamt in die griechisch-römische Zeit. Damit liegt gut ein Jahrtausend zwischen der Entstehung von TB 35 sowie des besagten Textzeugen in der 18. Dynastie und den ersten Belegen für die Wächterschlangen, womit Backes' Interpretation der Passage abzulehnen ist.

Zusammenfassend lässt sich über TB 35 sagen, dass sich zwar für viele Passagen Parallelen finden lassen, einige Phrasen und Motive allerdings in diesem Spruch singulär erscheinen, wodurch eine Deutung deutlich erschwert wird. Klar vor Augen steht – wie bereits in TB 33 und TB 34 – der Zweck des Spruches, nämlich abermals die Abwehr einer Schlange. Dabei soll hier im Gegensatz zu TB 34, in dem in einigen Textzeugen stattdessen das Motiv des Verhinderns eines Schlangenbisses erscheint, das Gefressenwerden des Toten verhindert werden.

[158] S. die Textedition von Sethe, *Pyr. II*, 33–37; belegt bei P (A/W 27–29), M (A/W inf 14–21) und N (A/W n 15–inf 4).

[159] S. Leonard Lesko, *The Ancient Egyptian Book of Two Ways* (Berkeley-Los Angeles-London 1972), bes. 6f.

[160] S. Edmund Hermsen, *Die zwei Wege des Jenseits. Das altägyptische Zweiwegebuch und seine Topographie*, OBO 112 (Freiburg-Göttingen 1991), 66.

[161] Vgl. zu diesem Ausdruck Theis, *Deine Seele zum Himmel*, 17, Anm. 5 mit gesammelter Literatur.

[162] S. die Publikation von Daniel Werning, *Das Höhlenbuch I* (Wiesbaden, 2011), 248f.

[163] Vgl. Hermann Schlögl, *Der Gott Tatenen. Nach Texten und Bildern des Neuen Reiches*, OBO 29 (Freiburg-Göttingen, 1980), 13.

[164] S. die Textedition von de Buck, *CT I*, 93b; idem, *CT II*, 111f.

[165] Vgl. Bonnet, *RÄRG*, 867.

[166] So die Übersetzung zu Spruch 35 von Burkhard Backes unter <http://totenbuch.awk.nrw.de/spruch/35>.

[167] Für Belege s. Leitz, *LGG* II, 199b.

Schlussbemerkung

Die gemeinsame Thematik der drei behandelten Sprüche – das Abwehren von Schlangen bzw. einer spezifischen Schlange – liegt bei deren Betrachtung auf der Hand. Papyrus Paris, Louvre, E. 11085 stellt einen der frühesten Exemplare unter den Belegen des Totenbuchs dar und fungiert als Textzeuge für alle drei Sprüche, wobei bisher nur für TB 33 ein noch früherer Beleg nachzuweisen ist. Bei dem Textzeugen aus der 13. Dynastie (Sarg der *Mnṯw-ḥtp(.w)*), welcher gleichfalls in der Region um Theben gefunden wurde,[168] handelt es sich zwar im Wesentlichen um denselben Spruch, der Wortlaut stimmt aber mit den bekannten Textzeugen aus dem Neuem Reich nicht vollständig überein. Stattdessen könnte es sich gleichfalls um eine abgewandelte Form von CT V, 31 (Spruch 369) handeln, der passagenweise mit dem Text des Totenbuches nahezu identisch ist. Desgleichen verhält es sich mit einigen anderen Sprüchen des Totenbuches, die auf dem Sarkophag zu finden, aber auch in den Sargtexten vorhanden sind. Obwohl die Sprüche noch nicht vollständig in ihre endgültige kanonisierte Form gefunden haben, ist der Sarg für die Erforschung des Totenbuchs essentiell. Bedauerlicherweise ist er heute verschollen, wobei seine einzige Dokumentation von Gardner Wilkinson im Jahre 1832 angefertigt wurde.[169] Als Besitzerin des Sarges konnte die Königin *Mnṯw-ḥtp(.w)*, Gemahlin des wenig bekannten Pharaos *Ḏḥwti* identifiziert werden. In der Forschung herrschte lange Zeit Zweifel darüber, ob dieser in die 13. oder die 17. Dynastie datiert werden muss.[170] Dabei gelang es Christina Geisen überzeugende Argumente für eine zeitliche Einordnung in die 13. Dynastie zu finden.[171] In der Totenbuchdatenbank werden noch weitere Textträger geführt, deren Datierung noch nicht gesichert ist.[172] Allerdings erscheinen auf den Textzeugen zunächst v.a. ältere Textüberlieferungen: So ist auf beiden als Beispiel genannten Textträgern Spruch 17 erhalten, welcher mit CT IV, 184–317 (Spruch 335) eine Parallele in den Sargtexten besitzt. Außerdem ist auf Papyrus London, UC 55720.1 möglicherweise ein Überrest von TB 18 erhalten. Dieser Spruch ist bisher aus den Sargtexten nicht bekannt, weswegen allerdings nicht auszuschließen ist, dass der Text bereits dort tradiert wurde. Sogar der zwölften Dynastie wird in der Totenbuchdatenbank mit Sarkophag Lischt MH1A bereits ein Textzeuge zugeordnet.[173] Jedoch ist diese Nennung als äußerst fragwürdig zu erachten, denn James P. Allen, der den Sarg publizierte, spricht ausschließlich von Sargtexten, die auf dem Sarg angebracht sind.[174] In einem Grab in Abydos (D 25) wurde ein Sarg gefunden (Sarg Oxford, Ashmolean Museum, E. 1952a–o + E. 1953), der zeitlich sicher in die 13. Dynastie eingeordnet werden kann und auf den laut den Angaben des Totenbuchprojekts in Bonn ebenfalls TB 33 bzw. CT V, 31 (Spruch 369) angebracht wurde.[175] Da das vorhandene Fragment meines Erachtens aber eher zu dem – zugegebenermaßen sehr ähnlichen – Sargtextspruch passt, wurde der Textzeuge in der Synopse außen vor gelassen. Die auf dem Sarg vorhandene Textpassage ist auch für Wolfram Grajetzki gleichfalls nicht identisch mit TB 33:

"Coffin Text spell 369 found on the Abydos coffin is slightly different to the other Coffin Texts versions but also not identical to Book of the Dead chapter 33."[176]

[168] Wilkinson vermerkte auf einen seiner Zeichnungen "Gourna, Thebes" als Fundort; vgl. Geisen, *Die Totentexte des verschollenen Sarges der Königin Mentuhotep aus der 13. Dynastie*, Tf. 3.

[169] Vgl. Geisen, *Die Totentexte des verschollenen Sarges der Königin Mentuhotep aus der 13. Dynastie*, 1.

[170] Vgl. Jürgen von Beckerath, *Die Chronologie des pharaonischen Ägypten*, MÄS 46 (Mainz, 1997), 138; idem, *Handbuch der ägyptischen Königsnamen*, MÄS 49 (Mainz, 1999, 2. Auflage), 127; Thomas Schneider, *Lexikon der Pharaonen. Die altägyptischen Könige von der Frühzeit bis zur Römerherrschaft* (Zurich, 1994), 114.

[171] Vgl. hierfür Geisen, "Zur zeitlichen Einordnung des Königs Djehuti an des Ende der 13. Dynastie."

[172] Dabei handelt es sich z.B. um Pap. London, UC 55720. 1 (vgl. *Totenbuchprojekt Bonn, TM 134796*, <totenbuch.awk.nrw.de/objekt/tm134796>) und Sarg London, BM, EA 29997 (vgl. *Totenbuchprojekt Bonn, TM 135250*, <totenbuch.awk.nrw.de/objekt/tm135250>).

[173] Vgl. *Totenbuchprojekt Bonn, TM 135513*, <totenbuch.awk.nrw.de/objekt/tm135513>.

[174] S. die Publikation von James Allen, "Coffin Texts from Lisht," in Harco Willems, ed., *The World of the Coffin Texts, Proceedings of the Symposium Held on the Occasion of the 100th Birthday of Adriaan de Buck; Leiden, December 17–19, 1992* (Leiden, 1996), 1–15.

[175] Vgl. *Totenbuchprojekt Bonn, TM 135508*, <totenbuch.awk.nrw.de/objekt/tm135508>.

[176] Wolfram Grajetzki, "Another early source for the Book of the Dead," *SAK* 34 (2006), 205–16, hier: 213.

Desgleichen verhält es sich für Spruch 149. Bei diesem sind zwar nur noch zwei Zeilen vorhanden, die allerdings eine größere Differenz zum Text des Totenbuches aufweisen und somit diesem nicht bedingungslos zugeordnet werden können: Vielmehr vermutet Grajetzki einen bisher nicht erhaltenen, weiteren Sargtextspruch. In der Tat muss dies für einen Textzeugen in Sargform im ausgehenden Mittleren Reich durchaus in Betracht gezogen werden. Gleichfalls ist dies für den Textzeugen Pap. London, UC 55720. 1, auf dem Überreste von TB 18 vermutet werden,[177] anzunehmen.

Während die Textzeugen für die drei behandelten Sprüche bis zum Ende des Neuen Reiches allesamt aus Theben oder einem Ort unbekannter Herkunft stammen, ändert sich dies in späterer Zeit. Zwar ist in der dritten Zwischenzeit Theben weiterhin der einzig gesicherte Herkunftsort für Textzeugen der drei Sprüche, wohingegen in der Spät- und Ptolemäerzeit nur noch die Hälfte der bekannten Textzeugen aus Theben stammt und mit Saqqara ein weiterer wichtiger Fundort hinzukommt. Für das Totenbuch insgesamt gilt, was die Herkunft betrifft, eine ähnliche Verteilung: So stammen von den 2992 in der Totenbuchdatenbank geführten Exemplaren 981 aus Theben – was einem Anteil von über 32% entspricht. Dabei ist die Anzahl der Exemplare vor dem Neuen Reich nur von geringer Relevanz. Im Neuen Reich kann für etwa 50% der bekannten Exemplare eine Herkunft aus Theben als gesichert gelten, wohingegen es den Anschein hat, dass die Textzeugen für die drei hier behandelten Schlangensprüche beinahe ausschließlich aus Theben stammen. Damit scheinen sich die drei Sprüche zur Zeit des Neuen Reichs in Oberägypten besonders großer Beliebtheit zu erfreuen. Es ist die Frage zu stellen, ob sich dies mit einem erhöhten Vorkommen an gefährlichen Schlangen erklären lässt, das zum häufigen Gebrauch der Sprüche geführt haben könnte. Allerdings besteht gleichfalls die Möglichkeit, dass es lediglich auf Zufall beruht, dass die Sprüche zunächst nur in ihrem mutmaßlichen Entstehungsort Theben Fuß fassen konnten. Aus dem römerzeitlichen Ägypten ist nur noch für TB 33 ein möglicher Textzeuge, die Mumienbinde M. Madrid, Museo Arqueológico Nacional 2 bekannt, deren Herkunft bedauerlicherweise ungeklärt ist.[178] Schwerwiegender erscheint an dieser Stelle allerdings, dass auch die Datierung keinesfalls als gesichert gelten kann. Geht man allerdings davon aus, dass diese korrekt ist, so wäre Spruch 33, dessen ältester Beleg in die 13. Dynastie datiert, wohl einer der am längsten tradierten Sprüche des Totenbuchkanons überhaupt. Aber auch die beiden anderen hier behandelten Sprüche können eine lange Tradierungszeit aufweisen, so sind sie von der frühen 18. Dynastie bis in die Spätptolemäerzeit anzutreffen. Dies zeigt die kontinuierliche Relevanz des Anliegens der drei Sprüche: Der prophylaktischen Abwehr von Schlangen.

Das Totenbuch war eine Tradition, die im antiken Ägypten fast zwei Jahrtausende gepflegt wurde und die sowohl religiöse Vorstellungen wie auch moralische und soziale Normen widerspiegelt. Dadurch stellt es einen Schatz an Wissen über die Lebenswelt des alten Ägypters zur Verfügung. Aufgrund dessen lohnt sich eine Auseinandersetzung mit den Texten des Totenbuches allemal. In dieser Untersuchung wurden drei thematisch verwandte Sprüche sowohl inhaltlich wie auch textlich behandelt, wobei sich auf die Textzeugen bis zum Ende des Neuen Reiches beschränkt wurde. Dabei existieren allerdings innerhalb des Totenbuchkorpus noch weitere "Schlangensprüche," die gleichfalls noch auf eine Behandlung warten. Somit bieten diese Sprüche noch großes Potenzial für weitere Forschungen.

University of Heidelberg

[177] So die Angabe in der *Totenbuchprojekt Bonn, TM 134796*, <*totenbuch.awk.nrw.de/objekt/tm134796*>.

[178] Zu TB 33 auf der Binde vgl. Ricardo Caminos, "Bandages with Book of the Dead Spells," in John Baines et al., eds., *Pyramid Studies and other Essays presented to I.E.S. Edwards*, Occasional Publications 7 (London, 1988), 161–67, hier: 165.

"Isisblumen" au Pays de Kouch: Bilan et Perspectives

Tsubasa Sakamoto

Abstract

This article summarizes and critically assesses current data about the "Isisblumen," a term coined by Günther Roeder to describe the way in which the encounter between Egypt and Nubia produced a new religious landscape in the last centuries of paganism. After providing an exhaustive catalogue of the materials, the present author will explore how this motif illustrates the interaction between the two worlds and how it relates to the nomadic populations who had been living along the southern frontier of Egypt, i.e., the Blemmyes and the Noubades. A discussion will also be given on their role in the maintenance of religious activity of Philae.

Introduction

À l'automne 1907,[1] au cours de la construction du premier barrage d'Aswan, le jeune égyptologue allemand Günther Roeder partit sur le terrain à la frontière égyptienne chargé d'une mission importante et urgente : les relevés archéologiques, épigraphique et photographique des monuments immergés de la Nubie entre Debod et Kalabsha. De nombreux édifices religieux se trouvant dans cette région,[2] il s'est fixé pour but principal de documenter les inscriptions et les iconographies gravées sur les temples. Le résultat de cette campagne, sans doute considérable, fut immédiatement publié dans son ouvrage.[3]

Il est cependant curieux de constater que la première étude de Roeder s'intéressait non pas aux temples eux-mêmes, mais à un motif assez modeste que l'on trouvait près de ces derniers.[4] Ce motif, selon lui, correspond au bouquet (*Blumenstabstrauß*[5]) de l'Égypte ancienne et se trouve en grande quantité sur les parois des carrières de Kertassi. Un fait remarquable est que l'un des exemplaires a été peint devant le signe hiéroglyphique du siège (fig. 1).[6] Il a ainsi nommé ce motif "Isisblumen" (désormais "Blumen") et l'a associé au culte d'Isis pratiqué dans le Dodécaschène.[7]

[1] Sauf mention contraire, toutes les dates sont "apr. J.-C." Cette recherche a été rendue possible grâce à une subvention accordée par The Takanashi Foundation for Historical Science, que nous remercions vivement.

[2] Pour un aperçu récent, voir Günther Hölbl, *Altägypten im römischen Reich: Der römische Pharao und seine Tempel II. Die Tempel des römischen Nubien* (Mainz, 2004); Friederike Herklotz, *Prinzeps und Pharao: Der Kult des Augustus in Ägypten*, Oikumene 4 (Frankfurt, 2007), 139–65. Pour la période ptolémaïque, voir entre autres Gertrud Dietze, "Philae und die Dodekaschoinos in ptolemäischer Zeit: Ein Beitrag zur Frage ptolemäischer Präsenz im Grenzland zwischen Ägypten und Afrika an Hand der architektonischen und epigraphischen Quellen," *AncSoc* 25 (1994), 102–8.

[3] Günther Roeder, *Debod bis Bab Kalabsche* (Cairo, 1911).

[4] Günther Roeder, "Die Blumen der Isis von Philä," *ZÄS* 48 (1910), 115–23. Voir déjà Georg Schweinfurth, "Bega-Gräber," *ZE* 31 (1899), 540.

[5] Cf. Ludwig Keimer, "Egyptian Formal Bouquets (Bouquets montés)," *AJSL* 41/3 (1925), 145–61; Sven Kappel, "Stabsträusse, Blumenhalskragen, Girlanden und Kränze: Floristische Kunstwerke der Ägypter," dans André Wiese et Christiane Jacquet, éd., *Blumenreich: Wiedergeburt in Pharaonengräbern* (Basel, 2014), 95–99.

[6] Roeder, *Debod bis Bab Kalabsche*, I, 136, L 348; Emmanuel Deronne, "Recueil des inscriptions grecques de Kertassi en Nubie," PhD diss., Université Charles-de-Gaulle-Lille-3, 1992, 984, texte no 41.

[7] Pour le Dodécaschène, voir Josef Locher, *Topographie und Geschichte der Region am ersten Nilkatarakt in griechisch-römischer Zeit*, AfP Beiheft 5 (Stuttgart-Leipzig, 1999), 230–33.

Journal of the American Research Center in Egypt 53 (2017), 91–103
doi: http://dx.doi.org/10.5913/jarce.53.2017.a004

Si l'interprétation isiaque de Roeder est toujours sujette à caution,[8] une nouvelle piste de recherche a été ouverte par Herbert Ricke en 1967.[9] C'est ce dernier qui a mis en lien le motif avec les feuilles de palmier (cf. *infra*) mentionnées dans le décret divin de l'Abaton,[10] un texte hiéroglyphique datable du IIe siècle et gravé sur la paroi nord de la porte d'Hadrien à Philae.[11] Selon ce décret, les prêtres allaient verser des libations sur les trois-cent-soixante-cinq tables d'offrandes qui entouraient le tombeau d'Osiris, maître de l'Abaton, et, tous les dix jours, Isis, maîtresse de Philae, traversait le bras du fleuve en portant une offrande de lait.[12] S'ajoutaient à ce rite des feuilles de palmier qui étaient disposées sur les tables d'offrandes.[13] Ce scénario paraît en effet être corroboré sur le terrain, notamment le *Mittelbau* de Tafa, où Ricke a découvert de nombreux éléments architecturaux avec bassins en forme de signe-*ḥtp*.[14] Des arguments supplémentaires furent ensuite apportés par Louis Žabkar en 1975, proposant à nouveau le lien entre les "Blumen" et le décret divin de l'Abaton.[15]

Toutefois, le sujet n'a pas été approfondi depuis lors. Ceci est d'autant plus regrettable qu'au corpus croissant des "Blumen" est venue s'ajouter une découverte remarquable : des montants de chapelles funéraires portant le même motif ont été mis au jour dans le cimetière royal postméroïtique (*X-group*) de Qustul.[16] Il semble donc que, comme le remarque Bruce Williams,[17] des structures religieuses associées à Isis y étaient installés et avaient donc un intérêt particulier pour le roi et son peuple. La question est en effet importante car des textes de cette époque montrent que les Blemmyes et les Noubades participaient à l'activité religieuse de Philae, d'où ils ont emporté une statue d'Isis pour la consulter dans leurs pays.[18] Si les documents écrits sont riches d'informations, il convient de ne pas perdre de vue l'ensemble des matériels qui témoignent un motif associé, éventuellement, au culte d'Isis en Nubie.[19] Le présent article propose donc de dresser un catalogue des "Blumen" attestées à Philae et en Nubie, ce qui nous permettra ensuite, avec quelques renseignements complémentaires, de tenter de les replacer dans leur contexte historique au cours des derniers siècles du paganisme.

Catalogue

Le catalogue ci-dessous est le recueil des "Blumen" identifiées sur des matériels divers (autels, montants, tables d'offrandes, céramiques, etc.).[20] Il convient toutefois, avant d'aborder chaque exemplaire, de souligner que ce motif ne correspond pas nécessairement aux feuilles de palmier. Il serait en effet judicieux de réserver l'identification de

[8] Louis Žabkar, "A Hieracocephalos Deity from Naqa, Qustul and Philae," *ZÄS* 102 (1975), 148.

[9] Herbert Ricke, *Ausgrabungen von Khor-Dehmit bis Bet el-Wali*, OINE 2 (Chicago, 1967), 20–21.

[10] Hermann Junker, *Das Götterdekret über das Abaton*, DAWW 56 (Vienna, 1913).

[11] Pour la datation, voir Locher, *Topographie*, 167, n. 7.

[12] Junker, *Das Götterdekret*, 18–20, 23–24. Cf. Silke Caßor-Pfeiffer, "'Milch ist es, es ist kein Wasser darin': Bemerkungen zu den Szenen des sogenannten Übergießens der Opfergaben mit Milch in Philae und den unternubischen Tempeln," dans Horst Beinlich, éd., *9. Ägyptologische Tempeltagung: Kultabbildung und Kultrealität. Hamburg, 27. September-1. Oktober 2011*, KSG 3,4 (Wiesbaden, 2013), 5–22.

[13] Junker, *Das Götterdekret*, 18.

[14] Ricke, *Ausgrabungen*, 13–14, fig. 24 (BK 2, 5, 9–12), 26 (BK 13, 16).

[15] Žabkar, "A Hieracocephalos Deity," 149.

[16] Bruce Williams, *Noubadian X-Group Remains from Royal Complexes in Cemeteries Q and 219 and from Private Cemeteries Q, R, V, W, B, J, and M at Qustul and Ballana*, OINE 10 (Chicago, 1991), 74.

[17] Williams, *Noubadian*, 74.

[18] Tormud Eide, Tomas Hägg, Richard Pierce, et László Török, *Fontes Historiae Nubiorum: Textual Sources for the History of the Middle Nile Region Between the Eighth Century BC and the Sixth Century AD III. From the First to the Sixth Century AD* (Bergen, 1998), 1157; Jitse Dijkstra, *Philae and the End of Ancient Egyptian Religion: A Regional Study of Religious Transformation (298–642 CE)*, OLA 173 (Leuven-Paris-Dudley, 2008), 151–52; idem, "Blemmyes, Noubades and the Eastern Desert in Late Antiquity: Reassessing the Written Sources," dans Hans Barnard et Kim Duistermaat, éd., *The History of the Peoples of the Eastern Desert*, CloA Monograph 73 (Los Angeles, 2012), 242.

[19] Voir, à titre d'exemple, Jean Leclant, "Isis au pays de Koush," *AEPHE* 90 (1981–82), 39–59; Inge Hofmann, "Die meroitische Religion: Staatskult und Volksfrömmigkeit," *ANRW* II.18.5 (1995), 2827–32; Ian Rutherford, "Island of the Extremity: Space, Language and Power in the Pilgrimage Traditions of Philae," dans David Frankfurter, éd., *Pilgrimage and Holy Space in Late Antique Egypt*, RGRW 134, (Leiden-Boston-Cologne, 1998), 229–56.

[20] On pourrait y ajouter une trentaine d'autres exemplaires, qui ne portent certes pas le même motif mais dont le décor incite quelques chercheurs à les associer également au décret divin de l'Abaton. Ce décor, décrit comme "arêtes de poisson," a déjà fait l'objet d'interprétations diverses : bouquets montés stylisés, feuille de palmier, épi isiaque ou encore "Isis-garlands." Mais l'origine du décor n'est pas nécessairement acquise, et il est même possible qu'il représente des lignes d'eau déformées pour évoquer l'écoulement des libations. Ces exemplaires sont

la branche de palmier à encoche *rnpt* au motif placé devant le siège (fig. 1) et renvoyant au signe offert, par exemple, lors des naissances royales ou des jubilés.[21] Il s'agirait même de bouquets montés, entre autres assez communément appelés dans la sphère égyptienne, depuis au moins le Nouvel Empire et jusque dans les grands temples d'époque gréco-romaine. Le fait que ces compositions florales sont très fréquentes dans un contexte rituel nous fait également nous pencher sur la question religieuse, plus particulièrement celle de la fête et la procession,[22] comme l'avait déjà avancé Roeder à Kertassi.[23] Cette diversité iconographique était notée, nous allons maintenant voir une soixantaine d'exemplaires.

Cat. 1–13: Philae, temple d'Isis, graffiti dans la "chambre méroïtique"; seconde moitié du IIIe siècle

En face du mammisi, dans le deuxième espace au nord-est du pylône, se trouve une salle appelée "chambre méroïtique."[24] Cette appellation provient de figures gravées de dignitaires méroïtes, envoyés en délégation par le roi au sanctuaire d'Isis à Philae. Les "Blumen" peintes en gris ou en noir sont utilisées ici comme canne par chaque personnage (fig. 2).[25] Une datation de la seconde moitié du IIIe siècle est proposée par László Török.[26]

Fig. 1. "Blumen" sur la paroi occidentale des carrières de Kertassi (d'après Roeder, Debod bis Bab Kalabsche, *I, 136).*

Cat. 14–16: Philae, temple d'Isis, graffiti sur la paroi extérieure du mur du portique est situé entre les deux pylônes; premier tiers du Ve siècle

Sur cette paroi, trois exemplaires du motif sont portés chacun, assez curieusement, par un crocodile pourvu d'une tête de faucon (fig. 3).[27] Des divinités similaires sont connues à Naga et à Qustul,[28] et le fait qu'elles tiennent dans leurs deux pattes une palme (un sceptre-palme végétal?[29]) a conduit Žabkar à y retrouver l'origine des

donc ici exclus. Voir Charles Kuentz, "Bassins et tables d'offrandes," *BIFAO* 81 suppl. (1981), 263, 265; Kazimierz Michałowski, *Faras: Fouilles polonaises 1961* (Warsaw, 1962), 76; Michela Schiff Giorgini, "Sedeinga, 1964–1965," *Kush* 14 (1966), 258; Williams, *Noubadian*, 73.

[21] Žabkar, "A Hieracocephalos Deity," 144; Ingrid Gamer-Wallert, *Der Löwentempel von Naq'a in der Butana (Sudan) III: Die Wandreliefs 1. Text*, TAVO 48.3 (Wiesbaden, 1983), 153.

[22] Cf. Aylward Blackman, *The Temple of Dendûr* (Cairo, 1911), pl. XX.1, LVII; Mohamed Aly, Fouad Abdel-Hamid, et Christian Leblanc, *Le Temple de Dandour II: Dessins* (Cairo, 1979), pl. XIII, LXV; Hermann Junker, *Der grosse Pylon des Tempels der Isis in Philä*, DÖAW Sonderband (Vienna, 1958), fig. 21, 155, 159; Eleni Vassilika, *Ptolemaic Philae*, OLA 34 (Leuven, 1989), FLW 1–13, DADO 42, 44. Il n'est peut-être pas anodin de noter que la place accordée aux bouquets montés en contexte royal méroïtique semble essentielle. On comparera par exemple avec une autre forme de bouquet tenu par Arensnuphis et publiée dans Fritz Hintze, Ursula Hintze, Karl-Heinz Priese, et Kurt Stark, *Musawwarat es Sufra I.2: Der Löwentempel. Tafelband* (Berlin, 1971), pl. 29; Gamer-Wallert, *Der Löwentempel*, 156, 159. Pour le lien entre Philae et Musawwarat es-Sufra, voir Jochen Hallof, "Philae in Musawwarat es Sufra," *MittSAG* 16 (2005), 41–45.

[23] Roeder, *Debod bis Bab Kalabsche*, I, 137–42.

[24] Francis Griffith, *Meroitic Inscriptions II: Napata to Philae and Miscellaneous*, ASE 20 (London, 1912), 34–42, pl. XVIII; Horst Beinlich, *Die Photos der preußischen Expedition 1908–1910 nach Nubien 4: Photos 600–799*, SRAT 17 (Dettelbach, 2012), B0712–0721. Pour la localisation précise, voir Eide, et al., *Fontes Historiae Nubiorum III*, 1024–25.

[25] Cf. Nettie Adams, "Images of Men in the 'Ethiopian Chamber' of the Isis Temple at Philae: What Were They Wearing?" dans Michael Zach, éd., *The Kushite World: Proceedings of the 11th International Conference for Meroitic Studies Vienna, 1–4 September 2008*, BzS Beiheft 9 (Vienna, 2015), 448.

[26] László Török, "Two Meroitic Studies: The Meroitic Chambers in Philae and the Administration of Nubia in the 1st to 3rd Centuries A.D.," *Oikumene* 2 (1978), 223–29; idem, *Between Two Worlds: The Frontier Region between Ancient Nubia and Egypt 3700 BC-500 AD*, PÄ 29 (Leiden-Boston, 2009), 468–69.

[27] Voir aussi Beinlich, *Die Photos*, B0656–0657.

[28] L*D* V, pl. 65b; Walter Emery et Laurence Kirwan, *The Royal Tombs of Ballana and Qustul* (Cairo, 1938), I, 278; II, pl. 67 (Q 17–61). Voir également Gamer-Wallert, *Der Löwentempel*, 68. Pour des représentations similaires possibles, voir Charles Woolley et David Randall-MacIver, *Karanòg: The Romano-Nubian Cemetery*, EBCJEN 3–4 (Philadelphia, 1910), pl. 33, E 8081, 8083, 8085; Inge Hofmann, "Ein weiteres Beispiel eines falkenköpfigen Krokodils aus dem spätmeroitischen Reich," *GM* 22 (1976), 29; William Adams, *The West Bank Survey from Faras to Gemai 2: Sites of Meroitic and Ballaña Age*, BAR-IS 1335 (Oxford, 2005), 50, 81, pl. 14c.

[29] Gamer-Wallert, *Der Löwentempel*, 153–55, 267–68, fig. 44–48. Voir aussi Françoise Labrique, "La tunique historiée de Saqqara: Maât-Alêtheia *versus* Isis-Perséphone," dans Frédéric Colin, Olivier Huck, et Sylvie Vanséveren, éd., *Interpretatio: Traduire l'altérité culturelle dans les civilisations de l'Antiquité*, EAHA 25 (Paris, 2015), 245–46, pl. II.

Fig. 2. "Blumen" portées par la délégation méroïtique, dans la chambre méroïtique de Philae (d'après Griffith, Meroitic Inscriptions II, *pl. XVIII).*

"Blumen."[30] L'association de ces dernières avec les inscriptions gravées sur la même paroi permet de les dater du premier tiers du Ve siècle.[31]

Cat. 17: Philae, *Building B*, graffito sur un bloc du mur nord

L'exemple présenté ici se trouve sur le côté droit d'une empreinte de pieds votive de Bek, fils de Tetow.[32] Ce personnage paraît avoir laissé quelques inscriptions démotiques à Philae, précisant qu'il était prêtre d'Isis de Philae et de l'Abaton.[33]

Cat. 18: Hatara, graffito sur une paroi rocheuse

Hatara est un village situé à 38 km au sud de Philae. Un graffito représentant les "Blumen" est gravé sur une paroi rocheuse située sous les habitations actuelles.[34] On y trouve également une figure d'homme vue de face, avec la main droite sur la hanche et la gauche à hauteur d'oreille et un graffito.[35]

Cat. 19–31: Kertassi, graffiti autour de la niche de la paroi occidentale des carrières; première moitié du IIIe siècle.

Treize "Blumen" à l'encre rouge figurent sur la queue d'aronde des *tabulae ansatae*.[36] Selon Friedrich Zucker qui a examiné les inscriptions grecques, les graffiti peuvent être datés de la première moitié du IIIe siècle.[37]

[30] Žabkar, "A Hieracocephalos Deity," 143–45.

[31] Étienne Bernand, *Les inscriptions grecques et latines de Philae II: Haut et Bas Empire* (Paris, 1969), nos 190–92; Eugene Cruz-Uribe, *The Demotic Graffiti from the Temple of Isis on Philae Island*, MVCAE 3 (Atlanta, 2016), 106–7 (GPH 626).

[32] Francis Griffith, *Catalogue of the Demotic Graffiti of the Dodecaschoenus* (London, 1937), I, 128; II, pl. LXX (Ph. 445).

[33] Griffith, *Catalogue*, 67, 71, 80 (Ph. 134, 168, 239); Cruz-Uribe, *The Demotic Graffiti*, 182 (GPH 815), 195 (GPH 134).

[34] Roeder, *Debod bis Bab Kalabsche*, I, 144; II, pl. 57b, 116c.

[35] Wilhelm Spiegelberg, "Die demotischen Inschriften von Kertassi," dans Roeder, *Debod bis Bab Kalabsche*, I, 223 (Nr. 5); Sven Vleeming, *Demotic Graffiti and Other Short Texts Gathered from Many Publications (Short Texts III 1201–2350)*, StudDem 12 (Leuven-Paris-Bristol, 2015), 21–22, no 1256.

[36] Roeder, *Debod bis Bab Kalabsche*, I, 135–37. Pour une observation supplémentaire, voir André Bernand, "Révision des inscriptions de Kertassi (Nubie)," dans Jean Bingen, Guy Cambier, et Georges Nachtergael, éd., *Le monde grec: Pensée, littérature, histoire, documents. Hommages à Claire Préaux*, Travaux de la Faculté de philosophie et lettres de l'Université de Bruxelles 52 (Brussels, 1975), 524, no 19.

[37] Friedrich Zucker, *Debod bis Bab Kalabsche III* (Cairo, 1912), 73–77; Deronne, "Recueil," 59–72.

Fig. 3. "Blumen" portées par la divinité hiéracocéphale, sur la paroi extérieure du mur du portique est du temple d'Isis de Philae (d'après Bernand, I.Philae II, *pl. 40 supérieure).*

Cat. 32: Kertassi, graffito sur la paroi orientale des carrières

Contrairement à la niche de la paroi occidentale, aucune installation religieuse n'existe dans cette partie des carrières. Néanmoins, des graffiti divers s'y trouvent dont l'un, à l'extrémité est, représente des "Blumen."[38]

Cat. 33: Tafa, *Nordtempel*, relief du chapiteau de la colonne est; IVe siècle(?)

Cet exemplaire se situant à 5 km au sud de Kertassi ne concerne pas le graffito postérieur à la construction du temple, mais bien le relief qui fait partie de la décoration originelle(?) de celui-ci.[39] Une découverte remarquable est une inscription grecque attestée sous le toit, qui, selon Friedrich Zucker, mentionne un édifice religieux réalisé par des adorateurs d'Isis au cours du IVe siècle.[40]

Cat. 34: Tafa, *Nordtempel*, décoration d'une table d'offrande; IVe siècle(?)

De ce même site provient un autre exemplaire de "Blumen." Il s'agit de la table d'offrande avec bassin à escaliers, mise au jour lorsqu'une mission égyptienne a démonté le *Nordtempel* pour le reconstruire au Pays-Bas.[41] Ce démontage a eu pour résultat la découverte d'objets religieux, dont un autel à cornes et le fragment d'une figure de sirène. Un autel presque identique a été trouvé dans les *Talkessels* (voir ci-dessous).[42]

Cat. 35–36: Tafa, *Talkessels*, graffiti sur le plateau rocheux; IVe siècle(?)

Dans un ouadi à environ 400 m à l'ouest de Tafa se situe une petite chapelle fortement ruinée. Dotée à l'origine de mobilier assez particulier, parmi lesquels un autel à cornes et un bassin à escaliers (*Heiligen Sees*) méritent d'être mentionnés, elle paraît avoir été utilisée comme réserve de statuettes divines.[43] Si l'hypothèse de Ricke identifiant cette chapelle à la construction religieuse mentionnée par l'inscription du *Nordtempel* est exacte,[44] ceci

[38] Roeder, *Debod bis Bab Kalabsche*, I, 168 (Nr. 11).

[39] Roeder, *Debod bis Bab Kalabsche*, I, 201; II, pl. 126i; Maarten Raven, "The Temple of Taffeh: A Study of Details," *OMRO* 76 (1996), 44, 47. Pour un parallèle possible, voir Aminata Sackho-Autissier, "Ouad Ben Naga Inconnu: Quelques objets en faïence du palais royal," dans Vincent Rondot, Frédéric Alpi, et François Villeneuve, éd., *La pioche et la plume: Autour du Soudan, du Liban et de la Jordanie. Hommages archéologiques à Patrice Lenoble* (Paris, 2011), 365, fig. 11; idem, "Les faïences d'époque méroïtique conservées au musée du Louvre. Technologie et production: les prémices d'une recherche," *Dotawo* 3 (2016), 37, fig. 7. Pour l'ajout de fleurs sur tige entre deux boutons floraux de chapiteaux, voir par exemple Gustave Jéquier, *Manuel*, 242, fig. 153.

[40] Zucker, *Debod bis Bab Kalabsche*, I, 164, CIG 5038; Eide, et al., *Fontes Historiae Nubiorum III*, no 312.

[41] Shafik Farid, "Brief Report on the Excavations of the Antiquities Department at Tafa (1960)," *ASAE* 61 (1973), 27–30. Pour la table d'offrande, voir Ricke, *Ausgrabungen*, 21, fig. 24, T 37. Pour le temple, voir Hans Schneider, *Taffeh: Rond de wederopbouw van een Nubische tempel* (The Hague, 1979), 92–104.

[42] Ricke, *Ausgrabungen*, 30, fig. 43, T 14.

[43] Ricke, *Ausgrabungen*, 25–32.

[44] Ricke, *Ausgrabungen*, 32.

permet de proposer comme datation le IV^e siècle. C'est dans cet ouadi sur le plateau rocheux que deux "Blumen" sont gravées.[45]

Cat. 37: Tafa, *Mittelbau*, décoration d'une table d'offrande; seconde moitié du IV^e siècle

Ce bâtiment fournit, comme nous l'avons évoqué en introduction, des données importantes. Il fait partie d'un des trois édifices religieux construits au sommet de la crête locale que Roeder a nommé "Bergkapelle." On y notera tout d'abord une table d'offrande décorée de "Blumen";[46] mais la découverte la plus importante concerne une grande statue de femme drapée tenant une lampe grecque dans la main gauche—probablement la déesse Isis[47]—dont des fragments ont été trouvés dans le *Mittelbau* et à ses alentours.[48] Quant à la datation du site, elle nous est donnée par une monnaie romaine frappée entre 354 et 378 et trouvée près du *Nordbau*.[49]

Cat. 38: Kalabsha, en périphérie du temple de Mandulis, décoration d'une stèle(?)

À 10 km au sud de Tafa, se trouvait un grand temple consacré au dieu nubien Mandulis.[50] Ayant découvert près de celui-ci un fragment de pierre décoré de "Blumen," Roeder y a reconnu une stèle.[51] Mais il s'agirait plutôt d'un autel à cornes, dont un exemplaire complet a été mis au jour dans le temple d'Isis à Qasr Ibrim (cat. 46).

Cat. 39–40: Kalabsha, mur d'enceinte du temple de Mandulis, décoration de deux tables d'offrandes; entre I^er et III^e siècle

Les exemplaires présentés ici ont été découverts par une mission italienne en 1962. En explorant la zone à l'arrière du temple, les archéologues ont mis au jour plusieurs tables d'offrandes réemployées dans le mur d'enceinte. Deux d'entre elles portent des "Blumen."[52] Si l'on excepte la seconde, dotée d'un bassin à escaliers mais dont l'état fragmentaire ne nous permet pas d'établir le détail iconographique, la première s'orne de nombreux pains et de jarres posées sur une base.

Cat. 41: Gerf Hussein, cimetière 72, décoration d'une jarre; période postméroïtique

Gerf Hussein se situe à 87 km en amont de la première cataracte. Ce district a fait l'objet d'une fouille archéologique au début du XX^e siècle: un cimetière postméroïtique d'une richesse considérable a livré une jarre décorée de "Blumen."[53] Celle-ci a été mise au jour dans une tombe à chambre axiale à puits, à côté du défunt en position contractée.

Cat. 42: Qurta, cimetière 122, décoration d'une jarre; période postméroïtique

Ce site (y compris Maharraqa[54]) a été l'objet d'un grand débat concernant l'identification géographique de la limite sud du Dodécaschène.[55] Il est maintenant certain que ce lieu formait l'extension sud de la région des douze schènes, et c'est là qu'une jarre décorée de "Blumen" a été découverte.[56] La provenance exacte de la céramique est toutefois incertaine par définition.

[45] Ricke, *Ausgrabungen*, pl. 15d.

[46] Ricke, *Ausgrabungen*, 20, fig. 30.

[47] Schneider, *Taffeh*, 82.

[48] Roeder, *Debod bis Bab Kalabsche*, I, 208–9; II, pl. 91a; Ricke, *Ausgrabungen*, 21, fig. 31–32.

[49] Ricke, *Ausgrabungen*, 16, n. 26.

[50] Pour ce temple, qui est étroitement lié avec la théologie de Philae, ainsi qu'avec les Blemmyes, voir Erich Winter, "Octavian/Augustus als Soter, Euergetes und Epiphanes: Die Datierung des Kalabscha-Tores," *ZÄS* 130 (2003), 210–11; cf. Horst Jaritz et Ewa Laskowska-Kusztal, "Die Eingangstor zu einem Mandulisheiligtum in Ajuala/Unternubien," *MDAIK* 46 (1990), 169–70, 176–77.

[51] Roeder, "Die Blumen der Isis von Philä," 120, fig. 7.

[52] Silvio Curto, Vito Maragioglio, Celeste Rinaldi, et Luisa Bongrani, *Kalabsha*, OAC 5 (Rome, 1965), 62–63, fig. 17–18.

[53] On comparera Cecil Firth, *The Archæological Survey of Nubia: Report for 1908–1909* (Cairo, 1912), I, 92, fig. 45.1, avec Roeder, "Die Blumen der Isis von Philä," 122, fig. 8.

[54] Pour le lien entre Qurta et Maharraqa, voir Locher, *Topographie*, 263.

[55] Kurt Sethe, *Dodekaschoinos: Das Zwölfmeilenland an der Grenze von Aegypten und Nubien*, UGAÄ 3 (Leipzig, 1901). Voir également Solange Ashby, "Calling Out to Isis: The Enduring Nubian Presence at Philae," PhD diss., université de Chicago, 2016, 11, n. 19.

[56] Cecil Firth, *The Archæological Survey of Nubia: Report for 1910–1911* (Cairo, 1927), 156, fig. c.

Cat. 43–44: Shablul, décoration de deux tables d'offrandes; période méroïtique

À environ 200 km au sud de la première cataracte, aux alentours du village nommé Shablul, se situe une nécropole datable des premiers siècles de notre ère.[57] On sait qu'elle a été utilisée comme cimetière principal pour les envoyés méroïtiques auprès de l'Égypte romaine.[58] Mais les deux tables d'offrandes portant les "Blumen" sont anépigraphes,[59] ce qui ne nous permet pas de préciser leurs propriétaires.

Cat. 45: Karanog, décoration d'une table d'offrande; période méroïtique

Comme Shablul, un nombre remarquable d'inscriptions méroïtiques a été découvert dans le cimetière méroïtique de Karanog. Mais ce lieu en diffère par le fait qu'il est l'une des nécropoles principales de *peseto*, à savoir le vice-roi de Basse Nubie.[60] La table d'offrande ornée de "Blumen" et présentant un décor d'une vigne assez curieuse est ici aussi anépigraphe.[61]

Cat. 46: Qasr Ibrim, temple d'Isis, décoration d'un autel à cornes; période postméroïtique

En 1986, une mission anglaise a fouillé un temple postméroïtique qui se situe à quelques mètres au nord de la cathédrale de Qasr Ibrim.[62] Cet édifice, vraisemblablement dédié à Isis, livra deux autels à cornes dont le plus grand est décoré de "Blumen."[63]

Cat. 47: Qasr Ibrim, temple d'Isis, sceau d'estampage; période postméroïtique

Un sceau d'estampage en bois, décoré de "Blumen" ainsi que d'uraeus, fut mis au jour dans le temple d'Isis.[64]

Cat. 48: Qasr Ibrim, aux alentours du temple d'Isis, sceau d'estampage; période postméroïtique

Est également attesté un autre exemplaire en pierre portant des "Blumen"(?) sur sa face plane.[65] Sa provenance paraît cependant puisqu'incertaine par définition.

Cat. 49–51: Qasr Ibrim, cimetière 192, empreinte sur trois bouchons d'argile; période postméroïtique

Cette nécropole se trouve à environ 500 m au nord de la cathédrale. Une fouille de plus de cent tumuli a livré trois bouchons d'argile portant l'empreinte à l'encre rouge de "Blumen."[66] Contrairement aux deux exemplaires provenant de sépultures relativement modestes, le troisième a été découvert dans la tombe numéro 2, la plus grande et la plus riche.

Cat. 52: Arminna Ouest, église, décoration d'un montant de chapelle funéraire; période de transition postméroïtique

Arminna Ouest se situe à 15 km de distance de Qasr Ibrim. L'édifice appelé église a été fouillé en 1961–62 par une équipe américaine et a livré un grand bloc orné de "Blumen."[67] Il s'agit d'un montant de chapelle fu-

[57] David Randall-MacIver et Charles Woolley, *Areika*, EBCJEN 1 (Philadelphia, 1909), 23–42.

[58] Francis Griffith, *Karanòg: The Meroitic Inscriptions of Shablûl and Karanòg*, EBCJEN 6 (Philadelphia, 1911), 82. Pour l'envoyé, voir récemment Jeremy Pope, "Meroitic Diplomacy and the Festival of Entry," dans Julie Anderson et Derek Welsby, éd., *The Fourth Cataract and Beyond: Proceedings of the 12th International Conference for Nubian Studies*, BMPES 1 (Leuven-Paris-Walpole, 2014), 577–82; cf. Ashby, "Calling Out to Isis," 137.

[59] Randall-MacIver et Woolley, *Areika*, pl. 39, E 5124–25.

[60] REM 0208 (*Ddokr*), 0247 (*Ḫwitror*), 0251, 0252, 0321=1088, 1333 (*Brtoye*), 0277 (*Mloton*), 0278 (*Netewitr*). Voir Eide, et al., *Fontes Historiae Nubiorum III*, nos 264, 268–70. Pour le *peseto* et son rôle administratif, voir László Török, *Economic Offices and Officials in Meroitic Nubia*, StudAeg 5 (Budapest, 1979), 118–27; idem, *Der meroitische Staat 1: Untersuchungen und Urkunden zur Geschichte des Sudan im Altertum*, Meroitica 9 (Berlin, 1986), 78–83; idem, *Between Two Worlds*, 496–505.

[61] Woolley et Randall-MacIver, *Karanòg*, pl. 20, E 7108; Inge Hofmann, *Steine für die Ewigkeit: Meroitische Opfertafeln und Totenstelen*, BzS Beiheft 6 (Vienna, 1991), 104.

[62] Boyce Driskell, Nettie Adams, et Peter French, "A Newly Discovered Temple at Qasr Ibrim: Preliminary Report," ANM 3 (1989), 11–54; William Adams, *Qasr Ibrim: The Ballaña Phase*, EES EM 104 (London, 2013), 60–61, 129–36.

[63] Adams, *Qasr Ibrim*, 284, pl. 51b.

[64] Adams, *Qasr Ibrim*, 301, pl. 68a-b.

[65] Adams, *Qasr Ibrim*, 121, fig. 46c.

[66] Anthony Mills, *The Cemeteries of Qasr Ibrîm*, EES EM 51 (London, 1982), 13, 16–17, pl. 10, 14, 16 (nos 192.2.59, 192.14.13, 192.17.8).

[67] Bruce Trigger, *The Late Nubian Settlement at Arminna West*, PPYE 4 (New Haven-Philadelphia, 1970), 77, pl. IXa, et voir aussi Williams,

néraire, transporté d'une nécropole méroïtique (AWB) et réutilisé comme seuil d'une pièce. Ce cimetière serait cependant attribuable à la période de transition postméroïtique car les datations radiocarbones le situent, après calibration, dans une fourchette chronologique comprise entre 100 et 420.[68]

Cat. 53–56: Qustul, décoration de quatre montants de chapelle funéraire; période postméroïtique

Si l'on excepte un exemplaire dont la provenance exacte n'est pas connue, trois autres portant des "Blumen" sont attestés dans le cimetière postméroïtique de Qustul.[69] Ils ont été mis au jour dans les locaux suivants : QB 2, QC 1–3 et QC 17. Ce sont les cinq chapelles funéraires parmi plus d'une centaine d'autres, construites au nord de tumuli royaux et arasées jusqu'à la dernière assise de brique.[70] Il n'est donc plus possible de savoir combien d'entre elles ont à l'origine été dotées du même type de montant. Mais, comme nous l'avons évoqué précédemment, ces exemplaires constituent un témoignage important pour la compréhension de l'activité religieuse pratiquée au sein de la cour royale de la Nubie.

Cat. 57: Qustul, décoration d'une table d'offrande; période postméroïtique

Cette activité religieuse est encore complété par un autre élément de preuve. Il s'agit de la table d'offrandes, qui provient d'une chapelle funéraire (QB 42) et qui porte des "Blumen" sur les deux côtés de son bassin simple (probablement aussi sur son bec).[71] Lors de sa découverte, cet objet était posé sur un petit podium construit devant la chapelle.

Cat. 58: Qustul, décoration d'une amphore; période postméroïtique

Contrairement aux éléments précédents trouvés en contexte royal, l'exemplaire présenté ici a été découvert dans une sépulture privée.[72] Cette amphore est cependant importante car elle est ornée non seulement de "Blumen," peintes en noir, mais aussi de taches superposées dites "splash pattern."[73] Classée en type 7a par Walter Emery et Laurence Kirwan, cette céramique est caractéristique de Qustul et on ne la trouve jamais dans le cimetière opposé, et plus tardif, de Ballana.[74] Il est donc certain qu'elle date d'une période antérieure au déplacement de la nécropole royale, événement que Török situe en an 420.[75]

Cat. 59: Qustul, empreinte sur un bouchon d'argile; période postméroïtique

Parmi les céramiques du type que nous venons de décrire, il y en a une dont le bouchon d'argile est estampé de "Blumen" en rouge.[76] Elle provient du tumulus royal Qu 36.

Cat. 60: Ballana, décoration d'un montant de chapelle funéraire; période postméroïtique

Comme à Arminna Ouest, un montant décoré de "Blumen" s'est trouvé réutilisé dans un tumulus royal de Ballana (Ba 95).[77] Mais le fait qu'aucune chapelle funéraire n'ait été mise au jour dans cette nécropole nous laisse supposer son transport depuis Qustul.

Noubadian, 74, n. 10.

[68] Dorian Fuller, "A Parochial Perspective on the End of Meroe: Changes in Cemetery and Settlement at Arminna West," dans Derek Welsby, éd., *Recent Research in Kushite History and Archaeology: Proceedings of the 8th International Conference for Meroitic Studies*, BMOP 131 (London, 1999), 205, n. 16–17.

[69] Williams, *Noubadian*, 193, 207, 216, fig. 74a-b, 83, 88.

[70] Williams, *Noubadian*, 26–27, 181 225. Voir aussi Keith Seele, "University of Chicago Oriental Institute Nubian Expedition: Excavations between Abu Simbel and the Sudan Border, Preliminary Report," *JNES* 33 (1974), 3–6.

[71] Williams, *Noubadian*, 191, fig. 72d.

[72] Williams, *Noubadian*, 282, fig. 130e, pl. 47c (Q 51A-1).

[73] Cf. Rachael Dann, *The Archaeology of Late Antique Sudan: Aesthetics and Identity in the Royal X-Group Tombs at Qustul and Ballana* (Amherst-New York, 2009), 241–42.

[74] Emery et Kirwan, *The Royal Tombs of Ballana and Qustul*, I, 389; II, pl. 111.

[75] László Török, *Late Antique Nubia: History and Archaeology of the Southern Neighbour of Egypt in the 4th-6th c. A.D.*, Antaeus 16 (Budapest, 1988), 221.

[76] Emery et Kirwan, *The Royal Tombs of Ballana and Qustul*, I, 401; II, pl. 115, no 25.

[77] Emery et Kirwan, *The Royal Tombs of Ballana and Qustul*, I, 136; II, pl. 27d.

Cat. 61 : Faras, aux alentours de l'église, décoration d'une stèle(?)

Ce site évidemment connu pour sa grande nécropole méroïtique a également fourni un exemplaire de "Blumen."[78] C'est une stèle similaire à celle de Kalabsha (cat. 38), dont nous avons déjà remis en question l'identification en faisant une nouvelle proposition en faveur d'un autel à cornes (ou d'un montant de chapelle funéraire?).

Cat. 62 : Nubie, provenance inconnue, décoration d'une table d'offrande; période méroïtique

Cette table d'offrande a été acquise par le Musée du Caire et publiée en 1912.[79] Avec les "Blumen" qui figurent sur son bec, elle est gravée d'une inscription méroïtique adressant une invocatoire à Isis et à Osiris. Sa provenance exacte n'est cependant pas connue.

Cat. 63–64 : Nubie(?), provenance inconnue, décoration de deux tables d'offrandes

En 1981, Charles Kuentz a publié deux tables d'offrandes.[80] L'une, acquise par le Musée du Caire, est dotée d'un bassin à escaliers ainsi que de "Blumen" sur son bec. Il en est de même pour l'autre conservée au British Museum, qui s'orne en plus d'éléments tels que pains ou jarres. Si l'on se fie à ce savant concluant à leur "style nubien,"[81] les objets peuvent provenir de cette région.

<center>Discussion</center>

Au terme de ce catalogue dont la liste détaillée figure en annexe (Table 1), nous replaçons succinctement les "Blumen" dans leur contexte historique. Une première importance à cet égard est les graffiti de Kertassi (cat. 19–31) car ils sont datables avec précision de la première moitié du IIIe siècle. Si la position chronologique des graffiti est vérifiable, l'identité des personnes qui les ont réalisés sur les parois des carrières—liées étroitement au mot grec *gomos*[82]—est également claire. Il s'agit de prêtres égyptiens, qui se sont installés à Kertassi vers le début du IIIe siècle et qui ont rendu un culte régulier devant la niche.[83] Son lien avec la déesse Isis est d'ailleurs acquis par une inscription grecque écrite par un certain Orsès (fils de) Psentuaxis, témoignant le transport au temple d'Isis de Philae de 110 pierres taillées dans ces carrières.[84]

Reste cependant un point énigmatique : pourquoi cette communauté égyptienne a-t-elle disparu vers le milieu du IIIe siècle? S'il est évidemment difficile de donner une réponse exacte, il est assez tentant d'associer cette disparition avec un événement politique de l'époque, à savoir la visite de deux ambassadeurs méroïtes au sanctuaire d'Isis à Philae.[85] La première a eu lieu en 251/2 et la seconde en 260. Engagé à l'initiative du roi Teqorideamani, ce pèlerinage avait évidemment pour but de négocier une sorte de traité de paix avec l'Égypte.[86] La région de la première cataracte semble avoir vécu alors un bouleversement social; le fait que la dernière inscription de Kertassi soit datée de l'an 251 n'est évidemment pas sans intérêt pour la vraisemblance de cette hypothèse.[87]

[78] Francis Griffith, "Oxford Excavations in Nubia XLIII–XLVIII," *LAAA* 13 (1924), pl. XXXVII.6. S'ajouterait peut-être une céramique modelée noire publiée dans Griffith, "Oxford Excavations," pl. XLIV.1, no 2013/R (information de Romain David que je remercie ici).

[79] REM 0133. Voir Griffith, *Meroitic Inscriptions II*, 57, pl. 44.

[80] Kuentz, "Bassins et tables d'offrandes," 273, fig. 41, pl. XXXII en bas.

[81] Kuentz, "Bassins et tables d'offrandes," 281.

[82] On comparera Zucker, *Debod bis Bab Kalabsche*, 21–30 et Deronne, "Recueil," 147–63. Ce dernier savant démontre de façon convaincante que *gomos* n'est pas le nom ancien de Kertassi, mais le mot qui signifie simplement "transport" ou "cargaison" des pierres. Sur l'organisation du *gomos*, voir récemment Carola Zimmermann, *Handwerkervereine im griechischen Osten des Imperium Romanum*, RGZM 57 (Mainz, 2002), 159.

[83] Pour deux interprétations légèrement différentes, voir Roeder, *Debod bis Bab Kalabsche*, I, 122–43; Zucker, *Debod bis Bab Kalabsche*, 46–59. E. Deronne ("Recueil," 100–104), pour sa part, nuance fortement cette idée d'un culte local très régulier en soulignant, à partir de la chronologie précise des inscriptions, que les nombreux "hiereis" auteurs de proscynèmes ne peuvent pas être des "prêtres de Kertassi"; ce sont plutôt des clients des carrières présentes très sporadiquement sur place et associés au culte local à cette occasion.

[84] Roeder, *Debod bis Bab Kalabsche*, I, 161, L 373; Deronne, "Recueil," 808–25, texte no 32.

[85] Eide, et al., *Fontes Historiae Nubiorum III*, nos 260–61, 265–66. Cf. Jeremy Pope, "The Demotic Proskynema of a Meroïte Envoy to Roman Egypt (Philae 416)," *Enchoria* 31 (2008–9), 94–95.

[86] Bernand, *I.Philae II*, 197, no 181.

[87] Török, "Two Meroitic Studies," 227–29; Inge Hofmann, "Die Helfer des Kaisers Decius gegen die Blemmyer," *GM* 50 (1981), 30–34.

Table 1. Liste des "Blumen" à Philae et en Nubie

Cat.	Site	Provenance	Date / siècle
1	Philae	Temple d'Isis, chambre méroïtique, personnage A	Seconde moitié du IIIe
2	Philae	Temple d'Isis, chambre méroïtique, personnage B	Seconde moitié du IIIe
3	Philae	Temple d'Isis, chambre méroïtique, personnage C	Seconde moitié du IIIe
4	Philae	Temple d'Isis, chambre méroïtique, personnage D	Seconde moitié du IIIe
5	Philae	Temple d'Isis, chambre méroïtique, personnage E	Seconde moitié du IIIe
6	Philae	Temple d'Isis, chambre méroïtique, personnage F	Seconde moitié du IIIe
7	Philae	Temple d'Isis, chambre méroïtique, personnage G	Seconde moitié du IIIe
8	Philae	Temple d'Isis, chambre méroïtique, personnage H	Seconde moitié du IIIe
9	Philae	Temple d'Isis, chambre méroïtique, personnage I	Seconde moitié du IIIe
10	Philae	Temple d'Isis, chambre méroïtique, personnage J	Seconde moitié du IIIe
11	Philae	Temple d'Isis, chambre méroïtique, personnage L	Seconde moitié du IIIe
12	Philae	Temple d'Isis, chambre méroïtique, personnage M	Seconde moitié du IIIe
13	Philae	Temple d'Isis, chambre méroïtique, personnage O	Seconde moitié du IIIe
14	Philae	Temple d'Isis, portique est, près de Bernand, *I.Philae II*, nos 190–92	Premier tiers du Ve
15	Philae	Temple d'Isis, portique est, près de Bernand, *I.Philae II*, nos 190–92	Premier tiers du Ve
16	Philae	Temple d'Isis, portique est, près de Bernand, *I.Philae II*, nos 190–92	Premier tiers du Ve
17	Philae	*Building* B, près de pieds votive de Bek (Ph. 445)	–
18	Hatara	Paroi rocheuse indéterminée	–
19	Kertassi	Carrières, paroi occidentale, près de la niche, L 325 = Der. 46	249
20	Kertassi	Carrières, paroi occidentale, près de la niche, L 327 = Der. 44	– (Der. 247)
21	Kertassi	Carrières, paroi occidentale, près de la niche, L 329 = Der. 40	243 (Der. 243/250)
22	Kertassi	Carrières, paroi occidentale, près de la niche, L 330 = Der. 39	243
23	Kertassi	Carrières, paroi occidentale, près de la niche, L 331 = Der. 35	235 (Der. 235/244)
24	Kertassi	Carrières, paroi occidentale, près de la niche, L 333 = Der. 25	218/233
25	Kertassi	Carrières, paroi occidentale, près de la niche, L 338 = Der. 29	224
26	Kertassi	Carrières, paroi occidentale, près de la niche, L 344 = Der. 34	234–35
27	Kertassi	Carrières, paroi occidentale, près de la niche, L 348 = Der. 41	244
28	Kertassi	Carrières, paroi occidentale, près de la niche, L 348 = Der. 41	244
29	Kertassi	Carrières, paroi occidentale, près de la niche, L 355 = Der. 50	–
30	Kertassi	Carrières, paroi occidentale, près de la niche, L 358 = Der. 37	220–24 (Der. 237/246/256)
31	Kertassi	Carrières, paroi occidentale, près de la niche, L 372 = Der. 33	233
32	Kertassi	Carrières, paroi orientale, Nr. 11	–
33	Tafa	*Nordtempel*, chapiteau de la colonne est	IVe (?)
34	Tafa	*Nordtempel*, T 37	IVe (?)
35	Tafa	*Talkessels*, plateau rocheux	IVe (?)
36	Tafa	*Talkessels*, plateau rocheux	IVe (?)
37	Kalabsha	*Mittelbau*, BK 3	Seconde moitié du IVe
38	Kalabsha	Temple de Mandulis, en périphérie	–
39	Kalabsha	Temple de Mandulis, mur d'enceinte, *Reperto* no 17	Ier – IIIe siècle

Cat.	Site	Provenance	Date / siècle
40	Kalabsha	Temple de Mandulis, mur d'enceinte, *Reperto* n° 18	I^er – III^e siècle
41	Gerf Hussein	Cimetière 72, tombe 91	postméroïtique
42	Qurta	Cimetière 122, tombe indéterminée	postméroïtique
43	Shablul	Cimetière, entre les tombes 7 et 7a, E 5124	méroïtique
44	Shablul	Cimetière, tombe 21, E 5125	méroïtique
45	Karanog	Cimetière, tombe 261, E 7108	méroïtique
46	Qasr Ibrim	Temple d'Isis, *Unit* 1100-R3, n° 86/1165	postméroïtique
47	Qasr Ibrim	Temple d'Isis, *Unit* 1129-R1, n° 86/772	postméroïtique
48	Qasr Ibrim	Temple d'Isis, en périphérie, n° 74/81	postméroïtique
49	Qasr Ibrim	Cimetière 192, tombe 2, n° 59	postméroïtique
50	Qasr Ibrim	Cimetière 192, tombe 14, n° 13	postméroïtique
51	Qasr Ibrim	Cimetière 192, tombe 17, n° 8	postméroïtique
52	Arminna Ouest	Église, *Room* 16	transition postméroïtique
53	Qustul	Cimetière royal, chapelle funéraire, QB 2, OIM 20460	postméroïtique
54	Qustul	Cimetière royal, chapelle funéraire, QC 1–3, OIM 20600	postméroïtique
55	Qustul	Cimetière royal, chapelle funéraire, QC 17, OIM 21305	postméroïtique
56	Qustul	Cimetière royal, chapelle funéraire indéterminée, OIM 20279	postméroïtique
57	Qustul	Cimetière royal, chapelle funéraire, QB 42, OIM 20787	postméroïtique
58	Qustul	Cimetière privé, tombe Q 51A, n° 1, OIM 20219	postméroïtique
59	Qustul	Cimetière royal, tumulus Qu 36	postméroïtique
60	Ballana	Cimetière royal, tumulus Ba 95	postméroïtique
61	Faras	Église, en périphérie	méroïtique (?)
62	?	Musée du Caire, JE 41772, REM 0133	méroïtique
63	?	Musée du Caire, registre temporaire 17-8-19-1	–
64	?	British Museum, n° 1067 [717]	–

Quelle que soit la raison du déclin de la communauté égyptienne de Kertassi, c'est à cette période que les "Blumen" apparaissent à Philae (cat. 1–13) et le plus remarquable est qu'elles ont été apportées par des dignitaires méroïtes. La délégation était menée par les deux personnages les plus éminents, Manitawawi et Bekemete, et on sait que ce dernier est mentionné dans une inscription démotique écrite en 253[88]; la datation contemporaine du motif ne fait ainsi aucun doute. Mais pourquoi les Blumen" d'origine égyptienne sont-elles apportées ici par les Méroïtes? Évidemment, il serait tentant d'y voir un éventuel contact entre la délégation du royaume de Méroé et la communauté égyptienne de Kertassi. Rappelons à cet égard une inscription démotique écrite par un certain Petephowt, qui, selon Francis Griffith, est un orfèvre attaché à un roi méroïtique.[89] La question doit, cependant, rester en suspens pour l'heure.

Pour la datation, voir Zucker, *Debod bis Bab Kalabsche*, 117–18, L 343; Deronne, "Recueil," 1122–25, texte no 48. Ce dernier savant propose d'ailleurs deux autres solutions possibles, soit l'an 252, soit l'an 255.

[88] Griffith, *Catalogue*, I, 119 (Ph. 417); Eide, et al., *Fontes Historiae Nubiorum III*, no 261.

[89] Griffith, *Catalogue*, I, 38–39 (Girt. 1); Edda Bresciani, *Graffiti démotiques du Dodécaschoene: Qertassi - Kalabcha - Dendour - Dakka - Maharraqa* (Cairo, 1969), pl. V, (Inscr. 1). Pour ce personnage, voir également Adelheid Burkhardt, *Ägypter und Meroiten im Dodekaschoinos*, Meroitica 8 (Berlin, 1985), 33–34.

Les "Blumen" des autres sites ne peuvent pas être datées avec précision. Un élément certain néanmoins est qu'elles apparaissent en Nubie au plus tôt pendant la deuxième moitié du IIIe siècle, confirmant que les Méroïtes continuaient à les employer dans leur royaume.

Les "Blumen" sont également observées à la période postméroïtique. C'est en effet au cours de cette époque qu'elles se répandent sur une vaste étendue de la Nubie, avec une forte concentration sur les sites suivants: Tafa, Kalabsha, Qasr Ibrim et Qustul (cat. 33–40, 46–51, 53–59). Il est cependant curieux de constater que ce motif réapparaît à Philae (cat. 14–16). Si l'on accepte la datation actuellement proposée, il y a un décalage d'environ cent ans entre les exemplaires méroïtiques et postméroïtiques. Il est donc impossible d'envisager de lien direct entre les deux groupes. Comme évoqué plus haut, le premier de ces groupes est lié à la délégation méroïtique et les "Blumen" qui y figurent sont portées par les Méroïtes. Qu'en est-il alors du second groupe?

La réponse à la question résiderait dans le fait que les "Blumen" postméroïtiques de Philae sont accompagnées de proscynèmes grecs réalisées par trois "Barbares": Pasnous fils de Pachoumios; Pamèt fils de Bérèos; Panouchèm fils de Tabolbolos.[90] Bien qu'aucune autre information ne soit disponible pour le troisième personnage, on sait que les pères des deux premiers ont exercé la fonction de prophète de Ptireus,[91] un dieu peu connu. Ce dernier a déjà fait l'objet de nombreuses interprétations. Si Griffith y a reconnu le nom d'une divinité grecque, Žabkar a remis en question cette hypothèse et a proposé une origine égyptienne.[92] Plus récemment encore, une nouvelle étude effectuée par Jitse Dijkstra l'a rapproché du culte du faucon.[93] Mais un point beaucoup plus important pour nous est que ce même Pasnous a laissé un autre proscynème daté de l'an 456/7, sur le mur extérieur est du naos, et que celui-ci correspond à la dernière inscription païenne rédigée en grec de Philae.[94] Deux remarques sont donc possibles : d'une part, Pasnous et ses deux collègues appartenaient aux derniers prêtres de ce sanctuaire égyptien ; d'autre part, les "Blumen" qu'ils ont utilisées avec leurs proscynèmes sont nées au tout début du christianisme.

La vraie question reste celle de l'identité des derniers prêtres. À propos des trois "Barbares" cités ci-dessus, Žabkar, après avoir effectué une étude approfondie, a conclu qu'ils étaient des Blemmyes, et ce, pour deux raisons.[95] Tout d'abord, alors que le mot prophète mentionné dans les proscynèmes de Pasnous et de Pamèt laisse supposer une administration égyptienne, le même terme apparaît dans des documents des Blemmyes. Il est donc certain que ces ethnies l'ont adopté pour désigner leur prêtre. Ensuite, parmi les inscriptions grecques gravées par les derniers prêtres de Philae, il en existe au moins une qui déclare que son propriétaire, Smetchen, est "venu ici."[96] Il semble donc probable que ce personnage ne vivait pas sur l'île sainte et qu'il ne s'y était rendu qu'à l'occasion de fêtes et de processions célébrées dans le temple d'Isis. Dijkstra remet néanmoins en doute ce scénario et, s'appuyant sur leurs noms apparemment égyptiens, semble retenir l'idée traditionnelle que les prêtres en question sont originaire d'Égypte.[97] Le sujet fait toujours débat.

Malgré la complexité du sujet, notre étude semble à nouveau peser en faveur des Blemmyes.[98] Rappelons que les "Blumen" postméroïtiques se concentrent sur les sites nubiens suivants : Tafa, Kalabsha, Qasr Ibrim et Qustul. Les trois premiers sont associés aux Blemmyes car Olympiodore de Thèbes, diplomate byzantin qui visita

 [90] Bernand, *I.Philae II*, nos 190–92; Eide, et al., *Fontes Historiae Nubiorum III*, no 315. Voir aussi Ashby, "Calling Out to Isis," 231–34.

 [91] Pour la lecture, voir Heinz-Josef Thissen, "Varia Onomastica," *GM* 141 (1994), 93–94. Pour ce dieu, voir dernièrement László Török, *The Image of the Ordered World in Ancient Nubian Art: The Construction of the Kushite Mind (800 BC–300 AD)*, PÄ 18 (Leiden-Boston-Cologne, 2002), 229; Eleonora Kormysheva, *Gott in seinem Tempel: Lokale Züge und ägyptische Entlehnungen in der geistigen Kultur des alten Sudan* (Moscow, 2010), 312–13; Holger Kockelmann, "Zur Kultpraxis auf Philae," dans Beinlich, *9. Ägyptologische Tempeltagung*, 99, n. 8.

 [92] Griffith, *Catalogue*, I, 59 (Ph. 77); Žabkar, "A Hieracocephalos Deity," 149–53; cf. Cruz-Uribe, *The Demotic Graffiti*, 19–21.

 [93] Jitse Dijkstra, "'Une foule immense de moines': The Coptic Life of Aaron and the Early Bishops of Philae," dans Bernhard Palme, éd., *Akten des 23. Internationalen Papyrologenkongresses, Wien, 22.-28. Juli 2001*, Pap. Vind. 1 (Vienna, 2007), 196–97; idem, *Philae*, 213.

 [94] Bernand, *I.Philae II*, no 199.

 [95] Žabkar, "A Hieracocephalos Deity," 146–47. Voir aussi Bernand, *I.Philae II*, 242–43.

 [96] Bernand, *I.Philae II*, 197.

 [97] Dijkstra, *Philae*, 211–13. Cf. László Castiglione, "Vestigia," *Acta Archeologica Academiae Scientiarum Hungaricae* 22 (1970), 116–17.

 [98] Ainsi, Eugene Cruz-Uribe, "The Death of Demotic Redux: Pilgrimage, Nubia and the Preservation of Egyptian Culture," dans Hermann Knuf, Christian Leitz, et Daniel von Recklinghausen, éd., *Honi soit qui mal y pense: Studien zum pharaonischen, griechisch-römischen und spätantiken Ägypten zu Ehren von Heinz-Josef Thissen*, OLA 194 (Leuven-Paris-Walpole, 2010), 504–5; idem, *The Demotic Graffiti*, 6–10; Ashby, "Calling Out to Isis," 251–53.

leur pays au V^e siècle,[99] décrit qu'ils occupaient Prima (Primis/Qasr Ibrim?[100]), Phoinikon (el-Laqeita), Khiris(?), Thapis/Taphis (Tafa) et Talmis (Kalabsha).[101] Ce rapprochement est d'autant plus probable que, si l'on excepte les trois "Blumen" en question (cat. 14–16), aucun autre exemplaire n'est attesté à Philae au cours des IV^e et V^e siècles. Une telle absence est difficilement compréhensible si le motif a été gravé par des prêtres égyptiens, officiant depuis toujours dans les temples de cette île sainte. Il faut donc plutôt supposer que les "Blumen" ont été utilisées à l'occasion de visites, comme c'est le cas pour celles de la chambre méroïtique ; or, les trois "Barbares" qui les ont gravées avec leurs proscynèmes venaient de Tafa, Kalabsha ou Qasr Ibrim. Autrement dit, il s'agit de Blemmyes.[102]

Ces ethnies n'étaient pas les seules à avoir recours aux "Blumen." La concentration de celles-ci à Qustul, i.e. la nécropole des probables souverains du royaume de Nobadia,[103] nous laisse supposer que les Noubades s'étaient également engagés dans un rituel similaire. Mais leur façon de le pratiquer paraît être manifestement différente car, pour la première fois dans cette région, les "Blumen" apparaissent sur le montant de chapelles funéraires dont plus d'une centaine d'exemplaires ont été trouvés dans la nécropole de Qustul.[104]

Ce motif iconographique et sa valeur religieuse semble être finalement abandonnés par les souverains de Ballana. Une tombe royale (Ba 95) a certes livré un montant décoré de "Blumen" (cat. 60), mais il ne faut pas oublier que celui-ci est une réutilisation et qu'aucune chapelle funéraire n'est attestée dans la même nécropole. On peut donc supposer que cet objet a été apporté de Qustul et, en conséquence, se demander si l'abandon des "Blumen" n'est associé de manière importante au déplacement de la nécropole royale. À quel point on peut mettre cet événement en relation avec l'avènement du christianisme dans le royaume de Nobadia?[105] Afin de ne pas dépasser les limites de notre étude, nous nous en tiendrons à cette interrogation.

Université Charles-de-Gaulle Lille 3, France

[99] Pour la date de visite, cf. Andrew Gillett, "The Date and Circumstances of Olympiodorus of Thebes," *Traditio* 48 (1993), 13.

[100] Dijkstra, *Philae*, 153; Artur Obłuski, "Dodekaschoinos in Late Antiquity: Ethnic Blemmyes vs. Political Blemmyes and the Arrival of Nobades," *MittSAG* 24 (2013), 142, n. 19. Török remet cependant en doute l'identification de *Prima* d'Olympiodore à Qasr Ibrim (*Primis*), proposant en revanche Qurta. Cette conclusion est récemment reprise par Tsubasa Sakamoto, "Qurta, une ville commerciale du roi Kharamadoye?" *GM* 251 (2017), 99–100.

[101] Eide, et al., *Fontes Historiae Nubiorum III*, no 309.

[102] Pour le lien possible de Qasr Ibrim avec les Noubades, voir Adams, *Qasr Ibrim*, 153; Jitse Dijkstra, "Qasr Ibrim and the Religious Transformation of Lower Nubia in Late Antiquity," dans Jacques van der Vliet et Joost Hagen, éd., *Qasr Ibrim, between Egypt and Africa: Studies in Cultural Exchange (NINO symposium, Leiden, 11–12 December 2009)*, EgUit 26 (Leiden, 2013), 119; idem, "'I, Silko, Came to Talmis and Taphis': Interactions between the peoples beyond the Egyptian Frontier and Rome in Late Antiquity," dans Jitse Dijkstra et Greg Fisher, éd., *Inside and Out: Interactions between Rome and the Peoples on the Arabian and Egyptian Frontiers in Late Antiquity*, LAHR 8 (Leuven-Paris-Walpole, 2014), 310.

[103] On consultera, entre autres, Hermann Junker, "Die Grabungen der ägyptischen Altertumsverwaltung in Nubien," *MDAIK* 3 (1932), 158–59; Friedrich von Bissing, "Compte rendu de Emery et Kirwan, *The Royal Tombs of Ballana and Qustul*," *OLZ* 42 (1939), 507–8; Ugo Monneret de Villard, "Le necropoli di Ballāna e di Qōsṭul," *Or* 9 (1940), 64–66.

[104] Williams, *Noubadian*, 27. Il ne serait peut-être pas absurde de mettre en relation ce nombre assez étonnant des chapelles funéraires avec celui des trois-cent-soixante-cinq (tables d'offrandes) du décret divin de l'Abaton. Cf. László Török, "The End of Meroe," dans Welsby, *Recent Research in Kushite History and Archaeology*, 142.

[105] Pour l'avènement du christianisme dans le royaume de Nobadia, voir Dijkstra, *Philae*, 293–94, 302. Cf. dernièrement Artur Obłuski, *The Rise of Nobadia: Social Changes in Northern Nubia in Late Antiquity*, JJP Suppl. 20 (Warsaw, 2014), 174; Effrosyni Zacharopoulou, "Justinian and Theodora: Rivals or Partners in the Christianisation of Nubia? A Critical Approach to the Account of John of Ephesus," *Journal of Early Christian History* 6/3 (2016), 75–80.

The Coptic Monastery at the First Pylon of Karnak Temple

Emad Ghaly

Abstract

In the second half of the first century early Christianity was on the rise in Egypt. From this time on early Christians of Egypt adapted their life, art, habits, names, daily life language, and worship. Christianization of ancient pagan sites became a phenomenon within the Roman Empire. Early Christians reused ancient temples and tombs as parts of monasteries and cities. Egypt is a special case when talking about temple conversion in late antiquity. This study focuses on the early Christian reuse at the first pylon of Karnak temple on the city of Luxor in Upper Egypt.

Introduction

The process of Christianization in late antiquity represents many faces and characteristics of the Egyptian society within the Roman Empire in the early centuries AD as early Christians of Egypt Christianized all aspects of life.[1] It seems reasonable to read the process of "temple conversion" in late antiquity in terms of religious, political, social, and economic contexts, because behind each code or imperial edict there was a world of social diversity and traditions. Although the imperial edict provides insight in aspects of the top-down reign of an emperor, it does not cover society generally.[2]

According to Psalm 24 "The earth is the Lord's, and the fullness thereof; the world, and they that dwell therein." Psalm 26 says: "For all the gods of the nations are idols: but the Lord made the heavens." The early abbots of Coptic monasticism had the same perspective on ancient temples.[3] In the Book of Kings the prophet Elijah confronted the priests of Baal.[4] Elijah was one of the best-known Old Testament prophets and an inspiration for early monks by living an ascetic life and challenging secular or pagan concepts and their clergy. The early Christian monks considered all the ancient deities as demons; hence they inspired peoples to suppress ancient cults and to proceed to temple conversion. The monks were the first groups to reuse temples.[5] In the words of Frankfurter, "It was really monks and their abbots, who inspired the most drastic demolition."[6] When talking about the anti-pagan movement, scholars have to distinguish between the movement of Egyptian intelligentsia and the anti-Hellenistic manifestations. The movement of the Egyptian intellectuals rejected the pagan popular traditions (like adoration of idols and human scarification), while the anti-Hellenistic manifestations appeared in the east before Christianity.[7]

[1] Cf. R. Bagnall, *Egypt in Late Antiquity* (Princeton, 1993), 278–88.

[2] R. Byliss, *Provincial Cilicia and the Archaeology of Temple Conversion* (Oxford, 2004), 119.

[3] J. Westerfeld, "Christian Perspectives on Pharaonic Religion: The Representation of Paganism in Coptic Literature," *JARCE* 40 (2003), 5–12.

[4] See 1 Kings 18: 17–39.

[5] For further readings about the attitude of monks toward paganism read: D. Brakke, "From Temple to Cell, From Gods to Demons; Pagan Temples in the Monastic Topography of the Fourth-Century Egypt," in J. Hahn, et al., eds., *From Temple to Church: Destruction and Renewal of Local Cultic Topography in Late Antiquity* (Leiden, 2008), 91–112.

[6] D. Frankfurter, *Religion in Roman Egypt: Assimilation and Resistance* (Princeton, 1998), 283.

[7] R. Shoucri, "Les coptes sont-ils responsables de la destruction des temples pharaoniques?" *Le Mond Copte* 8 (Limoges, 1979), 26–27.

Journal of the American Research Center in Egypt 53 (2017), 105–121
doi: http://dx.doi.org/10.5913/jarce.53.2017.a005

After Constantine and Licinius had issued the edict of Milan, which granted toleration to Christianity (AD 313), the Egyptians were encouraged to desert the pagan temples. Theodosius the Great (AD 379–395) put an end to ancient religions, as he ordered the ban of paganism and the abandonment of ancient cults, temples, and habits; hence Christianity began to flourish and reached its peak.[8] Christianity became the official religion of the Roman Empire. According to "The Story of the Three Thetas," one may conclude that it was easy for the Coptic patriarch to send to the emperor Theodosius II asking for the gold or the properties of pagan temples. Interestingly, Theodosius allowed the Coptic patriarch to use the pagan gold for the upkeep and the restoration of Coptic churches.[9] Scholars use many terms to describe this incident, such as Christianization, Transformation, and Conversion, indicating the different aspects of conversion from paganism into Christianity during late antiquity.[10]

Peoples in different parts of the Roman Empire began to practice their Christian worship freely after the era of Roman persecution against Christians had ended. It became a phenomenon in the Roman Empire to convert an ancient pagan site to Christian worship after rededicating the site by many prayers in the presence of the bishop or the patriarch.[11] Christians were strongly supported and endorsed by the prefects, representing the imperial power. Moreover, there were rhetorical contests by leaders of each religion, which marked this period of history.[12]

Based on the historic incidents, there was a triangle: the Roman emperor, pagans, and Christians. When the emperor stood by pagans, the latter persecuted Christians, but when the emperor embraced Christianity, he ordered the abandonment of pagan cults and temples; hence Christians initiated the temple-conversion process.

The abandoned temples were not converted directly to Christian worship, but it was an indirect conversion throughout Late Antiquity[13] This phenomenon went hand in hand with an increase in the construction of churches. Direct conversions from pagan to Christian places of worship are almost exclusively attested after the middle of the fifth century.[14] Temples that were not converted were abandoned and often disappeared because they were victims of stone robbery and spoliation.[15]

Some scholars suggest that early Egyptian Christians guided by their propagandists destroyed some temples of Greco-Roman origins,[16] but the literature of those Christian leaders proves that the violence was used only if these temples had threatened their civil safety.[17] The only known example of transforming an active temple or pagan center is the temple of Isis at Philae in the sixth century. The majority of temples of ancient Egyptian origin had become inactive for decades, generations, or sometimes centuries before being transformed to churches.[18] According to Socrates, the bishop Theophilus requested an imperial order before converting the Serapeum into a church.[19] This suggests that the attitude toward non-Christian buildings varied from one province to another and between the east and the west within the borders of the Roman Empire.[20]

The church of the Holy Sepulchre at Jerusalem is the earliest-known example of transforming a temple to Christian church, which was done during the reign of Constantine. Julian the Apostate issued edicts, which

[8] L. Kàkosy, "Paganism and Christianity in Egypt," in A. Atiya, ed., *Coptic Encyclopedia*, vol. 6 (New York, 1991), 1865–71.

[9] Westerfeld, "Christian Perspectives on Pharaonic Religion," 5–12.

[10] See M. Youssef, *The Rule and Relations of Coptic Church, from Establishing the Church till 431 A.D*, vol. I, 2nd ed., (Cairo, 2000).

[11] Jacqui Bolt studied many examples about temple conversion in Anatolia. See J. Bolt, *Converting the Polytheist the Persistence and Disappearance of Paganism in Early Christian Anatolia*, published Mmasters thesis, (Leiden, 2007).

[12] C. Shepardson, *Controlling the Contested Places: Late Antioch and the Spatial Politics of Religious Controversy* (Berkeley, 2014), 241–42.

[13] Cf. Westerfeld, "Christian Perspectives on Pharaonic Religion," 5–12.

[14] See the fourth chapter of R. Byliss, *Provincial Cilicia*, 50–56; De Lacy O'Leary, "La destruction des temples en Égypte," *BSAC* 4 (1938), 51–58.

[15] J. Hahn, et al., "From Temple to Church; Analyzing a Late Antique Phenomenon of Transformation," in Hahn, *From Temple to Church*, 11.

[16] Read: J. Schwartz, "La fin du Sérapéum d'Alexandrie," *Essays in Honor of C. Bradford Welles* (New Haven, 1966), 97–111; T. Orlandi, "Uno scritto di Teofilo di Alessandrino sulla distruzione del Serapeum?" *La Parola del Passato* 23(21) (1968), 295–304; O'Leary, "La Destruction," 51–58; Shoucri, "Les coptes sont-ils responsables," 26–27.

[17] Cf. Hahn, et al, "From Temple to Church," 4–5; Westerfeld, "Christian Perspectives on Pharaonic Religion," 5–12.

[18] Hahn, et al, "From Temple to Church," 12.

[19] O'Leary, "La destruction," 51–58.

[20] F. Deichmann, "Frühchristliche Kirchen in Antiken Heiligtümern," *JDAI* 54 (1939), 105–36.

returned the Roman Empire to the former religions. The temple conversion to Christian worship became more effective later on supported by imperial edicts that encouraged early Christians everywhere to reuse the ancient temples.[21]

Sometimes the pagan infrastructure was reused by means of imperial order in functions other than religious purposes. Some pagan infrastructures were reused as private, public, and official places, for example, as tax offices. Studies outline that ancient Roman temples were reused for many other practical uses all over the Roman empire before the religious edicts issued by Theodosios in AD 390. Outside of Egypt, the Hadrianeion was transformed into a prison, the Kaisareion became a public building then a church.[22] In Egypt, the Romans inserted a military camp within the precincts of Luxor temple in the third century.[23] Later on, early Christians inserted churches into Luxor temple. This may have been to keep temples prestigious instead of leaving them wholly to full decay or irretrievable destruction.[24] Interestingly, some other pagan infrastructure was converted to churches as many of the Hermopolite agora, for example, was transformed to churches. Hermopolis itself is a great example for studying all kinds of conversion within its borders.[25]

According to Richard Byliss, the fate of the temples was deconsecration rather than destruction. When Christianity became the official religion in the Roman Empire of the fourth century, temples were neglected. Thus, the destruction of the pagan sites was not so much a matter of violent Christianization as it was a simple matter of a lack of resources available to restore them.[26]

With the passage of time Egypt lost much of its special status in the Roman Empire. The relation between Egypt and Constantinople started to strain after AD 451, especially after the council of Chalcedon, which separated the Christians into monophysites and Melchites.[27] The taxes were varied, were imposed, and were enforced by law. The lives of tax collectors themselves were at risk owing to conditions that they did not abide by regulations of the taxation system to achieve their target. Even the tax exemptions, which were applied in some cases for priests and temples, differed from place to place and from temple to temple. From the reign of Diocletian (AD 284–305) until the early Arab era nothing significant changed in the taxation system in Roman Egypt. The salaries of officials and the army were collected in the form of taxes from the Egyptians. It was a difficult and potentially unbearable system, which depleted and exhausted the Egyptians.[28] Although some emperors donated to the construction of new churches, there was no known strategy to endow or to donate for this purpose during Byzantine era. This indicates a financial reason behind the Christian reuse of the infrastructure of former religions in Egypt.

It is clear then, that early Egyptian Christians did not set out to destroy temples, or systematically dismantle pagan buildings. Although Theodosios the Great ordered the closure of temples empire-wide, his order did not have the impact that has been ascribed to it. There were also many temples protected by law in many cities and at least practicing the ceremonies of pagan worship were allowed after abandoning the temple.[29] The fate of temples varied from time to time and place to place, and did not directly depend on the imperial laws,[30] so each state of the Roman empire must be studied separately. Doing so may open the way for further comparative studies to investigate the different attitudes of Christians toward the buildings of ancient religions and to investigate the different factors that lead to their reusing these sites in either religious and non-religious purposes.

[21] F. Deichmann, *Rom, Ravenna, Konstantinopel, Naher Osten. Gesammelte Studien zur Spätantiken Architektur, Kunst und Geschichte* (Wiesbaden, 1982), 56–94.

[22] Hahn, et al, "From Temple to Church," 8.

[23] P. Grossmann, "Luxor Temples," in Atiya, ed., *Coptic Encyclopedia* 5, 1484–86.

[24] J. Hahn, et al., "From Temple to Church," 9.

[25] J. Westerfeld, "Saints in the Caesareum: Remembering Temple-Conversion in Late Antique Hermopolis," in M. Bommas, et al., eds., *Memory and Urban Religion in the Ancient World*. Cultural Memory and History in Antiquity 2 (London, 2012), 59–85.

[26] Byliss, *Provincial Cilicia*, 8–31.

[27] L. Capponi, *Roman Egypt*, Classical World 34 (London, 2011), 39–40.

[28] For more about taxation system in Roman Egypt read: R. Coquin, "Taxation in Roman Egypt," in Atiya, *Coptic Encyclopedia* 7, 2202–7; N. Lewis, *Life in Egypt under Roman Rule*, Classics in Papyrology, 2nd ed. (Atlanta, 1999), 156–84.

[29] Byliss, *Provincial Cilicia*, 31.

[30] See Byliss, *Provincial Cilicia*, especially: "The Fate of the Temples," 8–31, and "Between Temple and Church," 58–64.

Fig. 1. Early Christian reuse of Karnak Temple. The cross sign indicates the sites of churches, while the other sign indicates the monastic residences. Drawing after LdÄ III, 346.

The Monastic Vestiges at the First Pylon of Karnak

Detailed and accurate studies about reuse at each site and the different aspects of reuse are an important complement to the general considerations of reuse as found in the literature. Karnak temple has a wealth of Christian additions in the shape of buildings, walls, representations, texts, miniatures, and graffiti, which offers a chance to study the attitude of early Egyptian Christians toward ancient Egyptian temples and helps in the general understanding of the theory of contested spaces in late antiquity. The phenomenon of temple conversion in Egypt is illustrated well by the early Christian additions to the first pylon of Karnak temple. The main focus of this study is to determine to what extent the Christians made use of this area during Late Antique Egypt. It answers four questions: why, when, how, and by whom that place was settled.

Early Christians found Karnak temple a suitable place for installing religious and monastic buildings.[31] Dwellings are situated around the area of the first pylon at the entrance of Karnak. Its ruins are located to east, west, south, and north of the first pylon (see fig. 1).

The Southern Tower of the First Pylon

Western Side

The monastic buildings extended to cover both sides of this tower during the early Christian reuse. On the western façade of the southern tower just under the four windows opened on the tower, two rows of holes can be seen, which reach the shoulder of the entrance between the two towers. It is supposed that these two rows of

[31] Jacquet, "Karnak in the Christian Period," 1392–94.

holes were used to receive the ends of wooden beams, which were supporting the ceilings of a two-floor monastic building (fig. 2).[32] Furthest to the south of this tower there are obvious early Christian additions in the form of numerous cells for monks to pray and to live in quiet, and have a peaceful place. Remains of about three cells can be seen at the site even today.

South of the Pylon

The remains situated to the south of the southern tower, indicating that the place might include the main church of the monastery. Traces of mud-brick walls still stand there with broken columns lying on the ground (fig. 3).[33]

Eastern Side

The kings of the Twenty-Second dynasty had left the first pylon unfinished.[34] They left a ramp of mud at the base of the two towers of the pylon, by which they could transfer the stones to higher levels during construction work. These mounds of mudbricks and rubble reached the half height of the pylon.[35] The early Christians made great use of both these piles, and the pylon itself. The ramp was used as a base for their newly added buildings, while the solid stones of the pylon strengthened the poorly constructed dwellings; hence these simple monastic buildings could survive for a long time. Today only some remains survive upon the base of mud, including walls dividing the whole building into rooms or cells. Each cell would have accommodated a monk (fig. 4). The style of those single cells can be compared with the style of monk cells incorporated in the monastic fortifications, which were built in monasteries later on. Interestingly, the later monastic fortifications at the monasteries of the Wadi El-Natroun look like the tower of the temple pylon. This shape of the brick building on the base of mud can be explained as monastic cells, magazines, or a library if compared with the holes on the eastern tower of the eighth pylon (fig. 5).

A shell surmounted by a cross adorns the upper most part of this tower near its middle (fig. 6). It is a well-carved shell with sixteen ridges, and a pearl in its heart. The pearl at the heart of the shell may have reminded Christians that real faith should be in their hearts.[36]

A representation of a cross crowns the frieze of the shell. This cross is made up with four representations of Greek iota (I), which is the first letter of "Jesus" in Greek (Ἰησοῦς).[37] This shell on the back of the southern tower of the first pylon can be compared with the shell on the ninth pylon (fig. 7).

Entrance between the Two Towers

On both sides of the entrance there are more holes, the location and distribution of which indicate that beams were inserted probably to support a wooden bridge between the two towers to keep the two parts of the monastery connected.[38]

[32] Jacquet, "Karnak in the Christian Period," 1392–94.

[33] E. Ghaly, "The Coptic Additions on the Ancient Egyptian Monuments in Qena Governorate from the 1st to the 7th Centuries," M.A. thesis, Fayoum University, 2011, 206.

[34] P. Barguet, "Le temple d'Amon-Rê à Karnak; Essai d'exégèse," *RAPH* 21 (Cairo, 1962), 46.

[35] H. Munier, and M. Pillet, "Les édifices chrétiens de Karnak," ***RÉA*** 2 (1929), 58–88.

[36] For more about the symbols of the shell read: R. Boutros, "La symbolique de la conque dans l'Égypte chrétienne et musulmane," *Le Monde Copte* 20 (Limoges, 1992), 81–87.

[37] For more about symbols of the Coptic cross see G. Ludwig, "La croix dans l'art copte," *Le Monde Copte* 9 (Limoges, 1980), 3–12.

[38] Jacquet, "Karnak in the Christian Period," 1392–94.

Fig. 2. The southern tower of the First Pylon, Karnak Temple. Photograph by E. Ghaly.

Fig. 3. Vestiges of the main church to the south of the First Pylon, Karnak Temple. Photograph by E. Ghaly.

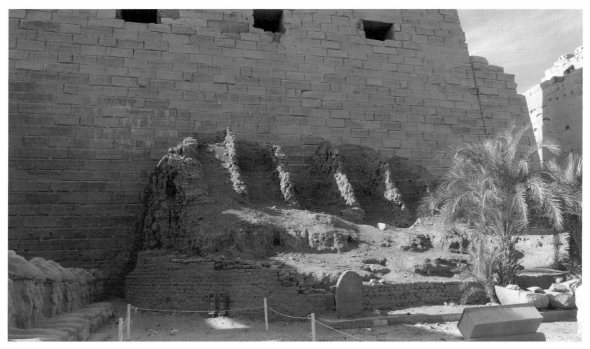

Fig. 4. Vestiges of monastic buildings, east of First Pylon, first Court, Karnak Temple. Photograph by E. Ghaly.

Fig. 5. Remains of monastic additions to the Eighth Pylon (eastern tower). Photograph by E. Ghaly.

Fig. 6. The shell on the eastern face of the southern tower, First Pylon, Karnak Temple. Photograph by E. Ghaly.

Fig. 7. A shell crowned by a Coptic cross, on the Ninth Pylon, Karnak Temple. Photograph by E. Ghaly.

The Northern Tower of the First Pylon

Western Side

The monastic building here seems to have been larger than the building on the west of the southern tower. There are three rows of holes indicating possible floors instead of two floors on the southern tower, so it was probably composed of three floors (fig. 8). The buildings were of mud bricks on a base of mud, the remains of which were still visible during the nineteenth century (fig. 9).

North of the Pylon

To the north of the tower, there are vestiges of monk cells. There are four rows of beam holes along the brick téménos wall protecting the temple precinct. These beam holes were made

*Fig. 8. The northern tower of First Pylon, Karnak Temple.
Photograph by E. Ghaly.*

*Fig. 9. Mounds of mud before the northern tower, First Pylon,
Karnak Temple. Photograph by Griffith Institute, University of
Oxford http://www.griffith.ox.ac.uk/perl/gi-em-lmakedeta.
pl?&sid=1432648836–194.81.125.225&1=Karnak&3=x
&en=cl11–064.*

by the occupants to support the beams of their monastic buildings. There are some niches or forms of primitive church apse on the brick wall adjacent to the northern tower facing the east. It can be also explained as a niche on a monk cell (fig. 10).

Many stone jars and vessels were found which may have been used for making the holy bread for the monastery or at least for their daily use (fig. 11). These objects bear witness to the early Christian religious life. The existence of these objects may prove that there was a bakery for the monastery at this place or elsewhere close to it.

The noteworthy thing here is that the traces of monastic buildings to the west of the first pylon can be compared with those to the north of the eighth pylon (figs. 4 and 12).

Eastern Side

The pylon supported a mud-brick building, which consisted of at least one floor, as only one row of beam holes can be seen on the tower. Today no remains of this building exist there.

Fig. 10. Vestiges of monk cells with niche/apse, to the north of the First Pylon, Karnak Temple. Photograph by E. Ghaly.

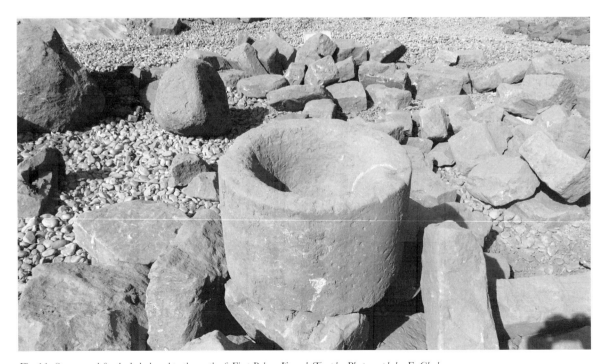

Fig. 11. Stone vessel for the holy bread to the north of First Pylon, Karnak Temple. Photograph by E. Ghaly.

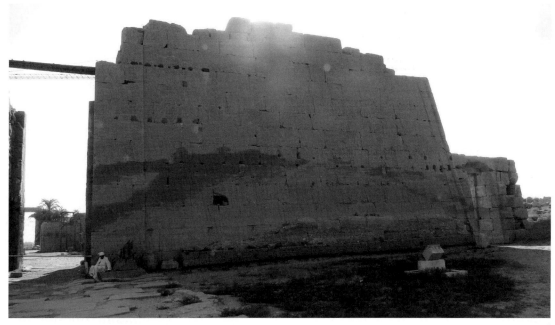

Fig. 12. Remains of monastic buildings on the Eighth Pylon (western tower). Photograph by E. Ghaly.

The Row of Nine Column

On the southern side to the first court of Karnak stands a row of nine columns, which precedes the temple of Ramses III. There is a great deal of evidence of early Christian reuse of this place recorded in the form of graffiti and miniatures on the surfaces of some columns. I list them here beginning with the first pylon.

The Fifth Column

- A representation of an unknown warrior saint riding an unidentified animal while holding a lance on his right hand (fig. 13).
- A representation of a man in a standing position holding *w3s*-scepter in his right hand while holding *ʿnḫ*-sign in his left hand (fig. 14). This might be considered nostalgia or imitation of the art of the figures found throughout the temple.

The Sixth Column

- A representation of a bark with helm and oars (fig. 15).
- A representation for another bark surmounted by the Holy Cross (fig. 16).
- Munier could read two Coptic names scratched on this column: ⲡⲉⲡⲉ and ⲁⲍⲁⲣⲓⲁⲥ.[39]

The Seventh Column

- A representation of a bark with a helm surmounted by a chapel with a representation of the Holy Cross (fig. 17).

[39] Munier, and Pillet, "Les édifices chrétiens de Karnak," 58–88.

Fig. 13. A warrior saint on a ride (animal). Photograph by E. Ghaly.

Fig. 14. A saint holding w3s-scepter and ʿnḫ-sign. Photograph by E. Ghaly.

The Eighth Column

- A miniature of Coptic/Greek letter Π (fig. 18).
- Another representation of a bark with a helm surmounted by a chapel dedicated to the Holy Cross (fig. 19).
- A representation of a bark with mast, oars, and main sail surmounted by the Holy Cross (fig. 20).

The Ninth Column

- Representations of birds the traditional sign of the Holy Spirit in early Christian iconography, and a representation of an eagle (fig. 21). The eagle refers to the existence of Jesus Christ.[40]

Discussion

Early Christian additions in the form of graffiti, miniatures, and mud-brick buildings in Karnak temple show that early Christians did not destroy, nor did they intend to destroy, but rather reused some parts of the temple for new purposes. It is in line with the general impression that the temple conversion process in Egypt involved reuse rather than violent destruction.

Early Egyptian Christians abandoned traditional religious temples, idols, and practices. They suppressed building and dedicating new temples to ancient deities. Ancient Egyptian temples were deserted for some time after the conversion of the Egyptian population to Christianity. After the Roman persecutions against Christians had stopped, many Egyptians initiated the monastic life in quiet places, deserted places, and protected areas

[40] R. Boutros, "The Coptic Basilica Inside the Temple of Dendara," *Week of Coptology 11* (Cairo, 2006), 157–79.

Fig. 15. Bark with a helm and oars surmounted by a the Holy Cross. Photograph by E. Ghaly.

Fig. 16. A bark surmounted by a chapel of the Holy Cross. Photograph by E. Ghaly.

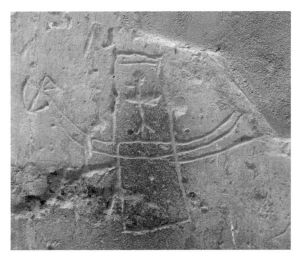

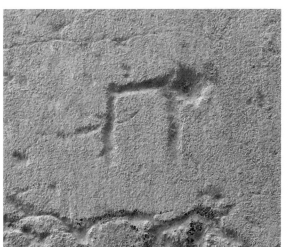

Fig. 17. Bark surmounted by a chapel of the Holy Cross. Photograph by E. Ghaly.

Fig. 18 The Greek letter Π. Photograph by E. Ghaly.

away from the hustle of the cities, but not very far from those cities. The deserted temples were excellent places, which fit their new dedication. Later they moved toward the full desert, which replaced the earlier deserted locations. The monks began to search for fully deserted quiet places, like mountains and ancient tombs,[41] or places that were semi-deserted, like ancient temples or buildings.[42] The monks were the most active groups in the process of temple conversion.[43]

Apparently, Egypt is a special case with respect to temple conversion. Some early Christians showed respect for ancient Egyptian buildings and sites.[44] The Theodosian code and early abbots of Coptic monasticism presented Christianity as the legal heir of ancient sites.[45] Early Christians of Egypt reused these ancient sacred

[41] A. Badawy, "Les permièrs établissements chètiens dans les anciennes tombs d'Égypte," in *Publication de l'Institut d'Études Orientales de la Bibliothèque Partriarcale d'Alexandrie* 2 (Alexandria, 1953), 67–89.

[42] See R. Kamal, "Coptic Monuments at Pagan Sites in Egypt, and Utilizing Them in the Field of Religious Tourism," M.A. thesis, Alexandria University, 2008, in which she studies different temples, tombs, cities, and ancient sites reused all over Egypt by early Christians.

[43] Brakke, "From Temple to Cell, From Gods to Demons," 91.

[44] H. Shenouda, "Who Are the Copts; Comptes-Rendus," *BSAC* 17 (1963–1964), 253–56.

[45] Westerfeld, "Christian Perspectives on Pharaonic Religion," 5–12.

Fig. 19. A bark surmounted by a chapel of the Holy Cross. Photograph by E. Ghaly.

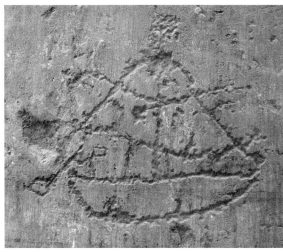

Fig. 20. A bark with mast, oars, and main sail surmounted by the Holy Cross. Photograph by E. Ghaly.

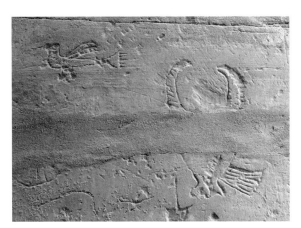

Fig. 21. Representations of birds and larger eagle. Photograph by E. Ghaly.

places for their new Christian worship with the same respect they were showing to them.[46] Early Christians reused not only ancient temples, but also ancient tombs all over Egypt.[47] Monks were the first groups to stay in these ancient buildings facing the mystery of ancient Egyptian gods, beliefs, tombs, and temples.[48] Monastic buildings were the first additions to be inserted into temples during the early Coptic era, and then ordinary people followed the monks reusing parts of the temples. One complete town inserted into a temple precinct can be seen in the Coptic town of Djemi found in and around the temple of Medinet Habu on the western bank of Luxor. There is much evidence that paganism existed in Egypt together with Christianity up through the sixth century under the cover of edicts of religious tolerance issued by Roman emperors.[49] Not until the reign of Justinian did Egypt witness the closing of the Isis temple in Philae (AD 540).[50] Some scholars suggest that the Roman persecution and their system of taxation caused the abandonment of some cities and consider it one of the main reasons why early Christians settled in ancient sites.[51] This may be a logic reason in the context of fourth and fifth centuries, and only if we are talking about creating new communities in isolated places like some of the monasteries dating to this era, or if only we are talking about the reuse of ancient tombs. In the case of Karnak temple, however, it is the reuse of a temple which was situated in a crowded

[46] Shoucri, "Les coptes sont-ils responsables de la destruction des temples pharaoniques?" 26–27.

[47] E. O'Connell, "Tombs for Living: Monastic Reuse of Monumental Funerary, Architecture in Late Egypt," Ph.D. diss., University of California (Berkeley, 2007), 7–8.

[48] Ghaly, *The Coptic Additions*, 466.

[49] Kàkosy, "Paganism and Christianity in Egypt," 1865–71.

[50] Bagnall, and Dominic, *Egypt from Alexander to the Early Christians*, 36; see also D. Frankfurter, *Religion in Roman Egypt: Assimilation and Resistance* (Princeton, 1998), 105.

[51] For further readings see H. Alibiary and H. Youssef, *The Social and Economic History of Egypt in the Roman Era*, Dra Elelm (Fayum, 2004), especially "Development of Religion during Roman Rule," 199–208, and "Taxation on Agrarian Lands," 235–45; Lewis, *Life in Egypt under Roman Rule*, 156–84.

Fig. 22. A Suggested Plan of Early Christian Additions at First Pylon of Karnak Temple.
Key:
A. A row of nine columns with graffiti and miniatures.
B. A mound of mud upon which the vestiges of walls dividing the whole building into cells and the Coptic shell.
C. The place of the one-storey building on the eastern side of the northern pylon.
D. The cells of monks on the north of the first pylon with some stone objects, which indicate a place for a bakery.
E. The place of three-storey building on the western side of the northern tower of the first pylon.
F. Graffiti of two ships on the southern shoulder of the entrance.
G. The place of the two-storey building on the western side of the southern tower of the first pylon.
H. Suggested place for the main church.
I. Temple of Khonsu, which includes a Coptic church.

city among people. This requires a different explanation than persecution and taxation; moreover, many scholars date the reuse of many temples at the east bank of the Nile in Luxor to the sixth and seventh centuries AD.[52] After the council of Chalcedon AD 451, the Copts were in control of all local affairs in Egypt till the ninth century. The Egyptians embraced Christianity leaving the ancient worships, deities, temples, and ignoring the ancient rites and prayers, which lead to the abandonment of most temples.[53] A new prayer called "the consecration/

[52] See: Barguet, *Le temple d'Amon-Rê à Karnak*, 23; Munier, and Pillet, "Les édifices chrétiens de Karnak," 74; Ghaly, *The Coptic Additions*, 163–64.
[53] Habachi, "Les coptes sont-ils responsables," 15–19.

dedication of church" was created during that time to rededicate the ancient temples to Christian worship, by which early Christians adapted and transformed the ancient buildings to churches.[54] According to Jitse Dijkstra, Christianity passed through four main stages during the Late Antique period in Egypt.[55] First, they organized the constitutional church in the shape of bishoprics and with episcopal sees in many cities.[56] Second, there was the expansion of Christianity. Third, we see the creation of ascetic or monastic life. Fourth was the changing of the Egyptian landscape to be filled with churches and monasteries.[57]

Temples continued to hold their significance for Egyptians, even when these temples were in decline.[58] Grossmann says that Christians did not destroy most temples for religious reasons, but temples were reused for other purposes, and sometimes they were dismantled to retrieve building materials. Many temples remained untouched.[59] Moreover, the secular reuse of parts of many temples not only in Egypt, but also all over the Roman Empire occurred. Most of the temples have been deserted before the Christian reuse.[60] Based on that, temples were transformed into not only religious, but also non-religious buildings. It is preferable to use the term "temple conversion" rather than "temple destruction" while discussing the fate of ancient Egyptian temples in late-antique Egypt,[61] because this conversion was for the practical reuse more than the idea of the dramatic destruction of ancient temples or civilizations. The reuse of ancient temples developed with the passage of time based on a sociopolitical and economic context.[62]

Conclusion and Results

Most ancient Egyptians were worshipping their traditional deities even under Greek or Roman rule. Once they converted to Christianity, they Christianized all aspects of their previous life. They Christianized their names, music, prayers, art, rites, habits, festivals, etc. They also Christianized the ancient deserted temples; the places they used to respect, and they intended to incorporate them respectfully in their new cult. This is the reason why early Christians of Egypt were not shy to reuse ancient sites of ancient deities for the worship of Christ. It seems that they did so after many prayers to rededicate the ancient place of worship to Christ and after making many crosses on the walls and columns to dedicate the place to the Christian cult.

Apparently, many factors influenced the temple conversion in Egypt, which is a special case when it comes to the phenomenon of temple conversion. This phenomenon differs from one province to another throughout the Roman Empire. The temple conversion conducted by early Christians of Egypt kept the converted temples in better condition than if the temples had been left unused or unmaintained.

The conversion of Karnak temple occurred after the imperial edicts, which had been issued by Theodosius the Great (AD 392). Those edicts legitimized the settlement of monks at Karnak precinct after the fall of paganism and the full abandon of the temple. There is no evidence indicating any kind of conflict between the early Christians and any traditional priests at Karnak temple. The monks intended to reuse not to destroy any part of the temple. They reused many parts of Karnak temple in the form of churches and monastic buildings (see fig. 1). They reused the area around the first pylon as a monastic residence according to the above-mentioned details of the reuse (see the suggested plan of their reuse in fig. 22).

[54] Ghaly, *The Coptic Additions*, 468.

[55] J. Dijkstra, *Philae and the End of Ancient Egyptian Religion, A Regional Study of Religious Transformation (298–642 CE)* (Leuven, 2008), 46–47.

[56] A. Martin, "L'Église et la khôra égyptienne au IVᵉ siècle" *REAug* 25 (1979), 3–26.

[57] See Dijkstra, *Philae and the End of Ancient Egyptian Religion*, 85–110.

[58] D. Frankfurter, "Iconoclasm and Christianization in Late Antique Egypt: Christian Treatments of Space and Image," in Hahn, *From Temple to Church*, 149.

[59] P. Grossmann, "Tempel als Ort des Konflikts in Christlischer Zeit," in P. Borgeaud, et al., eds, *Le temple, lieu de conflit: Actes du colloque de Cartigny 1991* (Leuven, 1994), 181–201.

[60] Cf. Westerfeld, "Christian Perspectives on Pharaonic Religion," 5–12.

[61] Dijkstra, *Philae and the End of Ancient Egyptian Religion*, 94.

[62] H. Saradi-Mendelovici, "Christian Attitudes Toward Pagan Monuments in Late Antiquity and Their Legacy in Later Byzantine Centuries," *Dumbarton Oaks Papers* 44 (1990), 47–61.

Monks added mud-brick buildings to adapt places for their residences. The monks did not destroy or dismantle any part of Karnak temple, but rather added a cover of stucco or brick buildings in front of the stone masonry of their ancestors to get more support for their weak new buildings. The additions around the first pylon preserved the ancient buildings, walls, and scenes in better conditions The monks, who reused this part of Karnak temple, built their church as a freestanding building on the south of the first pylon assuring the separation of the church to somewhat out of the temple. This may have been to avoid the confusion with the pagan buildings. Building a free-standing church with stone columns reflects their creativity and their ability to build either in mud bricks or in stone.

Early Christian graffiti on the columns indicate the Egyptian and Christian identity of the persons who lived there and left their graffiti and miniatures in the form of crosses inside traditional chapels, warrior saints, and ancient bark surmounted by crosses, which can be considered nostalgia for the art of their ancestors. These representations resemble the ancient representations of warrior kings, ancient chapels, and solar barks.

Interestingly, The monks who reused this part of Karnak temple led a communal life (Cenobitic life) not an ascetic or semi-ascetic life. It is easy to conclude this based on the monastic additions, which included a church on the south, cells on the north and the east, a library, and a bakery. These additions were in Karnak temple, which allowed them to benefit from its enclosure walls. These walls protected the monks and their monastic buildings. The enclosure walls kept the monks in one unit and separated them from the secular life out of the temple.

The current writer suggests naming this place "Monastery of the Holy Cross at Karnak" based on the variety of representations of the Holy Cross on the surfaces of the columns and wonders if current Copts could get an allowance to pray a mass at any of the ancient churches of Karnak during the celebrations of the Theban Coptic saints adding a new dimension that may attract domestic and international tourists to the city of Luxor.

Fayum University

The Journey of Muhammed Bey al-Alfi to London: An Eye-Opening Journey

Doaa A. M. Kandil and Ahmed M. H. A. Fakhry

Abstract

Through close analysis of a wide array of archival sources like Foreign Office Records and War Office Records as well as diverse contemporary sources like chronicles, memoires, correspondences, and press, this article provides an investigation of the journey of the Mamluk chief Muhammad bey al-Alfi to London in 1803 on behalf of the Mamluk beys of Egypt. It seeks to illuminate the various aspects of this journey was shrouded in obscurity and left out of the prevailing historical narrative. The paper also highlights the underlying motives of this journey as well as its implications on the Mamluk institution. It also outlines the diplomatic, economic and social activities that Alfi bey conducted there. It argues that this journey was truly an eye-opening experience if not a life-altering one for Alfi bey. Evidently, it had a lasting impact on him and helped him to articulate a new political vision by its end. As a result, he returned back Egypt with a recipe for its progress and a full determination to initiate an entire political makeover.

Introduction

Following the departure of the French expedition from Egypt in 1801 and the reestablishment of the Ottoman rule there, the Mamluks found themselves in a precarious position. The Ottomans were no longer willing to tolerate the Mamluks in Egypt or to share power with them the way it used to be before the coming of the French expedition. In a later development, they even tried to eradicate the Mamluks and undermine the leftovers of their power.

To spare the Mamluk institution from the unenviable fate that awaited it, Muhammad bey al-Alfi turned to the British and sought their assistance. To this end, he headed to London in March 1803 on a highly sensitive diplomatic mission. He wished to discuss with the British government on which he put much hope, the arrangements needed for the return of the Mamluks to power. Nevertheless, he did not reach his destination until October of the same year as he was forced to stay in Malta for almost six months against his will before he could proceed to London.

In the course of his visit to London, Alfi bey conducted a number of activities (diplomatic, social, and economic ones) however; his meeting with the king formed its high point. There Alfi bey appeared to be a natural diplomat who knew well how to address those in power and show them the due respect as well as how to direct his negotiations back-and-forth to guarantee its success. He was also keen to develop a conceptual framework of understanding with the British side to harmonize their interests. More importantly, he came to learn quite a deal from this cross-cultural encounter that reshaped his outlook and enabled him to discover points of strength and points of weakness in his own institution. Therefore, this journey marked a large shift in Alfi's political course.

Much to one's surprise, most of the contemporary historical sources have maintained silence regarding this journey, which was accompanied by profound reconfigurations at both the political and cultural levels. Indeed, much has been written about Egypt's conditions in the aftermath of the French expedition and the struggle for power it had witnessed, yet there has been little scholarly attention given to Alfi bey's mission in London, which remains understudied. Apart from a brief reference to the timing, duration, and main purpose of the journey,

Journal of the American Research Center in Egypt 53 (2017), 123–137
doi: http://dx.doi.org/10.5913/jarce.53.2017.a006

one can hardly find anything related to it in contemporary sources. There is no mention whatsoever of the details of the journey itself or its fatal consequences on the political scene in Egypt then.

By lifting the veil on this journey, this article tries to fill the gap in order to contribute to our understanding of the complex relations, contradictions, and ambiguities of this traumatic period. Thus, we thoroughly examine Alfi bey's tremendous efforts in London to restore the Mamluks to power and his negotiations there as a high-powered Mamluk chief with the British king himself as well as with other eminent figures in office. Equally important, we examine his entirely ignored six-month forced stay on Malta and his struggle to break this impasse. We also uncover an old forgotten portrait of Alfi bey, which is little known to a specialized audience. This portrait, which depicted Alfi bey in full splendor, was painted in the opening years of the nineteenth century while he was at the height of his power (fig. 1).

Furthermore, our research reveals that this journey had a very positive effect on Alfi bey, who came to experience a new culture that brought to his attention some worthy themes that he had never considered before.

Fig. 1. Portrait of Muhammed Bey al-Alfi (after http://www.alamy. com/stock-photo-elfi-bey-56772245.html).

On the other side, it had a negative, if not detrimental, effect on the crumbling Mamluk institution as a whole. Although it was meant to secure the Mamluk position in Egypt and serve their cause, this journey led to more complications since it aroused the animosity and jealousy of other Mamluk chiefs. This served to widen the split between them and accelerate the eventual disintegration of their institution.

<center>Who Is Muhammad Bey al-Alfi?</center>

Muhammad bey al-Alfi bey (fig. 1) was one of the foremost powerful Mamluk figures who steered the Mamluk institution in Egypt during the second half of the eighteenth century. His surname "al-*Alfi*"[1] reflected his eminent status. According to Al-Jabarti, he was so-called because his original master, Murad bey, paid 1,000 *ardabs* of wheat to purchase him, which was a fortune at that time. It seems that Murad bey had much appreciated the massive potentials of this Mamluk, and was keen to incorporate him into his household at any cost. Later, Murad bey manumitted him and appointed him Kashef (provincial governor) of Sharqeyya province.[2] As time lapsed, al-Alfi rose to prominence and played a crucial role in resisting the French expedition in 1798. After the departure of the French in 1801, he made big efforts to restore the Mamluks to power once again.[3]

As a matter of fact, Alfi bey was a controversial figure who combined a lot of contradictions. On the one hand, he was energetic, ungainly, and extremely cruel. On the other hand, he was known for his gallantry as he protected the poor peasants from Bedouin raids.[4] At the same time, he was a knowledgeable person who read a large number of books in various branches of human knowledge. Such readings had shaped his orientations

[1] The word *Alfi* means one thousand in the Arabic language.
[2] Abd Al Rahman Al Jabarty, in Abd al-Rahim Abd Al-Rahman, ed., *Adjaib Al-Athar Fil-Taradjim Wal-Akhbar* (Cairo, 1998), 4:47.
[3] Al Jabarty, *Adjaib Al-Athar*, 4:51.
[4] Al Jabarty, *Adjaib Al-Athar*, 4:48.

and influenced his character. As a result, he interpreted many incidents that took place around him in a totally different way than the rest of the Mamluks.[5]

He was originally born in Georgia and was about five feet eight inches high. At the time of his journey to London, he was a middle-aged man of forty-three or forty-four years.[6] He had a ruddy complexion like his Mamluk peers and a long black beard reaching down to his chest that gave him an air of majesty.[7] In short, his physical features also mirrored his high status.

A Chaotic Status

The coming of the French expedition to Egypt in 1798 had unified the Mamluks and the Ottomans, who realized that they had to stand together in the face of that common threat. No wonder the Mamluk beys had faithfully supported the Ottoman forces that came to expel the French and restore the Porte's dominion over Egypt.[8] At the same time, they continued to fight the French in Upper Egypt until their power was exhausted. Only then, and due to the urgency of the situation, the Mamluk beys were forced to negotiate with the French.[9] These negotiations resulted in a peace treaty with the French.[10] Apparently it was only a maneuver[11] the Mamluks unwillingly resorted to in order to get a breathing space and to ensure the safety of their families and their possessions in Cairo. However, things abruptly changed with the arrival of the British troops at Abukir. The commander of the British campaign, General Hutchinson,[12] promised to help the Mamluks in reestablishing their sovereignty over Egypt once again. He even swore in the name of his religion, his king, and his own honor to do so.[13]

Much impressed with the language of General Hutchinson and believing in the sincerity of his promises, most of the Mamluk beys ignored their treaty with the French and allied themselves with the British[14] and thus risked their own lives. They offered all kinds of supplies for the joint Anglo-Ottoman troops[15] to get rid of the French and endured a lot of hardships during that critical period. After the departure of the French expedition in October 1801, the Mamluk beys waited with baited breath the fulfillment of General Hutchinson's promises. To their chagrin, the Ottoman Vizier together with Captain Pasha were working secretly to oust them from the political scene and liquidate them.[16]

It should be noted here that Alfi bey, unlike the rest of the beys, suspected the Ottoman intentions towards them. Therefore, he warned his brethren against Ottoman deception. However, none of them listened to his warning.[17]

Before long, the Ottomans revealed their true face and massacred a huge number of the Mamluks. It was only the direct interference of the British General Hutchinson that checked the Ottomans and prevented the entire destruction of the Mamluks during the struggle for power.[18]

[5] William Hamilton, *Remarks on Several Parts of Turkey: Agyptiaca* (London, 1809), 1:27–28.

[6] *Morning Post*, 17th October 1803.

[7] *Morning Herald*, 12th October 1803.

[8] W.O.1.347, Papers relative to the claims of Mahomet BeyElfi transmitted by Lieutenant Colonel L. Moore, November 1803.

[9] Doaa Kandil, *The Neo-Mamluks in Ottoman Egypt*, PhD diss., Helwan University, 2005, 421–22.

[10] Peace Treaty signed between Murad bey and Kleber in the 8th Year of Republic, French Expedition Records, Dossier 19, B6 42, Egyptian National Archives.

[11] Kandil, *The Neo-Mamluks*, 421–22.

[12] John Hely Hutchinson (1757–1832) was the commander in chief of the British troops in Egypt in 1801.

[13] W.O.1.347, Papers relative to the claims of Mahomet Bey Elfi transmitted by Lieutenant Colonel L. Moore, November 1803.

[14] W.O.1.347, Papers relative to the claims of Mahomet Bey Elfi, November 1803.

[15] W.O.1.347, Papers relative to the claims of Mahomet Bey Elfi, November 1803.

16 De Rossetti a Rathkeal, Cairo, 30th October 1801 Published in Angelo Sammarco, *Il Regno di Mohammed Ali nei Documenti Diplomatici Italiani Inediti* (Luglio 1801 - Luglio 1804) (Cairo, 1930), 1:12.

[17] Al Jabarty, *Adjaib Al-Athar*, 4:52–53.

[18] W.O.1.347, Papers relative to the claims of Mahomet Bey Elfi transmitted by Lieutenant Colonel L. Moore, November 1803.

The Mamluks Crisis

At that juncture, Major General Stuart,[19] who was the commander of the British army in Egypt, then received royal orders with the immediate withdrawal of the British troops from Egypt.[20] At the same time, he was instructed to communicate with the representative of the Porte in Egypt and to inform him of the evacuation of the British troops and ask him to take all necessary measures to maintain tranquility in Egypt and secure the Porte's interests there.[21]

Mr. Rossetti, the Austrian consul in Egypt at the time, referred to this communication that took place between General Stuart and the *wali* of Egypt in one of his letters. He put emphasis in that letter on Stuart's efforts to reach a settlement with the Ottomans with respect to the Mamluks before the departure of the British troops and his request to put an end to such hostilities that badly affected agriculture and trade in Egypt. However, the Ottomans were ostensibly reluctant to answer his request and to restore the Mamluks to power.[22] The best they could do was to offer the four prominent beys of the Mamluk institution a huge sum of money (2400 Purse) and a satisfactory annual pension for their maintenance from the Porte as a compensation for them and in return, they would have to quit Egypt[23] and retire to a country that was not specified yet.[24] On realizing that this offer was no more than a disguised exile, the leading beys of the Mamluk institution turned it down, which worsened the situation.[25]

It seems safe to say that General Stuart had tried to maintain a delicate balance between Ottoman and Mamluk interests and to remain neutral in their fierce struggle for power. This neutrality appeared markedly in his letter to the Grand Vizier written on the 26th of November 1802. He explained in this letter his endeavor to keep the promises given to the Mamluks earlier by General Hutchinson in the name of the king. Concomitantly, he confirmed his devotion to serve the interests of the Porte, which was dictated by those sacred treaties honored by the king of Britain himself.[26] Despite Stuart's alleged neutrality and the cordiality he showed to both parties,[27] he failed to bring about a reconciliation between them.

Sensing a storm brewing, Alfi bey sent a flattering letter to General Stuart in order to attract him to the Mamluk side. He portrayed Stuart in this letter as his adviser, patron, and protector in order to gain his full support: *"Looking upon you as my adviser and patron; for God first guides my steps and next to him Your Excellency … I speak in my own name as I am only my own master; and you are my patron and protector…."*[28]

He also expressed in this letter his mounting anxiety because of the rumors that spread everywhere about concluding a peace between the French and the Turks and their expected return to Egypt before the reestablishment of the Mamluks. At the same time, he directed Stuart's attention to the four main concerns that worried the Mamluks: *"first of the distress of the mamlukes, secondly of their great enmity against the Turks, thirdly of the want of discipline among the Osmanlis who have neither rule nor subordination and do not obey their chiefs like Europeans and fourthly of our situation in these parts….these four considerations make us apprehensive lest our inferior mamlukes should join the French."*[29]

In the same vein, Alfi bey asked General Stuart to allow the Mamluk beys to proceed to Upper Egypt[30] til finding a way out of this impasse. Nevertheless, all such efforts proved to be futile especially with the outbreak of the civil war between both parties and the approaching of the date of the departure of the British troops from Egypt without defusing the explosive situation. As a result, the Mamluk beys had no other choice but to request that Major General Stuart allow one of them to accompany the British troops on their departure to England.

[19] Sir John Stuart (1759–1815) was the Major General of the British army in Egypt from July 1802 to March 1803.
[20] W.O.6.183, Lord Hobart to General Stuart, Downing Street, 26th November 1802.
[21] W.O.6.183, Lord Hobart to General Stuart, Downing Street, 26th November 1802.
[22] De Rossetti to Stürmer, Cairo, 2nd February 1803, 1:47.
[23] De Rossetti to Stürmer, Cairo, 2nd February 1803, 1:49.
[24] F.O.78–39, A. Straton to Lord Hawkesbury, Pera, 22nd March 1803.
[25] W.O.₁.346, le Major General Stuart to Lord Hobart, Alexandria, 28th February 1803.
[26] W.O.₁.346, le Major Général Stuart to Grand Vizir, Alexandria, 26th November 1802.
[27] F.O.78–36, Lord Elign to Lord Hawkesbury, Constantinople, 24th December 1802.
[28] W.O.₁.346, Mohamed Bey Elfi to Major General Stuart, 26th December 1802.
[29] W.O.₁.346, Mohamed Bey Elfi to Major General Stuart, 26th December 1802.
[30] W.O.₁.346, Mohamed Bey Elfi to Major General Stuart, 26th December 1802.

This bey would act as an envoy to his majesty, the king of England. He would speak on behalf of the beys and present their case there.[31] At first General Stuart totally refused this request, but after giving it second thoughts, he changed his mind probably to guarantee exerting prodigious influence over the beys. Therefore, Stuart agreed to the request and acceded at last to Alfi bey's "*strong and urgent solicitations*"[32] as he described it. It was quite clear that Stuart wished to make use of Alfi's eminent status among both the Mamluks and the Arabs in the hope of extendind the British sphere of influence in Egypt. More importantly, he wished to utilize Alfi bey to serve the British interests in Egypt and to abort any possible forthcoming French scheme to seize Egypt: "*... he may be a forcible instrument in the hands of the government ... and at the same time counteract any projects of the French....*"[33]

Departure to London

General Stuart started making the necessary arrangements for the departure of the British army from Egypt. Accordingly he sent his secretary, Major Misset, to Cairo to act as the British Agent in Cairo, while he appointed Mr. Briggs as Vice Consul in Alexandria. On the other side, the Ottoman troops under the command of Kiaya Bey withdrew to Cairo. At the same time the Mamluk beys had made their preparations to retire to Upper Egypt and imposed heavy taxes over the neighborhoods where they were stationed to cover their expenses. Similarly, Alfi Bey made his preparations to travel to England in the company of General Stuart[34] as an extraordinary ambassador of the beys to the court of London.[35]

On the 11th of March 1803, the British troops evacuated Alexandria under the command of General Stuart and set out to Malta.[36] Muhammed Bey al-Alfi departed with them and was accompanied with a retinue formed up of fifteen Mamluks.[37] Three beautiful women, one of them Georgian and the other two Circassian, accompanied him likewise to entertain him at his leisure time with dancing and singing. In addition, there were four servants who attended him at dinner. There was also his secretary who acted as his interpreter as well.[38]

Two weeks later, the British Army arrived at Malta on the 27th of March 1803.[39] Against his will, Alfi bey was obliged to stay in Malta for six months before heading towards England.

Actually, Alfi's six-month stay at Malta is almost shrouded in mist. It raises a lot of nagging questions about the reasons behind his long, forced stay at Malta and about his response to it. The scarcity of historical sources dealing with it adds to the mystery.

After a long and extremely tiring search in the British and French archives, we found a few scattered, though valuable, references to this stay that have allowed us to reconstruct the events and interpret them. From a letter sent from Sir G. C. Boughton to J. Sullivan, one learns that Alfi bey stayed under detention there and was not even allowed to write to his fellows in Egypt[40] or communicate with them. At the very beginning, Alfi bey expected to return to Egypt or to send his news to the Mamluks within six months after meeting with "*some person in authority.*"[41] However, facts on the ground had soon impaired his original plan. Apparently, this detention was a British attempt to consume time and thus cause Alfi to lose hope and return to Egypt empty-handed. Nevertheless, he did not submit to this plan of action.

It is quite clear that the news of the departure of Alfi bey in the company of the British army and his embassy to the king's court had much alarmed the Ottoman side and caused the British government much embarrassment with the Porte. It is also evident that General Stuart did not get the consent of the British government

[31] W.O.₁.346, Les Beys to Major General Stuart, 20th February 1803.

[32] W.O.₁.346, le Major General Stuart to Lord Hobart, Alexandria, 28th February 1803.

[33] W.O.₁.346, le Major General Stuart to Lord Hobart, Alexandria, 28th February 1803.

[34] De Rossetti a Stürmer, Cairo, 9th March 1803, 1:50–53.

[35] *Times*, From the French Papers, 3rd May 1803, 3.

[36] W.O.₁.346, le Major General Stuart to Lord Hobart, Malta, 7th April 1803.

[37] F.O.78–39, J. Chabert to M. Straton, Constantinople, 26th March 1803.

[38] The Annual Register or a View of the History, Politics and Literature for the Year 1803 (London, 1805), 438.

[39] W.O.₁.293, Le Major General Stuart au Major General Brownrigg, Malta, 6th April 1803.

[40] W.O.₁.347, Sir G. C. Brathwaite Boughton to J. Sullivan, 17th October 1803.

[41] W.O.₁.347, Sir G. C. Brathwaite Boughton to J. Sullivan, 17th October 1803.

before allowing Alfi to accompany him, which made the situation more complicated. Knowing that Alfi constituted a formidable power to reckon with, Stuart might have wished to guarantee his loyalty by answering his request. He might have also considered putting an eye on him to prevent any move that might negatively affect the British interests.

Without wasting time, the French diplomats at Istanbul tried to exploit the situation to their advantage. They sowed dissension between the Porte and the British government. General Brune, the French ambassador in Istanbul then described Alfi bey as "*an ambassador, who had formally been received as such by the court of London.*"[42] He also spoke of the British intention to divide Egypt with the Mamluks[43] and regarded this partition project as the hidden impetus of his visit.

In other words, Alfi's visit to London was a golden opportunity that presented itself to the French diplomats who decided not to miss it. No wonder Brune discussed Alfi bey's journey at length in his letter to Talleyrand on the 9th of April 1803.[44]

As the British government was keen to retain its good relations with the Porte and to refute such French claims, Drummond, the British ambassador in Istanbul, then rejected Brune's entire statements. On the contrary, he depicted Alfi bey as "*a stranger, to whom the common laws of hospitality extended.*"[45] This declaration was meant to appease the Sublime Porte and to contain his anger. In the same vein, Drummond later received a letter from Lord Hawkesbury after Alfi's arrival at London confirming that "*this Mamluk chief has arrived in this country without the knowledge or sanction of his Majesty's government*"[46] and assuring that the British government was determined "*not to listen to any proposals from him which may affect the interest or the rights of the Ottoman Porte in Egypt.*"[47]

It seems safe to say that the British little cared about the Mamluks. They were only trying to reduce the Mamluks to become a submissive tool in their hands so as to serve their interests. Therefore, they maintained a system of checks and balances in Egypt to leach the beys. In reality, the British had no intention to leave them on the saddle in Egypt as Drummond revealed in one of his letters: "*It never can be consistent with our policy to leave the beys in the independent of Egypt….*"[48] They even mistrusted the beys, whom they believed to be "*treacherous chiefs of lawless banditti.*"[49] At the same time, they were trying to avoid anything that might worsen their strong relations with the Porte.

A Smart Maneuver

The maltreatment that Alfi bey was subject to on Malta had seemingly awakened him from his delusions. He realized that he put too much trust on the British side and incautiously threw his lot in with them while they let him down. More significantly, he found himself a prisoner in Malta under the thumb of the British, which caused him a great loss of face. His anxiety was much multiplied after receiving the news of the appointment of Ali pasha as governor of Alexandria. Alfi bey was afraid that Ali pasha might align himself with the French[50] to deal a severe blow to the beys in Egypt. Therefore, he decided to move swiftly. Alfi resorted to a smart maneuver to free himself from British clutches.

He spread rumors everywhere that he had hired a Swedish ship and that he would embark with his baggage to Marseilles or any other French port to start negotiations with the French side.[51] It seems that the deception worked and the British government grew alarmed because of these false rumors. It is not surprising that the

[42] F.O.78–40, W. Drummond to Hawkesbury, Buylukdere, 11th July 1803.

[43] F.O.78–40, W. Drummond to Hawkesbury, Buylukdere, 11th July 1803.

[44] Brune à Talleyrand, Constantinople, 9th April 1803 Published in Georges Douin, *Correspondance des Consuls de France en Égypte (l'Égypte de 1802 A1804)*(Cairo, 1925), 47.

[45] F.O.78–40, W. Drummond to Hawkesbury, Buylukdere, 11th July 1803.

[46] F.O.78–40, Lord Hawkesbury to W. Drummond, Downing Street, 18th October 1803.

[47] F.O.78–40, Lord Hawkesbury to W. Drummond, Downing Street, 18th October 1803.

[48] Shafik Ghorbal, *The Beginnings of the Egyptian Question and the Rise of Mehemet Ali* (London, 1928), 217.

[49] Ghorbal, *The Beginnings of the Egyptian Question*, 217.

[50] W.O.$_1$.347, Sir G. C. Brathwaite Boughton to J. Sullivan, 17th October 1803.

[51] *Times*, 10th October 1803.

British government made all the precautions to watch the shores and prevent him from sailing to France.[52] Obviously, he suffered a lot during his forced stay in Malta. However, he was not that kind of person who could submit easily to the status quo. No wonder he gave Alexander Ball, the British Consul at Malta a hard time.[53]

To put an end to the headache that Alfi bey caused the British government, Vice Admiral Lord Viscount Nelson gave his orders to Sir Richard Bickerton to make the necessary arrangements to set out for England and to take Alfi bey with him on board of one of the British ships stationed at Malta.[54] These orders were received on the 10th of July 1803. After a while, Alfi bey set out to England. On his way, the ship stopped at Gibraltar where Alfi bey met with Captain Thomas Fernyhough on the 3rd of September 1803 as Captain Thomas later revealed in his military memoires.[55]

Arrival at London

Finally, Alfi bey arrived at Portsmouth on the 3rd of October 1803 from Gibraltar.[56] There he was received with all signs of honor by the Admiral and captains of the fleet.[57] He was delayed for one day at Portsmouth because of a sudden storm. Thus he reached London on the 7th of October 1803.

The British government had assigned a comfortable house for his stay at Baker Street.[58] Crowds of people gathered in large numbers in this street. They were curious to watch that Mamluk chief with his luxurious costume and dark countenance. The scene had also attracted many ladies who stood at windows to see him.[59] It was quite evident that people were taken with his awesome look that some of them called him "*a mummy,*"[60] others called him "*a sphinx,*"[61] and finally they agreed to call him "*a live crocodile.*"[62] The way he dressed had impressed the audience and thus was described in details in the press: "*he wears a very rich inside dress of red and white stripped silk, red satin trousers, red silk stockings, with yellow sandals, a beautiful shawl, forming a drapery about the body and over that a rich silk mantle trimmed with fur.*"[63]

Later Alfi bey changed his place of residence at Baker Street because it was not spacious enough for him. He used to live in Egypt in lofty palaces like his grand palace at Al-Azbakiyya where Bonaparte resided. He moved to Sir Lawrence Parson's residence at Berkeley Square[64] and that was probably more adequate for him.

Alfi bey's Activities in London

From the first moment, Alfi bey expected to proceed to meet the king to pay his respect and consideration to him while accompanied with his secretary and four servants.[65] He might have thought that the royal court of London was much similar to the *Diwan* of the citadel in Egypt where anyone could easily proceed to it at any time. However, he soon found out that he was mistaken and that he had to wait before he could be let into the king's presence.

[52] *Times*, 10th October 1803.

[53] Ghorbal, *The Beginnings of the Egyptian Question*, 216.

[54] Nelson and Bronte Instructions to rear-admiral Sir Richard Bickerton, Bart, Amphion off Toulon, 10th July 1803. Published in *The Dispatches and Letters of Vice Admiral Lord Viscount Nelson*, notes by Nicholas Harris Nicolas (London, 1845), 5:126–27.

[55] Captain Thomas Fernyhough, *Military Memoirs of Four Brothers (Natives of Staffordshire) Engaged in the Service of their Country as well in the New World and Africa as on the Continent of Europe* (London, 1829), 25.

[56] Georges Douin, *L'Ambassade D'Elfi Bey À Londres (Octobre- Décembre 1803)*, BIE (Cairo, 1924–1925), 7:103.

[57] *Times*, 8th October 1803, 3.

[58] *Morning Herald*, 12th October 1803

[59] *Times*, 17th October 1803, 2.

[60] *Times*, 17th October 1803, 2.

[61] *Times*, 17th October 1803, 2.

[62] *Times*, 17th October 1803, 2.

[63] *Morning Herald*, 12th October 1803.

[64] *Times*, 14th October 1803, 2.

[65] *Morning Chronicle*, 12th October 1803.

Fig. 2. Hyde Park (after "Old and New London," London, *1804, Vol. 4).*

During his waiting period, Alfi bey visited many places in London and became acquainted with number of prominent figures. On the 11th of October 1803, Alfi bey accompanied by Lord Blantyre rode a coach and went on a tour through the principal streets of the west end of the town.[66]

On the 23th of October 1803, Alfi bey took a promenade to the Hyde Park (fig. 2).[67] Knowing that Hyde Park was the "Show Shop"[68] of London where crowds used to gather while wearing their most fashionable clothes, Alfi bey went there in his full splendor while riding his carriage and accompanied with his assistant, interpreter, and servants to impress the audience.[69] One must take into account that Alfi bey, like his Mamluk contemporaries, had a notable tendency to show off to draw people's attention to them. It seems that they regarded such eye-catching spectacles as a visible sign of their elitism which gratified them.

No doubt, Alfi bey was deeply affected by the atmosphere of this place. He realized that the Hyde Park was not only a park, but it was a platform for English people from all walks of life and an outlet for them. There they could meet on Sundays to celebrate festivals, rejoice and most of all express themselves and communicate their ideas freely and without fears. In other words, he was introduced to people's lifestyle in this Western society. He might have drawn a comparison between the people he saw there and the people he used to rule and who suffered misery and suppression because of Mamluk coercive rule.

More interestingly, the Londoners made a fuss over Alfi bey's visit and were occupied with watching his activities. It is not surprising that a fashion fair was held particularly in Alfi bey's honor. Among the exhibits of this fair were Mamluk headdresses, shawls, vests, and veils. The fair took place at the Egyptian hall inside the Mansion House that was adorned with unique Egyptian decorative motifs like gold and silver lotuses, crocodiles, crescents, nilometers, sphinxes, and other similar patterns related to Egyptian art.[70]

On the 2nd of November 1803, Alfi bey visited the Royal Circus to enjoy the entertainments performed under his patronage and at his presence.[71] To give him a grand welcome, a guard of honor from the first regiment of Surrey Volunteers attended his entrance to the theater together with his full retinue.[72] He also attended an Opera show in the theater on the 21st of November 1803.[73] It seems safe to say that Alfi bey's charm and cha-

[66] *Morning Herald*, 12th October 1803.
[67] *Morning Herald*, 24th October 1803.
[68] http://www.british-history.ac.uk/old-new-london/vol4/pp375–405.
[69] *Morning Post*, 27th October 1803.
[70] *Times*, 18th October 1803, 2.
[71] *Times*, 2nd November 1803, 1.
[72] *Times*, 2nd November 1803, 1.
[73] *Times*, 18th December 1803.

Fig. 3. The Prince of Wales accompanied by Alfi bey, his interpreter, and Muhammed Aga, his principal officer, and Colonel Moore at Pall Mall riding-house (after The Family Cyclopedia: Complete Treasury of Useful Information *[London, 1859], 82).*

risma had always worked in his favor. Wherever he went, he captured people's attention as journalists reported: "*Indeed, every eye was fixed upon him and every face was strongly expressive of pleasure as well as of respect for this illustrious visitant.*"[74]

On the 10th of November 1803, the Prince of Wales received Alfi bey with much respect at Carlton House. They had a long conversation together where the Prince expressed his admiration of Mamluk remarkable equestrian skills.[75] Then he challenged Alfi bey so as to test those skills saying "*I now have in my stud an Egyptian horse, so wild and ungovernable that he will dismount the best horseman in Elfi bey's retinue.*"[76] In response Alfi bey replied in a confident manner in Italian (which he had mastered) "*I shall gratify your Royal Highness's curiosity tomorrow.*"[77]

On the next day the Prince of Wales together with several noblemen who came specifically to eye witness this encounter warmly received Alfi bey at Pall Mall riding-house (fig. 3). Alfi was accompanied with his interpreter and Muhammed Agha, and Colonel Moore. They all waited for Alfi bey and his retinue to display their striking equestrian abilities. The grooms led out the horse which no one could ride and which had a frightening appearance: "*spotted like a leopard and his eyes were so fiery and enraged.*"[78] Without delay, Muhammed Agha moved towards the horse and jumped instantly on its back keeping his seat for more than twenty minutes. This ability to control the unruly horse and to tame it aroused the surprise of the prince and his distinguishable guests.[79]

Undoubtedly, this spectacular show must have augmented Alfi's prestige among the Londoners. As a result, the contemporary British press spoke highly of him and put much emphasis on his gallantry and prowess: "*one of the Mameluke chiefs, who fought so bravely at Alexandria. He was wounded in the side by a musket-ball and concealed it for two days, lest if known his danger should produce a cabal among the other rival chief and dismay among his troops.*"[80] They also numerated his heroic acts, such as resisting the French during their invasion of Egypt instead of acquiescing to them and his wandering in the desert while they were chasing him which gained him the title of "*the Antelope.*"[81]

[74] *Times*, 9th November 1803, 4.

[75] *Morning Chronicle*, 14th November 1803.

[76] The Annual Register, 455–456.

[77] The Annual Register, 455–456.

[78] The Annual Register, 455–456.

[79] The Annual Register, 455–456.

[80] The Annual Register, 438.

[81] *Morning Post*, 17th October 1803.

They also praised his extraordinary power, what was shown vividly in cutting off the head a buffalo with one strike from his sword.[82]

On the other side, Alfi bey was keen to visit Greenwich Hospital where he was also well received. Markedly, he acknowledged the high value of this institution as well as its wonderful structure. Then he paid a visit to the Observatory located at Greenwich Park. He was very impressed with the apparatuses he saw there.

He also visited the London docks where he met several members of its directors. Then he was conducted to Blackwall where he spent a number of hours inspecting the public works there as well as the docks and the warehouses. He also had some refreshments prepared by the directors for this occasion to welcome him. After this tour, he returned back to town and was invited to dine with the Prince of Wales.[83] This provides ample proof that Alfi bey was not treated as a *persona non grata* in the English society as the British ambassador in Istanbul claimed. On the contrary, he was received everywhere with all signs of appreciation. On the other side, Alfi bey himself was eager to explore English society and learn more about modern Western civilization.

However, Alfi bey's visit to the East India House at its headquarters in London on November 1803 had a special significance for him. It reflected his intention to carry out an economic development plan in Egypt in the future. Therefore, he was keen to establish economic ties with this imposing company. It is not surprising that he not only met with several directors, but also had a special meeting with Mr. Roberts, the Deputy Chairman, who conducted him to the Committee of Correspondence room. There, Alfi bey met Mr. Bosanquet, the Chairman himself and had a talk together.[84]

It seems that Alfi bey wished to revive that old Mamluk dream of restoring the old trade route that was once controlled by the Mamluks to bring economic prosperity to Egypt. To this end, trade relations were established earlier in the second half of the eighteenth century between the Mamluk beys and the East India Company. It was Ali bey al-Kabir who took this initiative. He ignored that embargo imposed by the Porte on the navigation in the Red Sea and allowed the ships of the East India Company to enter and sail from the port of Suez. He even assured George Baldwin "*if you bring the India ships to Suez, I will lay an aqueduct from the Nile to Suez and you shall drink of the Nile water.*"[85]

After Ali bey al Kabir's downfall, his successor Muhammed bey Abu al-Dahab followed in his footsteps. On the 7th of March 1775, he signed a treaty of commerce with the East India Company that provided for: "*free navigation and commerce between the subjects of both countries….*"[86]

However, this project was interrupted with the sudden death of Muhammad bey Abu Al Dahab and the political turmoil that followed under the duumvirate of Ibrahim bey and Murad bey. At that conjuncture, Alfi bey had seemingly found the time ripe for resuming such relations to generate revenues badly needed for the maintenance and perpetuation of the Mamluk institution in Egypt.

In the course of Alfi's visit to East India House, he toured the factory and made a complete survey of it. He visited the company's warehouses in New Street as well as the guard-rooms there. Then he returned to the main office and inspected the Court, the Sale rooms as well as the Correspondence room. Obviously, he wanted to learn more about the company's activities and to observe things at close range. Besides, he watched carefully the magnificent collection of art works displayed there and paid much attention to the *Musical Tiger* taken from Seringa Patam Palace[87] after its siege in 1799 as well as the *Golden head of a Tiger* that once adorned the foot-stool of the throne of Tipu Sultan[88] and that was displayed inside the Correspondence room.[89]

Then he proceeded to the Company Museum where he was fascinated with the rare collection of masterpieces preserved in the repository of eastern literature there. He was particularly touched by the *Poem of the Shri*

[82] *Morning Post*, 17th October 1803.

[83] *Times*, 12th November 1803, 3.

[84] *Times*, Elfi Bey, 9th December 1803, 3.

[85] George Baldwin, *Political Recollections Relative to Egypt* (London, 1802), 4.

[86] M. Anis, *Some Aspects of British Interest in Egypt in the Late 18th Century (1775–1798)*, PhD diss., University of Birmingham, 1950, 147–48.

[87] It was the summer residence of Tipu Sultan situated at SeringaPatam (200 Miles West of Medras in India), http://www.historytoday.com/richard-cavendish/tipu-sultan-killed-seringapatam

[88] Tipu sultan: (1750–1799) known also as "Tiger of Mysore" was the ruler of Mysore in Southern India from 1782 till his death while resisting the British East India Company troops.

[89] *Times*, Elfi Bey, 9th December 1803, 3.

Bhagvata.[90] This confirms that Alfi bey was not that savage or capricious[91] person as habitually portrayed. On the contrary, he appeared to be a cultivated person who had a refined taste. It seems that Alfi bey's obsession with power, heroism, and glorification stood behind such admiration of these pieces in particular since they commemorated Tipu Sultan's gallantry and unyieldingness. In fact, Alfi bey was much like an excavator who was exploring a new world he was less familiar with. At the same time, he was eager to prove to everyone there that he was a *"Man of Sense"*[92] and that he stood on an equal footing with them all.

A New Vision

In fact, Alfi bey's experience in London had profoundly affected him. It helped him to articulate a new vision concerning Egypt's future. He became determined more than ever to modernize Egypt and to initiate an ambitious all-encompassing development program to improve its conditions. It comes as little surprise that he decided to take back with him to Egypt some experts who would form the backbone of the renaissance he was looking for. Therefore, he asked the permission of the British government to send with him a number of experts (astronomers, literati, geographers, physicians, and surgeons, etc.[93]) to train Egyptians on the latest and advanced technologies. Obviously he was endeavoring to bring that western civilization to Egypt to guarantee its independence in the future. This was best manifested in the course of his conversation with Captain Hallowell[94] when clarified to him that *"he should be glad to encourage the importation of English manufactures, but never wished to see an English soldier in the country."*[95]

Later after his return to Egypt, Alfi bey disclosed to one of his Mamluks called Solaiman bey Al-Bawwab that he should bring a whole sea change in the way they ruled the country in case of their return to power. He also pledged himself to look after his people and to take good care of them instead of impoverishing them[96] as they had done in the past. This was probably the biggest lesson he learned from his experience there.

Alfi bey's Negotiations in London

In November 1803, Alfi bey authorized Colonel Moore to submit his demands to his Majesty's Government. Alfi bey made it very clear that he did not come to that country in order to involve the British Government in the ongoing struggle with other foreign powers. On the contrary, he only tried to present his case to exonerate himself and his brethren from the false charge of rebelling against the Porte. He also referred to the political turmoil that spread over Egypt in the aftermath of the departure of the French expedition till the departure of British army from Egypt. In the same vein, he spoke of the hard time that the Mamluks had been through as well as the promises of General Hutchinson to support them.[97]

Then he presented his Memorial to the Britannic Majesty's Government to remind it again with the promises given earlier to the Mamluk beys: *"the undersigned of this memorial has the honor to inform his Britannic Majesty's Government, that above -Mentioned Generals of his Majesty's forces gave their words and faiths to the whole corps of the Beys of Egypt, that they would find justice and redress from his Britannic Majesty; and the above Mentioned Beys believed and as firmly relied on these promises as if they were pronounced by his Majesty's royal mouth ; on which account, the above mentioned Beys deputed the undersigned as their agent, to come to his Britannic Majesty's Court to request the confirmation of the Afore- said promise...."*[98]

[90] *Times*, Elfi Bey, 9th December 1803, 3.

[91] W.O.₁.347, Captain B. Hallowell to Lord Saint-Vincent, H.M.S. Argo, Malta, 3rd February 1804.

[92] *Morning Post*, 7th November 1803.

[93] *Morning Post*, 17th November 1803.

[94] Admiral sir Benjamin Hallowell (1761–1834) was the commander of Argo ship.

[95] Captain Hallowell to Vincent Nelson, H.M.S. Argo, Malta Harbour, 16th March 1804, published in Georges Douin, *L'angleterre et L'Égypte: La politique Mameluke (1803–1807)* (Cairo, 1930), 2:127.

[96] Al Jabarty, *Adjaib Al-Athar*, 4:68.

[97] W.O.₁.347, Papers relative to the claims of Mahomet Bey Elfi transmitted by Lieutenant Colonel L. Moore, November 1803.

[98] W.O.₁.347, Memorial of Mahomet Bey Elfi.

He then expressed his wish that his Majesty would speed up the process of restoring the Mamluks to power and asked him to assign a timeline for its execution. He also lamented overloading the British Government with the expenses of his prolonged stay away from Egypt: "*His Majesty's answer with a full determination of what succors we are to expect from him with finally put a period to our expectations as his residence in this country, being prolonged at Government's expense will be extremely disagreeable to the feeling of the Beys.*"[99]

In response, Alfi bey received an appeasing letter from the Britannic Government on the 15th December 1803 concerning his memorial that was presented by Colonel Moore on his behalf. Alfi bey was assured in this letter that the king appreciated all the services which the Beys had rendered to the British army in Egypt and that the king would save no effort to support them: "*his Majesty will immediately employ all his good office and influence at the sublime Porto, by means of his ambassador at the court to accomplish a reconciliation between the Beys and their lawful sovereign,... and to reestablish the interests of the beys in Egypt upon a basis not less advantageous to them than that on which they stood at the period of the French invasion of that country.*"[100]

Although the assurances that the letter included were supposed to placate the beys and contain their anger, they did not in practice contain any well-defined official commitment from the British side towards the Mamluks. They were no more than an attempt to show the British good will towards the beys, however, without any binding or clear-cut pledges.

At the end of the letter, he was informed that a war ship would be placed at his disposal to carry him back to Alexandria or any other Egyptian ports together with his suite.[101]

Meeting the King

Before the departure of Alfi bey from London, he requested from General Stuart to be honored with meeting the king. General Stuart referred to Alfi bey's desire to be admitted into the king's presence in his letter to Lord Hobart on the 9th December 1803. Surprisingly, Stuart himself, who transmitted Alfi bey's wish and who had allowed Alfi bey before to depart with him from Egypt at his own responsibility, thought that his request must be denied on the grounds that he was unacquainted with the principles of etiquette.[102] On the same day Lord Hobart presented Alfi bey's wish to the king who unexpectedly agreed to the coming of Alfi bey under the care of Lt. Col. Desbrowe to Windsor Palace on the following Sunday.[103]

On the fixed date, Alfi bey arrived at Castle Inn at Windsor accompanied with Colonel Moore, Lord Blantyre, his interpreter, and his Mamluk suite. They all proceeded with General Stuart to the Palace and were led to the Armoury where they met the king and the queen. On seeing their majesties, Alfi bey made a bend of low respectful salutation to them. As for the king and the queen, they received him in a very friendly manner and had a long talk with him.

The king and queen highly praised his valor as well as that of the Mamluks that appeared vividly during the French Expedition on Egypt. In response, Alfi expressed his deep homage to the British nation. He also revealed his wish to restore stability and peace in Egypt through the king's help. He also confirmed the Mamluks' loyalty to the Ottoman Sultan whom they regarded as their father and that they all had common interests.[104] It seems that Alfi bey was deeply affected by the King's cordiality and he talked spontaneously in a way that made everyone feel his warm sincerity. [105]

Contrary to Stuart's expectations, Alfi bey behaved during this meeting in a very civilized manner. He proved that he was not the savage Mamluk Stuart had in mind. In other words, Stuart had misjudged Alfi bey and un-

[99] W.O.$_1$.347, Memorial of Mahomet Bey Elfi.

[100] W.O.$_1$.347, To Mahomet Bey Elfi, Downing Street, 15th December 1803.

[101] W.O.$_1$.347, To Mahomet Bey Elfi, Downing Street, 15th December 1803.

[102] W.O.1.347, General Stuart to Lord Hobart, Bruton St., 9th December 1803.

[103] A. Aspinall C.V.O., *The Later Correspondence of George III* (Cambridge, 1968), 4:146.

[104] *Times*, Mahomet Elfi Bey, 20th December 1803, 2.

[105] *Times*, Mahomet Elfi Bey, 20th December 1803, 2.

derestimated his talents. Certainly Alfi bey's meeting the king was truly a face-saver for him as it enabled him to maintain his dignity and self-esteem before his Mamluk fellows after his return.

After meeting the king, Alfi bey went to dinner at Roehampton accompanied with Military officers. He also visited the Royal Highnesses, the Prince of Wales, the Commander- in Chief of the Forces, and several officers of state[106] to bid them farewell before he departed.

In spite of his short stay in London, which lasted for only three months, Alfi bey had influenced English society that followed his news with much curiosity. Suffice to say that many years after Alfi bey's visit to London and after his death, a historical play inspired from his rich biography and carrying his own name[107] was performed in Theatre Royal in 1817.[108] Similarly, Countess De Tott paid tribute to the awe-struck bey who became a London celebrity within a short period and received wide acclaim. She portrayed him together with Colonel Moore and published a pastel after his departure in September 1804[109] at the Royal Academy of Arts.

Unpleasant Surprise

On the 31st of January 1804, Alfi bey arrived at Malta together with Captain Hallowell on board of the Argo ship. At their arrival, Captain Hallowell received Selim Effendi who came from Egypt specifically to meet him. Selim Effendi carried with him a confidential letter from Ibrahim bey and Osman bey Bardissi and he handed it to Captain Hallowell during their meeting. The content of this letter was shocking for Captain Hallowell and had much aroused his astonishment. The beys requested from the British government to prevent the return of Alfi bey to Egypt once again.

As such, Captain Hallowell demanded an explanation from Selim Effendi. He knew that Alfi bey was the chief of the Mamluks in Egypt and their envoy to England so he could not understand that sudden change in the stance of the beys towards him. However, Selim Effendi sharply attacked Alfi bey saying that *"Alfi bey was a troublesome character that he was disliked by all the Mamlukes and that they explained his turbulent disposition to General Stuart and requested he would take him anywhere out of the country or tranquility would never be restored in Egypt … they consented to his going to England, in hopes he might not return, but never vested him with any authority as their ambassador…."*[110]

He also accused Alfi bey of having established secret connections with the French: *"… they say that he has been suspected of attachment to French and when he was at Alexandria, a man by the name of Caffe resided there… and was at that time agent in the French Republic … Elfi Bey had frequent meetings with him… under the pretence of selling him commercial transactions… and with another person came down with him to Malta and through him Elfi bey had secret communications with General Vial, French Minister at that time at Malta … and intended to go to Toulon"*[111]

Clearly, the news of the return of Alfi bey to Egypt after his negotiations in London had increasingly alerted other Mamluk chiefs. They were afraid that Alfi bey's alliance with the British would clear the way for him to rise to primacy at their expense. Therefore they tried to get rid of him to spare their leadership.

Captain Hallowell then required Selim Effendi to meet with Alfi bey under his own protection. It was quite evident that he wanted a confrontation between both of them to find out the truth. However, Selim Effendi tried to conceal the real purpose of his visit from Alfi bey. Yet, Alfi bey proved to be smarter and he rightly suspected him.

On realizing the hidden intentions of Selim Effendi, Alfi bey's Mamluks who were in his company warned Selim Effendi as a representative of Osman bey from fomenting troubles for Alfi bey or clashing with him. Otherwise, the British government would send troops (about 15,000) to Egypt in his support.[112] On hearing Alfi bey's Mamluks threat to Selim Effendi, Captain Hallowell who despised Alfi bey and longed for *"getting rid of him"*[113]

106 *Times*, Mahomet Elfi Bey, 20th December 1803, 2.
107 The play was called "Elphi Bey; or the Arabs' Faith."
108 *Times*, 15thApril 1817, 2.
109 https://www.royalcollection.org.uk/collection/619142/elphi-bey-and-colonel-moore.
110 W.O.₁.347, Captain B. Hallowell to Lord Saint-Vincent, H.M.S. Argo, Malta, 3rd February 1804.
111 W.O.₁.347, Captain B. Hallowell to Lord Saint-Vincent, H.M.S. Argo, Malta, 3rd February 1804.
112 W.O.₁.347, Captain B. Hallowell to Lord Saint-Vincent, H.M.S. Argo, Malta, 3rd February 1804.
113 W.O.₁.347, Captain B. Hallowell to Lord Saint-Vincent, H.M.S. Argo, Malta, 3rd February 1804.

contradicted their talk. He assured Selim Effendi that the British government would not interfere in their quarrels and would keep its friendly relations with all beys.[114]

Clearly, Selim Effendi's talk contained many contradictions and fallacies with respect to Alfi bey. Nevertheless, it confirmed the radical change in the beys' policy towards Alfi bey after his departure to England. Meanwhile, Alfi bey with his far-sight suspected such a change. He knew well that Mamluk tendency to fragmentation and factionalism. He must have also recalled those bloody conflicts that ensued among them every now and then. Therefore, he was very cautious and even considered purchasing a schooner to use it in case of any attack he might be subject to after his return. He also tried hard since this meeting with Selim to get by all means six brass field pieces with harness to defend himself in case he was obliged to retreat to Upper Egypt.[115]

It seems that Selim Effendi's talk had aroused Captain Hallowell suspicions too. Thus, he asked Alfi bey some questions that had latent implications and insisted on getting a firm reply from him. He asked Alfi bey "*if the French were to land while I was in Alexandria, whether he would co-operate with me in the defense of the place.*"[116] With unshakable confidence, Alfi bey replied that he "*would fight against any enemy that might attempt to possess themselves of his country….*"[117] Then Hallowell repeated the same question about his stance if the French attempted to land in Egypt and again he stressed that "*if any enemy was to attempt to land he would devour the flesh from their bones and enforced his expressions by taking hold of his hand between his teeth saying thus I would treat them….*"[118]

Obviously, Alfi bey had by the time of his return to Egypt become politically mature. Therefore, he was keen on all his answers to show his sharp determination to safe-guard Egypt's independence from any colonial power. One can safely say that his replies held an implicit warning to the British government too so as not to think of occupying Egypt one day. He was in need of the British, but he had no intention of selling out or bending his knees to them. This was probably the message he wished to convey to them. In short, his answers were that of a prudent statesman who was well-versed in politics and who rightly assessed his strength.

A Safe Return

At last, the Argo ship arrived safely at Abukir on the 10th of February 1804. It then headed to Rosetta, which it reached on the 14th of February 1804. The news of Alfi bey's return had enraged Osman bey who was bent on eliminating his long-standing archrival at any cost. However, Osman bey's attempt to arrest Alfi bey or to assassinate him failed and he made a narrow escape. Alfi bey took refuge with a Bedouin tribe and soon marched towards the desert.[119] As mentioned before, he nurtured good relations with the Bedouins who always admired his valor and ferocity. No wonder, a tribal woman provided him with a horse as well as provisions and all other supplies[120] needed for his flight in this critical time. Such Mamluk divisions continued and thus kindled their struggle for power until Alfi bey's sudden death in 1807. No doubt, it had impaired all their efforts to recover their former power in Egypt and paved the way for the rise of Muhammad Ali.

Conclusion

When Alfi bey travelled to London in 1803, he was full of aspirations. He much counted on the support of the British government to turn the tide in Egypt to the Mamluks' favor. However, his negotiations with the British side had failed to meet his high expectations. Indeed, he had received a verbal promise from the king himself to try through his ambassador in Istanbul to fix things out with the Porte, yet it lacked specific procedures or timeline.

[114] W.O.₁.347, Captain B. Hallowell to Lord Saint-Vincent, H.M.S. Argo, Malta, 3rd February 1804.

[115] W.O.₁.347, Captain B. Hallowell to Lord Saint-Vincent, H.M.S. Argo, Malta, 3rd February 1804.

[116] Captain Hallowell to Vincent Nelson, 2:126.

[117] Captain Hallowell to Vincent Nelson, 2:126.

[118] Captain Hallowell to Vincent Nelson, 2:126.

[119] W.O.₁.347, E. Missett to Lord Hobart, Cairo, 22nd February 1804.

[120] De Rossetti a Stürmer, Cairo, 24th February 1804, 1:121.

Nevertheless, Alfi bey did not return to Egypt empty-handed as some historians claimed. His experience in British society was truly an eye-opening one which enabled him to envision a new future for Egypt and to reassess many aspects inside the worn-out Mamluk institution. Therefore, he returned to Egypt with a new outlook and an ardent desire to carry out a major transformation inside their institution to cure its evils. The high sense of commitment towards his subjects and the earnest desire to improve their conditions and to work for their own welfare was probably the most important lesson he returned to Egypt with. However, he never had the chance to put it into practice or to enact the reform program he was longing for. The plots that his Mamluk peers hatched against him and the ascension of Muhammad Ali to power spoiled all his plans.

Helwan University

The Barque of *Wenut-Shemau* at the Sed-Festival:
An Old Kingdom Temple Relief from Herakleopolis

JOSEF WEGNER

Abstract

In the collection of the University of Pennsylvania Museum is a limestone relief depicting a king at life-size engaged in a boat ritual as part of the Sed-festival. Discovered in 1904 at Herakleopolis, this object can be dated, based on context, iconography, and style to the early Old Kingdom. Only the upper part of this monumental relief is preserved and the name of the king does not survive. However, the associated labels show that the scene depicted a king, accompanied by Iunmutef, receiving the barque of the goddess Wenut-Shemau, or Nekhbet, at the Sed-festival. This relief, reused in the foundations of the Twelfth Dynasty at Herakleopolis derives from what was evidently a large-format tableau of Sed-festival scenes in a royal cult complex of the Old Kingdom. The relief is a forerunner to scenes in the Twentieth Dynasty tomb of Setau at El Kab depicting the arrival of Wenut-Shemau at the site of the Sed-festival. The ceremonial mooring of the barques of Wadjet and Nekhbet at the Sed-festival may form a central, but hitherto unrecognized, element of the Sed-festival. The closest surviving parallels to the Herakleopolis scene occur in fragmentary reliefs from the Valley Temple of Sneferu at Dahshur. Attribution is proposed to Huni, Sneferu or Khufu. The Sed-festival block may have been transported to Herakelopolis from one of the Memphite pyramid complexes, or from Meidum, during the early Twelfth Dynasty. Alternatively, the relief may derive from an early Old Kingdom royal complex at Herakelopolis itself, possibly originating in a mortuary complex of Huni that once stood at that site.

Introduction

During his 1904 excavations at Ihnasya el-Medina—ancient Herakleopolis Magna—Flinders Petrie discovered a decorated block, attributable to the Old Kingdom, that had been reused in the earliest phase of the temple of Herishef.[1] The raised-relief scene on the limestone block depicts a king engaged in the ceremonies of the Sed-festival. Petrie included a field photograph and brief description of its find-spot in the Egypt Exploration Fund report, *Ehnasya 1904*.[2] In his commentary he stated that the block, originating in some earlier monument, had been used as a foundation stone beneath the Twelfth Dynasty temple of Herishef. Petrie further noted his impression that hieroglyphs on the block bore similarities to inscriptions of the Sixth Dynasty he had observed at Dendera. Therefore, in his estimation the block—which does not preserve a royal name—might depict a Sixth Dynasty king.[3]

As part of the division of finds from the 1904 season the Herakleopolis block was sent to the Egyptian Section of the University of Pennsylvania Museum (fig. 1). Upon its arrival in Philadelphia the relief was relegated

[1] I would like to thank Jennifer Wegner and Kevin Cahail for their help in the analysis of the Sed-festival block from Herakleopolis, Penn Museum E16109. Thanks to Marcel Marée for comments on the false door of Kanefer in the British Museum and the photograph included in this article. I am also indebted to the anonymous reviewer of this article for useful comments and observations.

[2] W. Petrie, *Ehnasya 1904* (London, 1905), 5, 19 and pl. 11:1.

[3] Petrie compared the hieroglyphs on the Herakleopolis block with texts in the tomb of Mena at Dendera stating "It is of fine Old Kingdom work; and the style of the hieroglyphs is most like that on the slab of prince Mena of Dendereh, at the end of the VIth Dynasty," Petrie, *Ehnasya 1904*, 19.

Journal of the American Research Center in Egypt 53 (2017), 139–180
doi: http://dx.doi.org/10.5913/jarce.53.2017.a007

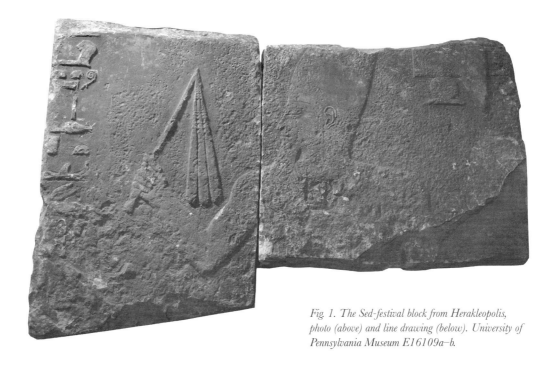

Fig. 1. The Sed-festival block from Herakleopolis,
photo (above) and line drawing (below). University of
Pennsylvania Museum E16109a–b.

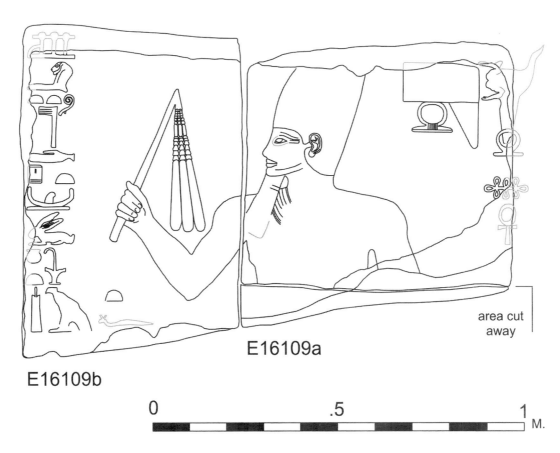

E16109b

E16109a

area cut
away

0 .5 1 M.

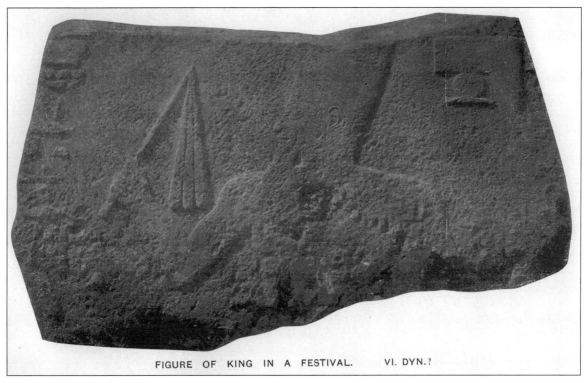

FIGURE OF KING IN A FESTIVAL. VI. DYN.?

Fig. 2. The original field photograph of the Herakleopolis block (after Petrie, Ehnasya 1904, *pl. 11).*

to the storeroom and forgotten to scholarship. This beautifully carved relief in fine-grained white limestone has, at present, never been cleaned or conserved. Consequently, this notable fragment of Old Kingdom royal art has never been displayed. Despite its significance to the archaeology of the Old and Middle Kingdoms, as well as to understanding the early development of Herakleopolis, the presence of this block in the University of Pennsylvania Museum's Egyptian collection has remained unrecognized for more than a century.[4] Moreover, although the field photograph in *Ehnasya 1904* clearly shows a king engaged in one of the rites of the Sed-festival (fig. 2), the block has been overlooked in the principal studies of the Heb-Sed.[5] As we examine in this article, the relief provides significant information relevant to understanding the ritual organization of the Sed-festival during the Old Kingdom.

Despite the limited commentary on the block, based on Petrie's field photograph and without knowledge of its existence in the University of Pennsylvania Museum, two scholars, M. Mouktar[6] and J. Allen,[7] have observed that the Herakleopolis block shows a king engaged in a form of boat ritual. This identification derives from the clearly preserved, upper part of the hieroglyphic label (part of which is readable in the field photograph), which states: *šsp ḥ3tt dpt-nṯr* "*taking the prow-rope of the divine barque.*" Fortunately, however, the text preserves more than is visible in Petrie's original photograph. As published here for the first time, the primary label reads: *šsp ḥ3tt dpt-nṯr Wnwt-Šmᶜw*, "*Grasping the prow-rope of the divine barque of Wenut-Shemau.*" Below this is a second label: *Iwnmwt.f,*

[4] Porter and Moss cited the block's discovery at Herakleopolis along with its supposed Sixth Dynasty attribution: Porter and Moss, *TB IV*, 119. However, Porter and Moss were unaware of the block's current location in the University of Pennsylvania Museum.

[5] See the chronological catalogue of Sed-festival sources: E. Hornung and E. Staehelin, *Neue Studien zum Sedfest*, AH 20 (Basel, 2006), 13–32.

[6] M. El-Din Mokhtar, *Ihnasya el-Medina (Herakleopolis Magna): Its Importance and its Role in Pharaonic History* (Cairo, 1983), 75–76.

[7] J. Allen, "Re'wer's Accident," in A. Lloyd, ed., *Studies in Pharaonic Religion and Society in Honour of J. Gwyn Griffiths*, (London, 1992), 16. Allen mentioned the block through personal communication from E. Brovarski who dated it (based on Petrie's photograph) as "Dynasty 3 (?)." We shall examine the date and royal attribution in further detail below.

"Iunmutef." The stance of the king, with in-turned flail, indicates a striding pose akin to that of the ceremony of "circling of the field." This aspect of the scene, as well as the presence of other symbols associated with the Sed-festival, shows that this particular boat ritual occurs as part of the Sed-festival ceremonies.

As I shall examine in this article, this relief depicts a king, accompanied by the god Iunmutef, grasping the prow-rope of the barque of the goddess Nekhbet in a particular form known as *Wenut-Shemau*. The ritual depicted here is an Old Kingdom precursor to scenes in the tomb of Setau at El-Kab which show the reception of the barque of *Wenut-Shemau*/Nekhbet by Ramses III at the beginning of his Sed-festival. As proposed in the following analysis, the significance of the arrival of *Wenut-Shemau* appears to have transcended the representation of Egypt's local gods at the Sed-festival. The king's reception of the Nekhbet barque appears to have been a central component of the territorial symbolism of the Sed-festival. Nekhbet appears in this ritual context as the premier territorial goddess representing *Shemau*, Upper Egypt. Presumably there was a similar ritual of reception for a matching barque belonging to Wadjet as territorial goddess of the Delta/*Ta-Mehu*. Due to the fragmentary nature of the sources, the vital symbolic moment at which the barques of the two territorial goddesses arrived at the site of the Heb-Sed has remained hitherto unrecognized in studies of the structure and development of the Sed.

Unlike the later scenes in the tomb of Setau, which focus on the tomb owner's official participation in the Sed-festival, the Old Kingdom block derives from a group of Sed-festival scenes of monumental scale. The life-size figure of the king is part of what must have been an extensive program of Sed imagery that can only have originated in a royal cult complex of considerable scale. Considerations on the date of the Sed-festival scene presented here suggest it can be attributed not to the late Old Kingdom as Petrie had speculated, but rather to the late Third or Fourth Dynasty. References to Nekhbet of El-Kab in her form *Wenut-Shemau* appear on Fourth Dynasty funerary monuments and royal cylinder seals at Dahshur and Giza during the reigns of Sneferu, Khufu and Khafre, corroborating the occurrence of this goddess on the Sed block from Herakelopolis.

The find-spot of this Heb-Sed relief at Herakleopolis introduces the question of its original monumental context. Dating, attribution and origin of the reused block are not simple matters. In view of the nature of the scene, the block is unlikely to have been associated with an Old Kingdom god's temple dedicated to Herishef. Nor, due to its large scale does it appear likely to derive from a royal Ka-chapel. In all probability the relief originated in a royal mortuary complex of the Old Kingdom. To what specific period, and to what possible reigns, might we date the carving of this Sed-festival scene? From what site does it originally derive? When and why was it reused in the foundations of the Herishef temple? These are questions we shall consider in the following analysis. Here we shall discuss a late Third Dynasty or Fourth Dynasty date with possible attribution to Huni, Sneferu or Khufu. In considering the origin and reuse of this Sed-festival relief we shall ponder the relative merits and shortcomings of three alternative models: (1) the block derived from one of the Memphite Fourth Dynasty complexes, transported southwards to Herakleopolis as part of the reuse of Memphite masonry concomitant with the construction of the Twelfth Dynasty residence city at *Itj-Tawy*; (2) the block may have been taken from the pyramid complex at Meidum or the associated residence city of *Djed-Sneferu* at closer proximity to Herakleopolis; or (3) Herakleopolis itself may have been the location of a major royal cult complex of the early Pyramid Age: possibly one established there during the reign of Huni. This relief showing the royal reception of the barque of *Wenut-Shemau* could well belong to the historically pivotal, but poorly attested, reign of the final king of the Third Dynasty.

The Relief and Text

At the time of its discovery the Herakleopolis block was a single slab of limestone measuring 88 by 134 cm with a maximum thickness of 16 cm. Presently, the block consists of two adjoining slabs numbered E16109a (right) and E16106b (left).[8] The accession records in the University of Pennsylvania Museum relating to the Egypt

[8] The block is also has a division number AES 1611 (visible in fig. 3:3). This number was assigned for the division of material to the American Exploration Society which supported the Egypt Exploration Fund on behalf of the University Museum, for the history of which see D. O'Connor and D. Silverman, "The University Museum in Egypt," *Expedition* 21:2 (1970), 4–8; and D. Winegrad, *Through Time and Across Continents: A Hundred Years of Archaeology and Anthropology at the University Museum* (Philadelphia, 1993), 20–21.

Exploration Fund division indicate it arrived in Philadelphia in two pieces. Therefore, the large relief had been cut in half while still in Egypt. Modern saw marks show where the block was cut vertically through the middle.[9] The lower edge on both sides was also trimmed. This modern alteration only minimally affected the block's left half. However, a portion of the block's lower right side that appears in Petrie's site photograph is now missing and must have been removed and discarded in Egypt (compare figs. 1–2).[10] This cutting and squaring of the substantial relief appears to have been intended to make it more easily transportable.

This block is one that evidently went through a phase of substantial damage in ancient times, and prior to its deposition in the foundations of the Herishef temple at Herakleopolis. The surface is abraded and pitted on its lower half, a fact that obscures the fine quality of the relief carving. In contrast, the upper half the scene—including the king's face, flail, and the upper section of the scene label—are comparatively well preserved. None of the damage appears intentional. The surface abrasion is consistent with a block that was eroded by natural factors compounded by being moved, dragged and subjected to accidental damage prior to its reuse in the foundations of the Twelfth Dynasty Herishef temple. The block remains discolored over most of its surface and, as noted above, has never been cleaned or conserved. However, areas that are chipped (see fig. 3:6) reveal the stone to possess the fine grain and brilliant white coloration characteristic of the limestone deriving from the Tura-Ma'asara quarries.[11]

The fragment preserves the upper part of the king's body, evidently in a striding pose. He faces towards the left with his flagellum (*nḫ3ḫ3*) turned inwards above his right arm. He wears the White Crown, a false beard, and a beaded collar. In front of the king is a vertical row of hieroglyphs (fig. 4), well preserved at the upper end but badly effaced on the lower end. Here, as elsewhere on the relief, the hieroglyphic labels lack borders. The vertical label reads: *šsp ḫ3tt dpt-nṯr Wnwt-Šmʿw*, "*Grasping the prow-rope of the divine barque of Wenut-Shemau.*" The surviving text begins at the base of the *šsp*-sign. Therefore, the extant text elements may have continued a longer statement initiated above. The signs composing the name of the goddess, *Wnwt-Šmʿw*, are eroded below the *wn*-rabbit hieroglyph. The *nw*-jar in particular is badly effaced with no clearly preserved edges although the circular shape and location of the sign are discernible. The *t* and *Šmʿw* (sedge-plant) are also damaged but remain readable and the name of the goddess associated with the divine barque is as follows: 🔣.

As explained in detail below, *Wenut-Shemau* is a particular form of the goddess Nekhbet of El Kab emphasizing her symbolic role as territorial goddess of the south. The Herakleopolis relief depicts the king receiving the barque of Nekhbet, as tutelary goddess of Upper Egypt, at the site of his Sed-festival.[12] It is significant that the king wears the White Crown in this ritual context. Here he may be shown specifically in his guise as king of Upper Egypt welcoming Nekhbet as divine representative of the south. This geographical specificity implies there may have originally existed a balancing scene where the king, wearing the Red Crown, welcomed the barque of Wadjet, Nekhbet's northern counterpart, to the Sed.

Although the block preserves only the upper part of the king's body, the position of the missing lower part of his body is indicated by the inward-turned flail. This reverse position for the flail indicates forward motion and shows the figure was depicted in a striding stance. This particular pose is most familiar from scenes in which the king runs the territorial circuit or the "encircling of the field."[13] At first glance the Herakleopolis block might

[9] The block was cut across its vertical dimension from the back to a point within 2–3 centimeters of the decorated face. The block was then snapped in half leaving an unsawn edge that can be rejoined without major impact to the decorated face. Petrie's workers appear to have purposefully used this technique of cutting the block to allow the two sides to be rejoined.

[10] Petrie's published field photograph (see fig. 2) was cropped in the publication and cuts off areas of the block's edges including the upper right where the Selket scorpion is preserved.

[11] On a visual basis I would provisionally attribute the block to the limestone quarries of Tura which produced the majority of fine limestone for the Old Kingdom Memphite pyramid complexes. See R. Klemm and D. Klemm, *Steine und Steinbrüche im Alten Ägypten* (Berlin, 1993), 65–71. The grain of the Herakleopolis block compares closely with the sample in pl. 2.1.

[12] It may be noted that the principal god of Herakleopolis, Herishef, possessed his own divine barque which was named *ʿ3-šfyt*, "Great-in-Dignity," see: D. Jones, *A Glossary of Ancient Egyptian Nautical Titles and Terms* (London, 1988), 241, n. 9; and Montet, *Géographie*, 188–89. The present block does not relate directly to the cult of Herishef, nor to the sacred barque of that deity. Rather, it commemorates ritual actions of the Sed-festival.

[13] Throughout this article I will refer to this ritual (*pḥr sp 4 sḫt*) as the "encircling of the field." The running stance of the king occurs in other royal rites as well including the "encircling of the wall" (*pḥr ḥ3 inb*) associated with coronation of the king, and the running of the

Fig. 3. Edges of the Herakleopolis block showing the original edges (1–3) and modern cuts through the center and along the base (4–6).

appear to represent a scene with the king completing the "encircling of the field" itself. Significantly, however, on E16109 there is no evidence of the king's left arm crossing upwards over his chest as normally occurs in depiction of the "encircling of the field." The content of the main label clarifies this aspect of the scene. The king's left arm was not bent upwards over his chest, but rather extended downwards behind his body where he grasped the prow rope of the barque of *Wenut-Shemau*.[14] The barque itself would have been depicted behind the king as he moored it at the site of the Sed-festival. As I shall propose below, there may have been an intentional use of the image of the striding king—thereby echoing the "encircling of the field"—but here expressed for specific symbolic reasons in the context of receiving the barque of Nekhbet. In view of the large-format of the composition

Apis (*pḥrr Ḥp*) which occurs in association with the Sed. H. Kees, *Der Opfertanz des ägyptischen Königs* (Munich, 1912) is the classic study of the ritualized run of the king in different contexts.

[14] The area of the left arm where it angles away from the king's torso is not preserved. However, the field photograph published in *Ehnasya 1904* shows that slightly more of the arm was present prior to the trimming of the block's lower edge. In that photograph we do see indications of the outward-angle to the arm (see fig. 2).

this may be a scene in which the barque itself was rendered at large scale,[15] and with considerable detail.[16]

Immediately below the vertical label is another section of text, now running horizontally and extending further towards the right than the vertical label. Still reading from left to right, is the name of the god *Iwnmwt.f.* This text element is evidently associated with a now-missing figure of Iunmutef, a deity who frequently appears in the Sed-festival rites.[17] Based on its position, the shift from vertical to horizontal text, and lack of grammatical association with the rest of the label, the Iunmutef element cannot form a continuation of the vertical label directly above it. Rather, it is likely part of a label surmounting an image of Iunmutef who precedes the king. Due to the orientation of the hieroglyphs, a figure of Iunmutef positioned below the lower edge of the preserved block would have faced the same direction as the king. Iunmutef would have been depicted here at a smaller scale than the primary royal figure, a convention familiar from the mode in which the god normally appears in attested Sed reliefs.[18]

To the right of the king is a set of symbols that provide further confirmation of the ritual context of this scene as part of the Sed-festival. Behind his crown is a well-preserved half sky (*pt*) emblem atop a *shen* sign. This element—the *tpht*—is a standard component of scenes depicting royal actions in the Sed-festival.[19] The position of the surviving *tpht* emblem shows that there would have been a second identical emblem directly above, filling the space extending up to the top of the White Crown. To the right of the surviving *tpht* emblem is a vertical column of signs, badly battered, but with several discernible elements. Adjacent to the *tpht* emblem is the front part of the human-armed Selket scorpion atop a *shen*. Below Selket is a clearly preserved *s3*-sign written with the looped hobble hieroglyph.[20] As I have noted above, the lower right corner of the block was trimmed away below this point. However, Petrie's field photograph taken prior to the alteration of the block shows an additional sign below the *s3*. This hieroglyph has a distinctive looped top—likely the *ankh*—suggesting the right column comprises a version of the formulaic combination of elements labeling the king's bodily protection by Selket during the Sed-festival.

The surviving elements of the scene show this was a relief that adhered closely to the use of a grid system. Superimposition of an 18-square grid (with the grid interval defined by the 2-unit convention between shoulder

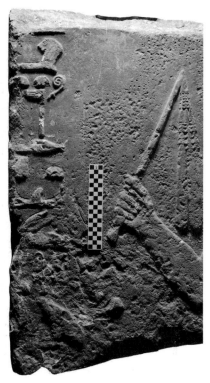

Fig. 4. Detail of the text label.

[15] The scale of the image of the Nekhbet barque would be governed by the architectural context of the scene. The closest surviving parallels come from the Valley Temple of Sneferu at Dahshur. One depiction of the king receiving a divine barque occurs on a decorated pillar face and is adapted to that limited area by reduction of the scale of the barque relative to the scale of the king: A. Fakhry, *The Monuments of Sneferu at Dahshur. Volume II: The Valley Temple* (Cairo, 1961), figs. 79–83. Another barque mooring scene may have existed on the wall of the "Hall of Nomes" but there the boat appears likely to have been shown at larger relative scale, see discussion below.

[16] As depicted in later New Kingdom, Late Period, and Ptolemaic scenes, the barque of Nekhbet of El-Kab took a particular form with a prow decorated with dual animal heads: a forward-facing bovine and a rear-facing oryx (see the discussion and depictions of the barque from the tomb of Setau at El-Kab below). Whether the barque had this same form in the Old Kingdom is uncertain.

[17] This lower corner of the block is badly damaged but the *iwn* and *mwt* hieroglyphs are relatively clear, as is the *t* sign displaced to the right below the base of the king's figure. The *f*-viper sign is not preserved but the general profile of the surface reflects a long horizontal sign in this area. The *f* hieroglyph is shown as reconstruction in lighter gray in the illustration here.

[18] For this juxtaposition of king at large scale with Iunmutef at smaller scale, see for example: U. Rummel, *Iunmutef. Konzeption und Wirkungsbereich eines altägyptischen Gottes* (Berlin, 2010), pls. 1, 3, 4, 7, and elsewhere.

[19] For discussion of the half sky symbols see J. Spencer, "Two Enigmatic Signs and their Relation to the Sed-festival," *JEA* 64 (1978), 52–55; and N. Millet, "A Further Note on an Egyptian Sign," *GM* 173 (1999), 11–12. The *tpht* symbols have been variously interpreted as bird's wings, door-leafs or hinges, or perhaps both concepts symbolizing the 'doors of heaven'. See the comments of A. Ćwiek, "Relief Decoration in the Royal Funerary Complexes of the Old Kingdom," PhD diss., Warsaw University, 2003, 228.

[20] Gardiner sign list V16.

Fig. 5. The Sed-festival scene with superimposed 18-unit grid based on the height from shoulder to hair-line and extrapolation of the White Crown, and lower body.

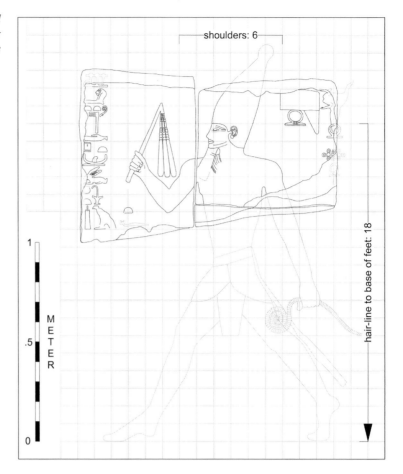

and hair-line) over the royal figure indicates that most elements of the composition fall on or close to grid lines (fig. 5).[21] In particular, we may note the near-perfect span of 6 squares for the width of the king's shoulders. Superimposition of a grid allows us to reconstruct the scale of the rest of the figure based on the 18-square convention from base of feet to the hair-line. Extrapolation of the White Crown to a height of 4.5 squares (following Early Dynastic and Old Kingdom comparanda),[22] and 18 squares from hairline to base of the feet shows the original figure to have stood approximately 2 m in height to the top of the White Crown. Interestingly, many of the other elements on the relief fall close to grid lines or half-grid intervals. We may note, for instance, the centerline of the vertical texts on either side of the king, and the position of the *tpḥt* emblem appear to have adhered the same grid system as that used for the royal figure. Clearly, the Herakleopolis relief derives from a much larger wall composition which was composed and carved with close adherance to a single overall grid system.

The block preserves no traces of the king's titulary. Minimally, one indispensible element of royal identification—the Horus-name in *serekh* – was likely was positioned above the king's figure. However, a wall scene as large as this could have employed a fuller version of the royal titulary.[23] In all likelihood the king's name would have surmounted the scene in combination with other standard elements such as winged Horus falcon, or a Nekhbet

[21] G. Robins, *Proportion and Style in Ancient Egyptian Art* (London, 1994), 73–76, and with proportions of running figures, 228–233 and 236–44 (Djoser).

[22] See discussion of I. Incordino, *Chronological Problems of the IIIrd Egyptian Dynasty: A Reexamination of the Archaeological Documents*, BAR International Series 1882 (Oxford, 2008), 42–67.

[23] The elements of the titulary employed would also be dependent on conventions of the period at which it was carved. For comments on royal titulary in Old Kingdom temple inscriptions: E. Windus-Staginsky, *Der ägyptische König im Alten Reich: Terminologie uns Phraseologie* (Wiesbaden, 2006), 71. Regarding the date and possible attribution see the discussion below.

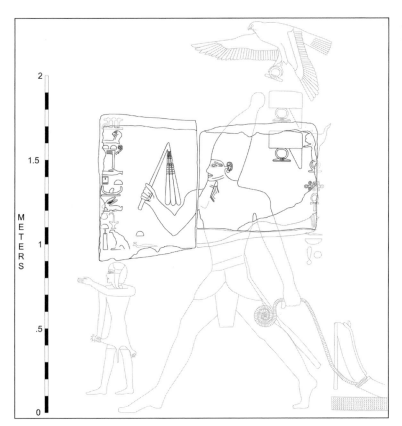

Fig. 6. *Suggested reconstruction of the primary elements in the Sed-festival boat scene.*

vulture (the second possibility being particularly relevant to the arrival of the Nekhbet barque depicted here). With probable addition of the king's *serekh*, and other elements such as a Horus falcon or Nekhbet vulture, this was a scene of substantial height on the order of ca. 2.5+ m. A suggested reconstruction of the scene based on the attested elements is shown in figure 6.

The Barque of the Goddess Wenut-Shemau

The label on the left side of the Herakleopolis block reads: *šsp ḥȝtt dpt-nṯr Wnwt-Šmꜥw*, "*Grasping the prow-rope of the divine barque of Wenut-Shemau*." Here we have an identification of the specific ritual, as well as the goddess associated with this particular divine barque.[24] *Wnwt-Šmꜥw* in this context is a sobriquet for the Upper Egyptian goddess Nekhbet of El Kab. Nekhbet is one of a number of goddesses to have a designation incorporating the *Wnwt* element. *Wnwt* itself is a term of obscure meaning but may relate, in part, with goddesses linked to the passage of hours and symbolized in the celestial realm by specific constellations and asterisms.[25] In a number of texts *wnwt* occurs in association with the uraeus and *wnwt* is most frequently determined by the cobra determinative. The occurrence of Wenut with a cobra/uraeus determinative indicates a direct association with Wadjet,[26] as indeed is demonstrated by passages in the Coffin Texts and pLeiden I 348.[27] By extension, this association with

[24] The barque of Nekhbet is known by the time of the New Kingdom to have possessed its own name: *mr / mr(.t) nbw*, "the one who loves gold," Montet, *Géographie*, 44. The label on the Herakleopolis block does not provide the actual barque name but rather expresses its association with Nekhbet in her form as *Wenut-Shemau*. Emphasized here is the territorial identity of the goddess and her barque as a symbol of the south as a whole.

[25] C. Leitz, ed., *Lexikon der ägyptischen Götter und Götterbezeichnungen*, vol. II, OLA (Leuven, 2002), 390–92.

[26] Examples cited in *Wb.* I, 317–18.

[27] *CT* VI 225 mentions the *wnwt* (with cobra determinative) who "laughs at/with Wadjet." Papyrus Leiden I 348, Spell 30 addresses: "*O Spr.tw.n.s, wife of Horus, Nekhbet, Nubian (woman), Easterner, Wenut, Lady of Hermopolis, come may you do what you can achieve,*" J. Borghouts, *The*

Fig 7. Scene in the tomb of Setau at El Kab showing the towing of the barque of Wenut-Shemau (Nekhbet) to the Sed festival of Rameses III (after Kruchten and Delvaux, La tombe de Sétaou, *347).*

the king's uraeus expresses a connection with both of the *nbty*, the Two-Ladies, or Crown goddesses who sit on the king's brow.[28] *Wnwt* therefore referred to both Wadjet and Nekhbet who could together be called the *W3dty*, or "two-uraei." *Wnwt* appears periodically in the compound form *Wnwt-Šmˁw*, "*Wenut of Upper Egypt*," where the literal meaning "uraeus-goddess of the south" makes clear its reference to Nekhbet. There appears to be no attestation of an explicit northern geographical counterpart (i.e., *Wnwt-(T3)-Mḥw*, "*Wenut of Lower Egypt*"), likely because the notion of the uraeus was more explicitly linked with Wadjet than it was with Nekhbet and did not require the geographical specification that occurs when it refers to Nekhbet.

Sed-festival scenes in the Twentieth Dynasty tomb of Setau at El Kab form a notable parallel to the Old Kingdom block and help to independently corroborate that *Wnwt-Šmˁw* in this case is Nekhbet (fig. 7). Despite the significantly later date, decoration in the tomb of Setau records the occurrence of a central ceremonial event of the Sed festival: the journey of the sacred barque of Nekhbet to the royal residence.[29] A scene showing the transport of the Nekhbet barque to the Sed festival of Rameses III at Per-Ramses occurs on the north wall of Setau's tomb chapel.[30] The Nekhbet barque itself is depicted as a vessel with a double animal-headed prow consisting of a forward-facing bovine and a rearward-facing oryx.[31] The barque is towed northward by another vessel and is received by Ramses III who grasps the prow rope of the barque upon its arrival at the royal residence. The royal figure is unfortunately destroyed but his position is indicated by the Horus falcon at the upper left end of the scene. Due to the rightward orientation of the falcon it appears the king was shown facing towards the barque of Nekhbet, rather than away as is the case on the Old Kingdom block from Herakleopolis.

Magical Texts of Papyrus Leiden I 348 (Leiden, 1971). A possible early appearance of Wadjet with the uraeus determinative in association with a boat occurs on a fragmentary stela dated to the Second Dynasty from Gebelein in the Museo Egizio, Turin (Turin Supplement no. 12341), E. Scamuzzi, *Egyptian Art in the Egyptian Museum in Turin* (Turin, 1963), pl. VIII.

[28] See the discussion of A. Gardiner, "The Goddess Nekhbet at the Jubilee Festival of Rameses III," *ZÄS* 48 (1910), 49–50.

[29] Gardiner, "The Goddess Nekhbet," 47–51.

[30] J.-M. Kruchten and L. Delvaux, *La tombe de Sétaou*, El Kab VIII (Brepols, 2010), 113–19 (commentary), pls. 26–27 (line drawings), and 73 (photo).

[31] Gardiner identified the two animal heads that adorn the prow of the barque of Nekhbet as antelopes: Gardiner, "The Goddess Nekhbet," 48. The two animals are different. The forward-facing one has curved horns that look distinctively bovine whereas the rearward-facing animal has long, tapering horns suggesting it is an oryx.

The lower register shows the return of the Nekhbet barque after conclusion of the Heb-Sed. The accompanying scene label reads:[32]

Rnpt-sp 30 ḫr ḥm n nswt-bity nb tȝwy (Wsr-mȝ°t-R°-mry-Ỉmn) sȝ R° nb ḫ°w (R° ms-s-ḥkȝ-Ỉwnw)| di °nḫ sp tpy ḥb-sd wḏ.n ḥm.f dit m-ḥr n imy-r niwt Ṯȝty Ṯ r iṯ ȝ dpt-nṯr n Nḫbt r pȝ ḥb-sd r irt nt-°. s m ḥwwt ḥb-sd spr r Pr (R°-ms-sw-mry-Ỉmn)| pȝ kȝ °ȝ] n pȝ R°-ḥr-ȝḫty m rnpt-sp 30 ///... šsp ḥȝt(t) dpt-nṯr in nswt ḏs.f.

Year 30 under the majesty of the king of Upper and Lower Egypt, lord of the Two-Lands, (Usermaatre-MeryAmun) son of Re, lord of appearances, (Rameses (III), ruler of Heliopolis) given life, the first occasion of the Sed-festival. His majesty commanded the governor of the residence city, the vizier Tao, to bring the divine barque of Nekhbet to the Sed-festival and to carry out her sacred rites in the chapels of the Sed-festival. Arrival at Per-Rameses-the great Ka of Ra-Horakhty in Year 30 ///... Grasping the prow rope of the divine barque by the king himself.

The depiction of the barque of Nekhbet in this context is significant. Atop the shrine on the barque perches an image of Nekhbet in her vulture form accompanied by the label *Wnwt-Šm°w*, (fig. 8). As the high priest of Nekhbet, Setau was a key official responsible for the transport of the Nekhbet barque to the Heb-Sed. He is likely one of the figures shown standing on the deck of the barque, probably the man immediately in front of the goddess' shrine. Matching the identification of Nekhbet as *Wnwt-Šm°w*, Setau employs the title *ḥm-nṯr tpy Wnwt-Šm°w*, "high priest of *Wenut-Shemau*."[33]

Although it is possible to interpret the barque journey of Nekhbet as simply one of the many deities and associated local priesthoods that would be represented at the Sed-festival, there are reasons for suggesting that the arrival of Nekhbet in her form as *Wenut-Shemau* was of particular significance to the formal structure of the Sed-rites. The journey of *Wenut-Shemau* to the Sed festival appears to be one element in the overt geographical symbolism that characterizes the wider panoply of the jubilee. It is probable that the role of Nekhbet as tutelary goddess of Upper Egypt – familiar in in royal iconography and titulary such as the *nbty*/Two-Ladies name—was matched with a journey of the divine barque of Wadjet forming the requisite Lower Egyptian symbolic complement. The moment of arrival of the two barques and the king's ceremonial mooring of the goddesses' vessels would appear to be key events that set the ritual sequence of the Sed in motion, as we shall investigate below.

Fig. 8. Detail of the towing of the barque of Nekhbet to the Sed-festival of Rameses III with the designation of the goddess, Wenut-Shemau, in front of her shrine.

The Sed-festival block from Herakleopolis is therefore an Old Kingdom precursor to the scenes of *Wenut-Shemau* in the chapel of Setau.[34] However, unlike the scene in Setau's chapel where the event is commemorated at small scale commensurate with the modest dimensions of a private tomb chapel (the entire scene covers 2.4 m

[32] *KRI* V, 430, lines 5–15.

[33] Kruchten and Delvaux, *La tombe de Sétaou*, 185–87.

[34] A suggestion has been made that the barque of Nekhbet was depicted already during the Early Dynastic Period on ivory labels dating to the reign of Aha from the mastaba of Neithhotep at Nagada. Depictions of a barque surmounted by a bird emblem occur on two slightly different labels from the Neithhotep tomb: see A. Serrano, *Royal festivals in the Late Predynastic Period and the First Dynasty* (Oxford, 2002), 94–96 and Fig. 55. Vikentiev suggested the possibility that the bird emblem is that of Nekhbet and the boat, which has an animal prow on one of the two labels, might be that of Nekhbet; a precursor to the imagery of Nekhbet's barque as shown in the chapel of Setau at El-Kab: V. Vikentiev, "Les monuments archaiques III. -A propos du soi-disant nom de Ménès dans la tablette de Nagâda," *ASAE* 48 (1948), 665–85. This identification appears unlikely. There is a superficial resemblance of the animal headed prow on the Nagada tag to the dual bovine/oryx headed barque of Nekhbet as depicted in the Setau scene. It does not appear that the same divine barque is depicted on the Neithhotep

in width), the block recovered at Herakleopolis is part of a monumental relief program depicting events of the Sed-festival. Extrapolating outwards from the ca. 2.5 m tall scene we see indications for a cycle of Sed-festival reliefs that must have been of tremendous scale. Assuming other key ritual actions of the Heb-Sed were depicted at equivalent size, the Herakleopolis relief must originate in a building complex characterized by a substantial degree of monumentality. Where did this reused block originate: from a building at Herakleopolis itself, or was it taken to that site from elsewhere? We will investigate the possible dating and question of the block's origins after a further discussion of the deities involved and the role of the barque ritual of *Wenut-Shemau* in the Sed-festival.

Wenut-Shemau in the Memphite Necropolis During the Fourth Dynasty

Although the majority of references to *Wenut-Shemau* derive from later periods, Nekhbet in this particular form already occurs during the early Old Kingdom in association with royal cults in the Memphite necropolis. *Wenut-Shemau* is attested specifically during the Fourth Dynasty, in two dated contexts. The first example occurs on the false door of the son of Sneferu, Kanefer (British Museum EA1324) from his mastaba at Dahshur (fig. 9).

Kanefer has a series of administrative titles that include his primary role as overseer of the king's pyramid *Kha-Sneferu*,[35] In addition, Kanefer holds a group of priestly titles including *ḥm-nṯr Wnwt-Šmʿw*, "god's servant priest of *Wenut-Shemau*."[36] Notably, the text on the false door of Kanefer employs the same spelling for *Wnwt-Šmʿw* as we see on the Herakleopolis block: the *wn* rabbit followed by the *nw* jar, *t*, and sedge hieroglyph atop a flat base (𓃹 𓏌 𓏏 𓇬). Perhaps not coincidentally, Kanefer has additional priestly titles that link him with the cult of Nekhbet of El-Kab. He bears the designation *ḥrp wʿbw Nḥb*, "director of the Wab-priests of Nekheb." Moreover, he had a role in the administration of divine barques (although the specific divinities associated with the barques are not specified); he is designated in two instances as *ḥtmty-nṯr wiꜣ*, "god's sealer of the divine barque."

Judging from his numerous titles as well as other biographical evidence, Kanefer appears to have had a long career bridging several Fourth Dynasty reigns. The final completion of Kanefer's mastaba can be dated subsequent to the reign of his father, Sneferu. Consequently, the primary construction may have occurred during the reign of Kanefer's brother, Khufu, with the stone elements completed during the reigns of Djedefre or Khafre.[37]

The goddess *Wenut-Shemau* occurs again in the Fourth Dynasty, attested during the reign of Khafre on clay seal impressions from Giza. Two impressions of a royal-name cylinder seal recovered during Karl Kromer's 1971–1975 excavations in the South Field name *Wenut-Shemau*.[38] The seal incorporates the Horus name, Woserib, and prenomen of Khafre along with the statement *mry Wnwt-Šmʿw*, "*beloved of Wenut-Shemau*."[39] Beneath the *serekh* on one of the fragments is an image of the king embraced on either side by Horus and Seth (fig. 10, left). The seal also names a particular ritual structure, the *wʿbt-nswt* or "royal purification house."[40] This particular seal expresses

labels. Serrano, *Royal Festivals*, 95–96, has recently provided a more convincing interpretation of the imagery associated with production and dedication of a royal statue.

[35] Kanefer is stated to be overseer of the pyramid *Kha-Sneferu* but without specification as to whether this is the northern or southern pyramid at Dahshur. The term *Kha-Sneferu*, however, may refer to both of the Dahshur pyramids as a single mortuary complex: S. Quirke, *The Cult of Ra* (London, 2001), 116–17. See also the recent discussion of M. Nuzzolo, "The Bent Pyramid of Sneferu at Dahshur: A Project Failure or an Intentional Architectural Framework?" *SAK* 44 (2015), 259–82.

[36] P. Scott-Moncrieff and W. Budge, *Hieroglyphic Texts from Egyptian Stelae in the British Museum*, Part I (London, 1911), 6 and pl. 4 (line drawing); and British Museum, *Wall Decorations of Egyptian Tombs* (London, 1914), 4 and fig. 1 (photograph).

[37] The mastaba of Kanefer (numbered DAM 15 in recent work of the German Archaeological Institute) was originally excavated by De Morgan and produced the false door dedicated to Kanefer by his son Kawab, as well as an offering table (British Museum, EA1345) and decorated niche (Louvre E11286). For the recent investigation of the Kanefer mastaba see discussion of N. Alexanian, R. Schiestl, and S. Seidlmayer, "The Necropolis of Dahshur: Excavation Report Spring 2006," *ASAE* 83 (2009), 25–41. These authors date the false door of Kanefer to the reign of Khafre through iconography and its dedication by Kanefer's son, Kawab.

[38] K. Kromer, *Siedlungsfunde aus dem frühen Alten Reich in Giseh: Österreichische Ausgrabungen 1971–1975* (Vienna, 1978). The material excavated by Kromer contributed to the identification of the Giza settlement under ongoing investigation by Ancient Egypt Research Associates under direction of Mark Lehner, and the associated workers' cemetery excavated by Zahi Hawass.

[39] P. Kaplony, *Die Rollsiegel des Alten Reiches* (Brussels, 1981), 78 and pl. 26 (nos. 57–58). Kaplony translates the term inaccurately as *wnwt rsy*, for which see also note in Leitz, *LGG II*, 392.

[40] Use of this term, which is associated with the royal funerary workshop, could relate the seal specifically to the royal mortuary rites of Khafre.

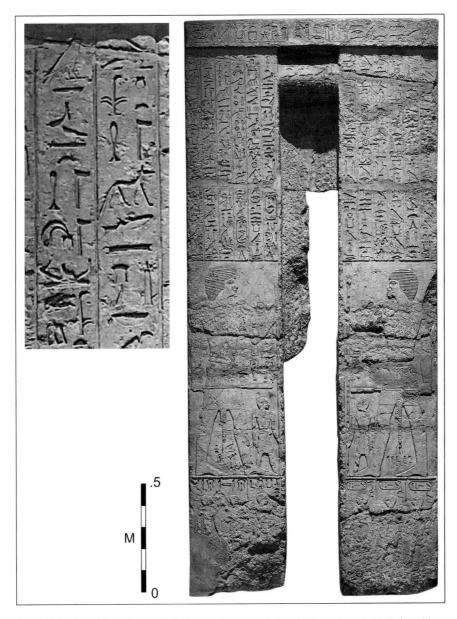

.5

M

0

Fig. 9. False door of Kanefer (EA1324, photograph courtesy of British Museum), with detail of the title ḥm-nṯr Wnwt-Šmꜥw.

a thematic focus on the affirmation of kingship, perhaps indicative of a royal-name cylinder seal commemorative of a ceremony such as the coronation or Sed-festival. Other seal impressions employing explicit imagery associated with the Sed-festival occur in the same strata of Kromer's exposure in the South Field.[41] There may be a relationship in this case between the commemoration of *Wenut-Shemau* and royal ceremonies of Khafre including the Sed-festival.[42]

The spelling of the name of *Wenut-Shemau* on the Giza seal impressions is identical to that on the Kanefer false door and the Sed-festival block from Herakleopolis. These Fourth Dynasty examples of *Wenut-Shemau* are significant from two respects. Firstly, they highlight the role of the goddess in connection with royal cults and commemoration during the earlier Old Kingdom in the Memphite necropolis.[43] Secondly, the orthography of the writing of the goddess' name is identical to that on the Herakleopolis relief, suggesting they may all date to the same timeframe. Unlike later writings, which typically employ additional determinatives or variant paleography (for instance, the writing

[41] For example, Kaplony, *Rollsiegel*, vol. 3, pl. 27: 65 with the king shown in the "encircling of the field."

[42] For recent discussion of the Giza seals: J. Nolan, "Mud Sealings and Fourth Dynasty Administration at Giza," PhD diss., University of Chicago, 2010.

[43] Seals articulating the royal connections with Nekhbet and Wadjet form a major sub category in the Old Kingdom royal seal corpus: Kaplony, *Rollsiegel* vol. 2, 254–65.

in the tomb of Setau discussed previously), the orthography of *Wnwt-Šmꜥw* on the Herakleopolis block is consistent with these Fourth Dynasty dated examples.

These parallels in the Fourth Dynasty suggest that the Herakleopolis block may derive from the same time period. Given the long-term continuity in the role of *Wenut-Shemau* into the late New Kingdom we may be certain that the goddess remained a key element of royal ritual and the Sed-festival during the later Old Kingdom. The orthography of the name may not have changed during the Fifth and Sixth Dynasties.[44] Therefore, in view of the lack of preserved evidence for the goddess' name from the later Old Kingdom, a Fifth or Sixth Dynasty date for the Herakleopolis relief should not be excluded based solely on the Fourth Dynasty attestations. However, I would suggest that stylistic features of the relief are also suggestive of an early Old Kingdom date, a topic we shall examine further below.

The Role of Iunmutef

While the label on the Herakleopolis block identifies the scene's thematic focus on the arrival of the barque of *Wnwt-Šmꜥw*, there is a second deity involved: Iunmutef. As suggested above, the damaged, but readable, lower section of the left side of the block demonstrates that Iunmutef preceded the striding royal figure. The presence of Iunmutef in a ceremony relating to the Sed-festival is not surprising in view of the fact that this god—the divine Sem-priest—is frequently an integral figure in the wider corpus of Sed-scenes.[45] Significantly, the present relief block—following the early Old Kingdom dating suggested in this article—may now become one of the two earliest known ritual scenes to incorporate Iunmutef.[46]

Iunmutef is best known as a ritual provider for the king through the god's role as an incarnation of Horus acting on behalf of his father Osiris in ceremonial contexts. The earliest clearly dated occurrence of Iunmutef in a royal ritual scene occurs in the Ka-chapel of Pepi I at Bubastis.[47] During the Twelfth Dynasty we find Iunmutef involved in the Sed-festival: for instance on a block of Amenemhat III also from Bubastis, showing Iunmutef

Fig. 10. Wenut-Shemau on clay seal impressions of Khafre (after Kaplony, Die Rollsiegel des Alten Reiches, pl. 26), and reconstruction of the seal (author).

[44] Texts mentioning *Wenut-Shemau* are not preserved among the fragmentary Sed-festival scenes of Sahure, Neferirkare, Pepi II, nor the larger corpus of scenes from the Sun Temple of Niuserre. The goddess may have been named in the boat mooring scenes of Niuserre, as discussed further below, but the text labels for those scenes are not preserved.

[45] Rummel, *Iunmutef*, 157–66.

[46] A figure that has not been previously recognized to be Iunmutef occurs on the Second Dynasty royal stela from Gebelein mentioned above (Turin Supplement no. 12341): Scamuzzi, *Egyptian Art*, pl. VIII. A male figure with the sidelock and panther skin garment held in the pose typical of Iunmutef stands behind a king who is engaged in some ritual action. The figure is labeled with a vulture and sign that may be read as *iwn*; probably to be read as *Iwn-mwt[.f]* with the vulture in graphic transposition. If the late Second Dynasty date for stela Turin Suppl. 12341 is correct, this would be the earliest known depiction of Iunmutef.

[47] L. Habachi, *Tell Basta*, Supp. ASAE 22 (Cairo, 1957), 14–17 and fig. 2. The Ka-chapel of Pepi I at Bubastis is discussed further below.

standing before balanced images of the seated king in Red and White Crowns in the Sed-pavilion.[48] In line with his role as divine provisioner, Iunmutef confers the king with the requisite physical materials for the Sed rites including ritual oil, incense, and *idmi*-linen used to fashion the Sed-robe.[49] More than being the divine patron of material used in the Heb-Sed, however, Ute Rummel has observed that the role of Iunmutef "corresponds to the semantic categories of 'opening ways', 'transition' and 'regeneration'."[50] These aspects of Iunmutef are expressed in passages in the Pyramid Texts, Coffin Texts, and Book of the Dead. An early emergence of the concept of Iunmutef as a deity who opens the path for the king's rebirth and reaffirmation is reflected in Pyramid Texts Spell 587 where he is said to precede the king in the opening of the cardinal directions.[51]

On the Herakleopolis relief we see that Iunmutef, depicted at smaller scale, would have walked in front of the king as he strode forward grasping the prow-rope of the barque of *Wenut-Shemau*. I would suggest that the god is present here not in his more common role providing physical materials for eternal kingship, but in the mode in which he appears in PT587: leading or guiding the king as part of the Sed rituals. We have already discussed the fact that the divine barque depicted here is a specific vessel with geographical connotations expressed by Nekhbet's emblematic status as territorial goddess of Upper Egypt. The appearance of Iunmutef appears fully appropriate to the geographical symbolism inherent in the reception of the divine barque of *Wenut-Shemau*, as well as the function that Iunmutef plays as divine conductor at various stages in the Sed-festival rituals. I would suggest that the role of Iunmutef in this context may be paralleled in other fragmentary scenes depicting the reception of divine barques at the Sed-festival as we now discuss.

Receiving the Barque in Old Kingdom Sed-Festival Scenes

The Herakleopolis block is, at present, unique among surviving Old Kingdom Sed-festival imagery in its depiction of the king grasping the prow-rope of the barque of *Wenut-Shemau*/Nekhbet. However, the instrumental role of divine barques in the ritual mechanics of the Heb-Sed is hinted at in other fragmentary representational and textual sources of the Early Dynastic Period and Old Kingdom. The earliest surviving object showing the king ceremonially grasping the prow rope of a divine barque is a fragment of a decorated wooden box discovered beneath the Step Pyramid.[52] The identity of the barque shown on this fragment is uncertain but it may represent the Henu-barque of Sokar.[53] Despite the similarity in ritual action, the association in this case is not specifically with the Sed-festival. The reception of divine barques linked to the Heb-Sed occurs in the Valley Temple of the Bent Pyramid of Sneferu at Dahshur, and among the scenes from the Heb-Sed chapel of the sun temple of Niuserre at Abu Ghurab. The existence of these parallels raises the possibility that many of the scenes from other contexts could also relate to the ceremonial arrival of the barques of *Wenut-Shemau*/Nekhbet and her northern counterpart Wadjet as the emblematic territorial goddesses of the Two-Lands. Let us turn firstly to examine the later evidence for the ritual of receiving the barque before considering the close parallels to the Herakleopolis scene that occur in the Sneferu fragments from Dahshur.

Depictions of the king engaged in a barque ceremony occur in scenes among the reliefs of Niuserre from Abu Ghurab.[54] The fragmentary Niuserre scenes show the king wearing his Sed-robe, in a procession fronted by priests with the divine barque stationed behind the king (fig. 11:1). The composition here differs from the Herakelopolis

[48] Deriving from the Middle Kingdom palace at Bubastis for which recently: M. Bietak and E. Lange, "Tell Basta: the Palace of the Middle Kingdom," *Egyptian Archaeology* 44 (2014), 4–7.

[49] U. Rummel, "Weihrauch, Salböl und Leinen. Balsamierungsmaterialien als Medium der Erneuerung im Sedfest," *SAK* 34 (2006), 381–407.

[50] U. Rummel, "Generating 'Millions of Years': Iunmutef and the Ritual Aspect of Divine Kingship," *Memnonia –Cahiers Supplémntaire 2* (2010), 194.

[51] Rummel, *Iunmutef*, 50–53.

[52] C. Firth and J. Quibell, *Excavations at Saqqara: The Step Pyramid II* (Cairo, 1935), pl. 109.

[53] G. Gaballa and K. Kitchen, "The Festival of Sokar," *Orientalia* 38 (1969), 19, note 1; F. Friedman, "The Underground Relief Panels of King Djoser," *JARCE* 32 (1995), 25, n. 133.

[54] For discussion of the architectural context and overall structure the Niuserre reliefs: F. von Bissing, *Untersuchungen zu den Reliefs aus dem Re-Heiligtum des Rathures* (Munich, 1922); W. Kaiser, "Die Kleine Hebseddarstellung im Sonnenheiligtum des Neuserre," *Beiträge Bf* 12 (Wiesbaden, 1971), 87–105.

scene in that the king is standing motionless with his flail and a long staff in a forward position. Although the Niuserre blocks do not preserve the king's upper body, based on his stance it does not appear that he is shown physically grasping the prow rope of the barque. Nevertheless, the scene may depict the moment immediately following the reception of the barque at the site of the Heb-Sed. Three smaller fragments (fig. 11:2–4) show attendants assisting in the movement or mooring of the barque by pulling the prow rope. On the larger fragment the Sem-priest stands immediately before the royal figure, a position that equates with the likely location of Iunmutef on the Herakleopolis relief. Given that Iunmutef functions as the divine Sem-priest, the substitution of a human Sem-priest in the same relative position in the Niuserre scenes conspicuously echoes the imagery on the Herakleopolis block.

Significantly, this juxtaposition of the king and Sem-priest—symbolically acting in place of Iunmutef—at the ritual of taking the prow rope of a divine barque also occurs in the well-known Fifth Dynasty biographical stela of Rawer at Giza (fig. 12).[55] The terminology used (*šsp ḥ3tt dpt-nṯr*) is identical to that on the Herakleopolis block and refers to the ritual reception of a divine barque by Neferirkare:

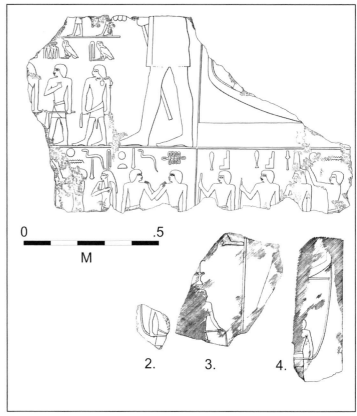

Fig. 11. The king and Sem-priest with divine barque (1); and attendants with mooring rope of a divine barque (2–4), from the Sed-chapel of Niuserre, Abu Ghurab (after von Bissing and Kees, Das Re-Heiligtum des Königs Ne-Woser-Re, *vol. 3, pls. 9–10).*

(*Ny-swt-bity Nfr-ir-k3-rꜥ*) | *ḥꜥ m bity hrw n šsp ḥ3t(t) dpt-nṯr sk sm Rꜥ-wr tp rdwy ḥm.f m sꜥḥ.f n sm iry ḫr-ꜥ*

"(*King of Upper and Lower Egypt Neferirkare*) | *appeared as King of Lower Egypt on the day of taking the prow-rope of the divine-barque, while the Sem-priest Rawer was at his majesty's feet, in his office of Sem-priest and keeper of accoutrements...*"

The remainder of the stela recounts how Rawer accidentally touched, or tripped over, the staff of the king during the barque ceremony, and emphasizes the king's kind words even in the midst of such a solemn ceremony.[56] As J. Allen has suggested, the event recorded by Rawer is not necessarily the Sed-festival since there is no independent historical confirmation that Neferirkare completed a Heb-Sed.[57] Nevertheless, the context of the event,

[55] Hassan, *Giza 1*, 18–19. For the Rawer stela see particularly: Allen, "Re'wer's Accident," 14–20.

[56] Some scholars have viewed the event as a reflection of the divinity of the royal person during the Old Kingdom: H. Frankfort, *Kingship and the Gods* (Chicago, 1948), 360; and J. Wilson in H. Frankfort, *The Intellectual Adventure of Ancient Man* (Chicago, 1946), 75.

[57] Allen suggests the ceremony may have occurred as part of Sahure's funerary ceremony or Neferirkare's coronation: Allen, "Ra'wer's Accident," 17. One other possibility may be the ceremony of *ḫꜥt ny-swt-bity* for which see T. Wilkinson, *Early Dynastic Egypt* (London and New York, 1999), 212.

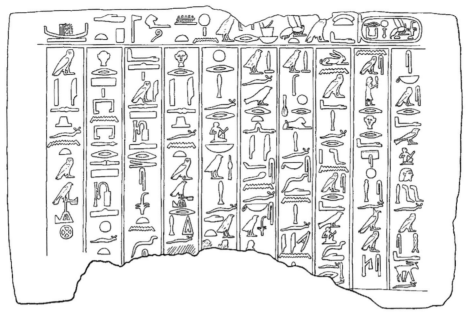

Fig. 12. The stela of Rawer from Giza (after Hassan, Excavations at Giza: 1929–1930, *18).*

and juxtaposition of Sem-priest and king, corresponds with that depicted graphically in the Niuserre reliefs, as well as in the Herakleopolis relief where Iunmutef himself occurs in his role as divine Sem-priest.

I would add here an observation regarding what may be a crucial element in the description of the barque ceremony on the Rawer stela. Although no deity is specifically named in connection to the barque, the stela's first sentence—emphasized graphically as a horizontal line heading the inscription in vertical columns,—employs explicit geographical symbolism that may imply the identity of the divine barque in question. Neferirkare is stated to be King of Upper and Lower Egypt but then is stated to *ḫꜥ m bity*," *rise as the King of Lower Egypt,*" in this ceremonial context. The link with the north is explicitly expressed in use of the Red-Crown atop *neb*-basket as determinative for *bity*. Here the geographical symbolism that we see expressed also in the reception of the barque of *Wenut-Shemau* is apparent. Is this an oblique reference to the northern counterpart of Nekhbet: the ceremonial grasping the prow rope of the barque of Wadjet? If so, the arrival of the barque of the northern goddess would be an initial event triggering a sequence of rituals affirming the king's rulership over the Delta.[58]

Apart from the scenes in the tomb of Setau which we have already examined, later sources indicate the ritual significance of the taking the prow rope of divine barques in the context of the Sed-festival. The action of grasping of the prow rope of a divine barque occurs in association with the Sed-festival of Amenhotep III as recorded in the tomb of Kheruef. These scenes, however, do not correspond with the royal reception of the Nekhbet barque at the Sed as commemorated on both the Herakleopolis block and in the tomb of Setau. Although they employ the same terminology (*šsp ḥꜣtt dpt-nṯr*) Kheruef's texts instead record the role of the king in pulling the day and night barques of the sun god.[59] The accompanying imagery lacks the striding image of the king so emblematic of the Sed-festival.[60] Scenes of the Sed-festival of Amenhotep III in the temple at Soleb are missing the

[58] Further discussion of the Rawer text is included in: M. Chioffi and G. Rigamonti, "Antico Regno' Sua Maestà fece che si onorasse Abutiu" (Imola, 2017), 89–113.

[59] The king's association with the day barque (*mꜥndt*) and night barque (*msktt*) of Ra is attested during the Old Kingdom although not explicitly in the context of the Heb-Sed. The Palermo Stone records the king's role in maintaining the solar barques, for example in the Fifth Dynasty reign of Neferirkare: T. Wilkinson, *Royal Annals of Egypt: The Palermo Stone and its Associated Fragments* (London and New York, 2000), 179–80.

[60] The Epigraphic Survey, *The Tomb of Kheruef* (Chicago, 1980), pl. 24. The text states that the king "*grasps the prow rope of the night barque*

beginning sections where images of the royal reception of divine barques might have appeared.[61] The ritual of pulling the barques of the sun-god is an ancient rite that may have occurred as part of the Heb-Sed and other royal ceremonies,[62] but is clearly to be distinguished from the royal reception and mooring of the barque of *Wenut-Shemau*/Nekhbet discussed here.

An intriguing New Kingdom parallel to the image of the striding king pulling a divine barque does occur in lost scenes recorded by Champollion in the now-destroyed temple of Rameses II at El-Kab (Elethya).[63] Two different scenes depict the king dragging a divine barque: in one instance delivering the vessel to a figure of Sobek, and in the other to Nekhbet. In these examples we find the king in a striding stance like the Herakleopolis relief. The term *šsp* again labels the king's action in grasping the barque's prow-rope. Despite their overall similarity these later El-Kab scenes display some differences from the Herakleopolis scene. Firstly, in both scenes the king does not hold the flail, but rather the *ḥpt* implement used in riverine navigation.[64] Given the presence of the *hepet* these particular scenes may instead show the king's symbolic involvement in divine barque processions. For that reason, it is unclear whether these examples are related to the Sed-festival. However, the striding stance of the king could be intended to express a connection between the barques of these deities and the territorial symbolism of the Heb-Sed. The wider context of these El-Kab scenes has not survived.

It is worth observing that scenes showing the reception of the divine barques—whether the solar barques or those belonging to the tutelary goddesses of north and south—do not appear among the most extensive surviving set of Sed-festival scenes: those on the festival gateway of Osorkon II at Bubastis. It is conceivable such scenes may have existed in missing sections of the decoration. However, as Eva Lange has discussed, the Osorkon Sed-festival reliefs represent an 'independent creation'—a nuanced selection from a wider pool of Sed imagery applicable to kingship during the Libyan Period. Certain ritual actions may not have been chosen for this particular monument.[65] We may note here that the Osorkon gateway also lacks preserved depiction of the "encircling of the field" (*pḥr sp 4 sḫt*), a rite which forms an ancient and potent visual statement on the territorial aspects of rulership and legitimacy. What is notable in the content of the Osorkon reliefs is the continued emphasis on geographical symmetry and the instrumental functions of Wadjet and Nekhbet in the rites of reaffirming kingship. In view of their enduring role in the ceremonies of the Sed one suspects that the symbolic arrival of the two goddesses may have been more commonly depicted than has survived in the highly fragmentary record.

Fragments from the Valley Temple of the Bent Pyramid of Sneferu

While the sources just reviewed provide indications for the role of boat rituals in the Sed-festival, there is one particular structure which has the most direct bearing on the iconography, and probable date, of the Herakleopolis relief. The closest surviving parallels to the barque scene on the Herakleopolis block occur on a set of fragments from the Valley Temple, or "Heb-Sed temple,"[66] of Sneferu's Bent Pyramid at Dahshur.[67] These relief fragments, recovered by Ahmed Fakhry in 1951–1955, are only minor components of large-format scenes. One

and the prow rope of the day barque, rowing the gods of the Sed-festival."

 [61] M. Schiff Giorgini, C. Robichon and J. Leclant, *Soleb V: Le Temple, Bas-Reliefs et Inscriptions* (Cairo, 1998).

 [62] Amenhotep III states that he restructured the Sed-festival based on consultation of ancient records. A ritual involving models of the solar barques occurred in the reign of Neferirkare, although not part of the Sed itself: Wilkinson, *Royal Annals of Egypt*, 179–80.

 [63] Champollion, *Mon.* 12, pl. 140, nos. 1–2; and *PM* V, 174.

 [64] The *ḥpt* symbol is associated with barque processions and may be an implement used in riverine navigation (Gardiner, *EG*, sign Aa 5).

 [65] See the overview of these reliefs in: E. Lange, "The Sed-Festival Reliefs of Osorkon II at Bubastis: New Investigations," in G. Broekman, R. Demarée and O. Kaper, *The Libyan Period in Egypt* (Leuven, 2009), 203–18; and summary in E. Uphill, "The Egyptian Sed-Festival Rites," *JNES* 24:4 (1965), 365–83.

 [66] The so-called Valley Temple of Sneferu is not a true valley temple in that it is not positioned at the edge of the floodplain and appears to constitute an intermediary cult building on the causeway approach to the pyramid. Due to the primary emphasis on the Sed-festival in the building's decorative program, Stadelmann has called the structure a "Heb-Sed temple": R. Stadelmann, "The Heb-Sed Temple of Senefru at Dahshur," in M. Bárta, F. Coppens, and J. Krejčí, eds., *Abusir and Saqqara in the Year 2010*, Vol. 2 (Prague, 2011), 736–46. Here I will use the term Valley Temple for ease of reference, as this term continues still to be broadly used in the published literature.

 [67] Regarding the possible architectural association of the two Dahshur pyramid complexes with the Sed-festival of Sneferu see the discussion of Nuzzolo, "The Bent Pyramid of Sneferu at Dahshur," 259–82.

group of fragments derives from the inner, deco-
rated pillars of the temple. Another fragment
belongs to a wall scene in the "Hall of Nomes,"
the primary entrance chamber that leads to the
temple's central courtyard. Given their fragmen-
tary state it is hazardous to try to draw definitive
conclusions from them. Nevertheless, they pro-
vide some significant insights when considered in
association with the *Wenut-Shemau* barque scene
on the Herakleopolis block. Here the fragments
are discussed in detail along with some tenta-
tive observations about their relationship to the
building's decorative program focused on the
Sed-festival.

Three fragments deriving from the temple's
decorated pillars depict boats and ropework as-
sociated with the ritual mooring of divine vessels
(fig. 13:1–3).[68] Most significant in connection to
the Herakleopolis block is a fragment showing
the king in a striding pose with his arm extended
downwards behind his waist and grasping the
prow rope of a boat (fig. 13:1). The king's calf
and heel are preserved showing a stance similar
to that of the "encircling of the field" during
the Sed-festival: the same position of the figure
in the Herakleopolis scene.[69] Notably the scale
of the king's figure in this scene is life-size and
therefore on a par with the degree of monumen-
tality implied by the Herakleopolis relief. A rope
extending from the king's hand attaches to the
prow of a barque shown at small scale relative
to the size of the king and raised above his back
leg. Significantly, a second line of rope extends
from the king's hand above the surviving barque.
It appears possible the king is shown in this single
scene grasping the prow ropes of two different barques.

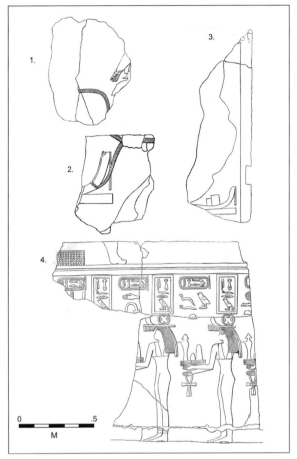

Fig. 13. *Fragments depicting the royal reception of divine barques
from the Valley Temple of the Bent Pyramid of Sneferu at Dahshur
(after Fakhry,* Monuments of Sneferu at Dahshur, *figs. 25 and
81–83). Fragments 1–3 belong to one of the pillars; fragment 4 comes
from the east wall of the entrance passage.*

A second fragment (fig. 13:2) with an additional section of cordage and part of the Horus falcon (possibly
the king's Horus name), may derive from the upper element of the mooring line extending to a second barque.
The relatively small scale of the surviving barque and its raised position above the king's rear leg appears to be a
graphic adaptation to the narrow space provided by the pillar face which would not permit a boat to be shown at
larger scale.[70] A third fragment (fig. 13:3) preserves a smaller barque in front of the royal figure and adjacent to
the right edge of a pillar. According to Fakhry's reconstruction this fragment joins another fragment showing the
king's arm grasping an inward-facing flail and therefore matches the running stance of the king on the fragment

[68] Fakhry, *Monuments of Sneferu at Dahshur: The Valley Temple Vol. II, Part I,* 91–93 and figs. 79–83.

[69] As already discussed above, the Herakleopolis block preserves only the king's torso but the position of the flail turned inward from his
forward arm indicates he is in motion. The leg and arm position preserved in the Dahshur block appear to fit with the probable stance of
the lower body of the king on the Herakleopolis block.

[70] The temple's ten rectangular pillars were ca. 5 m in height with wider face of ca. 1.85 m to 2.1 m, and a narrow width of 1.2 to 1.4 m.
The resulting twenty scenes would have been adapted to these differing widths: Fakhry, *Monuments of Sneferu at Dahshur,* 59–60.

Fig. 14. A tentative reconstruction of the Sed-festival scenes in the Valley Temple of Sneferu at Dahshur showing the ritual grasping of the prow rope of divine barques (possibly of Nekhbet and Wadjet).

showing the barque behind the king's leg.[71] The smaller barque in front of the king appears to be a hieroglyphic determinative functioning as part of the scene label,[72] i.e., similar to the text fronting the royal figure on the Herakleopolis scene where the barque determinative occurs as part of the statement *šsp ḥꜣtt dpt-nṯr*, "*grasping the prow-rope of the divine barque….*"

From the temple's entrance hall, the "Hall of Nomes," comes a fragment showing the lower part of a large-scale wall scene that may also show the king grasping the prow rope of a divine barque. This chamber was decorated on the lower part of the wall with personified estates, depicted as female offering bearers and grouped sequentially according to the nomes in which they were located. The nomes of Upper Egypt occur on the west wall and the nomes of Lower Egypt on the east wall (see schematic: fig. 14). The sequential ordering of the estates in the entrance chamber continued after a break with additional estates flanking the pillared inner end of the main courtyard. The estates on both sides face inward towards the building's inner end where there were six niches containing engaged statues of Sneferu. The rows of offering bearers constitute a decorated dado that was surmounted with large scale scenes. The east wall of the entrance chamber was poorly preserved but a substantial relief fragment that must derive from this wall shows a group of Lower Egyptian estates, above which occurs the foot of the king in striding stance directly in front of a rectangular water feature (fig. 13:4). The orientation of this scene faces outward against the direction of the estates. Unfortunately, only the lower part of the scene is preserved and identification remains provisional. No boat is preserved, however, the combination of striding stance and water feature suggest the king was shown here again grasping the prow rope of a barque. The boat would appear to have been depicted at larger scale than occurs on the pillar fragments with the base of the boat now level with the king's foot. The rectangular water feature may be the equivalent of the base of the moored barque shown in the Sed-festival scenes of Niusurre but here with the king in striding stance pulling the prow rope. The wall scene would have shown the king at life-size with the barque now at a larger scale that was not permitted on the pillar faces.

The Sneferu Valley Temple therefore preserves evidence for scenes of similar composition to the Herakleopolis Sed-festival relief in two locations: among the group of decorated pillars depicting key rituals of the Sed, as well in the main entrance chamber. It appears likely that these scenes are specifically linked with the temple's programmatic focus on the Sed-festival and here we see the role of the royal reception of the divine barques integrated into a chronological progression of the Heb-Sed that also echoes the geographical symbolism of the jubilee. Despite the highly fragmentary nature of the evidence I would like to present some tentative suggestions

[71] Fakhry, *Monuments of Sneferu at Dahshur*, 92, fig. 80.

[72] This identification as a text label was noted also by Ćwiek, "Relief Decoration in the Royal Funerary Complexes of the Old Kingdom," 243.

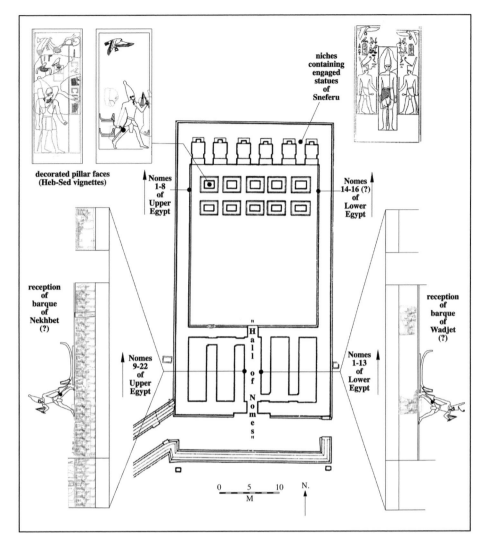

Fig. 15. The Valley Temple of the Bent Pyramid at Dahshur showing the possible location and characteristics of divine barque scenes in the building's Heb-Sed program.

(fig. 15). Reception of divine barques was shown on at least one of the decorated pillars among scenes of the key Heb-Sed rites. Given that the surviving fragments can all be accommodated on one pillar face and it appears there may have been depiction of the mooring of two barques, could we see a single scene which showed, in abbreviated form, the royal reception of the barques of Nekhbet and Wadjet representing Upper and Lower Egypt? This was tied programmatically to the ordering of Sed-related vignettes on the pillar faces and linked to statue niches behind.

Above the procession of estates, and forming part of the main wall scenes of the "Hall of Nomes," we then have a fuller rendition of the symbolic reception of the divine barques. Following the geographical organization of the temple—with Lower Egypt on the east and Upper Egypt on the west—the possible boat scene on the east may have shown the king wearing the Red Crown and grasping the prow rope of the barque of Wadjet. The king faces outwards as the nomes move inwards to the temple's courtyard as if arriving at the location of the Sed. No evidence survives for a matching scene on the west side of the chamber but the central section of the west wall preserves none of the primary scenes above the rows of estates. Here too, there might have been a

boat scene showing the king welcoming the barque of Nekhbet as the Upper Egyptian estates move inwards to the temple courtyard. Spatially, such a location for the barque scenes could reflect the integral role hypothesized here: the arrival of Nekhbet in her form of *Wenut-Shemau*, and Wadjet as her northern counterpart at the site of the Heb-Sed symbolized the representation of the Two-Lands at the ceremony of reaffirmation of kingship. As with the Herakleopolis barque scene, use of the image of the striding king visually situates the ritual within the Sed-festival, and may doubly refer to the particular stance of the king as he physically encompasses the Two-Lands as part of the "encircling of the field" performed in the context of the Sed around the territorial markers (*tpḥt*) confirming his dominion over Upper and Lower Egypt.

The present article is not the context for a fuller discussion of the structure and development of the Sed-festival. However, the evidence just reviewed shows the important role of the ritualized reception of sacred barques in the Sed-festival rites. More specifically, the Herakleopolis block and its Old Kingdom parallels suggest the possibility that a crucial—but previously unrecognized—component of the Sed-festival rites was the formalized reception of the barques of Nekhbet and Wadjet. This may have been depicted in the Niuserre Heb-Sed chapel as well as integrated in a more specific geographical mode in the decoration of the Sneferu Valley Temple. This element of the Sed-festival, now datable to the early Old Kingdom, was still in existence as late as the Twentieth Dynasty where we see it commemorated in the chapel of Setau, high priest of *Wenut-Shemau*, at El-Kab.

While the king may logically have welcomed the barque of every deity in attendance at the Heb-Sed, it was the arrival Nekhbet and Wadjet as the emblematic goddesses of south and north that was most fundamental to the confirmation of the king's claim to dominion over the Two Lands. Behind its complex panoply the Heb-Sed was profoundly focused on the reaffirmation of the king's legitimacy as King of Upper and Lower Egypt.[73] Aside from their geographical symbolism these two goddesses function as the "Crown Goddesses" and were responsible for both the initial coronation of the king, as well as the reconferral of the Red and White Crowns in the context of the Heb-Sed.[74] This dual geographical symbolism permeated the Sed rites and is indicated by the focal emblem of the Heb-Sed: the double dais depicting the enthronement of the king wearing the Red and White Crowns of north and south: the *wṯst Ḥr ḥḏt dšrt mryt*, the *"Horus throne of the Crowns of Upper and Lower Egypt."*[75] The geographical symbolism extends physically to other structures used in the Sed such as shrines of north (*pr-nw*) and south (*pr-wr*). The ritualized affirmation of rulership was also expressed by the ancient rite of encircling of the field by the king while wearing the crowns of north and south.

Here I would propose that the ceremonial arrival of the sacred barques of Nekhbet in her form as *Wenut-Shemau* along with her northern counterpart Wadjet, can now be recognized to be an ancient component of the Sed-festival that goes back to the Fourth Dynasty, and likely earlier.[76] The arrival of these goddesses may have been absolutely vital to the formal initiation of the Sed-festival ceremonies. Indeed, the royal reception of the barques of the *nbty*-goddesses would constitute an official acknowledgement of the participation of the Two Lands without whose presence the events of the Heb-Sed would be invalid.

 In its mode of depiction in Old Kingdom Sed-festival reliefs we find the same striding posture for the king's reception of the goddesses' barques as occurs while performing the "encircling of the field." While he cannot hold the *mks* to his chest, due to his hand now grasping the prow rope, he holds the *nḥȝḥȝ*-flagellum in the same attitude as the ritual circuit of encompassing the Two Lands. Use of this posture was likely intentional as the goddesses themselves are emblematic of the Two Lands and the king's action of mooring the barques becomes, in essence, a statement on his dominion over Upper and Lower Egypt. Just as he affirms his territorial claim to rulership in the running of the territorial race, so too his physical act of grasping the prow rope of the barques

[73] For an overview of the rites and the sources: Hornung and Staehelin, *Neue Studien zum Sedfest*, 91–95; also comments of W. Barta, *Untersuchungen zur Göttlichkeit des Regierenden Königs: Ritus und Sakralkonigtum in Altägypten nach Zeugnissen der Frühzeit und des Alten Reiches* (Munich, 1975), 62–74.

[74] Lange, "The Sed-Festival Reliefs of Osorkon II at Bubastis," 214–15; Uphill, "The Egyptian Sed-Festival Rites," 370–71.

[75] H. Kees, "Die weiße Kapelle Sesostris I in Karnak und das Sedfest," *MDAIK* 15 (1958), 194–213, with discussion of the chronological changes and variation in terminology.

[76] The appearance of the *nbty* or Two-Ladies name at the beginning of the First Dynasty indicates an early date for the integration of Wadjet and Nekhbet into royal identity, and the ceremonial activities that established and affirmed royal legitimacy. See T. Wilkinson, *Early Dynastic Egypt*, 203–6; R. Leprohon, *The Great Name: Ancient Egyptian Royal Titulary* (Atlanta, 2013), 13–15. See also discussion of the evidence for the Sed-festival in the Early Dynastic Period: A. Serrano, *Royal festivals in the Late Predynastic Period and the First Dynasty* (Oxford, 2002), 42–78.

of Nekhbet and Wadjet at the site of the Heb-Sed forms a potent statement of territorial control and affirmation of his authority.[77]

Dating the Herakleopolis Wenut-Shemau Barque Scene

As we have seen, the life-size scene of the king towing the barque of *Wenut-Shemau* during the Sed-festival provides crucial evidence on the ritual structure of the Sed-festival. The relief indicates the role that the barques of the territorial goddesses played in the Sed-festival ceremonies, a practice that survived from the Old Kingdom through at least the Twentieth Dynasty as commemorated in the tomb chapel of Setau. However, who is the king on the relief and what is the block's relationship with the history of Herakleopolis? Before specifically discussing the dating of the relief, let us step back briefly and consider whether this block might not derive from a phase of time after the Old Kingdom. Could the relief date rather to the Herakleopolitan Period or Middle Kingdom?

The possibility of a post-Old Kingdom date can be reasonably excluded based on style and composition of the relief as well as its archaeological context. Although masterfully carved at large scale, this relief has a distinctively archaic feel to it. The lack of text borders is a notable feature of the composition, as is the close junction between the vertical and horizontal labels. The style and compositional features of the scene not only argues against a Middle Kingdom date but suggests a relatively early date within the Old Kingdom, perhaps as early as the transition between the Third and Fourth Dynasties. Here we may note again the closest surviving parallels for the scene type occur in the Valley Temple of Sneferu at Dahshur, and the presence of *Wenut-Shemau* in royal cults of the Fourth Dynasty at Dahshur and Giza. Archaeological context also suggests an Old Kingdom, or earlier, date for the object. We shall examine the context in more detail below, but the discovery of the block as a reused foundation stone beneath Middle Kingdom architecture at the lowest levels of the Herishef temple necessitates a pre-Middle Kingdom date. The substantial degree of surface damage that had evidently effected the monument in question prior to the point of the block's reuse implies it originated in a building of substantially greater antiquity than the Middle Kingdom. On this basis the block can be dated with a high degree of probability to the Old Kingdom and most likely relatively early in the Old Kingdom. Can we go beyond this general Old Kingdom attribution of the scene? To what dynasty, and to what possible king, or kings, might we attribute this monument? With no royal name, or other directly associated relief fragments, it is not presently possible to attribute this block with absolute certainty. However, it is feasible to consider attribution by identifying a "best possible fit" for the block based on style and other criteria.

Two prior suggestions have been made for the date of the relief. As we have noted above, Petrie originally speculated the block might date to the Sixth Dynasty based on the appearance of the hieroglyphs. No more specific detail, however, was provided and this observation remains essentially impressionistic. More recently, James Allen, citing Ed Brovarski, and based on the photograph published in *Ehnasya 1904*, suggested the block might date rather to the Third Dynasty.[78] This transitional Early Dynastic-Old Kingdom date for the relief is a reasonable suggestion, but Allen cited no specific observations underlying this tentative Third Dynasty date. One reason for suggesting a Third Dynasty date may be the similarity in general appearance of the striding figure holding a backward-oriented flail with the carved panels in the South Tomb of the Step Pyramid of Netjirikhet/Djoser. Added to this, the impression of the block, as imparted in Petrie's field photograph, is reminiscent of the group of Third Dynasty royal lapidary scenes from Wadi Maghara in the Sinai: in particular the well-known smiting scene of Sanakht (British Museum: EA691). However, it must be stressed that the sense of relatively rough carving style provided in Petrie's photograph is misleading. This impression is accentuated by the relatively damaged condition of the lower half of the block and the areas of pitting on the surface. Rather, the carving

[77] The act of grasping the prow rope of the territorial barque of *Wenut-Shemau*, and that of her northern counterpart, would in this case form a parallel concept to that of encircling the Two-Lands: for the magical symbolism of encircling (*pḥr*), see R. Ritner, *The Mechanics of Ancient Egyptian Magical Practice* (Chicago, 1993), 57–63.

[78] Allen, "Re'wer's Accident," 16, citing personal communication from Brovarski who dated it (based on Petrie's photograph in *Ehnasya 1904*) as "Dynasty 3 (?)."

Fig. 16. Detail of the king's face on the Herakleopolis Sed-festival relief.

style of the raised relief is quite fine with a strong, smooth edge to the raised elements, well-rendered internal details on the hieroglyphs, as well as subtle modeling on the face and details of the royal figure.

Stylistic dating of this relief is a challenging proposition given the damage to the block. However, the proportions and relief style of the better-preserved upper part of the figure provide some relevant observations. This is a large-scale figure, masterfully carved in low, raised relief. The hieroglyphs range between 3–5 mm and the royal figure 3–6 mm in height. The edges of the relief have strong, crisp lines with, in most areas, a low vertical edge of ca. 2 mm giving way to a gently rounded curve to the interior of the raised elements. Insofar as preserved, the internal parts of the body (face and forearm) show subtle modeling of flesh and musculature (fig. 16). Considerable attention is invested in the anatomy of the ear which is rendered with a high degree of realism. The king's right arm is bent in a close-to perfect 90° angle; forearm and upper arm each angled at 45° with respect to the main figure. The length of the king's forearm (elbow to end of hand) is equal to three times the width of the figure's hand. The same proportion applies to the upper arm with three hand-widths from elbow to shoulder. The proportions of the upper body preserved on the Herakleopolis block are closely comparable to the few Old Kingdom parallels, such as the images of the striding king in the Sed-festival scenes of Niuserre.

Useful comparison may perhaps be made with preserved examples of Old Kingdom Sed festival scenes. When contrasted with the Niuserre Sed festival reliefs, just mentioned, it becomes clear that the scene on the Herakleopolis block derives from a royal decorative program of not just significantly larger scale, but one characterized by a qualitatively higher carving quality. The Niuserre scenes employ an extremely shallow relief in which the edges of the figural elements lack the rounded profile and strong, smooth lines seen on the Herakleopolis relief.[79] To a significant extent this may reflect architectural context where, in the case of the Niuserre Heb-Sed chapel, complex scenes were adapted to fit wall areas of quite modest scale.

Let us turn back at this point to recall one other issue mentioned earlier in this article. Namely, the appearance of the goddess *Wenut-Shemau* in inscriptional evidence from the Fourth Dynasty pyramid cemeteries at Dahshur and Giza. As noted, the same orthography for the writing of the goddesses' name occurs. Moreover, the specific

[79] See for example photograph and stylistic discussion in Arnold, *Egyptian Art in the Age of the Pyramids*, 258–59.

context in which *Wenut-Shemau* occurs—in the priestly titles of Khufu's brother, prince Kanefer, and cylinder seals with titulary of Khafre—appears to reflect a role for the goddess in royal rituals during the Fourth Dynasty. This evidence along with the stylistic observations made above further underlines the possibility of an early Old Kingdom date for the block.

Corroborating the textual evidence just mentioned, the overall visual impression imparted by the carving, as well as aspects of the block's treatment suggest a date in the late Third Dynasty or Fourth Dynasty. Published photographs of the raised relief from the Valley Temple of Sneferu compare more closely with the Herakleopolis Sed-festival scene than those of Niuserre. Relief carving in the Sneferu Valley Temple displays two styles: a higher relief with pronounced degree of internal sculpting, and a flatter style with more cursory treatment of the surface of the figures.[80] These two styles may represent concurrent styles or chronologically distinct phases in the completion of the Valley Temple. One of the distinctive attributes of Sneferu's relief is the retention of a strongly marked vertical edge to the carved figures.[81] This carving style displays continuity from Third Dynasty relief carving but appears to have vanished subsequent to Sneferu's reign. Raised relief dated to the reign of Khufu is characterized by use of a consistently lower relief with rounded edges and well-executed, but more subtle, internal modeling than occurs in the higher relief of Sneferu.[82]

The 3–6 mm high bas-relief of the Herakleopolis scene appears to correspond well with the flatter, second style of the Sneferu reliefs, but displays a finer carving quality than the lower relief style of Sneferu. Areas of the carving, however, do employ a low, vertical edge, typically measuring 2 mm in height around most of the elements (fig. 17). This occurs around the arm which projects to a maximum height of 5 mm with a 2 mm vertical edge before rounding inwards to the interior surface of the figure. A 2 mm vertical edge also occurs at the back of the crown. A more pronounced vertical edge of nearly 4 mm occurs on the inner edge of the false beard, although this space represents the central, and highest raised, part of the royal figure. The taller edge was required to set off the internal triangular space between the beard and neck. Other areas of the relief where the edge is well preserved, such as the flail, show an essentially rounded profile without any pronounced vertical edge.

The overall visual effect of the face and crown appears quite similar with the figures of Sneferu, although with some qualifications.[83] The appearance of the mouth and chin on the Herakleopolis block lacks the slightly upturned mouth profile, lip definition and slightly inset chin, that frequently characterize images of Sneferu. The combination of features on the Herakleopolis figure, to my eye, give the face a somewhat more severe appearance than is typical of images of Sneferu. Nevertheless, it appears absolutely possible the relief might be attributed to Sneferu. The presence of the vertically raised edge in the relief may be an indication that the relief dates to the reign of Sneferu or from the immediately preceding reign of Huni at the end of the Third Dynasty.

Meaningful stylistic comparison with the late Third Dynasty is hampered by the dearth of evidence for royal monuments of the kings following Netjirykhet-Djoser. The authenticity of the Louvre relief of Horus Qahedjet, associated by many with Huni, has recently been cast into doubt with redating of that relief to the Saite Period or later.[84] Prior to this we have the Wadi el-Maghara rock reliefs of Sanakht and Sekhemkhet, as well as the decorated panels of Djoser. None of these approach the large scale of the Herakleopolis relief: the Djoser panels being one-third, and the Wadi el-Maghara figures being one-fourth the scale of the figure on the Herakleopolis block.[85] The figure on the Herakleopolis block employs a finer carving quality and much more developed approach to modeling than these earlier Third Dynasty reliefs. But, we must acknowledge the difference in medium and scale: a life-size figure carved in Tura limestone as opposed to smaller figures cut into natural rock. I would, however, suggest a date at the end of the Third Dynasty is a reasonable possibility and would agree on that basis with Allen and Brovarski's prior suggestion of a Third Dynasty date for the relief.

[80] Fakhry, *Monuments of Sneferu at Dahshur*, 1–17; S. Hassan, *The Great Pyramid of Khufu and its Mortuary Chapel* (Cairo, 1960), 17–24 (for comparison between Sneferu and Khufu reliefs).

[81] Arnold, *Egyptian Art in the Age of the Pyramids*, 196–98.

[82] Arnold, *Egyptian Art in the Age of the Pyramids*, 222–29.

[83] Compare the Herakleopolis figure with the fragments of figures of Sneferu: Fakhry, *Monuments of Sneferu at Dahshur*, pls. 16–19.

[84] J.-P. Pätznick, "L'Horus Qahedjet: souverain de la 3ᵉ dynastie?" in J.-Cl. Goyon and C. Cardin, eds., *Proceedings of the Ninth International Congress of Egyptologists I* (Grenoble, 2007), 1455–73.

[85] For an overview: Incordino, *Chronological Problems of the IIIrd Egyptian Dynasty*, 39–74.

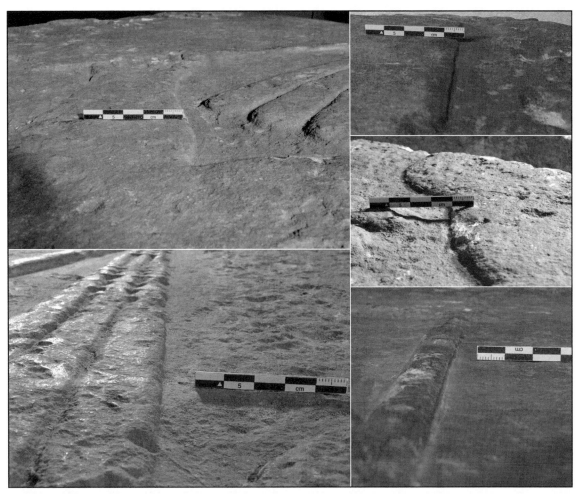

Fig. 17. Details of the edges of the figural elements on the Herakleopolis block: (1) king's forearm holding flail; (2) edge of the flail; (3) back of the White Crown; (4) king's shoulder and bicep; (5) handle of the flail.

The overall visual effect of the Herakleopolis relief, as well as consideration of some of the technical qualities of the carving suggest that the block dates to the early Old Kingdom. I would not categorically exclude the possibility of a date prior to the late Third Dynasty, nor the possibility of a date subsequent to the Fourth Dynasty. But, in terms of scale, carving style and quality, the late Third-early Fourth Dynasty appears to represent the best chronological fit for this relief. There seems to be a good possibility the relief can be attributed to Sneferu or his predecessor Huni. Nevertheless, the high quality of this relief is such that I would not exclude a date later in the Fourth Dynasty. In particular, given the carving quality and subtle modeling of the body and head, an attribution to the reign of Khufu would also appear to be viable.

Aside from defining the possible chronological parameters of the Sed-festival block is the issue of its original monumental context. The block was found reused in the foundations of a building at Herakleopolis which—judging from the battered condition of the relief—long post-dated its original monumental setting. Let us turn now to examine the mode of reuse of the block and its archaeological context at Herakleopolis in more detail in light of our suggested early Old Kingdom date for the relief.

Reuse of the Sed-Festival Block at Herakleopolis:
The Archaeological Evidence

Petrie's brief description of his find-spot
of the Sed-festival block in *Ehnasya 1904*
leaves little doubt as to the pre-Middle
Kingdom date for the relief. Whatever its
original architectural context may have
been, the block was reused as a foundation
stone beneath masonry belonging to the
earliest documented phase of the Herishef
temple: a structure likely attributable to the
Twelfth Dynasty and therefore establishing
an approximate *terminus ante quem* for the re-
used block. The context at Herakleopolis,
however, raises the question of the block's
reuse in conjunction with the construction
history of the temple of Herishef.

The Sed-festival relief is one of a small
group of reused Old Kingdom architec-
tural fragments associated with the Heri-
shef temple (fig. 18). Two other decorated
blocks, also recovered during Petrie's work,
are elements from an Old Kingdom tomb
chapel bearing the name Meret-Hathor.
These were used as foundation elements
in the New Kingdom hypostyle hall rather
than the earlier Middle Kingdom archi-
tecture.[86] We may also mention here the
well-known group of six red-granite palmi-
form columns recarved by Rameses II for
the pronaos of the Herakleopolis temple.[87]
Erasure of the original inscriptions by Ra-
meses II leaves the date of these columns
in doubt.[88] They may well originate in one
of the Old Kingdom Memphite pyramid
complexes, although a Middle Kingdom
date has also been assumed. The Valley

*Fig. 18. Petrie's plan of the Herishef temple showing the New Kingdom architecture
(light gray) with underlying in-situ Middle Kingdom elements (dark gray, hatched).
The Old Kingdom block appears to have derived from the dotted area.*

Temple of Djedkare-Isesi has been suggested as one possible point of origin.[89] Dieter Arnold has proposed an
alternate interpretation: that they originated rather in hypostyle halls of the Old and Middle Kingdoms and un-
derwent reuse near their original site, rather than being transported from great distance.[90] These palmiform col-

[86] Petrie, *Ehnasya: 1904*, 20 and pl. 12.

[87] Most recently see: Y. Yasuoka, "Some Remarks on the Palm Columns from the Pronaos of Herakleopolis Magna," *JEA* 97 (2011),
31–60.

[88] One of the Herakleopolis columns, now in the University of Pennsylvania Museum (E636) was examined in detail recently and
photographed using reflectance transformation imaging to enhance minor surface details. The area of erasure of the original inscriptions (a
rectangular panel on the upper part of the column shaft) is distinct but there are absolutely no vestiges of any of the original text.

[89] Yasuoka, "Some Remarks on the Palm Columns from the Pronaos of Herakleopolis Magna," 34–35.

[90] D. Arnold, "Hypostyle Halls of the Old and Middle Kingdom?" in P. Der Manuelian, *Studies in Honor of William Kelly Simpson I* (Boston,
1996), 39–54.

umns as well as the two mastaba blocks already mentioned, however, are all associated with the New Kingdom phase of the Herishef temple. Their reuse must be differentiated from the Sed-festival block which associates rather with the foundation level of the earlier Middle Kingdom phase of the temple.

The date of the earliest building phase of the Herishef temple in which the Sed-festival block was reused remains open to discussion. Because the temple's earliest building phase was directly superimposed upon by the architecture of the Eighteenth Dynasty and Ramesside Period, Petrie suggested its date based on the earliest reused fragments retrieved from the New Kingdom structures. These included reused Middle Kingdom relief fragments bearing the titulary of Senwosret II, Senwosret III and Amenemhat III uncovered both by Petrie,[91] as well as in the earlier work of Naville.[92] Petrie's conclusion was that a relatively modestly scaled Twelfth Dynasty temple had seen its upper, decorated elements removed with wall bases directly built upon in the Eighteenth Dynasty, and later substantially augmented under Ramses II. However, no inscriptional material was found in situ directly related with the earlier temple phase.

A significant result of Petrie's soundings beneath the Herishef temple is the evidence that this pre-New Kingdom phase of the temple is not underlain by any earlier cult building, but rather by tombs in several areas interspersed with thin-walled courtyards and circular granaries. Petrie identified this pre-temple phase as a cemetery of the late First Intermediate Period and Eleventh Dynasty, thereby providing a *terminus post quem* for the establishment of the first temple phase during the Twelfth Dynasty. This stratigraphic evidence effectively precludes the possibility that the earliest phase might date itself to the late Old Kingdom or Herakleopolitan Period. This Twelfth Dynasty date, based on the cemetery below it, is then in accordance with reused blocks of Senwosret II, Senwosret III and Amenemhat III integrated into the New Kingdom temple. Problematically, the artifact assemblage associated with the group of excavated tombs does not appear to be chronologically uniform. Several of the tombs include diagnostic First Intermediate Period seal forms including a button seal and scaraboids. Two of the tombs, however, included scarabs with amuletic hieroglyphs that appear to be later in date, possibly late Middle Kingdom. On that basis, G. Mokhtar has suggested the Twelfth Dynasty temple may have fallen into decay during the Second Intermediate Period with intrusive burials occurring below the temple pavement.[93]

The site of the Herishef temple evidently has a complex stratigraphic and spatial development only glimpsed in a rudimentary way through Petrie's 1904 exposures. The cemetery evidence appears to reflect more than a simple pattern of vertical growth. There may indeed be burials both below, and adjacent to the temple architecture, that occurred during different phases. Without further direct evidence it appears more specific dating of the pre-New Kingdom temple phase remains uncertain. However, the extant evidence weighs strongly in favor of a major phase of temple construction during the Twelfth Dynasty. With no evidence of an earlier Old Kingdom temple phase beneath it, we can reasonably exclude the origin of the Sed-festival block deriving from an earlier in-situ temple beneath the known Herishef temple. Textual evidence shows that there must certainly have been earlier stages of the Herishef temple dating back at least to the Early Dynastic Period.[94] Evidently, such structures must have existed elsewhere at Herakleopolis and remain yet to be located.

The Sed-festival block therefore effectively stands alone as a probable Old Kingdom architectural element reused in the Twelfth Dynasty Herishef temple. Two issues of interest emerge: (1) why is the Sed-festival block the singular element of reused architecture connected with the Twelfth Dynasty phase of the temple, and (2) can the block be attributed to localized reuse of pre-Middle Kingdom architecture at Herakleopols itself, or is it more likely to derive from elsewhere?

Regarding the first issue, I would suggest that the apparent exceptionality of the Sed-festival block is almost certainly a product of Petrie's limited exposure beneath the in-situ architectural remains of the New Kingdom temple. It is clear from Petrie's plan and description that he encountered Middle Kingdom masonry in several areas directly beneath intact elements of the New Kingdom architecture. In some areas where the New King-

[91] Petrie, *Ehnasya 1904*, 3–4 and pl. 4.

[92] E. Naville, *Ahnas el-Medineh: Herakleopolis Magna*, (London, 1894), 9–11; pl. I d–e.

[93] Mokhtar, *Ihnâsya el-Medina*, 77–78.

[94] A temple of Herishef is mentioned in the Palermo Stone in the entries associated with the First Dynasty: H. Schäfer, *Ein Bruchstück altägyptischen Annalen*, 20, no. 9. The temple of Herishef also occurs in the context of the Herakleopolitan Period in the Eloquent Peasant. See discussion of Mokhtar, *Ihnâsya el-Medina*, 77.

dom temple was less well-preserved—particularly the area in front of the pronaos—he was able to excavate deeper and expose pavement and wall segments he could attribute, based on their relative depth and sequential relationships, to the temple's Middle Kingdom phase. It was in one such exposure in front of the pronaos that he exposed the Sed-festival block. However, he did not disassemble the architecture to search for broader evidence of reused blocks, particularly as New Kingdom architecture was in many cases sitting directly atop extant Middle Kingdom masonry. The quite substantial, articulated features, as well as paving and foundation blocks left in-situ, may well conceal extensive additional evidence for reuse.[95]

The nature of Petrie's spatially-limited sounding of the earliest phase of the temple's architecture explains why only one reused block emerged in 1904. I would suggest the existence of the Sed-festival block likely indicates a wider pattern of reuse of Old Kingdom masonry in the Middle Kingdom phase of the Herishef temple. Resumed work at the site could potentially expose more reused blocks. Recent excavations at the Herishef temple by the mission of the Museo Arqueològico Nacional, Madrid, have focused on documentation and conservation of the temple's New Kingdom architecture.[96] There appears to have been no further investigation into the lower levels of the temple at the present time. Indeed, the recent photographs indicate that the Middle Kingdom levels are now submerged below ground water making any reinvestigation of the context of the Old Kingdom Sed-festival block highly challenging.[97]

Regarding the second issue—the potential localized reuse of preexisting Old Kingdom architecture deriving from an earlier stage of the Herishef temple—both the stratigraphy of the site as well as the nature of the Sed-festival relief strongly weigh against that possibility. As we have seen, Petrie found no evidence of an earlier temple phase beneath the earliest, probable Twelfth Dynasty architecture. This necessitates that the block came from elsewhere, either locally or from greater distance. If it came from the local environs of Herakleopolis that structure does not appear likely to have been an Old Kingdom forerunner to the Herishef temple. Although an extensive comparative corpus of Old Kingdom temples dedicated to major local gods has not survived, excavations of pre-Middle Kingdom sanctuaries is sites such as Medamud or Elephantine suggest that regional temples lacked extensive stone-built architectural features of Middle Kingdom and later temples.[98] The presence of scenes of the Sed-festival in the decorative program of a regional god's temple of the Old Kingdom does not in itself appear improbable; Heb-Sed imagery certainly forms a standard element in local temples in many later periods. What appears unlikely is the existence of a decorative program at such large scale displaying extensive, nuanced elements of the rituals of the Sed festival in a regional god's temple during the Old Kingdom. More generic Sed imagery such as images of the enthroned king, or scene elements specifically connected with the representation of Herishef in the context of the Heb-Sed would appear understandable. The life-size scene of the mooring of the *Wenut-Shemau*/Nekhbet barque in the Sed-festival seems rather out of place at Herakleopolis.

Origin in an Old Kingdom Royal Ka-Chapel?

It appears highly unlikely that a Sed-festival program of the scale and complexity indicated by the *Wenut-Shemau* relief can be attributed to the Old Kingdom phase of the Herishef temple itself. However, another option to consider is the possibility that the block derives from an associated royal cult building: a *ḥwt-kꜣ* or Ka-chapel that existed in the orbit of the main Herishef sanctuary. The practice of establishing royal cult buildings in proximity to the temples of major local gods is well documented, particularly for the later Old Kingdom at sites such as Bubastis, Abydos, Hierakonpolis and elsewhere.[99] Ka-chapels emerged as a temple form already during the

[95] A recent (2017) announcement was made by the Ministry of State for Antiquities and the Museo Arqueològic Nacional, Madrid, of a previously unknown, reused block of Senwosret II in connection with the New Kingdom temple. Many such blocks are likely concealed in the standing architectural components.

[96] M. Pérez-Die, "Excavaciones en Ehnasya el Medina: Heracleópolis Magna," *Informes y trabajos* 11 (2014), 159–75.

[97] Pérez-Die, "Excavaciones en Ehnasya el Medina: Heracleópolis Magna," 165–66, and figs. 5 and 11.

[98] For an overview of the archaeological evidence for Old Kingdom provincial gods temples: B. Kemp, *Ancient Egypt: Anatomy of a Civilization* (London, 2006), 112–35.

[99] D. O'Connor, "The Status of Early Egyptian Temples: an Alternative Theory," in R. Friedman and B. Adams, eds., *The Followers of Horus: Studies Dedicated to Michael Allen Hoffman* (Oxford, 1992), 83–98. See critique of E. Lange, discussed further below.

Early Dynastic Period; textual sources indicate the existence of royal Ka-chapels as early as the First Dynasty.[100] However, the earliest archaeologically documented Ka-chapels date to the late Old Kingdom. Known structures range from modestly scaled buildings to larger structures such as the chapels of Teti and Pepi I at Bubastis.[101] The decorative programs of royal Ka-chapels revolve around the relationship of the king with the local god, but incorporate imagery, and statue programs, [102] associated with kingship and the Sed-festival.

A valuable indication for the characteristics and scale of an Old Kingdom royal Ka-chapel is the chapel of Pepi I at Bubastis, at present the only architecturally preserved Old Kingdom Ka-chapel. The structure was initially excavated in the 1940s with publication by Labib Habachi.[103] More recently, renewed investigations have been conducted by Eva Lange.[104] The building is a substantial multi-room building housed within a larger supporting enclosure of 30 x 50 m. Access to the enclosure occurred through two portals. The primary entrance. oriented to the main temple of Bastet, survived intact with decorated jambs and lintel depicting Pepi I offering to Bastet. The Ka-chapel proper, a structure which underwent multiple phases of alteration, was a 15.25 x 16.8 m building with a double pillared entry leading to an 8-pillared hall and a sanctuary comprised of five chambers.[105] Analysis of the architecture by Christian Tietze suggests the building's layout mimicked royal cult buildings associated with the Old Kingdom pyramid complexes. Specifically, Tietze has suggested that the Valley Temple of the Bent Pyramid of Sneferu at Dahshur forms a precursor to the architectural layout of the Pepi I Ka-chapel.[106]

As substantial as the Pepi I Ka-chapel at Bubastis was, that building does not appear physically suited to have accommodated a relief program of the type indicated by the Herakleopolis Sed-festival block. Primary construction of the chapel was in mudbrick with the decorated stone elements limited to the square pillars and the jambs and lintels of the doorways. There does not appear to have been anything like the ca. 2.5+ m life-size Sed-festival scene we are investigating here. I would not categorically exclude the possibility that the Herakleopolis block derives from an Old Kingdom royal Ka-chapel. However, if so, it must have been a Ka-chapel of significantly larger scale and monumentality than we have preserved in the example of Pepi I at Bubastis.

It is apparent that the Sed-festival relief is not convincingly accommodated either in the context of a god's temple or an associated royal Ka-chapel at Herakleopolis. At this juncture we arrive at the most challenging issue regarding the Old Kingdom Sed-festival relief. Where did it originate and how did it come to be reused as a foundation stone in the Middle Kingdom temple of Herishef? As with the specific royal attribution discussed above, it does not appear to be possible to answer this question with certainly. But, we may examine several options with an eye to establishing the "best probable fit" for the data at hand.

<center>Reuse of Masonry from the Old Kingdom Pyramid Complexes?</center>

Although the scene of the king receiving the barque of *Wenut-Shemau* from Herakleopolis is a unique specimen of Old Kingdom royal art, as we have discussed earlier, it is not unparalleled in terms of the ritual action depicted, nor the broader genre of Sed-festival imagery to which it belongs. Depiction of the Sed festival was a major component of the decorative program of the Memphite Old Kingdom pyramid complexes, occurring both in the pyramid temples and valley temples of that era.[107] Subsequent to the Sed themed panels and architecture of the Step Pyramid of Djoser, Sed imagery occurs in the relief programs of the Fourth Dynasty

[100] For an overview of attested Old Kingdom Ka-chapels: E. Uphill, "The Royal Ka Houses of Egypt: a Survey," *The Journal of the Ancient Chronology Forum* 5 (1992), 77–88.

[101] E. Lange, "The Old Kingdom Temples and Cemeteries at Bubastis," *Egyptian Archaeology* 42 (2013), 8–10.

[102] Such as the copper statues of Pepi I (Cairo JE33034) set up at Hierakonpolis commemorating the first occasion of the Sed-festival: J. Quibell, *Hierakonpolis I* (London, 1900), pls. 44–45; and *Hierakonpolis II* (London 1902), pl. 50.

[103] L. Habachi, *Tell Basta*, Supp. ASAE 22 (Cairo, 1957), 11–43.

[104] E. Lange, "Die Ka-Anlage Pepis I. in Bubastis im Kontext königlicher Ka-Anlagen des Alten Reiches," *ZÄS* 133 (2006), 121–40.

[105] C. Tietze, "Die Architektur der Ka-Anlage Pepis I. in Tell Basta," *ZÄS* 135 (2008), 165–79.

[106] Tietze, "Die Architektur der Ka-Anlage Pepis I," 176–77.

[107] Z. Hawass, "Programs of the Royal Funerary Complexes of the Fourth Dynasty," in D. O'Connor and D. Silverman, eds., *Ancient Egyptian Kingship* (Leiden, 1995), 221–53; Ćwiek, "Relief Decoration in the Royal Funerary Complexes of the Old Kingdom," 225–38.

pyramid complexes of Sneferu, Khufu, as well as the statue program of the Valley Temple of Menkaure.[108] Sed imagery is consistently attested through the Fifth and Sixth Dynasties, occurring at the pyramid temples of Userkaf,[109] Sahure,[110] Neferirkare,[111] Unas,[112] Teti,[113] Pepi I,[114] and Pepi II.[115] Although fragmentary in all instances, many of these complexes included large format depictions of the king engaged in the rites of the Sed-festival. Sed-festival scenes occurred also in the Sun Temples during the Fifth Dynasty with the scenes from the Heb-Sed chapel of Niuserre providing the most extensive surviving set of Old Kingdom Sed-festival imagery.[116]

Given that the closest surviving parallels to the scene on the Herakleopolis block occur in the Valley Temple of the Bent Pyramid of Sneferu at Dahshur, the question naturally arises: was the Sed-festival block transported to Herakleopolis from one of the Old Kingdom pyramid complexes? Is this a block that is not original to the site, but was moved to Herakleopolis in the Twelfth Dynasty concomitant with the establishment of the Middle Kingdom phase of the Herishef temple? More specifically, given the proposed early Old Kingdom date, can we identify one or more complexes from which the relief might derive?

Fig. 19. The region between Memphis and Herakleopolis showing distances involved in the possible distribution of Memphite reused blocks to the Fayum region via Itj-Tawy.

Clearly the distance from the Memphite region to Herakleopolis is substantial and would appear to detract from the likelihood of such a long distance reuse. However, we know from the significant numbers of reused Old Kingdom blocks in the pyramid of Amenemhat I at Lisht that there was a mechanism for southward transport of pyramid masonry in the early Twelfth Dynasty. Moreover, there is one Old Kingdom pyramid site, the complex of Sneferu at Meidum, which is relatively close (40 km) to Herakleopolis and might have been the source for reused masonry (fig. 19). Here I would like to investigate two primary possibilities that might be viable explanations for transport of the Sed-festival relief to Herakleopolis: (1) "Model A" proposes the arrival of the block as part of state-initiated building work at Herakleopolis, redistributed to the site via the Twelfth Dynasty capital at *Itj-Tawy*; and (2) "Model B" examines the derivation of the Sed relief from the Meidum pyramid complex of Sneferu. Finally, we will discuss the possibility of a third scenario: (3) "Model C" suggests that the block derives from an early Old Kingdom mortuary complex that once existed at Herakleopolis itself, attributable to Huni.

Model A: Masonry Disbursement via Itj-Tawy

Although the Sed-festival block under discussion here is only a single piece of reused masonry associated with the Middle Kingdom phase of the Herakleopolis temple, its existence does imply a more extensive pattern of reuse.

[108] F. Friedman, "Economic Implications of the Menkaure Triads," in P. Der Manuelian and T. Schneider, *Towards a New History for the Egyptian Old Kingdom* (Leiden, 2015), 18–59.

[109] A. Labrousse and J.-Ph. Lauer, *Les complexes funéraire d'Ouserkaf et de Néferhétepès* (Cairo, 2000), 120–23 and figs. 263–68.

[110] L. Borchardt, *Das Grabdenkmal des Königs Sahu-re II* (Leipzig, 1915), pls. 45–47.

[111] Hornung and Staehelin, *Neue Studien zum Sedfest*, 16.

[112] J.-Ph. Lauer and J. Leclant, *Le temple haut du complex funéraire du roi Ounas* (Cairo, 1977), 85–87.

[113] Quibell, *Excav. Saqq. II*, pl. 54:3; J.-Ph. Lauer and J. Leclant, *Le temple haut du complexe funéraire du roi Téti* (Cairo, 1972), 26, 62–67, 90–92.

[114] J. Leclant, "Fouilles et travaux en Égypte et au Soudan, 1972–1973," *Orientalia* 44 (1975), 208.

[115] G. Jéquier, *Pepi II* vol II, pls. 16, 21, 25, 460–60, vol. III, pls. 25, 40.

[116] F. von Bissing and H. Kees, *Das Re-Heiligtum des Königs Ne-woser-re (Rathures)* II (Leipzig, 1923) and III (Leipzig, 1928).

The best documented case for the reuse of Old Kingdom masonry of this type occurs in the Memphite blocks at Lisht. The nature of reuse of Old Kingdom masonry at Lisht offers the potential for illuminating reuse further south at Herakleopolis. Indeed, it appears possible there could be a specific, systemic connection between these two major sites on the north and south ends of the Fayum entrance.

Reused masonry of Old Kingdom date occurs extensively in the pyramid complex of Amenemhat I. This material occurs distributed throughout the complex: in the pyramid's internal architecture, in the pyramid superstructure, as well as in the paving and foundations of the mortuary temple. In his original publication of the reused blocks at Lisht, Hans Goedicke advanced the theory that blocks bearing the names of Khufu, Khafre, Userkaf and Pepi II are the product of the purposeful reemployment of material taken from the Memphite pyramid complexes.[117] In attempting to explain the transfer of masonry from the Memphite area to Lisht, Goedicke discounted the possibility of an "irreverent economy"—the extraction of stone from earlier complexes to save time and investment in new quarrying. He theorized there may have been an underlying symbolic rationale to this process with the incorporation of fragments of the Old Kingdom pyramids establishing an association between Amenemhat I and Old Kingdom rulers with whom the founder of the Twelfth Dynasty sought to link himself.[118]

Peter Jánosi in his recent discussion of the Lisht reliefs has questioned this interpretation and suggested that demolition and transport of Old Kingdom architectural elements from the Memphite pyramids to Lisht is improbable.[119] He has proposed, although with no supporting discussion, that the Lisht blocks originated, instead, from Old Kingdom temples that lay in closer proximity to Lisht, a possibility that Goedicke had previously considered and rejected. Such local temples would have provided geographically more convenient locations for acquisition of masonry.[120] Although Jánosi has rightly observed that the argument for reuse from the Memphite pyramid complexes is hampered by the lack of extensive comparative evidence for Old Kingdom gods' temples,[121] his dismissal of the origin of the Lisht blocks in the Old Kingdom Memphite pyramid complexes appears unconvincing. The suggestion is weakened by the thematic range represented in the corpus of reused Old Kingdom blocks. Even without the benefit of a comparative corpus of scene types deriving from local god's temples of that era, the reused blocks at Lisht remain highly diagnostic of the decorative program of Old Kingdom pyramid complexes.

Tellingly, reused blocks at Lisht include a number bearing the names of the pyramid complexes of Khufu and Pepi I.[122] Even more diagnostic are the blocks with personifications of royal estates and the delivery of offerings displaying the maintenance of the royal mortuary cult.[123] Strongly indicative of origin in royal pyramid complexes is the substantial sub-group depicting the Sed-festival (thirteen blocks attributed to Sed-festival scenes of Khufu).[124] Other scene elements, including royal attendants and members of the royal entourage, appear likely to represent components of the decorative program of pyramid complexes rather than local temples. Discrete scene types such as the substantial group dating to the reign of Khufu depicting boats and ships,[125] as well as the possible attribution of scenes of shipbuilding to the same group,[126] would also appear likely to be part of the decorative program of the royal pyramid complexes but an improbable component of local god's temples. The preponderance of evidence from the blocks themselves strongly supports the viability of Goedicke's suggestion that the bulk of the reused blocks at Lisht originate in a finite group of Old Kingdom Memphite pyramid complexes. What has remained a debated issue is how and why these blocks were taken to Lisht.

[117] H. Goedicke, *Re-Used Blocks from the Pyramid of Amenemhat I at Lisht*, PMMA 20 (New York, 1971).

[118] Goedicke, *Re-Used Blocks*, 4–7.

[119] P. Jánosi, *The Pyramid Complex of Amenemhat I at Lisht: The Reliefs*, PMMA 30 (New York, 2016), 13–30.

[120] This parallels Arnold's suggestion that the reused palm columns originated not in royal pyramid complexes but in the hypostyle halls of local temples.

[121] Jánosi, *Amenemhat I*, 13.

[122] Jánosi, *Amenemhat I*, 27 and pl. 17 (pyramid of Pepi I).

[123] Arnold, *Egyptian Art in the Age of the Pyramids*, 226 (Cat. 41).

[124] Goedicke, *Re-Used Blocks*, 29–48.

[125] Goedicke, *Re-Used Blocks*, 86–121.

[126] Arnold, *Egyptian Art in the Age of the Pyramids*, 224–25 (Cat. 40).

The motivations behind the redistribution of masonry from the Memphite complexes during the early Twelfth Dynasty might appear puzzling. In attempting to understand it, I would suggest that we should not overstate the physical obstacles to this phenomenon of reuse. The cult buildings—the valley temples and causeways in particular—of many of the Memphite complexes lay in close proximity to quays, canals, and watercourses. Consequently, masonry from a range of complexes could have been relatively easily loaded aboard boats and—once waterborne—moved over substantial distances. Indeed, the distance between Lisht and the Memphite region is only slightly greater than the north to south span of the primary Old Memphite pyramid sites themselves (from Giza to south Dahshur). This distance could be rapidly traversed by large boats and ships carrying substantial loads of dismantled blocks. Many of these pyramid sites lay closer than the limestone quarries of Tura-Ma'asara and potentially would provide large pre-cut blocks of the same fine stone in abundance (fig. 18).

In his mention—and rejection—of a possible economic motive behind the reuse of Memphite masonry Goedicke interpreted the Lisht blocks in terms of their appearance in the Amenemhat I pyramid alone. I would suggest the pyramid should not be understood in isolation, but rather as one part of the wider building program in and around *Itj-Tawy*. Insofar as the Lisht pyramid is presumably closely positioned relative to the, still unidentified, site of the Twelfth Dynasty royal residence at *Itj-Tawy* the possibility should be entertained that the blocks are symptomatic of a larger phenomenon of reuse that characterizes the beginning of the Twelfth Dynasty.[127] The foundation of the new residence city at *Itj-Tawy* late in the reign of Amenemhat I forms a historical context that may have catalyzed the process of dismantling defunct Old Kingdom pyramid complexes. After a period of time when Memphis had functioned as his capital, Amenemhat I established the Twelfth Dynasty residence city toward the end of his reign.[128] The inception of *Itj-Tawy* would have generated an immediate need for massive quantities of high quality masonry. While new stone was likely being quarried for this, and other state projects, the volume of masonry needed for building an entire new residence city may have effectively outstripped the state's short-term capacity for quarrying. In the context of a greatly heightened demand for stone, defunct Memphite pyramid complexes could have been an alluring source for the rapid acquisition of high quality building stone.

If this is the case, there may have been an additional factor at play in this process. Prior to the initiation of *Itj-Tawy*, Amenemhat I had used Memphis as the royal capital for as much as two decades.[129] During that time he had undertaken substantial work on a pyramid complex named *3ḥ ist ib 'Imn-m-ḥ3t* near Memphis: one that preceded his Lisht pyramid.[130] This first pyramid of the Twelfth Dynasty may have involved reuse of elements of abandoned Old Kingdom structures in the area of Saqqara. The initial establishment of a royal residence at Memphis, and an accompanying monumental program in and around the Memphite region, may have generated a royally-sponsored policy of reuse drawing on the masonry reserves of certain Old Kingdom Memphite complexes. This program of reuse may then have continued and expanded during the period of the construction of the new capital at *Itj-Tawy* and the nearby pyramid at Lisht.

The bulk of the Memphite material may have been destined for temples and other stone-built structures in *Itj-Tawy* proper. But, a substantial volume of material was allocated concomitantly to the pyramid complex of Amenemhat I. If this is the case, the reused blocks at Lisht represent less of a symbolic statement on Amenemhat's personal desire for Old Kingdom associations than a subset of the more extensive assemblage of reused Old Kingdom masonry that characterized the construction of *Itj-Tawy* as a whole. This would be reuse driven by current needs of an expanding royal building program and the expediency of stripping Memphite complexes for building materials. As a phenomenon it would find a parallel in the later construction of Cairo in the Fatimid

[127] Regarding the likely proximal location of *Itj-Tawy* to Lisht see recently: D. Lorand, "À la recherche de *Itj-Taouy*/el-Licht: à propos des descriptions et cartes du site au XIXᵉ siècle," in M. Betrò and G. Miniaci, eds., *Talking along the Nile: Ippolito Rosellini, Travellers and Scholars of the 19th Century in Egypt* (Pisa, 2013), 137–50.

[128] The timing of the establishment of *Itj-Tawy* remains unclear in relation to the king's earlier Theban phase and his subsequent use of Memphis as royal residence: W. Simpson, "Studies in the Twelfth Egyptian Dynasty I-II," *JARCE* 2 (1963), 53–59; Do. Arnold, "Amenemhet I and the Early Twelfth Dynasty at Thebes," *MMJ* 26 (1991), 14–21.

[129] L. Berman, "Amenemhet I," PhD diss., Yale University, 1984, 29–30.

[130] D. Silverman, "Non-Royal Burials in the Teti Pyramid Cemetery and the Early Twelfth Dynasty," in D. Silverman, W. Simpson and J. Wegner, eds., *Archaism and Innovation: Studies in the Culture of Middle Kingdom Egypt* (Philadelphia and New Haven, 2007), 72–78.

and Ayyubid Periods making extensive use of stonework from the Memphite pyramid cemeteries as well as the ruins of Memphis and Heliopolis.[131]

Expanding on the last set of points I would suggest the following scenario. During the period of construction of *Itj-Tawy* royal builders were actively dismantling abandoned and accessible Memphite pyramid complexes in order to meet the huge demand for building stone. A substantial southward flow of building materials occurred deriving especially from the immediate floodplain-adjacent components of select pyramid complexes. These included the complexes of Pepi I, Unas, Khafre, but especially Khufu. It is striking that blocks attributable to the complex of Khufu compose such a numerically dominant group at Lisht. The valley temple, causeway and pyramid temple of the Great Pyramid may therefore have been particularly targeted.[132] One motivating factor may well have been the relative size of the Khufu complex which offered both substantial volume, as well as masonry blocks of substantial scale and quality. However, the extent of the demand meant that many other abandoned royal complexes also underwent dismantlement.

Reserves of reused stone may have been piled up and managed in state-managed stone-yards which were restocked and drawn upon as the construction of *Itj-Tawy* and associated satellite building projects developed. This would explain the mixing of reused masonry from multiple sources attested in the reused blocks at Lisht North. The influx of stone to *Itj-Tawy* would create a situation where the new royal capital may have become an entrepôt for stone which was then secondarily disbursed to a variety of other royal building initiatives. Beyond the immediate area of the new royal capital there may have been spillover of reused blocks into other early Twelfth Dynasty building projects in the greater Fayum region. Conceivably, therefore, one of these structures may be the temple of Herishef at Herakleopolis.

One problem facing this scenario is the uncertain dating for initiation of the Middle Kingdom phase of work on the Herishef temple *vis-a-vis* the establishment of *Itj-Tawy*. The Twelfth Dynasty temple at Herakleopolis can be dated primarily on the basis of royal names on reused blocks in the later New Kingdom temple. The earliest royal titulary attested in the building is that of Senwosret II. If the Herishef temple was not under construction until the reign of Senwosret II, the possible synchronism between work at *Itj-Tawy* and Herakleopolis appears less certain. It is noteworthy in terms of the Lisht evidence that no reused Old Kingdom masonry occurs in the pyramid of Senwosret I, suggesting the phenomenon was one of short duration and linked only to the initial foundation of the residence city.[133] Disbursement of masonry later on, therefore, would appear less likely. However, given the prominence of Herakleopolis and the god Herishef in particular it would appear viable that state-initiated building work began under Amenmhat I at the beginning of the Twelfth Dynasty. Inception of a newly established Herishef temple could have occurred contemporary with the establishment of the Twelfth Dynasty and the emerging program of development of the Fayum region that characterizes the Twelfth Dynasty. Indeed, the foundation of *Itj-Tawy* by Amenemhat I, midway between Memphis and the Fayum mouth, appears to reflect a conspicuous policy of state investment in the Fayum region.[134]

If the Sed-festival block was transported to Herakleopolis through the mechanism of masonry redistribution via *Itj-Tawy*, then there is a statistically significant possibility that it could derive from the most prominent source for reused Old Kingdom masonry at Lisht: the pyramid complex of Khufu. Many of the Khufu blocks recovered at Lisht belong within a complex cycle of Sed-festival scenes. The original context of the Sed-festival scenes is debated although Goedicke has speculated these may derive primarily from the Valley Temple at Giza.[135] Many of the Lisht blocks comprise scenes of smaller scale than the Herakleopolis relief: they primarily show the king at half life-size rather than life-size. However, a block deriving from Sed-festival scenes excavated at the entrance to

[131] This process of deconstruction is an earlier, pharaonic forerunner to the later Medieval phenomenon of the dismantling of Memphite pyramids as well as the stone temples of Memphis and Heliopolis in the construction of Cairo in the Fatimid and Ayyubid Periods. For discussion of this phenomenon with references to the literature: J. Wegner, *The Sunshade Chapel of Meritaten from the House-of-Waenre of Akhenaten* (Philadelphia, 2017), 141–47.

[132] Some 30 of 92 blocks published by Goedicke arguably originate in the complex of Khufu. Many additional blocks among the 35 undated examples may also derive from there. On that basis, we might hypothesize that a substantial proportion of the initial construction of *Itj-Tawy* incorporates stonework stripped from the Great Pyramid complex.

[133] D. Arnold, *The Pyramid of Senwosret I* (New York, 1988), 71.

[134] J. Wegner, "Tradition and Innovation: the Middle Kingdom," in W. Wendrich, ed., *Egyptian Archaeology* (Oxford, 2010), 120–21.

[135] Goedicke, *Re-Used Blocks*, 153–55.

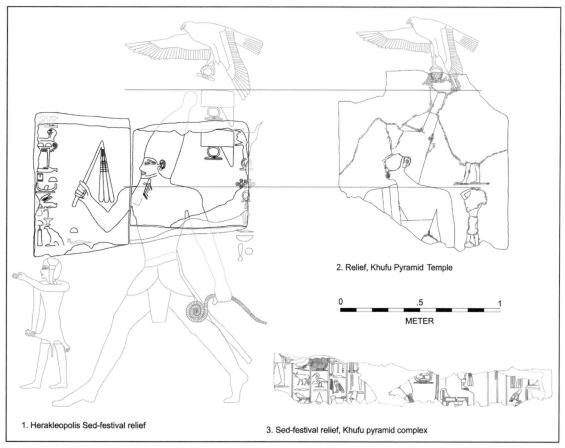

2. Relief, Khufu Pyramid Temple

0 .5 1
METER

1. Herakleopolis Sed-festival relief

3. Sed-festival relief, Khufu pyramid complex

Fig. 20. Scale comparison of the reused Sed-festival block from Herakleopolis with fragments from the pyramid temple of Khufu showing a life-size royal figure and Sed-festival relief with the king at full and half life-size.

the Khufu pyramid temple itself suggests the presence of larger-scale images in combination with smaller scale scenes (fig. 20). Moreover, its association with the pyramid temple suggests that like many of the Old Kingdom complexes the pyramid temple itself was an equally important location for Heb-Sed scenes. Interestingly, we may also note here one of the few other relief fragments excavated at the pyramid temple of Khufu is part of a ritual scene showing the royal figure at identical scale to the Herakleopolis relief. While commonality of scale may be purely coincidental in this case, this block and the Sed-festival block with Khufu at both smaller and larger scale show that imagery of the Sed was an integral part of the Khufu pyramid temple.

The Herakleopolis block, as we have already discussed, could be accommodated stylistically within the small, known corpus of Khufu reliefs. In view of the statistical prominence of reused blocks of Khufu at Lisht it appears possible the block could derive from that source and is part of a wider phenomenon of reuse of masonry from the Memphite pyramid complexes during the early Twelfth Dynasty. If so, the block could be a southern outlier of a process of disbursement of Giza masonry to *Itj-Tawy* and the Fayum area. This particular explanation, however, may not represent the best fit for the scene of the king mooring the *Wenut-Shemau* barque.

Model B: Reuse of Masonry from the Meidum Complex

One of the crucial points made earlier in this article is the fact that the closest parallels to the Herakleopolis relief occur in the Valley Temple of the Bent Pyramid of Sneferu at Dahshur. The preserved elements from the Valley

Temple are highly fragmentary but indicate the presence of scenes showing the arrival of divine barques during the Heb-Sed in both the entrance hall, as well as on pillars inside the temple's central court. I have proposed above that these scenes could have depicted the arrival of the barques of the territorial goddesses and the formal initiation of the Heb-Sed rites. Intriguingly, as discussed above, among the priestly titles of Sneferu's son, prince Kanefer, is the designation ḥm-nṯr Wnwt-Šmꜥw, "god's servant priest of Wenut-Shemau," the very same deity that appears on the Sed-festival relief from Herakleopolis. Given this set of evidence there appears to be a reasonable possibility that the block derives from one of the monuments of Sneferu.

Could the Herakleopolis block originate from either of Sneferu's two pyramid complexes at Dahshur? We may observe here that relief fragments recently attributed to Sneferu, and ascribed to his Dahshur complexes, occur among the reused blocks in the pyramid of Amenemhat I at Lisht.[136] From Dahshur itself, the scale of the life-size, striding king in the Herakleopolis relief is commensurate with the royal figures in the Valley Temple at Dahshur. In situ evidence excavated by Fakhry recovered only the lower portions of many of the larger wall scenes that once surmounted the rows of personified royal estates. Those missing blocks must have been removed in antiquity and could have been reused elsewhere. Potentially masonry originating in Sneferu's Dahshur complexes made its way not just to Lisht, but also to Herakleopolis as part of Twelfth Dynasty state-sponsored building activities through the mechanisms discussed above.

An origin of the Sed relief in one of the Dahshur complexes of Sneferu, while an attractive possibility for the reasons just summarized, entails the same issues of long-distance transport that effect Giza or other pyramid sites in the Memphite necropolis. In the case of attribution to Sneferu, however, there is another option which emerges: a point of origin in the Meidum pyramid complex just north of the Fayum entrance. Types of relief decoration attested at Dahshur may have had parallels in decorated cult buildings which have not survived at Meidum, in particular the never-located Valley Temple, or perhaps cult structures that once stood in the never-discovered residence city of Djed-Sneferu near Meidum.

Halfway between Lisht/Itj-Tawy and the Fayum entrance, Meidum would offer an excellent source for masonry in royal building initiatives in the Fayum region at the beginning of the Twelfth Dynasty. Only forty kilometers from Herakleopolis, Meidum was a highly visible site with masonry that could have been considered viable for removal during the Twelfth Dynasty. Reuse of masonry from Meidum during that timeframe could theoretically echo the group of Lisht blocks from the Memphite pyramids.[137] The Meidum pyramid complex itself presents many problems of evidence and interpretation that lie beyond the scope of the present discussion. Some scholars have argued the site was initiated under Huni and completed by Sneferu while a majority of researchers view the complex to be exclusively the product of Sneferu.[138] Whether or not the complex spans two reigns, or was completed entirely by Sneferu, Meidum was almost certainly the location of the residence city named Djed-Sneferu attested on titles in the Fourth Dynasty Meidum necropolis.[139] A settlement bearing that same name was still in existence during the later Old Kingdom,[140] and survived into the Middle Kingdom.[141]

If the series of dated ink texts recovered by Petrie and more recently by el-Khouli are properly assigned to Sneferu, building activity at the site extended over a substantial period of Sneferu's reign and overlapped with work on the Bent Pyramid complex at Dahshur.[142] Ink inscriptions associated with the construction of the Meidum pyramid span the timeframe from the Seventh, to the year after the Eighteenth, occasion of the biennial

[136] Arnold, *Egyptian Art in the Age of the Pyramids*, 224–225 (Cat. 40)

[137] Meidum has been mentioned as a potential source for masonry used at Lisht/Itj-Tawy although with no clear evidence. See comments of H. Goedicke, *Reused Blocks*, 5; Goedicke see no indications for reuse of masonry from Meidum but observes the proximity of the site to Lisht and contrasts this as a potential source against the greater distance involved for transport of masonry from pyramid sites in the Memphite necropolis.

[138] For a recent discussion of the evidence: C. Reader, "The Meidum Pyramid," *JARCE* 51 (2015), 203–24.

[139] J. Yoyotte, "Études géographiques, II: les localités méridionales de la région memphite et 'le Pehou d'Héracléopolis'," *RdE* 15 (1963), 87–119; V. Maragioglio and C. Rinaldi, "Considerazioni sulla città ḏd-snfrw," *Orientalia* 40 (1971), 67–74.

[140] T. Rzeuska, "Meidum Revisited: Remarks on the Late Old Kingdom Topography of the Site," in M. Bárta, F. Coppens, and J. Krejčí, eds., *Abusir and Saqqara in the Year 2010*, vol. 2 (Prague, 2011), 709–22.

[141] F. Gomaà, *Die Besiedlung Ägyptens während des Mittleren Reiches I* (Wiesbaden, 1986), 374.

[142] R. Stadelmann, "Snofru und die Pyramiden von Meidum und Dahschur," *MDAIK* 36 (1980), 437–49; M. Verner, *The Pyramids* (New York, 2001), 159–68.

cattle count suggesting the complex was under construction during, and after, the king's first celebration of the Sed-festival.[143] Work continued at Meidum contemporary with the construction of the Bent Pyramid complex as well as the Valley Temple of the Bent Pyramid which has dated ink texts from the Fifteenth occasion of the count and a likely association with the first Sed festival of Sneferu.[144] If cult buildings at Meidum were completed and decorated during this timeframe they would likely have incorporated Sed-festival imagery. The relief fragments showing Sneferu receiving divine barques during the Sed-festival from the Bent Pyramid at Dahshur offers a tantalizing hint that a Valley Temple at Meidum or other cult structures could also have incorporated Heb-Sed imagery of the type used in the reused relief from Herakleopolis.

This attractive possibility is tempered to some extent by the lack of decoration in the pyramid temple at Meidum. While that structure was architecturally complete, and later formed a destination for New Kingdom visitors who added graffiti naming Sneferu, it was left devoid of decoration during the Fourth Dynasty. Compounding this issue, physical remains of the Valley Temple at Meidum have never been located. The question thus arises, could Meidum have incorporated a completed and decorated Valley Temple paired with an undecorated pyramid temple?[145]

The presence of the undecorated pyramid temple at Meidum might be taken as an indication that the entire complex was never formally completed. However, I would caution here that the lack of decoration on that particular structure may not provide an accurate reflection of the state of completion of the Valley Temple or other parts of the Meidum complex. It is well established that the three-phased transformation of the pyramid involved its completion as a step-pyramid prior to its final alteration to a smooth-sided pyramid.[146] The initial stages of work on the pyramid could well be associated with completion of a Valley Temple but not the final decoration of the pyramid temple. The relatively simple pyramid temple with its pair of standing stelae was designed essentially as a mortuary offering place. The changes in the pyramid superstructure would have necessitated the relocation of the pyramid temple two times prior to the final, surviving temple. Ultimately, the lack of decoration in the pyramid temple might reflect the decision to use Dahshur as the king's burial locale. Therefore, lack of decoration in the mortuary temple would not necessarily preclude completion of a Valley Temple that commemorated the king's reign in other ways, or which could have served in ceremonies celebrated during the period of use of the king's residence city at *Djed-Sneferu*. Furthermore, the presence of the residence city *Djed-Sneferu* in proximity to Meidum raises the possibility that there may have been other cult buildings erected in association with Sneferu's reign which stood apart from the pyramid complex proper.

In considering Meidum as a possible site of origin for the Herakleopolis Sed-festival block it is worthwhile at this juncture to note the continuing arguments concerning the possible initiation of the Meidum complex by Huni. Although an association with Huni has long been discounted, recent discussion has resurrected the possibility that Meidum may be the product of two reigns: Huni and Sneferu. A number of scholars have argued that the initial step pyramid was completed under Huni. That structure was then altered during the early stages of Sneferu's reign,[147] at which point Huni may have been buried elsewhere.[148] Activity in the mastaba field

[143] I.e., the regnal year span should run from Sneferu's regnal Year 14 to Year 36. There are, however, problems caused by variation in the periodicity of the cattle count, see recent discussion of Reader, "The Meidum Pyramid," 212–16.

[144] R. Stadelmann, "The Heb-Sed Temple of Senefru at Dahshur," in Bárta, Coppens, and Krejčí, *Abusir and Saqqara in the Year 2010*, vol. 2, 736–46.

[145] Recent overview and additions to the Meidum visitors' graffiti: H. Navrátilová, "Additions to the Maidum Visitors' Graffiti," in Bárta, Coppens, and Krejčí, *Abusir and Saqqara in the Year 2010*, vol. 1, 106–18. One might question how the long-term recognition of the Meidum pyramid's association with Sneferu was maintained if there were not some form of standing royal monuments at the site. Oral traditions, and inscriptions in the nearby Fourth Dynasty mastabas could have played a role, but visitor graffiti such as that left by Akhkaperreseneb inside the pyramid temple during the reign of Thutmose III might suggest the presence of standing royal monuments: I. Edwards, *The Pyramids of Egypt* (New York, 1985), 77. Possibly a partially dismantled Valley Temple could have formed part of the landscape at Meidum in the New Kingdom.

[146] Defined first by L. Borchardt, *Die Entstehung der Pyramide an der Baugeschichte der Pyramide bei Meidum nachgewiesen*, Beiträge Bf. 1:2 (Berlin, 1937).

[147] J. M. Parra Ortiz, "Houni et Snéferou: les pyramides de Meidoum et Dahchour," *GM* 154 (1996), 77–91; Reader, "The Meidum Pyramid." 214–18.

[148] One possibility is that Huni was buried in the large Mastaba 17 adjacent to the main pyramid at Meidum. Based on a mastaba at Abu Sir dating to the reign of Huni, Bárta has suggested Huni''s burial place may in the northern end of the Memphite necropolis: M. Bárta,

north of the pyramid could reflect this longer chronological span. Yvonne Harpur's analysis of the mastaba of Nefermaat and Atet suggests that Nefermaaat was the eldest son of Huni and not the son of Sneferu as commonly assumed.[149] Sneferu too was a son of Huni so this reinterpretation of the royal family relationships does not necessarily impact the initiation of the Meidum pyramid itself. Furthermore, if Huni were associated with the primary construction phases of the Meidum complex why would the residence city named *Djed-Sneferu* be so closely linked with this particular locale?

It appears that Meidum could well have been a point of origin for reused blocks deriving from cult buildings of Sneferu, although the existence of any structures there belonging to Huni would appear a more remote possibility. In either case, the status of any decorated buildings at Meidum remains an argument *ex silentio*. The major index to the demolition and removal of masonry from Meidum—the pyramid superstructure—remains ambiguous and there is no clear reason to date a major phase of reuse to the Middle Kingdom. Indeed, consensus appears to be that demolition of the outer parts of the superstructure occurred primarily post New Kingdom.[150]

Through its association with Sneferu, and geographical proximity to Herakleopolis, Meidum appears to be a viable point of origin for the reused Sed-festival relief. However, there is a third option to consider. Although the Sed-festival relief does not appear likely to derive from an early stage of the Herishef temple, nor from a royal Ka-chapel, it remains possible there was another form of royal cult complex at Herakleopolis. The style of the relief we have suggested above would suggest an attribution to the late Third Dynasty or Fourth Dynasty. While Sneferu appears to form an attractive candidate based on the similar scenes in the Valley Temple at Dahshur, the reign of his father Huni also appears to be viable.

Model C: A Cult Complex of Huni at Herakleopolis?

In the preceding discussion we have examined possible scenarios in which the Sed-festival block reused at Herakleopolis originated in one of the Memphite pyramid complexes, or derived from Meidum only 40 km from Herakleopolis. If, however, we discount the likelihood for the dispersal of the block from these sites further to the north, we are forced to conclude there must have been a quite substantial, stone-built, early Old Kingdom temple somewhere in the environs of Herakleopolis. The nature and scale of the scene appears to surpass the form of decoration diagnostic of a royal Ka-chapel. Therefore, this would have to have been a royal cult complex decorated with scene types that characterize the royal pyramid complexes including extensive, large-format tableaux depicting the Sed-festival. Could it be the case that the Sed-festival block is to be attributed to an early Old Kingdom royal cult complex that once stood at—or near—Herakleopolis itself?

In 1976, Wolfgang Helck proposed the theory that the name of Herakleopolis, *Ḥnn-nswt*,[151] which appears first in the Sixth Dynasty,[152] is a derivation from the name of a royal cult foundation established at that location by king Huni at the close of the Third Dynasty.[153] Helck's argument derived from his interpretation of the name of Huni. While the nomen of Huni is traditionally read as *nswt Ḥwny*, or *nswt Ḥwy*, "the fighter,"[154] Helck suggested that writings of this king's name in later sources including the Turin Canon and Saqqara kinglist are abbreviated versions of an earlier name which, uniquely, is written with a *nswt* element inside the cartouche

"An Abusir Mastaba from the Reign of Huni," in V. Callender: *Times, Signs and Pyramids: Studies in Honour of Miroslav Verner on the Occasion of His Seventieth Birthday* (Prague, 2011), 41–50. However, the existence of a contemporary burial is not a strong indicator for the location of Huni's own tomb.

[149] Y. Harpur and P. Scremin, *The Tombs of Nefermaat and Rahotep at Maidum: Discovery, Destruction and Reconstruction* (Oxford, 2001), 29–30.

[150] Reader, "The Meidum Pyramid," 210–14.

[151] The name of Herakleopolis is alternatively read as *Nn-nswt*, literally: *city of the "baby of the king,"* Mokhtar, *Ihnasya el-Medina*, 2–14. However, omission of the *Ḥ*-element fails to account for continuity of that pronunciation into later Coptic and Arabic derivations of the toponym (i.e., Henes, Ihnasya).

[152] The earliest writing of the name *Ḥnn-nswt* occurs on a Sixth Dynasty statue from Sedment: H. Fisher, "An Occurrence of *Ḥnn-nswt* 'Ehnasya' on Two Statuettes of the late Old Kingdom," *JAOS* 81:4 (1961), 423–25.

[153] W. Helck, "Der Name des letzten Königs der 3. Dynastie und die Stadt Ehnas," *SAK* 4 (1976), 125–30.

[154] L. Borchardt, "König Huni?," *ZÄS* 46 (1909), 12–13; H. Schafer, "König Huni," *ZÄS* 52 (1914), 98–100; E. Meltzer, "A reconsideration of (⸗)|," *JEA* 57 (1971), 202–4; W. Barta, "Zum altägyptischen Namen des Königs Aches," *MDAIK* 29 (1973), 1–4; Seidlmayer, "Dynasty 3," 121–23.

(☥ ⌒ 𓏏)| It is noteworthy that the single inscribed monument of any scale attributed to Huni, a granite cone found near the small Third Dynasty pyramid at Elephantine, has the name written with *nswt* embedded in the nomen and within the cartouche.[155] Helck proposed the king's nomen should properly read as (*Ḥw-ny-nswt*), literally, "*The-utterance-belongs-to-the-king*," a nominal structure paralleled in other Old Kingdom personal names such as *Kȝ-ny-nswt*. Helck's understanding of the name of Huni, while doubted by a number of scholars,[156] has been further borne out by the recent discovery of an inscribed stone vessel at Abusir bearing the royal name *ny-swt-bity Nswt-Ḥ(w)-n(y)*, not written in a cartouche but confirming the fact that *nswt* is a bound part of the name just as Helck had concluded.[157]

The toponym of Herakleopolis, *Ḥnn-nswt*, Helck surmised was a derivation from a foundation name (*ḥwt*) *Ḥw-ny-nswt*. A cult establishment dedicated to Huni at Herakleopolis may have been one of a group of mortuary cult centers established under Huni in major urban centers, or the principal beneficiary of a network of mortuary estates dedicated to Huni. Mention of mortuary estates associated with Huni occurs during the Old Kingdom in the biographies of Metjen and Pehernefer.[158] Among Metjen's titles is *ḥkȝ ḥwt-ḥwni* written in an enclosure followed by a triple *niwt* determinative.[159] The continued existence through into the reign of Neferirkare of a royal cult foundation connected with Huni occurs in the Palermo Stone which includes mention of land endowments to a mortuary estate of king Huni (*nswt Ḥwni*) during the year of the 5th occasion of the cattle census under Neferirkare (Year 10).[160]

According to this interpretation—in a situation comparable to the application of the name *Mn-nfr-Ppi* (the pyramid complex of Pepi I at Saqqara) to the city of Memphis—Herakleopolis became known through its distinction of being the location of a major cult complex of king Huni. Despite the extreme paucity of archaeological evidence that has survived from Huni's reign, it is clear the king was remembered both as the predecessor of Sneferu, as well as for specific political and economic achievements that may have resonated through the Old Kingdom. The existence of a major cult installation of Huni at Herakleopolis appears both viable and intriguing given the possible late Third to Fourth Dynasty date we have proposed here for the Sed-festival block. If attributed to Huni, the relief could be a physical remnant of a cult complex dedicated to the elusive final king of the Third Dynasty. Perhaps this block derives from the very same royal complex which gave its name to Herakleopolis.

Huni has been suggested to have established the pattern of local pyramids documented near primary urban and religious centers in Upper and Middle Egypt: Elephantine, Tukh (Nagada), Kula (Hierakonpolis), Nag el-Ghonomeiya (Edfu), Sinki (south Abydos), and Zawiyet el-Meitin (near Minya).[161] The best documented of these, Huni's pyramid at Elephantine, appears to have been associated with a royal palace or cult establishment called *sšd* (*nswt-Ḥw-ny*)|, "palace of the '*diadem of Huni*'," recorded on the granite cone previously mentioned. This suggests a foundation that included a substantial royal cult building that likely incorporated visual commemoration of Huni's kingship. These pyramids may have been associated with provincial nome capitals and, in particular, localities that maintained regional royal residences.[162] The hypothesized (*ḥwt*) *Ḥw-ny-nswt* at Herakleopolis may have been a substantial royal cult complex that included an overt mortuary function. Presumably any establishment at Herakleopolis may have been of the scale and grandeur to put its mark on the landscape,

[155] Seidlmayer, "Dynasty 3," 121, n. 28, expresses doubt that inclusion of *nswt* within the cartouche indicates that it is an element of the king's nomen. He views this usage as paralleling inclusion of the *sȝ-Rˁ* element within the prenomen. This objection is, however, faulty in that *sȝ-Rˁ* occurs in multiple examples, whereas Huni is the only king to include *nswt* within the cartouche. Moreover, the word *nswt* alone should not properly introduce the nomen: rather it should be preceded by the combined term *ny-swt-bity*, "king of Upper and Lower Egypt," as we see, for instance, appearing in the reign of Sneferu ahead of the nomen. Consequently *nswt* embedded in Huni's name does not seem to have the function of introducing the nomen. Helck's suggestion seems viable, if not probable.

[156] Stadelmann: "King Huni: His Monuments and His Place in the History of the Old Kingdom," 425.

[157] Bárta, "An Abusir Mastaba from the Reign of Huni," 48, fig. 6.

[158] On the Metjen biography: J. Baines, "Forerunners of Narrative Biographies," in A. Leahy and J. Tait, eds., *Studies on Ancient Egypt in Honour of H. S. Smith* (London, 1999), 29–34.

[159] W. Helck: *Untersuchungen zur Thinitenzeit* (Wiesbaden 1987), 268–74.

[160] T. Wilkinson, *Royal Annals of Egypt: The Palermo Stone and its Associated Fragments* (London and New York, 2000), 177–78.

[161] G. Dreyer and W. Kaiser: "Zu den kleinen Stufenpyramiden Ober- und Mittelägyptens," *MDAIK* 36 (1980), 55–57.

[162] A. Ćwiek, "Date and Function of the so-called Minor Step Pyramids," *GM* 162 (1998), 39–52.

and survive as the toponym of the city from the Old Kingdom onwards. A possible cult complex of such scale would presumably exceed the more modest proportions expected of a Ka-chapel and explain the presence of large scale Sed-festival reliefs.

There exists no historical confirmation that Huni celebrated a Sed-festival: a not surprising problem given the extremely meager evidence that exists for his reign. As noted above, however, the figure of twenty-four years in the Turin Kinglist implies a reign of substantial duration. Notably the figure for Huni is close to the twenty-five years cited in that same document for Sneferu, whom we know from contemporary Fourth Dynasty texts to have reigned for closer to fifty years.[163] If the figures in the Turin Kinglist for these two rulers were derived from the biennial cattle count used in Old Kingdom administrative practices then Huni should have a reign of comparable duration to that of Sneferu.[164] This would provide ample time for the celebration of multiple Sed-festivals following the classical structure of the first Heb-Sed, *sp tpy Ḥb-Sd*, occurring in Year 30.[165] A shorter reign, however, would not necessarily preclude an earlier celebration of the Sed, or the symbolic depiction of the Sed-festival in reliefs commemorating Huni's kinship. We may also note in this connection the anonymous granite head, Brooklyn Museum 46.167, which has often been attributed to Huni.[166] This statue represents an over-life size king wearing the Sed-festival robe and has been tentatively placed at the end of the Third Dynasty by Hornung and Staehelin,[167] among others. Some scholars have suggested this figure might represent Sneferu or Khufu, but equally well—like the Herakleopolis relief—could depict Huni engaged in the Sed-festival.

No pyramid or other royal mortuary structure has been identified dating to the Old Kingdom on the desert edge west of Herakleopolis. However, millennia of landscape alteration in the multi-phase cemetery fields between Sedment on the north and the southern areas of the greater Herakleopolis cemeteries in the region of Mayana could easily conceal the ruins of such a monumental complex.[168] Herakleopolis was a major religious and urban center at the entrance to the densely inhabited Fayum region and deconstruction of a pyramid superstructure for masonry reuse could well have occurred in subsequent periods. The fact that the Sed-festival block had been reused already in the foundations of the Twelfth Dynasty Herishef temple could reflect an early Old Kingdom royal complex at the site that had suffered abandonment and damage during the First Intermediate Period, and which was then subject to reuse as construction as the temple of Herishef, and other building initiatives, occurred in the early Middle Kingdom. It can be hoped that ongoing excavation program of the Museo Arqueològico Nacional, Madrid, might uncover further evidence to illuminate this possibility. It appears likely that additional Old Kingdom blocks should exist, reused in the in-situ Middle Kingdom elements of the Herishef temple. A major Old Kingdom complex should presumably have left additional remnants scattered among the masonry of later buildings in and around Herakleopolis.

A potential association of Huni with Herakleopolis is intriguing in view of the debate that has surrounded attribution of the Meidum pyramid complex to Huni, to his successor Sneferu, or to both of these kings. The situation of the Meidum complex has appeared incongruous to many scholars, a seemingly random location without precedent on the northern flank of the Fayum entrance. However, what if it were the case that Huni had invested significantly in Herakleopolis with a major royal cult complex? Could the selection of Meidum then have been influenced by an establishment—either contemporary or preexisting—of Huni at Herakleopolis on the south side of the Fayum entrance? If not initiated already under Huni, Sneferu may have positioned his first pyramid complex and the associated residence city, *Djed-Sneferu*, on the northern side of the Fayum echoing his predecessor's establishment at Herakleopolis. Indeed, the small pyramid at Seila directly west of Meidum is the

[163] See R. Stadelmann, "King Huni: His Monuments and His Place in the History of the Old Kingdom," in Z. Hawass and J. Richards, eds., *The Archaeology and Art of Ancient Egypt: Essays in Honor of David B. O'Connor II*, Supp. ASAE 36 (2007), 425–26; S. Seidlmayer, "Dynasty 3," in E. Hornung, R. Krauss, and D. Warburton, eds., *Ancient Egyptian Chronology* (Leiden, 2006), 121–23.

[164] Reader, "The Meidum Pyramid," 215–16.

[165] It is unclear what the periodicity of the Sed festival may have been in the early periods as clear evidence for the tradition of Year 30 for the *sp tpy ḥb-sd* derives primarily from the New Kingdom: Wilkinson, *Early Dynastic Egypt*, 212–13, with references to the primary sources.

[166] C. Ziegler in *Egyptian Art in the Age of the Pyramids* (New York, 1999), 194, Cat. 21, with additional references.

[167] Hornung and Staehelin, *Neue Studien zum Sedfest*, 15.

[168] One may note in this connection that royal tombs of the Herakleopolitan Ninth and Tenth Dynasties have never been located in the desert-edge cemeteries west of Herakleopolis. Such structures must have been of substantial scale but are also missing from the landscape. For a chronological overview of the cemeteries: W. Grajetzki, *Sedment: Burials of Egyptian Farmers and Noblemen over the Centuries* (London, 2005).

only regional pyramid associated with Sneferu rather than Huni and may indicate a conspicuous derivation from the monumental program of Huni.[169] There might even be a form of intentional geographical symmetry with a new site situated with respect to a preexisting one forming a balanced pair flanking the Fayum entrance.[170] In view of the lack of compelling attribution of any of the Memphite area pyramid sites to Huni's long reign, it appears conceivable that Huni's primary funerary complex was at Herakleopolis and the development of Meidum under Sneferu is an outgrowth of the monumental program developed during his father's reign.

It is an appealing possibility that the Herakleopolis Sed-festival relief might be attributed to Huni. Added to that is the intriguing option that it might derive from a major, early Old Kingdom royal cult complex that could have been the source for the name of Herakleopolis in later periods. Indeed, with the uncertainty regarding the attribution of the relief of Horus Qa-Hedjet, previously thought to belong to Huni,[171] but now considered to be a Saite relief or a modern forgery,[172] the Herakleopolis Sed-festival relief could be the only surviving image to depict the elusive final king of the Third Dynasty. This is admittedly a lot of weight to place on one Sed-festival relief, but such is the nature of the archaeological evidence for the beginning of the Egypt's Pyramid Age.

Conclusions

The life-size scene, discovered at Herakleopolis, of an Old Kingdom ruler, accompanied by Iunmutef, receiving the barque of Nekhbet in her form *Wenut-Shemau* at the Sed-festival provides new insight into the early ritual structure of the Heb-Sed. The relief, part of a larger tableau which has not survived, suggests the existence of a previously unrecognized set of rituals that expressed fundamental geographical dimensions of pharaonic kingship. The king's formal reception of *Wenut-Shemau*/Nekhbet appears to highlight her presence as representative of Upper Egypt, as well as divine witness and participant in the rituals of the Sed. Although no direct evidence has survived confirming a northern counterpart to the barque of *Wenut-Shemau*, the ritual was likely matched by the arrival of the barque of Wadjet: the two goddesses together forming a fundamental statement on the recognition of the king's Heb-Sed by Upper and Lower Egypt. It appears probable that the arrival of the barques of the two territorial goddesses transcended that of the wider representation of regional deities at the Sed. As emblematic goddesses of Upper and Lower Egypt, and key goddesses underlying the definition of kingship, the arrival of the *nbty* or "Crown Goddesses," Wadjet and Nekhbet, may have constituted a pivotal moment that legitimized the larger sequence of Heb-Sed rites. It is likely the reception of the barques of Nekhbet and Wadjet occurred at the very beginning of the sequence of events that structured the Sed-festival and formed a fundamental recognition of the king's territorial legitimacy and claim to celebrate the Sed.

Although the Herakleopolis relief remains unique in many respects, it is not unparalleled, either in terms of the king's ritual action of grasping the prow rope of a divine barque, or in the Sed-festival symbolism it expresses. The scene's closest contemporary parallels occur in the, unfortunately fragmentary, scenes in the "Valley Temple" or "Heb-Sed temple" associated with the Bent Pyramid of Sneferu at Dahshur. Here we have suggested that the relief recovered at Herakleopolis derives from a structure comparable in scale and decoration to the Sneferu Valley Temple: a building that once contained a nuanced program of large-scale Sed-festival scenes. Consideration of the Valley Temple suggests its entrance hall may have held scenes showing the royal reception of the barques of Nekhbet and Wadjet in the same pose employed in the Herakleopolis relief: the striding stance used in the "encircling of the field" and affirming the king's bodily authority over the Two Lands emblemized by the *nbty* goddesses, Wadjet and Nekhbet. Remarkably, the journey of *Wenut-Shemau* to the Heb-Sed was still

[169] R. Stademann, "Snofru: Builder and Unique Creator of the Pyramids at Seila and Meidum," in O. el-Aguizy and M. Ali, eds., *Echoes of Eternity: Studies Presented to Gaballa Aly Gaballa* (Wiesbaden, 2010), 31–38; K. Muhlestein, "New Evidence from the Seila Pyramid," *SAK* 44 (2015), 249–58.

[170] For a discussion of the importance of the Fayum region during the period under consideration: A. Ćwiek, "Fayum in the Old Kingdom," *GM* 160 (1997), 17–22.

[171] J. Vandier, "Une stèle égyptienne portant un nouveau nom royal de la troisième dynastie," *CRAIBL* (1968), 25–38; T. Wilkinson, *Early Dynastic Egypt* (London and New York, 1999), 104–5.

[172] Pätznick, "L'Horus Qahedjet: souverain de la 3ème dynasty ?," 1455–73.

practiced some 1500 years later during the Twentieth Dynasty when, in his tomb chapel at El-Kab, Setau commemorated his accompaniment of the *Wenut Shemau* barque to the Sed-festival of Rameses III.

Now well over a century after its discovery in 1904, this Sed-festival relief remains the only royal relief attributable to the Old Kingdom at Herakleopolis. Its presence at that particular site—and mode of reuse as a foundation slab in the Middle Kingdom level of the Herishef temple—presents a challenging set of archaeological questions that cannot be conclusively resolved. Despite the anonymity of the king depicted, the relief appears to date to the early Old Kingdom and likely derives from a major monumental complex of the late Third or Fourth Dynasty. Here we have considered various possible explanations including its derivation from a now-lost Old Kingdom phase of the Herishef temple or from a royal Ka-chapel that once stood in the vicinity of the Herishef temple. However, the nature and scale of the scene do not appear to fit well with its origin in a local god's temple, nor in a Ka-chapel. Rather it appears to have derived from a royal cult complex of significant scale and with a decorative program similar to the Old Kingdom pyramid complexes. Long-distance transport of the block from the Memphite necropolis, or the closer site of Meidum, appear to offer viable explanations for the block's reuse at Herakleopolis. Nevertheless, reuse of the block so far from these possible points of origin remains fundamentally unsettling in terms of the block's prosaic reuse as a foundation stone.

A more attractive explanation is the possibility that Herakleopolis was itself home to a major, early Old Kingdom royal mortuary complex. In this connection the intriguing theory, originally proposed by Helck, that the historical name of Herakleopolis—*Henen-Nesut*, is a derivation from the name of a cult complex of the last king of the Third Dynasty, *Hu-ny-nesut* (Huni), provides a fascinating possibility to explore. The Sed-relief could, in this case, depict the poorly documented king Huni, long known to have built regional pyramids and cult locales in many parts of Egypt, but for whom we lack a confirmed pyramid complex or burial locale. With its closest stylistic and programmatic parallels in the reign of Sneferu, it is tantalizing to consider that the Sed-relief from Herakleopolis might depict Sneferu's father Huni and come from a royal mortuary complex belonging to him that has yet to be identified in the region of Herakleopolis Magna. While the block raises many questions, and its specific attribution remains open to discussion, it appears that further scrutiny by scholars, paired with new archaeological results from sites including Herakleopolis itself, may shed additional light on this notable fragment of Old Kingdom royal architecture.

Egyptian Section, University of Pennsylvania Museum

Unusual Middle Kingdom Funerary Stela of a Man
at Alexandria National Museum no. 223

MARZOUK AL-SAYED AMAN

Abstract

Publication of a Middle Kingdom stela, is exhibited in Alexandria National Museum (Inv. No. 223), including comments on the style, iconography, paleography, and dating criteria.

The stela is housed in Alexandria National Museum with the inventory number 223.[1] This monument was originally in the Cairo Museum (CG 20509= JE 10371) and was noted in the H. Lange and H. Schafer 1908 Cairo catalogue.[2] The provenance of the stela is unknown. This stela and other pieces came from the Cairo Museum to the Alexandria National Museum which was inaugurated on 31 December 2003 (figs. 1–2).

Description of Stela

The stela is a rectangular round-topped stela of unpainted limestone. This type of object is attested in Dynasty 11 during the earlier part of the reign of Montuhotep I, probably first at Abydos and later at Thebes.[3] The stela is generally in good condition; the surface was carefully prepared and it is smooth. The stela measures 37 cm by 24 cm. There is a large figural field of a man in raised relief. The man has no offering table in front of him, but we do see a boat instead. There are also three main horizontal lines of hieroglyphic text in sunk inscription at the top. Parts of the figure and inscriptions are incomplete. There is a break on the owner's right foot. One can see also the absence of borderlines. The main points of interest are the relatively poor quality of the inscription and other idiosyncrasies which suggest that the object was never completed.

The figure of the owner (a) stands on the left, facing right. He wears a close-fitting wig with over lapping rows of locks that leaves the ears exposed. (b) The ear of the owner is missing. He wears a broad collar and a projecting knee-length kilt. A belt is shown in raised relief on the surface of the garment without a diagonal stripe across the kilt (c). In his left hand, he holds a short staff (d), the lower part of the staff was ignored; the right hand holds

[1] I wish to thank Dr. Nadia Khedr, Director of Alexandria National Museum and the staff of the Museum, for permission to publish the stela and for providing the photograph. Further thanks are due to Prof. Adel El-Tokhy for his review this article. I am also grateful to the referees for their comments; the present text owes much to their recommendations. All the contents of the article are my responsibility.

[2] See Lange and Shäfer, *CG 20001-20780 II*, 98 (20509).

[3] Cf. the stela of Nakhty (probably from Abydos; now at Chatsworth 720/12), Turin Cat. no.1513, Pittsburgh Z9–497, Copenhagen JEIN 963 (bought at Luxor), and, from the second half of Montuhotep's reign, Turin Cat. no. 1447 and Louvre C 14 (both probably from Abydos), from the same reign is Cairo TR 3/6/25/1, found at el-Tarif see Detlef Franke, "The Good Shepherd Antef (Stela BM EA 1628)," *JEA* 93 (2007), 168–69, n. 77; *PM I*, 596 (12); Vandier, *Manuel II*, 475, n. 1, 477 (fig. 293). See also Stela Florence 6364 (from Luxor; said to be from Edfu) is not dated. From the end of Dynasty 11 are BM EA 159, R. Faulkner, "The Stela of Rudj'ahau," *JEA* 37 (1951), pl. V, II, and EA 152 (Stele of Nefer-Tut) from Abydos, T. James, ed., *Hieroglyphic Texts from Egyptian Stelae, etc., in the British Museum* II (London, 1912), pl. xxxiv), noted in Franke "The Good Shepherd Antef," 169, n. 77.

a scepter (e). The scepter is shown behind the owner's kilt. A representation of a ship above water (f) is poorly incised in front of the owner.

Remarks on the Representations and the Style

Iconographic Dating Criteria

a) The owner carries a stick with his left hand and the scepter in his right is a style commonly used in the Old Kingdom. This posture can be seen as early as Dynasty 3 and became common during the Old Kingdom,[4] the Dynasty 11[5] and later. For Dynasty 11 examples, see the stela of the National Archaeological Museum, Athens L131,[6] and the stela of Wahankh Intef.[7]

b) The style of this wig was common during Late First Intermediate Period and Dynasty 11 stelae, see, for example, the stela of Khuy (Late First Intermediate Period), the stela of Iteti (JE 46049, Cairo Museum),[8] and the stela of the Antef (BM EA 1628, Dynasty 11).[9]

c) The belt is without a diagonal stripe across the kilt. This style was popular throughout Dynasty 11, for example, the stela of Wahankh Intef,[10] the stela of Intef born of the lady Tjefi (MMA 57.95),[11] the stela of Antef (BM EA 1628[12]), the stela of Amenemhat (Brooklyn Museum 37.1346E),[13] and the stela of Iny and Imy, (Cairo Museum JE36422=CG 20800, dated between Dynasties 11 and 13).[14]

d) The staff and the scepter are indicative of a high status.[15] In this stela the staff is incomplete. Compare the staff and scepter which are frequently held by the owner of the

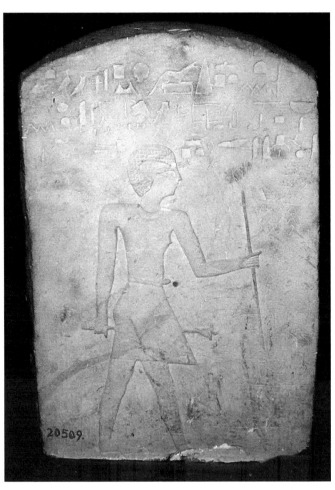

Fig. 1. Stela of Sobekhetep (photograph courtesy of the Alexandria National Museum, no. 223).

[4] Cf. Y. El-Masry, "An Unpublished Stela from the Ancient Cemetery of Thinis," *SAK* 31 (2003), 272.

[5] K. Pflüger, "The Private Funerary Stelae of the Middle Kingdom," *JAOS* 67(2), (1947), 130.

[6] D. Stefanović, "Four Middle Kingdom Stelae from the National Archaeological Museum, Athens," *JEA* 96 (2010), 210, fig. 2.

[7] "Stelae of the Early 11th Dynasty – UCL" (www.ucl.ac.uk/museums-static/digitalegypt/thebes/.../antefstelae.html).

[8] M. El-Khadragy, "A Late First Intermediate Period Stela of the Estate Manager Khuy," *SAK* 27 (1999), 223–24, fig.1; A. Abdalla, "Two Monuments of Eleventh Dynasty Date from Dendera in the Cairo Museum," *JEA* 79 (1993), 253, pl. XXIV, 2, fig. 2.

[9] Franke, "The Good Shepherd Antef," fig. 3, pl. VI.

[10] "Stelae of the Early 11th Dynasty – UCL" (www.ucl.ac.uk/museums-static/digitalegypt/thebes/.../antefstelae.html).

[11] H. Fischer, "An Example of Memphite Influence in a Theban Stela of the Eleventh Dynasty," *Artibus Asiae* 22, No. 3 (1959), 240, fig. 4.

[12] Franke, "The Good Shepherd Antef," fig. 3, pl. VI.

[13] D. Spanel, "Palaeographic and Epigraphic Distinctions between Texts of the So-called First Intermediate Period and the Early Twelfth Dynasty," in P. Der Manuelian ed., *Studies in Honor of William Kelly Simpson, II, Museum of Fine Arts* (Boston 1996), 780–81, figs. 4–5.

[14] R. Baligh, "Three Middle Kingdom Stelae from the Egyptian Museum in Cairo," *JARCE* 44 (2008), 182, fig. 3.

[15] Cf. Baligh, "Three Middle Kingdom Stelae," 170–72, fig. 1.

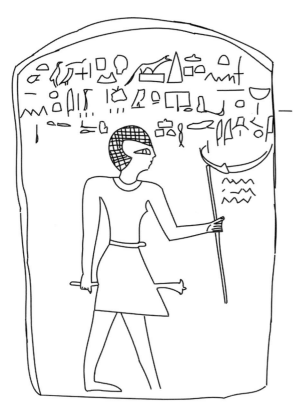

Fig. 2. Stela of Sobekhetep (line drawing by the author).

dated stelae of Dynasty 11.[16] See also the stela of Wa-hankh Intef,[17] the stela National Archaeological Museum, Athens L131 (early Middle Kingdom[18]), the stela of Imeny (Cairo Museum JE 45246=CG 20810[19]), the stela of Antef (BM EA 1628[20]), the stela of Amenemhat (Brooklyn Museum 37.1346E[21]), and the stela of Iny and Imy (Cairo Museum JE36422=CG 20800[22]).

e) The scepter is shown behind owner's figure in order not to cut it.

It is not shown in raised relief in the surface of the kilt as usual. This type was popular throughout Dynasty 11 as seen on the stela of Wahankh Intef,[23] the stela of Amenemhat (Brooklyn Museum 37.1346E[24]), and the stela of Imeny (Cairo Museum JE 45246=CG 20810[25]).

Discussion of the Boat

f) The aim of this ship is obscure. Although this man has another stela with a similar representation of a boat in front of him (CG20508[26]), neither the boat nor any other titles that connect the man with it were mentioned in the hieroglyphic texts of the two stelae. On the other hand, after 1300 BC, votive stelae of the royal court include the motif of the sun Ra in boat,[27] but the boat in our stela does not have any reference to the sun god. The representation of the boat is incomplete; it is without oars or post. However, it is closest to the style of models and paintings of boats found in Dynasty 11 (compare the boat paintings from Kheti's tomb at Beni Hasan and the boats models of Meketre).[28]

Ships have been mentioned on the texts and the stelae of some of the persons associated with the vessels or their supervision during the era of the Old Kingdom,[29] Dynasty 11, the beginning of Dynasty 12, and thereafter, for example: the drum of a false-door from the mastaba of Ankhu (Real Academia de Cordoba, Spain, 1981/1/299, Old Kingdom), where Ankhu holds a title that shows he performed duties connected with boats 𓏤𓏤 *ḥrp ꜥpr(w) ksw* "crew commander of *ks*-ships."[30] On the upper part of a false-door belonging to Pernedju, (Dynasty 6, Saqqara), Pernedju was depicted with his wife sitting facing each other and sharing the

[16] Pflüger, "The Private Funerary Stelae of the Middle Kingdom," 130.

[17] "Stelae of the Early 11th Dynasty – UCL" (www.ucl.ac.uk/museums-static/digitalegypt/thebes/.../antefstelae.html).

[18] Stefanović "Four Middle Kingdom Stelae from the National Archaeological Museum, Athens," 210, fig. 2.

[19] This stela is dated to the late Dynasty11 to early Dynasty 12, see Baligh, "Three Middle Kingdom Stelae," 170–72, 174, fig. 1.

[20] Franke, "The Good Shepherd Antef," fig. 3, pl. VI.

[21] Spanel, "Palaeographic and Epigraphic Distinctions," 780–81, figs. 4–5.

[22] Baligh, "Three Middle Kingdom Stelae," 182, fig. 3.

[23] "Stelae of the Early 11th Dynasty – UCL" (www.ucl.ac.uk/museums-static/digitalegypt/thebes/.../antefstelae.html).

[24] Spanel, "'Palaeographic and Epigraphic Distinctions," 780–81, figs. 4–5.

[25] This stela is dated to the late Dynasty 11 to early Dynasty 12, see Baligh, "Three Middle Kingdom Stelae," 170–72, 174, fig. 1.

[26] Lange and Shäfer, *CG 20001-20780 II*, 98 (20508).

[27] S. Quirk, *Exploring Religion in Ancient Egypt* (Oxford, 2015), 128.

[28] Cf. D. Spanel, "Ancient Egyptian Boat Models of the Herakleopolitan Period and Eleventh Dynasty," *SAK* 12 (1985), 244–46, figs. 1–2.

[29] See J. Galán, "Two Old Kingdom Officials Connected with Boats," *JEA* 86 (2000), 145–50.

[30] Galán, "Two Old Kingdom Officials Connected with Boats," 145–46, fig. 1.

loaves placed on the funerary table that stands between them. At each side of the scene there is a column with four boats, one above the other. These eight boats are different in their profiles. Pernedju's main title describes his occupation as: ⟦hieroglyphs⟧ *sš tst ʿprw n ḫrt nsw Pr-nḏw* "scribe of enrollment for the crew of the royal property, Pernedju."[31] We also note the architrave of Hornakhte (Dynasty 11, Cairo JE46048,[32]), the stela of Thethi (BM 614, Dynasty 11[33]), and the stela of Antefoker (Dynasty 12), which indicate that the ships were built in the dockyards of Coptos and then rebuilt on the shore of the Red Sea'[34] and the stela used for building the shrine of Ankhou (Dynasty 12), the leader of naval expedition to the land of Bia, Punt.[35] The title *imy-r pr ḥsb ʿḥʿw* "the steward of reckoning of ships" was mentioned on a funerary stela dating back to the end of Dynasty 12, its owner called Dedusobek (lower part of stela, Acc.No.E.51.1901[36]). We should compare these with a stela in the Brooklyn Museum (Acc. No. 37.1919E, probably Dynasty 19), which depicted a man with a large flail who kneels before a table stacked with offerings. Above him there is seen a ship with a large cabin and a long steering oar which sails above a strip of water above four fish.[37]

In our stela the owner was depicted in a supervisory role. He is standing and holding a staff and a scepter. Based on foregoing comments, he was possibly a steward of ships. We must also keep in mind that boats were the means for transport of the deceased to the "Beautiful West" where Osiris resided.[38]

The Inscription

The text runs right to left, it contains offering formula.

Transliteration and translation of text

[1] *ḥtp di nisw inpw tpy ḏw.f imi wt* [2] *nb tȝ ḏsr prt-ḫrw t ḥnkt ḫȝ m kȝw ȝpdw iḫt n* [3] *imȝḫy sbk ḥtp mȝʿ ḫrw*

"[1] An offering which the king gives[g] and Anubis,[h] who is on[i] his mountain,[j] who is in the place of embalming,[k] [2] lord of the sacred land[l][39] an invocation offering[m] (consisting of) a thousand[n] of bread, beer, oxen, and fowl[o], for[p] [3] the venerated[q] Sobekhetep[r] true of voice.[s]"

Textual Commentary and Dating Criteria

g) The writing of the *ḥtp-di-nsw* formula with this arrangement of the signs ⟦hieroglyphs⟧ is the most common found on the monuments of Dynasties 11–13.[40] For examples see the stelae of Antef (Cairo CG 20009), and

[31] Galán, "Two Old Kingdom Officials Connected with Boats," 148–49, fig. 2.

[32] See Abdalla, "Two Monuments of Eleventh Dynasty Date," 249, pl. XXIV, fig.1.

[33] See A. Blackman, "The Stele of Thethi, Brit. Mus. No. 614," *JEA* 17, No. 1/2 (May, 1931), 56, pl. III, line 11.

[34] A. Monem A.H. Sayed, "The Land of Punt: Problems of the Archaeology of the Red Sea and the Southern Delta," in Z. Hawass, ed., *Egyptology at the Dawn of the Twenty-First Century, Proceedings of the Eighth International Congress of Egyptologists, Cairo 2000, I* (Cairo, 2003), 433.

[35] Sayed, "The Land of Punt," 433.

[36] G. Martin, et al., *Stelae from Egypt and Nubia in the Fitzwilliam Museum, Cambridge, C. 3000 BC- AD 1150* (Cambridge, 2005), 26.

[37] "Stela with a Boat and Osiris ca.1292–1075 B.C.- Brooklyn" (https://www.brooklynmuseum.org./opencollection/objects/118424).

[38] I. Medvedev-Mead, "Soul Boats," *The San Francisco Jung Institute Library Journal* 24, No. 3, August (2005), 18, 23–24; M. Lurker, *The Gods and Symbols of Ancient Egypt* (London, 1980), 31–32.

[39] Cf. El-Khadragy, "A Late First Intermediate Period Stela of the Estate Manager Khuy," 225.

[40] P. Smither, "The Writing of *ḥtp-di-nsw* in the Middle and New Kingdoms," *JEA* 25 (1939), 34; see also Barta, *Opferformel*, 43–84; H.

Rudj'aḥau (BM EA 159[41]), both from Dynasty 11,[42] the stela Cairo Museum (R22, N8) JE 37515, which dates to Dynasty 12,[43] the stela of Ankhib (private collection), which dates to Dynasties 12–13,[44] the stela of Dienraankh (Cairo Museum, CG 20684), and the stela of Dedusobek (Cairo Museum, TN 30.10.17.5), which also dates to Dynasties 12–13.[45] The arrangement of ⳼ ▱ ▱ 𓊪𓊪 𓉐𓊪 ḥtp-di-nsw, as it is found on our stela, was known and usual from Dynasties 5 to 11.[46] For a Dynasty 11 example see the inscription of Henui (Berlin Museum 13772[47]). During Dynasty 12 the same arrangement was found, but without the sign t in the writing of the word ḥtp.[48] This arrangement was uncommon from Dynasties 13 to 18.[49]

h) In Dynasty 11 Anubis is often invoked in the ḥtp-di-nsw formula[50] (Cairo CG 20542,[51] and inscriptions of Henui, Berlin Museum 13772).[52] In Dynasty 12 Anubis is replaced in many cases by Wepwawet,[53] (stela 720/12 at Chatsworth[54]). In our stela the name of Anubis was written without phonetic signs, a style which is uncommon before the First Intermediate Period and Early Middle Kingdom, although irregular earlier examples are known.[55] For a Dynasty 11 example, see the stela of Antef (Cairo CG 20009[56]).

i) In our stela the head sign of the word tpj lacks the beard. The beard is usually present in the head sign in the groups from Dendera dated to the Old and Middle Kingdoms, and it is as often omitted as it is present in Dynasty 11, while it is completely absent in the group going in date from Dynasties 8 to 10.[57] For Dynasty 11 examples, see the stela of Antef (Cairo CG 20009[58]), and the Antef Stela (BM EA 1628[59]).

j) One of the important criteria for dating this stela is the sloping sides of mountain sign ◁▷ (Gardiner N6) of the word ḏw, as it has been suggested to be characteristic of the Dendera inscriptions from Dynasty 8, or slightly earlier, down to Dynasty 11.[60] For Dynasty 11 examples see the architrave of Hornakhte (Cairo JE46048[61]) and the stela of Antef (Cairo CG 20009[62]).

Selim, "Three Identical Stelae from the End of the Twelfth or Thirteenth Dynasty," *SAK* 29 (2001), 325–26; K. El-Enany, "Une stèle privée de la fin du Moyen Empire découverte à Karnak: Le Caire, Musée Ēgyptien JE37515," *BIFAO* 108 (2008), 108; P. Vernus, "Sur les graphies de la formule 'l'offrande que donne le roi' au Moyen Empire et à la Deuxième Période Intermédiaire," in S. Quirke, ed., *Middle Kingdom Studies* (New Malden, 1991), 144–45; H. Satzinger, "Beobachtungen zur Opferformel: Theorie and Praxis," *Lingua Aegyptia* 5 (1997), 177–88; L. Morenz, "Lesbarkeit der Macht. Die Stele des Antef (Kairo, CG 20009) als Monument eines frühthebanischen lokalen Herrschers," *Aula Orientalis* 21 (2003), 240, fig.1.

[41] Faulkner, "The Stela of Rudj'aḥau," 47–48, pl. VII.

[42] Morenz, "Lesbarkeit der Macht," 240, fig. 1.

[43] K. El-Enany, "Une stèle privée de la fin du Moyen Empire," 95–108.

[44] R. Leprohon, "A Late Middle Kingdom Stela in a Private Collection," in P. Der Manuelian and R. Freed, eds., *Studies in Honor of William Kelly Simpson*, II (Boston, 1996), 523, 528–29, figs. 1–2.

[45] Selim, "Three Identical Stelae from the End of the Twelfth or Thirteenth Dynasty," 319–30, figs. 1–2.

[46] Barta, *Opferformel*, 12, 21, 36, 43.

[47] *Berl. Insch.*, I, 231.

[48] See Barta, *Opferformel*, 53; A. Gardiner and T. Peet, *The Inscriptions of Sinai*, I (London, 1917), fig. 48, nr. 121.

[49] Barta, *Opferformel*, 72–138.

[50] C. Bennett, "Growth of the ḥtp-di-nsw Formula in the Middle Kingdom," *JEA* 27, (1941), 80.

[51] See Lange and Shäfer, *CG 20001-20780 II*, 16 3(20542).

[52] *Berl. Insch.*, I, 231.

[53] Bennett, "Growth of the ḥtp-di-nsw Formula in the Middle Kingdom," 80

[54] D. Franke, "The Middle Kingdom Offering Formulas: A Challenge," *JEA* 89 (2003), 50.

[55] Cf. El-Khadragy, "A Late First Intermediate Period Stela of the Estate Manager Khuy," 229; idem, "The Adoration Gesture in Private Tombs up to the Early Middle Kingdom," *SAK* 29 (2001), 191.

[56] Morenz, "Lesbarkeit der Macht," 240, fig. 1.

[57] Cf. El-Khadragy, "A Late First Intermediate Period Stela of the Estate Manager Khuy," 229. See also the stela of Antef, Cairo CG 20009; Morenz, "Lesbarkeit der Macht," 240, fig. 1.

[58] Morenz, "Lesbarkeit der Macht," 240, fig. 1.

[59] Franke, "The Good Shepherd Antef," fig. 3, pl. VI.

[60] Cf. W. Petrie, *Dendereh 1898* (London, 1900), pl. VIII; El-Khadragy, "A Late First Intermediate Period Stela of the Estate Manager Khuy," 229; Y. El-Masry, "An Unpublished Stela from Thinis," 271, n.11.

[61] Abdalla, "Two Monuments of Eleventh Dynasty Date from Dendera in the Cairo Museum," 249, pl. XXIV, fig. 1.

[62] Morenz, "Lesbarkeit der Macht," 240, fig. 1.

k) The writing of the epithet *jmj wt* using the Anubis determinative is a useful criterion for the dating of this stela. According to Schenkel[63] *jmj wt* is written with the city-determinative (Gardiner O49) until the end of Dynasty 6, then with the pustule determinative (Gardiner Aa2) or the like until Dynasty 12.[64] Our stela has ⟨⟩ which has some similarity with the regular determinative which is attested from the end of Dynasty 6 and during Middle Kingdom.[65] For an end of Dynasty 6 example, see the Mena sarcophagus.[66] For Dynasty 11 examples, see the Antef Stela (BM EA 1628[67]), and the stela of Antef (Cairo CG 20009[68]). One should also notice here the grouping of *jmj wt*, in which the *m*-sign is found among the *jmj* and *wt*.

l) One should also notice here the absence of the desert-determinative (Gardiner N25) in the word *t3 ḏsr*.[69] Compare to the Antef Stela (BM EA 1628[70]), and the stela of Antef (Cairo CG 20009[71]).

m) The loaf-sign (Gardiner X3) in *prt ḫrw* is missing. Also, the sign ⟨⟩ is incomplete, only its upper part is incised. In Dynasty 11 the *prt-ḫrw* invocation is normally used, for example in the Antef Stela (BM EA 1628[72]), while in Dynasty 12 the formula *di.f prt-ḫrw* "that he may give an invocation" is preferred.[73]

n) The sign *ḫ3* is incomplete; the lower part of it is missing. The arrangement of *ḫ3* + an offering is sometimes characteristic of Dynasty 11 texts, see the stela of Antef (Cairo CG 20009[74]), the Antef Stela (BM EA 1628[75]), and from the end of Dynasty 11 the Rudj'aḥau stela (BM EA 159[76]).

o) The head of the ox in the offering formula is simply formed in outlines only without internal details. The usual offerings mentioned in the formula in Dynasty 11 are bread, beer, oxen, fowl, alabaster, and linen (e.g., the Antef Stela BM EA 1628 and the Rudj'aḥau stela BM EA 159). In Dynasty 12 incense and oil are often added.[77]

p) The papyrus scroll without ties (Gardiner Y2) in the word *iḫt* occurs in Dynasty 11 (Stela BM EA 1628[78]) and still occurs in the reign of Senwosret II.[79]

q) Bennett mentioned that in Dynasty 11 and usually in the reign of Sesostris I, the deceased is noted as being *im3ḫw/im3ḫy*, the "honored one."[80] There are numerous examples from Dynasty 11 into Dynasty 12 (e.g., Dynasty 11 false door from Kom el Akhdar and Dynasty 11 offering slab[81]). Franke[82] and Pflüger[83] mentioned also that the title *im3ḫw/im3ḫy* was used during early Dynasty 12. The title *im3ḫy* is inscribed in this stela with the sickle and the double reed-leaf found grouped with Gardiner F39. The double reed-leaf ending is common in Dynasty 12 inscriptions, but the sickle is also found in earlier writings.[84]

[63] W. Schenkel, *Frühmittelägyptische Studien* (Bonn, 1962), 40–41,107; cf. El-Khadragy, "A Late First Intermediate Period Stela of the Estate Manager Khuy," 229, and El-Masry, "An Unpublished Stela from Thinis," 271, n. 12.

[64] Schenkel, *Frühmittelägyptische Studien*, 40–41; El-Khadragy, "The Adoration Gesture in Private Tombs up to the Early Middle Kingdom," 191–92.

[65] Petrie, *Dendereh 1898*, pl. III; cf. El-Masry, "An Unpublished Stela from Thinis," 271, n. 12; Franke, "The Good Shepherd Antef," fig. 3, pl. VI; Morenz, "'Lesbarkeit der Macht," 240, fig. 1.

[66] Petrie, *Dendereh 1898*, pl. III; cf. El-Masry, "An Unpublished Stela from Thinis," 271, n. 12.

[67] Franke, "The Good Shepherd Antef," fig. 3, pl. VI.

[68] Morenz, "Lesbarkeit der Macht," 240, fig. 1.

[69] See *Wb* V, 228.6–9; cf. Franke, "The Good Shepherd Antef, fig. 3, pl. VI; Morenz, "Lesbarkeit der Macht," 240, fig. 1.

[70] Franke, "The Good Shepherd Antef," fig. 3, pl. VI.

[71] Morenz, "Lesbarkeit der Macht," 240, fig. 1.

[72] See n. 70.

[73] Bennett, "Growth of the *ḥtp-di-nsw* Formula in the Middle Kingdom," 77; Barta, *Opferformel*, 46, 56.

[74] See n. 71.

[75] See n. 70.

[76] See n. 41.

[77] Bennett, "Growth of the *ḥtp-di-nsw* Formula in the Middle Kingdom," 79.

[78] See n. 70.

[79] Cf. Franke, "The Good Shepherd Antef,"167, fig. 3, pl. VI; see Schenkel, *Frühmittelägyptische Studien*, 27, §2; Spanel, "Palaeographic and Epigraphic Distinctions," 779–84.

[80] Bennett, "Growth of the *ḥtp-di-nsw* Formula in the Middle Kingdom," 79.

[81] H. Fischer, "Some Early Monuments from Busiris, in the Egyptian Delta," *MMJ* 11 (1976), 7, 9, figs. 3–4, and 7.

[82] Franke, "The Middle Kingdom Offering Formulas: A Challenge," 48, n. 50.

[83] Pflüger, "The Private Funerary Stelae of the Middle Kingdom," 133.

[84] S. Orel, "Two Unpublished Stelae from Beni Hasan," *JEA* 81 (1995), 217, a.

r) The crocodile sign in the name of the man is poorly formed in outline only without internal details. The form of the seated-man determinative used in text is poorly incised, and it is typical for a group of Dynasty 11 texts from Dendera (compare the architrave of Hornakhte, Cairo JE46048).[85]

According to Ranke, the name of Sobekhetep was common during Old, Middle and New Kingdom period, mainly as a masculine name, but also occasionally as a feminine name.[86] According to Petrie, there is a tomb-pit in Dendera belonging to a man named Sobekhetep, which he dates to Dynasty 11.[87] It is possible that he is the owner of our stela.

s) *mꜣꜥ ḫrw* is poorly incised.

Conclusions

The stela under consideration probably came from cemetery of Dendera, which extends from the back of the temple, up a decline of desert, for about a third of a mile, to a boundary bank which surrounds it. This cemetery contains a series of mastabas and tomb-pits dating back to different ages.[88] One of these tomb-pits dating back to Dynasty 11 belongs to a person named Sobekhetep,[89] who is possibly the owner of our stela. On the other hand, many of palaeographic details also point to this cemetery as a provenance of this stela, for examples, the absence of the bread in the head sign of the word *tpj*,[90] the sloping sides of mountain sign of the word *ḏw*,[91] and the form of the seated-man determinative used in our text which is typical for a group of Dynasty 11 texts from Dendera.[92]

On the whole, the stylistic, iconographic, palaeographic, and epigraphic details of the stela suggest a date within Dynasty 11, such as the owner carrying the stick with his left hand and the scepter in his right a Dynasty 11 style.[93] The belt without diagonal stripe across the kilt,[94] and the scepter which is shown behind owner's figure,[95] were popular throughout Dynasty 11.

The motif of the boat in front of the owner of the stela is very rare; however, this boat is closest to the style of models and paintings of boats of Dynasty 11.[96] In addition the arrangement of signs, the omitting of the beard on *tpj*, the variation on the *wt*-determinative, the format of the *prt-ḫrw* formula are all characteristic of Dynasty 11 texts. Lastly, the name of Sobekhetep, who had a tomb-pit in Dendera, dating back to Dynasty 11

[85] Abdalla, "Two Monuments of Eleventh Dynasty Date from Dendera in the Cairo Museum," 251, pl. XXIV, fig. 1; Petrie, *Dendereh 1898*, pl. XV.

[86] See Ranke, *PN* I, 305.6.

[87] Petrie, *Dendereh 1898*, 13.

[88] Petrie, *Dendereh 1898*, 2, 4–31.

[89] Petrie, *Dendereh 1898*, 13.

[90] Cf. El-Khadragy, "A Late First Intermediate Period Stela of the Estate Manager Khuy," 229. See also the stela of Antef (Cairo CG 20009), Morenz, "Lesbarkeit der Macht," 240, fig. 1.

[91] Cf. Petrie, *Dendereh 1898*, pl. VIII; El-Khadragy, "A Late First Intermediate Period Stela of the Estate Manager Khuy," 229; El-Masry, "An Unpublished Stela from Thinis," 271, n. 11; Abdalla, "Two Monuments of Eleventh Dynasty Date from Dendera in the Cairo Museum," 249, pl. XXIV, fig.1; Morenz, "Lesbarkeit der Macht," 240, fig. 1.

[92] Cf. the architrave of Hornakhte, Cairo JE46048, Abdalla, "Two Monuments of Eleventh Dynasty Date from Dendera in the Cairo Museum," 251, pl. XXIV, fig. 1; Petrie, *Dendereh 1898*, pl. XV.

[93] Pflüger, "The Private Funerary Stelae of the Middle Kingdom," 130.

[94] "Stelae of the Early 11th Dynasty – UCL" (www.ucl.ac.uk/museums-static/digitalegypt/thebes/.../antefstelae.html); Fischer, "An Example of Memphite Influence in a Theban Stela of the Eleventh Dynasty," 240, fig. 4; Baligh, "Three Middle Kingdom Stelae from the Egyptian Museum in Cairo," 182, fig. 3; Franke, "The Good Shepherd Antef," fig. 3, pl. VI; Spanel, "Palaeographic and Epigraphic Distinctions," 780–81, figs. 4–5.

[95] "Stelae of the Early 11th Dynasty – UCL" (www.ucl.ac.uk/museums-static/digitalegypt/thebes/.../antefstelae.html); Baligh, "Three Middle Kingdom Stelae from the Egyptian Museum in Cairo," 170–72, 174, fig. 1; Spanel, "Palaeographic and Epigraphic Distinctions," 780–81, figs. 4–5.

[96] Cf. D. Spanel, "Ancient Egyptian Boat Models of the Herakleopolitan Period and Eleventh Dynasty," *SAK* 12 (1985), 244–46, figs. 1–2.

strongly suggests that our stela ultimately comes from that necropolis. All of foregoing iconographic, epigraphic, and paleographic dating criteria indicate a date of sometime in Dynasty 11.

Assiut University

Come My Staff, I Lean Upon You: The Use of Staves in the Ancient Egyptian Afterlife

Nicholas R. Brown

Abstract

Sticks are some of ancient Egypt's most versatile tools, which functioned in many different ways and feature in a variety of scene types, including funerary and afterlife. Within these scenes, the deceased may be shown carrying the mdw staff and/or wȝs scepter, sometimes in conjunction with an ꜥnḫ sign and other insignia. Earlier studies have examined ancient Egyptian staves individually, though no former scholarship has exclusively examined how the mdw staff and wȝs scepter function within the funerary rites of the deceased. The use of sticks as a tool in the transformative process of the deceased is the focus of the current study, with a particular emphasis on both textual and artistic representations.

The staff, or stick, was one of the most commonly used tools by the ancient Egyptians.[1] It took diverse forms and was used in a variety of contexts. Staves often feature in tomb and temple decoration from the Predynastic period through the Greco-Roman era. They were held by gods, kings, priests, the elite, workers, and farm laborers. The use of the staff varied from serving as a walking aid for the elderly, a baton for disciplining by the police, a military weapon, an agricultural tool for farmers herding livestock, a ceremonial implement carried by priests during religious rituals, and as a form of insignia, to outwardly express a person's social and economic standing in society. Previous scholarship on staves focuses on their names, the inscriptions inscribed on them, and their religious function.[2] This work, however, explores the use of staves as tools for the transformation of the deceased into a deity, as well as their use as a symbol of divine status after the deceased's metamorphosis. Evidence is derived from the Old Kingdom through the end of the New Kingdom, as this time period provides the largest corpus of both textual references and artistic representations of staves within funerary and afterlife contexts.

Religious Contexts of the *wȝs* and *ḏꜥm* Scepters

There are staves from ancient Egypt that carry significant religious connotations and are associated with concepts relating to the cardinal points and divine authority. Two of these staves are the *wȝs* 𓌅𓏤𓏭𓏛 and *ḏꜥm* 𓄋𓄿𓌀 scepters. Early evidence of the *wȝs* scepter being associated with the cardinal directions is derived from the First Dynasty ivory comb of king Djet from Abydos, where two *wȝs* scepters are shown supporting the heavens, represented by wings carrying a solar bark.[3] Scholars have suggested that both these *wȝs* scepters are a two

[1] This article is a result of my Masters thesis from the American University in Cairo, as well as a paper presented at the 2016 meeting of the American Research Center in Egypt at Atlanta. I am grateful for the assistance, encouragement, and comments of Doctors Salima Ikram, Anna Stevens, and Andre Veldmeijer throughout the entire research. I, of course, remain responsible for the contents herein.

[2] A. Hassan, *Stöcke und Stäbe im Pharaonischen Ägypten* (Munich, 1976); H. Fischer, "Notes on Sticks and Staves," *MMJ* 13 (1978), 5–32; A. Gordon and C. Schwabe, "The Egyptian *wȝs*-Scepter and its Modern Analogues: Uses as Symbols of Divine Power and Authority," *JARCE* 32 (1995), 185–96.

[3] JE47176, Petrie, *Tombs of the Courtiers*, pl. II.

Journal of the American Research Center in Egypt 53 (2017), 189–201
doi: http://dx.doi.org/10.5913/jarce.53.2017.a009

Fig. 1. Detail from the Roman period Temple of Kalabsha, showing the patron deity, Mandulis, carrying both a wꜣs scepter and ꜥnḫ sign together (photograph by the author).

dimensional representation of the four *wꜣs* scepters that stood at each cardinal point.[4] Within the Pyramid Texts, the *wꜣs* and *ḏꜥm* scepters are both said to be used as supports for the heavens, by means of the four cardinal gods who sit near, stand by, or lean upon (electrum) staves[5] (PT 264 and 573).[6] Furthermore, a Late Period relief fragment from the Yale University Map Archive depicts a cardinal god standing in a *ḥwt* shrine, leaning upon a *wꜣs* scepter.[7] Since the straight-bodied *wꜣs* scepter is sometimes used as the determinative for the name of the *ḏꜥm* staff,[8] which is normally distinguished by its undulating shaft, scholars suggest that both the *wꜣs* and *ḏꜥm* scepters are two variants of the same object,[9] and thus can be used interchangeably.

The *wꜣs* scepter is not exclusively used by the cardinal deities, but as early as the Predynastic period, the staff served as a divine scepter for other gods. An Early Dynastic slate palette depicts an anthropomorphized beetle carrying the *wꜣs* scepter in one hand, and another, unidentified staff in the other.[10] Additionally, a stone bowl inscribed for the Second Dynasty king Hotepsekhemwy, found at Saqqara, depicts the lioness goddess Websetet holding a *wꜣs* scepter before the king's *serekh*.[11] The *wꜣs* scepter continued to be used as such into the Greco-Roman era (fig. 1), and was carried by male deities, such as Anubis, Ptah, Seth or Amun-Re (to name a few), and female deities, including Isis, Nephthys, and Hathor.[12] The gods, either male or female, carry the staff most often in conjunction with an *ꜥnḫ* sign (note fig. 1). *ꜥnḫ* is generally translated as "life,"[13] while *wꜣs* may be translated into "dominion," or "lordship,"[14] suggesting that the gods are not only the possessors of sovereignty over the universe, but they carry eternal life with them. In this context, the staff became symbolically relevant and potent for funerary beliefs. Within Spell 1130 of the Coffin Texts, a deity who is called "Him whose names are secret" is quoted as saying "I possess life (*ꜥnḫ*), because I am

[4] A. Gardiner, "The Baptism of Pharaoh," *JEA* 36 (1950), 12; H. Schäfer, *Principles of Egyptian Art* (Oxford, 1986), 235 and 236; A. Mace and H. Winlock, *The Tomb of Senebtisi at Lisht* (New York, 1916), 89.

[5] *ḏꜥmw* 𓂧𓂝𓅓𓏛 𓏤𓏤𓏤, Sethe, *Pyr.*, 184, line 233.

[6] Gordon and Schwabe, "*wꜣs*-Scepter," 190; Mace and Winlock, *Senebtisi*, 88; Hassan, *Stöcke und Stäbe*, 172.

[7] Yale *61, C. Manassa, ed., *Echoes of Egypt: Conjuring the Land of the Pharaohs* (Yale, 2013), 8.

[8] See n. 5. *Wb* V, 537, 4; Jéquier, *Pyramides des Reines Neit et Apouit*, pl. XII.

[9] Gordon and Schwabe, "*wꜣs*-Scepter," 186.

[10] Brussels E. 578, D. Patch, *Dawn of Egyptian Art* (New York, 2011), Cat. 180.

[11] JE65413, Lacau and Lauer, *Pyramide à Degrés*, 13 and pl. 11 no. 58.

[12] Mace and Winlock, *Senebtisi*, 88; Hassan, *Stöcke und Stäbe*, 171.

[13] *Wb* I, 193, 2.

[14] *Wb* I, 260, 6.

its lord, and my staff (*wȝs*) will not be taken away,"[15] recalling this imagery of the gods carrying both the *wȝs* scepter and *ꜥnḫ* sign together.

Funerary Associations of the *wȝs* Scepters

Due to its association with the cardinal directions and divine authority, the *wȝs* scepter also played an important role within the funerary realm. Representations of Osiris show him carrying his usual crook and flail, together with the *wȝs* scepter and *ꜥnḫ* sign (fig. 2).[16] This illustrates how both of these objects were used by the deity to outwardly express his divine authority amongst the dead at their final judgment. The *wȝs* scepter and the *ꜥnḫ* sign also function as tools used during the "hourly vigil"[17] to reanimate the corpse of Osiris after he is embalmed. In CT Spell 754, Osiris says to Horus "How happy are those who see, how content are those who hear, when Horus is seen extending the *wȝs*-staff to his father Osiris,"[18] while in Book of the Dead Spell 146, Horus is quoted as saying "I am Horus, the son of Osiris… I have brought life (*ꜥnḫ*) and dominion (*wȝs*) to my father Osiris."[19] Starting in the Nineteenth Dynasty, and continuing intermittently into the Twenty-sixth Dynasty,[20] a funerary scene found in royal and elite tomb decoration depicts the royal characteristics of the embalming ritual of Osiris. The scenes show Horus, or the heir acting as Horus,[21] reanimating the corpse of his father who lies on an embalming table surrounded by kingly regalia. Reanimation is achieved by using an *ꜥnḫ* sign, literally to give life back to the dead god, and a *wȝs* scepter,

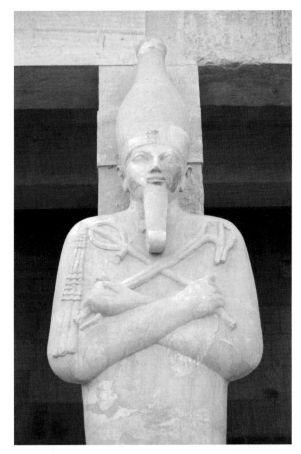

Fig. 2. Osiride statue of Queen Hatshepsut from Deir el-Bahari. Note how she holds the wȝs scepter and ꜥnḫ sign, along with the crook and flail (photograph by the author).

to reestablish his sovereignty over the universe. These particular scenes illustrate how these two emblems were important tools of the reanimation ceremony of Osiris, supporting his divine and authoritarian status, and subsequently of any deceased individual who was reborn as Osiris N as well.

[15] De Buck, *CT VII*, 467; R. Faulkner, *The Ancient Egyptian Coffin Texts Volume III: Spells 788–1185 and Indexes* (Warminster, 1978), 168.

[16] Another example includes the Stela of Neferhotep (Brussles E 2156).

[17] J. Assmann, *Grabung im Asasif 1963–1970, Band VI: Das Grab der Mutirdis* (Mainz am Rhein, 1977), 92–93; H. Willems, "The Embalmer Embalmed: Remarks on the Meaning of the Decoration of Some Middle Kingdom Coffins," in J. van Dijk, ed., *Essays on Ancient Egypt in Honour of Herman te Velde* (Groningen, 1997), 359.

[18] Faulkner, *CT* II, 288.

[19] T. Allen, *The Book of the Dead or Going Forth by Day: Ideas of the Ancient Egyptian Concerning the Hereafter as Expressed in Their Own Terms* SAOC 37 (Chicago, 1974), 136 (Spell 146w, 6–7); J. Roberson, *The Awakening of Osiris and the Transit of the Solar Barques: Royal Apotheosis in a Most Concise Book of the Underworld and Sky* (Switzerland, 2013), 12.

[20] H. Frankfort, *The Cenotaph of Seti I at Abydos, Volume II: Plates* (London, 1933), pl. LXXIV; Roberson, *Awakening of Osiris*, 1 and pls. 2–4; Also, the Twenty-fifth Dynasty tomb of Queen Qalhata, at al-Kurru, M. Fisher, P. Lacovara, S. Ikram, and S. D'Auria, eds., *Ancient Nubia: African Kingdoms on the Nile*, (Cairo, 2012), fig. 94.

[21] Roberson, *Awakening of Osiris*, 132–35; Willems, "The Embalmer Embalmed," 367–68.

Starting in the Middle Kingdom, object friezes begin to decorate the coffins of the high elite, with depictions of religious tools used during the funerary ceremonies, as well as kingly insignia, dress, and crowns.[22] The *wȝs* scepter is sometimes included among the kingly regalia used to equip and transform the deceased into Osiris.[23] The objects that were depicted on the coffin walls were meant to magically be used by the deceased for a variety of tasks, including as aids to help them travel from this world to the next, to assist with their transformation into semi-divine beings, and to allow them to function effectively in the afterlife.[24] Royal dress and insignia were usurped by the elite who aspired to divinity themselves, which was previously only available to the ruler. An Eighteenth Dynasty example of an object frieze from the tomb of Haremheb (TT78) depicts a group of objects above a scene of the final judgment of the deceased. Included amongst the kingly regalia meant to legitimize the deceased's transformation, and his right to rule in the afterlife, are both a *wȝs* scepter and *ʿnḫ* sign.[25] These royal objects, including the *wȝs* scepter, were then to be utilized as symbols and badges of the deceased's otherworldly, divine power.[26] The emblems of kingship provided the king's subjects with the tools and symbols to embody the characteristics of the two main gods of the afterlife, Ra and Osiris.[27]

Religious Contexts and Funerary Associations of the *mdw* Staff

In addition to the *wȝs* and *ḏʿm* scepters, the *mdw* ⫯ staff also has funerary associations, both as a stick and as a religious tool. From the Middle Kingdom coffin friezes, the *mdw* staff features in sets of four, amongst the other insignia that serve as offerings for the deceased.[28] From these coffin friezes, it is apparent that the *mdw* staff was associated with the four cardinal directions, as each individual staff may be labeled as *š rsy* "(Staff of) the Southern Pool," *š mḥty* "(Staff of) the Northern Pool," *š imnty* "(Staff of) the Western Pool," or *š iȝbty* "(Staff of) the Eastern Pool." Sometimes, the four are collectively labeled as *š rsy ḥȝ(y) imnty iȝbty* "(Staves of) the Southern, Northern, Western, and Eastern Pools."[29] In CT Spell 173, the deceased says "that staff (*mdw*) which separated sky and earth is in my hand,"[30] illustrating how this stick, in addition to the *wȝs* and *ḏʿm* scepters, was considered a support for the heavens. Additionally, on a Twenty-fifth Dynasty stela dedicated to Osiris by Shepenwepet, the daughter of Osorkon the High Priest of Amon, a *mdw* staff is depicted supporting a winged sun-disk, meant to represent the heavens (fig. 3).[31] Depicted on this same stela, Osiris is shown carrying a *mdw* staff rather than a *wȝs* scepter, along with his crook and flail, while Shepenwepet makes an offering to him. This suggests that the *mdw* staff also had divine associations with the gods, and served as "a symbol of the divine power" that supports the heavens.[32]

The relationship between the four cardinal directions and the *mdw* staff is best exemplified in the Twelfth Dynasty Theban tomb of Senet, the wife or mother of Antefoker (TT60), where the body of the deceased is dragged in a funerary sledge, which has four poles that resemble the *mdw* staff supporting a roof shaped like the *pt* hieroglyph (Gardiner N1).[33] Other funerary scenes from the Eighteenth Dynasty tombs of Ramose (TT55)[34] and Amenemhet (TT82),[35] depict funerary priests leading the funerary procession carrying *mdw* staves that are identical in shape to the columns that support the roofs of the funerary barges. This suggests that each corner

[22] Jéquier, *Frises d'Objets*, III and 159.

[23] S. Quirke, *Exploring Religion in Ancient Egypt* (West Sussex, 2015), 213; H. Willems, *Chests of Life: a Study of the Typology and Conceptual Development of Middle Kingdom Standard Class Coffins* (Leiden, 1988), 221 and 242.

[24] Willems, *Chests of Life*, 222 and 226; J. Forman and S. Quirke, *Hieroglyphs and the Afterlife in Ancient Egypt* (Norman, 1996), 68–69.

[25] An. and Ar. Brack, *Das Grab des Haremheb- Theben Nr. 78* (Cairo, 1980), pl. 17.

[26] Forman and Quirke, *Hieroglyphs*, 69.

[27] S. Quirke, *Ancient Egyptian Religion* (London, 1992), 158.

[28] Jéquier, *Frises d'Objets*, 160; Hassan, *Stöcke und Stäbe*, 80.

[29] *Wb* IV, 397, 11–12; Mace and Winlock, *Senebtisi*, 90; Jéquier, *Frises d'Objets*, 160; Hassan, *Stöcke und Stäbe*, 7–8 and 113.

[30] Faulkner, *CT I*, 148; de Buck, *CT III*, 49.

[31] Turin C. 1632. Presumably a second staff was shown on the right side, but is now lost (note fig. 3).

[32] Mace and Winlock, *Senebtisi*, 91.

[33] Davies and Gardiner, *Antefoker*, pl. XXI.

[34] Davies, *Ramose*, pls. XXV and XXVI.

[35] Davies and Gardiner, *Amenemhet*, pl. XII.

of the canopy may symbolically represent one of the cardinal directions, while the roof symbolizes the heavens, thus creating a cosmos in miniature for the deceased during the funerary procession.

It is possible to suggest that the *mdw* staff may have had its origins as a tent pole or structural column, which was later transferred to people to give them support by means of a physical staff. Mace and Winlock first proposed that the reading of *mdw* could be "pillar" instead of "staff," and that the *mdw* staff had its origins as a structural support for early reed shrines. [36] However, the ancient Egyptian word for "column" or "tent pole" is *wḫ3* 𓎛𓏏𓄿𓂝. [37] But the hieroglyphic determinative of the word illustrates how columns originated as wooden structural supports. There are depictions of canopy and kiosk columns that take the same shape of the *mdw* staff, and further suggest the origins of this particular stick as a structural pillar. These include the canopies used by the king during the Sed Festival,[38] funerary shrines and sledges with pillars that closely resemble the sticks the funerary procession members carry (see discussion above), and the kiosks carrying royal statues during the "(Beautiful) Festival of the Valley."[39] Three-dimensional representations of supports in the form of the *mdw* staff occur in the funerary canopy of queen Hetepheres (fig. 4) or on the solar bark of king Khufu (fig. 5). Therefore, Mace and Winlock were possibly correct in assuming that the origin of the *mdw* staff came from tent supports or poles.

The two different names for "column," *mdw* and *wḫ3*, were perhaps used to distinguish the size of the object: *mdw* could denote a smaller

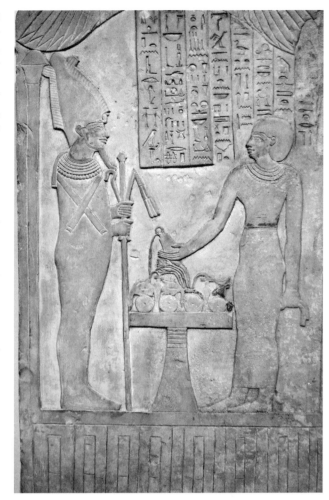

*Fig. 3. Stela dedicated to Osiris by Shepenwepet, daughter of the High Priest of Amon Osorkon (Turin C. 1632). Note the **mdw**-shaped column that carries the winged solar disk, along with the **mdw** staff that Osiris holds. Courtesy of the Museo Egizio di Torino (photograph by the author).*

object that can be carried with ease by a person, while the word *wḫ3* may be used in conjunction with the larger structural supports of tents and buildings. With this in mind, and due to its associations with the funerary procession and ceremony, it is tempting to suggest that the *mdw* staff may have had its origins as a structural support for embalming tents. It is possible that the use of the *mdw* staff by funerary priests within the procession to the tomb might be an archaic practice of taking all embalming materials, perhaps including the funerary tent itself, to be interred with the deceased. However, it should be noted that no such pole has been found in embalming deposits to date.[40]

[36] Mace and Winlock, *Senebtisi*, 91.

[37] *Wb* I, 355.

[38] Such as a Twelfth Dynasty depiction of Senuseret III in his Sed Festival canopy, JE56497A; J. Von Beckerath, *Handbuch der Ägyptischen Königsnamen* (Mainz, 1999), XXI.

[39] In the tomb of Kenamun, TT93; Davies, *Ken-Amun*, pls. XV-XVI.

[40] S. Ikram and M. Lopez-Grande, "Three Embalming Caches from Dra Abu el-Naga," *BIFAO* 111 (2011), 205–28.

Fig. 4. Detail of the funerary canopy of Queen Hetepheres, with supports in the form of the **mdw** *staff. Courtesy of the Egyptian Museum in Cairo (photograph by the author).*

Fig. 5. Deck Canopy of Khufu's Solar Boat, with supports in the form of the **mdw** *staff (photograph by L. Bertini).*

Textual Evidence of Staves in the Afterlife

Funerary texts, such as spells from the Pyramid and Coffin Texts, as well as the Book of the Dead, hint at the importance of using sticks in the afterlife. Sticks are used in the afterlife by deceased people to express their divine status, and they are sometimes described as the object used to transfigure an individual into a divine being. The use of staves by the transformed deceased in the afterlife is first seen in the Pyramid Texts, where sticks feature as important insignia. Examples include PT 570A: "This Pepi will sweep away with you (the imperishable gods) with a *staff of authority* (*wȝs*) and an *electrum staff* (*dꜥm*),"[41] and PT 263: "It has become good for Unis with his *ka*: Unis will live with his *ka*, his leopard-skin on him, *his staff* (*ȝms*) *in his arm*, his baton in his hand."[42] Other spells from the Coffin Texts highlight the divine nature and function of staves, including Spell 3 where the deceased is instructed to "Take your staff, your loincloth and your sandals, and go down to the Tribunal, that you may be vindicated against your foes, male or female, against those who would harm you, and those who would have judgment against you."[43] Or in CT Spells 16 and 17, where the deceased, as Horus, is seated before the god Geb, carrying various royal regalia including two staves (*iȝȝyt*)[44] that Osiris presented to him.[45] A strikingly similar reference occurs in a Twenty-First Dynasty Book of the Dead, where the deceased says, "His (Osiris') staff is in my hand."[46]

Other spells from the Book of the Dead also highlight the use of staves by divinized persons. Chapter 65 in the Book of the Dead of Maiherperi describes the deceased, after his transformation into Osiris, as being given life and power while carrying an *ȝms* staff of gold.[47] In Chapter 65 of the Book of the Dead of Nespasef, the deceased says, "See, I have gone out on this day, transfigured… The ka spirit of my mother is content, seeing me standing on my feet, my staff (*mdw*) in my hand of gold."[48] Additionally, in Book of the Dead Chapter 168 the deceased is instructed to "Take to thee thy clothing, thy sandals, *thy staff*, thy linen garment, and all thy weapons

[41] J. Allen, *The Ancient Egyptian Pyramid Texts* (Leiden, 2005), 178; emphasis by author. J. Leclant, et al., *Les textes de la pyramide de Pépy Ier. 2: Facsimilés* (Cairo, 2001), pl. XX, line 20. Note that this also recalls Book of the Dead Chapter 130 from pChicago OIM 9787: "He (the deceased) has taken the staff; he has swept the Sky therewith," T. Allen, *The Egyptian Book of the Dead Documents in the Oriental Institute Museum at the University of Chicago* (Chicago, 1960), 16–17 and 213.

[42] Sethe, *Pyr.*, 182 (line 473); Allen, *Pyramid Texts*, 43; emphasis by author.

[43] Faulkner, *CT I*, 2.

[44] de Buck, *CT I*, 49; *Wb* I, 27, 10. Note that the word may also be translated as "rod" or "scepter."

[45] Faulkner, *CT I*, 8.

[46] pChicago OIM 18039; Allen, *Documents*, 60 and 113; Allen, *Book of the Dead*, 38 (BD 28e).

[47] CG24095, Daressy, *CG 24001-24990*, 42.

[48] JE95714, S. Quirke, *Going Out in Daylight: the Ancient Egyptian Book of the Dead* (London, 2013), 161.

for (the journey) …"[49] These spells indicate the importance of sticks in the funerary realm even into the New Kingdom.

Inscriptions on staves may also indicate that they are to be used after death. A staff of Khonsu, son of the Deir el-Medina artist Sennedjem, reads: "You have accepted old age in silence, within the Place of Truth, so that you may follow Amun whenever he appears, by the servant in the Place of Truth, Khonsu, justified."[50] Another, from the tomb of Tutankhamun, reads "Take the rod of gold to accompany your exalted father (in the procession), O favorite of Amun, the powerful one of the gods…"[51] Hassan writes that even though inscriptions do not provide sufficient evidence to suggest that staves were made specifically as funerary offerings, their inscriptions do, in fact, exemplify how the sticks were meant to be used after death by the deceased.[52] It would appear that walking sticks found within the burial of the deceased also had a magical intent, where the staves worked like amulets to restore the deceased and allowing them to traverse between the world of the living to the world of the dead.[53]

Texts also indicate that sticks were tools utilized in the transformation of the deceased into a deity. In the Pyramid Texts of Neith, daughter of Pepi I and wife of Pepi II, Spell 68 instructs the deceased queen to "Fill your hand with the *Horus-Staff* (*mdw-Hr*). Provide yourself with the *Horus-Staff*, and it will provide you as a god."[54] The "Horus-Staff" is another name given to the *mdw* staff within the Middle Kingdom coffin friezes.[55] This staff is also used by the god Re in the Coffin Texts, where in Spell 473 it is described as being held in the deity's hand, a symbol of power.[56] Both the name, as well as its use by the gods, highlight the divine character of this one particular stick.[57] Coffin Text spells also describe using staves to transform the deceased into a god. In Spell 469, the deceased says "I find Orion standing in my path with his staff of rank (*dˁm*)[58] in his hand; I accept it from him and I will be a god *by means of it*… I ascend and appear as a god, *my signs of rank* are on me."[59] The same scenario is repeated again in Spell 470.[60] These spells suggests that the *mdw* staff and *wȝs* and *dˁm* scepters may represent a divine power that is used to reanimate the deceased, which is used by the deceased to rule and live eternally as Osiris N.

Artistic Evidence of Staves in the Afterlife

In addition to textual references to sticks, there are artistic representations that show deceased individuals using staves in funerary rituals or in the afterlife. One interesting depiction of the use of sticks in the afterlife comes from the Memphite tomb of Horemheb, where the deceased is shown in the Fields of Iaru after death.[61] Horemheb is depicted standing, with an unidentifiable staff in one hand, and an *ˁbȝ* scepter, bouquet, and handkerchief in the other. His image is purified by a priest, while an attendant stands nearby, presenting both a *wȝs* scepter and another, unidentifiable staff to Horemheb after his purification.[62] This particular scene recalls an Opening of the Mouth episode from the Eighteenth Dynasty tomb of Amenhotepsise (TT75), where instead of an attendant, an anthropomorphized djed-pillar is shown extending insignia to the official.[63] Within the scene, the deceased

[49] Allen, *Book of the Dead*, 176 (BD 168e).

[50] JE27310i, Hassan, *Stöcke und Stäbe*, 138.

[51] JE61726, D. Kurth, "Die Inschriften auf den Stöcken und Stäben des Tutanchamun" in H. Beinlich, ed., *"Die Männer hinter dem König": 6. Symposiom zur ägyptischen Königsideologie. Iphofen, 16.–18. Juli 2010* (Wiesbaden, 2012), 76.

[52] Hassan, *Stöcke und Stäbe*, 138.

[53] MFA, *Egypt's Golden Age: the Art of Living in the New Kingdom* (Boston, 1982), 203.

[54] Allen, *Pyramid Texts*, 309 and 319; Hassan, *Stöcke und Stäbe*, 7. Emphasis by author.

[55] *Wb* II, 178, 6; Mace and Winlock, *Senebtisi*, 90; Hassan, *Stöcke und Stäbe*, 7.

[56] Faulkner, *CT II*, 108; de Buck, *CT V*, 5.

[57] Jéquier, *Frises d'Objets*, 160.

[58] de Buck, *CT V*, 390. Note the determinative is a *wȝs* scepter, rather than a *dˁm* staff.

[59] Faulkner, *CT II*, 101–2. Emphasis by author.

[60] Faulkner, *CT II*, 105.

[61] G. Martin, *The Memphite Tomb of Horemheb, Commander-In-Chief of Tutankhamun, Volume I: the Reliefs, Inscriptions, and Commentary* (London, 1989), 123.

[62] Martin, *Horemheb I*, 137.

[63] Davies, *(Tombs of) Two Officials*, pl. XV.

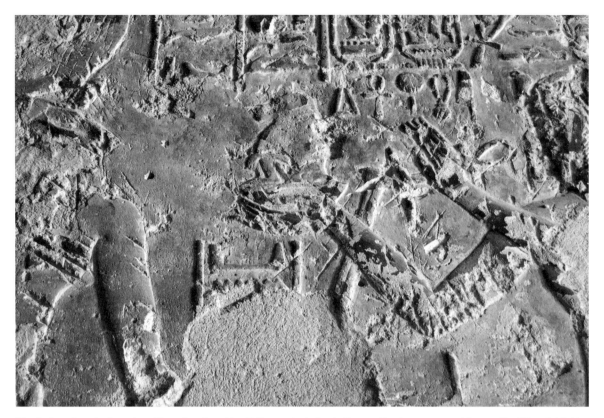

Fig. 6. Scene from the Speos Artemidos, where the goddess Pakhet carries both a lotiform staff and wꜣs scepter while extending life to Seti I (photograph by the author).

official is shown being purified and censed by priests, while the personified djed-pillar extends to Amenhotepsise a staff, a ꜥbꜣ scepter, and a shawl. Davies interprets the scene as taking place in the afterlife, and that the djed-pillar carries insignia that were meant to be used by the deceased in the underworld.[64] Similar scenes occur in other Theban tombs as well. In the Nineteenth Dynasty tomb of Amenemope (TT41), a djed-pillar stands by the deceased during an Opening of the Mouth ritual extending both a shawl and staff to the official,[65] while in the Eighteenth Dynasty tomb of Sennefer (TT96), the deceased is shown already holding his staff as a personified djed-pillar presents him with an ꜥbꜣ scepter and long, white shawl.[66] The scene from Horemheb's tomb, when compared with the scenes of Amenhotepsise, Amenemope, and Sennefer, seems to confirm that the staves the attendant carries serve a divine purpose in the afterlife, rather than serving as status symbols used in life. Additionally, it might be possible that these staves in Horemheb's tomb served as part of the funerary ritual, as well as being indicators of the transformed state of the deceased.

Sometimes, a figure may be depicted carrying both the *mdw* staff and the *wꜣs* scepter together at the same time. The use of the *mdw* staff and *wꜣs* scepter together illustrates how these two sticks are both used as agents of transformation for the dead and highlights their divine associations. The divine associations of using of multiple sticks at the same time is exemplified by two examples of deities carrying two staves simultaneously. One example, from the Nineteenth Dynasty decoration of the Speos Artemidos, shows Pakhet carrying two staves together: her lotiform staff and *wꜣs* scepter with an ꜥnḫ attached to it (fig. 6). This is offered to Seti I, who in turn

[64] Davies, *(Tombs of) Two Officials*, 16.
[65] J. Assmann, *Das Grab des Amenemope TT41* (Mainz am Rhein, 1991), pl. 18.
[66] S. Hodel-Hoenes, *Life and Death in Ancient Egypt: Scenes from Private Tombs in New Kingdom Thebes* (New York, 2000), fig. 99.

presents a clepsydra, in the form of a baboon sitting on a *nb* sign.[67] In the Twenty-second Dynasty tomb of Sheshonq III at Tanis, there is an image of a statue of Sokar-Osiris.[68] The god carries the royal insignia associated with Osiris, emphasizing his role as king of the underworld, as well as a *mdw* staff, *wȝs* scepter, and *ꜥnḫ* sign in his other hand, perhaps to illustrate Sokar-Osiris' divine status in both the world of the living and the world of the dead.

The earliest evidence for both the *mdw* staff and the *wȝs* scepter being used together is from a royal context, in the Sixth Dynasty funerary temple of Pepi II at Saqqara. Two scenes from the antechamber of the temple, where the king undergoes his final transformation, show Pepi II carrying both staves together, before a procession of deities.[69] During the Middle Kingdom, the evidence of the two staves being used together, either in texts or artistic representations, is lacking. However, images of the deceased carrying both the *wȝs* scepter and *mdw* staff together seem to be a renewed phenomenon during the New Kingdom, perhaps as a result of changing religious beliefs. Examples occur at the New Kingdom necropolis of Saqqara, just south of the pyramid of Unas, as well as the Theban necropolis on the West Bank.

A painted relief fragment of the New Kingdom, most likely originating from Thebes, depicts an anonymous official carrying both the *mdw* and *wȝs* scepter together in one hand, while holding an *ꜥnḫ* sign and *ꜥbȝ* scepter in the other (fig. 7).[70] This imagery recalls Pyramid Text 213, where the deceased is told "You have not departed dead, you have de-

Fig. 7. A painted New Kingdom fragment (Turin RCGE 15992/ S1349.1) depicting the deceased carrying both a mdw staff and wȝs scepter together in one hand, and an ꜥnḫ sign and ꜥbȝ scepter in the other (photograph © Museo Egizio di Torino, used with permission).

parted alive! Seat yourself on the throne of Osiris, your *ꜥbȝ*-scepter in your (one) hand, that you may command the living; your *mks* staff and "bud" scepter are in your (other) hand, that you may command those whose seats are hidden."[71] Divinity, which was once reserved exclusively for royalty, was eventually appropriated by private individuals. By the Twelfth Dynasty, religious beliefs had started to change, and everyone was able to become a god, specifically Osiris, in the next life.[72] As such, the privilege to be transformed into a deity was no longer exclusive to royalty, but it was available to the elite. For this to happen, however, the appropriate insignia were needed to effect the transformation as well as to outwardly assert authority amongst both the living and the dead. The deceased here, in the Turin fragment, may carry his *mdw* staff and *ꜥbȝ* scepter as symbols of his earthly authority, while at the same time he holds a *wȝs* scepter and *ꜥnḫ* sign to illustrate his divine sovereignty amongst the dead. Unlike the Middle Kingdom coffin friezes, the deceased now directly carries the symbols and badges of their otherworldly, divine status.

Some New Kingdom depictions where a figure is shown carrying both the *mdw* staff and *wȝs* scepter together give the epithet *mȝꜥ-ḫrw* to the staff-holder, while the remainder are too fragmentary to know for certain.[73] The

[67] PM IV, 164 (19).

[68] Montet, *Tombeau de Chéchanq III*, pl. XXIX.

[69] Jéquier, *Pepi II*, pls. 46 and 50.

[70] L. Manniche, *Lost Ramessid and Post-Ramessid Private Tombs in the Theban Necropolis* (Copenhagen, 2011), fig. 75.

[71] J. Assman, *Death and Salvation in Ancient Egypt*, trans. D. Lorton (Ithaca, 2005), 142.

[72] Assman, *Death and Salvation*, 141–42; Forman and Quirke *Hieroglyphs*, 68–69.

[73] These fragmentary reliefs include: G. Martin, *The Tomb of Maya and Meryt, Volume I: the Reliefs, Inscriptions, and Commentary* (London, 2012), pl. 21 [18a and 20]; M. Raven and R. Walsem, *The Tomb of Meryneith at Saqqara* (Belgium, 2014), fig. 29; M. Raven, *The Tomb of Pay and Raia at Saqqara* (London, 2005), pls. 45 [41] and 53 [57].

Fig. 8. Pyramidion of Ptahmose (Florence 2537), showing the deceased being censed and offered to while carrying a mdw staff and wȝs scepter. Courtesy of Museo Archeologico Nazionale di Firenze (photograph by F. Bini).

Fig. 9. Detail from the Book of the Dead of Yuya (CG51189). Yuya carries a mdw staff and wȝs scepter while he is purified and offered to by two priests. Courtesy of the Egyptian Museum in Cairo (photograph by the author).

connection of the term *mȝꜥ-ḫrw* with deceased persons and the afterlife beliefs has long been established,[74] though recent scholarship has suggested even though figures may be labeled as *mȝꜥ-ḫrw*, this does not necessarily mean that the person depicted is deceased.[75] Scenes where the figure carries two staves together and is named *mȝꜥ-ḫrw* include offering scenes, such as from the Memphite tomb of Horemheb,[76] the Pyramidon of Ptahmose from Memphis (fig. 8),[77] an anonymous official depicted on a relief fragment from Memphis,[78] a fragmented relief from the Memphite tomb of Pay and Rai,[79] or that of the Mayor Paser at Thebes.[80] Additionally, the figure may be named as *mȝꜥ-ḫrw* when they are purified or censed by a priest, as in Maya from Memphis,[81] Huy at Thebes (TT40),[82] or from the funerary papyrus of Yuya (fig. 9).[83]

[74] J. Wegner, *The Mortuary Temple of Senwosret III at Abydos* (Philadelphia, 2007), 28. R. Anthes, "The Original Meaning of *mȝꜥ-ḫrw*," *JNES* 13 (1954), 21.

[75] Anthes, "*mȝꜥ-ḫrw*," 31; J. Wegner, "The Nature and Chronology of the Senwosret III–Amenemhat III Regnal Succession: Some Considerations Based on New Evidence from the Mortuary Temple of Senwosret III at Abydos," *JNES* 55.4 (1999), 278; D. Doxey, *Egyptian Non-Royal Epithets in the Middle Kingdom* (Leiden, 1998), 92 and 204.

[76] Martin, *Horemheb I*, pl. 92.

[77] Florence no. 2537; PM III.2, 712.

[78] G. Martin, *Corpus of Reliefs of the New Kingdom from the Memphite Necropolis and Lower Egypt* (London, 1987), pl. 13.

[79] Raven, *Pay and Raia*, pl. 53 [51].

[80] S. Schott, *Wall Scenes from the Mortuary Chapel of the Mayor Paser at Medinet Habu* (Chicago, 1957), pl. 1.

[81] Martin, *Maya and Meryt*, pl. 24.

[82] Davies and Gardiner, *Huy*, pl. XXXV.

[83] T. Davis, *The Funeral Papyrus of Iouiya* (London, 1908), pl. XVIII.

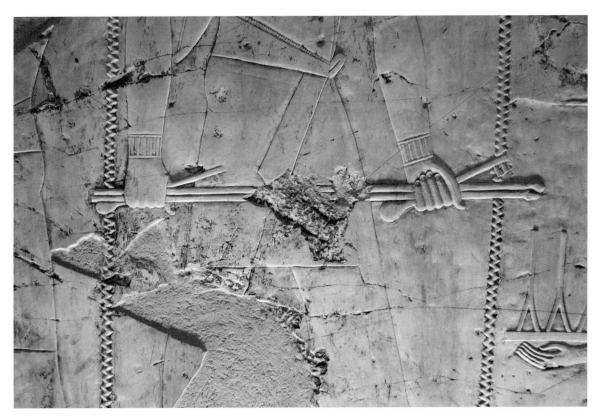

*Fig. 10. Detail from the Opening of the Mouth ritual in the tomb of Khaemhet (TT57). Note how the deceased holds two batons, both shaped like the **mdw** staff, and two hieroglyphs for **bd** or "natron" (photograph by the author).*

For these purification scenes, an interesting parallel occurs within the tomb of Khaemhat (TT57), where the deceased is shown being purified and offered to by priests during an Opening of the Mouth ritual. The figure of the tomb owner carries two *mdw*-shaped batons, as well as two hieroglyphic signs for natron, *bd* (fig. 10).[84] In the inscription running above the scene, Khaemhat is named as *m3ᶜ-ḫrw*, and it is important to note that he carries two signs for the chief embalming agent for mummification.[85] Both of these observations strongly suggests that the image of Khaemhat is meant to show him in the process of transformation, emphasized by his carrying the symbol for purity, as well as two batons that resemble the *mdw*-staff, a divine insignia. A parallel occurs in the tomb of Ramose (TT55), where priests purify the deceased during an Opening of the Mouth ceremony. However, in Ramose's tomb scene, the deceased only carries one *mdw* staff and one *bd* sign.[86]

In addition to private, elite citizens, kings are also depicted carrying two staves simultaneously.[87] The earliest king shown using two staves is Pepi II during the Sixth Dynasty (see discussion above). From the Eighteenth Dynasty tomb of Amenemone at Memphis, the Fifth Dynasty king Menkauhor is shown carrying a *mdw* staff and *w3s* scepter at the same time (Louvre B48).[88] In the Eighteenth Dynasty tomb of Amenemhet, called Surer (TT48), three statues of Amenhotep III are presented as New Year's Festival tribute to the living king; each statue

[84] *Wb* I, 486, 10.

[85] S. Ikram, *Death and Burial in Ancient Egypt* (Harlow, 2003), 54.

[86] Davies, *Ramose*, pl. XXI.

[87] Daily life scenes of kings carrying staves, such as Akhenaten (Davies, *Amarna I*, pl. XXX and *Amarna VI*, pl. III) or Tutankhamun (JE61477), are being studied in a separate, forthcoming publication (S. Ikram and A. J. Veldmeijer, personal communication).

[88] B. Ockinga, *Amenemone the Chief Goldsmith: a New Kingdom Tomb in the Teti Cemetery at Saqqara* (Oxford, 2004), pl. 68.

Fig. 11. An offering scene from the Mortuary Temple of Seti I, where the king holds both a w3s scepter and mks staff together at the same time while being offered to by Inmutef (photograph by the author).

is shown carrying a *w3s* scepter and an unidentifiable staff.[89] During the Nineteenth Dynasty, Seti I is shown carrying a *w3s* scepter and *mks* staff together while receiving offerings in his mortuary temple at Thebes from Wepwawet[90] and Inmutef (fig. 11),[91] and while receiving life and dominion from Thoth at his temple in Abydos.[92] Finally, from the Twentieth Dynasty, one relief at Medinet Habu depicts Ramses III seated within a kiosk, carrying a *w3s* scepter and unidentifiable staff, while receiving offerings from eight princes.[93] These scenes show that this scene-type had its origins in the Old Kingdom, where it was reserved exclusively for the king, and was then revived during the New Kingdom, for use by both royalty and the elite.

Conclusions

The use of both the *mdw* staff and the *w3s* and *ḏˤm* scepters, whether by a deceased official, the king, or gods, is meant to highlight the divine nature of the figure holding them. The *mdw*-shaped staff that the figure holds may either be the earthly insignia of the deceased, or it may represent a divine staff, such as the *mdw-Ḥr* or one of the *mdw* staves associated with the cardinal directions. The *mdw* staff may also represent a power, which is conferred to the deceased after becoming a divine being, who lives eternally as Osiris. When the deceased carries the *w3s* scepter, it functions either as the tool by which the deceased is reanimated in the afterlife, or it is used to highlight the newly transformed state of the staff-holder into a god, i.e., Osiris N. It is possible that the *w3s* scepter may be used both as the object by which the deceased is brought back to life in the afterlife, along with serving as a sign of their "other-worldly" authority amongst both the living and the dead. Since the *mdw* staff and *w3s* scepter are often shown being used in conjunction with other objects and symbols, such as the *ˤnḫ* sign, their meaning can be elevated to that of the religious realm. In this context, the staff no longer serves simply as a marker of status or as the functional tool used to reanimate the deceased. The deceased persons who carry the *mdw* staff or *w3s* scepter in the afterlife are shown depicted in a venerated state, one that elevates them to the same level as the ancient Egyptian pantheon.

The ancient Egyptians, through death, mummification, and resurrection in the afterlife, were transformed into divine beings. In both textual references and artistic representations, the deceased uses the *mdw* staff and/ or the *w3s* scepter to emphasize their divinity in the afterlife. It is possible that the funerary rites would have used physical examples of such staves to bring about the transformation of the deceased, as examples of sticks have

[89] T. Säve-Söderbergh, *Four Eighteenth Dynasty Tombs* (Oxford, 1957), pl. XXXVII.

[90] PM II, 411 (36); author's observation.

[91] PM II, 411 (37); author's observation.

[92] Calverley and Gardiner, *Abydos IV*, pl. 33.

[93] *Medinet Habu V*, pl. 339.

been found in the intact tombs of Kha and Merit (TT8),[94] and Pseusenes I at Tanis,[95] and in the nearly intact tombs of Djehutynakht,[96] and Tutankhamun (KV62).[97] Sticks in ancient Egypt not only served a purpose in life, but they served one in death: aiding the deceased to achieve divine status, to traverse the path between this world and the next, as well as to assert his authority amongst the dead. As Khonsu spoke to his own staff: "Come my staff, I lean upon you, to follow into the Beautiful West."[98]

UCLA

[94] Schiaparelli, *Cha* (Turin, 2007 reprint), 30.

[95] P. Guilloux, *Le mobilier funéraire de Psousennès Ier* (Arles, 2010), 305.

[96] R. Freed, L. Berman, D. Doxey, and N. Picardo, eds., *The Secrets of Tomb 10A* (Boston, 2009), 11 and 140–41.

[97] N. Reeves, *The Complete Tutankhamun*, (London, 1990), 178–79.

[98] JE27310.b; Hassan, *Stöcke und Stäbe*, 136.

Defining the Hyksos: A Reevaluation of the Title *ḥḳ3 ḫ3swt* and Its Implications for Hyksos Identity

DANIELLE CANDELORA

Abstract

This paper considers the significance of the title ḥḳ3 ḫ3swt during the Second Intermediate Period through a theoretical framework of identity negotiation and transience in contexts of cultural contact. By studying extant examples of this title throughout pharaonic history in context, the unique nature of the title during the period of interest becomes apparent. The use of this title by the Hyksos reflects their self-conception and helps to elucidate the process of identity negotiation within the borderland of the Eastern Delta.

Cultural contact, including both the material and conceptual aspects of identity negotiation and interaction, has become a popular topic in the archaeology of the ancient Near East and Egypt.[1] Spanning from ancient Nubia[2] to Kültepe in Anatolia,[3] and even encompassing much of the fertile crescent,[4] the study of identity is finding a strong foothold due to the numerous sites and instances of interaction in this broad region. Tell el-Dab'a, capital of the Hyksos Dynasty in the Eastern Delta of Egypt, is just such a borderland, a hotbed for cultural contact and identity negotiation between native Egyptians and an immigrant Levantine populace. Excavations at the site have uncovered evidence for exchange and hybridity, beginning with the initial settlement of Levantine people in the late Twelfth Dynasty, and continuing through the Hyksos Period.[5] Both the maintenance of

[1] I would like to thank Drs. Willeke Wendrich, Thomas Schneider, and Kara Cooney for their invaluable guidance and comments. Funding for this research was generously granted by the Orange County Chapter of the Archaeological Institute of America. I am also extremely grateful to the curators and conservators of the Museo Egizio di Torino and Dr. Ben-Dor Evian of the Israel Museum for their facilitation of this research.

[2] S. Smith, "Revenge of the Kushites: Assimilation and Resistance in Egypt's New Kingdom Empire and Nubian Ascendancy over Egypt," in G. Areshian, ed., *Empires and Complexity: On the Crossroads of Archaeology* (Los Angeles, 2013); S. Smith, *Wretched Kush: Ethnic Identities and Boundaries in Egypt's Nubian Empire* (London- New York, 2003); P. Van Pelt, "Revising Egypto-Nubian Relations in New Kingdom Lower Nubia: From Egyptianization to Cultural Entanglement," *Cambridge Archaeological Journal* 23: 3 (2013), 523–50; E. Minor, "The Use of Egyptian and Egyptianizing Material Culture in Nubian Burials of the Classic Kerma Period," PhD diss., University of California, Berkeley, 2012.

[3] S. Lumsden, "Material Culture and the Middle Ground in the Old Assyrian Colony Period," in C. Michel, ed., *Old Assyrian Studies in Memory of Paul Garelli* (Leiden, 2008), 21–43; M. Larsen and A. Lassen, "Cultural Exchange at Kültepe," in M. Kozuh, W. Henkelman, C. Jones, and C. Woods, eds., *Extraction and Control: Studies in Honor of Matthew W. Stolper* (Chicago, 2014), 171–88.

[4] A. Burke, "Entanglement, the Amorite Koine, and Amorite Cultures in the Levant," *ARAM* 26: 1–2 (2014), 357–73; idem, "Amorites, Climate Change, and the Negotiation of Identity at the End of the Third Millennium BC," in F. Höflmayer, ed., *The Late Third Millennium in the Ancient Near East: Chronology, C14, and Climate Change*, Oriental Institute Seminars 11 (Chicago, 2017), 261–307; G. Schwartz, "An Amorite Global Village: Syrian-Mesopotamian Relations in the Second Millennium B.C.," in J. Aruz, S. Graff, and Y. Rakic, eds., *Cultures in Contact: From Mesopotamia to the Mediterranean in the Second Millennium B.C.* (New York-New Haven, 2013), 2–11.

[5] M. Bietak, "The Predecessors of the Hyksos," in S. Gitin, J. Wright, and J. Dessel, eds., *Confronting the Past: Archaeological and Historical Essays on Ancient Israel in Honor of William G. Dever* (Indiana, 2006), 285–93; idem, "Where Did the Hyksos Come from and Where Did They Go?" in M. Marée, ed., *The Second Intermediate Period (Thirteenth-Seventeenth Dynasties): Current Research, Future Prospects*, OLA 192 (Leuven, 2010), 139–81.

Journal of the American Research Center in Egypt 53 (2017), 203–221
doi: http://dx.doi.org/10.5913/jarce.53.2017.a010

specific identities,[6] and the blending thereof, can be seen in domestic and temple architecture,[7] tombs,[8] and ceramics.[9] Bettina Bader has also explicitly applied both migration theory,[10] as well as concepts of cultural mixing, including creolization, mestizaje, and hybridity,[11] to the case of Tell el-Dab'a.

The Hyksos themselves are an excellent case study in cultural blending, as they both maintained aspects of their foreign origin and adopted Egyptian conventions of rule and administration. They likely arose from among the immigrant population at Tell el-Dab'a, gaining power in the context of the political fragmentation and economic crisis that characterized the Second Intermediate Period.[12] Until the discovery of the *Skr-Hr* door jamb[13] at Tell el-Dab'a (fig. 1), the widespread assumption was that the Egyptians had labeled these foreign kings as *ḥḳȝ ḫȝswt* (Hyksos). However, the door jamb preserves a partial traditional Egyptian titulary alongside the use of *ḥḳȝ ḫȝswt*, leading scholars to suggest that the Hyksos may have taken on the *ḥḳȝ ḫȝswt* title for themselves.[14] Bietak proposed that "although this new term perhaps was originally applied by the Egyptians in a disparaging way to the new rulers of the land, the rulers themselves employed 'Hyksos' as an official ruler's title."[15] Although the first statement is certainly a possibility, based on a survey of the extant evidence, this paper demonstrates that the Hyksos are not called *ḥḳȝ ḫȝswt* in Egyptian sources. While the recent scholarship has accepted that the Hyksos adopted the title for themselves, the misconception concerning the Egyptian sources has been maintained, primarily in introductory texts.[16] However, few

Fig. 1. Door Jamb of Skr-Hr (line drawing by author, after Bietak, Avaris, 66, fig 52).

[6] M. Bietak, "The Egyptian Community in Avaris during the Hyksos Period," *Ä&L* 26 (2016), 263–74.

[7] M. Bietak, N. Math, and V. Müller, "Report on the Excavations of a Hyksos Palace at Tell el-Dab'a/Avaris: (23rd August–15th November 2011)," *Ä&L* 22/23 (2012-2013), 17–53; M. Bietak and I. Forstner-Müller, "Der Hyksos-Palast bei Tell el-Dab'a: zweite und dritte Grabungskampagne (Frühling 2008 und Frühling 2009)," *Ä&L* 19 (2009), 91–119. Mit einem Beitrag von F. van Koppen und K. Radner; M. Bietak, "Near Eastern Sanctuaries in the Eastern Nile Delta," *BAAL Hors-Série* VI (2009), 209–26; idem, "Two Ancient Near Eastern Temples with Bent Axis in the Eastern Nile Delta," *Ä&L* 13 (2003), 13–38.

[8] I. Forstner-Müller, "Tombs and Burial Customs at Tell el-Dab'a during the Late Middle Kingdom and the Second Intermediate Period," in Marée, *The Second Intermediate Period*, 127–38; B. Bader, "Traces of Foreign Settlers in the Archaeological Record of Tell el-Dab'a /Egypt," in K. Duistermaat and I. Regulski, eds., *Intercultural Contacts in the Ancient Mediterranean*, OLA 202 (Leuven, 2011), 127–48.

[9] B. Bader, "Migration in Archaeology: An Overview with a Focus on Ancient Egypt," in M. Messer, R. Schroder, and R. Wodak, eds., *Migrations: Interdisciplinary Perspectives* (Vienna, 2012), 213–26; Bader, "Traces of Foreign Settlers," 145–47; M. de Vreeze, "'A Strange Bird Will Breed in the Delta Marsh' The Evolution of Tell El Yahudiya Juglets and the Role of Tell el-Dab'a as a Hybrid Zone," in B. Bader, C. Knoblauch, and C. Köhler, eds., *Vienna 2 - Ancient Egyptian Ceramics in the 21st Century, Proceedings of the International Conference Held at the University of Vienna 14th-18th of May, 2012*, OLA 245 (Leuven, 2016), 155–78.

[10] Bader, "Migration in Archaeology," 213–19.

[11] B. Bader, "Cultural Mixing in Egyptian Archaeology: The 'Hyksos' as a Case Study," *Archaeological Review from Cambridge* 28:1 (2013), 257–86.

[12] M. Bietak, "Avaris, Capital of the Hyksos Kingdom: New Results of Excavations," in E. Oren, ed., *The Hyksos: New Historical and Archaeological Perspectives*, University Museum Monograph 96 (Philadelphia, 1997), 113.

[13] M. Bietak and I. Hein, eds., *Pharaonen und Fremde - Dynastien im Dunkel: Sonderaustellung des Historischen Museums der Stadt Wien in Zusammenarbeit mit dem Ägyptologischen Institut der Universität Wien und dem Österreichischen Archäologischen Institut Kairo, Rathaus Wien, Volkshalle, 8. Sept. - 23. Okt. 1994* (Vienna, 1994), 151–52.

[14] D. Redford, "The Hyksos Invasion in History and Tradition," *Orientalia* 39:1 (1970), 13.

[15] Bietak, "Avaris, Capital of the Hyksos Kingdom," 113.

[16] K. Bard, *An Introduction to the Archaeology of Ancient Egypt* (Oxford, 2007), 199; M. Van de Mieroop, *A History of Ancient Egypt*, Blackwell History of the Ancient World (Chichester, West Sussex-Malden, MA, 2011), 132.

have considered *why* the Hyksos adopted the title and what significance it might have held for them, especially in the context of extended cultural interaction.

Past scholarship on the subject of cultural contact focuses on acculturation and assimilation, the unidirectional imprint or adoption of culture onto another group. More recent work has emphasized the indigenous perspective and agency within what is actually a reciprocal interaction between two groups. Lyons and Papadopoulos argue that "assimilation was not the endpoint of interaction but a creative strategy by which native peoples incorporated selected ideas and objects into existing categories of meaning, while maintaining their traditional beliefs and customs."[17]

Identity Theory in general discusses identity as subjective, socially constructed, and a continuous process of identification by oneself and others. Identity groups are heterogeneous and polythetic;[18] as Shennan puts it "untidiness is, in fact, the essence of the situation."[19] Barth was one of the first scholars to argue against the Culture-History approach of seeing a one-to-one correlation between a defined archaeological culture and an ethnic/identity group.[20] Instead he (and many others citing him) have both proposed and demonstrated that such a correlation does not exist because identity boundaries are constantly renegotiated and permeable. Identity is also contextually dependent, can be adapted or altered to different situations, and individuals may ascribe to multiple identities simultaneously.[21] Due to this fluid, amorphous nature of identity, scholars have turned to Bourdieu's notion of the *habitus*, or "systems of durable, transposable dispositions" which are embodied at an early age through social experience in a specific context, and which structure and inform future practice.[22]

Identity studies often concentrate on borderlands or liminal spaces, contexts of cultural contact where diversity is negotiated.[23] Furthermore, archaeologists applying this sort of theory pay closer attention to the context of objects, as well as deposits that may reflect practice, rather than simply assigning a "culture" to a material assemblage.[24] This framework also utilizes the idea of hybridity, which suggests that in the marginal spaces where cross-cultural contact occurs, the material culture will begin to reflect this interaction by integrating stylistic and formal aspects of both cultures together.[25] Overall, these collected theories of cultural contact stress that both groups involved in contact zones will mutually influence one another and this contact will result in new or modified components of culture.[26] The more cerebral aspect of such interaction is explored in Richard White's Middle Ground Theory. In this work, White proposes that in situations of cultural contact, different groups will create a conceptual "middle ground," a newly created and shared worldview which allows both groups to live and function together, which often includes invented kinship or shared origins and myths.[27]

As mentioned above, much of this theoretical framework has recently been applied to cases of extended cultural interaction in the ancient Near East, and at Tell el-Dabʿa specifically. Archaeological evidence from the site

[17] C. Lyons and J. Papadopoulos, eds., *The Archaeology of Colonialism*, Issues & Debates (Los Angeles, 2002), 7.

[18] S. Jones, *The Archaeology of Ethnicity: Constructing Identities in the Past and Present* (London-New York, 1997); M. Díaz-Andreu, S. Lucy, S. Babic, and D. Edwards, eds., *The Archaeology of Identity: Approaches to Gender, Age, Status, Ethnicity and Religion* (London, 2005); F. Barth, ed., *Ethnic Groups and Boundaries: The Social Organization of Culture Difference*, Reissued (Long Grove, Illinois, 1998); S. Shennan, ed., *Archaeological Approaches to Cultural Identity*, One World Archaeology 10 (London, 1989); G. Bentley, "Ethnicity and Practice," *Comparative Studies in Society and History* 29:1 (1987), 24–55.

[19] Shennan, *Archaeological Approaches to Cultural Identity*, 13.

[20] G. Emberling, "Ethnicity in Complex Societies: Archaeological Perspectives," *JAR* 5:4 (1997), 298–99.

[21] M. Díaz-Andreu and S. Lucy, "Introduction," in Díaz-Andreu, Lucy, Babic, and Edwards, *The Archaeology of Identity*, 11.

[22] P. Bourdieu, *Outline of a Theory of Practice*, Cambridge Studies in Social and Cultural Anthropology 16 (Cambridge, 1977), 72.

[23] Lyons and Papadopoulos, *The Archaeology of Colonialism*, 7.

[24] M. Dietler, *Archaeologies of Colonialism* (Berkeley, 2010); K. Lightfoot, *Indians, Missionaries, and Merchants* (Berkeley, 2005); K. Lightfoot, A. Schiff, and A. Martinez, "Daily Practice and Material Culture in Pluralistic Social Settings: An Archaeological Study of Culture Change and Persistence from Fort Ross, California," *American Antiquity* 63 (1998), 199–222.

[25] A. Ackermann, "Cultural Hybridity: Between Metaphor and Empiricism," in P. Stockhammer, ed., *Conceptualizing Cultural Hybridization: A Transdisciplinary Approach* (Heidelberg-New York, 2012), 11–16. See also J. Maran and P. Stockhammer, eds., *Materiality and Social Practice: Transformative Capacities of Intercultural Encounters* (Oxford, 2012); P. Stockhammer, ed., *Conceptualizing Cultural Hybridization: A Transdisciplinary Approach* (Heidelberg-New York, 2012).

[26] Dietler, *Archaeologies of Colonialism*; idem, "Colonial Encounters in Iberia and the Western Mediterranean: An Exploratory Framework," in M. Dietler and C. López-Ruiz, eds., *Colonial Encounters in Ancient Iberia: Phoenician, Greek, and Indigenous Relations* (Chicago, 2009), 3–48.

[27] R. White, *The Middle Ground: Indians, Empires, and Republics in the Great Lakes Region, 1650 - 1815*, Cambridge Studies in North American Indian History (Cambridge, 1991).

is used to examine the negotiation of identity between local Egyptians and the immigrant Levantine population, known generally to the Egyptians as *ꜥ3mw*, or "Asiatics."[28] But, in his seminal study of these Asiatic individuals, Thomas Schneider demonstrated that very few monuments survive that both reference *ꜥ3mw* and are proven to have been commissioned by Asiatics.[29] Bader then recognized that this particular lack of evidence bars scholars from knowing how these Asiatics viewed themselves, a crucial aspect of understanding identity.[30] However, it is possible to access a portion of this emic perspective for the Hyksos themselves. By performing a much closer analysis of the usage and find contexts for the term *ḥk3 h3swt*, it can be demonstrated that in the Second Intermediate Period, this term was adopted by the Hyksos kings as a self-ascriptive title, likely in an effort to negotiate their identity within an Egyptian worldview.

Egyptian Texts Which Refer to the Hyksos

As stated above, the notion that the Egyptians called the Fifteenth Dynasty "Hyksos" can be negated by a survey of the relevant textual evidence. Among the most common Egyptian sources cited for the Hyksos Period, or directly describing this foreign dynasty and the Hyksos-Theban war, are the Carnarvon tablet, the First, Second, and Third Stelae of Kamose, the autobiography of Ahmose son of Ibana, the Speos Artemidos Inscription of Hatshepsut, and the *Quarrel of Apepi and Seqenenre*.[31] While all of these texts directly refer to the Hyksos and their subjects in the Eastern Delta, none of them ever employ the title *ḥk3 h3swt*. The first five of these sources are contemporary with and record the events of the Hyksos-Theban wars at the close of the Second Intermediate Period, and are referring to Apepi, or possibly Khamudi,[32] yet rarely call these Hyksos by name and never use the *ḥk3 h3swt* title. In the Autobiography of Ahmose son of Ibana, the northern enemies are distinguished as the Hyksos only by the use of two geographical locations, Avaris and Sharuhen.[33]

Common terms for Asiatics[34] are frequently used to describe individual kings, especially within the Kamose texts. For example, in the Second Stela, the Egyptian author labels Apepi *ꜥ3m ḥsi* twice and simply *ꜥ3m* once,[35] while the First Stela and the Carnarvon Tablet label him, slightly less virulently, as an *ꜥ3m*.[36] These texts also use a variety of other terms of rulership to denote the Hyksos Apepi, including *wr, nb,* and *ḥk3*.[37] In certain instances, these titles are defined more specifically, such as *wr n Rtnw* and *ḥk3 n ḥwt-wꜥrt*.[38] H. and A. Smith have discussed the distinction in these rulership titles in terms of legitimacy, whereby any title other than *ḥk3* indicated some form of subordinate ruler.[39] Flammini has done an in-depth study of the usage of the title *ḥk3* in the Kamose texts, noting that it occurs six times within the Second Stela, referring equally to Apepi, Kamose, and the ruler of Kush, yet with two different classifiers: the papyrus roll (Y1) and the ruler wearing the white crown (A43). She argues that the use of A43 is the semantic equivalent in these texts of the phrase "ruler of Upper Egypt," as

[28] For a discussion of the usage and derivation of *ꜥ3m*, see D. Redford, "Egypt and Western Asia in the Old Kingdom," *JARCE* 23 (1986), 126–32.

[29] T. Schneider, *Ausländer in Ägypten während des Mittleren Reiches und der Hyksoszeit II: Die ausländische Bevölkerung*, ÄAT 42 (Wiesbaden, 2003), 334–35.

[30] Bader, "Traces of Foreign Settlers," 150; see also Shennan, *Archaeological Approaches to Cultural Identity*.

[31] D. Redford, "Textual Sources for the Hyksos Period," in Oren, *The Hyksos*, 1–44. Redford also includes other contemporary Second Intermediate Period sources that do not deal directly with the Hyksos conflict. None of these sources use the phrase *ḥk3 h3swt*.

[32] K. Ryholt, *The Political Situation in Egypt during the Second Intermediate Period, C. 1800-1550 B.C.*, CNI Publications 20 (Copenhagen, 1997), 120.

[33] M. Lichtheim, *Ancient Egyptian Literature: Volume II, The New Kingdom*, 2006 edn. (Berkeley, 1976), 12–13.

[34] Redford, "Egypt and Western Asia," 125–43; Schneider, *Ausländer in Ägypten II*, 5–15.

[35] L. Habachi, *The Second Stela of Kamose and His Struggle against the Hyksos Ruler and His Capital* (Glückstadt, 1972), 36. Second Stela lines 11, 16.

[36] H. Smith and A. Smith, "A Reconsideration of the Kamose Texts," *ZÄS* 103 (1976), 48–76; W. Helck, *Historisch-Biographische Texte der 2. Zwischenzeit und Neue Texte der 18. Dynastie* (Wiesbaden, 1975); A. Gardiner, "The Defeat of the Hyksos by Kamose: The Carnarvon Tablet, No. I," *JEA* 3:2 (1916), 95–110.

[37] Ryholt, *The Political Situation*, 325–26.

[38] R. Flammini, "Disputed Rulership in Upper Egypt: Reconsidering the Second Stela of Kamose (K2)," *JSSEA* 38 (2011–2012), 61–64.

[39] Smith and Smith, "A Reconsideration of the Kamose Texts," 68–69.

opposed to Y1, which is followed by other locations (specifically Avaris and Kush).[40] Although the A43 classifier is applied once to Apepi and once to the ruler of Kush, Flammini suggests that to Kamose's followers, the classifiers supplied would have emphasized the legitimacy of Kamose as king of Upper Egypt.[41]

The final two texts, which postdate the Hyksos Period, still clearly refer to the Hyksos, yet never utilize the term *ḥḳꜣ ḫꜣswt*. The Speos Artemidos Inscription[42] of Hatshepsut is cited in the scholarly literature as an example of negative New Kingdom propaganda against these foreign kings.[43] While it is clear from the reference to *ḥwt wꜣrt*, ancient Avaris, that the text is dealing with the Hyksos period, the title *ḥḳꜣ ḫꜣswt* is absent. The section of this text which most directly mentions this period is lines 37–38: *wn ꜥꜣmw m-ḳbs n tꜣ mḥw ḥwt wꜣrt šmꜣw m-ḳbs.sn ḥr sḫn iryt* "Asiatics were in the midst of the Delta (at) Avaris, while nomads in their midst were destroying what had been made."[44] Clearly, especially given the deliberate double use of *m-ḳbs*, the general population of Avaris are labeled *ꜥꜣmw*, while the *šmꜣw* are considered a separate group. Redford notes that *šmꜣw* can be translated as "wanderers" or "wandering demons" and comes to be used to designate general foreignness. However, he argues that the determinative (Gardiner's sign A33) must indicate a transhumant group or nomads.[45] A careful reading of this passage suggests that it was not the Asiatic population of Avaris, but specifically the nomads in their midst who were remembered later as destructive.

The second of these texts is the *Quarrel of Apepi and Seqenenre* from Papyrus Sallier I. This story, recorded during the reign of Merenptah, is often discussed as a fictional story with some historical implications, but certainly as another Egyptian text which vilifies and mocks the Hyksos,[46] or sets Apepi up as a foil to Seqenenre.[47] Again, the text is unquestionably set during the Hyksos period, yet lacks any use of the phrase *ḥḳꜣ ḫꜣswt*. The name of the Hyksos king Apepi appears in the surviving text nine times, and while never accompanied by the title *ḥḳꜣ ḫꜣswt*, he is called *wr* once and *nsw* at least five times.[48] Furthermore, the nine occurrences of the name Apepi are all enclosed in cartouches and followed by the kingly epithet *ꜥnḫ wḏꜣ snb*. These cognizant choices on the part of the Egyptian author may be viewed through the literary theory of Deconstruction, or how "internal contradictions" within the text can betray an authors' innate biases, socio-historical contexts, and purposes for writing.[49] If the main propagandistic agenda of this literary work was to demean the Hyksos, the author should have utilized phrases like the *ꜥꜣmw ḫsi* of the Second Kamose Stela. Instead, the author's use of the word *nsw*, exclusive to Egyptian pharaohs and meaning "king," as opposed to "ruler" or "chief," as well as the royal epithet "life, prosperity, health," indicates that perhaps in the cultural memory of the Ramesside Period (or at the very least in the mind of this individual author), the Hyksos dynasts were considered perfectly legitimate kings of a time several centuries past.[50]

The only Egyptian-authored text which may refer to the Fifteenth Dynasty as Hyksos is the Turin King List. The most extensive reconstruction of the Second Intermediate Period section was undertaken by Ryholt[51] and then refined further by both Ryholt and Allen.[52] However, due to the fragmentary nature of the document, the small area designated to the Fifteenth Dynasty is largely absent or illegible. Ryholt proposes that the Fifteenth

[40] Flammini, "Disputed Rulership in Upper Egypt," 57–59.

[41] Flammini, "Disputed Rulership in Upper Egypt," 64.

[42] A. Gardiner, "Davies' Copy of the Great Speos Artemidos Inscription," *JEA* 32 (1946), 43–56; Redford, "Textual Sources for the Hyksos Period," 16–17.

[43] Redford, "The Hyksos Invasion," 32–33.

[44] Translation after Redford, "Textual Sources for the Hyksos Period," 17.

[45] Redford, "Textual Sources for the Hyksos Period," 32, no. 207.

[46] C. Manassa, *Imagining the Past: Historical Fiction in New Kingdom Egypt* (New York, 2013); Redford, "The Hyksos Invasion," 35–36.

[47] A. Spalinger, "Two Screen Plays: 'Kamose' and 'Apophis and Seqenenre'," *JEgH* 3: 1 (2010), 115–35.

[48] Spalinger, "Two Screen Plays," 123–24.

[49] S. Dyson, "Is There a Text in This Site?" in D. Small, ed., *Methods in the Mediterranean: Historical and Archaeological Views on Texts and Archaeology* (Leiden, 1995), 25.

[50] This is especially interesting given the inclusion of the Hyksos in the Turin King-List, and the continuity in cult and choice of Eastern Delta capitals in both the Hyksos and Ramesside periods. See for example T. Schneider, "Wie der Wettergott Ägypten aus der großen Flut errettete: Ein 'inkulturierter' ägyptischer Sintflut-Mythos und die Gründung der Ramsesstadt," *JSSEA* 38 (2011), 188–90.

[51] Ryholt, *The Political Situation*, 118–23.

[52] K. Ryholt, "The Turin King List," *Ä&L* 14 (2004), 135–55; J. Allen, "The Second Intermediate Period in the Turin King-List," in Marée, *The Second Intermediate Period*, 1–10.

Dynasty heading is *ḥḳꜣ ḫꜣswt*, which also replaces the expected *nsw bjtj* in front of the native kings' names. This reconstruction is based entirely on the lack of cartouche and replacement of the falcon on a standard with a throwing stick in the name of Khamudi, which is the only name preserved in this section, as well as the word *ḫꜣswt* in the summary line. Despite the fragmented evidence, the reconstruction is still plausible given the distinct change from the standard conventions in the remainder of the document. However, this reconstruction then raises the question of why the Turin King List is the sole Egyptian source which preserves the Hyksos' use of the *ḥḳꜣ ḫꜣswt* title, a question which falls outside the scope of this paper.[53]

Use of ḥḳꜣ ḫꜣswt Outside the Second Intermediate Period

Before discussing the unique usage of the title *ḥḳꜣ ḫꜣswt* during the period of interest, it is important to understand the application of the term throughout pharaonic history. Outside the Second Intermediate Period, this title is found only sparsely, and usually in monumental contexts. The thirty-two attestations known to me[54] are catalogued in Table I in chronological order, if possible listed with their date, a brief description, and provenience information or archaeological context. I have also included a geographical location of the referenced foreign ruler, since ancient Egyptians seem to have considered geographical regions as closely associated with potential ethnic or cultural identity.[55] I use the term "general" to indicate that, from the text or corresponding imagery alone, the geographic assignment of the *ḥḳꜣ ḫꜣswt* is indeterminate.

As indicated by Table I, the diachronic distribution of the non-Second Intermediate Period examples is relatively balanced,[56] exhibiting intensification in the Eighteenth Dynasty. This marked New Kingdom increase is due to the inclusion of the phrase *ḥwi ḥḳꜣw ḫꜣswt pḥw sw* "[who] has struck the rulers of foreign lands who had attacked him," within the jubilee epithets of Thutmose III. Seven examples are from the first line of the jubilee names of Thutmose III, identically replicated on his Karnak obelisks, the Amun Temple at Karnak, the Akhmenu, and the temples at Medinet Habu, Elkab, Semna, and Heliopolis.[57] Three more examples are described by Sethe as Ehrenbezeichnungen of Thutmose III, occurring twice more at Medinet Habu and once again at the Akhmenu at Karnak.[58] Another example can be found on the back side of the left obelisk erected at Heliopolis to commemorate the Third Jubilee of Thutmose III, now in New York.[59] Amenhotep II also incorporated this phrase into his kingly epithets on the Eighth Pylon at Karnak.[60] Therefore, this standardized replication of the title *ḥḳꜣ ḫꜣswt* can be considered a single example for each Thutmose III and Amenhotep II, eliminating the Eighteenth Dynasty as an outlier within the chronological distribution.

The results are also evenly distributed in terms of the geographic, and the potentially linked ethnic, association for the use of *ḥḳꜣ ḫꜣswt*. The non-Second Intermediate Period examples all occur in Egyptian sources, texts or artifacts clearly commissioned by Egyptian individuals, including Execration Texts, tomb autobiographies, royal inscriptions, the Story of Sinuhe, etc. In these cases, the title *ḥḳꜣ ḫꜣswt* is an etic label applied by Egyptian

[53] I believe this is linked to the idea of a unique, regionally specific cultural memory of the Eastern Delta, in which the Hyksos were considered entirely legitimate Egyptian kings. Documents or monuments produced locally in the area of Avaris would have perpetuated the memory of their kingship, and may have been the original sources copied by the Turin King-List (also possibly composed in the Eastern Delta). This then helps to explain the cultural continuity between the Hyksos and Ramesside periods, given the centrality of the Eastern Delta to both.

[54] This paper examines the use of the title *ḥḳꜣ ḫꜣswt*, and so any usages of the two words in broader phrases were not included. For example, *ḥḳꜣ n ḫꜣst nbt* in line 176 of Papyrus Berlin 3022 (the Story of Sinuhe); *ḥḳꜣw imw ḫꜣst nbt* in an inscription in the Tomb of Intef at Dra Abu el-Naga; and *ḥḳꜣ n ḫꜣst nbt* in an inscription at the Esna temple of Diocletian. Much of the catalog is found in Redford, "Textual Sources for the Hyksos Period," 19.

[55] Smith, *Wretched Kush*; S. Smith, "Ethnicity and Culture," in T. Wilkinson, ed., *The Egyptian World* (London, 2007), 218–41; T. Schneider, "Foreigners in Egypt," in W. Wendrich, ed., *Egyptian Archaeology*, Blackwell Studies in Global Archaeology 13 (Chichester, U.K.-Malden, MA., 2010), 143–63.

[56] The lack of examples from the First and Third Intermediate Periods is not unexpected given the general dearth of evidence.

[57] *Urk. IV*, 599.

[58] *Urk. IV*, 555.

[59] *Urk. IV*, 593.

[60] *Urk. IV*, 1333.

authors to these foreign individuals. The term references both Levantine and Nubian leaders, as well as more abstract examples of ideological enemies. As discussed above, the New Kingdom contains many more examples which fall into this latter category due to the inclusion of the title in jubilee titulary. Otherwise, no marked shifts occur in the Egyptian usage of the term as a result of the Hyksos' appropriation.

The usage of *ḥḳꜣ ḫꜣswt* does undergo a shift beginning in the Twenty-fifth Dynasty, when Montuemhat adopts the title for himself.[61] He seems to have set a fashion, as other high elites and pharaohs of the Late and Ptolemaic Periods also adopt the title as a personal epithet, including a Saite elite named Padiharessne,[62] Philip Arrihaeus,[63] Ptolemy XIII,[64] and a Ptolemaic general by the name of Nectanebo.[65] The title *ḥḳꜣ ḫꜣswt* is twice included in the epithets of divinities, once in a Nineteenth Dynasty votive stela from Deir el Medina dedicated to Shed,[66] and once in the Ptolemaic period as an epithet of Min at Dendera.[67] Perhaps the most interesting later occurrence of the title is in the tomb of Petosiris at Tuna el-Gebel, in which he refers to Artaxerxes III as a *ḥḳꜣ ḫꜣswt*.[68] Unfortunately in this case it is impossible to know whether the Persian ruler consciously adopted the title in a manner similar to the Hyksos,[69] or if the tomb owner commissioned the work as a factual description of his sovereign's foreign origin.

Use of ḥḳꜣ ḫꜣswt in the Second Intermediate Period

The diachronic distribution of *ḥḳꜣ ḫꜣswt* exhibits a spike during the Second Intermediate Period with a total of thirty-one occurrences, all of which can be associated with a Levantine geographical referent. These examples, compiled in Table II, occur almost exclusively on seals and seal impressions, with the sole exception of the monumental door jamb of *Skr-Ḥr*,[70] and are the only instances of the use of *ḥḳꜣ ḫꜣswt* which are contemporary with the Hyksos Period. Interestingly, all but five of these examples belong to Khyan. Most importantly for the study of Hyksos identity, all of these artifacts were likely commissioned by the Hyksos themselves, or were manufactured for the administrative use of their officials. Therefore, they exemplify the elusive combination which Schneider sought for *ꜥꜣm* and Levantine individuals, having both the use of a specific identifying word and a secure commission by the same group which is referenced.[71]

Each of these instances feature the term *ḥḳꜣ ḫꜣswt* followed by the personal name of the ruler, which are in each case Semitic: *ꜥpr-ꜥnti* (fig. 2), *ꜥnt-ḥr* (fig. 3), *Smḳn* (fig. 4), *Ḥyꜣn* (fig. 5), and *Skr-Ḥr*.[72] There is some debate over the chronological position of *ꜥnt-ḥr*: while Ward assigns this king to the Fifteenth Dynasty based primarily on the use of the *ḥḳꜣ ḫꜣswt* title,[73] Ryholt locates him in the Twelfth Dynasty based on the style of elytra on one of his two total scarabs.[74] In my view, the combination of the Semitic name and *ḥḳꜣ ḫꜣswt* title would most likely place *ꜥnt-ḥr* in the very late Thirteenth, Fourteenth, or Fifteenth Dynasty, alongside the proposed chronological positions of the other four kings attested with this title. Indeed, it seems much more likely that a Twelfth Dynasty scarab was reused, and only the inscription was re-carved for *ꜥnt-ḥr*.

[61] Leclant, *Montouemhat*, 254.

[62] L. Christophe, "Trois monuments inédits mentionnant le grand majordome de Nitocris, Padihorresnet," *BIFAO* 55 (1956), 81f.

[63] Gauthier, *LR IV*, 206; *Urk. II*, 9.

[64] Junker, Philae I, 72 Abb. 37.

[65] *Urk. II*, 24 no. 7.

[66] B. Bruyère, *Deir El Médineh*, DFIFAO 20 (Cairo, 1952), 165.

[67] Mariette, *Dendérah I*, 23.

[68] G. Lefebvre, *Le tombeau de Petosiris* (Cairo, 1923), 81, no. 28.

[69] See below.

[70] Bietak and Hein, *Pharaonen und Fremde*, 155ff.

[71] See above Schneider, *Ausländer in Ägypten II*, 334–35.

[72] Ryholt, *The Political Situation*, 123–25; T. Schneider, *Lexikon der Pharaonen: Die altägyptischen Könige von der Frühzeit bis zur Römerherrschaft* (Zurich, 1994), 275; idem, *Ausländer in Ägypten während des Mittleren Reiches und der Hyksoszeit I: Die Ausländischen Könige*, ÄAT 42 (Wiesbaden, 1998), 41–42.

[73] W. Ward, "Royal Name Scarabs," in O. Tufnell, *Studies on Scarab Seals. Volume II: Scarab Seals and Their Contribution to History in the Early Second Millennium B.C.* (Warminster, 1984), 170.

[74] Ryholt, *The Political Situation*, 122. The style features the elytra divided by three lines, which is usually found during the Twelfth Dynasty.

Fig. 2 (left). Scarab of ꜥpr-ꜥnti in the Petrie Museum (line drawing by author, after Tufnell, Studies, #3464).

Fig. 3 (right). Scarab of ꜥnt-ḥr (line drawing by author, after Newberry, Scarabs, #11).

While the name of Khyan is preserved on numerous scarabs with the traditional Egyptian royal title *sꜣ rꜥ*, it is in the earlier reign of *Skr-Hr* that we have evidence of a Hyksos adopting most of the five-fold titulary. However, while the door jamb still utilizes the *ḥkꜣ ḫꜣswt* title following the Nebty and Golden Horus names,[75] by the following reign, Apepi has seemingly left the term behind.[76] Ryholt uses this apparent shift in titulary to assign an order to the reigns of these kings, proposing that *Skr-Hr* should be Khyan's immediate predecessor. He suggests that Khyan himself only used the term early in his reign, and upon conquering all of Egypt, adopted the traditional Egyptian titulary and "abandon[ed] the use of the 'petty' title *ḥkꜣ ḫꜣswt*."[77] According to Ryholt, this would also explain why no *ḥkꜣ ḫꜣswt* titles survive from the reigns of Apepi and Khamudi.[78]

Although Ryholt does raise the question of why these final two kings are recorded as *ḥkꜣ ḫꜣswt* in the Turin King List despite never having used the title themselves, he suggests that the early Eighteenth Dynasty sources would have preserved the title for reasons of consistency or to "mark the entire dynasty as dissident." This notion is built off of the passage in the Speos Artemidos inscription claiming that "they ruled without acknowledging Re,"[79] and not on the actual usage of the title *ḥkꜣ ḫꜣswt*, which, as demonstrated above, is not used to refer to the Hyksos until the Turin King List. Instead, it is possible that Apepi and Khamudi did in fact employ the title *ḥkꜣ ḫꜣswt*, but that no examples survive. Given that *ꜥpr-ꜥnti, Smkn,* and *Skr-Hr* are each attested with the title only once, and *ꜥnt-ḥr* twice, we are in theory only one discovery away from an example for Apepi or Khamudi. Furthermore, all but the *Skr-Hr* example occur on seals and sealings, small mobile objects, easily displaced or in the case of the latter, often fragmentary or destroyed by environmental conditions. Also in support of this notion is that the Turin King List may have been copied from a monument or document contemporary with the Fifteenth Dynasty, which would explain the maintenance of the *ḥkꜣ ḫꜣswt* title throughout the dynasty.

Additionally, the proposal that these kings dropped the less prestigious title *ḥkꜣ ḫꜣswt* in favor of Egyptian titulary is called into question by scarabs from slightly earlier in the Second Intermediate Period. For example, the kings *Šši* and *Yꜥkb-Hr* have been assigned by Ryholt to the early and later Fourteenth Dynasty respectively, based on archaeological contexts at Uronarti, Shiqmona, and Kerma.[80] Scarabs of these kings almost always employ *nfr nṯr* with the prenomen and *sꜣ rꜥ* with the nomen, and often the *sꜣ rꜥ* examples also feature the king's name

[75] Ryholt, *The Political Situation*, 124.

[76] No examples have been found pairing the *ḥkꜣ ḫꜣswt* title and the name of Apepi.

[77] Ryholt, The Political Situation, 124-25. Part of his argument is that some of the *sꜣ rꜥ* examples are accompanied by Khyan's name in the royal cartouche, while the *ḥkꜣ ḫꜣswt* examples do not feature the cartouche. However, on the door jamb of *Skr-Hr*, the *ḥkꜣ ḫꜣswt* title is followed by the ruler's name in a cartouche. See also R. Roberts, "Hyksos Self-Presentation and 'Culture'," in E. Frood and A. McDonald, eds., *Decorum and Experience: Essays on Ancient Culture for John Baines* (Oxford, 2013), 286, in which the author proposes a similar significance to the lack of *nsw biti* or *nb-tꜣwy* titles before the reign of Apepi—namely that the earlier Fifteenth Dynasty kings did not consider themselves rulers of both Lower and Upper Egypt until Apepi.

[78] See also Allen, "The Second Intermediate Period in the Turin King-List," 5.

[79] Ryholt, *The Political Situation*, 125.

[80] Ryholt, *The Political Situation*, 42–50.

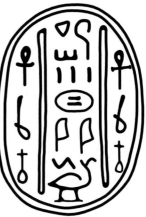

*Fig. 4 (left). Scarab of **Smkn** (line drawing by author, after* Tufnell, *Studies, #3463).*

Fig. 5 (right). Scarab of Khyan in Cairo (line drawing by author, after Newberry, Scarab Shaped Seals, *CG36027).*

in a cartouche.[81] Neither of these kings are attested with the *ḥḳꜣ ḫꜣswt* title. These kings, with Semitic names, are already employing the supposedly more significant Egyptian titulary before the Hyksos Dynasty, and cannot be discounted in this model of titular negotiation. Ryholt also proposes that Khyan's shift to the *sꜣ rꜥ* title corresponds with his "conquest" of all of Egypt. However, there does not seem to be direct evidence for this conquest, nor for the chronological separation in Khyan's use of the *ḥḳꜣ ḫꜣswt* versus *sꜣ rꜥ* titles. It also seems unlikely that *Ššỉ* and *Yꜥḳb-Hr* were in control of all of Egypt, which, as Ryholt suggests, might be the criteria for the use of *sꜣ rꜥ* and a cartouche. Especially considering his placement of *ꜥnt-ḥr* and his *ḥḳꜣ ḫꜣswt* title in the Twelfth Dynasty, an explanation must be given for why the title *ḥḳꜣ ḫꜣswt* would have fallen out of favor twice.

Many of these chronological issues may be solved by the potential overlap between the late Thirteenth and Fifteenth Dynasties proposed by Moeller and Marouard. Their discovery of sealings of both Khyan and Sobekhotep IV, found in a secure archaeological context at Edfu dating to the late Thirteenth Dynasty, has sparked intense debate concerning the chronology of the Second Intermediate Period. The Khyan sealings suggest that this king held economic or diplomatic contacts with Upper Egypt and should perhaps be located early in the Fifteenth Dynasty.[82] These conclusions further complicate Ryholt's timeline and causation for the abandonment of the *ḥḳꜣ ḫꜣswt* title, and may help to clarify the relatively early style of the *ꜥnt-ḥr* scarab. In addition, further archaeological contexts from Tell el-Dabꜥa have yielded evidence to support the potential overlap of the Thirteenth and Fifteenth Dynasties, as well as an earlier date for the reign of Khyan.[83] Thus the ongoing excavations at Edfu and Tell el-Dabꜥa, as well as new radiocarbon dates,[84] may have widespread ramifications for our understanding of the Second Intermediate Period, both in terms of chronology and political organization.

While it is important to discuss the geopolitical and chronological significance of these titles, it is also crucial to consider how these titles are linked to the self-conception of the rulers who adopted them. A few scholars have started to apply this framework of identity, such as Bader, who described the combination of Egyptian

[81] Ryholt, *The Political Situation*, 45–46.

[82] N. Moeller and G. Marouard, with a contribution by N. Ayers, "Discussion of Late Middle Kingdom and Early Second Intermediate Period History and Chronology in Relation to the Khayan Sealings from Tell Edfu," *Ä&L* 21 (2012), 87–121. See also N. Moeller and G. Marouard, "The Context of the Khayan Sealings from Tell Edfu and Further Implications for the Second Intermediate Period in Upper Egypt," in N. Moeller and I. Forstner-Müller, eds., *The Hyksos Ruler Khayan and the Early Second Intermediate Period in Egypt: Problems and Priorities of Current Research* (Vienna, in progress).

[83] I. Forstner-Müller and P. Rose, "Grabungen des Österreichischen Archäologischen Instituts Kairo in Tell El-Dabꜥa /Avaris: Das Areal R/III," *Ä&L* 22–23 (2012-13), 62; C. Reali, "The Seal Impressions from ꜥEzbet Rushdi, Area R/III of Tell El-Dabꜥa: Preliminary Report," *Ä&L* 22/23 (2012-13), 69–71; N. Sartori, "Die Siegel aus Areal F/II in Tell El-Dabꜥa. Erster Vorbericht," *Ä&L* 19 (2009), 284. See also the respective papers by Forstner-Müller, Moeller and Marouard, and Reali in the forthcoming volume: N. Moeller and I. Forstner-Müller, eds., *The Hyksos Ruler Khayan*, in progress.

[84] See the paper by Höflmayer in Moeller and Forstner-Müller, *The Hyksos Ruler Khayan*, in progress.

titulary and *ḥḳꜣ ḫꜣswt* on the door jamb as a "good example demonstrating cultural mixture."[85] Allen developed the chronological argument further and suggested that the first kings of the Fifteenth Dynasty adopted the title *ḥḳꜣ ḫꜣswt* to "reflect the dynasty's initial view of itself as different from previous and contemporary Egyptian rulers."[86]

Expanding on these observations, this paper investigates the situation through the lens of individual agency, emphasizing the purposeful choices made by the Hyksos to employ this title, as well as the meaning the title might hold for them. I believe the Hyksos's adoption of the title *ḥḳꜣ ḫꜣswt* is indicative of their attempts to negotiate their foreign identity from an Egyptian perspective. This interpretation is in line with Richard White's Middle Ground Theory, which proposes that the social groups involved in creating the Middle Ground were willing, and perhaps attempting, "to justify their actions in terms of what they perceived to be their partner's cultural premises."[87] Perhaps the Hyksos sought to commemorate their foreign origins in a way that would still convey their royalty, power, and ties to their homelands, yet using a title that their Egyptian subjects would recognize because it hailed from their own cultural milieu.[88]

It is possible that the Hyksos use of the *ḥḳꜣ ḫꜣswt* title parallels the widespread elite adoption of Amorite titles alongside traditional Mesopotamian titles across the Near East in the early second millennium B.C.E. It was around this period, after the collapse of the Third Dynasty of Ur, that individual city-states headed by Amorite rulers—or at least rulers self-identifying as Amorite—appeared from Southern Mesopotamia to Syria. These sovereigns took the expected Mesopotamian titles alongside their personal Amorite names, but added more which directly linked them to the Amorites or Amorite sub-groups.[89] In fact, Hammurabi himself took the title "King of all the Amorite land,"[90] which best illustrates the similarity in intent behind this titulary. In a Near Eastern context, elites associated themselves with this powerful, well-known group. However, the Hyksos, situated as they were in their Egyptian setting, took on a title that their Egyptian subjects were familiar with yet communicated the same idea—in the Egyptian context, it mattered less which foreign lands/people were controlled, only that they were foreign. Thus, perhaps the *ḥḳꜣ ḫꜣswt* title is the Egyptian substitute for these Amorite-affiliation titles, especially given that identity is known to be malleable and often contextually-dependent.[91]

The Hyksos were also preserving their foreign identity by purposefully displaying their origins in other ways. The monumental architecture at Tell el-Dabʿa, namely the palace[92] and two temples,[93] appears to be Near Eastern in style. If one is willing to extrapolate from older strata at Tell el-Dabʿa, these immigrants made an effort to maintain religious beliefs,[94] mortuary practice,[95] craft traditions,[96] even ceramic forms, and potentially the

[85] Bader, "Cultural Mixing," 277.

[86] Allen, "The Second Intermediate Period in the Turin King-List," 5. Contra Roberts, "Hyksos Self-Presentation," 285–88, who argues that the titles on scarabs and seals are beyond the scope of royal self-presentation, and are more likely reflective of the "perceived identity" given to the rulers by the artisans producing the seals. However, he does concede that the royal self-identity and their perceived identity were likely the same because royal artisans and the kings themselves functioned within the same ideological milieu.

[87] White, *The Middle Ground*, 52.

[88] Contrary to the idea proposed by Redford, who suggested that the Egyptians and Hyksos rejected one another and any associated traditions. See Redford, "The Hyksos Invasion," 8.

[89] Schwartz, "An Amorite Global Village," 2–5.

[90] Schwartz, "An Amorite Global Village," 3.

[91] Díaz-Andreu and Lucy, "Introduction," 10–11. It is interesting to speculate that if the beginning of the Old Babylonian letter fragment discovered in the Fifteenth Dynasty palace at Tell el-Dabʿa had been preserved (see Bietak and Forstner-Müller, "Der Hyksos-Palast," 93–118) perhaps the Amorite-affiliation titles would have been used. In the context of diplomatic correspondence with another Amorite ruler, it seems likely that the Hyksos would have consciously chosen to self-identify as Amorite, actively maintaining kinship ties and ascribing to the international elite identity of the day. Indeed, Moeller and Marouard suggest a similar conscious selection of titulary when trading with Upper Egypt, noting that the Khyan sealings from Edfu only feature the *sꜣ rꜥ* title: see Moeller and Marouard, "The Context of the Khayan Sealings," in progress.

[92] Bietak, Math, and Müller, "Report on the Excavations of a Hyksos Palace," 19–32; Bietak and Forstner-Müller, "Der Hyksos-Palast," 93–118; M. Bietak, "Le Hyksos Khayan, son palais, une lettre cuneiforme," *CRAIBL* II (Paris, 2010): 973–90.

[93] Bietak, "Near Eastern Sanctuaries," 213–20; Bietak, "Two Ancient Near Eastern Temples," 13–22.

[94] Bietak, "Near Eastern Sanctuaries," 209–15; E. Porada, "The Cylinder Seal from Tell el-Dabʿa," *AJA* 88: 4 (1984), 485–88.

[95] Forstner-Müller, "Tombs and Burial Customs," 128–32.

[96] G. Philip, *Tell el-Dabʿa XV: Metalwork and Metalworking Evidence of the Late Middle Kingdom and Second Intermediate Period.*, UZK 26 (Vienna, 2006), 231–41.

attendant foodways.[97] In every case however, this marked persistence of their origins was in constant negotiation and dialog with Egyptian traditions. The Hyksos adoption of the *ḥḳꜣ ḫꜣswt* title may be yet another example of this negotiation process.

Indeed, the occurrence of these *ḥḳꜣ ḫꜣswt* examples almost exclusively on seals and sealings is further indicative of the blending of broader Near Eastern and Egyptian glyptic styles. The Hyksos hail from a Syro-Mesopotamian glyptic tradition featuring full graphic scenes carved on cylinder seals. This type of seal can be exemplified in the Baal-Zephon cylinder seal found at Tell el-Dabꜥa in area F/I on the floor of the Thirteenth Dynasty palace, which contains a Syrian-style scene yet appears to have been carved locally.[98] However, all but three of the seals featuring the *ḥḳꜣ ḫꜣswt* title are scarabs, and all examples favor inscription over imagery (even the three cylinder seal examples). Therefore, it appears that the Hyksos were operating from within an Egyptian administrative tradition, most likely because their administrative officials were either Egyptian or local Levantines who had been employed under earlier Egyptian kings.

It is important to keep in mind that much of the cultural material that the Hyksos produced is lost. However, it is significant that we see this conscious negotiation of foreign and Egyptian identity in two particular contexts: monumental inscription and administrative seals, both extremes on the spectrum of royal display.

Titulary Wordplay: Unique Examples Featuring ḥḳꜣ

The active process of identity negotiation undergone by the Hyksos can be further elucidated in examples of unique experimentation with the word *ḥḳꜣ*, starting in the late Twelfth Dynasty through the Hyksos Period and into the early Eighteenth Dynasty. One of the most cited scenes in discussions of the Hyksos is the painting of Asiatics and the *ḥḳꜣ ḫꜣswt* Abshar in the tomb of Khnumhotep II at Beni Hasan.[99] On the mastaba of his son, Khnumhotep III, at Dashur, a historical inscription in the style of a literary text has been partially preserved. In the preliminary report on this text, Allen notes that the word *ḥḳꜣ* is provided with a classifier sign of "a seated man with the beard and 'mushroom' hairdo, holding a round-bladed ax."[100] Indeed, the classifier bears a remarkable resemblance to the Beni Hasan individual and the over-lifesize sculptures discovered at Tell el-Dabꜥa.[101] This is an unusual way of writing the word, and similar "Asiatic" classifier signs are used on the same monument for both *ꜥꜣm* and *mnti*.[102] These examples are also paralleled on an obelisk-shaped stela from Serabit el Khadim, on which the Semitic names of individuals involved in mining expeditions are determined by the same seated, mushroom-haired Asiatic with a rounded ax.[103] It seems that by the late Twelfth Dynasty, at least in the case of the Beni Hasan scene and Dashur inscription, Asiatics and the term *ḥḳꜣ* are becoming more closely associated.[104] Perhaps Levantine rulers were adopting this Egyptian title for themselves, or at the very least Egyptians were labeling these foreign leaders with the native title *ḥḳꜣ*—in either case, examples such as these may have served as partial inspiration for the Hyksos' choice of Egyptian title.

By the height of the Fifteenth Dynasty, the Hyksos had begun adopting aspects of the traditional Egyptian titulary. The *Skr-Ḥr* door jamb is the most complete example, but numerous other objects are inscribed with a Hyksos personal name alongside Egyptian titles, of which *sꜣ rꜥ* is by far the most common. For example, a scarab

[97] Bader, "Traces of Foreign Settlers," 137–47; de Vreeze, "'A Strange Bird'," 155–78; C. Redmount, "Ethnicity, Pottery, and the Hyksos at Tell El-Maskhuta in the Egyptian Delta," *The Biblical Archaeologist* 58: 4 (1995), 184–88.

[98] Porada, "The Cylinder Seal," 485.

[99] Newberry, *Beni Hasan I*, 69, pl. XXXI.

[100] J. Allen, "The Historical Inscription of Khnumhotep at Dashur: Preliminary Report," *BASOR* 352 (2008), 33.

[101] Do. Arnold, "Image and Identity: Egypt's Eastern Neighbours, East Delta People and the Hyksos," in Marée, *The Second Intermediate Period*, 191–200; R. Schiestl, "The Statue of an Asiatic Man from Tell El-Dabꜥa, Egypt," *Ä&L* 16 (2006), 177–80.

[102] Meaning "Asiatic" and something like "Asiatic Bedouin," respectively. See Allen, "The Historical Inscription of Khnumhotep," 33.

[103] A. Gardiner, T. Peet, and J. Černy, *Inscriptions of Sinai: Parts I-II* (London, 1952), pl. 51 no. 163.

[104] It is also interesting to note that these sources are roughly contemporary with the first influx of Asiatic settlers into the Eastern Delta, especially at Tell el-Dabꜥa, see Bietak, "Where did the Hyksos come from," 139–60.

Fig. 6 (left). Scarab of Skhꜥ-n-rꜥ in Jerusalem (line drawing by author).

Fig. 7 (right). Scarab of Ahmose in Turin inscribed "the son of Re, Ahmose Heqatawy" (line drawing by author, after Petrie, Historical Scarabs, *#779).*

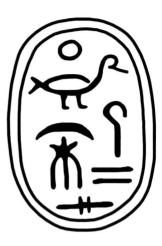

of Khyan[105] includes the *sꜣ rꜥ* title preceded by the phrase *nṯr nfr*, often included within the royal titulary.[106] An alabastron lid of Khyan found at Knossos, reads *nṯr nfr swsr-n-rꜥ sꜣ rꜥ Ḫyꜣn*.[107]

I know of only two examples which feature the signs *ḥkꜣ* and *nfr* together at the start of the inscription as though a single title. The first is a scarab seal in the Israel Museum inscribed *nfr ḥkꜣ sḫꜥn-rꜥ* (fig. 6).[108] The second is a cylinder seal now in the National Museum in Athens, with *ḥkꜣ nfr* followed by plural strokes and the name *Ḫyꜣn*.[109] Giveon identifies this as a "conflation of the title *ḥkꜣ ḫꜣswt* with *nfr nṯr*; the sign for foreign countries has been omitted and only its plural strokes remain."[110] Apepi has two scarabs inscriptions which contain *nsw nfr* and *nfr nsw bit*, which Ryholt also ascribes to scribal error, "reveal[ing] the inability of the craftsmen who produced the seals to understand the titles they were cutting."[111] While it is possible that these inscriptions were "errors," given that they all retain *nfr* and a word for some sort of ruler, they may instead represent a negotiation of, or experimentation with, the traditional Egyptian titulary. Perhaps these craftsmen intentionally inscribed these titles to evoke the idea of a "good ruler"[112] or "best of rulers" in the case of the Athens seal.

At the end of the Hyksos Period and into the early Eighteenth Dynasty, even the Theban kings begin to experiment with *ḥkꜣ* titles. This transitional period is marked by a manipulation of titles which not only deviates from traditional Egyptian titulary, but is clearly a response to the titles adopted by the Hyksos. In the reign of Kamose, his name was occasionally replaced in cartouches by names featuring *ḥkꜣ*: *pꜣ ḥkꜣ rsy, pꜣ ḥkꜣ kn,* and *pꜣ ḥkꜣ ꜥꜣ*.[113] Harvey has also commented that Kamose's adoption of *sḏfꜣ tꜣwy* as his Horus name is likely in direct response to Apepi's Horus name, *sḥtp tꜣwy*.[114] Harvey proposes that this emphasis on the use of *ḥkꜣ* was to "reinforce his identity against the insult of the Hyksos king Apepi, who apparently referred to Kamose as a mere *wr*."[115] Ahmose then took this a step farther by taking the prenomen *ḥkꜣ tꜣwy*, simultaneously a play on the traditional *nb tꜣwy* and *ḥkꜣ ḫꜣswt*, removing any doubt as to his supremacy not over foreign lands, but over the two lands of Egypt.[116]

[105] This piece reads *nṯr nfr sꜣ rꜥ swsr-n-rꜥ*, W. Petrie, *History of Egypt* I (London, 1894), 119.

[106] J. von Beckerath, *Handbuch Der Ägyptischen Königsnamen*, MÄS 49 (Mainz, 1999), 2.

[107] A. Evans, *The Palace of Minos*, Vol. I (London, 1921), 419.

[108] IMJ 76.31.3883. http://www.imj.org.il/node/229771.

[109] Petrie, *History of Egypt I*, 119.

[110] R. Giveon, "A Sealing of Khyan from the Shephela of Southern Palestine," *JEA* 51 (1965), 204, no. 5.

[111] Ryholt, *The Political Situation*, 51–52.

[112] P. Labib, *Die Herrschaft der Hyksos in Ägypten und ihr Sturz* (Glückstadt, 1936), 31.

[113] Ryholt, *The Political Situation*, 400, no.1; H. Winlock, "The Tombs of the Kings of the Seventeenth Dynasty at Thebes," *JEA* 10: 3/4 (1924), 264.

[114] S. Harvey, "King Heqatawy: Notes on a Forgotten Eighteenth Dynasty Royal Name," in Z. Hawass and J. Richards, eds., *The Archaeology and Art of Ancient Egypt: Essays in Honor of David B. O'Connor*, Supp. ASAE 36 (Cairo, 2007), 343–56.

[115] Harvey, "King Hekatawy," 356.

[116] Harvey, "King Heqatawy," 355–56.

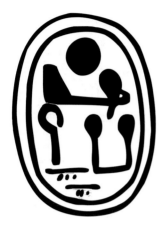

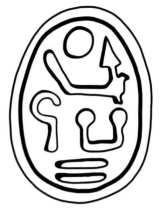

Fig. 8 (left). Scarab of Amenhotep I inscribed "Djeserkare Hekatawy" (line drawing by author, after Pier, Historical Scarab Seals, *#1254).*

Fig. 9 (right). Scarab of Amenhotep I in Basel inscribed "Djeserkare Hekatawy" (line drawing by author, after Hornung and Staehelin, Skarabäen, *#207).*

This unusual royal name has long been attested due to its early discovery on several small objects, including funerary cones of the Chief Prophet of Amun and Chief Treasurer Djehty,[117] as well as two scarabs (fig. 7).[118] Recently, Harvey and his team uncovered further examples of the unconventional name at south Abydos, stamped onto bricks from Building D.[119] Harvey makes the valid observation that by taking on this name, "Ahmose may have sought to remove any tarnish that traditional ideas of rulership had acquired during the Hyksos era, a period during which … the integrity of traditional Egyptian linguistic categories surrounding kingship" had come into question.[120]

Indeed, the impetus among the Egyptian rulers of the early Eighteenth Dynasty to reclaim these linguistic categories was so strong that the use of *ḥḳꜣ tꜣwy* continues for several reigns. Harvey discusses a scarab, which Winlock incorrectly assigned to Thutmose I, with both *ḥḳꜣ tꜣwy* and the throne name *ꜥꜣḫprwrꜥ*. Harvey suggests that it might be possible to read it as *ꜥꜣ ḫprw*, Ahmose's earlier Horus name, or that it was indeed intended for Amenhotep II.[121] Further examples of *ḥḳꜣ tꜣwy*, which Harvey does not discuss, occur on objects of Amenhotep I. The first is a scarab formerly in the collection of the Art Institute of Chicago with the inscription *ḏsrkꜣrꜥ ḥḳꜣ tꜣwy* (fig. 8).[122] The same inscription is featured on a scarab found at Semna,[123] and a scarab (fig. 9) and small plaque in Basel.[124] These examples illustrate the same identity negotiation process undertaken by the Hyksos: the early Eighteenth Dynasty intentionally and carefully selected new elements of titulary to reify their identities in response to and as separate from the Hyksos.

Conclusions

Throughout pharaonic history, the *ḥḳꜣ ḫꜣswt* title is used for foreign rulers from the Levant and Nubia, as well as ideologically generalized enemies of the state. For the kings of the later Second Intermediate Period, the title is employed uniquely as an indication of self. It is important to note that, with the exception of the Turin King List, none of the Egyptian sources referencing the Hyksos ever employ the title *ḥḳꜣ ḫꜣswt*. In the Late Period it

[117] N. Davies and M. Macadam, *A Corpus of Inscribed Egyptian Funerary Cones Part I* (Oxford, 1957), nos. 535–537. The funerary cone reads *sꜣ Rꜥ ḥḳꜣ tꜣwy di ꜥnḫ ḏt*. See also Winlock, "The Tombs of the Kings," 264; Harvey, "King Heqatawy," 343.

[118] The first is a scarab in Turin reading *sꜣ Rꜥ ḥḳꜣ tꜣwy Iꜥḥ-ms*, see W. Petrie, *Historical Scarabs: A Series of Drawings from the Principal Collections, Arranged Chronologically* (London, 1889), no. 779. The second scarab was previously in the Grenfell Collection, and reads *Nbpḥtyrꜥ ḥḳꜣ-tꜣwy*, see W. Petrie, *The Grenfell Collection of Scarabs* (London, 1916), 23 and 27, no. 16. See also Harvey, "King Heqatawy," 343.

[119] Harvey, "King Heqatawy," 344, fig. 4, 349. The bricks were inscribed for *ḥḳꜣ tꜣwy mry Wsir*.

[120] Harvey, "King Heqatawy," 346.

[121] Harvey, "King Heqatawy," 347.

[122] G. Pier, "Historical Scarab Seals from the Art Institute Collection, Chicago," *AJSL* 23: 1 (1906), 88. pl. V: 1254.

[123] D. Dunham and J. Janssen, *Second Cataract Forts Volume 1: Semna Kumma* (Boston, 1960), 75, pl. 121, no. 8.

[124] E. Hornung and E. Staehelin, *Skarabäen und Andere Siegelamulette aus Basler Sammlungen*, ÄDS I (Mainz, 1976), 232, nos. 207–208.

becomes a personal epithet for both high elites and gods, all of whom are associated with Upper Egypt[125]—an interesting divergence in usage, and perhaps a reflection of the notion that the center of "true" Egypt was in the Delta in this period. The preservation of the Fifteenth Dynasty as *ḥḳȝ ḫȝswt* in the Turin King List may reflect the same strong sense of regionality in the Second Intermediate Period, as it was perhaps copied from local Eastern Delta documents or monuments.

Rather than being passive recipients of the title, the Hyksos may have consciously selected *ḥḳȝ ḫȝswt* in order to proclaim their foreign origins, and perhaps even Amorite affiliation, in a manner that would be familiar and recognizable to Egyptians. The Hyksos adapted to their Egyptian context, adopting a title considered appropriate from a local perspective. They also disseminated the title in very Egyptian styles of royal display, employing the term from monumental inscriptions to the smallest seals, indicating that they were operating within Egyptian conceptions of kingship and administration. In fact, the Hyksos may have chosen this particular title to memorialize their foreignness as part of yet distinct from Egyptian kingship, in an attempt to create a Middle Ground. Theories of identity such as the Middle Ground have much to contribute to the discussion of the Second Intermediate Period, allowing a framework in which to better understand how the individuals engaged in extended periods of cultural contact adapted to new influences while maintaining their own traditions. This theoretical approach sheds light on how these individuals may have viewed themselves, and how that self-conception has impacted the material record which survives today.

UCLA

[125] Personal communication, Thomas Schneider.

Table I. *Examples of ḥkȝ ḫȝswt outside the Second Intermediate Period.*[1]

No.	Object Type	Geographical Association	Time Period	Reign	Inscription	Find Context	Reference(s)
1	Stela	Levantine	OK, Dyn. 5	Djedkare Isesi	ḥwi ḥkȝw ḫȝst	Wadi Maghara, now destroyed	Gardiner, Peet, and Černy, *Inscriptions of Sinai*, 61, pl. VIII, no. 14
2	Tomb Autobiography	Nubian	OK, Dyn. 6	Pepi I - Merenre	ḥkȝw ḫȝswt nw irtt wȝwȝt	Abydos, Tomb of Weni (now Cairo 1435)	*Urk.* I, 109
3	Tomb Autobiography	Nubian	OK, Dyn. 6	Pepi II	iw in.n ḥkȝwy n ḫȝswt ptn n ẖnw	Qubbet el Hawa, Tomb of Pepinakht Heqaib	*Urk.* I, 134
4	Execration Text	Nubian	OK		ḥkȝ ḫȝst iȝtrs Wnis-ꜥnḫ id Wmwt		A. Abu Bakr and J. Osing, "Ächungstexte aus den Alten Reich," *MDAIK* 29 (1973), 112, no. 199
5	Execration Text	Nubian	OK		ḥmt n ḥkȝ ḫȝst Kbiti		Abu Bakr and Osing, "Ächungstexte aus den Alten Reich," 112, no. 191
6	Vase fragment	Levantine	MK, Dyn. 12		ḥkȝ ḫȝst rw	Byblos, Tomb VII	P. Montet, *Byblos et l'Egypte: Quatre Campagnes de Fouilles À Gebeil* (Paris, 1929), 208
7	Papyrus	Levantine	MK, Dyn. 12		štiw wȝ r štm r sḥsf-ꜥ ḥkȝw ḫȝswt	Berlin Museum, P. Berlin 3022, line 98	R. Koch, *Die Erzählung des Sinuhe* (Brussels, 1990).
8	Tomb painting	Levantine	MK, Dyn. 12	Senwosret II	ḥkȝ ḫȝswt ꜥbš	Tomb of Khnum-hotep II, Beni Hasan	Newberry, *Beni Hasan I*, 69, pl. 31
9	Obelisk	General	NK, Dyn. 18	Thutmose III	ḥwi ḥkȝw ḫȝswt pḥw sw	Karnak Obelisks of Thutmose III	*Urk.* IV, 599, no. 191
10	Temple Inscription	General	NK, Dyn. 18	Thutmose III	ḥwi ḥkȝw ḫȝswt pḥw sw	Karnak, Annals of Thutmose III	*Urk.* IV, 599, no. 191
11	Temple Inscription	General	NK, Dyn. 18	Thutmose III	ḥwi ḥkȝw ḫȝswt pḥw sw	Karnak, Akhmenu ex. 1	*Urk.* IV, 599, no. 191
12	Temple Inscription	General	NK, Dyn. 18	Thutmose III	ḥwi ḥkȝw ḫȝswt pḥw sw	Medinet Habu ex. 1	*Urk.* IV, 599, no. 191
13	Temple Inscription	General	NK, Dyn. 18	Thutmose III	ḥwi ḥkȝw ḫȝswt pḥw sw	Elkab Temple	*Urk.* IV, 599, no. 191
14	Temple Inscription	General	NK, Dyn. 18	Thutmose III	ḥwi ḥkȝw ḫȝswt pḥw sw	Semna Temple	*Urk.* IV, 599, no. 191
15	Temple Inscription	General	NK, Dyn. 18	Thutmose III	ḥwi ḥkȝw ḫȝswt pḥw sw	Heliopolis Temple	*Urk.* IV, 599, no. 191
16	Temple Inscription	General	NK, Dyn. 18	Thutmose III	ḥwi ḥkȝw ḫȝswt pḥw sw	Medinet Habu ex. 2	*Urk.* IV, 555, section E

[1] This table is an expansion on the list from Redford, "Textual Sources for the Hyksos Period," 19.

No.	Object Type	Geographical Association	Time Period	Reign	Inscription	Find Context	Reference(s)
17	Temple Inscription	General	NK, Dyn. 18	Thutmose III	ḥwi ḥḳ3w ḫ3swt pḥw sw	Medinet Habu ex. 3	*Urk.* IV, 555, section E
18	Temple Inscription	General	NK, Dyn. 18	Thutmose III	ḥwi ḥḳ3w ḫ3swt pḥw sw	Karnak, Akhmenu ex. 2	*Urk.* IV, 555, section E
19	Obelisk	General	NK, Dyn. 18	Thutmose III	ḥwi ḥḳ3w ḫ3swt pḥw sw	Heliopolis obelisk of Thutmose III (left), now in New York	*Urk.* IV, 593, section B no. 3
20	Stela	Levantine	NK, Dyn. 18	Amenhotep II	mn jtḥ pḏt.f m msˁf m ḥḳ3w ḫ3swt wrw nw rṯnw	Amada	*Urk.* IV, 1290
21	Pylon Inscription	General	NK, Dyn. 18	Amenhotep II	ḥwi ḥḳ3w ḫ3swt pḥw sw	8th Pylon at Karnak	*Urk.* IV, 1333
22	Statue Plinth	General	NK, Dyn. 18	Amenhotep III	ḥḳ3w ḫ3swt wrw t3w	Fragmentary, found at Karnak	*Urk.* IV, 1744
23	Pylon Inscription	General	NK, Dyn. 19	Ramesses II	t3w nbw ḥḳ3w ḫ3swt	1st Pylon at Ramesses II Abydos Temple	M. Lefebvre, "Une chapelle de Ramsès II à Abydos," *ASAE* 7 (1906), 219
24	Temple Inscription	Nubian	NK, Dyn. 19	Ramesses II	ḥḳ3w ḫ3swt nw t3 stfw	S. Side, Portico, Ramesses II Abydos Temple	*KRI* I, 192
25	Stela	General	NK, Dyn. 19		ḥḳ3 ḫ3swt	Deir el Medina, titulary of the god Shed	Bruyère, *Deir El Médineh*, 165
26	Inscription	General	Late Pd., Dyn. 25		ḥḳ3 ḫ3swt	Epithet of Montuemhat	Leclant, *Montouemhat*, 254
27	Inscription	General	Late Pd., Dyn. 26		ḥḳ3 ḫ3swt	Epithet of Padiharesne	Christophe, "Trois Monuments," no. 81f
28	Tomb Inscription	Persian	Persian Pd., Dyn. 31	Artaxerxes III	ḥḳ3 ḫ3swt	Tomb of Petosiris, Tuna el Gebel, titulary of Artaxerxes III	Lefebvre, *Tombeau de Petosiris*, 81, 28
29	Inscription	General	Ptolemaic		ḥḳ3 ḫ3swt	Titulary of Philip Arrhidaeus	Gauthier, *LD*, Sethe, *Urk. II*, 9
30	Temple Inscription	General	Ptolemaic		ḥḳ3 ḫ3swt	Epithet of Min at Dendera Temple	Mariette, *Dendērah I*, 23
31	Inscription	General	Ptolemaic		ḥḳ3 ḫ3swt	Titulary of General Nectanebo	Sethe, *Urk. II*, 24 no.7
32	Temple Inscription	General	Ptolemaic	Ptolemy XIII	ḥḳ3 ḫ3swt	Great Pylon, Philae, titulary of Ptolemy XIII	Junker, *Philae I*, 72 Abb. 37

Table II. *Second Intermediate Period Examples of ḥkꜣ ḫꜣswt*

No.	Object Type	Geographical Association	Time Period	Reign	Inscription	Archaeological Context	Current Location	Reference(s)
1	Scarab	Levantine	SIP	Apr-anti	*ḥkꜣ ḫꜣswt ʿpr-ʿnti*	Unprovenanced	Petrie Museum UC 11655	Petrie, *Scarabs*, pl. XXI 15.1 (called Ontha); Tufnell, *Studies*, #3464; Ryholt, *The Political Situation*, File 15/2; G. Martin, *Egyptian Administrative and Private-Name Seals: Principally of the Middle Kingdom and Second Intermediate Period* (Oxford, 1971), #318
2	Scarab	Levantine	SIP	Anat-Hr	*ḥkꜣ ḫꜣswt ʿnt-ḥr*	Tell Basta?	Anonymous Private Collection	G. Fraser, *A Catalogue of the Scarabs Belonging to George Fraser* (London, 1900), #180; Newberry, *Scarabs*, pl. XXIII.11; Martin, *Administrative and Private-Name Seals*, #349; Hornung and Staehelin, *Skarabäen*, #165
3	Scarab	Levantine	SIP	Anat-Hr	*ḥkꜣ ḫꜣswt ʿnt-ḥr*	Unprovenanced	Michaelides Collection	Martin, *Administrative and Private-Name Seals*, #350
4	Scarab	Levantine	SIP	Khyan	*ḥkꜣ [ḫꜣs]wt Ḥyꜣn*	Unprovenanced	Petrie Museum UC 11656	Petrie, *Scarabs*, pl. XXI 15.3; Martin, *Administrative and Private-Name Seals*, #1170; Tufnell, *Studies*, #3212; Ryholt, *The Political Situation*, File 15/6.11
5	Scarab	Levantine	SIP	Khyan	*ḥkꜣ ḫꜣswt Ḥyꜣn*	Giza	Cairo JdE 30458	Newberry, *CG 36001-37521: CG36027*; Martin, *Administrative and Private-Name Seals*, #1171; Tufnell, *Studies*, #3210; Ryholt, *The Political Situation*, File 15/4.4
6	Scarab	Levantine	SIP	Khyan	*ḥkꜣ ḫꜣswt Ḥyꜣn*	Ezbet Rushdi		Martin, *Administrative and Private-Name Seals*, #1172; Tufnell, *Studies*, #3208; Ryholt, *The Political Situation*, File 15/4.2
7	Scarab	Levantine	SIP	Khyan	*ḥkꜣ ḫꜣswt Ḥyꜣn*	Unprovenanced	New York, MMA 10.130.36	Newberry, *Scarabs*, pl. XXII.21; Martin, *Administrative and Private-Name Seals*, #1173; Tufnell, *Studies*, #3211; Ryholt, *The Political Situation*, File 15/6.7
8	Scarab	Levantine	SIP	Khyan	*ḥkꜣ ḫꜣswt Ḥyꜣn*	Unprovenanced	Chicago, OI E18465, Acc. # 3081	Pier, "Historical Scarab Seals," #1242; T. Allen, *The Art Institute of Chicago: A Handbook of the Egyptian Collection* (Chicago, 1923), #142; Martin, *Administrative and Private-Name Seals*, #1174; Tufnell, *Studies*, #3215
9	Scarab	Levantine	SIP	Khyan	*ḥkꜣ ḫꜣswt Ḥyꜣn*	Tell el Yehudiyeh	Anonymous Private Collection	Newberry, *Scarabs*, pl. XXII.22; Petrie, *History of Egypt I*, 254; Tufnell, *Studies*, #3209; Hornung and Staehelin, *Skarabäen*, #141; Ryholt, *The Political Situation*, File 15/4.3

No.	Object Type	Geographical Association	Time Period	Reign	Inscription	Archaeological Context	Current Location	Reference(s)
10	Scarab	Levantine	SIP	Khyan	ḥḳꜣ ḫꜣswt Ḥyꜣn	Unprovenanced	ex von Bissing Collection	Newberry, *Scarabs*, pl. XXII.20; Martin, *Administrative and Private-Name Seals*, #1176; Ryholt, *The Political Situation*, File 15/6.3
11	Scarab	Levantine	SIP	Khyan	ḥḳꜣ [ḫꜣs]wt [Ḥ]yꜣn	Unprovenanced	ex Michaelides Collection	Martin, *Administrative and Private-Name Seals*, #1177; Ryholt, *The Political Situation*, File 15/6.6
12	Scarab	Levantine	SIP	Khyan	ḥḳꜣ ḫꜣswt Ḥyꜣn	Unprovenanced	ex Spicer Collection	Petrie, *History of Egypt I*, 254 fig. 151; Martin, *Administrative and Private-Name Seals*, #1178; Ryholt, *The Political Situation*, File 15/6.10
13	Scarab	Levantine	SIP	Khyan	ḥḳꜣ ḫꜣswt Ḥyꜣn	Unprovenanced	ex Petrie Collection	Petrie, *History of Egypt I*, 254 fig. 151; Martin, *Administrative and Private-Name Seals*, #1179; Ryholt, *The Political Situation*, File 15/6.9
14	Cylinder Seal	Levantine	SIP	Khyan	ḥḳꜣ ḫꜣswt Ḥyꜣn	Unprovenanced	ex Blanchard Collection	Martin, *Administrative and Private-Name Seals*, #1180; Ryholt, *The Political Situation*, File 15/4.5.1
15	Cylinder Seal	Levantine	SIP	Khyan	ḥḳꜣ ḫꜣswt Ḥyꜣn	Unprovenanced	ex Lanzone Collection	Petrie, *Historical Scarabs*, #729; Petrie, *History of Egypt I*, 253; Newberry, *Scarabs*, pl. VII.7; Martin, *Administrative and Private-Name Seals*, #1181; Ryholt, *The Political Situation*, File 15/4.5.3
16	Scarab in gold mount	Levantine	SIP	Khyan	ḥḳꜣ ḫꜣswt Ḥyꜣn	Gezer	Cast at Palestine Exploration Fund	R. Macalister, *Excavation of Gezer II* (London, 1912), pl. CCIV B.16; Giveon, "A Sealing of Khyan," 204; Martin, *Administrative and Private-Name Seals*, #1181a; Tufnell, *Studies*, #3214; Ryholt, *The Political Situation*, File 15/4.1
17	Scarab	Levantine	SIP	Smqn	ḥḳꜣ ḫꜣswt Smkn	Tell el Yehudiyeh?	Anonymous Private Collection	Fraser, *Catalogue*, #179; Newberry, *Scarabs*, pl. XXIII.10; Martin, *Administrative and Private-Name Seals*, #1453; Hornung and Staehelin, *Skarabäen*, #166; Tufnell, *Studies*, #3463; Ryholt, *The Political Situation*, File 15/1
18	Seal Impression	Levantine	SIP	Khyan	ḥḳꜣ ḫꜣswt Ḥyꜣn	Tell el-Dabʿa, Area F/II - r/22, Locus 81		Sartori, "Die Siegel aus Areal F/II," #9355; Bietak, "Le Hyksos Khayan," fig. 15
19	scarab	Levantine	SIP	Khyan	ḥḳꜣ ḫꜣswt [Ḥ]yꜣn	Unprovenanced	Jerusalem, IMJ 76.31.4593	D. Ben-Tor, *The Scarab: A Reflection of Ancient Egypt* (Jerusalem, 1989), 49 #6; Ryholt, *The Political Situation*, File 15/6.5
20	Scarab	Levantine	SIP	Khyan	ḥḳꜣ ḫꜣswt Ḥyꜣn	Unprovenanced	Berlin 193/73	Ryholt, *The Political Situation*, File 15/6.1
21	Scarab	Levantine	SIP	Khyan	ḥḳꜣ ḫꜣswt Ḥyꜣn	Unprovenanced	Berlin 328/73	Ryholt, *The Political Situation*, File 15/6.2

No.	Object Type	Geographical Association	Time Period	Reign	Inscription	Archaeological Context	Current Location	Reference(s)
22	Scarab	Levantine	SIP	Khyan	ḥḳꜣ ḫꜣswt Ḥyꜣn	Unprovenanced	ex Nash Collection	Ryholt, *The Political Situation*, File 15/6.8
23	Seal Impression	Levantine	SIP	Khyan	ḥḳꜣ ḫꜣswt Ḥyꜣn	Tell el-Dabʿa Area R/III, q/6-7, Locus 338		Reali, "The Seal Impressions from ʿEzbet Rushdi," #9464
24	Seal Impression	Levantine	SIP	Khyan	ḥḳꜣ ḫꜣswt Ḥyꜣn	Tell el-Dabʿa Area R/III, r/7, Locus 66		Reali, "Seal Impressions from ʿEzbet Rushdi," #9452 R
25	Seal Impression	Levantine	SIP	Khyan	ḥḳꜣ ḫꜣswt Ḥyꜣn	Tell el-Dabʿa Area R/III, s/6, Locus 325		Reali, "Seal Impressions from ʿEzbet Rushdi," #9466 N
26	Seal Impression	Levantine	SIP		ḥḳꜣ ḫꜣswt [...]	Tell el-Dabʿa Area F/II, r/23, Locus 81		Sartori, "Die Siegel aus Areal F/II," #9373 M
27	Seal Impression	Levantine	SIP		ḥḳꜣ ḫꜣswt [...]	Tell el-Dabʿa Area F/II, j/23, Locus 803		Sartori, "Die Siegel aus Areal F/II," #9376 J
28	Seal Impression	Levantine	SIP	Khyan	ḥḳꜣ ḫꜣswt Ḥ[yꜣn]	Tell el-Dabʿa Area F/II, r/23, Locus 81		Sartori, "Die Siegel aus Areal F/II," #9374 C
29	Seal Impression	Levantine	SIP	Khyan	ḥḳꜣ ḫꜣswt Ḥyꜣn	Tell el-Dabʿa Area F/II, r/22, Locus 81		Sartori, "Die Siegel aus Areal F/II," #9354
30	Seal Impression	Levantine	SIP	Khyan	ḥḳꜣ ḫꜣswt Ḥyꜣn	Tell el-Dabʿa Area F/II, Locus 81		Bietak, "Le Hyksos Khayan," fig. 15 (top right)
31	Door Jamb	Levantine	SIP	Skr-Hr	ḥḳꜣ ḫꜣswt Skr-ḥr	Tell el-Dabʿa Area H/III (in later context)	Cairo TD 8316	Bietak and Hein, *Pharaonen und Fremde*, 150–152; Ryholt, *The Political Situation*, File 15/3

Cryptography, the Full Moon Festivals of Min, and the King: Reading the Cryptographic Inscription of the Chapel of Min in the Temple of Ramses II at Abydos

Benoît Lurson

Abstract

In this paper, the author proposes a new reading of a cryptographic inscription engraved on the rear wall scene of Chapel XII in the temple of Ramses II at Abydos. According to this reading, which shows the importance of thematic cryptography for the conception of the inscription, a special form (ḫprw) of Min is said to go forth in procession at the occasion of the god's second full moon festival. As a matter of fact, the crown worn by Min in the scene makes his depiction special, the iconographic program of the chapel refers to a procession, and the association of the god with the moon is well established. This inscription thus enables the reconstruction of twelve full moon festivals of Min, which in addition to the Festival of Min that was known to have taken place in I Shemu, were all celebrated with a procession.

The iconographic program of Chapel XII also enables us to investigate the meaning of the full moon festival of Min. Royal ideology can be one level of meaning. Both in relation to the moon and its symbolism, the hypothesis of a celebration of Min as the divine father of the king can be put forward, whilst the takeover of the king might also have been in focus. Thus, this cryptographic inscription not only renews our knowledge of the New Kingdom theology and liturgy of Min, but also of the god's importance for the royal ideology of the Ramesside Period.

During the Ramesside Period, cryptographic inscriptions became a regular element of temple decoration. Such an inscription, situated on the rear wall scene of the chapel of Min (Chapel XII) in the temple of Ramses II at Abydos, directly before the god's depiction (fig. 1),[1] has been the object of two studies, one by Morenz in 2008 and another by Klotz in 2012.[2] These studies follow two very different approaches. Whilst Morenz looks at the inscription as an example of a "visuell-poetisch überhöhte Bildbeischrift,"[3] Klotz deals with acrophony and advocates the view that the phonetic values of the hieroglyphs of this inscription do not result from this principle. Despite this difference, both scholars almost exclusively focus on the inscription and set aside its context, thus

[1] Chapel XII is one of the six rooms opening in the second pillared hall of the temple. It is numbered "K" by Mariette and "XII" on the plan published in *PM* VI, 32 (also with Mariette's room numbers). For the scene, see *PM* VI, 38, no. 64; E. Naville, *Détails relevés dans les ruines de quelques temples égyptiens* (Paris, 1930), pl. 35 and 36; M. El-Noubi, "The Shrine of Min at the Temple of Ramesses II at Abydos," *SAK* 33 (2005), 340 and pl. 22, b; S. Iskander and O. Goelet, *The Temple of Ramesses II in Abydos*. Volume 1: *Wall Scenes*. Part 2: *Chapels and First Pylon* (Atlanta, 2015), 348 (drawing) and 349 (photography). In Ramses II's Abydos Temple, another cryptographic inscription, although lacunar, is to be found in the staircase opening in the first pillared hall; see S. Iskander and O. Goelet, *The Temple of Ramesses II in Abydos. Volume 1: Wall Scenes. Part 1: Exterior Walls and Courts* (Atlanta, 2015), 246–47, Bs1. I would like to warmly thank Jacqueline Harvey for improving my English. Should, however, any anomalies remain, they are entirely my own.

[2] See L. Morenz, *Sinn und Spiel der Zeichen. Visuelle Poesie im Alten Ägypten*, Pictura et Poesis. Interdisziplinäre Studien zum Verhältnis von Literatur und Kunst 21 (Cologne-Weimar-Vienna, 2008), 216–20; D. Klotz, "Once Again, Min (𓂝𓄿): Acrophony or Phonetic Change?" *GM* 233 (2012), 23–25. El-Noubi, "The Shrine of Min," 340, does not translate the inscription.

[3] Morenz, *Sinn und Spiel der Zeichen*, 216.

Journal of the American Research Center in Egypt 53 (2017), 223–241
doi: http://dx.doi.org/10.5913/jarce.53.2017.a011

disregarding its connection to the scene to which it belongs, to the iconographic program of the chapel and to the liturgy this program may refer to.

With the publication of the decoration of the chapel by el-Noubi in 2005 and of almost all of the temple by Iskander and Goelet in 2015,[4] it is now possible to re-examine this inscription in relation to its iconographic context and liturgical background. Before starting this re-examination, a new reading of the inscription is proposed.

The Cryptographic Inscription: A New Reading

A set of preliminary reasons justifies putting forward a new reading of this inscription. First, the copy of it used by Klotz is erroneous. The author indeed inserted a superfluous ⟨⟩-sign between columns 1 and 2, which obviously jeopardizes his reading and his translation of the second column of the inscription.[5] Second, considering the presence of a caption in the scene describing the depicted rite, as well as the orientation of the hieroglyphs in the cryptographic inscription, it is very unlikely that the latter can also be a caption labelling the rite performed by the king, as proposed by both scholars, even if one follows Morenz's solution whereby only the first column refers to the king's offering and the second to the god.[6] As Darnell states, "The final and most important of the criteria for certifying the accuracy of the translation of an enigmatic text is that the content of the inscriptions must be consistent with the compositions and genres of which they are a part."[7] Let us, then, look in detail at the problems posed by Morenz's and Klotz's readings in relation to the "genre" of the caption, before turning to the rules of "composition" in ancient Egyptian iconography.

For Morenz, the inscription is to be read "Geben für Min in seinem Tempel/Allerheiligsten in seiner Gestalt als Amun-Min: Schminken seines Auges. Amun-Min-Ka-mutef in dem ḥw.t bjtj (Alternative: Amun-Min-Ka-mutef im Fest)."[8] As for Klotz, he proposes: "Placing hand(s) upon Min in his shrine: his form of the 15th and 6th-day festivals, and his form of the 15th and 7th day festivals."[9] Yet, in Morenz's reading, the vocabulary that would be used for describing the unction, namely sdm ir.t=f 'Schminken seines Auges', is not attested in any caption for New Kingdom temple ritual scenes showing an unction or the offering of ointment-jars.[10] Or, with the reservation that it is based upon an erroneous copy of the inscription, Klotz's reading admittedly solves the syntactic problems posed by Morenz's translation,[11] but happens to raise other problems. For instance, in the lists of festivals, moon festivals are most usually listed in chronological order: new moon festival, 6th-day festival,

[4] See El-Noubi, "The Shrine of Min," 331–41; Iskander and Goelet, The Temple of Ramesses II in Abydos 1 (alone the scenes decorating the niches of the rooms X and XIV have not been published).

[5] See Klotz, "Once Again, Min," 23 and compare with our fig. 1.

[6] See Klotz, "Once Again, Min," 23, where the author calls the inscription "a caption to an offering scene"; Morenz, Sinn und Spiel der Zeichen, 217 and 219.

[7] J. Darnell, The Enigmatic Netherworld Books of the Solar-Osirian Unity. Cryptographic Compositions in the Tombs of Tutankhamun, Ramesses VI and Ramesses IX, OBO 198 (Fribourg-Göttingen, 2004), 11.

[8] Morenz, Sinn und Spiel der Zeichen, 217–18.

[9] Klotz, "Once Again, Min," 24.

[10] For the depiction of the unction throughout the New Kingdom and the captions associated with that rite, see B. Lurson, "Zwischen Kultabbildungen und Kultrealität: Die Rolle der ikonographischen Dynamik," in H. Beinlich, ed., 9. Ägyptologische Tempeltagung: Kultabbildung und Kultrealität. Hamburg, 27. September–1. Oktober 2011, KSG 3,4 (Wiesbaden, 2013), 231–33. For an exceptional caption using the verb wrḥ in a scene dating from the reign of Thutmosis III, see S. Biston-Moulin and C.Thiers, Le temple de Ptah à Karnak (Ptah, nos 1–191), Travaux du Centre Franco-Égyptien d'Étude des Temples de Karnak (Cairo, 2016), vol. I, 248–49 and vol. II, 170. During the Ramesside Period, the usual caption to the unction is ir.t mḏ.t, beside rdi.t/ḥnk m mḏ.t. The verb sdm is not to be encountered in the spells for offering the ointment either; see N. Braun, Pharao und Priester – Sakrale Affirmation von Herrschaft durch Kultvollzug. Das Tägliche Kultbildritual im Neuen Reich und der Dritten Zwischenzeit, Philippika 23 (Wiesbaden, 2013), 171–79. Although not crippling, let us also notice that the spell for placing the hands upon the god's statue does not contain any passage comparable to the mention of Min's forms such as Klotz's reading would reveal; see Calverley-Gardiner, Abydos, Vol. I, pl. 10, 19 and 27, and Vol. II, pl. 5, 15 and 23; Braun, Pharao und Priester, 158–59. For all questions relating to the ritual scenes such as the rarity of a depiction or of a caption, I use my database of New Kingdom temple ritual scenes, which contains about 7000 such scenes, including unpublished material.

[11] See Klotz, "Once Again, Min," 24, with n. 28.

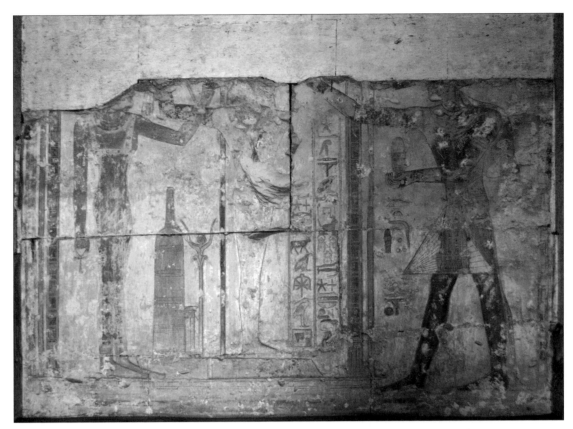

Fig. 1. The rear wall scene of Chapel XII in the temple of Ramses II at Abydos (photograph courtesy of Claude Obsomer).

15th-day festival or full moon festival,[12] etc.,[13] so that a mention of the 15th-day festival before the 6th-day or the 7th-day festivals is very unlikely.

Most importantly, there is already a caption in the scene, which happens to describe exactly the depicted rite, namely the unction (fig. 1): "Presenting the *mḏ.t*-ointment to his father Min-Re (*ir.t mḏ.t n it=f Mnw-Rꜥ*)."[14] Admittedly, it can happen that a caption describes only a part of the depicted rite, or, conversely, that it completes the depiction. Captions describing the censing or the libation with a depiction showing both, or describing both but with a depiction showing only one of them, are well known cases.[15] I know also of a few scenes in which the caption is at variance with the depicted rite, but this situation, which mostly results from a choice made by the image-maker to build supplementary networks of relationships between the iconographic and linguistic elements of a group of scenes,[16] is not the situation of the Abydos scene.

[12] For the equivalence between the Half Month festival, the 15th-day festival and the Full Moon festival, see for example K. Eaton, "Monthly Lunar Festivals in the Mortuary Realm: Historical Patterns and Symbolic Motifs," *JNES* 70.2 (2001), 243.

[13] See for example PT §860a–863c = F. Servajean, "Lune ou soleil d'or ? Un épisode des *Aventures d'Horus et de Seth* (pChester Beatty I R°, 11, 1–13, 1)," *RdE* 55 (2004), 131–32, for a translation.

[14] See above, n. 10.

[15] See for example H. H. Nelson, *The Great Hypostyle Hall at Karnak. Volume 1, Part 1, The Wall Reliefs*, OIP 106 (Chicago, 1981), pl. 42; The Epigraphic Survey, *Medinet Habu* VII, pl. 558.

[16] See B. Lurson, *Osiris, Ramsès, Thot et le Nil. Les chapelles secondaires des temples de Derr et Ouadi es-Seboua*, OLA 161 (Leuven-Paris-Dudley, MA, 2007), 157–58, with n. 42.

That having been said, the case of a scene showing two captions more or less related to each other as proposed by Morenz, or drastically different from each other and from the depicted rite for one of them according to Klotz, does not seem to be encountered in any of the New Kingdom ritual scenes that I know of.[17] Furthermore, even though the anointing of the divinity's statue and the placing of hands upon it are two rites that belong to the Clothing Ritual and, for that reason, possibly depicted next to each other,[18] they do not show any special iconographic link. When the offering of ointment or the unction is related to another rite, then it is with the offering of cloth,[19] and when the placing of the hands upon the divinity's statue is combined with another rite in a mixed caption, it is with the removing of the clothing.[20] Lastly, the presence of two sections of the same cryptographic inscription in a Late Period[21] text in Ay's speos at Akhmim,[22] engraved above and relating to a series of depictions of Min, is indirect proof that the Abydos inscription has nothing to do with the rite performed by the king, but refers to the god's depiction. Anyhow, the common orientation of both the cryptographic inscription and Min's depiction is enough to dismiss the possibility of a caption related to the rite.

A basic and crucial rule of Egyptian iconography, as it contributes in a decisive way to its intelligibility, is that a hieroglyphic inscription and an image facing the same direction refer to each other. In the case of ritual scenes, a hieroglyphic inscription facing the same direction as the depiction of a god or a king contains the god's or king's name, epithets, titles, etc., and/or describes the action in which they are engaged. Therefore, considering alone the orientation of the hieroglyphs in this cryptographic inscription, the latter must refer to the god's depiction. Not only this, its position before the god and in the chapel in which he is standing, is a usual location for a text related to the divinity. Consequently, Morenz's solution, that "eine Kolumne retrograd geschrieben ist. [...] Die Richtung dieser Inschrift wurde freilich von der Darstellung des Gottes in ihren Bann gezogen. So kam es zu einer sakral motivierten Umkehrung der Orientierung der Zeichen,"[23] seems to be more an *ad hoc* solution for the proposed translation than a possibility supported by parallels and the principles of Ancient Egyptian iconography.

There are admittedly some instances of captions in which the orientation of the god's name to whom the offering is presented by the king and/or the group *ir=f di ʿnḫ* is reversed, being the same as the god's and not as the acting king.[24] Such reversals of orientation, however, do not concern the whole of the caption, but only

[17] Such a situation is not to be confused with that of scenes showing two captions slightly different from each other, but with one of them opening the spell for the depicted rite; see for example Calverley-Gardiner, *Abydos* IV, pl. 46, which shows the offering of the ointment, with two captions: *rdi.t mḏ.t n it=f Rʿ-Ḥr-ʒḫty*, situated below the king's left hand, and *ir.t dw mḏ.t*, situated in the upper part of the scene and working as the title of the spell related to the offering of ointment. See also idem, *Abydos* IV, pl. 50.

[18] See e.g., H. Brunner, *Die südlichen Räume des Tempels von Luxor*, AV 18 (Mainz am Rhein, 1977), pl. 25, 132 and 135; Calverley-Gardiner, *Abydos* I and II, *passim*; for their belonging to the Clothing Ritual, see Braun, *Pharao und Priester*, 158–60 (placing the hands upon the divinity's statue) and 171–79 (anointing the divinity's statue and offering of the ointment). See also The Epigraphic Survey, *Medinet Habu* IX, 14, n. 124.

[19] See Lurson, *Osiris, Ramsès, Thot et le Nil*, 34, n. 36.

[20] See M. Aly, F. Abdel-Hamid, and M. Dewachter, *Le temple d'Amada, Cahier IV, Dessins, index, tables de concordances*, CEDAE, CS n° 54 (Cairo, 1967), pl. P 6–10; R. Caminos, *Semna-Kumma, II. The Temple of Kumma*, ASE 38 (London, 1998), pl. 69 and 73; *Medinet Habu* IX, 4–5, n. 30.

[21] K.-P. Kuhlmann, "Der Felstempel des Eje bei Achmim," *MDAIK* 35 (1979), 175–76, dates the second phase of the decoration of the Akhmim speos between the Twenty-sixth Dynasty and the reign of Ptolemy II, a period that he calls "Spätzeit" (166, n. 8). See also idem, "Archäologische Forschungen im Raum von Achmim," *MDAIK* 38 (1982), 350.

[22] See H. Kees, "Das Felsheiligtum des Min bei Achmim," *RecTrav* 36 (1914), 56; Kuhlmann, "Der Felstempel des Eje bei Achmim," 177–78 (with n. 46 for an amendment to Kees' copy). M. Gabolde, "La statue de Merymaât, gouverneur de Djâroukha (Bologne K.S. 1813)," *BIFAO* 94 (1994), 268, n. 22, already noted the closeness of the Abydos cryptographic inscription with the Akhmim inscription. Neither Morenz, *Sinn und Spiel der Zeichen*, 216–20, nor Klotz, "Once Again, Min," 23–25, mention that inscription. Therefore, Klotz, "Once Again, Min," 23, is certainly right when he criticizes Morenz, *Sinn und Spiel der Zeichen*, 217, who states that the Abydos cryptographic inscription is an "inhaltlich recht konventioneller Text" without quoting parallels, but the Akhmim inscription shows that the Abydos inscription is not, for all that, a *hapax*.

[23] Morenz, *Sinn und Spiel der Zeichen*, 217. See for example The Epigraphic Survey, *The Temple of Khonsu*, Volume 1. Plates 1–110, *Scenes of King Herihor in the Court with Translations of Texts*, OIP 100 (Chicago, 1979), pl. 55, col. 1, which refers to Min, who is represented in procession, and note how the orientation of this column of text opposes the orientation of the caption describing the offering of the papyrus by the king, in *The Temple of Khonsu* 1, pl. 55, col. 2. For the same remark about the orientation of the caption describing the procession of Amun-Re's bark in another scene of the same temple; see *The Temple of Khonsu* 1, pl. 44, cols. 1–3.

[24] Such cases have been studied by H. Fischer, *The Orientation of Hieroglyphs, Part I. Reversals*, Egyptian Studies II (New York, 1977), 93–95,

the god's name or the group *ir=f di ʿnḫ*. Since all the hieroglyphs of the Abydos cryptographic inscription are facing the same direction as the god, this orientation cannot be considered an example of that kind of reversal. Moreover, the cryptographic nature of an inscription is not likely to modify the rule applying to the orientation of the hieroglyphs, even if only parts of an inscription are cryptographic. Thus, in the caption of a few scenes dating from the reign of Ramses II, the word "mother" referring to the goddess presented with the offering is cryptographically written with the sign ◣▭ or the group ◣▭◠, both substituting for the usual 𓅐, but without their orientation being reversed or unexpected.[25]

Therefore, it is in consideration of these specifics, in particular that the cryptographic inscription must refer to the god's depiction since they both face the same direction, that the following reading is proposed. The drawing of the inscription used here is that published by Naville, with a few changes.[26] The commentaries that follow the translation focus on the alternative phonetic values proposed and address those put forward by Morenz and Klotz only when considered necessary.

[1] | $ḫ^{ʿa}$ n^b *Mnw m* $ḫn(w)^c$ m^d *ḫprw=f*
n $śmd.t$ $sn.nw.t^e$ $ir^f=f^2$ | $smd.t$ $nb.t^g$ m^h $sš(.w)^i$ m^j $pr-mdȝ.t^k$

[1] | Appearance of Min out of the resting-place in his form of the second full moon festival, so that he may celebrate [2]
| every full moon festival, according to the writings in the library.

(6)–(7) and 97–106, § 33b. See also R. Caminos, *The New-Kingdom Temples of Buhen, Volume II*, ASE 34 (London, 1974), 17–18 (only about the reversed orientation of the god's name).

[25] See *PM* II², 307, (27), East end (Luxor Temple; Scene A 75), 213, (45), 2 (Karnak, Temple of Amun-Re-Horakhte; scene I 232a), and 309, (33), II, 2 (Luxor Temple, Triple Shrine, chapel of Mut; scene B 54). The captions have been checked in situ. See also Calverley-Gardiner, *Abydos* IV, pl. 53, D,c and E, for dedicatory inscriptions dating from the reign of Seti I, in which "mother" is written with ◣▭◠, as well as *PM* II², 410, (18)–(21), II, 3, for the utterance of the goddess in a scene of the temple of Seti I at Gurna (checked in situ), in which "mother" is written with ◣▭, and H. Nelson, *Reliefs and Inscriptions at Karnak*—Volume I, Plates 1–78. *Ramses III's Temple within the Great Inclosure of Amon*, Part I, OIP 25 (Chicago, 1936), pl. 45, C, where the element *mw.t* in the god's name *Imn-Rʿ-kȝ-mw.t=f* is written with ◣▭, without the orientation of these signs being reversed in any of these inscriptions either.

[26] See Naville, *Détails relevés*, pl. 35. The changes are: the lower outline of the upper part of the *nemes* has been drawn horizontally; four oblique lines have been added to the loaf of bread in the second column; the horns in Seshat's emblem have been shortened. The drawing of the inscription published by Iskander and Goelet, *The Temple of Ramesses II in Abydos* 1/2, 348, needs three amendments. Col. 1: the ⤫ -sign has been drawn as if it were reduced to its left half, but its right half is in fact lost in a lacuna and was originally carved; although only a part of the 𓋝-sign has been drawn and the rest marked as lost in a lacuna, the outlines of the whole sign are visible; col. 2: the horns of the bovid are drawn as if they were a bull's, but they are undoubtedly cow horns.

a) The group ⚹ is read *di* by Morenz, *Sinn und Spiel der Zeichen*, 217–18, and *di(.t)* ꜥ*(.wy)* by Klotz, "Once Again, Min," 24, with nn. A and B. The reading proposed here is supported by the substitution of ⚹ for ⌂ = *ḥ*ꜥ in a cryptographic titulary of Seti I at Abydos; see É. Drioton, "Une figuration cryptographique sur une stèle du Moyen Empire," *RdE* 1 (1933), 206–7; idem, "La cryptographie égyptienne," *CdE* 18 (1934), 199–200; idem, "Les protocoles ornementaux d'Abydos," *RdE* 2 (1936), 5; idem, "Recueil de cryptographie monumentale," *ASAE* 40 (1940), 398 and 409, no. 3. In the group ⚹, ⌐ is consequently a phonetic complement with its usual phonetic value ꜥ. The orthography of *ḥ*ꜥ*(i)* in the infinitive form without a *.t* and/or the papyrus roll as a determinative is attested; see for example *Medinet Habu* IV, pl. 201, col. 2 and 238, A, col. 1.

b) The value ꜰ = *n* is also proposed by Morenz, *Sinn und Spiel der Zeichen*, 218. Klotz, "Once Again, Min," 24, rejects it, because it would result from the principle of acrophony, the name of the head-dress being *nmś*, since, for him, acrophony is not to be attested before the Roman Period (Klotz, "Once Again, Min," 21 in particular). As a matter of fact, to date the value ꜰ = *n* is not attested before that period; see Sauneron, *Esna VIII*, 174, no. 303 (*contra* Klotz, "Once Again, Min," 24, who states that this value is "unattested elsewhere"). However, thematic cryptography can explain the choice of the *nemes* to write *n* in that inscription, so that the question of acrophony is in this case irrelevant; see the next section of this contribution.

c) Morenz, *Sinn und Spiel der Zeichen*, 217 and Klotz, "Once Again, Min," 24, read *ḥm* 'shrine', 'temple' (see *Wb* III, 280), but considering the usual value ⬡ = *n*, which, in curious contradiction to his transliteration of the whole word, is the very same way Morenz, *Sinn und Spiel der Zeichen*, 217, reads the sign when on its own, there is no reason to discard the word *ḥn(w)* 'resting-place' (see *Wb* III, 288). This reading is sustained by the cryptographic writings of *ḥm*: ▦ (Drioton, "Recueil de cryptographie monumentale," 313–14, no. (17) = temple of Seti I at Gurna) and ⚑ (*KRI* II, 614, l. 6 = Luxor Temple, Ramses II), which are indeed clearly at variance with what is found here. See also the next section and the section on the full moon festivals of Min.

d) Klotz, "Once Again, Min," 24, rejects the value 🐕 = *m* < *miw* proposed by Morenz, *Sinn und Spiel der Zeichen*, 218, because "it does not occur elsewhere until the Roman Period," and proposes the value *f*. However, since the publication of Klotz's paper, the value 🐕 = *m* has been recognized in a cryptographic text dating from the reign of Hatshepsut; see A. Espinel, "Play and Display in Egyptian High Culture: The Cryptographic Texts of Djehuty (TT 11) and Their Sociocultural Contexts," in J. Galán, B. Bryan, and P. Dorman, eds., *Creativity and Innovation in the Reign of Hatshepsut, Papers from the Theban Workshop 2010*, SAOC 69 (Chicago, 2014), 317, t) and 331, no. E13.

e) Morenz, *Sinn und Spiel der Zeichen*, 218, reads *sdm* 'schminken'. Klotz, "Once Again, Min," 24, E, notes that the sign read *m* by Morenz, *Sinn und Spiel der Zeichen*, 219, is not ⬭, but the loaf of bread ⬭, so that it should be read *t*, according to its usual cryptographic value; see Drioton, "Recueil de cryptographie monumentale," 426, no. 180. Klotz, "Once Again, Min," 24, n. F, reads *snw.t* '6ᵗʰ-day (festival)' and tries to explain the absence of the expected *ḥb*-sign at the end of the word by means of an "haplography": "15ᵗʰ-day festival and 6ᵗʰ-day (festival)." Reading the word *sn.nw.t* 'second' is not only in accordance with the usual cryptographic value of the loaf of bread, but also fits with the absence of a *ḥb*-sign. About this reading, see also the discussion in the section on the full moon festivals of Min.

f) Morenz, *Sinn und Spiel der Zeichen*, 219, and Klotz, "Once Again, Min," 24, with n. G, also read 🦅 = *ir* (substitution of kind of 🦅 for ⬭), but translate "Auge" and "form," respectively. For *ir.t ḥb*, see *Wb* III, 58, no. 8, and for two examples with a divinity being the celebrant, see *Urk.* IV, 836, l. 7 and l. 15. For the choice of 🦅 in this inscription, see the next section.

g) For the value 🐂 = *nb.t*, see É. Drioton, "Cryptogrammes de la reine Nefertari," *ASAE* 39 (1939), 139–40 (titulary of Nefertari); M. Boraik, "Inside the Mosque of Abu el-Haggag: Rediscovering Long Lost Parts of Luxor Temple. A Preliminary Report," *Memnonia* 19 (2009), 134, as a cow-headed goddess (architrave in Luxor Temple; compare with *KRI* II, 612, l. 6, for the same inscription in *Klarschrift*). A value *nb* is also attested in Drioton, "Recueil de cryptographie monumentale," 411, no. 27 (examples from the reigns of Pinudjem I and Darius I). Morenz, *Sinn und Spiel der Zeichen*, 219, identifies a bull and

reads *k3*, but the shape of the horns and the presence of the udder undoubtedly show that a cow is to be recognized; see Iskander and Goelet, *The Temple of Ramesses II in Abydos* 1/2, 348–49; above, n. 26.

h) Alone the first 𓅓 (col. 1) is read *m* by Morenz, *Sinn und Spiel der Zeichen*, 218 and 219, as well as by Klotz, "Once Again, Min," 24 and 25, n. H. For this value, see Drioton, "Recueil de cryptographie monumentale," 413, no. 43 (example dating from Seti I). For *m* 'according to', see for example K*RI* II, 331, l. 1 (= D. Meeks, *Année lexicographique. Égypte ancienne. Tome 3 (1979)* (Paris, 1982), 79.1089) and 356, l. 13. For "according to the writings of Thoth," see for example Iskander and Goelet, *The Temple of Ramesses II in Abydos* 1/1, 164–65 (= K*RI* II, 532, l. 1) and K*RI* II, 651, l. 8. For "according to the writings of Thoth in the library" in Spell 24 of the Offering Ritual, see N. Tacke, *Das Opferritual des ägyptischen Neuen Reiches. Band I. Texte*, OLA 222 (Leuven-Paris-Walpole, MA, 2013), 70, no. 24.6b, and *Band II. Übersetzung und Kommentar*, 80, n. g. Note that in some versions of this spell, the preposition *m* is substituted by *r* and *ḫft*, confirming that *m* is to be translated "according to."

i) For Morenz, *Sinn und Spiel der Zeichen*, 219, Seshat's emblem 𓋇 has the phonetic value *f*, founded on the following derivation: *f* < *fḫ* < *sfḫ* < *sfḫ.t-ꜥb.wy*. For Klotz, "Once Again, Min," 24 and 25, n. H, the sign is to be read "seven," a reading founded on: *sfḫ* < *sfḫ.t-ꜥb.wy*. It is true that the name of the god-

dess is written 𓋇 in oCG 25029 dating from Ramses VI (see K*RI* VI, 378, 5 = C. Leitz, ed., *Lexikon der ägyptischen Götter und Götterbezeichnungen, Band VI, ḫ – s*, OLA 115 (Leuven-Paris-Dudley, MA, 2002), 303, no. [21]) and 𓋇 in a dedicatory inscription of the temple of Khonsu at Karnak by the Thirtieth Dynasty king, Teos (see U. Bouriant, "Notes de voyage," *RT* 11 [1889], 153 = Leitz, *LGG* VI, 303, no. [26], checked in situ; see also D. Budde, *Die Göttin Seschat*, KANOBOS 2 [Leipzig, 2000], 13; H. Sottas and É. Drioton, *Introduction à l'étude des hiéroglyphes* [Paris, 1922], 83, with n. 1). It is also true that when set on the side of Seshat's head by a headband, the flower on which the horns are set upon upside down usually has seven petals. All this may be enough to justify the derivations proposed by both scholars. However, there are also examples of this emblem with only five petals (see Budde, *Die Göttin Seschat*, 2–3 and 40), all the more when the goddess is called *Śfḫ.t-ꜥb.wy* (see for example Nelson, *Reliefs* II, pl. 97, F), so that the link between emblem and name may after all not be that obvious. As a matter of fact, when called *Śfḫ.t-ꜥb.wy*, the name of the goddess in never written with the 𓋇-sign, but always phonetically for the first part and ideographically for the second. In fact, a proof that the 𓋇-sign was not read *Śfḫ.t-ꜥb.wy* is to be found in a scene dating from Ramses II situated in the forecourt of Luxor Temple, in which the goddess bears her two names: *Śš3.t nb.t ḳd.w Śfḫ.t-ꜥb.w nb.t sš ḥn.wt pr-[md3.t]* […], with *Śš3.t* written 𓋇 and *Śfḫ.t-ꜥb.w* written phonetically for the first part and ideographically for the second (see *PM* II², 307–8, (27), II, 2, checked in situ; see also Budde, *Die Göttin Seschat*, 13 for a Graeco-Roman example of a similar double naming). The study of the names of the goddess by Budde, *Die Göttin Seschat*, 1–28, already showed the clear difference between *Śš3.t* and *Śfḫ.t-ꜥb.wy* (Budde, *Die Göttin Seschat*, 13, even sees in the latter an epithet of Seshat), as well as between their orthographies. The value *sš* that I propose for the 𓋇-emblem is based precisely on the orthographic difference between the two names of the goddess, as well as the fact that this sign is used to write the name *Śš3.t* only. Let us also note the absence of the feminine ending *.t* and/or of the egg-sign, which would be expected if the name of the goddess were really meant here (see Budde, *Die Göttin Seschat*, 3–6, particularly 3). Lastly, our reading 𓋇 = *sš* is supported by a New Kingdom cryptographic inscription quoted by both Morenz and Klotz, in which the sign has the value *sš*; see Morenz, *Sinn und Spiel der Zeichen*, 219, n. 843 = Berlin ÄM 20394 and Klotz, "Once Again, Min," 24, n. 29, who actually proposes the reading *sš*. For the choice of Seshat's emblem to write *sš(.w)* 'writings' in that particular inscription, see the next section of this contribution.

j) When found in a cryptographic inscription, 𓄿 usually has the phonetic value *t* or writes *ḏ.t* 'eternity'. According to Drioton, "Recueil de cryptographie monumentale," 324, (23) and 412, no. 41, this value would derive from *d3.t* 'crane'. The 𓄿-bird, however, is not a crane, but a heron, so that its name is not *d3.t*; see Vandier, *Manuel V*, 402–4, 407, 409, and 410, for lists of depictions of birds with their names; P. Houlihan, *The Birds of Ancient Egypt, The Natural History of Egypt: Volume I* (Warminster, 1986), 13–17, no. 7 (heron) and 83–86, no. 42 (common crane); Iskander and Goelet, *The Temple of Ramesses II in Abydos*

1/1, 210–11, for the depiction of a *ḏꜣ.t*-crane carried by an offering-bearer. Therefore, a substitution of kind precedes here any other principle from which the usual values of the heron result. To my knowledge, the value [glyph] = *m* is not attested so far in any other New Kingdom cryptographic inscription. Morenz, *Sinn und Spiel der Zeichen*, 219, also reads the sign that way, and justifies it by a substitution of kind between the heron and the owl. I propose to explain it by (1) a *pars pro toto* substitution [glyph] = [glyph], (2) the use of the latter as a determinative in [glyphs] 'temple' and (3) the consonantal principle *mꜣꜥ* > *m*. Compare with Darnell, *The Enigmatic Netherworld Books*, 600, for the value [glyph] = *ḫt*, which results from (1) the bird used as a determinative of the word *ḫt-ꜥꜣ* and (2) of the consonantal principle *ḫt-ꜥꜣ* > *ḫt*.

k) The reading of [glyph] as *pr-mḏꜣ.t*[27] 'library' is found on the following substitution and values:

1. [glyph] = [glyph] = *pr*. Although Drioton, "Recueil de cryptographie monumentale," 425, no. 165, did not take on the substitution of [glyph] for [glyph] in his list of the cryptographic values of [glyph], it is attested in the cryptographic inscription of the temple of Seti I at Gurna that he studies, more precisely in the word *ḥm* 'shrine'. In this inscription, *ḥm* is indeed written [glyph], whereas its usual determinative in *Klarschrift* is [glyph]; see above, n. c), also for the other cryptographic orthography of the word, which attests the same substitution, as well as DZA 27.846.360, DZA 27.846.370 and DZA 27.846.380, for the determinatives of *ḥm* during the New Kingdom. This substitution also fits with the cryptographic phonetic value [glyph] = *p* noticed by Darnell, *The Enigmatic Netherworld Books*, 2, n. 7 (New Kingdom inscription), as it is based on a double process: "Derivation: substitution of kind from *pr*-sign; phonetic shift for *pr*-sign for *p*" (Darnell, *The Enigmatic Netherworld Books*, 610). Another substitution of kind involving [glyph] is also missing in Drioton's list, although it is to be found in Seti I's inscription too: the substitution of [glyph] for [glyph] in the word *ꜥḥ* 'palace'; see Drioton, "Recueil de cryptographie monumentale," 313 and 309–10, for the same inscription *en clair*.

2. [glyph] = *mḏꜣ.t*. This value derives from the name of this cap, of which [glyph] is the determinative, as shown by a phonetically written occurrence of the word on the statue Bologna K.S. 1813 (end of the Eighteenth Dynasty/early Ramesside Period; see Gabolde, "La statue de Merymaât," 261–62 and 274–75). Compare with above, n. j), for step (1) of the principles from which the value [glyph] = *ḫt* results. This cap happens to be the flat-topped lower part of Min's or Amun's crown, onto which the two feathers (*šwty*) are set; see Gabolde, "La statue de Merymaât," 4, fig. 2, col. 5 (occurrence of the word on the statue), and 267–70, n. i (commentary; our inscription is mentioned on 268, no. (5)). R. Hannig, *Die Sprache der Pharaonen. Großes Handwörterbuch Ägyptisch – Deutsch (2800–950 v. Chr.)*, Kulturgeschichte der Antiken Welt 64 (Mainz am Rhein, 1995), 381, reads the word *mḏꜣ* and not *mḏꜣ.t*, but such a difference of gender does not impact the reading of this section of the Abydos inscription proposed here. For the choice of this sign, see the next section.

Unrelated to a version of the same text in *Klarschrift*, reading this cryptographic inscription is certainly challenging. Yet, the reading and the translation put forward here have the advantage of being in accordance with the basic principle that the depiction of a god and a hieroglyphic text facing the same direction refer to each other, with the latter mentioning the god's name and/or describing an action that he performs. As a matter of fact, this inscription appears to mention Min and to describe an action performed by him: his appearance at the occasion of his second full moon festival. As a first step, this enables an examination of the relationship between the inscription and the depiction of the god.

Thematic Cryptography and the Second Full Moon's Form of Min

In the cryptographic inscription, a form (*ḫprw*) of Min—called Min-Re in the caption—is especially mentioned: his second full moon festival.[28] If this inscription really refers to the god's depiction, as the translation put forward

[27] Curiously, Gabolde, "La statue de Merymaât," 268, (5), proposes to read [glyph] *ḥw.t-mḏꜣ*, but writes in n. 22 on the same page, that this reading is unlikely (see also 270, with n. 37).

[28] Unless the author's concern is the presence of "Re" in the god's name, it is unclear why Morenz, *Sinn und Spiel der Zeichen*, 217, writes

here implies, then this has a good chance of reflecting this depiction of him. As a matter of fact, even though its upper part is lost, the crown worn by the god makes his depiction very special.

Instead of the flat-topped crown with a ribbon (?) hanging down behind the god and upon which two feathers are set, or the headband sometimes substituting for it and holding the two feathers on the sides of the god's head, which are the usual crowns of Amun and Min, the preserved lower part of his crown indeed consists of a *nemes* behind which the ribbon (?) hangs down.[29] Admittedly, I know of three depictions for the whole New Kingdom of Amun or Min wearing a *nemes*, including the scene under discussion, so that the Abydos depiction is not a *hapax*. But I also know of 2252 New Kingdom temple depictions of Min or of the ithyphallic form of Amun wearing one of their usual feathered-crowns just described,[30] a difference that highlights the god's form depicted in the Abydos scene as special. I will come back in the next section to the two depictions of Amun wearing the *nemes* but firstly, the use of this headdress by this god invites us to re-examine a few signs of the cryptographic inscription in light of thematic cryptography.

To quote Darnell, thematic cryptography consists of "figures and objects of a cryptic inscription [that] may at times appear to relate to one another in the scene or text, with two, perhaps differing levels of meaning—one pictorial, one textual. [...] This does not necessarily limit the signs which could be employed for a given text, but would influence the choice and arrangement of signs for a given portion of the text."[31] Now, the choice of some of the signs of the inscription seems to have proceeded from this principle:

1. = *n*. Since the *nemes* characterizes the god's depiction, this can explain, along the lines of thematic cryptography, that the hierogrammat picked up this headdress to write the preposition *n*, although this cryptographic value is so far not otherwise attested during the New Kingdom.

2. = *mḏȝ.t*. In relation to the crown of the god too, the choice of this sign to write *mḏȝ.t* in *pr-mḏȝ.t* 'library' is to be mentioned, since it is the lower part of his usual crown, upon which two feathers are set. If, unlike the *nemes*, the sign does not echo the crown actually worn by Min in the scene, it contributes nonetheless to underline the *nemes* by reminding the observer of the crown that he "should" be watching.

3. = *ḫ* in *ḫn(w)*. As for the choice of this sign to write *ḫ* in *ḫn(w)* 'resting-place', it may be explained by the *šw.t-nṯr*, a kind of screen, found for example behind Min in the Medinet Habu depiction of his procession dating from Ramses III, and called that name with the orthography in another procession scene dating from Philip Arrhidaeus.[32] In this case, the "level of meaning," as Darnell writes, is textual, but also cultural, referring on the one hand to *ḫʿ*, as this verb means "appear" in the context of a procession,[33] and on the other hand to an object known from the hierogrammat to usually accompany the god in his processions.

4. = *sš*. The choice of Seshat's emblem to write *sš(.w)* 'writings' is certainly an allusion to Seshat's function as *nb.t*, *ḥnw.t* or *ḫnt(y).t pr-mḏȝ.t*, the place where the inscription states that the "writings" are kept,

that "Die Bezeichnung dieses Gottes als Min-Re [in the caption] widerspricht der Ikonographie, in der deutlich Amun-Min-Ka-Mutef gezeigt wird," since the form of appearance of Min is the same as the ithyphallic form of Amun. Therefore, even though the name attached to the god's depiction was "Amun-Re-Kamutef," which cannot be ascertained since the scene's upper part is lost, the fact that he is named "Min-Re" in the caption and Min in the cryptographic inscription is not problematical. On the contrary, calling the depiction Amun and mentioning Min in the caption, or the opposite, is well attested during the Ramesside Period, which undoubtedly is based on a theological closeness if not assimilation of both deities, as reflected in their common form of appearance; see for example Nelson, *The Great Hypostyle Hall at Karnak* I/1, pl. 82 (scene B 122d); C. Leblanc and S. El-Sayed Ismaïl, *Le Ramesseum IX-2. Les piliers "osiriaques,"* CEDAE, CS n° 34 (Cairo, 1988), pl. 27 and 46; *Medinet Habu* V, pl. 269, B and 275, B.

[29] See El-Noubi, "The Shrine of Min," 340 and pl. 22, b; Iskander and Goelet, *The Temple of Ramesses II in Abydos* 1/2, 348–49. The *nemes* does not appear on the drawing of the scene published by Naville, *Détails relevés*, pl. 35.

[30] I mean 2252 scenes showing Min, Min-Amun or Amun, ithyphallic or non-ithyphallic, in which the god's crown is preserved.

[31] Darnell, *The Enigmatic Netherworld Books*, 14–15. See also Drioton, "Recueil de cryptographie monumentale," 306, n. 1.

[32] See *Medinet Habu* IV, pl. 201 (Ramses III) and 217, A (Philip Arrhidaeus). Compare with D. Meeks, *Année lexicographique. Égypte ancienne.* Tome 2 (1978) (Paris, 1981), 78.4068 = *šw.t* 'toile de protection (?)'.

[33] See below, the section on the full moon festivals of Min.

as well as her function as *nb.t sš*, as we saw above with her name in the Luxor Temple scene.[34] Then, as for ⌐, the level of meaning is textual and cultural.

5. ✋ = *ir*. Lastly, the choice of the falcon's eye to write the verb *ir(i)* 'to celebrate' may relate to the expression "filling the Eye of Horus" (*mḥ ir.t Ḥr*). Indeed, this expression appears many times in Spell 54 for offering the *mḏ.t*-ointment of the Clothing Ritual, which is explicitly linked with *psḏntyw* the 6th day festival and the full moon festival in its version of pBerlin P. 3055 (Twenty-Second Dynasty).[35] In this case, the depicted offering, its lunar setting, and its mythological level, would be the elements that inspired the hierogrammat, the "level of meaning" being again cultural. I will come back below to this spell in the section on the full moon festivals of Min.

As one can see, thematic cryptography is certainly not to be underestimated among the principles to which the hierogrammat had recourse to conceive this cryptographic inscription. This shows that the discussion on the phonetic values of hieroglyphs used in a cryptographic inscription cannot be reduced to the opposition acrophony/no acrophony. Let us now move on to the two scenes showing the depiction of Amun wearing a *nemes*, in order to see whether they share more than just this headdress with the depiction of Min.

Min and the Lunar Context

The first depiction of Amun-Re wearing a *nemes* is located in the Karnak Great Hypostyle Hall and the second is in Room S of Abu Simbel Great Temple (fig. 2).[36] Unlike the Abydos scene, the upper part of the god's crown is preserved in both scenes. In Karnak, it consists of the usual two feathers. In Abu Simbel, it is the *pschent*.[37] If the crown's upper part had been the same in both these scenes, a reconstitution could have been proposed for that missing part in the Abydos scene, but with two different crowns in Karnak and in Abu Simbel, such a possibility must be ruled out. Interestingly, the ribbon (?) hanging down behind the god is of no help in that matter, as it is an element of the god's crown whatever its upper part. Its presence in Abydos is, therefore, no pointer toward the feathers, the *pschent*, or any other crown. Setting aside this aspect of the god's depiction, a comparison of the three scenes show that the Abu Simbel scene shares more common features with the Abydos scene than does the Karnak scene.

First, in Karnak, the scene shows the non-ithyphallic form of Amun-Re, not an ithyphallic god like in Abydos. It belongs to a series of four scenes showing the ithyphallic and the non-ithyphallic forms of Amun, with Ramses II consecrating offerings and utensils in three of them.[38] Second, even though the name of the god is lost in a lacuna,[39] but considering his non-ithyphallic form of appearance, he certainly was not called "Min" or "Amun-Re-Kamutef." On the contrary, the Abu Simbel scene shows the ithyphallic "Amun-Re-Kamutef, dwelling in (*ḥr(y)-ib*) his *Ipet*." Furthermore, the god is accompanied by a goddess, as is Min in Abydos: "the great (*wr.t*) Isis, god's mother" (fig. 2). And, even though her name is lost in the Abydos scene, the goddess was certainly Isis too, since she is the usual companion to Min, as well as to the ithyphallic form of Amun-Re, both

[34] See above, n. i. Add: Calverley-Gardiner, *Abydos* II, pl. 30: *Šš3.t wr.t nb.t pr-mḏ3.t*; *Medinet Habu* V, pl. 295, col. 6: *Šš3.t wr.t ḥnw.t pr-mḏ3.t*; Nelson, *The Great Hypostyle Hall at Karnak* I/1, pl. 49, cols. 9–10: *nb.t sš ḫnt(.t) pr-mḏ3.t* (epithets only); *Medinet Habu* VI, pl. 365, cols. 11–12 and pl. 376, D 3: *Šš3.t nb.t sš*. For the epithets of Seshat in general, see Budde, *Die Göttin Seschat*, 24–27 and 200–204 (more specifically related to the writing and the *pr-mḏ3.t*).

[35] See Braun, *Pharao und Priester*, 177, for *mḥ ir.t Ḥr*; below, n. 49.

[36] Karnak: see Nelson, *The Great Hypostyle Hall at Karnak* I/1, pl. 91; Abu Simbel: see B. Lurson, *Lire l'image égyptienne. Les "Salles du Trésor" du Grand Temple d'Abou Simbel* (Paris, 2001), 57 (Scene S. 1) and 60–62; M. Peters-Destéract, *Abou Simbel. À la gloire de Ramsès* (Monaco, 2003), 257, no. 1.

[37] Compare with S. Cauville. *Essai sur la théologie du temple d'Horus à Edfou*, BdE 102 (Cairo, 1987), 37, for a scene in Edfu showing Min wearing the White Crown.

[38] See Nelson, *The Great Hypostyle Hall at Karnak* I/1, pl. 90–93 and 250 for the wall.

[39] However, he is called "Amun-Re" in the caption and "Amun-Re, king of the gods" in the *Randzeile*; see Nelson, *The Great Hypostyle Hall at Karnak* I/1, pl. 91, cols. 1 and 10, respectively.

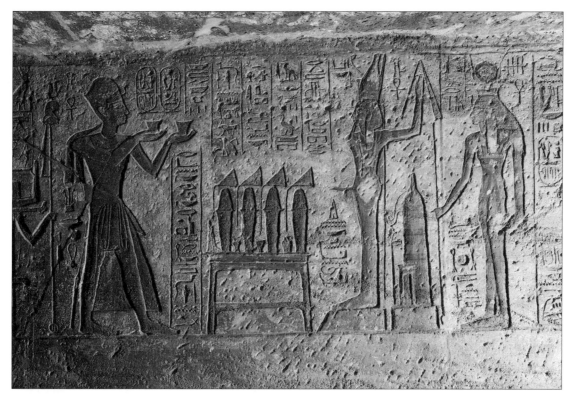

Fig. 2. Ramses II offering ointment to Amun-Re-Kamutef and Isis in Room S of Abu Simbel Great Temple (photograph courtesy of François Gourdon).

deities being "assimilated" to each other.[40] Another aspect of the Abydos and Abu Simbel scenes also deserves attention: the depicted offering.

In Abydos, the king is shown anointing the god, with the usual caption for describing that rite, as we saw above. In Abu Simbel, the king presents two "cups," a kind of container of which offering I know only four further examples during the Ramesside Period, with captions mainly referring to food.[41] However, the "caption" of the Abu Simbel scene and a few other scenes showing the king holding such a container in one hand while he is anointing a divinity with his other hand, one of them being in Abu Simbel's Room N,[42] allow us to identify the offering as the *mḏ.t*-ointment.[43]

It is noteworthy that the "caption" of this scene, situated before the king, is not introduced by a verb in the infinitive form, but by a "conjugated" verb in the first person singular: "(I) put for you your eyes to their place,

[40] After my own statistical research (see above, n. 10); see Lurson, *Osiris, Ramsès, Thot et le Nil*, 78, with n. 18, for bibliography concerning the usual companion to the ithyphallic Amun-Re. For the "assimilation" to each other of the ithyphallic Amun and Min, see above, n. 28, for general remarks.

[41] Three of these scenes date from Ramses II and decorate the Tanis naoi Cairo CG 70003 and CG 70004 (see Roeder, CG 70001-70050, 13–14, §§ 72–74, 16, §§ 91–93 and 20, § 118; checked in situ). The fourth dates from Ramses IV and is situated in the Karnak Temple of Khonsu (see *PM* II², 236, [40], I, 2; checked in situ). In two of the scenes dating from Ramses II, the caption is preserved and mentions the *ḥnk.t*-offerings, which can indeed be offered in such cups, although there are in such cases usually four of them, set upon a table that the king is elevating. Instead of the *ḥnk.t*-offerings, the caption of such scenes can also mention the *dbḥ.t-ḥtp* 'menu'; see for example *Medinet Habu* V, pl. 268, A (*ḥnk.t*-offerings) and Calverley-Gardiner, *Abydos* IV, pl. 18 (menu). In the scene dating from Ramses IV, the caption seems to mention the cups themselves: "Offering (*ḥnk m*) the cups (▽ᵢᵢ) to his father Shu, son of Re, he acted (*ir.n=f*), [given] life."

[42] See F. Abdel Hamid, S. Donadoni, and C. Leblanc, *Grand Temple d'Abou Simbel. Les Salles du Trésor sud, fascicule II*, CEDAE, CS n° 48 (Cairo, 1975), pl. 14.

[43] For the identification of the offering, see Lurson, *Lire l'image égyptienne*, 57, with n. 136; Peters-Destéract, *Abou Simbel*, 257.

(as) (I) offer them as *mḏ.t*-ointment; for his father (*rdi(=i) n=k ir.ty=k r s.t=s(y) ḥnk(=i) s m mḏ.t n it=f*)" (fig. 2). The mention of the *mḏ.t*-ointment is nonetheless unambiguous and shows that the king is offering it. Despite the "for his father" at the end of this inscription, when such texts are introduced by a verb "conjugated" in the first person singular and situated where a caption with a verb in the infinitive form is expected, they usually are an excerpt from a spell. It was not until very recently that this was actually confirmed, when in 2016 Spencer published the scenes decorating the temple of Amara West.

At the west end of the chapel's south wall, in a scene showing Ramses II anointing a seated god, the lower part of four columns of text situated behind the king is preserved, among which the almost exact same sentence as in the Abu Simbel scene is preserved by extraordinary chance: "[…] (I) put for you your eye to its place, (as) (I) offer it as *mḏ.t*-ointment […] ([...] *rdi(=i) n=k ir.t=k r s.t=s ḥnk(=i) s(.t) m mḏ.t* [...])."[44] The rest of the text confirms that it is a spell for the offering of the *mḏ.t*-ointment. The scarcity of the sentence needs to be underlined though, as, to my knowledge, it seems to be attested only in the Amara West and in the Abu Simbel scenes.[45]

In summary, the Abydos and the Abu Simbel scenes share a few key features: a special form of the ithyphallic god, of which the lower part of his crown indeed consists of a *nemes*; being accompanied by a goddess; and being offered ointment by the king. In the Abydos scene, the cryptographic inscription relates this form of Min to the god's second full moon festival. Now, the Abu Simbel scene decorates a room in which "stellar" deities prevail.[46] Among these deities, the presence of Thoth, situated in the first scene on the right, is to be underlined.[47] The room itself belongs to a group of three rooms situated in the north-western part of the Great Temple, in which Hermopolitan deities and divinities of the Osirian cycle predominate, complementing the symmetrical south-western group of three rooms, in which solar deities are dominant.[48] Therefore, even though it is not as clear-cut as in the Abydos scene thanks to the cryptographic inscription, the Abu Simbel depiction of Amun-Re-Kamutef can also be said to fall within a lunar context. This gives the *mḏ.t*-ointment a new dimension. Indeed, the end of Spell 54 for the offering of the *mḏ.t*-ointment in the Clothing Ritual puts it in a lunar context too, by describing the offering as a "rite (*ir.t*) for *psḏntyw*, for the 6th day festival, the full moon festival, and more than that."[49]

Thus, the Abu Simbel and Abydos scenes appear to be steeped in lunar influences, up to the choice of the *mḏ.t*-ointment as the offering. By also echoing the "lunar aspect" of Min, this offering confirms the importance of the god's relationship to the moon and spurs us to investigate in more detail his participation in the second full moon festival to which the cryptographic inscription refers.

The Full Moon Festivals of Min

Before moving on to this question, it is useful to be mindful of two points; namely the non-incidental character of the lunar aspects of Min, so that what is expressed in the Abu Simbel and Abydos scenes actually results from this aspect, and also that lunar festivals were celebrated monthly.

As Derchain explains, "Les relations de Min avec la lune, pour être difficiles à saisir, n'en sont pas moins certaines."[50] Thus, with the lunar aspects of the god being non-incidental, they cannot be considered specific to

[44] See P. Spencer, *Amara West III. The Scenes and Texts of the Ramesside Temple*, EM 114 (London, 2016), 28, pl. 172*h* and 176.

[45] A close sentence to that one – although not completely identical – is to be found in the spell accompanying the depiction of the king offering two ointment-jars in a scene of the Chapel of Amun-Re in Seti I's temple at Abydos; see Calverley-Gardiner, *Abydos* II, pl. 10, lower register, scene at the right end, cols. 6–7: *r<di>.n(=i) n=k ir.ty=k m mḏ.t*. Let us also note that the text of the last two columns of text in the Amara scene is identical to another section of the spell in the same Abydos scene; see Calverley-Gardiner, *Abydos* II, pl. 10, cols. 16–17; Braun, *Pharao und Priester*, 173.

[46] See Lurson, *Lire l'image égyptienne*, 60–66; Peters-Destéract, *Abou Simbel*, 257–59.

[47] Scene S. 5; see Lurson, *Lire l'image égyptienne*, 58 and 65; Peters-Destéract, *Abou Simbel*, 259, no. 6.

[48] See Lurson, *Lire l'image égyptienne*, *passim* and 143, for a short overview.

[49] Version of pBerlin P. 3055 (Twenty-second Dynasty); see Braun, *Pharao und Priester*, 171–77, especially 172 (transcription) and 177 (commentary). This spell is also the one of which a section is identical to the last two columns of text in the Amara scene; see above, n. 45. No offering of ointment is known among the spells for the new moon festival and the 6th day festival in the Offering Ritual (see Tacke, *Das Opferritual des ägyptischen Neuen Reiches* I, 273–81; idem, *Das Opferritual des ägyptischen Neuen Reiches* II, 250), but it is uncertain whether all spells pertaining to these festivals are listed.

[50] P. Derchain, "Mythes et dieux lunaires en Égypte," in *La lune. Mythes et rites*, SourcesOr 5 (Paris, 1962), 46, for the quotation and 46–48

either of the Abydos and Abu Simbel scenes. On the contrary, the features of the Abydos and Abu Simbel scenes proceed from these aspects. Thus, in Chapel XII, these aspects of him even extend to the lacunar inscription engraved behind the northernmost scene of the west wall, which states of the king: "[…] [he being rejuvenated] like the moon-*iꜥḥ*, so that he may be reborn as a child ([...] [*rnp.w*] *mi iꜥḥ ḫrd=f mś.wt*)."[51] But then, if, following Derchain's position, it is difficult to doubt the inherent quality of the lunar aspects of Min, it might be necessary to question the date of their existence.

Indeed, according to the scholar, the lunar aspects of the god are well documented during the Late Period, whereas the mention of a "protector of the moon" in the title to the depiction of the Min Festival in the temple of Medinet Habu is "sans doute la plus ancienne allusion connue au caractère lunaire de Min."[52] For the reign of Ramses III, one may also mention the combination of a new moon's day and the civil date of I *Shemu* 11 in the calendar of Medinet Habu Temple referring to the Festival of Min,[53] confirming the lunar auspices under which the latter was celebrated.[54] For the Twentieth Dynasty, the epithet of Min in the following title of Usermaatre-nakht, priest of the god under Ramses IV, may also show the link between Min and the moon: "dancer of Min, chief of the *psḏntyw* festivals (*iḥb Mnw ḥr(y)-tp psḏntyw.w*)."[55] Yet, the mention in the tomb of Khnumhotep II at Beni Hasan of "the festival of the going forth of Min (*pr.t Mnw*)" in association with "the twelve new moon festivals" allows for dating the lunar aspects of Min back to the Middle Kingdom.[56] By the way, this monthly appearance of the god at each LD30 may to be compared if not equated with the one mentioned in Kom Ombo in the Roman Period at each new moon.[57]

for Min and the moon. See also Kuhlmann, "Der Felstempel des Eje bei Achmim," 178, for the evocation of "an alten Mythus an, wonach der Gott im Gebirge nordöstlich der Stadt [Akhmim] sein (Mond-)Auge gesucht (und wohl auch gefunden) habe."

[51] See El-Noubi, "The Shrine of Min," 338 and pl. 22, a; Iskander and Goelet, *The Temple of Ramesses II in Abydos* 1/2, 344, 345 and 347. The choice of *rnp* in the restitution is required by the presence of *ḫrd* at the end of the inscription and bases on *Medinet Habu* VI, pl. 462, as well as parallels such as Nelson, *The Great Hypostyle Hall at Karnak* I/1, pl. 74, cols. 8 (*rnp.ti mi Rꜥ*) and 10–11 (*rnp=k mi itn m p.t*). Moreover, the absence of any visible *f*, although the determinative of the verb is preserved, allows for reconstructing an old perfective. The expression *rnp mi iꜥḥ* is briefly discussed by J. Quaegebeur, "Apis et la menat," *BSFE* 98 (1983), 31, who notes that "La notion de rajeunissement exprimée par le verbe *rnp* est liée au cycle lunaire." See also below, n. 97. The same interpretation can be put forward for *ḫrd mś.wt*, as the expression *mi iꜥḥ ḫrd=f mś.wt* 'like the moon-*iꜥḥ*, when it is reborn as a child', shows; see Iskander and Goelet, *The Temple of Ramesses II in Abydos* 1/1, 210–11.

[52] Derchain, "Mythes et dieux lunaires en Égypte," 46, for the quotation and 46–47 for this question; *Medinet Habu* IV, pl. 197, for the mention.

[53] See *Medinet Habu* III, pl. 167, List 66. See also below, n. 67.

[54] See A. Spalinger, "Egyptian Festival Dating and the Moon," in J. M. Steele and A. Imhausen, eds., *Under One Sky. Astronomy and Mathematics in the Ancient Near East*, AOAT 297 (Münster, 2002), 384–87, who examines this combination from a calendar point of view. For the Twentieth Dynasty, see also J. Clère, *Les chauves d'Hathor*, OLA 63 (Leuven, 1995), 54–55, who, based on the links between Min and the moon, discusses the likely location of *Pr-Tꜥḥ* in the 9th Nome of Upper Egypt. W. Waitkus, *Untersuchungen zu Kult und Funktion des Luxortempels. Teil I: Untersuchung*, AegHam 2 (Gladbeck, 2008), 72–75, in particular 74–75, discusses the link between the god and the moon in relation to the Min Festival in the Graeco-Roman Period.

[55] See G. Goyon, *Nouvelles inscriptions rupestres du Wadi Hammamat* (Paris, 1957), 24–25, no. 89, 103–106 (104, l. 3 for the title) and pl. 29. Goyon, *Nouvelles inscriptions rupestres*, 24 and 105, ligne 3: a., translates "Danseur de Min au début de la fête du 9ᵉ jour lunaire," but considering its orthography, the word has to be translated "new moon festival," not "ninth." Let us however note that the epithet *ḥr(y)-tp psḏntyw.w* is not listed in C. Leitz, ed., *Lexikon der ägyptischen Götter und Götterbezeichnungen*, Band V, *ḥ – ḫ*, OLA 114 (Leuven-Paris-Dudley, MA, 2002).

[56] See P. Newberry, *Beni Hasan*. Part I, ASE 1 (London, 1893), 53–54 and pl. 24. See also W. Barta, *Untersuchungen zur Göttlichkeit des regierenden Königs*, MÄS 32 (Munich-Berlin, 1975), 92–93, for whom an Old Kingdom festival of Min with procession "ursprünglich mit großer Wahrscheinlichkeit ein Mondfest darstellte" (Barta, *Untersuchungen zur Göttlichkeit*, 93). H. Gauthier, *Les fêtes du dieu Min*, RAPH 2 (Cairo, 1931), 71–72, discusses the Beni Hasan inscription and casts doubts on the possibility of twelve processions of Min at each new moon, but the Middle Kingdom stela of Shensetchy (Los Angeles County Museum of Art 50.33.31) at least mentions twelve appearances of Min, even though they are not related to a lunar phase; see A. Spalinger, *The Private Feast Lists of Ancient Egypt*, ÄA 57 (Wiesbaden, 1996), 45 and pl. 2. Note that Spalinger, *The Private Feast Lists*, 36 and 37, does not seem to understand the *pr.t Mnw* and the twelve *psḏntyw.w* as being linked with each other in the inscription of Khnumhotep II, at least according to the way the author presents them. On the contrary, for Eaton, "Monthly Lunar Festivals in the Mortuary Realm," 230, n. 12, "the Coming Forth of Min (day 30) is paired with the Blacked-out Moon (day 1)." See also Barta, *Untersuchungen zur Göttlichkeit*, 93. A key for the understanding of the group may lie in the identification of the sign written after *pr.t Mnw*, which for example Gauthier, *Les fêtes du dieu Min*, 71, reads *ḥb*, but which seems to be *nb* in *Beni Hasan* I, pl. 24. In the latter case, one could indeed translate "all the *pr.t Mnw* (of) the twelve new moons."

[57] See Gauthier, *Les fêtes du dieu Min* 1, 17, 71–72 and 174. For the mention in the calendar of Kom Ombo, see S. Cauville, "Le pronaos d'Edfou : une voûte étoilée," *RdE* 62 (2011), 43; A. Grimm, *Die altägyptischen Festkalender in den Tempeln der griechisch-römischen Epoche*, ÄAT 15

In regards to the Abydos cryptographic inscription, the fact that the lunar aspects of Min are essential to his personality, which may even be traced back to the Middle Kingdom, is an important factor. Indeed, since the lunar festivals were celebrated monthly, among which the "twelve full moon festivals," also quoted in the same inscription of Khnumhotep II's tomb,[58] this factor supports the reading of the section of the cryptographic inscription proposed above that refers to "every full moon festival" and to the appearance of the god at the occasion of the "second full moon festival." Based on this, it is therefore possible to reconstruct monthly full moon festivals of Min, even though they do not seem to be attested otherwise, and even though the god is mainly associated with the LD30/new moon.[59] Yet, if this full moon festival was celebrated monthly, why did the hierogrammat underline the second one in the cryptographic inscription?

One may wonder whether this second full moon festival actually coincides with another festival. To check on this possibility, let us try to determine the date in the civil calendar that could correspond to this second full moon to see if it does echo another known festival. Recent research tends to show that the notion of a civil-based lunar calendar should be discarded in favor of the notion of a Sothis-based lunar calendar,[60] although the matter remains difficult to solve.[61] Concretely, this would mean that "The first month of the year […] began with the first day of invisibility of the moon before sunrise after" the heliacal rising of Sothis.[62] According to the *Institut de mécanique céleste et de calcul des éphémérides de l'Observatoire de Paris*, the heliacal rising of Sothis happened on July 17/18 (Julian dates) from 1279 to 1277 B.C.[63] in Memphis, that is, during the first years of the reign of Ramses II, when his Abydos Temple was being built and decorated. The orthography *Wśr-M3ˁ.t-Rˁ* of his *prenomen* indeed shows that Chapel XII was entirely decorated at the end of his second regnal year, in the course of the third one at the latest.[64] For the same years and according to the *Observatoire de Paris*, the second full moon after the heliacal rising of Sothis fell on September 1, 1279 B.C., on September 20, 1278 B.C. and on September 9, 1277 B.C., all dates being Julian dates.[65] Converted into civil dates, these full moons happened on II *Akhet* 25 of regnal year 1; III *Akhet* 14 of regnal year 2; III *Akhet* 4 of regnal year 3.[66]

(Wiesbaden, 1994), 124–125 and 167, C 2**; G. Burkard, *Spätzeitliche Osiris-Liturgien im Corpus der Asasif-Papyri: Übersetzung. Kommentar. Formale und inhaltliche Analyse*, ÄAT 31 (Wiesbaden, 1995), 96 and 108–10. See also H. Jacobsohn, *Die dogmatische Stellung des Königs in der Theologie der alten Ägypter*, ÄF 8 (Glückstadt-Hamburg-New York, 1939), 26–27. Let us notice that in the first court of Ramses II's Abydos Temple, there is an ox among the daily offerings carried in procession, which is captioned "ox for the New Moon festival, from the divine offering (*iw3 n psḏn(tyw) n ḥtp-nṯr*);" see M. Abdelrahiem, "The Festival Court of the Temple of Ramesses II at Abydos (Part I)," *SAK* 39 (2010), 12 and 17; Iskander and Goelet, *The Temple of Ramesses II in Abydos* 1/1, 164–65. On this procession of offerings and that of Medinet Habu, see B. Haring, "Die Opferprozessionsszenen in Medinet Habu und Abydos," in D. Kurth, ed., *3. Ägyptologische Tempeltagung, Hamburg, 1.–5. Juni 1994. Systeme und Programme der ägyptischen Tempeldekoration*, ÄAT 33,1 (Wiesbaden, 1995), 73–89.

[58] See *Beni Hasan* I, pl. 24, for the aforementioned inscription, and pl. 25, col. 95, for a further mention of "the twelve Full Moon festivals;" U. Luft, *Die chronologische Fixierung des ägyptischen Mittleren Reiches nach dem Tempelarchiv von Illahun*, SÖAW 598 (Vienna, 1992), 100, about pBerlin 10132 n r°, ll. 3–4; Spalinger, *The Private Feast Lists*, 2, 23 and 36; P. Wallin, *Celestial Cycles. Astronomical Concepts of Regeneration in the Ancient Egyptian Coffin Texts*, USE 1 (Uppsala, 2002), 79. I am indebted to Louise Bressolette, MA for this reference.

[59] See, however, G. Priskin, "The Depictions of the Entire Lunar Cycle in Graeco-Roman Temples," *JEA* 102 (2016), 118, for an inscription at Dendara, in which Min is called "the one who appears on the fifteenth day," in a reference to the moon phases, as well as 139.

[60] For the discussion and conclusions, see R. Krauss, "Lunar Days, Lunar Months, and the Question of the 'Civil-Based' Lunar Calendar," in E. Hornung, R. Krauss, and D. Warburton, *Ancient Egyptian Chronology*, HdO 83 (Leiden-Boston, 2006), 389–91; idem, "Egyptian Sirius/Sothic Dates, and the Question of the Sothis-Based Lunar Calendar," in Hornung, Krauss, and Warburton, *Ancient Egyptian Chronology*, 452–56; idem, "Egyptian Calendars," *KBN* 3 (2006–2008), 111–12.

[61] See L. Depuydt, *Civil Calendar and Lunar Calendar in Ancient Egypt*, OLA 77 (Leuven, 1997), 39–41.

[62] R. Parker, *The Calendars of Ancient Egypt*, SAOC 26 (Chicago, 1950), 31, §151. For the first day of invisibility of the moon as the first day of the lunar month, see Krauss, "Lunar Days, Lunar Months," 387–89; idem, "Egyptian Calendars," 110.

[63] See https://www.imcce.fr/langues/fr/grandpublic/phenomenes/sothis/index64ab.html?popup=3. Even though the heliacal rising of Sothis had been observed in Elephantine, that is, a few days earlier than in Memphis, this wouldn't impact the civil dates proposed below for the second full moon.

[64] On the western thickness of the chapel's door, the king's nomen shows the orthography *Rˁ-mś-św-mr(y)-Imn*, but his prenomen is written *Wśr-M3ˁ.t-Rˁ* (see Iskander and Goelet, *The Temple of Ramesses II in Abydos* 1/2, 340–41), so that it cannot be inferred that this thickness has been engraved during the third decade of his reign. On the forms of the king's nomen until his prenomen was written *Wśr-M3ˁ.t-Rˁ-śtp(.w).n-Rˁ*, see C. Obsomer, *Ramsès II, Les grands pharaons* (Paris, 2012), 66–67.

[65] See https://www.imcce.fr/langues/fr/grandpublic/phenomenes/phases_lune/index.html#ici.

[66] Based on the tables published in *KRITANC* II, 636.

These results certainly depend on the system that was used by the Ancient Egyptians to determine the beginning of the lunar year, but they show, at any rate, that Min's second full moon festival underlined in the cryptographic inscription has no link with the Festival of Min, as it was celebrated in I *Shemu*.[67] Considering the period of the year to which the second full moon may be related according to this computation, the Festival of Opet is a potential candidate, since it is known to have been celebrated in II *Akhet*,[68] which the chronology of Ramses II's first regnal year confirms, since the king was in Thebes around this time to celebrate it.[69] Whether the link between the second full moon festival of Min and the Festival of Opet is the reason why the hierogrammat underlined it in the cryptographic inscription,[70] the latter informs us anyway of a hitherto unknown monthly full moon festival of Min. Can we reconstruct the liturgy of this festival?

With the verb *ḫꜥ(i)*, usually used for describing the procession of a deity[71] and the substantive *ḫn(w)* 'resting-place', the cryptographic inscription points at a procession. This is confirmed by the iconographic program of Chapel XII.[72] First, the west wall was showing the "portable statue of a god, which stood in a shrine, on a pedestal with a cornice, […] which was almost certainly that of Min," as El-Noubi describes.[73] Alone the lower part of the depiction is preserved, so that the inscriptions referring to the god are lost, but the identification of the god as Min is beyond any doubt. Second, the bark of a form of Osiris called "*Mer-ta*, dwelling in (*ḥr(y)-ib*) the temple of Ramses-meryamun, united with the nome of Abydos […],"[74] also resting upon a pedestal, is depicted on the opposite east wall. In front of [Min], the king is censing and in front of *Mer-ta*, he is censing and pouring a libation, both rites being linked with deities in motion.[75] Let us lastly underline the fact that Chapel XII is the only chapel that opens into the second pillared hall to be decorated with processional vessels, that kind of decoration being specific to the three sanctuaries (rooms XV–XVII) and to the chapels opening into the second court of the temple (chapels I–IV).[76]

Put together,[77] the cryptographic inscription, the iconographic program of Chapel XII, as such and as compared to the iconographic program of the similar rooms of the temple, allows us to see in Chapel XII a room whereby the decoration is about a procession of Min, which is nothing else but the liturgy of his (second) full moon festival(s). More importantly, all these elements enable the reconstruction of twelve full moon processions of the god, in addition to his (Theban) Festival in I *Shemu*, and, very probably, to twelve further processions at

[67] On this festival and his depictions, see Gauthier, *Les fêtes du dieu Min*; B. Lurson, "Compléments à la représentation de la 'Sortie de Min' du Ramesseum," *JSSEA* 38 (2011–12), 97–119; idem, "La ligne et le cadre. Les moyens d'expression du texte et de l'image comparés dans la relation de la 'Sortie de Min' à Medinet Habou," in *Actes du colloque "Les matériaux de l'historien de l'Orient," Colloque Société Asiatique – Collège de France – CNRS UMR 7192, JA* 301.2 (2013), 285–405 and 386, n. 3, for more bibliography. The date of the festival is I *Shemu* 11 in the calendar of Medinet Habu and I *Shemu* at the beginning of the "texte-programme" engraved above its depiction in the second court of the temple; see *Medinet Habu* III, pl. 167, List 66 and *Medinet Habu* IV, pl. 197, respectively.

[68] See W. Murnane, "Opetfest," *LdÄ* IV, 574–575; J. Darnell, "Opet Festival," in J. Dieleman and W. Wendrich, eds., *UCLA Encyclopedia of Egyptology* (Los Angeles, 2010), 1.

[69] See Obsomer, *Ramsès II*, 100–4, for the chronology of the first regnal year of Ramses II.

[70] I feel that the link is tangible and that a full moon determined the beginning of the Festival of Opet, but this needs further investigation for it to be demonstrated, and will be discussed in a forthcoming paper. In that case, the Festival of Opet would join the list of the very few annual festivals that A. Spalinger, "The Lunar System in Festival Calendars: From the New Kingdom onwards," *BSEG* 19 (1995), 26–29, considers "lunar oriented celebrations" (idem, "The Lunar System in Festival Calendars," 29). See also R. Krauss, *Sothis- und Monddaten. Studien zur astronomischen und technischen Chronologie Altägyptens*, HÄB 20 (Hildesheim, 1985), 142–44; idem, "Egyptian Calendars," 112–13.

[71] See *Wb* III, 240, III. For general remarks about *ḫꜥ(i)* being used instead of *pr.t* for describing the procession of Min, see Gauthier, *Les fêtes du dieu Min*, 16–17 and 174.

[72] For the decoration of the chapel, see El-Noubi, "The Shrine of Min," 331–41; Iskander and Goelet, *The Temple of Ramesses II in Abydos* 1/1, 258, C7b-260, C8 (exterior façade of the door); Iskander and Goelet, *The Temple of Ramesses II in Abydos* 1/2, 340–53 (door and inner walls). In this paragraph and the following, I will refer to the specific pages and plates of these publications only when necessary.

[73] El-Noubi, "The Shrine of Min," 337.

[74] Leitz, *LGG* III, 344, quotes the god, but mentions only the occurrence in TT 356 (= *KRI* III, 702, l. 16–703, l. 1; reign of Ramses II).

[75] See B. Lurson, *A Perfect King. Aspects of Ancient Egyptian Royal Ideology of the New Kingdom* (Paris, 2016), 99.

[76] See Iskander and Goelet, *The Temple of Ramesses II in Abydos* 1/2, 374–401 (rooms XV–XVII); 272–311 and 430–53 (chapels I–IV).

[77] One may want to add the dedicatory inscription engraved on the eastern thickness of Chapel XII's door, according to which the room is a "*per-wer* for his [= Min's] august processional statue (*sšm=f šps*) in his temple of millions of years, which is in Abydos" (see Iskander and Goelet, *The Temple of Ramesses II in Abydos* 1/2, 340–41), but this depends on the meaning of *sšm*, which can also basically mean "cult-statue" (see *Wb* IV, 291). Thus, if the dedicatory inscription of Chapel VI also mentions a *per-wer* built for the august *sšm*-statue (*sšm šps*) of Onuris, its iconographic program does not include any depiction of his bark; see Iskander and Goelet, *The Temple of Ramesses II in Abydos* 1/2, 312–25.

each LD30/new moon.[78] Whether each procession at the new moon and at the full moon was the return trip of the same journey is not to be excluded.[79] What then is the meaning of the full moon festival of Min?

Min, the Full Moon, and the King

Besides the meaning that the full moon festivals of Min had for the god himself in relation to his own theology, or in relation to his "assimilation" to Osiris, of which the first expressions are indeed older than the reign of Ramses II,[80] one of the scenes of the chapel may indicate a royal dimension to its meaning. This scene is situated at the northernmost end of the west wall, behind the scene showing the king censing Min. To it belongs the lacunar inscription concerning the king that has been mentioned above: "[…] [he being rejuvenated] like the moon-i^ch, so that he may be reborn as a child ([…] [$rnp.w$] mi i^ch $hrd=f$ $m\acute{s}.wt$)."[81] Only the lower part of the scene is preserved, but it is nevertheless possible to recognise a seated goddess facing to the left, in front of which a second goddess stands. The inscription is engraved behind her. Set on the $\acute{s}m\jmath-t\jmath.wy$ motif of the throne, the feet of a seated king facing to the right are still visible. According to the parallels, the king was seated on the lap of the goddess and was facing her. Such a scene is not only rare, but, as with this example, they are only found in Abydos as far as I am aware.[82]

Thus, in the second pillared hall of the temple of Ramses II, such a scene is to be found at the southernmost end of the east wall's northern half.[83] Like in Chapel XII, only its lower part is preserved. However, this is enough to identify a seated goddess facing the left and to see the feet of the seated king, but also to observe a difference between its design and that of Chapel XII: the absence of a goddess standing and facing the group. Instead, one finds four standing goddesses holding a *menat* in one hand (their other hand is lost), all facing the left like the seated goddess. All of them are turned towards a scene showing the modelling of the king by Khnum and Ptah. The second parallel is located in the second hypostyle hall of the temple of Seti I, in the lower register of the west wall's southern half.[84] Here, the scene is fully preserved, including the name and epithets of the goddess: "The great ($wr.t$) Isis, god's mother, dwelling in ($hr(y).t-ib$) the temple of Menmaatre." Her gesture is noteworthy: she puts a hand behind the king's head and "tickles" his chin with the other. In her utterance, the goddess states, among others, that the king is her son and that she raised (rnn) him to "be the sovereign ($hk\jmath$) of the Two Banks ($idb.wy$)." Let us note a scene showing the suckling of the king by Mut situated on the same west wall,[85] although its structural relation to the "tickling scene" is unclear. This suckling scene is nonetheless worth a mention because of the last parallel to the scene of Chapel XII.

This scene belongs to the lower register of the first hypostyle hall's south wall of the temple of Seti I.[86] In its actual state, the depicted king is Ramses II, but the design of the scene is to be dated to Seti I, the first hypostyle of the temple having been recarved in sunk relief by Ramses II.[87] The scene shows Isis, called "god's mother" in the inscription above her,[88] facing the right, standing and not seated, with the king seated on her left forearm. Despite her posture, she "tickles" the king's chin with one hand like in the scene of the second hypostyle. Among others, she mentions in her utterance the modelling of the king, but also his suckling. In point of fact, as in the

[78] See Barta, *Untersuchungen zur Göttlichkeit*, 93, who shares this opinion and compare with Burkard, *Spätzeitliche Osiris-Liturgien*, 109–10, about the "drei unterschiedliche Neumondfest-Zyklen."

[79] Compare with Gauthier, *Les fêtes du dieu Min*, 10–11 and 31–32, about the mention of Min's processions in the Esna calendar.

[80] See Gaboldе, "La statue de Merymaât," 273–74, who bases this on the inscription of the statue Bologna K.S. 1813.

[81] See above, n. 51, for the bibliography.

[82] In statuary, the motif of the king seated on the lap of his mother is already attested under Pepy II (Brooklyn Museum 39.119); see https://www.brooklynmuseum.org/opencollection/objects/3446.

[83] See Iskander and Goelet, *The Temple of Ramesses II in Abydos* 1/1, 266–67.

[84] See Calverley-Gardiner, *Abydos* IV, pl. 20.

[85] See Calverley-Gardiner, *Abydos* IV, pl. 23.

[86] See *PM* VI, 5, (49)-(50); R. David, *Temple Ritual at Abydos* (London, 2016), 51–53, with a sketch of the scenes of the wall's lower register.

[87] See J. Baines, "Colour use and the distribution of relief and painting in the Temple of Sety I at Abydos," in W. Davies, ed., *Colour and Painting in Ancient Egypt* (London, 2001), 146, fig. 1 and 147, for the most complete description of the recarvings of Ramses II in the Abydos Temple of his father.

[88] Of the name and epithet(s) of the goddess that were given in this inscription, only the epithet "god's mother" is preserved.

temple of Ramses II, this goddess is facing a scene showing the modelling of the king by Khnum and Ptah, but also opens a series of four Hathors, each suckling Ramses II.

In summary, the scene of Chapel XII can be reconstructed as a goddess tickling the chin of Ramses II seated on her lap. Parallels show that such a motif is associated with the modelling of the king and his suckling, either through its iconographic context, its inscriptions, or through both. It comes then as no surprise that an inscription comparable to the lacunar inscription of Chapel XII's "tickling scene" is to be found in a Karnak Hypostyle scene showing the modelling of Ramses II by Khnum, next to which the king's suckling is depicted: "[…] Horus as king. May you accomplish ($ir(y)=k$) the jubilees ($ḥb.w$-$śd$) like Atum and may you rejuvenate ($sḫrd(y)=k$) like the moon-god!"[89] One must certainly remain careful when interpreting iconographic programs, all the more as Chapel XII is decorated with five scenes only, and as the scene symmetrical to the "tickling scene" is almost completely lost and impossible to reconstruct.[90] However, related to the full moon processions of Min, the thematic unit of the king's modelling and the king's suckling is strongly reminiscent of the meaning of the Festival of Min of Pakhons 15 in the Graeco-Roman Period.[91]

Based on the information given by the Edfu and Dendara festival calendars, its "Mythologischer Bezugspunkt ist die Geburt des Harsomtous durch Hathor," to quote Burkard, who also adds: "Es kann […] nicht ausgeschlossen werden, daß unabhängig von einer umfassenden Gültigkeit des jeweiligen Festes an sich die mythologischen Bezugspunkte in den einzelnen Kultorten unterschiedlich sein mochten."[92] This remark admittedly is based on only two festival calendars dating from the Graeco-Roman Period, but if one adds the festivals of Pakhons 1 and Pakhons 15 such as described in the calendar of Esna, in which the birth house (pr-$mś$) is the goal of Min's procession or the place where he seems to appear,[93] one may wonder whether the Graeco-Roman festival of Pakhons 15 in Esna does not maintain the meaning of the full moon festivals of Min, of which Chapel XII gives a glimpse.[94] This does not mean that Chapel XII was the place where the birth of the king was celebrated or re-enacted at every full moon. According to the meaning of the relationship between Min or Amun-Re-Kamutef and the king during the Ramesside Period that can be deduced, one may rather propose a celebration of the god in his capacity as the divine father of the king.[95] This interpretation may be supported by a passage from a eulogy to Ay engraved on the façade of the speos that he dedicated to Min at Akhmim, which states: "One pleases your person as one says: 'Adorations to your *ka* and to the moon-god, according as [he] gave birth [to you] […]'."[96] This status of Min would be celebrated at the occasion of the full moon for two reasons, reasons that augment each other: the lunar aspects of Min and the "influence de la lune sur la fécondité," to quote Derchain, which may include pregnancy.[97] A further interpretation of the full moon festivals of Min, although still on a royal level, mays also be proposed, which could refer this time to the takeover by the new king.

[89] See Nelson, *The Great Hypostyle Hall at Karnak* I/1, pl. 66–67 for the scenes and 66, col. 2, for the inscription.

[90] See El-Noubi, "The Shrine of Min," 338 and pl. 25; Iskander and Goelet, *The Temple of Ramesses II in Abydos* 1/2, 350–52. It is impossible to know whether the king was presenting an offering or was being bestowed with something.

[91] See Grimm, *Die altägyptischen Festkalender*, 104–13, 291, no. (31) and 423–24.

[92] Burkard, *Spätzeitliche Osiris-Liturgien*, 97.

[93] See Gauthier, *Les fêtes du dieu Min*, 10–11 and 31–32; Grimm, *Die altägyptischen Festkalender*, 100–1 and 255–56, no. L 59 (Pakhons 1); 108–9 and 257–58, no. L 63 (Pakhons 15).

[94] However, for Gauthier, *Les fêtes du dieu Min*, 31–32, the Esna festivals would go back to the New Kingdom Festival of Min. He writes: "Au lieu même d'une seule procession du dieu ithyphallique, il semble qu'il y en ait eu alors *deux*; toutes deux avaient lieu au même mois de Pakhons que précédemment, le 1ᵉʳ et le 15 de ce mois." See also A. Egberts, *In Quest of Meaning. A Study of the Ancient Egyptian Rites of Consecrating the* Meret-*Chests and Driving the Calves*, EU 8 (Leiden, 1995), 408–9.

[95] On Amun-Re-Kamutef or Min and Isis as the divine parents of the king, see Lurson, *A Perfect King*, 57 and 174.

[96] See K.-P. Kuhlmann, "El-Salamuni: Der Felstempel des Eje bei Achmim," in G. Dreyer and D. Polz, eds., *Begegnung mit der Vergangenheit – 100 Jahre in Ägypten. Deutsches Archäologisches Institut Kairo 1907–2007* (Mainz am Rhein, 2007), 181, with fig. 256 for the stela itself.

[97] I elaborate on the remarks by Derchain, "Mythes et dieux lunaires en Égypte," 33–34, but see also Egberts, *In Quest of Meaning*, 408–9, for the ritual of the divine birth and its celebration during the month of Pakhons, while "In the temple of Dendera this event was linked to full moon day" (Egberts, *In Quest of Meaning*, 409). The frame of these remarks is a long examination of the decoration of Room XIII in Luxor Temple, the "birth room," and its potential links with the Graeco-Roman festival calendars; see Egberts, *In Quest of Meaning* 406–9, for the whole discussion. Waitkus, *Untersuchungen zu Kult und Funktion des Luxortempels*, 72–75, addresses the question again and has some reservations about Egberts' conclusions. The question is certainly complicated and is far beyond the limits of this contribution. If, however, the festivals celebrated during the Graeco-Roman Period (such as can be found in the festival calendars and the inscriptions of the temples) were not only the "descendants" of the I *Shemu* Festival of Min, but also of his LD30/new moon and full moon festivals, some of the problems

Beforehand, let us keep in mind that the proclamation of the takeover of the king compared to Horus, son of Isis, by the four *sr.wt*-birds is the climax of both the depiction and the *texte-programme* of the Festival of Min at Medinet Habu.[98] Moreover, in Spell 54 for offering the ointment-*md.t* of the Clothing Ritual already mentioned above, "Auf der herrschaftspolitischen Ebene geht es […] um die Herrschaftsübergabe bzw. -legitimierung," whereas its Abydos version "thematisiert ebenfalls diese Herrschaftsübergabe," through a reference to the myth of Horus and to the *wrr.t*-crown,[99] the very same crown by which the *sr.wt*-birds are supposed to announce the seizing (*iṯ(i)*) by the king.[100] Goebs has gathered a few Ramesside expressions, in which she sees "associations of the moon's seasonal rejuvenation with the king's sed-festivals," before comparing "how different crowns were bestowed on the cult-images of Khnum at Esna in the Graeco-Roman Period during the various festivals of the month Pakhons."[101] Again, this brings us back to the festivals of Pachons at Esna. Lastly, having studied reliefs dated to Osorkon III discovered in front of the Khonsu Temple at Karnak, Goyon concludes that "il faudra reconsidérer la fonction monarchique des divinités à caractère lunaire dans la théologie thébaine du Nouvel Empire."[102] From a theoretical point of view, the interpretation of the full moon procession of Min as linked with the takeover by the king is acceptable, but in comparison to the celebration of Min in his capacity as the father of the king, it is lacking iconographic substance in the chapel itself. However, our ignorance of the personality of the god *Mer-ta*, whose bark is depicted symmetrically to the processional Min, and the loss of the scene symmetrical to the "tickling scene," deprive us of essential information for deepening the discussion on this part of Chapel XII's iconographic program.

Conclusion

The new reading of the cryptographic inscription engraved on the rear wall scene of Chapel XII in the temple of Ramses II at Abydos proposed here is in accordance with the principle that the depiction of a deity and an inscription facing the same direction refer to each other. According to this reading, the inscription describes the appearance (*ḥꜥ*), that is, the procession of Min in his form of his second full moon festival. Echoing it, the *nemes* worn by the god in the scene makes his depiction very special. This reading also enlightens the importance of thematic cryptography as a principle of conception: the god's crowns, his procession and the depicted rite, namely the unction, seem indeed to have determined the choice of some of the signs.

and discrepancies between the different traditions may begin to find a solution. See also Barta, *Untersuchungen zur Göttlichkeit*, 93, for whom "Da noch das Totenbuch den Auszug des Min glossenartig als dessen Geburt bezeichnet […], wäre es denkbar, daß mit Hilfe des Minfestes das regelmäßige Wiederscheinen des Mondes, seine Wiedergeburt also, gesichert werden sollte, weshalb es innerhalb des Mondkalendars wohl auch allmonatlich begangen worden ist."

[98] See Lurson "La ligne et le cadre," 399–401 (with 400, figs. 3–4) and 403–4. See also C. Graindorge, "Von weißen Stier des Min zu Amenemope: Metamorphosen eines Ritus," in C. Metzner-Nebelsick, ed., *Rituale in der Vorgeschichte, Antike und Gegenwart. Studien zur Vorderasiatischen, Prähistorischen und Klassischen Archäologie, Ägyptologie, Alten Geschichte, Theologie und Religionswissenschaft. Interdisziplinäre Tagung vom 1.–2. Februar 2002 an der Freien Universität Berlin*, Internationale Archäologie. Arbeitsgemeinschaft, Symposium, Tagung, Kongress 4 (Rahden/Westf., 2003), 39–42.

[99] See Braun, *Pharao und Priester*, 173 (transcription) and 177 (commentary and quotation); Calverley-Gardiner, *Abydos* II, pl. 10, for the spell. See also Lurson, *A Perfect King*, 127–28, for the unction of the ithyphallic Amun-Re depicted in scene B 239 of Karnak Temple's Hypostyle Hall as possibly referring to the Clothing Ritual, as well as to the king's unction during his coronation.

[100] See *Medinet Habu* IV, pl. 207, A (depiction of Medinet Habu) and 213, A (depiction of the Ramesseum).

[101] K. Goebs, *Crowns in Egyptian Funerary Literature. Royalty, Rebirth, and Destruction*, Griffith Institute Monographs (Oxford, 2008), 364 for both quotations and 364–66 for the whole discussion. See also Waitkus, *Untersuchungen zu Kult und Funktion des Luxortempels*, 74–75.

[102] See J.-C. Goyon, "Aspects thébains de la confirmation du pouvoir royal: les rites lunaires," *JSSEA* 13 (1983), 2–9 (full quotation on p. 8). Goebs, *Crowns in Egyptian Funerary Literature*, 365, mentions also this work. J.-C. Goyon, "Thèbes : Khonsou, Thot et la monarchie pharaonique après la Troisième Période de Transition. La fête de Thot du 19 du premier mois de l'année et les rites de confirmation du pouvoir royal à Karnak, Edfou et Philae (I)," in C. Thiers, ed., *Documents de Théologies Thébaines Tardives (D3T 2)*, CENiM 8 (Montpellier, 2013), 33–93, re-examines the blocks of Osorkon III and publishes drawings of them, but focuses on the Late Period and the Graeco-Roman Period. However, I could not access the second part of the author's study: J.-C. Goyon, "Thèbes, Khonsou, Thot et la monarchie pharaonique après la IIIe Période de transition. Fête de Thot du 19 du premier mois de l'année et rites de confirmation du pouvoir royal à Karnak, Edfou et Philæ (II)," in C. Thiers, ed., *Documents de Théologies Thébaines Tardives (D3T 3)*, CENiM 13 (Montpellier, 2015), 29–89.

A comparison of the scene with another engraved in Abu Simbel confirms the importance of the "lunar aspects" of the god. These aspects are essential to the god. Based on the cryptographic inscription, the essential lunar character of Min and the fact that the full moon was celebrated monthly, it is possible to reconstruct twelve full moon festivals of Min. The reason why the hierogrammat highlighted the second full moon festival in his inscription remains unclear, although a link with the Festival of Opet should not be excluded. In any event, the vocabulary of the inscription and the iconographic program of Chapel XII also allows us to reconstruct the liturgy of these festivals: a procession. To the procession taking place during the Festival of Min, it is then possible to add twelve further processions of the god, happening at each full moon.

As for the meaning of the festival, unless this is limited to the second full moon festival, the iconographic program of the chapel points at a royal level, in relation to the moon and its symbolism. The god as the divine father of the king may well have been celebrated during this festival, although the takeover of the king might also have been part of the celebration. Unfortunately, the loss of most of the decoration of the north wall of the chapel does not allow us to investigate this aspect further.

If the reading of the cryptographic inscription proposed here is accurate, then it not only gives us a renewed insight into the New Kingdom theology and liturgy of Min, but also into his link to the king and, thereby, his place in the royal ideology of the Ramesside Period. Moreover, this reading highlights the importance of the phases of the moon for the festivals of Min, that is, the importance of the symbolism of the moon for celebrating the god. Whether this is likely to apply to other deities too, remains open. More generally, this inscription shows how little we actually know about the liturgy, the theology, and the New Kingdom divine festivals. Nonetheless, it shows that the religious and intellectual wealth of this period should not be underrated, even though at first sight it appears that the inscriptions are the poor relation in terms of the decoration of the temples of this period.

Université Libre, Brussels

A Textual Amulet from Theban Tomb 313 (Papyrus MMA 26.3.225)

Jacco Dieleman and Hans-W. Fischer-Elfert

Abstract

Edition of a textual amulet held in The Metropolitan Museum of Art in New York (MMA 26.3.225). Found in Theban Tomb 313 as a folded and tied packet, the papyrus sheet is inscribed with an apotropaic incantation and drawing. The incantation invokes "The Entities of Khemenu," that is, the eight members of the Ogdoad, and orders them to offer protection to the owner of the amulet. The drawing is only partly preserved, but depicted originally two symmetrically arranged crocodiles attacking a figure positioned between them.

This article is a study of a textual amulet that is held today in The Metropolitan Museum of Art in New York under the acquisition number 26.3.225 (Rogers Fund, 1926).[1] The artifact consists of a small, rectangular sheet of papyrus, torn in two halves (a, b: front side = fig. 1; back side = fig. 2), and a piece of string (c = fig. 3).[2] The sheet is inscribed with an apotropaic incantation and a drawing of two symmetrically arranged crocodiles attacking a figure, now lost in the lacuna, positioned between them.

1. Artifact

1.1 Provenance

The artifact was found in Theban Tomb 313 (MMA Excav. no. 510; PM I.1 388–89), tomb of the *i.a.* royal seal bearer Henenu (*floruit* Mentuhetep II–III),[3] during the MMA Egyptian Expedition at Deir el-Bahari directed by Herbert Winlock for the MMA between 1922 and 1923. In the same tomb were found another textual amulet (pMMA 26.3.226), Late Dynastic funerary equipment, and a Late Dynastic ostracon with a drawing of a Horus falcon wearing the double crown.[4] By reason of their association with these Late Period artifacts, the excavator

[1] We thank Diana Craig Patch, Lila Acheson Curator in Charge, Department of Egyptian Art at the Metropolitan Museum of Art in New York, for permission to publish the artifact; Adela Oppenheim, Curator, and Isabel Stünkel, Associate Curator in the Department of Egyptian Art at the MMA, for their assistance in studying the artifact and the archival materials; Gustavo Camps for taking photographs of the artifact; Gabriella Hoskin of the Institute for Advanced Study, Princeton, for assistance in producing a digital drawing of the amulet (below fig. 8). Jacco Dieleman conducted research for this article as a member of the Institute for Advanced Study, Princeton (Herodotus Fund; Fall 2016).

[2] High resolution photos can also be retrieved from the online Collection Database of The Metropolitan Museum of Art, http://www.metmuseum.org/art/collection.

[3] For his titles and dating see J. Allen, "The high officials of the early Middle Kingdom," in N. Strudwick and J. Taylor, eds., *The Theban Necropolis. Past, Present and Future* (London, 2003), 16.

[4] These objects are summarily described on MMA tomb cards 1731–1737 (The Metropolitan Museum of Art, Department of Egyptian Art Archives): fragments of cartonnage and wooden coffins of Dynasties 25–26, canopic jars, Ptah-Sokar-Osiris figurines, mummy braces, broad collar, bead nets, ushabtis, and lids of cylindrical wooden boxes(?).

Journal of the American Research Center in Egypt 53 (2017), 243–257
doi: http://dx.doi.org/10.5913/jarce.53.2017.a012

dated the two textual amulets mistakenly to the Late Dynastic Period.[5] As will be demonstrated below, the present artifact dates in fact to the Ramessid Period. Because no other materials dating to the Ramessid Period were discovered in the tomb, it is unclear how the textual amulet ended up there. One possible scenario is that the individual for whom the amulet was inscribed was buried in the tomb in the Ramessid Period and that the amulet was placed with the mummy, as it had provided its owner protection in life.[6] In the Late Period, the mummy and funerary equipment were then removed to make room for new burials. The amulet may have escaped attention due to its small size or may simply have been discarded. In any case, it was left in the tomb.

1.2 Measurements

The artifact was found as a tightly folded packet tied around one end with a string of linen (figs. 4–7). The packet measured 3.6 cm in length.[7] It had suffered significant damage at its central bend, where the outer and three of the inner layers were missing (see figs. 6–8). Accordingly, when William Barrett, Senior Restorer of the Department of Egyptian Art at The Metropolitan Museum of Art in New York, disassembled and unfolded the packet on October 26, 1979, it came apart as two loose fragments.[8] The fragments were glassed separately and given the letters [a] and [b] respectively, while the cord was given the letter [c]. Their measurements are:

> 26.3.225a: height = 9.3 cm; width = 11.5 cm
> 26.3.225b: height = 9.3 cm; width = 9.8 cm
> 26.3.225c: length = ca. 23 cm

When still intact, the sheet's height to width ratio was 0.44 (9.3: 11.5 + 9.8). This ratio falls squarely into the range of values attested for textual amulets dating to the Ramessid Period.[9] The sheet's broad format is characteristic for textual amulets of this period.

1.3 Material Properties

The artifact consists of a single sheet of papyrus inscribed on one side only with regular carbon black ink, and a string of linen used to tie the outer ends of the folded packet together. The papyrus sheet is of medium quality presenting a somewhat rough writing surface. It is composed of two smaller rectangular sheets of about equal size joined at their width. The sheet join, slightly discolored today, runs horizontally across about the middle of the full sheet's height under the third line of text, with the sheet's lower half pasted on top of the upper half. The sheet was new and blank when inscribed; no signs of reuse such as traces of a washed-off previous text can

[5] MMA tomb card 1735.

[6] In this regard, the two amulets would not be exceptional. Most textual amulets are without secure provenance, but those that have been found in controlled excavations come primarily from tombs. For example, TT 11 (Djehuty) and TT 233 (Saroy and Amenhotep) are two tombs in which similar textual amulets have recently been found. Both remain unpublished. For the former, see http://www.excavacione-gipto.com/campana/campana05_ing.jsp.htm and http://www.excavacionegipto.com/campana/campana06_ing.jsp.htm. For the latter, see M. Krutzsch, "Materialtechnische Beobachtungen während der Restaurierung," in H.-W. Fischer-Elfert, *Magika Hieratika in Berlin, Hannover, Heidelberg und München*. Ägyptische und Orientalische Papyri und Handschriften des Ägyptischen Museums und Papyrussammlung Berlin 2 (Berlin, 2004), 25 (TT 233). Such amulets were commissioned to protect the owner in life, but their protective power was apparently believed to continue after death; see also A. Berlejung, "Kleine Schriften mit großer Wirkung. Zum Gebrauch von Textamuletten in der Antike," in A. Kehnel and D. Panagiotopoulos, eds., *Schriftträger - Textträger: Zur materialen Präsenz des Geschriebenen in frühen Gesellschaften*. Materiale Textkulturen 6 (Berlin, 2014), 103.

[7] MMA tomb card 1735.

[8] The unfolding report is part of the supplementary file associated with the object. The file also contains photos and a timeline (from 9:45AM to 2:15PM) documenting the successive steps in unfolding the artifact. Note that Barrett mistakenly concluded that the packet comprised "two separate papyrus-amulets." In fact, the two halves join to form a single papyrus sheet, which was inscribed in one hand with a single, continuous text.

[9] J. Dieleman, "The Materiality of Textual Amulets in Ancient Egypt," in D. Boschung and J. Bremmer, eds., *The Materiality of Magic* (Paderborn, 2015), 23–58, 43.

Fig. 1. MMA 26.3.225a + b, front side [a = fragment to the right; b = fragment to the left] (photograph © The Metropolitan Museum of Art).

Fig 2. MMA 26.3.225a + b, back side [a = fragment to the left; b = fragment to the right] (photograph © The Metropolitan Museum of Art).

be detected. Its front side is inscribed with a text of four lines filling out its entire width, and a drawing at the bottom center. The text runs parallel to the sheet join and perpendicular to the sheet fibers. The sheet's back side was left blank.

These properties betray the scribe's working method. The presence of the sheet join demonstrates that he cut the sheet from a larger papyrus scroll made up of at least two sheets of papyrus. On such scrolls, sheet joins run vertically with the joins right over left, while the fibers run horizontally (recto). As the join runs here horizontally with bottom over top and the fibers vertically, it follows that the scribe turned the cut-out sheet 90° clockwise before inscribing it. Accordingly, the horizontal fibers of the sheet's recto side run now vertically, that is, perpendicularly to the writing direction. Such procedure was common scribal practice in preparing letters in Ramessid Egypt.[10] As the sheet measured originally about 21.3 cm in width, it was probably halved from a scroll of about

[10] Černý, *LRL*, xviii; A. Bakir, *Epistolography*, 24–28.

42–44 cm in height, which is a standard height for full-size papyri dating to the Ramessid Period.[11]

The string consists of two single yarns of linen (diameter of 0.6 mm each) twisted together in an "s" twist (not plied) (fig. 3).[12] It was wound around the folded packet five times (width 4.0 mm). One end was placed inside the central fold of the packet for attachment. The other end appears to have been tucked into the string's coils to string the packet's outer ends together. The cord was tied very tightly and its impression can still be detected on the unfolded sheet today. It also left a dark-stained or ink impression of two lines intersecting at a right angle on the sheet's back side, at the spot that formed the outside of the packet and where the cord was wound across (fragment [b], between fold lines 4 and 5, immediately next to the broken edge; see fig. 2).[13]

Fig. 3. MMA 26.3.225c (string) (photograph © The Metropolitan Museum of Art).

There are no signs of how the person for whom the amulet was inscribed wore the amulet on his or her body. As textual amulets were usually (if not always) worn on a twisted linen strip or cord around the neck, one may assume that this was the case here, too.[14] The folded packet was then likely attached to such strip or cord at its central bend, where the packet was damaged when found. The damage may then well be explained as resulting from ripping the packet off its string (possibly when the tomb was cleared of its Ramessid burials to make room for the Late Period burials).

1.4 Folding

Upon completing the text and the bottom drawing, the scribe did not wait for the ink to dry, but immediately folded the sheet into a small, rectangular packet. As a result, lines 1 and 2 each left faint mirrored ink marks on the opposite side of the fold line that runs between them. Likewise, a faint mirrored outline of the crocodile drawn at the bottom of fragment [a] can still be discerned underneath the crocodile. On the back side, ink marks of lines 3 and 4 are still visible along fold lines 2 and 3.[15] As the ink impressions left by lines 1 and 2 are the least faint of these three sets of ink marks, we conclude that the scribe made here the first fold.

The scribe proceeded as follows (see fig. 8). First he folded the sheet's upper edge inward along fold line 1. He then folded the sheet from bottom to top along fold lines 2, 3, 4, and 5. Changing now the folding direction, he next folded the resultant narrow strip from both ends twice inward, thus creating two folded parts that meet in the middle. He then folded the two parts together along the center's length (fold line 10) and tied a cord around the loose ends. He thus fashioned a small, rectangular folded packet, which counts as type III in Myriam

[11] R. Parkinson and S. Quirke, *Papyrus* (London, 1995), 16; Černý, *LRL*, xviii.

[12] Information taken from the yarn report made by Angela Lakwete, Senior Restorer in the Department of Egyptian Art in the MMA, on October 12, 1979, which is part of the supplementary file associated with the artifact in the Department of Egyptian Art in the MMA.

[13] We are unable to determine if this is simply discoloration due to dirt or if the scribe had applied some ink to the string. Irrespective, it is certainly not the remnant of an effaced apotropaic design such as can be found at the exact same spot on the textual amulet pBerlin P 14499 (= Magika Hieratika #6, in Fischer-Elfert, *Magika Hieratika*, 125–32).

[14] Dieleman, "Materiality of Textual Amulets."

[15] In his report on unrolling the artifact, William Barrett mistook these ink marks as traces of an earlier text and concluded incorrectly that the manuscript is a palimpsest.

Fig. 4. Archival photo, folded amulet, side view (photograph © The Metropolitan Museum of Art).

Fig. 5. Archival photo, folded amulet, side view (photograph © The Metropolitan Museum of Art).

Fig. 6. Archival photo, folded amulet, front view (photograph © The Metropolitan Museum of Art).

Fig. 7. Archival photo, folded amulet, back view (photograph© The Metropolitan Museum of Art).

Krutzsch's typology of folding patterns.[16] In doing so, the scribe followed a method that was common for preparing letters (and textual amulets) in the Ramessid Period.[17]

1.5 Date

The artifact can be dated by paleography and material properties to the Ramessid Period. The text is written in a hieratic hand typical of this period.[18] Unfortunately, there are no diagnostic signs or ligatures that could narrow the date down within this general period. Moreover, as mentioned above, the sheet's dimensions (half-sized from a standard scroll of 42–44 cm in height), the broad format (height to width ratio of 0.44), the fiber orientation on front side (recto fibers running vertically, that is, perpendicularly to writing direction), and the folding pattern (folded packet type III) are all indicative of a date in the Ramessid Period.

<div align="center">2. Text</div>

2.1 Transcription

2.2 Transliteration

1) *ind̠-<ḥr>=tn nꜣ Ḫmnyw nꜣ nḥm-Pꜣ-Rꜥ m-ꜥ ḫfty tpy nꜣ nḥm Pꜣ-Rꜥ m-ꜥ ḫfty sn.nw*
2) *nꜣ nḥm Pꜣ-Rꜥ m-ꜥ ḫfty ḫmt.nw nꜣ nḥm Pꜣ-Rꜥ m-ꜥ ḫfty ifd.nw ir pꜣ nḥm i.ir=tn*
3) *Pꜣ-Rꜥ-Ḥr-ꜣḫty m-ꜥ ḫfty tpy [m-ꜥ ḫfty sn.nw m-ꜥ] ḫfty ḫmt.nw m-ꜥ ḫfty ifd.nw mi.n*
4) *nḥm=tn ʾImn-… ms.n [… m-]ꜥ iḫt nb bin ḏw m-mitt*

2.3 Translation

1) Hail <to> you, O Entities of Khemenu (Ogdoad), the ones who rescued Pre from the first enemy, the ones who rescued Pre from the second enemy,
2) the ones who rescued Pre from the third enemy, the ones who rescued Pre from the fourth enemy! As for the rescue that you did
3) of Pre-Harakhti from the first enemy, [from the second enemy, from] the third enemy, from the fourth enemy: Come,
4) so you may rescue Amen-… born of [… from] everything bad and evil, likewise!

[16] Myriam Krutzsch distinguishes between folded packets ("Faltpäckchen") and folded rods or scrolls ("Faltstangen"). The latter is folded in a single direction, whereas the former is folded in two directions (an inner folding followed by an outer folding). Type III of folded packets are folded in such a way that no part of the inner folding is visible. M. Krutzsch, "Falttechniken an Handschriften aus dem alten Ägypten," in B. Backes, I. Munro, and S. Stöhr, eds., *Totenbuch-Forschungen. Gesammelte Beiträge des 2. Internationalen Totenbuch-Symposiums Bonn, 25. bis 29. September 2005.* SAT 11 (Wiesbaden, 2006), 175–76 and "Materialtechnische Beobachtungen," 15–17 (note the chart on p. 17, which shows that pBerlin P 30490 A/B and pBerlin P 30491 were folded in the exact same way as the present artifact).

[17] Černý, *LRL*, xviii; Bakir, *Epistolography*, 24–28; Dieleman, "Materiality of Textual Amulets," 43–44.

[18] In his report on unrolling the artifact, William Barrett dates the hand to Dynasties Twenty to Twenty-One. We prefer Dynasties Nineteen to Twenty.

Fig. 8. Digital drawing of sheet with fold lines (drawing by Jacco Dieleman).

2.4 Philological Commentary

The text's grammar shows Late Egyptian features, as is to be expected for a text of the Ramessid Period: the use of the definite article (passim), the *i*-prothetic with the relative form (*i.ir=tn*; line 2), and the plural imperative *mi.n* (line 3).

1) *ind-<ḥr>=tn*: The greeting formula *ind-ḥr* is so common that the emendation requires no further comment. It frames the incantation formally as a hymn.[19] Note that the scribe did not provide the book roll determinative (sign Y1) (underneath the *d* snake) with its usual diacritical dot above the sign. The sign resembles therefore *r* rather than book roll. As the word requires the latter sign, we consider it an inadvertent scribal error and transcribe a book roll.

1–5) *nḥm*: As noted by Günter Vittmann, the verb *nḥm* is ambiguous in meaning.[20] In collocation with the preposition *m-ꜥ* (literally, "out of the hand of" someone or something), it can mean either "to rescue" someone out of a perilous situation or "to protect" someone from possible harm. In this case, the verb must have the former meaning in the first two lines, because they refer to a time when the sun god was under enemy attack (see commentary below for more detail). It is, however, less clear which meaning the verb has in line 5, where it applies not to the sun god but to the wearer of the amulet. Was the amulet to "rescue" its owner from an affliction that had already taken hold or to "protect" from future harm? The generic expression [*m-*]ꜥ *iḫt nb bin dw*, "[from] everything bad and evil," suggests the latter, but possibly both meanings were intended.

2–4) The request formula is similar in syntax and wording to the request formula found in a spell for protection that invokes the vigil over Osiris by the "four spirits" (*ifdw ꜣḫw*)[21] as its mythical precedent.[22] The spell is preserved in three variants, that is, two recipes for a textual amulet (*mdꜣt*) that drives out the male and female *nesy*-disease demons and an activated textual amulet that offers general protection against demons. In both

[19] For this genre marker, see J. Assmann, "Hymnus," in *LdÄ* III, 105 (B [b]); A. Barucq, *L'expression de la louange divine et de la prière dans la Bible et en Égypte*, BdE 33 (Cairo 1962), 77–83 and 101–2 (with many examples).

[20] G. Vittmann, *Der demotische Papyrus Rylands 9. Teil II. Kommentare und Indizes*. ÄAT 38 (Wiesbaden 1998), 384–85.

[21] C. Leitz, *Lexikon der ägyptischen Götter und Götterbezeichnungen* I (Leuven, 2002), 44b-45a.

[22] For the common use of the so-called 'mythological precedent' in Egyptian magical texts, see T. Schneider, "Die Waffe als Analogie. Altägyptische Magie als System," in M. Bachmann and K. Gloy, eds., *Analogiedenken. Vorstöße in ein neues Gebiet der Rationalitätsforschung* (Freiburg-Munich, 2000), 37–85. J. Sørensen, "The Argument in Ancient Egyptian Magical Formulae" *Acta Orientalia* 45 (1984), 5–19.

instances, the request formula is structured as: 'As for X that you (pl.) did before, you should do likewise now'. The mythical precedent is topicalized with the particle *ir*, marked as a past event by means of the past relative form *i.ir=tn*, and connected with the request proper by means of the adverb *m-mitt* ("likewise") in the main clause or, in two variants, the preposition *mi* ("like") in the topicalized phrase.

In Papyrus Chester Beatty VI, a manual with recipes for healing that is more or less contemporary with the MMA textual amulet, the request formula runs as follows[23]:

> *ir p3 rs-tp i.ir=tn ḥr Wsir i.iry=tn m-mitt ḥr mn ms.n mnt r tm di.t ḫdb sw mwt mwtt ḏ3y ḏ3yt nb nty m ꜥt nb n mn ms.n mnt*

> As for the watch that you (pl.) kept over Osiris, may you do likewise over N born of N to prevent that will kill him any male or female dead, any male or female opponent, who might be in any limb of N born of N. [pChester Beatty VI verso, col. 2, ll. 5–8]

In a variant recipe in the manual Papyrus Athens National Library 1826, which dates to the late Ramessid period, the topicalized noun phrase ("the watch that you kept") has been changed into a prepositional phrase ("like the watch that you kept")[24]:

> *ir mi p3 rs i.ir=tn r ḥm n Wsir nn ḥꜥk sw mwt nb ḏ3 nb mwtt nb<t> ḏ3y nb<t> iḥ iry.tw rs m-mitt m grḥ m hrw m nw nb ḥr mn ms.n mnt m grḥ m hrw m nw nb*

> Like the watch that you (pl.) kept over the majesty of Osiris so that no male dead, male opponent, female dead, female opponent would harm him, may likewise a watch be kept at night, day, any moment over N born of N at night, day, any moment. [pAthens National Library 1826 rt x+5.10–12]

The same construction is used in textual amulet Papyrus Berlin 14499, which was inscribed for a certain Ankhef<en>Ptah in the early Third Intermediate Period[25]:

> *ir mi p3y rs-ḥr i.ir=tn r Wsir nṯr ꜥ3 <ḥk3> ḏt iḥ iry=tn s3 rs-ḥr r ꜥnḫ=f-<n>-Ptḥ ms.n T3-krry <r> tm di.t iw ḫfty pf<t> mwt mwt<t> ḏ3 nb ḏ3<t> nb<t> r h3y r=f m grḥ m hrw m nw nb*

> Like this watch that you (pl.) kept over Osiris, Great God, <Ruler> of Eternity, may you create protection for, and keep watch over, Ankhef<en>Ptah, born of Takerere, <to> prevent that will come an enemy, a fiend,[26] a male dead, female dead, any male opponent, any female opponent to fall upon him at night, day or any moment. [pBerlin 14499, ll. 5–9]

These three variants show that the formula was never a fixed form, but rather a general pattern. Variation is most prominent in the request clause proper. In pChester Beatty VI, the earliest witness, the request is expressed with an emphatic *i.sḏm=f*, foregrounding the adverb "likewise." In pAthens National Library 1826 and pBerlin 14499, it is expressed instead with an optative construction, that is, the particle *iḥ* followed by prospective *sḏm=f*. The scribe of the MMA textual amulet chose yet another option: he expressed the request with the plural imperative *mi.n* followed by prospective *sḏm=f*.

4) *Imn-…* : The amulet's beneficiary carried a theophoric name that has "Amun" as its first component. Even if the signs are well preserved, we cannot identify the remainder. The filiation marker *ms.n* is reduced to a di-

[23] A. Gardiner, *Hieratic Papyri in the British Museum. Third Series. Chester Beatty Gift* (London, 1935), 53–54, pl. 32.

[24] H.-W. Fischer-Elfert and F. Hoffmann, *Die magischen Texte des Papyrus Athen Nationalbibl. Nr. 1826* (in preparation).

[25] H.-W. Fischer-Elfert, *Magika Hieratika*, 128–30.

[26] The word is written as *pf* with evil determinative (forked stick Z6). It must be a misspelling of *pft*, a curious term that is attested in apotropaic formulae only. In most instances, it takes the position of *ḫftt*, "female enemy," in the standardized and gendered lists of possible inimical agents: *ḫfty pft mwt mwtt* …, "male enemy, fiend, male dead, female dead, etc."—as is also the case in the present passage. Its etymology and meaning are unclear. Our translation "fiend" follows Borghouts. For attestations and discussion, see J. Borghouts, *The Magical Texts of Papyrus Leiden I 348* (Leiden, 1971), 54, n. [50] and P. O'Rourke, *A Royal Book of Protection of the Saite Period: pBrooklyn 47.218.49*, YES 9 (New Haven, 2015), 49, n. [x].

agonal stroke (for the sign of woman giving birth, sign B.3) above horizontal stroke (for *n*). The mother's name is lost in the lacuna.

2.5 Textual Commentary

The text is a self-contained incantation, complete from beginning to end. Thanks to its formulaic nature, the lacunae can be restored with ease and confidence. The incantation is a hymn addressed to "The Entities of Khemenu" (*nꜣ Ḫmnyw*; with plural definite article). It praises them for having "delivered" (*nḥm*) the sun god from a foursome of "enemies" (*ḫfty*) and orders them now to "deliver" (*nḥm*) a private individual from harm likewise. "The Entities of Khemenu" is the collective name of a corporation of eight deities that derives its name from the name of the city Khemenu (*Ḫmnw*) or "Eight" in Middle Egypt (modern-day El Ashmunein; usually referred to by its Greek name Hermopolis Magna in scholarship), with which they were associated.[27] Comprising eight members, Egyptologists usually refer to this group as 'Ogdoad'.[28]

This mytheme of the Ogdoad defeating four enemies for the sun god is otherwise unattested.[29] In this regard, the MMA amulet offers a heretofore unknown variant upon the well-known myth complex of the cosmic battle between the sun god and the enemies of creation. The principal enemy in this combat is the serpent Apopis, who embodies the negative forces of non-existence.[30] In his recurrent attacks and obstructions, he poses a continual threat to the processes of creation and renewal. He is associated with a group of further enemies, collectively known as *msw Bdšt*, "Children of the Weak One."[31] Although the identity of "the Weak One" remains ambiguous,[32] its children are known from several sources. In the Book of Gates, they are depicted in the upper register of the eleventh hour of the night (scene 69) as four serpents trailing behind Apopis.[33] The scene shows how Apopis is subdued by the goddess Serqet and about to be slaughtered by a file of butchers, while the four *msw Bdšt* are bound by the four Sons of Horus under the supervision of the god Geb. In an execration ritual that aims at the destruction of Apopis and his confederates, the *msw Bdšt* are to be drawn on a sheet of papyrus as "four enemies with faces of [serpents],[34] bound and fettered with their arms behind them" (pBM EA 10188 32, 46–47).[35] Multiple sources locate the battle between the sun god and his enemies in Khemenu, or more specifically, on the "Isle of Fire" (*iw nsrsr*), which is the local name of the primeval hill where the sun god first emerged from the primeval waters to begin his work of creation.[36] According to a gloss to the first verse of Book of the

[27] Leitz, *LGG* V, 741c. Whether the group derives its name from the city or vice versa remains difficult to prove, but the earliest spellings (Old Kingdom) suggest that the former is the case. See also J. Parlebas, "Die Herkunft der Achtheit von Hermopolis," *ZDMG Suppl. III/1* (1977), 36–38.

[28] The history, theology, and iconography of the Ogdoad are complex. For a convenient summary, see C. Zivie-Coche, "L'Ogdoade à Thèbes à l'époque ptolemaïque et ses antecedents," in C. Thiers, ed., *Documents de théologies thébaines tardives (D3T 1)*, CENiM 3 (Montpellier, 2009), 167–225, 168–79. For attestations and further bibliography, see also Leitz, *LGG* V, 741c-743c.

[29] Cf. Leitz, *LGG* V, 742b, under 'C. In Beziehung zum Sonnengott'.

[30] Leitz, *LGG* II, 72b. J. Assmann, *Egyptian Solar Religion in the New Kingdom: Re, Amun and the Crisis of Polytheism* (London-New York, 1995), 51–57. For a convenient collection of relevant text passages, see J. Zandee, *Der Amunshymnus des Papyrus Leiden I 344, Verso* (Leiden, 1992), 143–68.

[31] Leitz, LGG III, 422c. For discussion, see idem, *Tagewählerei. Das Buch ḥꜣt nḥḥ pḥ.wy dt und verwandte Texte*, ÄA 55 (Wiesbaden, 1994), 99–102 and D. Meeks, *Mythes et légendes du Delta d'après le papyrus Brooklyn 47.218.84*, MIFAO 125 (Cairo, 2006), 198–207. Sources are collected and discussed in M. Tarasenko, *Studies on the Vignettes from Chapter 17 of the Book the Dead I: The image of ms.w Bdšt in Ancient Egyptian Mythology*, Archaeopress Egyptology 16 (Oxford, 2016).

[32] Leitz, *LGG* II, 844b. For discussion, see Meeks, *Mythes et légendes du Delta*, 201f.

[33] E. Hornung, *Das Buch von den Pforten des Jenseits*, AH 8 (Geneva, 1980) vol. I, 356, 359–60 and vol. II, 246–51. We agree with Leitz (*Tagewählerei*, 99; contra Hornung) that *msw Bdšt* refers collectively to all four serpents, not just the last three. The text gives the name of the first serpent (*wꜣmmty*; Leitz, *LGG* II, 245b) and not those of the others, because he is the leader of the pack.

[34] The word is lost in the lacuna, but the preserved snake determinative demonstrates that a word for serpent was written here.

[35] The execration ritual is appended to the "Book of Overthrowing Apopis:" pBM EA 10188, 22, 1–33, 18 (=pBremner-Rhind and TM 48496; February 6–March 7, 305 B.C.E.). E. Budge, *Facsimiles of Egyptian Hieratic Papyri in the British Museum* (London, 1910). R. Faulkner, *The Papyrus Bremner-Rhind (British Museum no. 10188)*, BAe 3 (Brussels, 1933). In lines 32, 53–54, the *msw Bdšt* are to be drawn again, this time with the heads of birds.

[36] Relevant text passages collected and analyzed in A.-C. Thiem, *Speos von Gebel es-Silsileh. Analyse der architektonischen Konzeption im Rahmen*

Dead spell 17, it was then and there that the *msw Bdšt* were defeated (*rdi*, "submitted;" var.: *sḥtm*, "destroyed") for the sun god.[37] The gloss does, however, not explicate who acted on behalf of the sun god.

In view of the mythological background, the four anonymous adversaries listed in the incantation on the MMA textual amulet as "the first, second, third, and fourth enemy" can now be identified more precisely as the four *msw Bdšt*, "Children of the Weak One." Although no other texts are known that mention, let alone elaborate on, this encounter between the "Entities of Khemenu" (Ogdoad) and these *msw Bdšt*, their association as opponents is fitting. The location of the combat being Khemenu, it makes sense that the local "Entities of Khemenu" are credited with defeating the enemies. Moreover, the "Entities of Khemenu" form an ideal group to counter the four "Children of the Weak One," because they are eight in number. That makes two warriors per enemy. Thus the incantation applies what the military theorist Carl von Clausewitz (1780–1831) has defined as force concentration through numerical superiority.[38] In this regard, the MMA textual amulet brings heavier force to bear on the *msw Bdšt* than scene 69 in the Book of Gates, where the four serpents are subdued by the four Sons of Horus, that is, one warrior per enemy.

The MMA textual amulet may be unique in crediting the "Entities of Khemenu" with defeating the four *msw Bdšt*, but it is by no means unique in invoking the episode as a suitable mythical precedent for protection against harm. The episode is invoked in two more apotropaic formulae. Like the MMA textual amulet, these formulae do not mention the *msw Bdšt* by name, but simply refer to them as a group of four anonymous foes (*ḥrwy*, not *ḫfty*, "enemy"). Unlike the MMA textual amulet, they associate the four foes explicitly with Apopis. Who defeated these four foes is left unsaid in the first formula. The second formula, on the other hand, ascribes their defeat to the sun god himself, not the "Entities of Khemenu" or any other agents.

The first formula is a singular, self-contained insertion in spell 15 of the Book of the Dead on the funerary papyrus of Nodjmet, wife of High Priest of Amun Herihor (Dynasty 21, Thebes).[39] The incantation celebrates the sun god's victory over his archenemy Apopis and adjures him to defeat similarly the enemies of Nodjmet, the owner of the manuscript. The text invokes then the very same mythical precedent of the defeat of the four foes. The foes are enumerated individually as first, second, third and fourth foe—thus revealing a clear intertextual link with the MMA textual amulet in its use of ordinal numbers. Even if their identity is not further specified, their affiliation with Apopis, who is the main target of the curse text, is textually obvious.

> *i Rꜥ-Ḥr-ꜣḫty nḥm=k Wsir N m-ꜥ ḫfty pft[40] ḏꜣḏꜣy mi nḥm.tw mi ḥsf.tw mi wḥꜥ.tw Rꜥ m-ꜥ ḥrwy=f[41] twy[42] tpy*
> *ḏd-mdw i.nḏ-ḥr=k Rꜥ nb mꜣꜥ.t imy kꜣr=f nb nṯrw nḥm=k N mꜣꜥ-ḥrw m-ꜥ ḫfty pft ḏꜣḏꜣy mi nḥm.tw mi ḥsf.tw mi wḥꜥ.tw Rꜥ m-ꜥ ḥrwy=f twy sn.nw*
> *i Ḫpri ḥry-ib wiꜣ=f nḥm=k Wsir N m-ꜥ ḫfty pft ḏꜣḏꜣy mi nḥm.tw mi ḥsf.tw mi wḥꜥ.tw Rꜥ m-ꜥ ḥrwy=f twy ḫmt.nw*
> *i Ḫpri ḥry-ib tꜣ mi ḳd=f nḥm=k Wsir N mꜣꜥ-ḥrw m-ꜥ ḫfty pft ḏꜣḏꜣy mi nḥm.tw mi ḥsf.tw mi wḥꜥ.tw Rꜥ m-ꜥ ḥrwy=f twy ifd.nw*

> O Re-Harakhti, may you rescue Osiris N from the enemy, the fiend, the adversary as Re was rescued, repelled, released from that his first foe.

des politischen und legitimatorischen Programmes der Nachamarnazeit. ÄAT 47 (Wiesbaden, 2000), 34–51, esp. 45–46. H. Kees, "Die Feuerinsel in den Sargtexten und im Totenbuch," *ŽÄS* 78 (1942), 41–53. G. Roeder, *Hermopolis, 1929–1939; Ausgrabungen der Deutschen Hermopolis-Expedition in Hermopolis, Ober-Ägypten* (Hildesheim, 1959), 36–37. H. Altenmüller, *Die Apotropaia und die Götter Mittelägyptens; eine typologische und religionsgeschichtliche Untersuchung der sogenannten "Zaubermesser" des Mittleren Reichs* (Munich, 1965), 97–109.

[37] Tb (Naville), vol. II, 33. G. Lapp, *Totenbuch Spruch 17*, TbT 1 (Basel, 2006), 16–17.

[38] C. von Clausewitz, *Vom Kriege* (Berlin, 1832), III.8.

[39] pBM EA 10541 (TM 133525; Twenty-first Dynasty). For transcription and translation, see A. Shorter, *Catalogue of Egyptian religious papyri in the British Museum: copies of the book Pr(t)-m-hrw from the XVIIIth to the XXIInd dynasty* (London, 1938), 60–78; for the lines in question, see 62–63 and 72–73.

[40] For *pft*, "fiend," which occurs four times in this passage, see n. 26 above.

[41] The noun is written with plural strokes throughout the passage. The noun must be singular nonetheless, because it is followed each time by a demonstrative pronoun and ordinal number in the singular.

[42] The presence of the feminine demonstrative adjective *twy* following the masculine noun *ḥrwy*, "foe," is puzzling. The common rule of gender agreement between noun and its attributive demonstrative adjective requires *pwy* instead.

Recitation: Hail to you, Re, Lord of Ma`at, Who is in his shrine, Lord of the gods; may you rescue Osiris N, justified, from the enemy, the fiend, the adversary as Re was rescued, kept back, released from that his second foe.

O Khepri, Who is inside his bark, may you rescue Osiris N from the enemy, the fiend, the adversary as Re was rescued, kept back, released from that his third foe.

O Khepri, Who dwells in the entire land, may you rescue Osiris N from the enemy, the fiend, the adversary as Re was rescued, kept back, released from that his fourth foe.

[pBM EA 10541 cols. 32–37]

The second formula is attested in three variants ranging in date from the late Ramessid to the Hellenistic Period.[43] It locates the defeat of the four foes (ḫrwy) and the enemy (ḫfty), which latter term must be a veiled reference to Apopis, in the area of Khemenu. Its earliest attested version occurs in a long incantation for protection against harm that is preserved in several fragmentary magic formularies of late Ramessid date, that is, more or less contemporary with the MMA textual amulet, all from Thebes.[44] The incantation is a first-person address spoken by a ritualist for the benefit of a client in need of protection. The ritualist identifies himself as Thoth, god of magic and medicine, and asserts that he will use his divine powers to protect the client against harm. To ensure that the client will indeed be safe, he equates the situation with several incidents in the mythical past when a deity successfully overcame a life-threatening opponent. The relevant formula, which happens to be preserved in one of the available text witnesses only, runs as follows:

> *ink Ḏḥwty iw=i <r> sḥr iḫt nb<t> bin<t> ḏwt nty iy r hȝy<.t> r dw ms.n pt mi nḥm sw Rꜥ m-ꜥ ḫftyw=f mi nḥm sw Ḫnmw m-ꜥ Sbk mi nḥm sw Ḥr m-ꜥ Stḫ mi nḥm sw Ḏḥwty m-ꜥ Bȝbȝ mi [nḥm] sw Rꜥ ds=f m-ꜥ pȝ ifd [ḫrwyw][45] i.ir m Ḥwt-wrt ḥnꜥ pȝ ḫfty nty <ḥr> mḥtt Wnw*

> I am Thoth. I will remove everything bad and evil that comes to fall upon N born of N as Re saved himself from his enemies, as Khnum saved himself from Sobek, as Horus saved himself from Seth, as Thoth saved himself from Baba, as Re himself [saved] himself from the four [foes], who acted in Hut-weret, and (from) the enemy who is <to> the north of Wenu. [pTurin CGT 54050 recto, col. 2, ll. 9–11]

The list of mythical precedents concludes with invoking how the sun god was once victorious over four foes in a place called Hut-weret and another enemy to the north of Wenu. Hut-weret is a variant spelling, not attested before Nineteenth Dynasty, of the toponym Her-wer, which town was located to the north of Khemenu in the Hare Nome (15th Upper Egyptian nome).[46] Wenu is the earliest name of the capital of the Hare Nome, which is otherwise better known as Khemenu. Wenu and Khemenu must originally have been two separate, neighboring settlements that grew into a single urban agglomeration, because the two toponyms are used interchangeably.[47] Given the location and the number and configuration of adversaries (four plus one), there can be no doubt that the formula refers to the cosmic battle between the sun god and Apopis with his four associates, the *msw Bdšt*.[48]

A variant of the same formula is quoted in a prayer to the sun god that is embedded in the 'Ceremony of Repelling the Evil One', a loosely arranged series of invocations, prayers, and curses against Seth recited for the benefit of Osiris (Urk. VI 61–129).[49] The ceremony is preserved in two copies from Thebes dating to the

[43] D. Kessler, *Historische Topographie der Region zwischen Mallawi und Salamut*. TAVO 30 (Wiesbaden, 1981), 154 [Dok. 47]. Altenmüller, *Apotropaia*, 103. E. Jelínkova-Reymond, *Les inscriptions de la statue guérisseuse de Djed-her-le-Sauveur*, BdE 23 (Cairo, 1956), 43, n. 3; Gardiner, *AEO*, vol. II, 82*.

[44] The best preserved text witness is pTurin CGT 54050 recto. For transcription and translation, including variant witnesses, see A. Roccati, *Magica Taurinensia. Il grande papiro magico di Tornio e suoi duplicati* (Rome, 2011). Roccati calls the text 'Papiro magico di Thot'.

[45] Roccati restores the lacuna with ḫftyw, "enemies"; *Magica Taurinensia*, 23 (line 11) and 96 (line 38). Although this is perfectly reasonable, we restore ḫrwyw, "foes," on account of the later variants of the formula (see below).

[46] Kessler, *Historische Topographie*, 120–85, esp. 149–50; Gardiner, *AEO*, vol. II, 84*-87* (#379). Montet, *Géographie*, vol. II, 151–52, views Hut-weret and Her-wer as two distinct towns located in close proximity:.

[47] Kessler, *Historische Topographie*, 83. Gardiner, *AEO*, vol. II, 79*-82* (#377 and 377A). Montet, *Géographie*, vol. II, 146–48.

[48] Of the same opinion are Leitz, *Tagewählerei*, 99 and J-C. Goyon, *Les dieux-gardiens et la genèse des temples d'après les textes égyptiens de l'époque gréco-romaine*, BdE 93 (Cairo, 1985), 154.

[49] S. Schott, *Urk* VI.

late fourth and third century B.C.E., that is, more than 600 years younger than the above mentioned Turin formulary.[50] The prayer starts with a hymnic address to the sun god and ends with the request to set the ritualist free from any adversities. The request is a variant of the formula, here phrased as a second-person address and using the verb *wḥꜥ*, "to release," instead of *nḥm*, "to save, protect, deliver." In both text witnesses, the name of the location of the encounter between the sun god and the four foes is spelled conventionally as Her-wer instead of Hut-weret.

> *wḥꜥ=k wi mi wḥꜥ=k tw m-ꜥ pꜣ ifd ḫrwyw irw r=k m Ḥr-wr ḥnꜥ pꜣ ḫfty nty ḥr mḥtt n Wnw*

> May you release me as you released yourself from the four foes who acted against you in Her-wer and (from) the enemy who is to the north of Wenu. [Urk. VI, 99.13–17][51]

The third variant of the formula is embedded in an address to the sun god as part of an incantation to cure a patient from the effects of venom. It is inscribed on the healing statue of Djedhor, the Savior, from Athribis, which dates to the late fourth century B.C.E. (Cairo JdE 46341).[52] Unlike the previous two versions, this variant does not mention *pꜣ ḫfty*, "the enemy," as a second adversary. Instead, the sun god battles the four foes in both Wenu and Her-wer.

> *mi nḥm=k s pn nty ḫr dmt mi nḥm=k tw=k ds=k m-ꜥ pꜣ ifd ḫrwyw i.ir iy r=k ḥr mḥt n Wnw i.ir iy r=k m Ḥ<r>-wr*

> Come so you may save this man who is bitten as you saved yourself from the four[53] foes who came against you to the north of Wenu and who came against you in H<er>-wer.[54] [Statue Cairo JdE 46341, lines 83–84 (§8)]

These two apotropaic formulae, attested from the Ramessid to the Hellenistic Period, demonstrate that the MMA textual amulet follows an established tradition of invoking the defeat of the four *msw Bdšt* for apotropaic purposes. The MMA amulet is unique, however, in crediting their defeat to the "Entities of Khemenu."

To our knowledge, the "Entities of Khemenu" are not often called upon in incantations for healing and protection.[55] We know of two instances only. In the *London Medical Papyrus*, dating to the late Eighteenth Dynasty, they are invoked as "these eight gods" (*pꜣ ḥmn nṯrw*) for assistance in a conjuration of the *nsy* and *tmyt* diseases (Pap. BM EA 100059, incantation 60; XIV, 13).[56] Due to the incantation's obscure nature, it is unclear what their precise role is. They occur again in the *Harris Magical Papyrus*, which dates to the Nineteenth or Twentieth Dynasty, in a spell for protection against lions, crocodiles, and snakes (Pap. BM EA 10042, section I; rt. VI, 4–9).[57] The incantation invokes Amun as the sun god seated in his solar bark, and curses the crocodile Maga, son of Seth, for obstructing the solar bark's journey. The instructions to this incantation prescribe drawing an image of a four-headed Amun standing on a crocodile and flanked on his right and left side by the "Entities of Khemenu" (*Ḥmnyw*) in adoration. The manuscript does not include an actual drawing alongside the text, but the description suffices to identify it as a variant upon a common icon that is attested on Horus stelae, healing statues, and

[50] The two papyri are pBM 10252 (TM 57226; copied in 307/306 B.C.E. from an earlier copy of 365/364 B.C.E.) and pLouvre N 3129 (TM 56591; fourth-third c. B.C.E.).

[51] One of the text witnesses includes a line-by-line translation of the 'Ceremony of Repelling the Evil One' from Middle Egyptian into an early form of Demotic (pBM 10252). In the translation of the formula, the toponym Her-wer has been rendered as *tꜣ st snd*, "the place of fear" and Wenu as Khemenu: Urk. VI, 99.14–18.

[52] Jelínková-Reymond, *Les inscriptions de la statue guérisseuse de Djed-ḥer-le-Sauveur*, 39 and 43.

[53] According to Reymond's hieroglyphic transcription, the inscription has three instead of four strokes for the number. We follow her in emending this to four strokes and thus read *pꜣ ifd ḫrwyw*, "the four foes."

[54] The use of the absolute object pronoun *tw=k* and the past tense participle *i.ir iy*, which are linguistic features characteristic of Demotic, betray that the formula has been slightly redacted to conform to contemporary speech.

[55] Leitz, *LGG* V, 741c.

[56] C. Leitz, *Hieratic Papyri in the British Museum VII: Magical and Medical Papyri of the New Kingdom* (London, 1999), 81 and pl. 39. Incantation 60 = Wreszinski Incantation 25.

[57] Leitz, *Magical and Medical Papyri of the New Kingdom*, 39 and pl. 17.

hypocephali (which all postdate the *Harris Magical Papyrus* as well as the MMA textual amulet).[58] On these objects, Amun is depicted with four ram-heads, seated inside a sun disk in the posture of a child holding the royal crook and flail. The sun disk is lifted up by *ka*-arms from the canal hieroglyph (sign N36), which represents the *Nun* or primeval waters. Baboons stand on either side with their arms raised in adoration. This cosmographic icon is a schematic representation of sunrise understood as a renewal of nature.[59] The sun god rises as a reborn child from the primeval waters into the sky, thus reestablishing himself as the ruler of the created world while imbuing it with life and light. The four ram-heads symbolize his four *ba*'s or manifestations that constitute the cosmos.[60] The baboons attend the event as the quintessential sun-worshippers, celebrating and acclaiming with song and dance the sun god's power and majesty.[61] In several versions of this icon, eight baboons are depicted. Usually, they are anonymous or simply named "Who are in jubilation" (*imyw ḥtt*),[62] but in a few cases, these eight baboons are specifically identified as the "Entities of Khemenu" (in text, image, or both). This means that the instructions in the above-mentioned spell in the *Harris Magical Papyrus* must be understood as directing the practitioner to draw four baboons on either side of the four-headed Amun.

This identification of the "Entities of Khemenu" as the sun-worshipping baboons at sunrise adds a meaningful nuance to the present incantation. The "Entities of Khemenu" can fittingly be integrated as warriors into the mytheme of the combat between the sun god and the forces of disorder because they are believed to be present at the sun god's daily rising from the underworld into the sky at the eastern horizon at dawn. As sunrise is a recurrent event, the protection offered by the incantation must perhaps accordingly be understood as recurring and enduring. This interpretation may find support by the shift in the sun god's name. In the opening address to the "Entities of Khemenu," the sun god is simply called *Pȝ-Rꜥ* four times (lines 1–2). In the request clause, however, he is referred to more specifically as *Pȝ-Rꜥ-Ḥr-ȝḥty* (line 3). This form of the sun god is associated particularly with the early morning.[63] The scribe may well have made this shift quite deliberately. By referencing *Pȝ-Rꜥ-Ḥr-ȝḥty* in the request clause, it may have been his intention to ensure that the amulet's ritual power would be renewed every morning.

3. Drawing

Upon completing the text, the scribe added a drawing in the bottom center of the sheet. The drawing is only partly preserved due to the hole that cuts down through the middle of the lower half of the sheet. To the right of the hole, a crocodile can be seen, facing left. To the left of the hole, a downward curved stroke is all that remains.

Drawings are a common feature on extant textual amulets and often prescribed in recipes for preparing textual amulets. As is the case here, they often occur in combination with a written incantation. But this is not necessarily so: many textual amulets lack writing altogether and are inscribed with drawings only. In fact, the dataset that is currently available to reconstruct the development of textual amulets suggests that the practice started with inscribing linen strips exclusively with apotropaic imagery and that the inclusion of a written incantation was a secondary development.[64] This goes to show that drawings were not considered supplemental to a written incantation, but a discrete and equally effective strategy to endowing an amulet with protective power. It is for this very reason that, when a written incantation occurs in combination with one or more drawings, the drawings rarely relate directly to, as if to illustrate, the substance of the incantation.[65] They are efficacious in and of

[58] Zivie-Coche, "L'Ogdoade à Thèbes à l'époque ptolemaïque et ses antecedents," 173; H. Sternberg-el-Hotabi, "Die Götterdarstellungen der Metternichstele. Ein Neuansatz zu ihrer Interpretation als Elemente eines Kontinuitätsmodells," *GM* 97 (1987), 25–70, esp. 35–39.

[59] On the iconography of the solar journey, see Assmann, *Egyptian Solar Religion*, 38–66.

[60] Assmann, *Egyptian Solar Religion*, 189.

[61] J. Assmann, *Liturgische Lieder an den Sonnengott. Untersuchungen zur altägyptischen Hymnik*, MÄS 19 (Berlin, 1969), 207–14; idem, *Der König als Sonnenpriester; ein kosmographischer Begleittext zur kultischen Sonnenhymnik in thebanischen Tempeln und Gräbern*, ADAIK 7 (Glückstadt, 1970), 48–53. I. Bohms, *Säugetiere in der altägyptischen Literatur*, Ägyptologie 2 (Berlin, 2013), 25–27.

[62] Leitz, *LGG* I, 272c

[63] J. Assmann, "Harachte," *LdÄ* II, 956–61.

[64] Dieleman, "Materiality of Textual Amulets," 41.

[65] Therefore, to avoid misrepresenting their function, it is preferable not to call them 'vignettes'.

themselves. It is therefore not odd to find here a crocodile drawn beneath an incantation that does not mention any crocodiles. Contrary to what one might perhaps expect, the drawing did not most likely depict the combat between the "Entities of Khemenu" and the "Children of the Weak One."

The drawing can be reconstructed with a fair degree of certainty thanks to parallels. There are four textual amulets extant, all from Deir el-Medina and dating to the Ramessid Period, that include a drawing featuring two or more crocodiles.[66] In each case, the crocodiles are arranged symmetrically around a figure in the middle, which they face and touch with their snout as if attacking and biting it from all sides. In the case of Papyrus Deir el-Medina 45, the centered, human-shaped figure is drawn in red ink and thus marked as representing a dangerous and chaotic force such as a demon or personified disease.[67] This is also the case on Papyrus Louvre E 32308.[68] On a linen strip from Deir el-Medina, the middle figure can be identified as a seated, highly schematic Seth animal, an alternative way of marking the figure as personifying violence and disorder.[69] On the linen strip that served as a necklace to a textual amulet inscribed for a certain Anynakht, the crocodiles' prey consists of two human-shaped stick figures, which, with their contorted bodies and arms thrown in the air, appear to succumb to the ferocious attack.[70] In each case, the centered figure carries clear negative connotations. It functions as a symbolic representation of the affliction or threat that the amulet is supposed to overcome. The crocodiles contain the danger by surrounding the figure and neutralize its maleficent effects by biting its body. The lethal aggression of the crocodiles is thus mobilized against the perceived threat or cause of misfortune.

The number of attacking crocodiles varies. On Papyrus Deir el-Medina 45, there are six crocodiles to the figure's left and six or seven to its right.[71] On Papyrus Louvre E 32308, there are fourteen crocodiles in total: three at the figure's head, one at its feet, five to its left, and another five to its right.[72] In three other cases, the number of crocodiles has been reduced to two. On the linen strip inscribed for Anynakht, the two stick men in the middle are enclosed by a crocodile on the left and the right. Similarly, on the other linen strip, the Seth animal is attacked by a crocodile from either side. The same configuration is used in a drawing prescribed in a recipe for making a textual amulet against the *rmnt* disease (Papyrus Chester Beatty VII vso II; Deir el-Medina, Ramessid Period).[73] Due to holes in the papyrus, the figure in the center is difficult to identify. Whatever its precise identity, it is also being attacked by a crocodile from both sides.

These last three parallels warrant the conclusion that the drawing on the MMA textual amulet consisted likewise of two symmetrically arranged crocodiles attacking an enemy figure in between. The downward curved stroke to the left of the hole is thus the tip of the tail of the left crocodile. No trace remains of the enemy figure. It is therefore impossible to say whether it was drawn in red ink, as is the case on the two above-mentioned parallels, or what its nature was. There does not seem to have been enough space available between the crocodiles for four figures representing the four enemies mentioned in the incantation. It is likelier that the scribe drew a single figure that is unrelated to the incantation's content. Due to the hole, its precise nature must remain unknown.

[66] On the amuletic power of crocodiles, see A. Gasse, "Crocodiles et revenants," in L. Gabolde, ed., *Hommages à Jean-Claude Goyon offerts pour son 70ᵉ anniversaire*, BdE 143 (Cairo, 2008), 197–204.

[67] Y. Koenig, "Histoires sans paroles (P. Deir el-Medîna 45, 46, 47)," *BIFAO* 111 (2011), 243–55; esp. 243–46 and fig. 1. On the properties of the color red in magical texts, see G. Pinch, "Red Things: the Symbolism of Colour in Magic," in: W. Davies, ed., *Colour and Painting in Ancient Egypt* (London, 2001), 182–85, esp. 84.

[68] Y. Koenig, "Le papyrus de Moutemheb," *BIFAO* 104 (2004), 291–326. See also M. Étienne, *Heka. Magie et envoûtement dans l'Égypte ancienne* (Paris, 2000) 59 (= Cat. no. 159).

[69] B. Bruyère, *Rapports sur les fouilles de Deir el-Médineh (années 1948 à 1951)*. FIFAO 26 (Cairo, 1953), 72, fig. 17.2. Dieleman, "Materiality of Textual Amulets," 38.

[70] S. Sauneron, "Le rhyme d'Anynakhté," *Kêmi* 20 (1970), 7–18, 7. For a picture of the linen strip with its drawings, see Bruyère, *Rapports sur les fouilles de Deir el-Médineh (années 1948 à 1951)*, 72, fig. 17.1; Dieleman, "Materiality of Textual Amulets," 28.

[71] Koenig, "Histoires sans paroles," 243. Due to holes in the papyrus, it is difficult to determine the exact number of crocodiles depicted. A. Gasse counts fifteen crocodiles, but that number is certainly too high; "Crocodiles et revenants," 201.

[72] Koenig, "Le papyrus de Moutemheb."

[73] A. Gardiner, *Hieratic Papyri in the British Museum. Third Series. Chester Beatty Gift*, vol. II, pl. 32A. The drawing is also discussed and reproduced in P. Eschweiler, *Bildzauber im Alten Ägypten. Die Verwendung von Bildern und Gegenständen in magischen Handlungen nach den Texten des Mittleren und Neuen Reiches*. OBO 137 (Freiburg-Göttingen, 1994), 38ff.; cf. the book review by M. Raven in *BiOr* 53 (1995), 695.

4. Concluding Remarks

Papyrus MMA 26.3.225 is in its manufacture, dimensions, page layout, and inscription a typical example of a textual amulet dating to the Ramessid Period. It is clear that the scribe did not improvise, but followed a well-established procedure in making the textual amulet. The artifact is nonetheless a noteworthy addition to the small corpus for two reasons.[74] First, it has a secure provenance. It was found in the reused Theban Tomb 313 (PM I.1 388–89), which is situated in the northern cliffside of Deir el-Bahari. This find location suggests that the person who wore the amulet in life was buried with the amulet, undoubtedly in the conviction that it would continue to protect its owner against harm in death. More importantly, the find location demonstrates that the creation and use of textual amulets were not restricted to Deir el-Medina in the Ramessid Period. Heretofore, all textual amulets dating to the Ramessid Period that have a secure provenance, came from Deir el-Medina. Whether scribes followed the same procedure in fabricating textual amulets outside the Theban area cannot be said, because no textual amulets of Ramessid date can be assigned so far to regions outside Thebes.

The artifact is also important for preserving a heretofore unknown variant episode of the myth of the sun god's battle against the forces of disorder. The incantation credits the "Entities of Khemenu," better known today as Ogdoad, with defeating the four "Children of the Weak One" for the sun god. Whereas the conflict between the sun god and the "Children of the Weak One" is referenced in other contemporary and later sources, no other source mentions the Ogdoad's role in the sun god's victory.

Whoever manufactured the amulet, he worked with knowledge that was locally available. The closest parallels to the mythical precedent invoked in the incantation are found in more or less contemporary manuscripts from Thebes: Book of Gates from the Valley of the Kings, a Book of the Dead manuscript from the Deir el-Bahari cache (TT 320), and magic formularies from Deir el-Medina. The drawing below the incantation follows a scheme found in contemporary magic manuals and textual amulets from Deir el-Medina: crocodiles surrounding and attacking an enemy figurine. In other words, the textual amulet is very much a product of the Theban region.

UCLA
Leipzig University

[74] The 'Appendix: corpus of Egyptian textual amulets made of papyrus' in Dieleman, "Materiality of Textual Amulets," 49–52, lists twelve items for the Ramessid Period. Since its publication, the list has grown to twenty-four items, including the current MMA textual amulet.

Processional and Chapel Oracular Practice
in The Place of Truth

Silvia Štubňová

Abstract

Standing in stark contrast to the relative wealth of evidence about royal and temple-based oracles, there is little to give us some notion of the analogous oracular practices of private religion during the New Kingdom of Egypt. The surviving documentation suggests that private individuals could approach their gods for oracular advice during festival processions. However, based on the Deir el-Medina materials, I argue that in addition to processional oracles, chapel oracles were employed by the villagers as well, if not more largely by common people in ancient Egypt. At Deir el-Medina, the former was given by the patron of the village, the deified king Amenhotep I, and was employed in an official setting in order to solve legal disputes. In contrast, the less documented chapel oracles, which could be perhaps delivered by deities other than Amenhotep I, concerned mostly mundane affairs. In both cases, however, oracles were mediated by the priests servicing the gods. This paper seeks to bring together and examine two sorts of evidence that are usually dealt with separately. Firstly, it provides an analysis of the available written testimonies on oracular ostraca found at Deir el-Medina, and discusses their textual significance by showing who the petitioners were, what kind of questions they asked and what the structure of the questions was. Secondly, it examines the archaeological remains of the chapels connected with oracles at Deir el-Medina and the role of the "brotherhood" of priests associated with them. I conclude with some remarks about the mechanics of the chapel oracles in connection with the modalities of their reception and the status of belief and faith.

Introduction[1]

In ancient Egypt, religion was an inseparable part of people's lives, of their world-view and of their traditions. The New Kingdom *Instruction of Any* says thusly:

> "Offer to your god,
> Beware of offending him.
> Do not question his images,
> Do not accost him when he appears.
> Do not jostle him in order to carry him,
> Do not disturb the oracles.
> Be careful, help to protect him,
> Let your eye watch out for his wrath."[2]

[1] I would like to express my deep gratitude to Dr. Anne-Claire Salmas and Dr. Cédric Gobeil for their invaluable help and support, and for their useful comments on the first draft of this paper, as well as to Dr. James Allen for his assistance with the translation of some difficult passages. All translations are my own unless indicated otherwise.

[2] Translation by M. Lichtheim, *Ancient Egyptian Literature II. The New Kingdom: A Book of Readings* (Berkeley, 1976), 141.

Journal of the American Research Center in Egypt 53 (2017), 259–281
doi: http://dx.doi.org/10.5913/jarce.53.2017.a013

In this extract, ancient Egyptian religion is addressed in its two different aspects: the "official" one and the "practical" one.[3] The former was usually held within the concealment of temples and focused on "royal-divine relations," whereas the latter refers to all "religious action(s) in an everyday context."[4]

Among the religious practices that could be included in the scope of "practical religion" are oracles, even though such a practice is also attested in a more official setting within the frame of temples and "national" festivals. Oracles are part of the practice of divination through which people can communicate directly, at least to some extent, with deities. An individual initiates a contact with a god, seeking help or advice. Subsequently, the god responds to the supplicant, indicating his will through various means. According to Herodotus, who was fascinated by the widespread popularity of oracles in Egypt, the ancient Egyptians seem to have been rather fond of this divinatory practice, which, however, differed from place to place: "As to the art of divination among them (= the Egyptians), it belongs to no man, but to some of the gods; there are in their country oracles of Heracles, Apollo, Athena, Artemis, Ares, and Zeus, and of Leto (the most honored of all) in the town of Buto. Nevertheless, they have several ways of divination, not just one."[5] However, it is not possible to establish to what extent their divinatory practices remained stable and homogenous throughout the history of ancient Egypt, mainly due to insufficient evidence from earlier periods.

Indeed, when considering the available documentation on the topic, only very few indications suggest that oracles might have been taking place on some occasions prior to the New Kingdom.[6] According to Baines, this lack of tangible proof can be explained by the contingencies of preservation and rules of decorum.[7] There is no reason to assume that oracles are the invention of the New Kingdom. Indeed, there is some indirect evidence for the consultation of oracles already in the Old Kingdom.[8] Nevertheless, during the New Kingdom the practice is better documented, especially thanks to a unique and coherent set of materials documenting the community's oracular practice coming from the site of Deir el-Medina. This site, which was part of the area known in the ancient times as *st Mȝꜥt* 'Place of Truth', was a settlement established in order to house the workmen who built and decorated the royal tombs in the Valley of the Kings and the Valley of the Queens during Dynasties Eighteen-Twenty.

The previous research on the oracles at Deir el-Medina is not very extensive, as the specifics of oracular mechanics in ancient Egypt are still poorly understood. The majority of the scholarly work on the Deir el-Medina oracles was done by Černý. While investigating the cult of Amenhotep I at Deir el-Medina,[9] he collected, transcribed and translated most of the ostraca, i.e., small pieces of limestone or pottery used as writing surfaces, containing oracular inscriptions.[10] However, his research is now over half a century old and since then the topic has been addressed only by a few scholars. McDowell in her publication *Jurisdiction in the Workmen's Community of Deir el-Medina* devoted one chapter to the oracles.[11] She focused mostly on the lengthier records of the oracular events and their judicial aspect. Also, several pages in her book *Village Life in Ancient Egypt: laundry lists and love songs* contain her translations of and commentary on a few ostraca with oracles.[12] Some of the oracular material from the village has also been described by Valbelle and Husson[13] in their discussion of the development of ancient Egyptian oracles. Moreover, Sweeney has written an article about the connection between gender and oracles at

[3] The term "practical religion" was coined by J. Baines, "Practical Religion and Piety," *JEA* 73 (1987), 79–98.

[4] Baines, "Practical Religion and Piety," 79.

[5] Herodotus II, 83.

[6] Baines, "Practical Religion and Piety," 89–90.

[7] Baines, "Practical Religion and Piety," 89.

[8] Specifically an inscription in Sinai from the reign of Djedkare Izezy (Dynasty Five). See J. Baines and R. Parkinson, "An Old Kingdom Record of an Oracle? Sinai Inscription 13," in J. van Dijk, ed., *Essays on Ancient Egypt in Honour of Herman te Velde* (Groningen, 1997), 9–27.

[9] J. Černý, "Le culte d'Amenophis Iᵉʳ chez les ouvriers de la nécropole Thébaine," *BIFAO* 27 (1927), 159–203.

[10] J. Černý, "Questions adressées aux oracles," *BIFAO* 35 (1935), 41–58; idem, "Nouvelle série de questions adressées aux oracles," *BIFAO* 41 (1942), 13–24; idem, "Troisième série de questions adressées aux oracles," *BIFAO* 72 (1972), 49–69.

[11] A. McDowell, *Jurisdiction in the Workmen's Community of Deir el-Medina* (Leiden, 1987), 182–240.

[12] A. McDowell, *Village Life in Ancient Egypt: Laundry Lists and Love Songs* (New York, 1999), 92, 107–10, 172–74, 177–83, 238.

[13] D. Valbelle and G. Husson, "Les questions oraculaires d'Égypte: histoire de la recherche, nouveautés et perspectives," in W. Clarysse, A. Schoors, and H. Willems, eds., *Egyptian Religion: The Last Thousand Years. Studies Dedicated to the Memory of Jan Quaegebeur.* Vol. 2 (Leuven, 1998), 1055–71.

Deir el-Medina.[14] As for the archaeological evidence for oracular ceremonies, some issues have been raised by Bomann in her discussion of private chapels at Deir el-Medina.[15]

As is evident from this short survey of previous research, only parts of the evidence for oracles at Deir el-Medina have been examined thoroughly. Therefore, the goal of this paper is to gather and analyze the polymorphic evidence pertaining to the oracles in this village. This will include the analysis of oracular texts, the study of the remains of the structures connected with oracular events, and a consideration of the issue of faith in delivering oracles. It is difficult to say to what extent Deir el-Medina oracles represent a homogenous Egyptian religious activity (as opposed to a unique local practice). Certainly, oracular practices underwent developments throughout different time periods, and synchronically, local variations and adaptations presumably existed as well. The fact remains that oracles in Egypt are well, and better, documented in the Late Period and the Graeco-Roman times. While comparisons will occasionally be made between oracular materials from Deir el-Medina and oracles as evidenced at other sites or in later periods, this is not to suggest that the oracular practices of ancient Egyptians remained the same in all places in all time periods. I hope that this paper will provide a more precise picture of the mechanisms of oracles in Ramesside Egypt and illustrate how they might have been perceived by their participants.

The Oracular Corpus

The corpus of ostraca with oracles to be examined has been chosen based on their classification in *The Deir el-Medina Database*.[16] In total, 173 documents in the database have been identified as oracular with varying degrees of certainty. Being the most informative texts, 129 have been chosen out of these for this research based on their good state of preservation and reliable connection to oracles. However, the other texts will sometimes be considered and mentioned as well. A list of all 173 oracular texts from Deir el-Medina is provided in the Catalogue below together with their transliteration and translation, or the most recent publications in the case of the longer texts.

The main evidence for the oracular practice at Deir el-Medina consists of 129 inscriptions with a mostly certain oracular content. The texts are written in hieratic, a cursive form of the hieroglyphic script, and in the Late Egyptian stage of the language. This group comprises 122 ostraca inscribed with either a short statement or a question (Cat. 1–122), as well as seven reports describing an oracular event in more detail and providing a background to it (Cat. 136–142). All of these texts are preserved on ostraca. In contrast, after the New Kingdom, only one demotic oracular text on an ostracon has survived, but many more are attested on papyrus.[17] In fact, papyrus was exclusively employed for oracles in the Greek Period.[18] Thus, one might wonder whether the use of ostraca in oracles was specific to Deir el-Medina due to the site's geological environment.

Moreover, several other texts from Deir el-Medina could be added to this list of evidence, even though they are not records of oracles *per se* or are not firmly linked with an oracular practice. Firstly, these include documents that are rather records of legal proceedings and letters mentioning oracles, as well as documents tentatively identified as oracles, but whose content is too fragmentary to ascertain so (Cat. 143–158). Despite their different nature, some of these documents will be used in the following discussion to illustrate certain points. Secondly, there are thirteen ostraca from Deir el-Medina that contain only the phrase "house of X" (Cat. 123–135). There is some evidence that these might have been used in the oracular ceremony and will be considered below together with a bundle of reeds containing similar inscriptions. Thirdly, a few ostraca preserve only one word or a noun phrase, such as the names of kings, deities and temples (Cat. 159–173), and their association with oracles

[14] D. Sweeney, "Gender and Oracular Practice at Deir el-Medina," *ŻÄS* 135 (2008), 154–64.

[15] A. Bomann, *The Private Chapel in Ancient Egypt: A Study of the Chapels in the Workmen's Village at El Amarna with Special Reference to Deir el-Medina and Other Sites* (New York, 1991), 69, 71–76.

[16] See http://www.wepwawet.nl/dmd/.

[17] Černý, "Egyptian oracles," 47.

[18] Valbelle and Husson, "Les questions oraculaires d'Égypte," 1068.

is disputable. However, the nature and possible use of the ostraca containing a single interjection ("No!") will be addressed in the following paragraphs (Cat. 159–163).

Dates and Findspots

In most cases it is impossible to assign precise dates to the majority of the ostraca linked directly or indirectly to oracular practices. We can only attribute them very broadly to Dynasties Nineteen and Twenty based on their paleographic features or references to particular known individuals. In contrast, the seven longer reports contain dates and thus can be placed within a specific year of the king's reign, mostly those of Ramesses III and Ramesses IV.[19]

As far as the findspots are concerned, most of the ostraca come from the "Great Pit" located north-east of the Ptolemaic temple. Originally serving as a well that quickly ran out of water, according to a recent hypothesis,[20] the "Great Pit" was filled with trash that included a great number of textual materials.[21] Furthermore, a small collection of ostraca, together with other hieratic documents, was found in the house of Prahotep at the southern end of the village (Cat. 2–3, 8–9, 59, 61–66). Almost all of these bear interesting markings on their verso and will be discussed below. Other ostraca come from disturbed contexts, such as rubbish heaps located to the south of the village (Cat. 37–38, 124–126.), east of the chapels designated as C.V. 1213 and C.V. 1219 (Cat. 28, 48, 104), and the necropolis (Cat. 41, 51). In addition, a few ostraca were discovered in the Valley of the Kings.[22] Several oracular texts were acquired through purchase in Luxor or at an auction, and thus their provenance remains unknown (Cat. 1, 4, 36, 121, 141, 145, 158). For the rest of the documents, the exact findspots were, unfortunately, not recorded; all that can be said is that they originally came from Deir el-Medina.

Oracular Questions

Topics

The themes expressed in the 122 short oracular questions and statements are diverse. However, approximately one third of the corpus (30 percent) concerns the issue of the ownership of various animals and building structures, as well as the issue of business dealings. An example of this question is: "Has the goat been given to the water-carrier Penpahapy?" (Cat. 92). Around 23 percent of the texts deal with theft in the village, reporting missing objects, or placing blame on someone, such as: "Is it he who stole this mat?" (Cat. 44). The next category, with 16 percent of the texts, includes matters linked to the work in the sacred domain of the Tomb, such as job allocation, writing to the vizier or distributing rations: "My good lord, l.p.h., will the rations be given to us?" (Cat. 47). More personal matters amount to 11 percent of the themes, including questions about dreams, illnesses or resolutions to do something, as is illustrated by the question: "Will the bladder appease her illness?" (Cat. 18). The rest of the ostraca (20 percent) contain questions whose context is hard to assess; for example, someone simply asked: "Are the things true?" (Cat. 40).

The content of the seven oracular reports focuses on the notion of ownership in diverse ways. Indeed, these documents concern a dispute over a rebuilt chapel (Cat. 137), over a hut (Cat. 142), or a theft of clothes (Cat. 136). In this respect, the topics are quite similar to those found in the most representative category of the shorter oracular statements.

[19] See *The Deir el-Medina Database*, http://www.wepwawet.nl/dmd/.

[20] See D. Driaux, "Le Grand Puits de Deir al-Medina et le question de l'eau: nouvelles perspectives," *BIFAO* 111 (2011), 129–42.

[21] See B. Bruyère, *Rapport sur les fouilles de Deir el Médineh (années 1948 à 1951)* (Cairo, 1953), 17–70.

[22] Cat. 138 came either from KV 6 (Ramesses IX) or KV 9 (Ramesses V and Ramesses VI); Cat. 148 from KV 37 (unknown); Cat. 6–7 from an unknown tomb. In fact, Dorn suggests that the niche above KV 37 marked a procession endpoint of Deir el-Medina festivals and that oracles presumably took place in the Valley of the Kings as well. See A. Dorn, *Arbeiterhütten im Tal der Könige.* Vol. 1 (Basel, 2011), 184.

Structure of the Oracular Documents

The seven reports are the most elaborate among all oracular documents from Deir el-Medina. Beginning with a date, they describe in length the addressed matter, give the names of witnesses and sometimes end with an oath taken by the guilty person. In addition, the tone of the reports in these oracular texts is rather impersonal; it simply narrates the event, referring to the involved parties in the third person.

A comparison can be made between these oracular reports and other legal documents that also mention oracles: in each case, the topic, the formulation as well as the structure are quite similar. Both of these textual categories were drawn up by a scribe,[23] surely in order to keep a record of the resolved matter for a future reference, either in a personal archive or the village archives. It thus seems likely that the kind of oracles written down in the oracular reports took place in order to solve legal disputes that could not be solved by the *knbt*, the local court.[24] If the *knbt* could not deal with some matters due to the lack of evidence or witnesses, for instance, such cases would be then brought in front of the god and the petitioner would have to rely on the judgment of the deity.

Apart from the seven longer reports, the 122 oracular questions were written down either in the form of a question marked by an interrogative particle at the beginning of a sentence or in the form of a statement. However, it is possible that the interrogative aspect of the latter was simply implied, based on the very context in which they were used, i.e., asking a deity for help. Thus, they would represent questions by intonation, which did not need to be marked in writing. In general, the questions were simple, requiring only a yes or no answer. However, in a few cases the god's reply would have needed to be longer. An example is the following question: "Where is this papyrus roll?" (Cat. 23).[25] The possible way(s) of answering such questions will be discussed below.

Lastly, it should be noted that the structure of Deir el-Medina's oracles seem to vary in style from those of later periods, which are also better documented.[26] Černý observed that the layout of the later oracular texts is generally composed on the same pattern that consists of three main parts: "an invocation of the local god sometimes followed by the self-introduction of the petitioner, exposition of the matter and request for an answer."[27] In contrast, only few Deir el-Medina oracular ostraca contain the introductory invocation "My good lord!" whereas one example ends with a demand, namely the imperative "Command the truth!" (Cat. 7).

Oracular Practices

Petitioners

The questions and statements posed to the oracle at Deir el-Medina mostly reflect the internal affairs of the villagers as well as personal concerns and problems (see above). When mentioned in the oracular texts, the petitioners were the inhabitants themselves. It is usually and rightfully assumed that every villager, regardless of their status, could approach the god, even women. Cat. 145 contains an appeal to a deity by a woman, since the text mentions "my husband." Women were also included in supplicants' oracular queries, as is illustrated by the oracular statement that refers to a man having made an exchange with a woman named Isis (Cat. 37).

The Consulted Deity/Deities

When mentioned, the oracular deity in Deir el-Medina's documents is always the deified king Amenhotep I. Several different manifestations of this god are known from the Theban area, such as Amenhotep of the Village, Amenhotep of the Garden, Amenhotep of the Forecourt, Amenhotep who Navigates on Waters, Amenhotep

[23] E.g., Cat. 148 and 150.

[24] See McDowell, *Jurisdiction*, 241–315.

[25] Similarly Cat. 22 and 112.

[26] Černý, "Egyptian oracles," 47.

[27] Černý, "Egyptian oracles," 47.

the Favorite of Amun, and Amenhotep of Pakhenty.[28] Amenhotep of the Village was probably the form of the god venerated at Deir el-Medina, based on the fact that the settlement was called *pꜣ dmj* "the village" and that Amenhotep I bore the epithet "lord of the village" in many textual sources recovered from the site.[29] The cult of Amenhotep I was probably established sometime in the reign of Amenhotep III,[30] having become very popular and important among the workmen.[31] It is thought, albeit without any tangible evidence, that Amenhotep I was the first king to have been buried in the Valley of the Kings and the one who had established the workmen's village.[32] In addition, it has been suggested that the cult of Amenhotep I might have originated at a site around Thebes and was transferred to Deir el-Medina by the workmen once the village had been founded.[33] Whichever the case, it is indisputable that the deified Amenhotep I enjoyed great popularity among the Deir el-Medina inhabitants in the Ramesside Period and came to be regarded as patron of the village. Together with his mother Ahmose-Nefertari, the "lady of the village,"[34] he was worshiped in the villagers' houses and appears on various pious monuments, such as tomb walls, votive stelae, lintels, offering tables, and others.[35]

Several cults of other deities, both Egyptian and foreign, were also established in the settlement, having been favored by the workmen as well. Among the most popular deities were Hathor, Amun, Ptah, and Meretseger.[36] Together with Amenhotep I and Ahmose-Nefertari, all these gods had their own places of worship at or around Deir el-Medina.[37] Other deities whose cults are documented in the community are Osiris, Renenutet, Meresger, Anukis, Satis, Khnum and the Asiatic gods Qedesh, Reshef, and Anat.[38]

Even though Amenhotep I is the only deity mentioned so far in the oracular documents, he is only referred to in seven texts out of the examined corpus. The rest of the texts say nothing about the god delivering the oracle. Could other gods than Amenhotep I have been approached during oracles at Deir el-Medina? I believe so, especially when considering both written and archaeological evidence. For instance, one fragmentary document (Cat. 148) refers to Ahmose-Nefertari and uses a vocabulary associated with oracles including such words and phrases as "to agree," "those under the god" and a list of priests (see below). In addition, the deified Ahmose-Nefertari is mentioned in a letter (P. DeM 6)[39] as the goddess consulted during an oracle. Thus, it is not surprising to see Ahmose-Nefertari, as the mother of Amenhotep I, giving oracles in the village as well. Sweeney has suggested that the oracles of Ahmose-Nefertari might have been reserved only for women,[40] but as she notes this claim is not supported by any evidence.[41]

During the New Kingdom, the most important oracular god at Thebes was Amun, although Mut, Khonsu and Montu were consulted as well.[42] Among other gods that were approached for oracles were, for example, Isis

[28] Černý, "Egyptian oracles," 41; Černý, "Le culte d'Aménophis Iᵉʳ," 162–3.

[29] Černý, "Le culte d'Aménophis Iᵉʳ," 169–170.

[30] G. Andreu, "Le culte posthume de deux souverains divinisés: la reine Ahmès Néfertari et son fils Aménophis Iᵉʳ," in G. Andreu, ed., *Les artistes de Pharaon: Deir el-Médineh et la Vallée des Rois* (Paris, 2002), 252.

[31] See Černý, "Le culte d'Aménophis Iᵉʳ," 159–203.

[32] E.g., Černý, "Egyptian oracles," 41; McDowell, *Village Life,* 92; F. Friedman, "Aspects of Domestic Life and Religion," in L. Lesko, ed., *Pharaoh's Workers: the Villagers of Deir el-Medina* (Ithaca, 1994), 95.

[33] R. Ventura, "Snefru in Sinai and Amenophis I at Deir el-Medina," in S. Groll, ed., *Pharaonic Egypt: The Bible and Christianity* (Jerusalem, 1985), 283–84.

[34] D. Valbelle, *"Les ouvriers de la tombe": Deir el-Médineh à l'époque ramesside* (Cairo, 1985), 314.

[35] Friedman, "Aspects of Domestic Life and Religion," 111.

[36] H. Jauhiainen, "Religious Buildings at Deir el Medina," in R. Preys, ed., *7. Ägyptologische Tempeltagung: Structuring Religion. Leuven, 28. September–1. Oktober 2005* (Wiesbaden, 2009), 160.

[37] A. Sadek, *Popular Religion in Egypt during the New Kingdom* (Hildesheim, 1987), 83–84.

[38] Bomann, *The Private Chapel in Ancient Egypt*, 73; McDowell, *Village Life,* 92.

[39] J. Černý, *Papyrus hiératiques de Deir el-Médineh* I (Cairo, 1978), 19, pls. 20 and 22a.

[40] Sweeney, "Gender and Oracular Practice," 160 and n. 78.

[41] A contrary piece of evidence to this suggestion could be perhaps Cat. 149. Firstly, the text preserved on this ostracon is addressed to the "divine wife of Amun." Secondly, if we suppose that the masculine first person suffix pronoun in hieratic was properly differentiated by the author from its feminine counterpart, then the composer of the text was a male. This would suggest that female deities, at least in the Theban area, could be approached by males as well. Surely, the motivations behind a person's choice of an oracular deity were more complex and did not solely rest on gender. For the hieratic and hieroglyphic text and translation, see P. Grandet, *Catalogue des ostraca hiératiques non littéraires de Deîr el-Médînéh, Tome IX – Nos 831-1000* (Cairo, 2003), 148–49 and 437.

[42] Černý, "Egyptian oracles," 40.

at Coptos, Ptah at Memphis, Seth at the Dakhla oasis, or Khnum at Elephantine.[43] Thus, it appears that most places of worship had a chief god for giving oracles, although other minor gods could have been appealed to as well. Therefore, Amenhotep I might have been addressed as the chief oracular god at Deir el-Medina, especially in order to resolve disputes whose proceedings needed to be written down for a future reference and needed to take place in the presence of witnesses. Turning to the patron of the village for advice would be natural, since he was supposed to watch over the community and understand the problems and disputes of its inhabitants. However, there is no reason to suppose that one could not have appealed to other (minor) gods as well, especially for advice involving small personal matters that did not require a written record.

Oracular Procedures as Suggested by the Textual Corpus

Of the whole corpus, the most informative documents are the seven ostraca (Cat. 136–142) that contain longer records of an oracular event and begin with a date. We learn from these reports that the supplicant either ꜥš 'calls' or *smj* 'reports' to the god Amenhotep I. The god then either *hn* 'moves forward' or *nꜥy n ḥꜣ=f* 'moves backwards', referring to the movement of the litter with the god's statue carried by priests during festival processions (see below). The forward movement expressed consent, whereas the backward movement showed the god's dissent.[44] In some cases, according to the text, the god also declares his will orally. For instance, in one example Amenhotep I says: "Give the chapel back to Kenna, its owner!" (Cat. 137). Such a process implies that the god was asked to choose between several possible answers that were most likely presented to him in writings, rather than actually uttering his verdict.[45] This is evidenced, for instance, by a Ramesside document that refers to *nꜣ mḏꜣwt* 'the documents' that were placed before the god so that he would state his decision by choosing one of them (P. Turin Cat. 1975). Another way to decide a matter, such as to identify a thief, was to read out a list of houses in the village by a scorpion charmer (Cat. 136). The god agreed when the house of the scribe Amennakht was read out, as the stolen items were with the scribe's daughter. I will come back to this practice in the next section.

In each of the seven cases, the oracles occurred in front of several witnesses, who are listed at the end of the records.[46] The witnesses consisted, first and foremost, of the most prominent members of the community, the so-called "Captains of the Tomb," i.e., the scribe(s) and the foremen.[47] Other inhabitants of the village could also partake in the process, as well as village outsiders such as doorkeepers and police members. Thus, the seven longer reports provide a few insights into the procedure of oracular consultations.

However, the rest of the texts used in oracles at Deir el-Medina are not very eloquent about the concrete procedure of how a request was presented to the deity and of how the latter might have responded to it. In this case, looking at evidence from slightly later periods and from other Egyptian sites may prove helpful, even though these examples do not represent rigid evidence for parallel practices at Deir el-Medina. In later times, it seems to have been common to write down two antithetical interrogative or assertoric sentences, an affirmative and a negative one, one of which would be chosen by the god. An example of this practice comes from late Dynasty Twenty or early Dynasty Twenty-One at El-Hiba, where two antithetical statements were drawn on two pieces of papyrus and were presented to the god Horus-of-the-Camp.[48] The two pieces come from a single papyrus sheet that was cut in half. One piece contains the following petition: "Horus-of-the-Camp, my good lord! Concerning this cow of which Teuhrai said: 'Karsasi son of Hartenu gave it to Pameshem in return for its price, and Pameshem paid him the first installment of its price, and (he) withheld the remainder.' You say: 'Pameshem is right! He completed the payment of the price for his cow of Karsasi to him.'"[49] The second petition includes

[43] L. Kákosy, "Orakel," *LdÄ 4*, 602–3. See also J.-M. Kruchten, "Oracles," in D. Redford, ed., *The Oxford Encyclopedia of Ancient Egypt*. Vol. 2 (New York, 2001), 609–12.

[44] See Černý, "Une expression désignant la réponse négative d'un oracle," *BIFAO* 30 (1931), 491–96.

[45] It cannot be ruled out that some questions might have been presented to the god orally.

[46] Except for Cat. 138 and Cat. 141 which is damaged.

[47] See McDowell, *Jurisdiction*, 266–77.

[48] K. Ryholt, "A Pair of Oracle Petitions Addressed to Horus-of-the-Camp," *JEA* 79 (1993), 189–90.

[49] Translations by Ryholt, "A Pair of Oracle Petitions," 193.

almost the same wording of the description of the matter, followed by the opposite statement: "You say: 'Karsasi is right! Pameshem did not pay him the (full) price in return for his cow.'" Two antithetical statements are also evidenced from Greaco-Roman Egypt in the form of "ticket oracles," as well as from the Christian era.[50]

Such a practice of antithetical questions might have been in use at Deir el-Medina as well, but it is not well documented. In fact, there is only one piece of evidence (Cat. 144). The text refers to the petitioner who "made two writings, and he placed them before the god himself. And the writing <i.e., the one chosen by the god> was put in the hand of the scribe Wennefer."[51] Furthermore, Cat. 58 and Cat. 75, which bear the questions "Should I burn it?" and "Should I not burn it?" respectively, are often cited as another example supporting such an oracular practice at Deir el-Medina. However, the two ostraca are written by different hands; and so unless one considers that two different people each wrote down a part of the same request, it is unlikely that they represent an antithetical pair of questions presented to the god at the same time. Rather, they might be two independent questions that share a similar concern, which is not uncommon among the Deir el-Medina oracular queries. In fact, no such pairs have yet been found among the Deir el-Medina ostraca, and Cat. 144 remains so far the only text that points to such a practice, which is indeed insufficient to make any firm conclusions. The lack of antithetical pairs at Deir el-Medina could, perhaps, be explained by the fact that only one part of the pair was kept, whereas the other statement was discarded or its surface re-used, but this is only a conjecture.

Also, at least one of the ostraca (Cat. 32)[52] from Deir el-Medina preserves records of two different oracular events. The recto of this ostracon concerns the ownership of the oxen of Amun, whereas the question on its verso refers to someone having been killed. The subject matters of these two texts lack an apparent connection and therefore could represent two different oracular inquiries. This is also supported by the handwriting that seems to be different on the recto and verso. Therefore, this ostracon most likely constitutes an example of its re-use in oracular ceremonies, with both of its sides used as writing surfaces.

Lastly, as for the use of the five documents containing the interjection "No!" (Cat. 159–163), there are several possible interpretations for these examples. They might represent an answer that was given to the supplicant by the priest addressing the god (see below), as demonstrated by O. BM EA 5624, where the supplicant received a reply from the god *m mḏȝt* 'in a document'. Alternatively, they could represent one of the two possible answers to an oracular question: yes and no. Unfortunately, no ostraca with the word "Yes!" have ever been found at Deir el-Medina, in contrast to some evidence from the Greek period.[53] Therefore, such a practice is unsure, but cannot be excluded.

For the rest of the ostraca that are inscribed with a single word or noun phrase (Cat. 164–173), it is more difficult to imagine a context in which these might have been used. Perhaps at least some of them might represent responses to questions that could not have been answered by a simple yes or no, such as "Who do the oxen of Amun belong to?" (Cat. 32). For example, one ostracon contained only the pronoun "He" (Cat. 165).[54] Assuming the ostracon is complete, for this case we might imagine a scenario in which a question would have been posed to the god orally, who might have had to choose from the answers "me" (i.e., the petitioner) and "him" (i.e., the opponent), representing the two disputing parties. Similarly, the phrase "mansion of Maatra" (Cat. 169)[55] could represent, for instance, an answer to an inquiry about the location of certain item(s), for instance "Where are the dates?" (Cat. 22). However, since most of these ostraca include names of kings and deities, they could have been employed in a different way than in oracular ceremonies, perhaps having served a certain administrative role. In any case, the exact purpose of these ostraca remains unknown and their use in oracles is more uncertain than the use of the "No!" examples.

[50] J. Černý, "Egyptian oracles," in R. Parker, ed., *A Saite Oracle Papyrus from Thebes in the Brooklyn Museum (Papyrus Brooklyn 47.218.3)* (Providence, 1962), 47; R. Gillam, "Historical Foundations," in R. Gillam and J. Jacobson, eds., *The Egyptian Oracle Project: Ancient Ceremony in Augmented Reality* (New York, 2015), 50.

[51] Translation by McDowell in McDowell, *Jurisdiction*, 430.

[52] Perhaps also Cat. 24.

[53] Valbelle and Husson, "Les questions oraculaires d'Égypte," 1068.

[54] For the hieratic text and translation, see P. Grandet, *Catalogue des ostraca hiératiques non littéraires de Deîr el-Médîneh, Tome VIII – Nos 706–830* (Cairo, 2000), 69 and 200.

[55] For the hieratic text and translation, see Grandet, *Catalogue des ostraca hiératiques VIII*, 75 and 210.

Random Draws?

In the oracular documentation, thirteen ostraca contain only the genitival expression "the house of X," where X stands for the name of a person, whereas in one instance it refers to a group of "servants" (Cat. 123–135). These ostraca should be compared with another set of texts, similar in nature, but different in form, namely a bundle of twelve reed pieces discovered at Deir el-Medina.[56] Each piece was inscribed on one side in hieratic. In nine cases out of twelve the text contained the phrase "house of X," in the other instances the text contained only a name, the phrase "man of the village" or "man of the outside."[57] All the reed pieces were folded in the middle, rendering the inscription invisible, and the whole bundle was tied together by a string.[58] The names on the reed pieces belong to Dynasty Twenty, and are different from the names on the ostraca in all but one case.[59] In contrast, the ostraca bearing the inscription "house of X" are from unknown context(s) and of unknown date(s).[60]

In his publication on the inscribed reed pieces, Černý has suggested that this is an instance of a random draw and that the bundle of reed pieces was used to determine a thief.[61] It is unknown, however, if such bundles were used during oracular ceremonies or in different contexts, such as the judiciary activities of the *ḳnbt*.[62]

Nevertheless, the parallel between the reed bundle and the Deir el-Medina ostraca with the noun phrases "house of X" is clear. However, a reed bundle seems like a more suitable material for a random draw than ostraca, as it can be folded in half; unless one considers that the ostraca were presented to the god turned upside down or placed in a single container. In fact, the ostraca were most likely employed in the manner described by the above-mentioned Cat. 136: during an oracular consultation, a (written) list of houses was read out in order for the god to identify the thief in the village. However, due to the lack of their context, it is impossible to determine how many of these ostraca were actually used together in a single oracular event.

"Marked" Oracular Ostraca

Finally, as mentioned above, a very peculiar group of ostraca (Cat. 2–3, 8–9, 59, 61–64, 66)[63] has been found in the house of Prahotep (SO IV), located at the southern end of the village. It consists of ostraca which bear an oracular inscription on the recto, whereas the verso preserves a hieratic sign.[64] These marks, usually called "funny signs," are known from numerous ostraca, pottery, and daily life objects from Deir el-Medina, as well as rock graffiti in the Theban area.[65] Haring has been able to link some of these marks with the workmen, and so they probably represent identity marks.[66]

[56] J. Černý, "Le tirage au sort," *BIFAO* 40 (1941), 135–41.

[57] Černý, "Le tirage au sort," 136–37.

[58] Černý, "Le tirage au sort," 135–36.

[59] Cat. 133 and one of the reed pieces mention "the house of Meryra." However, there were at least seven different Meryras known at Deir el-Medina. See B. Davies, *Who's Who at Deir el-Medina: a Prosopographic Study of the Royal Workmen's Community* (Leiden, 1999), 295.

[60] The names on the ostraca can be mostly associated with more than one person and therefore cannot be dated. In a couple of instances, only one person of such a name has been recorded in Davies's prosopographic study, but it is unknown if those two people can be equated. It is possible that more people of the same name lived in the village, but only one of them is documented among the surviving documents from the village. For instance, a certain Ptahmose (a name occurring in Cat. 123) is attested in the reign of Ramesses II, but we cannot know if this was the only Ptahmose living in the village during its existence. See Davies, *Who's Who*, 269–71.

[61] Černý, "Le tirage au sort," 138–41.

[62] See B. Bruyère, *Rapport sur les Fouilles de Deir el Médineh (1935–1940)*, Fasc. 2 (Cairo, 1952), 151–52.

[63] Cat. 65 is damaged, but it comes from the same findspot and thus might have originally contained a mark. Cat. 35 and Cat. 98 also bear marks on the *verso*, but were found in the Great Pit.

[64] E.g., signs D21, D56, F4, G17, G41, O4, and others.

[65] See E.-M. Engel, "Non-Textual Marking Systems: The Case of Deir el-Medina," in J. Budka, F. Kammerzell and S. Rzepka, eds., *Non-Textual Marking Systems in Ancient Egypt (and Elsewhere)* (Hamburg, 2015), 107–8; D. Soliman, "Workmen's Marks in Pre-Amarna Tombs at Deir el-Medina," in Budka, et al., *Non-Textual Marking Systems*, 109–32; A. Dorn, "Für jeden Arbeiter aus Deir el-Medine ein Namenszeichen?" in Budka, et al., *Non-Textual Marking Systems*, 143–58; S. Rzepka, "'Funny Signs' Graffiti vs. Textual Graffiti: Contemporary or not?" in Budka, et al., *Non-Textual Marking Systems*, 159–84.

[66] The ostraca marks have for several years been the subject matter of a research project led by B. Haring at Leiden University. See B. Haring, "Towards Decoding the Necropolis Workmen's Funny Signs," *GM* 178 (2000), 45–58; idem, "Workmen's Marks on Ostraca from

Firstly, it is interesting to note that the house of Prahotep contains a depiction of "Amenhotep I of the Village,"[67] the deity mentioned in the longest and most detailed testimonies of oracles at Deir el-Medina. However, this house is not the only one to have contained a decoration of this kind, and therefore, this does not necessarily indicate that the house was in itself connected with the oracular activity, even less a place where oracles took place. Rather, the collection might represent part of a personal archive, but not that of Prahotep, since he lived in this house during the reign of Ramesses II,[68] but the ostraca are dated to Dynasty Twenty.[69] It is unknown who lived in the house after Prahotep. However, the collection could have belonged to one of the priests who consulted the god during oracles, namely a member of the "brotherhood" of a chapel (see below), who decided to keep the ostraca with oracular questions that supplicants had given to him.

How, then, can we understand the presence of the "funny signs" on the verso of the oracular ostraca? Besides being identity marks, other interpretations of the marks include an indication of whether the answer was supposed to be affirmative or negative, or an abbreviation of the main theme of oracular questions.[70] However, none of these interpretations is consistent with all oracular ostraca marked in this way. It is possible that the marks served different purposes in each of the oracles. Even if this was the case, however, the question remains: why was the practice of identifying the correct answer or the content of an oracular question limited to only a dozen ostraca? Another explanation is possible and it includes personal choice: the inhabitant of Prahotep's house wanted to mark his collection, whatever the reason. The main issue, of course, remains in the chronological sequence of the process of inscribing the ostraca. One of the sides might have been inscribed a long time prior to the other. In such a case, the two sides of the ostraca would have no connection whatsoever with one another.

Temporal and Spatial Contexts of Oracles at Deir el-Medina

Based on the available evidence, it seems that there were two contexts in which supplicants could seek oracular advice at Deir el-Medina: during festival processions and within the more intimate framework of a divine chapel.[71] The former is the best known and better documented situation, whereas the latter could be traced through scanty evidence recently retrieved from the cultic area.

Processional Oracles

In general, the main occasion during which oracles could take place in ancient Egypt was during festival processions. Examples of such events are quite numerous in the textual and iconographic record. For instance, during the Opet festival, when the statue of the god Amun-Ra would be taken from the temple of Karnak and carried to the temple of Luxor, Ramesses II addressed the god about the appointment of the High-Priest of Amun.[72] Similarly, the High Priest Menkheperre consulted Amun-Re during the feast of Amun at the New Year.[73]

At Deir el-Medina, various festivals were celebrated regularly during the village's existence, though on a smaller scale.[74] The main feast was that of Amenhotep I, which is documented in both textual and iconographic

the Theban Necropolis: a Progress Report," in B. Haring and O. Kaper, eds., *Pictograms or Pseudo-Script? Non-textual Identity Marks in Practical Use in Ancient Egypt and Elsewhere: Proceedings of a Conference in Leiden, 19–20 December 2006* (Leiden, 2009), 143–67; idem, "Between Administrative Writing and Work Practice: Marks Ostraca and the Roster of Day Duties of the Royal Necropolis Workmen in the New Kingdom," in Budka, et al., *Non-Textual Marking Systems*, 133–42.

[67] Bruyère, *Rapport (1934–1935)*, 321.

[68] Davies, *Who's Who*, 150.

[69] See *The Deir el-Medina Database*, http://www.wepwawet.nl/dmd/.

[70] L. Weiss, "Markings on Oracle Ostraca from Deir el-Medina – Conflicting Interpretations," in Haring and Kaper, *Pictograms or Pseudo-Script?*, 224–29.

[71] See Černý, "Egyptian oracles," 37–38.

[72] Černý, "Egyptian oracles," 36.

[73] Černý, "Egyptian oracles," 38.

[74] See Valbelle, *Les ouvriers de la tombe*, 332–35.

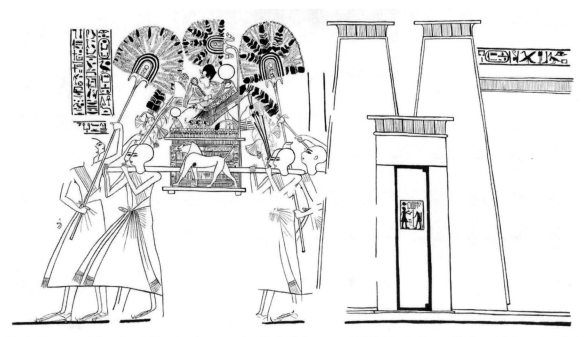

Fig. 1. The statue of the god carried by priests in a procession (Tomb of Amunmose, TT19) (after G. Foucart, Tombeau thébaines: nécropole de Dirâ Abû'n-Nága, 3, no. 4, pl. 28).

material.[75] During this festival the statue of the patron of the village was carried around the settlement as well as the necropolis, as evidenced by a document describing an oracular consultation during the procession of Amenhotep I (Cat. 137). The text notes that the oracle took place "at the entrance[76] of the tomb of the foreman Qaha" (TT 360). Furthermore, another oracle took place on the day of the "appearance of this god, king Amenhotep, the lord of the village" (Cat. 152).[77]

Mentions of oracles taking place during the festival processions of Amenhotep I are also known from Theban sites other than just Deir el-Medina. For instance, a particularly interesting and quite detailed wall scene can be found in Amunmose's tomb (TT19) at Dra Abu el-Naga.[78] The scene depicts the pylon of the temple of "Amenhotep I of the Forecourt," four priests acting as the "bearers of the god" and carrying the litter on which the statue of the deified king rests (fig. 1), musicians, and importantly two men in dispute (fig. 2). The accompanying text says: "Saying by the first priest of Amenhotep, Amunmose, saying: 'My good lord, saying is what the god has done: The servant Ramessesnakht is correct, Heqanakht is wrong'. And the god agreed very greatly, saying: 'The servant Ramessesnakht is correct'."

Based on the informative documentation, it is usually assumed that oracular events at Deir el-Medina match festival dates. However, Vleeming's re-evaluation of the issue has shown that the preserved dates on which oracles took place did not necessarily overlap with the known dates of festivals of any god in the village.[79] It is possible, though, that not all festival dates have survived in the written material from Deir el-Medina and thus there might be some feasts which we do not know about yet. Another problem is, of course, connected with the

[75] Valbelle, *Les ouvriers de la tombe*, 320–21; Černý, "Le culte d'Amenophis Ier," 184–94.

[76] Literally "mouth."

[77] *KRI* VII, 284.

[78] See G. Foucart, et al., *Tombeau thébaines: nécropole de Dirâ Abû'n-Nága*, MIFAO 57, 3, Part 4, (Cairo, 1935), pls. 28–32.

[79] S. Vleeming, "The days on which the *qnbt* used to gather," in R. Demarée and J. Janssen, eds., *Gleanings from Deir el-Medina* (Leiden, 1982), 187–89.

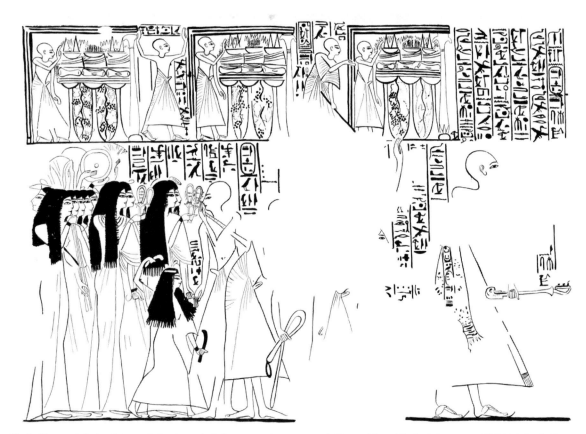

Fig. 2. Two men bringing their case before the oracle during a procession, accompanied by musicians (Tomb of Amunmose, TT19) (after G. Foucart, Tombeau thébaines: nécropole de Dirâ Abû'n-Nâga,3, no. 4, pl. 31).

issue of calendars used in ancient Egypt.[80] Moreover, we have only seven dated oracular reports and a handful of legal cases that mention oracles with dates. This number is in a very small proportion to over a hundred ostraca with oracular questions. McDowell has suggested that some processions could have been specifically arranged for oracular events, outside the scope of any religious feasts, but no evidence survives to corroborate such a suggestion.[81]

Nevertheless, it could be assumed that these various processions would have provided an opportunity, though rather limited, for the villagers to consult the deity/deities, even more so during the New Kingdom. Indeed, this period saw the rise of personal piety, characterized by Baines and Frood as the "sense of selection and active involvement between a deity and a human being or king."[82] Therefore, it could be expected that at this time, people sought to reach their gods more directly by various pious actions and rituals, whether held within the temple or domestic contexts.[83] In this respect, one should emphasize the erection of the temple of "Amun who Hears the Prayer" at the eastern Karnak during the reign of Ramesses II, which is preceded by an open-air

[80] See, e.g., L. Depuydt, "From Twice Helix to Double Helix: A Comprehensive Model for Egyptian Calendar History," *JEH* 2 (2009), 115–47.

[81] McDowell, *Jurisdiction*, 191–92.

[82] J. Baines, and E. Frood, "Piety, Change and Display in the New Kingdom," in M. Collier and S. Snape, eds., *Ramesside Studies in Honour of K. A. Kitchen* (Bolton, 2011), 3–4.

[83] J. Baines, "Society, Morality, and Religious Practice," in B. Shafer, ed., *Religion in Ancient Egypt: Gods, Myths, and Personal Practice* (Ithaca, 1991), 179–80.

esplanade especially designed for the public.[84] The same idea can be seen behind the creation of votive stelae depicting ears.[85] This practice, very popular among the Deir el-Medina's workmen,[86] expressed the desire of individuals to address directly their deity as well as one of the latter's qualities: the deity was supposed to hear the petitioners' requests just as during oracles. Since people turned more and more to their deities during the New Kingdom and frequently sought their help, why should the opportunity for accessing a god have been limited to only special festival processions? A person in need of a god's guidance would want to have the matter resolved as soon as possible.

Chapel Oracles

The need to consult the gods on a more regular basis than just during processions might have been felt more strongly in the New Kingdom, as exemplified indirectly by a letter (Cat. 158). It was probably composed during late Dynasty Twenty, at a time when the community of Deir el-Medina had already relocated to the temple of Medinet Habu.[87] Even though the letter does not come from the site of Deir el-Medina, the reference to the "scribe of the Tomb" suggests that it nevertheless concerned the workmen's community. The letter was addressed to an unnamed god and shows how the supplicant was disappointed that he could not approach his god since he was hidden in the sanctuary: "I was looking for you to tell you some matters of mine, (but) you were hidden in your sanctuary and there was no one admitted to you. Now, as I was waiting, I found Hori, this scribe of Usermaatre-Meryamun, and he said to me, 'I am admitted'; I am sending him to you." It is clear that a common person was not allowed inside the temple and that only a priest could mediate the supplicant's query or appeal to the god.

At Deir el-Medina, chapel oracles were connected with the north-eastern part of the settlement that contains numerous cultic structures. Around the temples primarily dedicated to Hathor and built in the names of kings[88] lie around thirty chapels, erected by the workmen's own initiative. Being the focus of the community's religious life, the chapels were private and more intimate places of worship than "national" temples. They centered around various deities, including royal ancestors, and thus are not to be confused with tomb chapels.[89] The chapels were served by the workmen themselves, who acted as priests. Unfortunately, most of the decoration in these chapels is not preserved and thus one can only guess at the identity of the god(s) worshiped inside them. There are, however, a few exceptions. For instance, C.V. 1213 appears to have been associated with the goddess Taweret, C.V. 1190 with Ptah, Amun criocephalus, probably Seti I and others, whereas Chapelle D was dedicated to the god Amenhotep I and goddess Ahmose-Nefertari.[90] More recently, the clearing and restoration of the so-called Opet Chapel has made it possible to re-attribute this place of worship to an ithyphallic god: either Min, Amun-Min, or Amun-Kamutef.[91]

The layout of most of these cultic chapels follows the general plan of Egyptian religious buildings, but on a smaller scale: a forecourt, outer and inner halls, a pronaos, a tripartite sanctuary and a side annex.[92] The recently restored chapel designated as C.V. 1, likely associated with Amun,[93] is probably one of the most illustrative of the matter. This building preserves a peculiar feature that might have existed in all chapels from Deir el-Medina: its inner hall contains two benches along its northern and southern walls.[94] Such benches were found in other Deir

[84] Sadek, *Popular Religion*, 46.

[85] See Sadek, *Popular Religion*, pls. 1–28.

[86] This practice is also attested at other sites, e.g., Memphis, Abydos, and Thebes. See Sadek, *Popular Religion*, 266.

[87] McDowell, *Village Life*, 109.

[88] There were the Hathor Temple of Ramesses II, the Hathor Temple of Merneptah, and the Hathor Temple of Seti I built next to each other.

[89] Bomann, *The Private Chapel in Ancient Egypt*, 73, 75–76.

[90] Bomann, *The Private Chapel in Ancient Egypt*, 69–72.

[91] Cédric Gobeil, personal communication.

[92] Bomann, *The Private Chapel in Ancient Egypt*, 40–54.

[93] D. Sweeney, "Sitting Happily with Amun," in B. Haring, O. Kaper, and R. van Walsem, eds., *The Workmen's Progress: Studies in the Village of Deir el-Medina and Other Documents from Western Thebes in Honour of Rob Demarée* (Leiden, 2014), 223–28.

[94] Bomann, *The Private Chapel in Ancient Egypt*, 40.

el-Medina chapels as well as temples.[95] According to Bomann, who worked at Amarna where similar religious structures have been found, the function of the benches was dual: they could be filled either with votive offerings or seats for seating priests.[96] It is assumed that the primary function of the benches at Deir el-Medina was for people to be seated, whether the benches contained seats or not. No such seats were retrieved for C.V. 1, but if they were present originally, then the benches would have been filled with either twelve[97] or fourteen[98] seats, depending on the authors' calculations of the available space. Nevertheless, fragments of such stone seats have been discovered in the cultic area: the most important ones were found by Schiaparelli and are now kept in the Turin Museum.[99]

These limestone fragments are either painted or engraved with the names of their owners, often preceded by the phrase "for the *ka* of." Bruyère has suggested that the uninscribed seats were used by living people, whereas the inscribed ones commemorated deceased people,[100] but this hypothesis now seems to have been dropped. The names inscribed on these seats belonged to the workmen of Deir el-Medina, who acted as priests in the chapels,[101] with their titles ranging from *ḥm nṯr* to *wꜥb*-priests.[102] It is unknown if the number of priests connected with each chapel was fixed, since the seats have been only partially preserved.[103]

Furthermore, a wall representation retrieved from the annex of the Temple of Hathor of Seti I is of particular interest when it comes to illustrating the religious and personal activities within Deir el-Medina's places of worship. Unfortunately, nothing of the wall representation survives today, but Bruyère reported traces of the depictions of men and women with the deities Amenhotep I, Ahmose-Nefertari, Amun and Hathor.[104] The people represented on the wall might have belonged to the *confrérie* or "brotherhood" of this chapel, as coined by Bruyère. Thus, a group of people acting as priests were responsible for servicing the cult of a deity in a chapel. This is also evident from their absences due to various religious duties noted in the crew's journal,[105] which recorded deliveries of food and supplies, "visits by outside authorities, and incidents" at work.[106] Unfortunately, we do not know anything about the process of the selection of the members of a "brotherhood."

In any case, oracles at Deir el-Medina could be also conducted in such "brotherhood" chapels. Petitioners would come to one of these chapel, probably depending on which deity they preferred, submit their oral or written request to the god through the mediation of a "brotherhood" priest, and receive the (oral or written) answer from the deity, again through the mediation of a priest.

Such a scenario is supported by recent finds by the French archaeological mission at Deir el-Medina during their 2014 campaign, when several written documents pertaining to oracles were discovered in the outer room of C.V. 1. This room probably represents the final part of the chapel that supplicants could access. Among the finds was a small ostracon, simply inscribed with "the manifestation (*bꜣw*) of Amenhotep I," a common oracular formula also known from other Deir el-Medina ostraca (e.g., Cat. 118).[107] This ostracon is of crucial importance as it comes from its original, albeit disturbed, stratigraphic context. It proves that oracles were indeed connected with the activity inside the chapels: a supplicant would enter the chapel, submit their question to one of the priests, presumably in the outer room of the chapel, and wait for the god's answer.

Lastly, such a process raises the question of who wrote down the oracular questions on the ostraca. Was it one of the scribes or were the workmen literate enough to write simple unofficial and non-literary texts? It is

[95] Opet Chapel; Temple of Hathor of Seti I; Temple of Amun of Ramesses II. See Bomann, *The Private Chapel in Ancient Egypt*, 47–48.

[96] Bomann, *The Private Chapel in Ancient Egypt*, 73.

[97] Bomann, *The Private Chapel in Ancient Egypt*, 71.

[98] B. Bruyère, *Rapport sur les Fouilles de Deir el Médineh (1931–1932)* (Cairo, 1934), 58.

[99] They may have come from the chapels north of the Ptolemaic temple or from the so-called Opet Chapel: Paolo Del Vesco (Turin Museum) and Anne-Claire Salmas, personal communications.

[100] Bruyère, *Rapport (1931–1932)*, 59.

[101] E.g., Valbelle, *Les ouvriers de la tombe*, 328.

[102] Bomann, *The Private Chapel in Ancient Egypt*, 75; Valbelle, *Les ouvriers de la tombe*, 329.

[103] Bomann, *The Private Chapel in Ancient Egypt*, 71.

[104] B. Bruyère, *Rapport sur les Fouilles de Deir el Médineh (1935–1940)* (Cairo, 1948), 103; Bomann, *The Private Chapel in Ancient Egypt*, 71–72.

[105] J. Janssen, "Absence from Work by the Necropolis Workmen of Thebes," *SÄK* 8 (1980), 146–49.

[106] McDowell, *Village Life*, 202.

[107] Cédric Gobeil, personal communication.

unknown to what extent ordinary workmen were literate, but it is probable that the levels of literacy at Deir el-Medina were exceptional.[108] Also, if all or most of the inhabitants were literate enough, was it then the priests or the supplicants who wrote the oracular questions and answers on the ostraca? In any case, the fact that direct contact with a deity was usually forbidden in Egyptian religion[109] might explain why many oracular questions have survived in the written form: the queries had to be mediated through both the priest or writing.

Conclusion: Final Remarks and the Issue of Faith

It has been often assumed that oracular consultations at Deir el-Medina involved the inhabitants writing two opposing statements on two different ostraca and then presenting these to the deified king Amenhotep I during festival processions.[110] However, the picture that emerges from the examination of all available material is not as straightforward as usually described. In fact, there seems to have existed two types of oracles at Deir el-Medina: the processional oracle and the chapel oracle. The former is attested only for the deified king Amenhotep I, the patron of the village. It would take place during festival processions when the statue of Amenhotep I would leave its sanctuary. After a question has been asked, the god would indicate his decision by movement. A forward or perhaps even upward movement would indicate the god's agreement, whereas the backward or downward movement would show disagreement.[111] In the case of multiple possibilities presented to the god, such as a list of houses, the god would indicate his will by a movement towards the desired option. However, there was also a second way in which a supplicant could approach a deity: by visiting a chapel and mediating his query through a priest.

The two types of oracles at Deir el-Medina might have been distinguished by the degree of their formality. The processional oracles would take place in front of most villagers during sporadic appearances of the deity from the sanctuary. This might have been the more formal type of the oracle, given by the patron of the village Amenhotep I, and consequently could have been used to settle legal disputes that the village administration could not deal with. These matters might have been first investigated by the *knbt*, but if the existing evidence proved insufficient, Amenhotep I would be approached for help. In contrast, through the chapel oracles one could address the god whenever they needed to do so. They could submit to him requests for advice and help with everyday matters and concerns, not just legal issues. Thus, the chapel oracles were less formal and so might have been sought after by the villagers more often than the more sporadic processional oracles. This could explain why the mundane internal affairs of the villagers, whether work-related matters or more personal ones, predominate in the surviving oracular record at Deir el-Medina, although this might be simply a contingency of preservation.

In its wider context, this research on oracles is especially interesting when it comes to the issue of faith. From a modern Western perspective, the god speaking his mind through the mediation of priests seems too obviously contrived to be believed as a credulous expression of divine will. This raises the question of whether the priests manipulated the oracles in some way and whether they consciously deceived the seekers of oracular advice. But the issue of external manipulation is rather irrelevant here since, as stated by Herodotus, "the art of divination among them (= the Egyptians) ... belongs to no man, but to some of the gods." For many Egyptians it would seem that oracles were a matter of authentic faith, namely a "complete trust or confidence in someone or something," a "strong belief in the doctrines of a religion, based on spiritual conviction rather than proof."[112] When the god speaks his mind, his words are sacred, though they might not be always regarded as definitive. Indeed, even though the god's decision in oracles was supposed to be resolute and binding, in some cases it would take several years to enforce it or several attempts to properly resolve the matter.[113]

[108] See J. Janssen, "Literacy and Letters at Deir el Medina," in R. Demarée and A. Egberts, eds., *Village Voices. Proceedings of the symposium "Texts from Deir el-Medina and their interpretation" Leiden, May 31 – June 1, 1991* (Leiden, 1992), 81–94.

[109] Baines, "Practical Religion and Piety," 82.

[110] J. Tyldesley, *Judgement of the Pharaoh: Crime and Punishment in Ancient Egypt* (London, 2000), 148–49; J. Ray, "Ancient Egypt," in M. Loewe and C. Blacker, eds., *Divination and Oracles* (London, 1981), 180.

[111] R. Gillam, "Historical Foundations," in Gillam and Jacobson, *The Egyptian Oracle Project*, 45.

[112] Definitions from the Oxford dictionary. It should be noted that Egyptian religion had no "doctrines."

[113] For instance, according to a legal document that mentions an oracular procedure (O. DeM 133), a police member had to be brought

In general, both the supplicants and the priests themselves would have believed that the priests were in fact vehicles for the deity and that they were influenced by the god revealing his will to them. This was also the case elsewhere in the ancient world, as in the Greek culture famous for its oracular consultations. The oracle at Delphi, for instance, was used and considered legitimate long after other oracles in Greece had been abandoned and stopped being an object of sincere belief.[114] Plutarch himself served as a priest at Delphi and we learn from his account that "the operators of the oracle clearly believed in what they were doing, and took as a given the notion that Apollo channeled divine utterance through the Pythia. They were not, despite some modern rationalist assumptions, simply well-established scam artists."[115] In the grip of "scientific rationalism," many scholars believed the Delphi oracle to be a "conscious and vastly profitable scam."[116] However, any manipulation would have become immediately public. But since the Delphi oracle was held in high respect for centuries, it would be reasonable to suppose that the participants experienced the oracle primarily as authentic.[117]

Similarly, the Deir el-Medina community was not particularly large and its members lived in close proximity to each other, and so the daily-life affairs and private matters of the inhabitants would have been known by most, if not all, villagers. These included the priests acting as intermediaries between the oracular god and the petitioner, whether during processions or inside the "brotherhood" chapels. Thus, following the preceding logic concerning the Delphi example, it is likely that the "divinely privileged nature of communications made under their (= the priests') guardianship"[118] was perceived as true by those involved in the oracular procedures at Deir el-Medina.[119] It is important to stress that when examining the issue of "truth" in oracles, we are concerned not with the problem of "objective" reality but rather with the subjective experience of the participants. After all, truth is "the most historical experience of all;"[120] it is forged and shaped by men themselves.

I would like to conclude with a mention of a rather modern event, which constitutes a curious parallel. A funerary procession was witnessed by the excavators at Abydos around twenty years ago, during which the body of the deceased was carried on a litter by six bearers, followed by a procession of people from the near-by villages.[121] The deceased would direct the movements of the bearers, who would pause if they were "unsure of his wishes and wait until one of them discerned the dead man's will."[122] Clearly, faith can be construed as "the most gloriously ... invincible phenomenon in all experience,"[123] having ensured the survival of oracular and similar religious practices throughout the documented history of Deir el-Medina, into Graeco-Roman times, Christian Egypt, and contemporary Egypt.

Brown University

before the god three times, since he failed to pay for the donkey that he had unlawfully appropriated. But this does not mean that he doubted the speech of the god. For the transcription and translation of this text, see KRI VI, 425–26 and McDowell, *Village Life*, 174, respectively.

[114] P. Green, "Possession and Pneuma: the Essential Nature of the Delphic Oracle," *Arion: a Journal of Humanities and the Classics* 17, 2 (2009), 30.

[115] Green, "Possession and Pneuma," 31.

[116] Green, "Possession and Pneuma," 38.

[117] Green, "Possession and Pneuma," 38.

[118] Green, "Possession and Pneuma," 45.

[119] That is not to say that the Egyptians were not aware of the possibility of manipulation and fraud, whether in oracles or in other situations; there must have been corrupt individuals in ancient Egypt who would try to manipulate and deceive for their own gain. But the presence of such people and their acts in society would not undermine the widespread religious beliefs and activities of the others, and perhaps not even their own. A person's manipulation of oracles is not tantamount to their or everyone else's lack of faith in the oracular practice. In fact, the priest who is accused of many misdeeds in the Turin Indictment Papyrus, including an attempt to manipulate the god's answer in the oracle of Khnum in order to have another priest expelled, approached the same god for his own oracular consultation on other occasions. Beliefs of ancient individuals are not accessible to us nowadays, and so in the end it is impossible to say what each person was thinking and how their beliefs shaped, or were shaped by, their actions. For the Turin Indictment Papyrus, see T. Peet, "A Historical Document of Ramesside Age," *JEA* 10 (1924), 116–27; A. Gardiner, *RAD*, 73–82.

[120] P. Veyne, *Les Grecs ont-ils cru à leurs mythes? Essai sur l'imagination constituante* (Paris, 1983), 11.

[121] Gillam, "Historical Foundations," 52–53; M.-A. Wegner, "Appendix A: a Funeral Procession in Modern Rural Egypt," in Gillam and Jacobson, *The Egyptian Oracle Project*, 218–19.

[122] Gillam, "Historical Foundations," 52–53; Wegner, "Appendix A," 218–19.

[123] E. Jones, *The Road to En-dor: being an account of how two prisoners of war at Yozgad in Turkey won their way to freedom*, Ebook edition (London: 2014), 343.

Catalogue of Oracular Texts from Deir el-Medina[124]

Short Oracular Texts			
	Name of the Ostracon	**Transliteration**	**Translation**
Cat. 1	O. Ashmolean Museum 0198 (O. Gardiner 0198)	[1]p3y.j nb nfr n3 tm.j [2]šm m-b3ḥ.f n jw wn(w)n ḫpr [3]m n3y.j mdwt nty jw.j ḏd.w n.f [4]tm šm.j	My good lord, should I not go before him? If threats occur in my words that I will say to him, should I (rather) not go?
Cat. 2	O. Ashmrolean Museum 1010 (O. Gardiner 1010)	[1]jr n3 ḳdw nty [2]jw.tw ḥr ptr.w [3]n3 nfrw	As for the dreams that are being seen, are they good?
Cat. 3	O. Ashmolean Museum 1014 (O. Gardiner 1014)	[1]n jr.j t3 mdt [2]m sḫ dj.t sw n Ṯtj	Should I put the matter in writing to give it to the vizier?
Cat. 4	O. BMFA 72.666 (O. S 261, no. 864)	[1]n p3 ḥm nṯr dpy n jmn [2]p3 nty jw.f r djt.n ḥrj	Is the high priest of Amun the one who will give us a chief?
Cat. 5	O. Brussels E 317	[1]n jṯ sw n3 rmṯ [2]p3 mšꜥ	Did the people of the army steal it?
Cat. 6	O. Cairo JE 59464 (O. Cairo pro. no. 352; O. Cairo SR 01853)	[1]n j(w).tw djt sty [2]r ḥm nṯr	Shall Sety be made a priest?
Cat. 7	O. Cairo JE 59465 (O. Cairo SR 01854)	[1]m ḥr ḫpr [2]jm.f j.wḏ m3ꜥt	Has Horus appeared(?) in him? Command the truth!
Cat. 8	O. Clere [1]	[1]n h3b(.j) ḥr-r.w [2]n m3ꜥt	Have I really written about them?
Cat. 9	O. Clere [2]	[1]dj(.j) wꜥ wp.w n [2]p3 sḫ 2	Have I given a *wep* to the two scribes?
Cat. 10	O. DeM 00573	[1]n ky jṯ [2]sw	Is it another that took it?
Cat. 11	O. DeM 00574	[1]p3y.j nb nfr wn [2]ꜥnḫ m-dj ptḥ-ms [3]m n3y ꜥnḫw	My good lord, is the goat that Ptahmose has from these goats?
Cat. 12	O. DeM 00575 (O. IFAO 01366; O. IFAO inv. no. SA 00154)	[1]n bn jn.sn r p3 [2]pr	Should I not bring them to the house?
Cat. 13	O. DeM 00576	[1]p3y.j nb ꜥ.w.s. nfr jr n3 jtj-[2]m-jtj j.jn n.j jn-mw b3k-n-mwt [3]bn jtj-m-jtj ḥ3r 6.5 p3y jn.f [4]n.j wḥm z3t.f jtj-m-jtj ḥ3r 1.0625 m z3t-ḥwt-ḥr [5]jtj-m-jtj ḥ3r 0.125	My good lord, l.p.h., as for the barley-as-barley which the water-carrier Bakenmut got for me, is barley-as-barley of 6 ½ sacks not what he got for me? His daughter also got me barley-as-barley of 1.0625 sack, and from Sihathor 0.125 barley-as-barley of 0.125 sack.
Cat. 14	O. DeM 00794 (O. IFAO 01708; O. IFAO inv. no. SA 13088)	n p-n nbw	Is it one of gold?
Cat. 15	O. DeM 00795 (O. IFAO 01366; O. IFAO inv. no. SA 00154)	[1]n jmn-ms jṯ m-jm.f [2]p3 jwf	Is Amenmose the one who stole the meat from him?
Cat. 16	O. DeM 00796 (O. IFAO 01683)	[1]n sw (m)-ꜥ ḥnwt-[2]š3	Is it in the possession of Henutsha?
Cat. 17	O. DeM 00797 (O. IFAO 01607; O. IFAO inv. no. SA 06332)	[1]n3 p3 d3jw [2](m)-ꜥ ḫꜥw	Is the garment in the possession of Khau?
Cat. 18	O. DeM 00798 (O. IFAO 01635; O. IFAO inv. no. SA 02209)	[1]n3 sḥtp špyt [2] mr.s	Will the bladder appease her illness?

[124] This catalogue includes all the texts, in total 173 ostraca and papyri, that have been classified as oracular according to The Deir el-Medina Database, http://www.leidenuniv.nl/nino/dmd/dmd.html. For each text, a transliteration and translation are given, with the exception of the well-published seven longer oracular reports, records of legal proceedings mentioning oracles, and too fragmentary texts. For these, publications with the most recent transcriptions and translations are provided. As discussed above, the interrogative nature of the sentences not specifically marked as a question was most likely implied by the context in which they were used; hence they are translated as questions rather than simple statements.

Cat. 19	O. DeM 00799 (O. IFAO 01743; O. IFAO inv. no. SA 11114)	(1)n3 jB.w n (2)dhr 2	Did they take the two hides?
Cat. 20	O. DeM 00800 (O. IFAO 01713; O. IFAO inv. no. SA 009264)	n jw.tw djt jst [n...]	Should one give the place [to...]?
Cat. 21	O. DeM 00801 (O. IFAO 01710; O. IFAO inv. no. SA 12232)	(1)n j(w).tw r jn (2)mh 8	Will one get 8 cubits?
Cat. 22	O. DeM 00802 (O. IFAO 01662; O. IFAO inv. no. SA 00092)	(1)sw tnw (2)n(3) bnr	Where are the dates?
Cat. 23	O. DeM 00803 (O. IFAO 01721; O. IFAO inv. no. SA 05103)	(1)sw tnw p(3)y (2)dmꜥ	Where is this papyrus roll?
Cat. 24	O. DeM 00804 (O. IFAO 01097; O. IFAO inv. no. SA 02644)	Recto: (1)rmt smdt b(2)nr Verso: nb(.j) nfr	A man of the smdt of the outside? (My) good lord.
Cat. 25	O. DeM 00805 (O. IFAO 1734; O. IFAO inv. no. SA 12992 (?))	(1)p3y.j nb [nfr...] (2)p3y mhr [...] (3)bty jm.f	My [good] lord, [...] this granary [...] is emmer in it?
Cat. 26	O. DeM 00807 (O. IFAO 01526; O. IFAO inv. no. SA 06280)	nty jr p-n-njwt [...]	(That) which Penniwt will [...]?
Cat. 27	O. DeM 00808 (O. IFAO 01625; O. IFAO inv. no. SA 07164)	(1)jr ꜥ3 bn mntk [...] (2)j.jr.k jB [...]	As for the donkey, you are not [...], did(?) you steal [...]?
Cat. 28	O. DeM 00809 (O. IFAO 01746; O. IFAO inv. no. SA 12706)	(1)jw.f jmn-p3-ḥꜥp(2)y	Does it belong (to) Amenpahapy?
Cat. 29	O. DeM 00810 (O. IFAO 01707; O. IFAO inv. no. SA 08833)	gs.f ḥr.f	Its half is added(?) to it?
Cat. 30	O. DeM 00811 (O. IFAO 01723; O. IFAO inv. no. SA 02751)	sw jB [...]	Has he stolen [...]?
Cat. 31	O. DeM 00812 (O. IFAO 01610; O. IFAO inv. no. SA 06507)	(1)nfr p3 jḥ nty dbn (2)109	Is the ox which is (of) 109 deben good?
Cat. 32	O. DeM 00980 (O. IFAO 01686; O. IFAO inv. no. SA 00437)	Recto: (1)n(y)-sw nm jḥw n (2)jmn p3-wn n[3?] (3)jmn n jpt [rsyt?] (4)n(y)-sw n jḥ(w) [...] Verso: (1)nty m-dj (2)s3w ḥꜥy (3)jw.f ꜥrk ḥtb[.w] (4)sw n zḫ mḥ	Who do the oxen of Amun belong to? Because those of Amun of Luxor(?) belong to the oxen [...]. (That) who is with the guard Khay, is he finished(?)? Did they kill him for the scribe Meh?
Cat. 33	O. DeM 00981 (O. IFAO 01677; O. IFAO inv. no. SA 00393)	(1)p3 wd3 n [...] (2) nty ḥr-ꜥ(wj) 3ny-[...]	Is the storehouse of [...] which is under the supervision of Any[...]?
Cat. 34	O. DeM 00982 (O. IFAO 01804; O. IFAO inv. no. SA 06425)	(1)n jw.w djt [...] (2)p3 [...]	Will they give the [...]?
Cat. 35	O. DeM 00983 (O. IFAO 01815; O. IFAO inv. no. SA 01984)	(1)p3y.j [nb nfr] (2)jr p3 ḥnw n [...] (3) gmt.f d3r	My [good lord], as for the chapel, will [...] be found removed(?)?
Cat. 36	O. Gardiner AG 051	Recto: (1)p3y(.j) nb{t} nfr ꜥ.w.s (2)jr t3 mss p3y ḥnw nḥḥ (3)j.dj.j (n) ḥrj r-dd jmj sw (4)n p3y rmt Verso: n st [...] r.f	My good lord, l.p.h., as for the tunic(?) and this hin of oil which I have given to Hori, saying: "Give it to this man!" Are they [...] against him?

Cat. 37	O. IFAO 00108	šb.f m.dj jst	Has he made an exchange with Isis?
Cat. 38	O. IFAO 00153	(1)šsp(.j) p3y (2)ʿnḫ	Should I take this goat?
Cat. 39	O. IFAO 00187	(1)p3(y.j) nb nfr (2)jr p3 sḫn (3)b3k.w p3 djw n t3(?) [...] (4)ḫ3r(?) smn	My good lord, as for the commission of their work, is the salary of [..] sack(s) fixed?
Cat. 40	O. IFAO 00198	n m3ʿ n3 mdwt	Are the things true?
Cat. 41	O. IFAO 00199	n bn jw.tw.s r djt n.j	Will she not give to me?
Cat. 42	O. IFAO 00200	(1)n jr n3 ṯtṯt j.jr[.j] (2)dpt m-jm.k	Will the quarrels which I made bite(?) you?
Cat. 43	O. IFAO 00392	n(y)-sw pn-ʿnkt	Does it belong to Penanket?
Cat. 44	O. IFAO 00501	(1)n ntf jṯ (2)p3y tm3	Is it he who stole this mat?
Cat. 45	O. IFAO 00502	(1)p3y.j nb nfr ḏd.f (2)t3y mdt n m3ʿt	My good lord, did he speak this thing truly?
Cat. 46	O. IFAO 00503	m sn r.ttf{f} sw	Is it Sen who spilled it?
Cat. 47	O. IFAO 00556	(1)p3y.j nb nfr ʿ.w.s [jn jw.tw] (2)r djt.n djw	My good lord, l.p.h., will the rations be given to us?
Cat. 48	O. IFAO 00557	(1)n jw(.j) n bn(2)r	Shall I go outside?
Cat. 49	O. IFAO 00558	[...].f sw ḵn-n3	[...] he [...] it (to) Kenna?
Cat. 50	O. IFAO 00559	(1)n st (ḥr)-ʿwj (2)p3 [...]	Are they under the supervision of the [...]?
Cat. 51	O. IFAO 00560	n snd.w	Should they be afraid?
Cat. 52	O. IFAO 00561	rwj(.j) sw m jdnw n t3 jst	Should I remove him from (the post of) the deputy of the crew?
Cat. 53	O. IFAO 00562	(1)n3 ḫd.j mtw.j šm (2)n.j mtw.j mḥ bsy	Should I go north or go away or should I fulfill the initiation?
Cat. 54	O. IFAO 00563	jṯ sw rmṯ	Has someone stolen it?
Cat. 55	O. IFAO 00598	(1)n3 rmṯ p3 ḫr (2)jṯ st	Is it the people of the Tomb who stole it?
Cat. 56	O. IFAO 00599	(1)n bn jw.f ḏb3(2).f n.s jw[...]	Will he not replace it for her [...]?
Cat. 57	O. IFAO 00657	(1)dj.j ḥnw.tw (2)r p3 nty p3y rmṯ (3)jm	Should I make one go to the (place) where this man is?
Cat. 58	O. IFAO 00680	n3 wbd(.j) sw	Have I burnt it?/Should I burn it?
Cat. 59	O. IFAO 00681	n ʿd3 n3 ḏd [...]	Is what [(someone)] said false?
Cat. 60	O. IFAO 00682	n3 nfr p3 k3 šsp(.j) sw	Is the bull good? Should I accept it?
Cat. 61	O. IFAO 00691	(1)n jw.f smtr.j (2)r ḥ ʿt.f	Will he investigate me himself?
Cat. 62	O. IFAO 00692	n jw.w sḫ3.j n ṯtj	Will they mention me to the vizier?
Cat. 63	O. IFAO 00693	(1)n jrt ṯtj jṯ (2)p3 5 ʿḏd	Will the vizier take the five boys?
Cat. 64	O. IFAO 00694	(1)n ṯ3y jw jw.f (2)ḫpr r.j	Is it something evil that will happen to me?
Cat. 65	O. IFAO 00695	(1)n bn sw [...] (2)mdt [...]	Is it not [...] thing [...]?
Cat. 66	O. IFAO 00696	(1)n jw.f w3ḥ.w ḥr (2)jst.w	Will he put them in their place?
Cat. 67	O. IFAO 00720	(1) n jw.tw r djt(.j) (m) m(2)tn	Will I be made scout?
Cat. 68	O. IFAO 00721	(1)ptr(.j) (2)p3 ʿ3t (3)n sḫ ḥr	Should I look at the donkey of the scribe Hori?
Cat. 69	O. IFAO 00848	(1)n tm.j (2)jnt.w	Should I not get them?
Cat. 70	O. IFAO 00849	(1)n jw.f r djt.n (2)ḥrj m t3 wnwt	Will he give us a chief now?
Cat. 71	O. IFAO 00850	(1)p3y.j nb nfr jr p3 mḳs (2)n(y)-sw p3-ḫy	My good lord, as for the meqes, does it belong to Pakhy?
Cat. 72	O. IFAO 00851	(1)n3 tm.j šm (2)r p3 nty sw m-jm	Should I not go to the (place) where he is?
Cat. 73	O. IFAO 00852	n3 rmṯ j.jr st	Is it people who did it?
Cat. 74	O. IFAO 00853	(1)n(y)-sw p3-šd s3 (2)ḥḥ-m-nḫ	Does it belong to Pashed, son of Hahem-nakh?
Cat. 75	O. IFAO 00854	(1)n tm(.j) wbdt(2).f	Should I not burn it?
Cat. 76	O. IFAO 00855	(1)n jw.tw r jr p3y 3ht (2)ḥrj mḏ3y nb-smn	Should one do the field of the chief of Medjay Nebsemen?

Cat. 77	O. IFAO 00856	[1]n sw (m)-ʿ nb-[2]nfr	Is it in the possession of Nebnefer?
Cat. 78	O. IFAO 00857	[1]n bȝw n [2]ȝny-nḫt	Is it the manifestation of Anynakht?
Cat. 79	O. IFAO 00858	nȝ sw šby(?) (r?) kmt	Is it ? (to/against?) Egypt?
Cat. 80	O. IFAO 00859 (O. IFAO inv. no. SA 04277; W. DeM 5406)	n fȝj(.j) ḫbs	Have I carried a lamp?
Cat. 81	O. IFAO 00860	[1]sw (m)-ʿ jḥ-mntf [2]n mȝʿt	Is it really in the possession of Akhentof?
Cat. 82	O. IFAO 00861	[1]n pȝ 5 dbn n [2]ḥmt nȝ djty n [3] pn-pȝ-[4]ḥȝpy	The 5 *deben* of copper, have they been given to Penpahapy?
Cat. 83	O. IFAO 00862	[1]n mn m.dj[2].s m-jm.w	Does she not have some of them?
Cat. 84	O. IFAO 00863	Recto: [1]jr pȝ pš n [2]mrwt Verso: jw.f r(?) […]	As for the share of Merut, will it […]?
Cat. 85	O. IFAO 00864	[1]n st dy m sḫt [2]ʿȝt r ḥʿt.f	Is it here in the Great Field itself?
Cat. 86	O. IFAO 00865	n st (ḥr)-ʿwj […].s […]	Are they under the supervision of […]?
Cat. 87	O. IFAO 00866	n(y)-sw bȝ-s	Does it belong to Bes?
Cat. 88	O. IFAO 00867	n(y)-sw ms	Does it belong to Mose?
Cat. 89	O. IFAO 00868	[1]nȝ rmṯ pȝ [2]ḥr n ẖnw	Is it someone of the Tomb of the Inside?
Cat. 90	O. IFAO 00869	[1]jr pȝ mȝwḏ [2]nty m tȝ kȝr [3]jnk sw	As for the carrying pole which is in the shrine, is it mine?
Cat. 91	O. IFAO 00870	[1]n ky jṯ [2]jṯ sw	Is it another thief who stole it?
Cat. 92	O. IFAO 00871	[1]n dj.tw pȝ ʿnḫ n [2]jn mw pn-pȝ-ḥȝpy	Has the goat been given to the water-carrier Penpahapy?
Cat. 93	O. IFAO 00873	nȝ jnn.tw(.j) m-bȝḥ	Should I be brought before (the god?)?
Cat. 94	O. IFAO 00874	[1]pȝ sẖ-ḥsb n [2]njwt jw.f djt n.j	Will the scribe of the accounts of Thebes give to me?
Cat. 95	O. IFAO 00876 (O. IFAO 00878)	nȝ nfr ḥmt 20	Are the 20 (*deben*) of copper good?
Cat. 96	O. IFAO 00877	bȝw n nṯr ʿȝ	The manifestation of the great god.
Cat. 97	O. IFAO 00878	[1]n jw.f wȝḥ(.j) ḥr [2]jst.f m pȝy.f pr	Will he put (me) in his place in his house?
Cat. 98	O. IFAO 00880	[1]jr pȝy ḥn(?) [2][…].f jw.f nfr jw [3][…] ḫpr	As for this ? [which he ….], is it good […] will occur(?)?
Cat. 99	O. IFAO 00881	[1]jw.tw djt tȝ štȝ[2]yt […]	Will one give the shrine(?) (to someone)?
Cat. 100	O. IFAO 00883	[1]djt(.j) jṯ.f r [2]tȝ sḫt	I have made him take (me) to the Field.
Cat. 101	O. IFAO 00884	[1]jr nȝ jḥ nty [2]tȝ rmṯ ḥr wẖȝ.w [3]n wn m.dj.s pš [4]m-jm.w	As for the cattle which the woman demands, does she have a share in it?
Cat. 102	O. IFAO 00941	nȝ nḫt	Is it Nakht?
Cat. 103	O. IFAO 00943	n(y)-sw jmn-pȝ-ḥȝpy	Does it belong to Amenpahapy?
Cat. 104	O. IFAO 00992	nty m pȝ sḫt	(That) which/who is in the Field?
Cat. 105	O. IFAO 00995	jw.f djt pȝ ʿȝ	Will he give the donkey?
Cat. 106	O. IFAO 00996	[1]n jw.tw r djt tȝ jst n [2]mn-nȝ m pȝy.s sḫr	Should one give the place to Menna, according to her plan?
Cat. 107	O. IFAO 00997	[1]n djt(.j) st n pȝ [2]wḏḥ nbw	Have I given it to the goldsmith?
Cat. 108	O. IFAO 00998	[1]šb.f m.dj [2]nḫw-m-mwt	Has he made an exchange with Nekhemmut?
Cat. 109	O. IFAO 00999	n rmṯ ḏrḏr	Is it a stranger?
Cat. 110	O. IFAO 01000	[1]pȝ 3 ḥrj m[2]dȝyw	The three chiefs of Medjay?
Cat. 111	O. IFAO 01396	[1]pȝy(.j) nb nfr jr […] [2]pȝy mr m pȝ(?) […] [3]r.mḥ m-jm.f	My good lord, as for […] this pyramid, is Pa(?)-[…one who?] laid hold of it?
Cat. 112	O. IFAO 01398	sw tnw n(ȝ) ȝw	Where are the vegetables(?)?
Cat. 113	O. IFAO 01501 (a) (O. IFAO 01001)	[1]nty jw.tw r šd.w m-dj […] [2]pȝ-ṯw-m-dj-jmn […]	(That) which will be recovered(?) from […] Patjauemdiamun […]?

Cat. 114	O. IFAO 01502 (a) (O. IFAO 01002)	(1)jmn-nḫt (2)nty m nṯr	Amennakht who is the god.
Cat. 115	O. IFAO 01503 (a) (O. IFAO 01003)	Reśtq: (1)yȝ j̓(2)ḥ p3 [...] ḥersq: ḥrj	What about the [... of?] Hori?
Cat. 116	O. IFAO 01506 (a) (O. IFAO 01006)	jw.f n n(y)-sw-jmn	Will it be for Nesamun?
Cat. 117	O. IFAO 01507 (a) (O. IFAO 01007)	nȝ j.jr.f r tȝy	Did he act against this?
Cat. 118	O. IFAO 01537	n bȝw n jmn-ḥtp	Is it the manifestation of Amenhotep?
Cat. 119	O. IFAO 01555	n jw.f ḥd sȝ(?) [...]	Will he go north after(?) [...]?
Cat. 120	O. Louvre E 27682	(1)pȝy.j nb nfr jr (2)pȝ ḳd nȝw (3)pȝ ḥr jṯ (4)sw	My good lord, as for the plaster, is it the ones of the Tomb who stole it?
Cat. 121	O. OIM 18876 (O. OIC 18876; O. OIC 1887b)	(1)nȝ jn.j tȝ bȝkt (2)n jw.s ḫprw	Should I get a female servant? Will it happen?
Cat. 122	O. Turin N. 57227 (O. Turin inv. no. 11359; O. Turin suppl. 6759)	(1)n mn shȝ (2)m-jm r ḥwt-nṯr n (3)nhy šȝw	Is there not a writing of some value(?) there about the temple?

"House of X" Ostraca

	Name of the Ostracon	Transliteration	Translation
Cat. 123	O. DeM 00600	pr n ptḥ-ms	House of Ptahmose.
Cat. 124	O. DeM 00813 (O. IFAO 00498)	pr n nfr-ḥtp	The house of Neferhotep.
Cat. 125	O. DeM 00814 (O. IFAO 00155)	pr nb-nḫt	The house of Nebnakht.
Cat. 126	O. DeM 00815 (O. IFAO 00135)	pr n ḥsy-sw-nb.f	The house of Hesysunebnef.
Cat. 127	O. DeM 00816 (O. IFAO 01701; O. IFAO inv. no. SA 08103)	pr n nḫt-sw	The house of Nakhtsu.
Cat. 128	O. DeM 00817 (O. IFAO 01706)	pr n ȝny-nḫt	The house of Anynakht.
Cat. 129	O. DeM 00818 (O. IFAO 01702; O. IFAO inv. no. SA 07828)	pr p-n-sbȝ	The house of Penseba.
Cat. 130	O. DeM 00819 (O. IFAO 01703; O. IFAO inv. no. SA 08522)	pr ḫnsw	The house of Khonsu.
Cat. 131	O. DeM 00820 (O. IFAO 01704; O. IFAO inv. no. SA 05137)	pr n p-n-njwt	The house of Penniut.
Cat. 132	O. DeM 00821 (O. IFAO 01705)	pr n jmn-m-ḥb	The house of Amenemhab.
Cat. 133	O. IFAO 00885	pr n mry-rᶜ	The house of Meryra.
Cat. 134	O. IFAO 01535	pr n ḳn	The house of Qen.
Cat. 135	O. IFAO 01554	pr n nȝ bȝkw	The house of the servants.

Longer Oracular Reports

	Name of the Ostracon	Publication	
Cat. 136	O. Ashmolean Museum 0004 (O. Gardiner 0004; HO 27,3)	See *KRI* VI, 142; W. Helck, *Die Datierten und Datierbaren Ostraka, Papyri und Graffiti von Deir el-Medineh* (Wiesbaden, 2002), 394; McDowell, *Village Life*, 181–82.	
Cat. 137	O. BM EA 05625	See *KRI* VI, 252–53; Helck, *Die Datierten*, 432; McDowell, *Village Life*, 177–78.	
Cat. 138	O. Cairo CG 25242 (O. Cairo JE 49554; O. Cairo SR 12025)	See *KRI* V, 531–32; Helck, *Die Datierten*, 305.	

Cat. 139	O. Cairo CG 2555 + O. DeM 00999 (O. Cairo JE 51517; O. IFAO 01280)	See *KRI* V, 456–57; Helck, *Die Datierten*, 229 and 232; McDowell, *Village Life*, 178–80.
Cat. 140	O. DeM 00448 (O. IFAO 00882)	See *KRI* V, 541; Helck, *Die Datierten*, 318.
Cat. 141	O. DeM 00672 (O. IFAO 01016)	See *KRI* V, 449; Helck, *Die Datierten*, 226.
Cat. 142	O. UC 39622 (HO 16,4; O. Petrie 21)	See *KRI* V, 518–19; McDowell, *Village Life*, 173–74.

Other Texts Mentioning Oracles & Fragmentary Oracular Texts

	Name of the Text	Publication
Cat. 143	O. Ashmolean Museum 0023 (O. Gardiner 0023; O. Hood; HO 43,4)	See *KRI* VI, 663; Helck, *Die Datierten*, 502.
Cat. 144	O. Ashmolean Museum 0103 (O. Gardiner 0103; HO 52,2)	See *KRI* V, 571–72; McDowell, *Jurisdiction*, 254–56.
Cat. 145	O. Berlin P 10629	See *KRI* V, 574; S. Allam, *Hieratische Ostraka und Papyri aus der Ramessidenzeit* (Tübingen, 1973), 27–29.
Cat. 146	O. BIFAO 76 (1976), 7	See C. Bonnet & D. Valbelle, "Le village de Deir el-Médineh: Étude archéologique (suite)," *BIFAO* 76 (1976), 333–34.
Cat. 147	O. BM EA 05637	See *KRI* V, 577; Allam, *Hieratische Ostraka*, 50–51.
Cat. 148	O. Cairo CG 25364 (O. Cairo SR 12077)	See *KRI* VII, 346–47; Černý, "Le culte d'Amenophis I chez les ouvriers de la nécropole thebaine," *BIFAO* 27 (1927), 193.
Cat. 149	O. DeM 00984 (O. IFAO 01764; O. IFAO inv. no. SA 06269)	See Grandet, *Catalogue des ostraca hiératiques* IX, 148–49, 437.
Cat. 150	O. Geneva MAH 12550 (O. Genf 12550)	See *KRI* V, 453; Helck, *Die Datierten*, 227–28.
Cat. 151	O. IFAO 01277	See Allam, *Hieratische Ostraka*, 196–97.
Cat. 152	O. Louvre N 0694,2	See *KRI* VII, 284; Helck, *Die Datierten*, 231.
Cat. 153	O. Louvre N 0697	See *KRI* VII, 193; Y. Koenig, "Les ostraca hiératiques du musée du Louvre," *RdE* 42 (1992), 112–13.
Cat. 154	O. UC 39617 (HO 21,1; O. Petrie 16)	See Allam, *Hieratische Ostraka*, 231–33; Černý-Gardiner, *Hier. Ostraca*, 7, pls. 21–21A.
Cat. 155	O. Varille 40	See *KRI* VII, 286.
Cat. 156	P. Bulaq 10 (P. Cairo CG 58092)	See *KRI* V, 449–51; Allam, *Hieratische Ostraka*, 289-93; McDowell, *Village Life*, 167–68.
Cat. 157	P. DeM 26	See *KRI* V, 461–66; Allam, *Hieratische Ostraka*, 297–301.
Cat. 158	P. Nevill	See J. Barns, "The Nevill Papyrus: A Late Ramesside Letter to an Oracle," *JEA* 35 (1949), 69-71; McDowell, *Village Life*, 109–10.

One-Word and Uncertain Oracular Texts

	Name of the Ostracon	Transliteration	Translation
Cat. 159	O. DeM 00572	*n-bj3t*	No!
Cat. 160	O. IFAO 00875	*n-bj3t*	No!
Cat. 161	O. IFAO 00879	*n-bj3t*	No!
Cat. 162	O. IFAO 01504 (a) (O. IFAO 01004)	*n-bj3t*	No!
Cat. 163	O. IFAO 01505 (a) (O. IFAO 01005)	*n-bj3t*	No!
Cat. 164	O. Berlin P 23403	*bj3t* (?)	Wonder/oracle (?).
Cat. 165	O. DeM 00806	*sw*	He.
Cat. 166	O. DeM 00822	*Ptḥ*	Ptah.
Cat. 167	O. DeM 00823	*Ptḥ n t3 st nfrw*	Ptah of the Place of Beauty (=the Valley of the Queens).
Cat. 168	O. DeM 00824	*M3ʿt-Rʿ ꜥ.w.s.*	Maatra l.p.h. (=Seti I ?).

Cat. 169	O. DeM 00825	[*tȝ*(?)] *ḥwt Mȝꜥt-Rꜥ*	The Mansion of Maatra (=Seti I ?).
Cat. 170	O. DeM 00985	*ȝ ḥwt Bȝ*(?)*-Rꜥ Mrj-Jmn*	The Mansion of Bara Mery-Amun (=Merenptah ?).
Cat. 171	O. DeM 00986	[1]*Jmn-ḥtp* [2]*200*	Amenhotep. 200.
Cat. 172	O. DeM 00987	*Wsr-Mȝꜥt-Rꜥ stp-n-Rꜥ ꜥ.w.s.*	Usermaatra Setepenra l.p.h. (=Ramesses II).
Cat. 173	O. DeM 10115	*Jmn-Rꜥ*	Amun-Ra.

Zwei zusätzliche Bemerkungen zu pBerlin 15765a

Abstract

In this contribution, some new thoughts concerning pBerlin 15765a are offered. In the first case, more parallels for the writing ḳm3 for km are presented. In the second case, the defective writing tr for twr is treated adequately. A basis for a reasoned discussion of the loss of w is provided. The phrase śf n twr "knife of reed" is compared to śfd g3š "knife of rush" in the Late Egyptian "Tale of the Two Brothers."

In der soeben erschienenen Frandsen-Festschrift wurde die scientific community durch Quack[1] mit dem späthieratischen pBerlin 15765a bekannt gemacht. Der mögliche Inhalt des dortigen Textes wird als mythologische Erzählung über die Geburt des Sonnengottes und Entstehung des Apophis bestimmt. Das Alter der in der Vergangenheit nur rudimentär behandelten Handschrift wird bewusst großzügig auf die Ptolemäerzeit eingeengt. Der Ansatz kann auf paläographischer Ebene durchaus abgesichert werden.

Der vorliegende Beitrag nimmt auf jenen Artikel direkten Bezug, wobei die Interpretation des Textes an ausgewählten Stellen fortgesetzt wird. In einzelnen Details kann so vielleicht ein kleiner Schritt weitergekommen werden. Der Hinweis erübrigt sich von selbst, dass sich spätere Bearbeiter immer in einer komfortableren Ausgangsposition als der Ersteditor befinden.

I.

Das erste Interesse kann die Stelle [...ḥ]f(3w) m 3.t m mḥ-ꜥ 170 (?) ḫ3ꜥy m km-3.t (Z. 1) für sich in Anspruch nehmen, für die Quack die Übersetzung "[...Schla]nge in einem Moment von 170 (?) Ellen Länge, die im Aufruhr war in einem kurzen Moment" anbietet. Die Aufmerksamkeit konzentriert sich hierbei auf das eigentlich dastehende Wort ḳm3, das Quack als Schreibung für km versteht. Der Gedanke wird durch den Hinweis auf die demotische Schreibung ḳm3-i3.wt=f für den thebanischen Urgott km-3.t=f zusätzlich gestützt.

Die Grundidee zielt in die richtige Richtung, kann aber noch erweitert werden. Die quasi-symbiotische Beziehung zwischen den beiden Wurzeln km und ḳm3 tritt noch an einigen anderen Stellen prägnant hervor. Die folgenden Beispiele sind darunter als erste Auswahl zu verstehen.

Das offenbar intendierte Wortspiel zwischen km "to complete" und ḳm3 "to create" nimmt den ersten Platz in diesem Register ein, das in ḳm3 3.t, km 3.t=f, k3 mw.t=f[2] aufgespürt werden kann. Die treffendste Übersetzung

[1] Joachim Friedrich Quack, "Die Geburt eines Gottes? Papyrus Berlin 15765a," in: Rune Nyord und Kim Ryholt, eds., *Lotus and Laurel, Studies on Egyptian Language and Religion in Honour of Paul John Frandsen*, CNI Publications 39 (Copenhagen, 2015), 317–28; zum Ursprung des Apophis aus der Nabelschnur des Re vgl. jetzt auch Joachim Friedrich Quack, "Sage nicht: 'Der Frevler gegen Gott lebt heute', auf das Ende sollst du achten!," in Beate Ego und Ulrike Mittmann, eds., *Evil and Death, Conceptions of the Human in Biblical, Early Jewish, Greco-Roman and Egyptian Literature*, Deuterocanonical and Cognate Literature Studies 18 (Berlin-Boston, 2015), 379–80; Ines Köhler, *Rage like an Egyptian, Möglichkeiten eines kognitiv-semantischen Zugangs zum altägyptischen Wortschatz am Beispiel des Wortfelds [Wut]*, BSAK 18 (Hamburg, 2016), 165 (an dieser Arbeit gibt es mehrere Dinge zu verbessern!).

[2] David Klotz, *Caesar in the City of Amun: Egyptian Temple Construction and Theology in Roman Thebes* (Turnhout, 2012), 133.

Journal of the American Research Center in Egypt 53 (2017), 283–285
doi: http://dx.doi.org/10.5913/jarce.53.2017.a014

würde wohl "he who created the moment, who completes his moment, Bull of his mother" lauten. Das Wortspiel bezieht höchstwahrscheinlich auch noch *kȝ mw.t=f* mit ein. Die unetymologische Schreibung *km* für *ḳmȝ* "beklagen"[3] dürfte in diesem Kontext eine zweite wichtige Rolle spielen. Der hier erkennbare Bedeutungsunterschied dürfte in dem Sinn kaum etwas ausmachen. Der gemeinsame Zeithorizont der Beispiele, die alle in die Spätphase der ägyptischen Sprachgeschichte gehören, sei nur am Rande angedeutet. Dass sich hier ein festes Schema abzeichnet, kann allerdings in keiner Weise ausgeschlossen werden.

Die Tatsache sollte zum Abschluss nicht unerwähnt bleiben, dass Schenkel[4] ein eigenes Lemma *ḳmȝ* "vollenden" ansetzt und mit akkadisch *gamār(um)*[5] "vollenden" und arabisch *gml*[6] "schön sein" in Zusammenhang bringt.

II.

Die nächste Beachtung wird der Stelle [...] *nḥm tȝ [m-ˤ?] šˤy(.t), m-ḫt r=f ȝ ḥśḳ np(ȝ)=f šsr n mw.t=f m śf n t(w)r* (Z. 3) geschenkt, für welche Quack die Übersetzung "[...] das Land [vor?] Gemetzel erretten, nachdem nun seine Nabelschnur abgeschnitten worden war, die Schnur seiner Plazenta, mit einem Messer aus Röhricht" vorschlägt. Das Wort *tr* am Ende des Satzes bestimmt er dabei als eventuelle Schreibung für *twr*, wofür die Schreibung *tri* für *twr* als Analogie angeführt wird.

In diesem Rahmen soll dazu lediglich eine Kleinigkeit ergänzt werden. Das entscheidende Faktum liegt darin, dass die betreffende Schreibung *tr* für *twr* auch sonst genügend häufig attestiert ist. Die folgende Auswahl kann dafür halbwegs repräsentativ stehen.

Die engste Parallele bietet zweifellos die Schreibung *tr*[7] für *twr* "Reed," die ebenfalls in die Ptolemäerzeit datiert und sich damit neben der Bedeutung auch in diesem Punkt absolut deckungsgleich verhält. Das doppelte Vorkommen der Schreibung in der jüngsten Phase der ägyptischen Sprachgeschichte könnte für einen gewissen Wiederholungseffekt sprechen. Das Beispiel *tr*[8] für *twr* "respektieren" aus dem Mittleren Reich zeigt jedoch, dass der Beginn des phonetischen Prozesses bei Wurzeln mit dieser Konsonantenstruktur schon sehr viel früher eingeleitet wurde. Die Zahl der Beispiele für die Schreibung *tr* für *twr* hat sich damit auf drei addiert.

Die Schreibung *tr* für *twr* spiegelt den Wegfall von *w* in der Mitte des Wortes wieder. In der Frage der Ursache des Phänomens ist am besten von folgender Lösung auszugehen: Die größte Wahrscheinlichkeit dürfte die Assimilation von *w* an *r* besitzen, für welche der entsprechende Lautwandel zwischen den beiden Konsonanten Sorge getragen haben dürfte. Der Lautwandel zwischen *w* und *r* konnte bereits bei früherer Gelegenheit plausibel gemacht werden[9]. Der generelle Wegfall von *w* in der Mitte des Wortes wird darüber hinaus in der Forschung schon seit längerer Zeit lebhaft diskutiert. Die Namen von Sethe,[10] Junker,[11] Edel,[12] Westendorf,[13] und Fecht[14]

[3] Andreas Pries, *Die Stundenwachen im Osiriskult, Eine Studie zur Tradition und späten Rezeption von Ritualen im Alten Ägypten, Teil 1: Text und Kommentar*, SSR 2 (Wiesbaden, 2011), 380, n. 1818.

[4] Wolfgang Schenkel, "Zu den Verschluss- und Reibelauten im Ägyptischen und (Hamito)Semitischen, Ein Vergleich zur Synthese der Lehrmeinungen," *LingAeg* 3 (1993), 142.

[5] Zu diesem Verb vgl. Wolfram von Soden, *Akkadisches Handwörterbuch Band I, A-L* (Wiesbaden, 1965), 276–78; A. Leo Oppenheim, *The Assyrian Dictionary*, Volume 5 G (Glückstadt, 1956), 25–32.

[6] Zu diesem Wort vgl. Götz Schregle, *Deutsch-Arabisches Wörterbuch*, Unter Mitwirkung von Fahmi Abu l-Fadl, Mahmoud Hegazi, Tawfik Borg und Kamal Radwan (Wiesbaden, 1974), 1325; Hans Wehr, *Arabisches Wörterbuch für die Schriftsprache der Gegenwart, Arabisch-Deutsch*, 5. Auflage, Unter Mitwirkung von Lorenz Kropfitsch (Wiesbaden, 1985), 201–2; zu dieser Wurzel und deren möglicher übertragener Verwendung vgl. Peter Munro, "Die Namen Semenech-ka-Re's. Ein Beitrag zur Liquidierung der Amarnazeit," *ZÄS* 95 (1969), 114, n. 21.

[7] Edfou, VI, 149, 1; zu dieser Stelle vgl. zuletzt Christoffer Theis, *Magie und Raum, Der magische Schutz ausgewählter Räume im alten Ägypten nebst einem Vergleich zu angrenzenden Kulturbereichen*, ORA 13 (Tübingen, 2014), 204.

[8] Gardiner, *Sinuhe*, 16

[9] Stefan Bojowald, "Zu den Wörtern *šḫ* und *šḫw* in den asiatischen Feldzugsberichten von Amenophis II. (mit einem Beitrag zum Austausch zwischen *w* und *r*)," *AcOr* 74 (2013), 149–55.

[10] Kurt Sethe, *Das aegyptische Verbum im Altaegyptischen, Neuaegyptischen und Koptischen, Erster Band, Laut- und Stammeslehre* (Leipzig, 1899), 103–4 (§§178–179).

[11] Hermann Junker, *Grammatik der Denderatexte* (Leipzig, 1906), 15.

[12] Edel, *Altäg. Gramm.*, 63–64 (§ 145).

[13] Westendorf, *Med. Gramm.*, Grundriss der Medizin VIII, 20.

[14] Gerhard Fecht, "Die Belehrung des Ba und der 'Lebensmüde'," Fs. Kaiser, *MDAIK* 47 (1991), 116.

können dafür als gute Beispiele dienen. Der Hinweis auf die Schwäche oder Halbschwäche des Konsonanten *w* dürfte am ehesten ans Ziel führen, worin sich eine Gemeinsamkeit zu *ꜣ* und *i* offenbart. Die Schwäche von *ꜣ* und *i* kann dank der Arbeiten von Sethe[15] und Westendorf[16] als fachinternes Allgemeingut gelten. Der vokalische/halbvokalische Charakter von *w*, auf den Allen[17] besonderen Wert legt, könnte als alternative Erklärung bemüht werden. Der betreffende Aspekt hat bekanntlich ebenfalls den Schwund von *w* hervorgerufen. Die Entscheidung für eine dieser beiden Möglichkeiten hängt daher von der persönlichen Vorliebe eines jeden Einzelnen ab. Die Wahrscheinlichkeit der beiden Alternativen kann zumindest in etwa gleich gewichtet werden. Die Wurzel selbst stellt auch sonst eine gewisse Anfälligkeit zu Radikalverkürzungen unter Beweis, wie sich an der Defektivschreibung *wr*[18] für *twr* "Reinheit" hervorragend zeigen lässt. Die Koordinaten sind hier im unmittelbaren Vergleich zu oben genau verschoben, da dieses Mal der Wegfall von *t* vor *w* zu beobachten ist. Das Material reicht wohl kaum aus, um daraus irgendwelche phonetischen Konsequenzen zu ziehen. Der dafür erforderliche Lautwandel zwischen *w* und *t* scheint jedenfalls noch nicht begegnet zu sein.

Das gerade eben erwähnte thematische Motiv findet im Übrigen eine schöne Entsprechung im neuägyptischen "Zweibrüdermärchen," die offenbar bisher noch nicht erkannt wurde. Im dortigen Kontext ist davon zu lesen, wie der jüngere Bruder sich nach den falschen Beschuldigungen durch die Frau des älteren Bruders selbst entmannt. Der Nexus wird durch die Wörter *iw=f ḥr in.(t) wꜥ n śfd gꜣš, iw=f ḥr šꜥd ḥnn=f, iw=f ḥr ḫꜣꜥ=f r pꜣ mw*[19] geschildert, die sich mit "Er brachte ein Schilfmesser, schnitt sein Geschlechtsteil ab und warf es ins Wasser"[20] wiedergeben lassen. In Hinblick auf diese Stelle denkt Peust[21] darüber noch, ob es sich bei besagtem Messer um ein Utensil aus Schilf oder nicht vielmehr einen Gegenstand zur Schilfernte handelt. Die Überlegung ist a priori als durchaus berechtigt zu respektieren. Im Lichte der Parallele zu pBerlin 15765a deutet aber vieles auf die erstere Möglichkeit hin. In jedem Fall bleibt festzuhalten, dass das ungewöhnliche Schneidewerkzeug aus Pflanzenfasern sowohl hier als auch dort zum Durchtrennen von weichem menschlichem Zellgewebe verwendet wird. Ob und gegebenenfalls inwiefern daraus weitere Schlussfolgerungen abzuleiten sind, kann an dieser Stelle nicht genauer untersucht werden. Die bloße Existenz einer zufälligen Koinzidenz will aber – das kann schon jetzt gesagt werden – nicht so richtig einleuchten.

Die vorherigen Bemerkungen mögen einen Teilbeitrag zur Verbesserung des Gesamtverständnisses leisten. Im Minimalfall hat die wissenschaftliche Auseinandersetzung neuen Schwung erhalten.

Bonn

[15] Zum Schwund von *ꜣ* vgl. Sethe, *Aegyptisches Verbum*, 42–44; zum Schwund von *i* vgl. Sethe, *Aegyptisches Verbum*, 67–72.

[16] Zum Schwund von *ꜣ* vgl. Westendorf, *Med. Gramm.*, 9; zum Schwund von *i* vgl. Westendorf, *Med. Gramm.*, 12–13.

[17] James Allen, *The Ancient Egyptian Language, An Historical Study* (New York, 2013), 43 (§ 5.1.4).

[18] Karl Jansen-Winkeln, *Biographische und religiöse Inschriften der Spätzeit aus dem Ägyptischen Museum Kairo, Teil 1, Übersetzungen und Kommentare*, ÄAT 45 (Wiesbaden, 2001), 163.

[19] Gardiner, *LES*, 17 (7, 8–7, 9).

[20] Edward Wente, "The Tale of the Two Brothers," in William Simpson, ed., *The Literature of Ancient Egypt, An Anthology of Stories, Instructions, Stelae, Autobiographies, and Poetry, Third Edition* (New Haven-London, 2003), 84; Wolfgang Wettengel, *Die Erzählung von den beiden Brüdern, Der Papyrus d'Orbiney und die Königsideologie der Ramessiden*, OBO 195 (Freiburg/Schweiz-Göttingen, 2003), 99; zu dieser Passage vgl. zuletzt Rana Sérida, *A Castration Story from the Tebtunis Temple Library*, The Carlsberg Papyri 14, CNI Publications 42 (Copenhagen, 2016), 51.

[21] Carsten Peust, *Das Zweibrüdermärchen*, in Manfried Dietrich, et al., eds., *Ergänzungslieferung*, TUAT (Gütersloh, 2001), 159.

The Ottoman Tiles of the Fakahani Mosque in Cairo

Hans Theunissen

Abstract

In this paper, the author presents a chronological overview of Ottoman-period tilework in Cairene build-ings with an emphasis on a detailed study of the tilework of one specific building: the Fakahani Mosque Complex in the historic city center of Cairo. The lack of a critical overview of tiles from various pro-duction centers used in Cairene architecture regularly leads to inaccurate attributions. Tiles, often auto-matically attributed to Iznik, frequently have more diverse origins both in place and period of production. The overview in this paper intends to raise awareness of this situation and to provide a timeline of tiles from various production centers which can be used for more focused studies of the tilework in individual buildings. In the second part of the paper the author deals with the tilework of the Fakahani Mosque Complex. All tiles used in the 1735–1736 renovation of this, originally, Fatimid mosque were produced in Istanbul by the Tekfur Sarayı workshops in the late 1720s and early 1730s. They probably belonged to a larger batch of tiles which were used to decorate a number of buildings built or renovated by two Cairene amirs, Uthman Katkhuda al-Qazdaghli and Ahmad Katkhuda al-Kharbutli. The use of tiles from the royal workshops not only illustrates that these amirs had good contacts with the center of power in Istanbul but also shows that tiles played an important role in the construction of political legitimacy and social status in mid-eighteenth-century Ottoman Cairo.

Introduction

In 2008, Jonathan Bloom published an article dealing with the "Fatimid" doors of the Fakahani Mosque[1] in the center of historic Cairo.[2] Bloom shows that the delicately carved wooden elements, which are part of the pres-ent doors, have a Fatimid origin (fig. 1). It is possible that these belonged to the remains of the earlier (originally

Editor's Note: While some of the many figures in this article are included in the print version, all of the photographs and figures can be found online at: https://opencontext.org/projects/2bc1f77d-fe36-41eb-99b9-c0261edb4f18.

[1] Jonathan Bloom, "The "Fatimid" Doors of the Fakahani Mosque in Cairo," *Muqarnas: An Annual on the Visual Culture of the Islamic World* 25 (2008), 231–42.

[2] The Fakahani Mosque is located on the east side of al-Mu'izz li-Din Allah Street, between the complex of al-Ghuri to the north and the Mosque of al-Mu'ayyad Shaykh and Bab Zuwayla to the south. See Nicolas Warner, *The Monuments of Historic Cairo. A Map and Descrip-tive Catalogue* (Cairo-New York, 2005), 105, and map 20 (no. 109). According to Warner, *Monuments*, 105, the doors "were the first parts of the mosque to be registered in 1908, with the remainder of the building, including a sabil-kuttab, following in 1937." However, *The Index to Muhammedan Monuments appearing on the Special 1:5000 Scale Maps of Cairo* (Cairo, 1980; AUC Reprint), 3, no. 109, still only lists the "Doors of the Mosque of al-Fakahānī." For this 1908 listing, see also *Procès-verbaux des séances du comité. Rapports de la section technique. Année 1908, 382e Rap-port de la section technique, 9o,* 18–19 (http://www.islamic-art.org/Comitte/BArchViewPage.asp?BookID=719andPO=23). For the Comité's restoration of the doors see *Ministère des Waqfs, Comité de conservation des monuments de l'art arabe, Comptes rendus des exercices 1915–1919* (Cairo, 1922), 38 (http://www.islamic-art.org/Comitte/BArchViewPage.asp?BookID=729andPO=1). For the activities of the *Comité* see 'Ala' al-Habashi and Nicolas Warner, "Recording the Monuments of Cairo: An Introduction and Overview," *Annales islamologiques* 32 (1998), 81–99; Alaa El-Din Elwi El-Habashi, "Athar to Monuments: The Intervention of the Comité de Conservation des Monuments de l'Art Arabe," PhD diss., University of Pennsylvania, 2001.

Journal of the American Research Center in Egypt 53 (2017), 287–330
doi: http://dx.doi.org/10.5913/jarce.53.2017.a015

twelfth-century) mosque, and were reused in order to create new doors during the reconstruction of the mosque by Ottoman regiment commander Ahmad Katkhuda Mustahfizan al-Kharbutli in 1148 AH/1735–36 CE:

> [t]he Fatimid doors were undoubtedly too short to fit the openings of the Ottoman-era mosque, so the decorated panels on their inner faces were saved and reused to good advantage, along with the Kufic inscription on stone and several rather good Iznik tiles, which were placed in positions of honor around and in the mihrab hood and in the lunettes over the doors.[3]

Bloom subsequently concludes that the new "Fatimid" doors of the mosque were assembled "with the purpose of creatively reusing and preserving vestiges of the old mosque."[4] Although Bloom does not extend this conclusion to the Kufic inscriptions and the İznik tiles explicitly (fig. 2), he does mention these items as recycled materials and thus indirectly suggests that—just as that of the Fatimid wooden panels—their reuse also gives expression to a "historicist" consciousness embedded in the reconstruction project.

Ahmad Katkhuda's reconstruction of the Fakahani Mosque is mentioned in the chronicles of both al-Damurdashi[5] and al-Jabarti.[6] Both authors look favourably upon Ahmad Katkhuda's lavish expenditure on the project, but unfortunately do not give any details concerning the works that were carried out. Nevertheless, it is likely that the project consisted of a comprehensive reconstruction of the mosque, which may have been in a ruinous state (fig. 3).[7] Apart from the reconstruction of the mosque, the project also included the construction of a *sabil-kuttab* (fountain-elementary school) on the street corner of the complex (fig. 4).[8] In addition to the "Fatimid" doors and carved stonework, the tiles are one of the most eye-catching forms of decoration of both the mosque and the *sabil-kuttab*, whose appearance is otherwise fairly modest.

Bloom attributes the tiles used during the eighteenth-century reconstruction to İznik (fig. 5). Based on this attribution, the tiles used in the Fakahani complex should originate in the sixteenth or seventeenth century, because İznik had ceased to be a center for the production of tiles by the beginning of the eighteenth century. This, then, would mean that, during the reconstruction, older tiles were reused for the decoration of the mosque and the *sabil-kuttab*. The question, of course, is: are the Fakahani tiles indeed *İznik* tiles from the *sixteenth* or *seventeenth century*, and were these tiles *reused* during the reconstruction of the Fakahani complex in 1735–1736 CE, and what is the basis for Bloom's assumption?[9] A short review of relevant scholarly publications could shed some light on the state of knowledge of the subject of Ottoman tiles in Cairene architecture and provide some background to Bloom's attribution.

The first scholarly publication that deals with Ottoman tiles in Cairene architecture is Claude Prost's *Les revêtements céramiques dans les monuments musulmans de l'Égypte*.[10] Although Prost also discusses the pre-Ottoman period, a substantial part of the book is devoted to architectural ceramics in the Ottoman period. Prost's work remains unsurpassed. It is by far the most systematic and complete study of the use of Ottoman tiles in Cairene (and other Egyptian) architecture. He not only lists buildings with tiles, but also gives descriptions of the tile-

[3] Bloom, "Fatimid Doors," 240–41.

[4] Bloom, "Fatimid Doors," 241.

[5] Daniel Crecelius and 'Abd al-Wahhab Bakr, eds., *Al-Damurdashi's Chronicle of Egypt 1688–1755. Al-Durra al-Musana fi Akhbar al-Kinana. Translated and Annotated* (Leiden, 1991), 307: "Ahmad Katkuda Kharbutli had appointed his Mamluk 'Ali Odabashı a *jawish*, then left the Jawishiya corps himself. He restored with his own money the Fakihani mosque and built shops for the sellers and producers of Rumi cords, braids and tassels (*al-'aqaddin*) around it. The mosque became important having a *minbar* and allowing much light inside."

[6] Thomas Philipp and Moshe Perlmann, eds., *'Abd al-Rahman al-Jabarti's History of Egypt. Text Volumes I and II* (Stuttgart, 1994), 274: "Ahmad Katkhuda al-Kharbutli. He rebuilt the mosque known as al-Fakahani in the district of al-'Aqqadin al-Rumi, Khushqadam Lane, expending 100 purses of his wealth on the project. The mosque had originally been built by al-Fa'iz Bi-llah, the Fatimid. The repairs were completed on the 11th of Shawwal 1148 (Feb. 24, 1736). The supervisor of construction was 'Uthman Çelebi, shaykh of the guild of Anatolian tasselmakers. (Ahmad Katkhuda) appointed his mamluk, 'Ali, supervisor of the mosque and executor of his estate."

[7] Bloom, "Fatimid Doors," 234–35. The inscriptions over the entrance doors speak of the renewal of the mosque.

[8] Bloom, "Fatimid Doors," 234–35. Although the inscription over the *sabil* window also speaks of the renewal of the fountain, it is unlikely that an already extant *sabil-kuttab* was renovated.

[9] Bloom, "Fatimid Doors," 235 and 241. Bloom describes the tiles as "Ottoman" in the subtitle of figure 5 (p. 235) and calls them "Iznik tiles" on p. 241, but does not substantiate this attibution.

[10] Claude Prost, *Les revêtements céramiques dans les monuments musulmans de l'Égypte* (Cairo, 1916).

work, which are useful for present-day scholars because he describes the situation one hundred years ago—a situation that sometimes no longer exists. Prost's study has thus become a valuable primary source. The main weakness of the publication lies in the limited knowledge of Ottoman tile manufacture in İstanbul and Anatolia. Prost regularly compares Cairene tiles with tiles in buildings in İstanbul, but a lack of knowledge means that he sometimes draws incorrect conclusions, for instance by attributing tiles to a wrong production center. However, this can hardly be qualified as a deficiency. Given the state of scholarly knowledge about Ottoman tile production at the beginning of the twentieth century, the quality of Prost's work commands even more respect. A useful companion to Prost's study is Max Herz Bey's *A Descriptive Catalogue of the Arab Museum*,[11] which gives descriptions of tiles in the collection of the museum (since 1952: the Museum of Islamic Art)[12] sometimes with valuable references to the buildings where the tiles originate from.

As recently as 1989 and 2002, two Turkish scholars published short articles with overviews of Ottoman tilework in Cairo and Egypt. Ülkü Bates' article is a brief (and consequently incomplete) survey of Ottoman-period tile revetments in Cairo;[13] and Ahmet Bayhan's article[14] mainly consists of a list of Egyptian buildings decorated with Ottoman-period tilework, which is compiled on the basis of a literature study. These two articles, in combination with Prost's study, two general overviews of Islamic architecture in Cairo by Nicholas Warner[15] and Caroline

Fig. 4. The sabil-kuttab (fountain-elementary school) on the street corner of the Fakahani Mosque Complex (photograph by H. Theunissen).

Williams[16] (with numerous references to buildings with tiles), and a number of studies in Arabic and Turkish dealing with Egyptian architecture and arts in the Ottoman period,[17] make it possible to compile a preliminary inventory of buildings with Ottoman-period tilework, which could form the basis for more comprehensive studies focusing on specific buildings and their tilework—an approach that so far has yielded only a limited number of publications. In the 1970s, Viktoria Meinecke-Berg published two articles dealing with the mid-seventeenth-century tiles of the Aqsunqur Mosque (and some other buildings);[18] and in the 2000s, a number of focused

[11] Max Herz Bey, *A Descriptive Catalogue of the Objects Exhibited in the National Museum of Arab Art* (Cairo, 1907).

[12] Mohamed Mostafa, *The Museum of Islamic Art. A Short Guide* (Cairo, 1955), 9; Bernard O'Kane, *The Illustrated Guide to the Museum of Islamic Art in Cairo* (Cairo-New York, 2012), 9–11.

[13] Ülkü Bates, "Evolution of Tile Revetments in Ottoman Cairo," *First International Congress on Turkish Tiles and Ceramics* (İstanbul, 1989), 39–58.

[14] Ahmet Bayhan, "Mısır'daki Osmanlı yapılarında çini kullanımı," *Uluslararası Sanat tarihi Sempozyumu. Prof. Dr. Gönül Öney'e Armağan. 10–13 Ekim 2001. Bildiriler* (İzmir, 2002), 105–12.

[15] Warner, *Monuments*.

[16] Caroline Williams, *Islamic Monuments in Cairo. The Practical Guide* (Cairo-New York, 2008).

[17] Rabi' Khalifa, *Funūn al-Qāhira fī al-'Ahd al-Uthmānī* (Cairo, 1984); Mahmūd Hāmid al-Husaynī, *al-Asbila al-'Uthmāniyya bi-Madīna al-Qāhira 1517–1798* (Cairo, 1988); Abdullah Atia Abdülhafız, "Osmanlı döneminde İstanbul ile Kahire arasında mimari etkileşimler," Phd diss., İstanbul Üniversitesi, 1994.

[18] Viktoria Meinecke-Berg, "Die osmanische Fliesendekoration der Aqsunqur-Moschee in Kairo. Zur Entwicklung der İznik-Fliesen des

articles dealing with the Dutch tiles in the mid-eighteenth-century *sabil-kuttab*s of Sultan Mahmud I[19] and Sultan Mustafa III[20] were published.

It is not unreasonable to conclude that a lack of studies dealing with the subject (in particular, studies dealing with specific buildings and their tilework) seriously hampers our understanding of the role tiles from various Ottoman production centers (İznik, Kütahya, Tekfur Sarayı/İstanbul, Cairo, Tunisia) and periods (sixteenth–eighteenth centuries) played in Cairene architecture throughout the Ottoman period (and beyond). Bloom's assumption thus merely reflects the state of the art of the field: a lack of research (and thus understanding of the phenomenon) forces scholars to "assume what seems to be the obvious": Ottoman tiles in Cairo are often automatically attributed to İznik, the best-known Ottoman center for the production of ceramics in the sixteenth and seventeenth centuries.

This observation directs the purpose of this article. I intend to make a preliminary chronological survey of Ottoman-period tilework in Cairene buildings and to study the tiles of the Fakahani Complex in detail in order to find out when and where these tiles were produced and how the Fakahani tilework fits into the development of the use of Ottoman tiles in the architecture of Cairo. In this way, I hope to present a framework that can be used for future studies on Ottoman tiles, which inevitably should focus on the tilework of individual buildings and could ultimately contribute to a better understanding of cultural life in Cairo in the Ottoman period.

Ottoman Tiles in Cairo: A Chronological Survey

In the first part of this article, I will present an inventory of Ottoman period tilework in Cairo. This inventory is based on a study of primary and secondary sources in combination with fieldwork in Cairo done over a number of years. The aim of this inventory is to create a chronological overview of tiles from different Ottoman production centers used in Cairene buildings. This overview does not have the ambition to be 100 per cent complete—not every building with tilework is necessarily included. Tiles in various museum collections (Museum of Islamic Art, Museum of Islamic Ceramics) are also not included systematically; references to tiles in museum collections are made though, in particular when these tiles originate from buildings that are dealt with. However, the survey does include the majority of buildings that still have Ottoman period tilework and hence creates a solid framework for future studies. In the second part of this article, the tiles of the Fakahani Mosque Complex take center stage. After studying the tiles of the complex, I will try to establish from which period and production center the tiles originate and position the tilework in the chronological overview in order to contribute to a better understanding of Ottoman tilework in Cairene buildings.

Historical Sources

In the 1670s, the Ottoman traveler Evliya Çelebi (b. c. 1611–d. after 1682 CE) visited Egypt. He probably lived in Cairo for a prolonged period of time and might even have died there. In the tenth volume of his monumental *Seyahat-name* (*Book of Travels*), he presents an extensive description of the city. Although Evliya Çelebi was not the first Ottoman Turk who wrote a description of Cairo—the sixteenth-century Ottoman administrator and

17. Jahrhunderts," *MDAIK* 29 (1973), 39–62; idem, "Osmanische Fliesendekorationen des 17. Jahrhunderts in Kairo," *IVème Congrès international d'art turc* (= Études historiques 3)(Aix-en-Provence, 1976), 153–59.

[19] Hans Theunissen, "Een Osmaans barok-rococo-interieur. Nieuwe ontdekking: Nederlandse tegels in de *sabil-kuttab* van Sultan Mahmud I in Caïro," *Keramika* 21/2 (2009), 27–31. See also Doris Behrens-Abouseif, "The Complex of Sultan Mahmud I in Cairo," *Muqarnas: An Annual on the Visual Culture of the Islamic World* 28 (2011), 195–220. The article by Behrens-Abouseif focuses on the architecture, but also deals with the tilework, albeit briefly.

[20] Hans Theunissen, "Als een rivier vol blauw glinsterend water. Nederlandse tegels in de *sabil-kuttab* van Sultan Mustafa III in Caïro," *Keramika* 18/2 (2006), 26–32; idem, "Dutch Tiles in 18th-Century Ottoman Baroque-Rococo Interiors: the *Sabil-Kuttab* of Sultan Mustafa III in Cairo," *Electronic Journal of Oriental Studies* 9/3 (2006), 1–283; Jaap Jongstra and Hans Theunissen, "Caïro revisited. Conserveren van Nederlandse tegels in de *sabil-kuttab* van Sultan Mustafa III in Caïro," *Keramika* 20/3 (2008), 12–17. See also Agnieszka Dobrowolska and Jaroslaw Dobrowolski, *The Sultan's Fountain. An Imperial Story of Cairo, İstanbul, and Amsterdam* (Cairo-New York, 2011).

historian Mustafa 'Ali completed his *Description of Cairo* in 1599 CE[21]—he is the first who pays careful attention to the buildings of the city and also touches upon the decoration of buildings with tiles (called *kaşi-i Çin* by Evliya Çelebi[22]). Evliya Çelebi mentions that (in his time) Cairo had no tilemakers.[23] When describing the buildings of Cairo, Evliya Çelebi mentions a gate with tilework in the citadel of Cairo,[24] the blue-tiled domes of the madrasa-mosque and tomb of Sultan Qansuh al-Ghuri (built in 1503–1505 CE),[25] the tiled dome of the mosque of Süleyman Paşa (built in 1528 CE) in the citadel,[26] and the emerald green-tiled minaret of the mosque of Amir Qawsun (built in 1330 CE) near the Birkat al-Fil.[27] In addition, he gives the following description of Cairene fountains in which he also mentions the application of tiles on the façades of fountain buildings:

> Because water plays such an important role, viziers, governors, notables and other important people have built elaborately decorated fountains everywhere. Their windows have ornamental brass and bronze grilles. You reach the windows by three or four stone steps. These fountains are decorated with tiles, agate, marble and porphyry.[28]

Evliya Çelebi also gives descriptions of two seventeenth-century buildings with tilework. The first building is the mosque of Amir 'Abidin, which was constructed in 1070–1071 AH (1659–1661 CE). According to Evliya Çelebi, both the walls and the mihrab of this mosque were lined with tiles.[29] The second building is the domed shrine with the Footprint of the Prophet Muhammad, which is part of the Athar al-Nabi Mosque Complex (Ribat Athar al-Nabi; called the Kubbe-i Kademü 'n-Nebi in Evliya Çelebi's *Seyahat-name*, built in 1073–1074 AH/1662–1664 CE).[30] In this complex, the mihrab and walls of the shrine are lined with tiles. Other tilework in Cairene buildings, however, is not mentioned by Evliya Çelebi. Evliya Çelebi most likely mentions the tiles on the façades of fountain buildings because such use of tiles was unusual for Ottomans from İstanbul. In İstanbul, tiles were rarely used for the decoration of (open air) façades of fountains (both *çeşme* and *sebil*), probably because of the climate. The two extant examples—both post-Evliya Çelebi—are the fountain of Sultan Ahmed III (1728–1729 CE), which is decorated with bands of Tekfur Sarayı tiles just under the wide (protective) eave of the building (fig. 6), and the Çinili Çeşme in Eyüp from the same period (fig. 7).[31] The two other tiled buildings mentioned by Evliya Çelebi—when he visited Cairo in the 1670s—had been recently constructed (in the early 1660s) and this may explain why he mentions these buildings with their tilework. However, many other buildings in Cairo were decorated with tilework in Evliya Çelebi's time, for instance the Aqsunqur Mosque. Although Evliya Çelebi gives a short description of this mosque he does not mention any tiles.[32] Likewise, in Evliya Çelebi's

[21] Andreas Tietze, *Mustafa 'Ali's Description of Cairo of 1599. Text, Transliteration, Translation, Notes* (Vienna, 1975).

[22] Evliya Çelebi call tiles *kaşi-i Çin*, i.e., "tile(s) of China." Evliya Çelebi's wording is a pun. *Kaşi* means tile (derived from the name of the Iranian city Kashan, which is famous for its ceramics), and *Çin* China (famous especially for its porcelain). However, the word *çini* (derived from *Çin*) also means tile in Ottoman-Turkish. Cf. Prost, *Les revêtements céramiques*, 49, n. 1.

[23] Seyit Ali Kahraman, Yücel Dağlı and Robert Dankoff, eds., *Evliya Çelebi Seyahatnamesi*, vol. 10 (Istanbul, 2007), 207.

[24] Kahraman, et al., *Evliya Çelebi Seyahatnamesi*, vol. 10, 96.

[25] Kahraman, et al., *Evliya Çelebi Seyahatnamesi*, vol. 10, 16.

[26] Kahraman, et al., *Evliya Çelebi Seyahatnamesi*, vol. 10, 124.

[27] Kahraman, et al., *Evliya Çelebi Seyahatnamesi*, vol. 10, 126.

[28] Kahraman, et al., *Evliya Çelebi Seyahatnamesi*, vol. 10, 151.

[29] Kahraman, et al., *Evliya Çelebi Seyahatnamesi*, vol. 10, 167.

[30] Kahraman, et al., *Evliya Çelebi Seyahatnamesi*, vol. 10, 140; Meinecke-Berg, "Osmanische Fliesendekorationen," 153–54; Meinecke-Berg, "Die osmanische Fliesendekoration," 59. According to Evliya Çelebi, the shrine was built in 1074 AH/1663–1664 CE. The index gives 1073 AH/1662–1663 CE as the construction date, whereas Meinecke-Berg gives 1071 AH/1660–1661 and 1662 CE. The inscriptions of the complex give the dates 1074 AH/1663–1664 CE and 1077 AH/1666–1667 CE. See Robert Mantran, "Inscriptions turques ou de l'époque turque du Caire," *Annales islamologiques* 11 (1972), 211–33, esp. 212–14.

[31] Baha Tanman and Belgin Demirsar Arlı, "İstanbul/Eyüp'te bulunan Çinili Çeşme hakkında," in Yıldız Demiriz, ed., *Prof. Dr. Şerare Yetkin anısına çini yazıları* (İstanbul, 1996), 167–78. Tanman and Arlı attribute this fountain to the second half of the seventeenth century or the beginning of the eighteenth century and the tiles to Kütahya (apart from some reused İznik and nineteenth-century European tiles). However, it is more likely that the fountain dates from the 1720s and that the "Kütahya" tiles are actually Tekfur Sarayı tiles. Cf. Mehmet Haskan, *Eyüp Sultan Tarihi* (İstanbul 1996), 134 and 383, who suggests that the fountain was built by Koca Yusuf Efendi in memory of his son Ahmed Efendi who died in 1138 AH/1725–1726 CE.

[32] Kahraman, et al., *Evliya Çelebi Seyahatnamesi*, vol. 10, 124.

description of Damascus, he only mentions the (unusual) green-tiled minaret of the mosque of Sinan Paşa (built in 1586–1591 CE)(figs. 8–9), but does not pay attention to tilework in other buildings of that city.[33] Evliya Çelebi's observations with regard to the use of tiles therefore have only limited value, because they do not reflect the complete story of the use of tiles as architectural decoration in Ottoman Cairo.

Another important (visual) source for Ottoman-period tilework in Cairo is *L'art arabe d'après les monuments du Kaire: depuis le VIIᵉ siècle jusqu'à la fin du XVIIIᵉ* by Émile Prisse d'Avennes, which was published in 1877.[34] This work—in the second and third volumes—presents some 25 depictions of tilework; the accompanying text is in volume 4.[35] Some of the depicted tiles can no longer be found in Cairo; the buildings in which these tiles were used no longer have any tilework or the buildings themselves, including the tilework, have not withstood the test of time.[36] Other images depict tiles that can still be found in Cairo, either in the buildings mentioned by Prisse d'Avennes or in other buildings. When compared with real tiles *in situ*, the depictions of Prisse d'Avennes often present "idealized" images of (complete and intact) tilework—usually in the form of large panels of identical repeating modular tiles framed by border tiles. Only in a small number of cases does such tilework (still) exist (for instance in the Aqsunqur Mosque). Moreover, when we take into consideration the remaining tiles in Cairo, it is doubtful whether such "idealized" tilework was ever representative of the way tiles were used as architectural decoration in Cairo.[37] Another group of images depicts tilework that cannot be found in Cairo. Although one would expect Prisse d'Avennes to only depict Cairene tilework, in reality this is not the case. Three images actually show tilework of the Takiyya al-Sulaymaniyya (built in 1554–1559 CE) and the Madrasa al-Salimiyya (built in 1566–1567 CE) in Damascus[38] and one image shows cuerda seca tiles, which are found on the façade of the

[33] Yücel Dağlı, Seyit Ali Kahraman and Robert Dankoff, eds., *Evliya Çelebi Seyahatnamesi*, vol. 9 (Istanbul, 2005), 272: "Bir yeşil minare-i mevzunu var" ("It has a well-proportioned green minaret"). In the inscription over the entrance of the mosque, the green minaret is likened to the cypress tree in the rose garden of paradise. See Nicolas Vatin, "Inscription de la porte d'entrée de la mosquée Sinâniyya à Damas," *Turcica* 43 (2011), 265–67, esp. 267.

[34] Émile Prisse d'Avennes, *L'art arabe d'après les monuments du Kaire: depuis le VIIᵉ siècle jusqu'à la fin du XVIIIᵉ* (Paris, 1877).

[35] Prisse d'Avennes, *L'art arabe*, vol. 4, 193–98, deals with architectural ceramics in Cairo in general; the accompanying texts to the figures are on pp. 274–76.

[36] Prisse d'Avennes, *L'art arabe*, vol. 2, CX: "Faïences murales. Bordures. XVIᵉ siècle;" CXI: "Faïences murales. Panneau représentant la Kaabah et ses alentours. XVIᵉ siècle." The figure shows a Mecca panel in the no longer existing palace of Khurshid Pasha—possibly Hurşid Ahmed Paşa, Ottoman governor of Egypt in 1804–1805 CE—which, according to Prisse d'Avennes, resembles the Mecca panel in the *sabil-kuttab* of 'Abd al-Rahman Katkhuda. Prisse d'Avennes, *L'art arabe*, vol. 4, 274, also refers to a third Mecca panel in the Takiyya al-Kulshani. Prisse d'Avennes, *L'art arabe*, CXIII: "Faïences murales du kiosque de Mahou Bey. XVIᵉ siècle; CXVI: Faïences murales du palais d'Ismayl Bey. XVIᵉ siècle; XVIII: Faïences murales de Qasr Rodouan. XVIᵉ siècle; CXXX: Études de feuilles et de fleurons peints sur faïence. (Grandeur d'exécution). CXXXI: Panneau ovoïde de faïence; CXXXII: Faïences murales d'un Hanout."

[37] Prisse d'Avennes, *L'art arabe*, vol. 2, CVIII: "Mihrab de la mosquée de Cheykhoun. Faïences murales. XIVᵉ siècle;" CIX: "Mihrab de la mosquée de Cheykhoun. Faïences murales. XIVᵉ siècle." Cf. Prost, *Les revêtements céramiques*, 45–46; Herz, *A Descriptive Catalogue*, 226; Williams, *Islamic Monuments*, 61: "the glazed tiles in the lowest part of the niche seem to have been imported from North Africa, and were perhaps embedded at a later date." Prisse d'Avennes, *L'art arabe*, vol. 2, CXII: "Faïences murales d'un kiosque. XVIᵉ siècle.'" The figure depicts tiles that can also be found in Bayt al-Suhaymi. Prisse d'Avennes, *L'art arabe*, vol. 2, CXVII: "Faïences murales de Qasr Rodouan. XVIᵉ siècle." The depicted tiles are not identical to but resemble tiles in the mosque of Alti Barmaq. Prisse d'Avennes, *L'art arabe*, vol. 2, CXIX: "Faïences murales de la mosquée d'Ibrahym Agha. XVIᵉ siècle;" [C]XX: "Faïences murales de la mosquée d'Ibrahym Agha. XVIᵉ siècle;" CXXI: "Mosquée d'Ibrahym Agha. Pseudo-Mihrab en faïence. XVIᵉ siècle;" CXXII: "Mosquée d'Ibrahym Agha. Panneau en faïence. XVIᵉ siècle." These figures show tiles in the Aqsunqur Complex. Prisse d'Avennes, *L'art arabe*, vol. 2, CXXIII: "Faïences murales. Du Tékyeh des Derwiches. XVIIᵉ siècle." The figure shows tiles that are used on the facade of the *sabil* of Mustafa Bey Tabtabay. The *takiyya* mentioned by Prisse d'Avennes is most likely the Takiyya al-Kulshani. Prisse d'Avennes, *L'art arabe*, vol. 2, CXXVI: "Faïences murales de Beyt El-Emyr. XVIIᵉ siècle." The figure shows tiles which are used to line a lunette over the entrance of the mosque of Shaykh Mutahhar. Prisse d'Avennes, *L'art arabe*, vol. 2, CXXVII: "Faïences émaillées à double jeu. XVIIIᵉ siècle." The figure shows tiles resembling those in the *sabil-kuttab* of 'Abd al-Rahman Katkhuda. Prisse d'Avennes, *L'art arabe*, vol. 2, CXXVIII: "Faïences murales de la mosquée de Cheykhoun. XVIIIᵉ siècle." The figure depicts tiles resembling those of the Aqsunqur Complex and the Athar al-Nabi Mosque Complex. Prisse d'Avennes, *L'art arabe*, vol. 2, CXXIX: "Faïences murales du Sibyl d'Abd-el-Rahmân Kyahya. XVIIIᵉ siècle." The figure depicts tiles of the *sabil-kuttab* of 'Abd al-Rahman Katkhuda. Prisse d'Avennes, *L'art arabe*, vol. 2, CXXXIII: "Couronnement de la porte du Mimbar de Gama Sysaryeh. XVIIIᵉ siècle." This is the mosque of Süleyman Paşa in the citadel of Cairo. Prisse d'Avennes, *L'art arabe*, vol. 3, CXLII: "Khosné Ahmed-el-Bordeyny. XVIIᵉ siècle."

[38] Prisse d'Avennes, *L'art arabe*, vol. 2, CXIV: "Mosquée cathédrale de Qous. Tympan et écoinçons en faïence. XVIᵉ siècle;" CXV: "Mosquée cathédrale de Qous. Décoration en faïence. XVIᵉ siècle;" CXXV: "Tékyeh des Derwiches. Tympan et bordure d'une arcade en faïence émaillée. XVIIᵉ siècle." Cf. Prost, *Les revêtements céramiques*, 50, who mentions that the tilework of the mosque in Qus is no longer present.

Fig. 10. Mamluk blue-and-white tile in the Tomb of ʿAli Najm in Cairo (second half of the fifteenth century) (photograph by H. Theunissen).

ʿArz Odası (Chamber of Petitions) in Topkapı Palace in İstanbul.[39] Although Prisse d'Avennes' *L'art arabe* is potentially an important (visual) source for the study of Cairene art, architecture, and decoration, when it comes to tiles the work should be used with caution.[40]

The Diversity of Cairene Tile Culture

The Cairene tradition of decorating buildings with tilework dates as far back as the early Mamluk period. This tilework, from the first half of the fourteenth century, was used on minarets and (the drums of) domes. Most of these tiles were monochrome—usually blue, turquoise, or green, but sometimes also white and purple.[41] However, the fifteenth century also produced blue-and-white tiles often decorated with Mamluk versions of motifs originating in the international Timurid decorative repertoire.[42] The use of this type of tile in architecture was usually restricted to lunettes (tympanums),[43] friezes (on the drums of domes), mihrabs, and single square tiles set in walls (fig. 10).[44] After the Ottoman conquest of Egypt in 1517 CE, the late-fifteenth- and early-sixteenth-century Mamluk practice of tiled minarets and domes initially continued.[45] The tiled minaret and domes of the Süleyman Paşa Mosque (1528 CE),[46] the tiled dome of the tomb of Shaykh Suʿud (1534 CE) (fig. 11),[47] and the tiled drum of the tomb of Amir Sulayman (1544 CE)[48] are representative examples of this tradition, which, however, was no longer practiced by the mid-sixteenth century.[49]

For the tilework of the Takiyya al-Sulaymaniyya and the Madrasa al-Salimiyya in Damascus see Hans Theunissen, "War, Propaganda and Architecture: Cemal Pasha's Restoration of Islamic Architecture in Damascus during World War I," in Erik-Jan Zürcher, ed., *Jihad and Islam in World War I. Studies on the Ottoman Jihad on the Centenary of Snouck Hurgronje's "Holy War Made in Germany,"* (Leiden, 2016), 223–73.

[39] Prisse d'Avennes, *L'art arabe*, vol. 2, CXXIV: "Faïences murales. Du Tékyeh des Derwiches. XVIIᵉ siècle." Similar (but not identical) cuerda seca tiles are, however, used in the decoration of the mosque of Muhammad Bey Abu al-Dhahab. It is possible that in Prisse d'Avennes' time the depicted tiles were still extant in Cairo.

[40] Works of nineteenth-century orientalist painters such as Frank Dillon (b. 1823, d. 1909), Rudolf Ernst (b. 1854, d. 1932), Ludwig Deutsch (b. 1855, d. 1935), John Frederick Lewis (b. 1804, d. 1876) and Jean-Léon Gérôme (b. 1824, d. 1904) often present "Cairene scenes" with tiled buildings. Some paintings depict tiles with décors that can indeed be found in Cairene buildings. These paintings, however, are usually not realistic renderings of existing buildings—with some notable exceptions.

[41] Michael Meinecke, "Die mamlukischen Fayencemosaikdekorationen: eine Werkstätte aus Tabriz in Kairo (1330–1350)," *Kunst des Islams* 11, 1/2 (1976–1977), 85–144; Prost, *Les revêtements céramiques*, 1–10.

[42] Gülru Necipoğlu, "From International Timurid to Ottoman: a Change of Taste in Sixteenth-Century Ceramic Tiles," *Muqarnas: An Annual on Islamic Art and Architecture* 7 (1990), 136–70, esp. 137.

[43] Heba Mahmoud Saad Abdel Naby, "The Treatment of the Architectural Unit above Openings of the Mamluk and Ottoman Facades in Cairo," *Journal of Islamic Architecture* 3/2 (December 2014), 82–93.

[44] Prost, *Les revêtements céramiques*, 11–17, 38–39; Herz, *A Descriptive Catalogue*, 221–24; John Carswell, "Six Tiles," in Richard Ettinghausen, ed., *Islamic Art in the Metropolitan Museum of Art* (New York 1972), 99–124; idem, "Some Fifteenth-Century Hexagonal Tiles from the Near East," *Victoria and Albert Museum Yearbook* 3 (London 1972), 59–75; idem, "Sin in Syria," *Journal of Persian Studies* 17 (1979), 15–24; Esin Atıl, *Renaissance of Islam. Art of the Mamluks* (Washington 1981), 149–51 and 176–82; John Carswell, "Two Tiny Turkish Pots—Some Recent Discoveries in Syria," *Islamic Art. An Annual Dedicated to the Art and Culture of the Muslim World* 2 (1987), 203–16; Michael Meinecke, "Syrian Blue-and-White Tiles of the 9th/15th Century," *Damaszener Mitteilungen* 3 (1988), 203–14; Lisa Golombek, "The Paysage as Funerary Imagery in the Timurid Period," *Muqarnas: An Annual on Islamic Art and Architecture* 10 (1993), 241–52; O'Kane, *The Illustrated Guide to the Museum of Islamic Art in Cairo*, 131 and 268.

[45] Prost, *Les revêtements céramiques*, 13–17; Abdülhafız, *Mimari etkileşimler*, 128–29.

[46] Prost, *Les revêtements céramiques*, 13–14; Abdülhafız, *Mimari etkileşimler*, 38–39 and 41–42, also 94; Warner, *Monuments*, 113.

[47] Prost, *Les revêtements céramiques*, 14; Doris Behrens-Abouseif and Leonor Fernandes, "Sufi Architecture in Early Ottoman Cairo," *Annales islamologiques* 20 (1984), 103–14, esp. 112; Warner, *Monuments*, 164.

[48] Prost, *Les revêtements céramiques*, 14–15; Abdülhafız, *Mimari etkileşimler*, 128–29; Williams, *Islamic Monuments*, 238. According to recent social media posts (March 2017) the tiles on the drum of the tomb of Amir Sulayman have now "disappeared."

[49] For an overview of building activities in Ottoman Cairo see André Raymond, "L'activité architecturale au Caire à l'époque ottoman

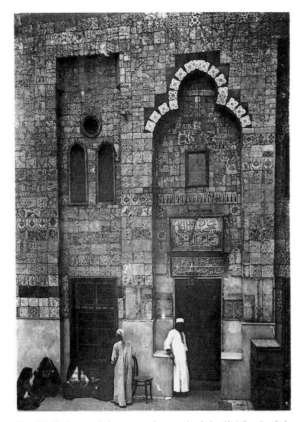

Fig. 12. Early twentieth-century photograph of the tiled façade of the Mausoleum of Ibrahim al-Kulshani in Cairo. After Claude Prost, Les revêtements céramiques dans les monuments musulmans de l'Égypte *(Cairo, 1916), pl. VIII, 1.*

Fig. 14. The tiled façade of the Mausoleum of Ibrahim al-Kulshani in 2008 (photograph by H. Theunissen).

Tiles imported from the Ottoman town of İznik[50] in north-west Anatolia were first introduced in Cairo in the late sixteenth or early seventeenth century. This can be deduced from the tilework in a number of buildings. The colors used on these tiles include the characteristic tomato red (Armenian bole), in addition to cobalt blue, turquoise, (emerald) green, and black (for contour lines) over a white ground. Several tiles on the façade of the mausoleum of Ibrahim al-Kulshani (İbrahim-i Gülşeni)[Index no. 100], part of the *takiyya* complex of al-Kulshani (926–931 AH/1519–1525 CE)[Index no. 332],[51] belong to this late sixteenth–early seventeenth-century group of İznik tiles with the color red. Originally, the complete area above the marble panels on the entrance façade of the tomb of Ibrahim al-Kulshani was faced with tiles. The photograph of the mausoleum in Prost's study shows this nineteenth–early twentieth-century situation (fig. 12). By the 1990s, the tiles on the lower part of the façade above the marble panels had already vanished (fig.13); in the late 2000s, more than half of all tiles had vanished (fig. 14). Bits and pieces still on the wall clearly show that the tiles were removed by force—most likely the work

(1517–1798)," *Annales islamologiques* 25 (1991), 343–59. For Ibrahim al-Kulshani, see Side Emre, *Ibrahim-i Gulshani and the Khalwati-Gulshani Order. Power Brokers in Ottoman Egypt* (Leiden, 2017).

 [50] In this article, all Ottoman tiles produced in İznik and Kütahya are called İznik. Cf. Nurhan Atasoy and Julian Raby, İznik: The Pottery of Ottoman Turkey (London 1989), 74: "The problem, therefore, is how to distinguish 16th and 17th-century Kütahya work from İznik. For the moment we have no choice but to call all Ottoman glazed pottery of the 16th and 17th centuries by the generic label of 'İznik', and to hope that in time we can learn to recognize the diagnostic features of contemporary 'Kütahya ware'."

 [51] Warner, *Monuments*, 145; Williams, *Islamic Monuments*, 158.

of thieves hoping to profit from the high prices Ottoman tiles command at international auctions of Islamic art (fig. 15). The remaining tilework on the façade includes: (most likely locally produced) monochrome green tiles; late sixteenth–early seventeenth-century İznik tiles with the color red; seventeenth-century blue-white-turquoise İznik tiles; Tekfur Sarayı tiles (with red and yellow) from the first half of the eighteenth century; blue-and-white Kütahya tiles from the second half of the eighteenth century; locally produced tiles from the second half of the eighteenth century; imported (eighteenth/nineteenth-century) polychrome North-African tiles; and (most likely nineteenth-century) blue-and-white European tiles with chinoiserie décors (figs. 16–18). This assemblage of tiles with different origins and from various periods, often broken or cut smaller, suggests that the tilework was the result of a later renovation project and that most tiles were reused older tiles.[52] The interior of the mausoleum was probably also renovated as part of the same project. The style of the paintings on the dome and the walls, which include stencilled (faux) tiles (figs. 19–20), indicates that this renovation took place in the first half of the nineteenth century.[53] Both Claude Prost and Doris Behrens-Abouseif refer to a restoration inscription from the 1830s in the nearby mosque of al-Mu'ayyad Shaykh. The panel in question is decorated with tiles similar tiles to those on the façade of the mausoleum of Ibrahim al-Kulshani. This would suggest that both renovations took place at approximately the same time, in the first half of the nineteenth century.[54]

Another building that hosts an intriguing collection of tiles from various production centers and different periods is Bayt (Manzil) al-Suhaymi (1058–1211 AH/1648–1797 CE)[Index no. 339].[55] Once again, the tiled

[52] Prost, *Les revêtements céramiques*, 25–26, mentions tiles from Anatolia, Syria, local production and imported tiles; Bayhan, "Çini kullanımı," 110 mentions "different types of tiles from different periods and in various colors;" Warner, *Monuments*, 145: "The separate stone-domed tomb chamber in the center of the courtyard is lined internally and faced externally with eighteenth-century blue-and-white İznik-style tiles;" Williams, *Islamic Monuments*, 158: "Some of the tiles and fragments are examples of sixteenth-century ceramics;" Behrens-Abouseif and Fernandes, "Sufi Architecture in Early Ottoman Cairo," 103–114, 109: "It is covered with tiles, haphazardly applied on the wall facing the platform. With a few exceptions, all are of the 18th century İznik type. This circumstance and the fact that no tiles are mentioned in the *waqf* indicate that they must be a later addition"; Doris Behrens-Abouseif, "The Takiyyat Ibrahim al-Kulshani in Cairo," *Muqarnas: An Annual on the Visual Culture of the Islamic World* 5 (1988), 43–60, esp. 49: "The façade of the mausoleum dome on the platform side is covered with Ottoman-style tiles of various types, periods, and colours, haphazardly applied. Most of them are of the Iznik type, though a few are monochrome green tiles reminiscent of the tiles on the mosque of Sulayman Pasha in the Citadel (1528, Index 142) and on the Qubbat Shaykh Sa'ud (1534, Index 510), also sponsored by Sulayman Pasha. Neither the waqfiyya of al-Kulshani nor the detailed description of this building made by Evliya Çelebi in the second half of the seventeenth century refers to the tiles. That they were a later addition is confirmed by the way they have been applied on the façade of the dome to hide the crenellation on that side of the building. A nineteenth-century photograph (fig. 11) tells us that the engaged columns at the corners and the original inscription band that flanks the entrance door were also once covered with tiles."

[53] Prost, *Les revêtements céramiques*, 26, mentions that there are no tiles in the interior. Williams, *Islamic Monuments*, 158, notes the painted tiles: "The decoration of the interior is curious: it is a painted facsimile of tiles." Cf. Warner, *Monuments*, 145: "The separate stone-domed tomb chamber in the center of the courtyard is lined internally [...] with eighteenth-century blue-and-white İznik-style tiles;" Behrens-Abouseif, "Takiyyat Ibrahim al-Kulshani," 49–50: "The interior of the dome is today occupied by an enclosure of later date which includes wooden cenotaphs, and the entire interior with stalactite triangular pendentives is painted in an early nineteenth-century style. Two inscription bands, one on the upper part of the rectangular chamber just below the transitional zone and the other between the lower and upper windows, are written in very heavily interlaced late Mamluk thuluth script. Underneath the upper windows of the rectangular chamber is a painted band of inscriptions set in cartouches, executed in nastaliq script. They are quotations from poetry and must have been put there when the interior was painted and tiled."

[54] Prost, *Les revêtements céramiques*, 26, n. 2: "Mosquée Al-Mu'ayyad. Dans le mur est du sanctuaire de la mosquée Al-Mu'ayyad, à droite du mihrâb, se trouvent deux panneaux composés de fragments de faïence assemblés sans ordre et de même genre que ceux du tekieh Al-Gulchâni. Des médaillons en marbre, encastrés dans ce champ de faïence, portent la date de 1254 H. (1838–1839) et mentionnent que « le seigneur Ibrahim, fils du seigneur Alî, serviteur des pauvres de Gulchâni », a restauré cet edifice"; Behrens-Abouseif, "Takiyyat Ibrahim al-Kulshani," 50: "In the sanctuary of the mosque of al-Mu'ayyad, an inscription decorated with tiles similar to those of the Kulshani mausoleum refers to a restoration made by Ibrahim ibn 'Ali, servant of the Kulshani order, in 1255 (1839), presumably the same Ibrahim ibn 'Ali mentioned in the inscription on the sabil added to the façade of the Kulshaniyya. The use of the same types of tile suggests that the restorations of the Kulshaniyya and of al-Mu'ayyad date from the same time and that they included painting, adding the tiles and the sabil, and most likely other work as well."

[55] Bernard Maury, André Raymond, Jacques Revault, and Mona Zakariya, *Palais et maisons du Caire. Tome II Époque ottomane (XVIᵉ–XVIIIᵉ siècles)*(Aix-en-Provence, 1983), 199–212; Warner, *Monuments*, 146; Williams, *Islamic Monuments*, 201–3. Other Cairene houses with Ottoman-period tilework (not included in this study): Manzil (Bayt) Gamal al-Din al-Dhahabi (1044 AH/1634–1635 CE)[Index no. 72]. See Maury, et al., *Palais et maisons du Caire*, 150–56; Warner, *Monuments*, 102; and Williams, *Islamic Monuments*, 164–65; house in the *waqf* of Zaynab Khatun (873 AH/1468–1469 CE–1125 AH/1713–1714 CE)[Index no. 77]. See Jacques Revault, Bernard Maury and Mona Zakaria, *Palais et mai-*

Fig. 21. Tilework of the great qa'a of the harem in Bayt al-Suhaymi in Cairo (late eighteenth–early nineteenth century) (photograph by H. Theunissen).

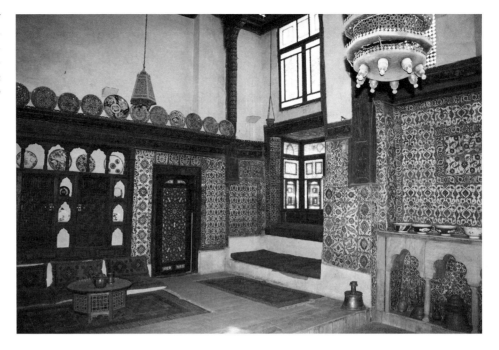

interior of one of the main rooms in this private residence (the great *qa'a* of the harem) seems to be the result of a renovation project—this time from the end of the eighteenth century or the beginning of the nineteenth century (fig. 21). Among the tiles used in the interior are: late sixteenth–early seventeenth-century İznik tiles with the color red; seventeenth-century blue-white-turquoise İznik tiles; Tekfur Sarayı tiles from the first half of the eighteenth century; locally produced tiles from the second half of the eighteenth century (among which imitations of imported Ottoman tiles); imported (eighteenth-/nineteenth-century) polychrome North African tiles; and imported (eighteenth-/nineteenth-century) southern European tiles (figs. 22–23). Among the seventeenth-century blue-white-turquoise İznik tiles are also the tiles with the décors that formed the models for the stencilled (faux) tiles in the interior of the mausoleum of Ibrahim al-Kulshani (fig. 24). Examples of these tiles can also be found on the façade of the mausoleum itself, and in the Aqsunqur Mosque, and the adjacent mausoleum of Ibrahim Agha Mustahfizan, which might well have been the source of these tiles. "Cannibalization" of tiles seems to have been common practice because there are more tiles in the Takiyya al-Kulshani and Bayt al-Suhaymi with identical décors. This suggests that another part of the tiles used for the decoration of both buildings may originally have come from yet other (unknown) sources. Moreover, this corroborates that older tiles were reused (possibly even several times) over longer periods of time and shows that tiles (even broken ones) formed an important form of architectural decoration in Cairo until well into the nineteenth century. In addition, this discussion of the tiles in these two buildings clearly indicates that we are dealing with tiles from different periods and from various production centers (both inside and outside the Ottoman Empire). Although İznik plays an important role in this story, it is, however, by no means the only production center that contributed to Cairene tile culture.

sons du Caire, du XIV^e *au XVIII*^e *siècle, Tome III* (Cairo, 1979), 1–12; Warner, *Monuments*, 103; Williams, *Islamic Monuments*, 173–74: "Ottoman Tunesian tiles;" Manzil (Bayt) al-Sadat al-Wafa'iyya (1070 AH/1659–1660 CE–1168 AH/1754–1755 CE)[Index no. 463]. See Maury, et al., *Palais et maisons du Caire*, 242–48; Warner, *Monuments*, 158; and Williams, *Islamic Monuments*, 153: "Turkish tiles cover the walls"; Manzil (Bayt) Ibrahim Katkhuda al-Sinnari (1209 AH/1794–1795 CE)[Index no. 283]. See Maury, et al., *Palais et maisons du Caire*, 249–57; Williams, *Islamic Monuments*, 155–56; Manzil (Bayt) al-Kiridliyya/Manzil (Bayt) Amna bint Salim (1041 AH/1631–1632 CE–947 AH/1540–1541 CE [Index no's 321 and 559]. See Maury, et al., *Palais et maisons du Caire*, 171–79; Williams, *Islamic Monuments*, 54–56. For more houses with tilework (at the beginning of the twentieth century) see Prost, *Les revêtements céramiques*, 34–35. For a middle-class house with tile decoration, see Nelly Hanna, "Bayt al-Istambulli: An Introduction to the Cairene Middle Class House of the Ottoman Period," *Annales Islamologiques* 16 (1980), 299–319.

Fig. 29. İznik tile lunette of the Hadım İbrahim Paşa Mosque in İstanbul (1551) (photograph by H. Theunissen).

Fig. 32. İznik tiles in the Tomb of Prince Mustafa (Muradiye Complex) in Bursa (1570s) (photograph by H. Theunissen).

Red İznik

Before İznik became the most important Ottoman center for the manufacture of tiles in the second half of the sixteenth century, its craftsmen had already enjoyed a reputation as makers of high quality pottery since the 1470s.[56] Tiles for royal commissions, however, were, until the mid-sixteenth century, mainly produced by specialist (and sometimes itinerant) tilemakers working for the Ottoman court. At the beginning of the fifteenth century, the "Masters of Tabriz" produced tilework such as that of the Yeşil Cami (Green Mosque) Complex in Bursa (1420s)(fig. 25) and the Muradiye Mosque in Edirne (1430s)(fig. 26). After the conquest of Constantinople in 1453 CE, these tilemakers probably moved to the new capital İstanbul. However, there were more tilemakers at work in the capital at that time. A group of Khurasani tilemakers was responsible for the tilework of the Çinili Köşk (Tiled Pavilion) of Topkapı Palace (fig. 27). These tilemakers probably later moved to Bursa. The first indications for the production of tiles in İznik date from the early sixteenth century. These tiles were, however, not used in royal building projects in the capital. In İstanbul, a separate development took place. The 1510s–1520s saw the emergence of a centralized organization of ceramicists resulting in the establishment of a court workshop in the capital, which was active from the 1520s to the early 1550s (fig. 28). In the 1550s, the Ottoman court and elite for the first time "outsourced" the production of tiles for royal and elite commissions to the ceramicists of İznik. The tilework of the Hadım İbrahim Paşa Mosque (1551 CE)(fig. 29) and that of the Süleymaniye Mosque Complex (1550–57 CE)(fig. 30) are the first examples of İznik tilework in the capital and illustrate the change in taste from

[56] For İznik pottery, see Atasoy and Raby, *İznik.*

an international Timurid decorative repertoire to a distinctly Ottoman vocabulary, characterized by vegetative-floral motifs painted in bold colors over a white ground under a transparent glaze.[57]

Early İznik tiles have a color scheme consisting of cobalt blue, turquoise, sage or olive green, eggplant (manganese) purple, and black for contour lines (fig. 31). However, in the 1550s–1560s, sage green and manganese purple were replaced by a strong emerald green and a fiery tomato red (Armenian bole)(fig. 32). At the beginning of the seventeenth century, the red tends to become less bright, sometimes even dull brownish (although occasionally a high quality bright red was still used, depending on the available finances) and the emerald green often runs, leading to less bold colors and less crisply painted décors (fig. 33). In general, the quality of the İznik tiles declined. İznik products from the "Red" period (1550s–1630s) also include tiles with a predominantly blue-white-turquoise color scheme; and occasionally green is the leading color of the tiles, with red playing a more supportive role (fig. 34).[58]

"Red İznik" tiles can be found in a whole range of buildings in Cairo, among which a considerable number of *sabil-kuttab*s. A chronological survey of these buildings reveals interesting patterns with respect to the ways the tiles were used and also provides clues to when the tiles were applied. The oldest building with Red Iznik tiles is the mosque of Ulmas (730 AH/1329–1330 CE)[Index no. 130]. The mihrab of this mosque was still decorated with tiles in the nineteenth century; however, already in Prost's time these tiles were no longer there. In terms of the tilework of this mosque, today only the tiled lunette over the entrance to the building remains.[59] The lunette is lined with two different tiles with red. At both ends of the lunette are pieces of blue-white-turquoise tiles with an identical décor to the tiles decorating the mihrab of the mosque of Malika Safiyya and a number of tiles in the mihrab of the mosque of Alti Barmaq. A similar layout is used for the tiled lunette of the *sabil* of Mustafa Sinan (1040 AH/1630–1631 CE)[Index no. 246](fig. 35).[60] The lunette over the grilled window of the *sabil* has inlays of one type of tile with red (similar to tiles used to decorate the outer wall of the Privy Chamber complex in Topkapı Palace and the Sultan Ahmed Mosque in İstanbul) and at both ends pieces of the same blue-white-turquoise tile as in the mosque of Ulmas, the mosque of Malika Safiyya, and the mosque of Alti Barmaq (fig. 36). The carved stonework roundels and corner elements at both sides of and above the stone inscription over the *sabil* window are inlaid with two different types of Red İznik tiles—one of which is the same as in the lunette—and small pieces of the same blue-white-turquoise tile as in the lunette (fig. 37). The large tiles are cut to size in order to fit into the available space and smaller pieces of tile are used to fill any remaining empty spaces. Similar cut-to-size inlays of blue-white-turquoise tiles are used to decorate the mihrab of the mosque of Malika Safiyya (1019 AH/1610–1611 CE)[Index no. 200](fig. 38).[61]

The interior of the *sabil*-tomb of 'Umar Agha (1063 AH/1652–1653 CE)[Index no. 240] was originally also decorated with tiles. However, in 1894, these tiles were transferred to the (then) Museum of Arab Art. The tiles are depicted in Herz's 1907 catalogue.[62] The same type of tile is also used on the qibla wall of the mosque of Alti Barmaq (Altı Parmak). According to the Index, the mosque of Alti Barmaq was built in 1123 AH/1711–1712 CE [Index no. 126]. This date is generally accepted; both Warner[63] and Williams[64] give the same date. However,

[57] Gülru Necipoğlu, *The Age of Sinan. Architectural Culture in the Ottoman Empire* (London, 2005), 216–20, 394–96; Necipoğlu, "From International Timurid to Ottoman," 136–58.

[58] Atasoy and Raby, *İznik*, 96–272; Venetia Porter, *Islamic Tiles* (London, 1995), 92–111; John Carswell, *İznik Pottery* (London, 1998), 56–89 and 106–11.

[59] Prost, *Les revêtements céramiques*, 26 and n. 3. Warner, *Monuments*, 110, and Williams, *Islamic Monuments*, 111, do not mention the tiled lunette.

[60] Prost, *Les revêtements céramiques*, 29; al-Husaynī, *al-Asbila al-'Uthmāniyya*, 143–44; Bayhan, "Çini kullanımı," 110, includes this *sabil* in a list of buildings with tiles but does not give a description; Warner, *Monuments*, 134, mentions "a tiled lunette and roundels with tile inlays"; Williams, *Islamic Monuments*, 92, mentions "floral spray tiles."

[61] Bates, "Tile Revetments," 41, mentions "Iznik tiles of late 16th century;" Abdülhafiz, *Mimari etkileşimler*, 56–57; Bayhan, "Çini kullanımı," 107, mentions İznik tiles; Warner, *Monuments*, 124, does not mention tiles; Williams, *Islamic Monuments*, 147–48, mentions "blue İznik tiles."

[62] Prost, *Les revêtements céramiques*, 28; Herz, *A Descriptive Catalogue*, 227; al-Husaynī, *al-Asbila al-'Uthmāniyya*, 164–65; Bayhan, "Çini kullanımı," 111. Warner, *Monuments*, 133, and Williams, *Islamic Monuments*, 87, do not mention tiles.

[63] Warner, *Monuments*, 109.

[64] Williams, *Islamic Monuments*, 93–94.

Fig. 35. Tiled façade of the sabil of Mustafa Sinan in Cairo (1630–1631) (photograph by H. Theunissen).

Bates,[65] Abdülhafiz,[66] and Bayhan[67] attribute the mosque to the first half of the seventeenth century. These authors refer to Evliya Çelebi, who gives a description of the mosque that fits the current building.[68] Hence, it is likely that the mosque already existed before the 1670s. Evliya Çelebi, however, does not mention tiles in his description of the mosque. The tiles line the qibla wall and the mihrab.[69] The qibla wall is faced with two types of Red İznik tiles and one type of Red İznik border tile with mainly floral motifs. They resemble tiles of the early seventeenth-century Sultan Ahmed Mosque in İstanbul. The lower part of the mihrab was originally lined with blue-white-turquoise tiles. On old photographs this original layout is still visible.[70] Today, however, only a few original tiles remain. At present, the lower part of both the qibla wall and the mihrab is retiled with modern blue and green sanitary tiles. The hood of the mihrab is decorated with pieces of cut tiles of all types used on the qibla wall and the lower mihrab. The hood is separated from the lower wall by a band of border tiles. The way the tiles are used is reminiscent of Mamluk-style mihrabs and qibla walls with polychrome marble inlay panels. The craftsmen who were responsible for the tiling of the mihrab evidently tried to imitate the layout of Mamluk-style marble inlay mihrabs by consciously using different types of tiles for the hood and the lower wall of the mihrab. On the qibla wall to the right of the mihrab are some eighteenth-century Tekfur Sarayı tiles, used to repair tile loss on the lower part of the wall. These tiles are already visible on old photographs and this suggests that this restoration took place in the second half of the eighteenth or the nineteenth century. The type of tiles used in the Alti Barmaq Mosque—which can also be found in the mosque of Malika Safiyya, the *sabil* of Mustafa Sinan, and the tomb-*sabil* of 'Umar Agha—suggests that the tiles and the building are actually contemporary: both probably date from the first half of the seventeenth century.[71]

[65] Bates, "Tile Revetments," 41, does not give a date, but mentions that the construction of the mosque must predate Evliya Çelebi's visit.

[66] Abdülhafiz, *Mimari etkileşimler*, 59, gives the date 1031 AH/1621–1622 CE.

[67] Bayhan, "Çini kullanımı," 107, states that the mosque was built before 1627 CE.

[68] Kahraman, et al., *Evliya Çelebi Seyahatnamesi*, vol. 10, 122.

[69] Bates, "Tile Revetments," 41: "The glaze on the tiles is discolored, and pigments are rather muddy. The square tiles were produced elsewhere at yet unidentified site, and sent to Cairo"; Bayhan, "Çini kullanımı," 107, attributes the tiles to İznik or the island of Roda. This last attribution is a misunderstanding of Williams' reference to "Rhodian because they were once thought to have been made on the island of Rhodes" (in Greece, that is to say not the Cairene island of Roda). Williams, *Islamic Monuments*, 94, mentions "a fine set of İznik tiles manufactured between 1550 and 1700;" Warner, *Monuments*, 109, mentions "İznik tiles decorating the surround to the mihrab."

[70] Edmond Pauty, "L'Architecture au Caire depuis la conquête ottomane (vue d'ensemble)," *BIFAO* 36 (1936–1937), 1–69, pl. III, d.

[71] Cf. Williams, *Islamic Monuments*, 94: "The mihrab is decorated with a fine set of İznik tiles manufactured between 1555 and 1700"

However, all other buildings in Cairo decorated with tiles from the Red İznik period were built later than the mid-seventeenth century. The first of these buildings is the mosque of Mustafa Shurbaji (Çorbacı) Mirza in Bulaq (1110 AH/1698–1699 CE)[Index no. 343]. In this building, tiles are used to decorate the upper walls above the Mamluk-style marble dadoes on the qibla wall and part of the adjacent east and west walls. Most tiles belong to a later group of İznik tiles from the second half of the seventeenth century with decors painted in cobalt blue, turquoise, and green (hereafter called "Blue İznik"); some tiles, however, belong to the earlier Red İznik group.[72] The use of tiles from both groups on the same walls suggests that all are most probably reused tiles that were originally used in other buildings before being "cannibalized" for the decoration of the mosque of Mustafa Shurbaji Mirza. This is probably also the case with the tiles used to decorate a series of early eighteenth-century *sabil-kuttab*s.[73] The *sabil-kuttab*s of ʿAli Bey al-Dumyati, Abu al-Iqbal ʿArifin Bey, Ibrahim Bey al-Munastirli, Mustafa Musali Shurbaji, Muhammad Mustafa al-Musahibji, Bashir Agha Dar al-Saʾada (Hacı Beşir Ağa), Muhammad Kathuda Mustahfizan, and Amir ʿAbdallah all have tiled lunettes over the *sabil* windows and/or over the entrance doors, which also include Red İznik tiles from the end of the sixteenth–first half of the seventeenth centuries.

The *sabil-kuttab* of ʿAli Bey al-Dumyati (1122 AH/1710–1711 CE)[Index no. 197] has a lunette with Red İznik tiles over one of the two windows of the *sabil*.[74] The tilework is no longer complete, but all remaining tiles have the same floral décor with red carnations (fig. 39). As can be seen on an old photograph, the lunettes over the second *sabil* window and over the entrance door were originally also lined with tiles (fig. 40). The tiles used for these lunettes were most likely locally produced copies of Tekfur Sarayı tiles from the 1750s–1760s. This suggests that the tilework of the *sabil-kuttab* of ʿAli Bey al-Dumyati was—at least partially—added later and not during the construction of the building. The *sabil-kuttab* of Abu al-Iqbal ʿArifin Bey (1125 AH/1713–1714 CE)[Index no. 73] also has tiled lunettes over the windows of the *sabil* (fig. 41).[75] One lunette is filled with tiles with a décor of *saz* leaves filled with tulips and various stylized vegetative and floral motifs (fig. 42). These tiles are identical to the most frequently used tile in the lunette over the entrance of the mosque of Ulmas. Like in the lunette of the mosque of Ulmas, the tips of the lunette are lined with pieces of Blue İznik tiles. This suggests that this type of layout, which originates in the first half of the seventeenth century, was still used in the early eighteenth century. Because the same types of tiles are used in both the mosque of Ulmas and the *sabil-kuttab* of ʿAli Bey al-Dumyati and because of the similar layout, the tilework in the lunette over the entrance of the mosque of Ulmas was probably also added somewhere in the first half of the eighteenth century, possibly during the renovation of the building after the collapse of the minaret in 1713 CE.[76] The second lunette of the *sabil-kuttab* of Abu al-Iqbal ʿArifin Bey is decorated with a number of identical tiles, but also lined with other types of tiles that were most likely added during a later restoration (fig. 43). The tiles used to repair the original tilework are mainly Tekfur Sarayı tiles from the first half of the eighteenth century and one piece of a Blue İznik tile from the seventeenth century. This repair work most likely took place in the second half of the eighteenth or the nineteenth century.

The *sabil-kuttab* of Ibrahim Bey al-Munastirli (1126 AH/1714–1715 CE)[Index no. 508] has a tiled lunette over the entrance and tile inlays in the carved stone strapwork decoration above and to the right and left of the lunette.[77] All Red İznik tiles have the same floral décor with red carnations, similar (but not identical) to that

and "The quality of the tiles indicates that they were probably made earlier than the building"; Warner, *Monuments*, 109: "The İznik tiles decorating the surround to the mihrab are older than the building itself, dating between 1555 and 1700." Abdülhafiz, *Mimari etkileşimler*, 62, attributes the tiles to the seventeenth century.

[72] Abdülhafiz, *Mimari etkileşimler*, 144–48, mentions the two types of tiles; Bayhan, "Çini kullanımı," 109, attributes the tiles to İznik and the first half of the seventeenth century; Williams, *Islamic Monuments*, 257: "the tiles are late and not of the best quality." See also Meinecke-Berg, "Die osmanische Fliesendekoration," 60.

[73] For an overview of Ottoman period *sabil-kuttab*s see André Raymond, "Les fontaines publiques (sabil) du Caire à l'époque ottomane (1517–1798)," *Annales islamologiques* 15 (1979), 235–91; al-Husaynī, *al-Asbila al-ʾUthmāniyya*.

[74] Al-Husaynī, *al-Asbila al-ʾUthmāniyya*, 199–200; Bayhan, "Çini kullanımı," 111, includes this *sabil-kuttab* in a list of buildings with tiles but does not give a description; Warner, *Monuments*, 123, does not mention tiles.

[75] Al-Husaynī, *al-Asbila al-ʾUthmāniyya*, 201–02; Bayhan, "Çini kullanımı," 111, includes this *sabil-kuttab* in a list of buildings with tiles but does not give a description; Warner, *Monuments*, 102, mentions "tiled lunettes."

[76] Williams, *Islamic Monuments*, 111.

[77] Al-Husaynī, *al-Asbila al-ʾUthmāniyya*, 203–04; Bayhan, "Çini kullanımı," 111, includes this *sabil-kuttab* in a list of buildings with tiles but

of the tiles of the *sabil-kuttab* of ʿAli Bey al-Dumyati. The *sabil-kuttab* of Mustafa Musali Shurbaji Mustahfizan (1127 AH/1715–1716 CE)[Index no. 232] has tiled lunettes over the entrance and the window of the *sabil*.[78] The décor of the Red İznik tiles in the lunette over the entrance consists of a vase filled with flowers painted in red, blue, green, and black, flanked by green cypress trees. The Blue İznik tiles of the lunette over the *sabil* window have a décor of swirling leaves filled with flowers painted in cobalt blue, turquoise, and green. The *sabil-kuttab* of Muhammad Mustafa al-Muhasibji (1129 AH/1716–1717 CE)[Index no. 329] has one tiled lunette over the *sabil* window (fig. 44).[79] The lunette is mainly lined with tiles with the same décor as those of the *sabil-kuttab* of Abu al-Iqbal ʿArifin Bey and the mosque of Ulmas. The décor consists of *saz* leaves filled with tulips and various stylized vegetative and floral motifs (fig. 45). This suggests that, in the 1710s, tiles with this particular décor were available in larger numbers on the Cairene market for second-hand tiles. It is not unlikely that they originate from the same (unknown) source. There is one Red İznik tile with a different décor in the middle of the lunette (a border tile of a tile panel). The use of this single different tile creates a contrast pattern that is a variation of the layout with different tiles at both ends of a lunette. A similar tilework layout can also be seen in the tiled lunette over one of the *sabil* windows of the *sabil-kuttab* of Bashir Agha Dar al-Saʿada (Hacı Beşir Ağa)(1131 AH/1718–1719 CE)[Index no. 309](fig. 46).[80] In the middle of a lunette filled with seventeenth-century Blue İznik tiles—identical tiles are also used for the

Fig. 40. Early twentieth-century photograph of the sabil-kuttab of ʿAli Bey al-Dumyati. The lunettes over the sabil window and the entrance of the building are here still lined with Tekfur Sarayı tiles. After Ludwig Borchardt and Herbert Ricke, Ägypten. Landschaft Volksleben Baukunst *(Berlin-Vienna-Zürich, 1929), 9.*

decoration of the tomb of Ibrahim al-Kulshani and the Aqsunqur Mosque—is one Red İznik tile with a décor of stylized vegetative and floral motifs in cobalt blue, turquoise, green, red, and black, which originally must have been part of a tile panel (fig. 47).

The *sabil-kuttab* of Muhammad Katkhuda Mustahfizan (1131 AH/1718–1719 CE)[Index no. 150] has two tiled lunettes, one over the main *sabil* window in the façade and one over a small window in the right side wall

does not give a description; Williams, *Islamic Monuments*, 46, mentions that the building is "distinguished by its decoration of tiles."

[78] Al-Husaynī, *al-Asbila al-ʾUthmāniyya*, 205–06; Bayhan, "Çini kullanımı," 111, includes this *sabil-kuttab* in a list of buildings with tiles but does not give a description; Warner, *Monuments*, 131, does not mention tiles.

[79] Al-Husaynī, *al-Asbila al-ʾUthmāniyya*, 207; Bayhan, "Çini kullanımı," 111, includes this *sabil-kuttab* in a list of buildings with tiles but does not give a description; Warner, *Monuments*, 144, mentions "tiled lunettes;" Williams, *Islamic Monuments*, 148, does not mention tiles.

[80] Al-Husaynī, *al-Asbila al-ʾUthmāniyya*, 208–09; Bayhan, "Çini kullanımı," 111, includes this *sabil-kuttab* in a list of buildings with tiles but does not give a description; Warner, *Monuments*, 142, does not mention tiles; Williams, *Islamic Monuments*, 151, also does not mention tiles. For the *waqf* and Bashir Agha himself, see Hamza ʿAbd al-ʿAziz Badr and Daniel Crecelius, "The awqaf of al-Hajj Bashir Agha in Cairo," *Annales islamologiques* 27 (1993), 291–308; Jane Hathaway, *Beshir Agha. Chief Eunuch of the Ottoman Imperial Harem* (Oxford 2005). For the role of the Ottoman *Darü ʾs-Saade Ağası* (head eunuch) in Egypt see also Jane Hathaway, "The Role of the Kızlar Ağası in 17th–18th Century Ottoman Egypt," *Studia Islamica* 75 (1992), 141–58; idem, *The Politics of Households in Ottoman Egypt* (Cambridge, 1997), 139–64; idem, "Exiled Chief Harem Eunuchs as Proponents of the Hanafi Madhhab in Ottoman Cairo," *Annales islamologiques* 37 (2003), 191–99.

(fig. 48).[81] This last lunette is filled with Red İznik tiles with a décor of swirling stylized vegetative and floral motifs (fig. 49). The lunette over the main *sabil* window, however, is faced with eighteenth-century Tekfur Sarayı tiles (fig. 50), which were not yet available when the *sabil-kuttab* was built. This tilework is thus most likely the result of a renovation in the second half of the eighteenth century or the nineteenth century. The last *sabil-kuttab* with Red İznik tiles is that of Amir ʿAbdallah Katkhuda ʿAzaban (1132 AH/1719–1720 CE)[Index no. 452].[82] The lunette over the *sabil* window is filled with various types of Blue İznik tiles with, in the middle, one Red İznik tile with a décor of an eight-pointed star filled and surrounded with stylized vegetative and floral motifs in turquoise, cobalt blue, green, red, and black (fig. 51). This type of tile is also used to decorate the outer wall of the Privy Chamber complex in Topkapı Palace (fig. 52).

Red İznik tiles are used in two specific periods. The tiles used in the first half of the seventeenth century are usually contemporary with the buildings in which they are used. However, Red İznik tiles used at the end of the seventeenth and in the early eighteenth centuries are most probably always cannibalized, reused tiles. Red İznik tiles are often consciously used in combination with for instance blue-white-turquoise İznik tiles (from the Red İznik or Blue İznik period) in order to create contrast patterns, either by placing contrasting blue-white-turquoise tiles at the tips of a tile lunette or by placing a Red Izik tile in the middle of a lunette otherwise lined with blue-white-turquoise tiles. The application of tiles itself is also an expression of a Cairene preference for contrast patterns. The tiles function as colorful accents on walls, either as inlays in carved stonework (façade decoration, lunettes, mihrabs, etc.) or as facing of upper walls over polychrome marble inlay dadoes on lower walls. Tiles are thus used in similar ways as (Mamluk-style) polychrome marble inlay panels and illustrate a characteristic Cairene taste for architectural decoration.

Blue İznik

At the beginning of the seventeenth century, a combination of factors, including a conflict of interests between the court in İstanbul and the ceramicists in İznik (who were selling tiles to outsiders, hence delaying deliveries to the court), a withdrawal of royal patronage (caused by a decline in royal building projects), and socioeconomic problems (social unrest, inflation) led to the production of cheaper tiles. Consequently, the quality of İznik tiles started to drop and standardization set in.[83] Moreover, the 1630s saw a return to early sixteenth-century international Timurid aesthetic preferences, characterized by tiles with an underglaze-painted blue-white-turquoise color scheme. In buildings from that period, these tiles were often used in combination with existing sixteenth-century polychrome cuerda seca tiles. Such combinations are found in the Revan en Baghdad Pavilions (built between 1635 and 1638 CE)(fig. 53) and the Sünnet Odası (Circumcision Room, renovated in 1641 CE)(fig. 54) in Topkapı Palace.[84] The tilework of the Çinili Cami (Tiled Mosque)(1640–1641 CE) in Üsküdar (fig. 55), the Yeni Cami (New Mosque) Complex (1660s)(fig. 56) in İstanbul, and the Imperial Hall (1660s) and Twin Pavilions (mid-seventeenth century)(fig. 57) of Topkapı Palace illustrates the continued popularity of the "Blue İznik" color scheme in the remainder of the seventeenth century (1630s–c. 1700). Blue İznik tiles also often use the color green in addition to cobalt blue and turquoise. In some tilework, green gains a more prominent position and sometimes even dominates the color scheme. A preference for cobalt blue and turquoise also does not exclude the use of tomato red, as can been seen on some of the tile panels of the tomb of *Valide Sultan* Hatice Turhan and the *hünkar mahfili* (sultan's prayer lodge) of the Yeni Cami Complex (fig. 58). The color red is, however, less dominant. Contour lines are usually painted in cobalt blue and no longer in black. The décors of Blue İznik are standardized, the motifs are painted less precisely and with less detail, and the often dull colors have sometimes run (fig. 59). In general, the technical quality and the designs of the products are less outstanding when compared

[81] Al-Husaynī, *al-Asbila al-ʿUthmāniyya*, 212–13; Warner, *Monuments*, 115, mentions "tile lunettes over the sabil grilles;" Williams, *Islamic Monuments*, 95, does not mention tiles.

[82] Al-Husaynī, *al-Asbila al-ʾUthmāniyya*, 210–11; Warner, *Monuments*, 157, mentions "tile inlay;" Williams, *Islamic Monuments*, 62, does not mention tiles.

[83] Atasoy and Raby, *İznik*, 273–80.

[84] Gülru Necipoğlu, *Architecture, Ceremonial and Power. The Topkapı Palace in the Fifteenth and Sixteenth Centuries* (New York, 1991), 189–97; Necipoğlu, "From International Timurid to Ottoman," 151–55.

with Red İznik tiles from the last quarter of the six-teenth century.[85]

İznik tiles with a predominantly blue color palette are by far the most common imported Ottoman tile in Cairo. Even today, the city hosts an impressive number of buildings decorated with Blue İznik tiles. It is possible to discern three distinct categories: pre-seventeenth-century buildings decorated with Blue İznik tiles, contemporary buildings decorated with Blue İznik tiles, and eighteenth- and nineteenth-century buildings decorated with Blue İznik tiles.

The Blue İznik tiles above the mihrab in the *zawi-yya* (dervish lodge) and *sabil* of Faraj ibn Barquq (811 AH/1408–1409 CE)[Index no. 203][86] belong to the first group (fig. 60). The tiles are used to decorate the area over the mihrab. It is likely that originally more tiles were used. However, today only an incomplete border remains. These tiles were possibly added in the second half of the seventeenth century. The *sabil-kuttab* of Khalil Efendi al-Muqati'ji (1042 AH/1632–1633 CE)[Index no. 71] has a lunette over the main *sabil* window filled with a row of Blue İznik border tiles standing on their sides (fig. 61).[87] These tiles are similar to those of the Aqsunqur Mosque. The building is older than the tiles, which must have been added later, most likely in the second half of the seventeenth century.

The tile inlays of the lunette and the carved stone strapwork decoration on the façade of the *sabil* of Mustafa Bey Tabtabay (1047 AH/1637–1638 CE)[Index no. 272][88] also have a blue-white-turquoise color scheme. The contour lines are painted in both black and cobalt blue. The décor consists of stylized vegetative and floral motifs filled with small flowers. From a technical and stylistic point of view, this tile does not belong to the Blue İznik period, but to the Red İznik period during which tiles with a predominantly blue-white-turquoise color palette were also produced. The tiles can tentatively be attributed to the early seventeenth century (before c. 1635, most likely 1610s–1620s).

The second group comprises by far the most buildings and clearly shows that in the mid-seventeenth century imports from İznik reached a peak; for the first time, huge amounts of Blue İznik tiles were used to decorate entire buildings. The most famous example is the mosque of Aqsunqur (fig. 62) and the adjacent tomb of Ibrahim Agha Mustahfizan (fig. 63), the military commander who was responsible for the renovation of this originally

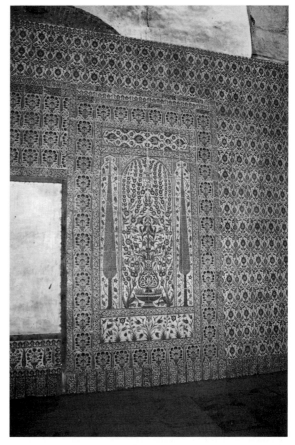

Fig. 62. Blue-white-turquoise İznik tiles on the qibla wall of the Aq-sunqur Mosque in Cairo (renovated in 1650–1652). The photograph was taken before the restoration of 2009–2015 (photograph by H. Theunissen).

[85] Cf. Veronika Gervers-Molnár, "Turkish Tiles of the 17th Century and their Export," in Géza Fehér, ed., *Fifth International Congress of Turkish Art* (Budapest, 1978), 363–84, 263–64.

[86] Warner, *Monuments*, 125, and Williams, *Islamic Monuments*, 106, do not mention tiles. In the early twentieth century the building was moved for the widening of a street and subsequently restored. In the early 2000s, the building was once again restored. It is likely that the present tiles are the remains of the Ottoman-period tilework in the interior and were not added during one of the later restorations.

[87] Prost, *Les revêtements céramiques*, 28; al-Husaynī, *al-Asbila al-'Uthmāniyya*, 147–48; Bayhan, "Çini kullanımı," 110, includes this *sabil-kuttab* in a list of buildings with tiles but does not give a description; Warner, *Monuments*, 102, does not mention tiles.

[88] Prost, *Les revêtements céramiques*, 29; al-Husaynī, *al-Asbila al-'Uthmāniyya*, 156–57; Bayhan, "Çini kullanımı," 110, includes this *sabil* in a list of buildings with tiles but does not give a description; Warner, *Monuments*, 138, mentions "a tiled lunette"; Williams, *Islamic Monuments*, 118: "The tiles are nice examples of Iznik ware in cobalt and turquoise."

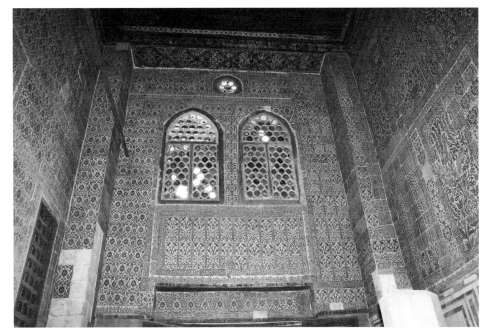

Fig. 63. Blue-white-turquoise İznik tiles in the tomb of Ibrahim Agha Mustahfizan in Cairo (1650–1652). The photograph was taken before the restoration of 2009–2015 (photograph by H. Theunissen).

Mamluk mosque complex (747–748 AH/1346–1348 CE)[Index no. 123] in 1061–1062 AH/1650–1652 CE. The Blue İznik tiles have given the complex its alternative name: the Blue Mosque (fig. 64). Viktoria Meinecke-Berg has studied the tilework of the Aqsunqur Complex in detail and has convincingly shown that the designs of the tilework are linked to the designs of the tiles of the Revan and Baghdad Pavilions in Topkapı Palace and the Çinili Cami from the 1630s–early 1640s, and of the Yeni Cami Complex and Topkapı Palace from the 1660s.[89] The Blue İznik tiles are mainly used in the mosque on the qibla wall around the marble inlay mihrab and in the tomb over the marble inlay dadoes that face the lower walls. The tiles are arranged in the form of large panels with borders. Special border tiles are used for the framing of unified-field panels with depictions of mihrab-like niches with vases with flowers or cypresses or panels consisting of repeating modular tiles (fig. 65). By profiting from the difference in the general impression of the tiles, which predominantly use cobalt blue and turquoise on a white background, one type of tile is successfully used to frame another type of tile. The application of tiles in the Aqsunqur Mosque Complex shows that dark tiles usually frame panels of lighter tiles. The same principle is also used with marble inlay panels where light borders frame darker panels and vice versa. The qibla wall also has a number of Red İznik tiles and other blue-white-turquoise tiles that clearly do not belong to the original Blue İznik tilework of the complex.[90] These were most likely added during a later (nineteenth or twentieth century) restoration in order to prevent further tile loss. Some of these tiles can also be found in other Cairene buildings; one Red İznik tile, for instance, is the same as the one that was originally used to decorate the *sabil*-tomb of

[89] Prost, *Les revêtements céramiques*, 19–22; Meinecke-Berg, "Die osmanische Fliesendekoration," 39–62; Meinecke-Berg, "Osmanische Fliesendekorationen," 153–59. See also Bates, "Tile Revetments," 42; Bayhan, "Çini kullanımı," 107–8; Warner, *Monuments*, 108; Williams, *Islamic Monuments*, 85–87: "The tiles were imported from either İstanbul or Damascus. They are typical of the tiles called Iznik, made in that city, although later imitated in other places. During the sixteenth and seventeenth centuries, tiles were an important feature of interior decoration of Ottoman mosques. The beautiful combination of light indigo and turquoise is the characteristic color scheme, while the designs show plants and cut flowers: cypress trees, carnations, tulips, bluebells, peach blossoms, and the long, serrated leaves known as *saz*. Ottoman tiles are used sparingly in Cairo, which is surprising considering the Ottoman fondness for them and the proximity of Damascus, where Iznik tiles were imitated until 1759. This mosque, in the tomb-chamber and on the qibla wall, exhibits the most lavish local use of tile as wall decoration." Williams' suggestion that the tiles might have come from Damascus is not correct.

[90] These tiles were still on the qibla wall until the late 2000s. However, the mosque was restored (as part of the Aga Khan Trust for Culture's conservation and revitalization project of Darb al-Ahmar) and reopened in 2015. I have not been able to verify if these tiles are still there. For the restoration see: https://ismailimail.wordpress.com/2015/05/03/the-cairo-post-cairos-blue-mosque-inaugurated-after-6-year-restoration/; https://ismailimail.wordpress.com/2015/05/05/the-aqsunqar-mosque-in-cairo-marks-the-intervention-of-three-significant-patrons/; https://www.wmf.org/project/jama%E2%80%99-al-aqsunqur-blue-mosque.

'Umar and the mosque of Alti Barmaq, and one blue-white-turquoise tile is identical to the tiles used to decorate the *sabil* of Mustafa Bey Tabtabay (fig. 66).

Although today no tiles remain in the mosque of Amir 'Abidin ('Abdin/'Abdi) (renovated in 1070–1071 AH/1659–1661 CE)[Index no. 524], Evliya Çelebi mentions that (in the 1670s) both the walls and the mihrab of this mosque were lined with tiles.[91] Since there must have been a substantial number of tiles, it is likely that these tiles belong to the same Blue İznik group as those of the Aqsunqur Mosque and the tomb of Ibrahim Agha Mustahfizan.[92] According to Abdullah Atia Abdülhafiz, the tiles were still there at the beginning of the twentieth century, though many had fallen off the walls. Subsequently, some of the tiles ended up in the Museum of Arab Art.[93] The 1907 catalogue, however, does not mention the tiles (and neither do the 1955 and 2012 guides).

Another building that was tiled in the same years is the domed shrine with the Footprint of the Prophet Muhammad part of the Athar al-Nabi Mosque Complex [Index no. 320].[94] Evliya Çelebi mentions the tilework of the shrine, which was built in 1073–1074 AH/1662–1664 CE) by Ottoman governor İbrahim Paşa.[95] The mihrab and qibla wall, and the other walls of the shrine are lined with Blue İznik tiles.[96] All tile types in the shrine are also used in the Aqsunqur Complex, which, however, has a wider range of tiles with different décors. The tiles of the shrine are all standard repeating modular tiles including border tiles, whereas in the Aqsunqur Complex there are also numerous unified-field panels.

More tiles from the same mid-seventeenth-century period are used to decorate the "Porcelain Mosque" (Masjid al-Sini, i.e., the Chinese or Tiled Mosque) in the center of Girga (Jirje), in Ottoman times an important seat of provincial government in Upper-Egypt. The mosque, which was built in 1711 and reconstructed in 1774–1775 CE, has a tiled lunette over the entrance door and in the interior a tiled mihrab and tiled walls. Parts of the lower walls are not (or are no longer) faced with tiles. The tiles are "nailed" to the walls with one large nail through a hole in the middle of the tile. The tilework mainly consists of repeating modular tiles of the same types as in the Aqsunqur Mosque in Cairo, but also includes a small unified-field panel in the mihrab.[97] These Blue İznik tiles were most likely first used in a (now no longer existing, unknown) building in mid-seventeenth-century Cairo[98] and later cannibalized and reused to decorate the "Porcelain Mosque," either when the mosque was built or reconstructed in the eighteenth century or not long thereafter. The person responsible for the tiling of the "Porcelain Mosque" must have been a person of power and wealth and most probably belonged to elite circles who had access to and could afford to buy a large stock of Ottoman tiles.[99] Second-hand tiles were evidently still treasured commodities in the eighteenth century.

From the late 1660s onwards, a whole series of Cairene buildings—mainly *sabil-kuttabs*—was decorated with Blue İznik tiles. The tiles are usually applied to lunettes or used as inlays in carved stonework façade decoration. In general, only small numbers of tiles are used. Moreover, the tilework often consists of an assemblage of small

[91] Kahraman, et al., *Evliya Çelebi Seyahatnamesi*, vol. 10, 167.

[92] Prost, *Les revêtements céramiques*, 26, mentions that the Mosque of al-Mar'a has a lunette over the entrance lined with Blue İznik tiles from the same group as as those of the Aqsunqur Mosque and the tomb of Ibrahim Agha Mustahfizan. Warner, *Monuments*, 123, however, does not mention these tiles. Prost, *Les revêtements céramiques*, 27, mentions that the mosque of al-Gawhari (1261–1265 AH/1845–1848 CE) [Index no. 462] also has a lunette and spandrels lined with Aqsunqur-type tiles. Warner, *Monuments*, 158, however, does not mention these tiles. Bayhan, "Çini kullanımı," 108, mentions Blue İznik tiles used to decorate a tomb (of 'Ukba ibn 'Amir) that was renovated in 1655 CE.

[93] Abdülhafiz, *Mimari etkileşimler*, 67; Bayhan, "Çini kullanımı," 108, thinks these tiles were brought from İstanbul.

[94] For Footprint shrines, see Perween Hasan, "The Footprint of the Prophet," *Muqarnas: An Annual on the Visual Culture of the Islamic World* 10 (1993), 335–43; Anthony Welch, "The Shrine of the Holy Footprint in Delhi," *Muqarnas: An Annual on the Visual Culture of the Islamic World* 14 (1997), 166–78; Christiane Gruber, "The Prophet Muhammad's Footprint," in Robert Hillenbrand, Andrew Peacock, and Firuza Abdullaeva, eds., *Ferdowsi, the Mongols and the History of Iran. Art, Literature and Culture from Early Islam to Qajar Persia* (London, 2013), 297–305.

[95] Prost, *Les revêtements céramiques*, 23–24; Kahraman, et al., *Evliya Çelebi Seyahatnamesi*, vol. 10, 140; Meinecke-Berg, "Osmanische Fliesendekorationen," 153–54; Meinecke-Berg, "Die osmanische Fliesendekoration," 59.

[96] Bayhan, "Çini kullanımı," 108, states that the tiles were brought from Anatolia.

[97] Prost, *Les revêtements céramiques*, 22, 49–50.

[98] Cf. Gervers-Molnár, "Turkish Tiles of the 17th Century," 369: "reused 17th-century tiles rescued from a building which had been destroyed by floods."

[99] Most likely, either Amir Muhammad Bey Çerkes who had built the mosque in 1711 or Shaykh 'Abd al-Mun'im Abu Bakr who was responsible for the reconstruction of the mosque in 1774–1775. Hamza 'Abd al-'Aziz Badr and Daniel Crecelius, "The Waqf of the Amir 'Isa Agha Çerkis. A Circassian Legacy in XVIIIth Century Jirje," *Annales islamologiques* 32 (1998), 239–47, esp. 240.

pieces with various décors. This suggests that no new large deliveries of İznik tiles reached Cairo after c. 1660 CE and that most tiles used in these buildings were cannibalized tiles originating from other buildings.

The mosque and *sabil* of Aqsunqur al-Farikani al-Habashli (1080 AH/1669–1670 CE)[Index no. 193] was built by Muhammad Katkhuda Mustahfizan and has lunettes lined with Blue İznik tiles over the entrance to the mosque and over the window of the *sabil* on the corner of the complex.[100] The tilework of the lunettes is no longer complete. The remaining tiles belong to the same types as in the Aqsunqur Mosque Complex. The *sabil-kuttab* of Udah (Oda) Basha/Bashi (or Dhu al-Fiqar)(1084 AH/1673–1674 CE)[Index no. 17] has elaborate carved stonework façade decoration inlaid with two types of Blue İznik tiles (fig. 67). One type is a repeating modular tile and the other a border tile.[101] The repeating modular tiles on the façade have a décor which is—as far as I have been able to verify—not used in the Aqsunqur Mosque Complex. This tile also lines the lunette over the *sabil* window of the contemporary *sabil-wikala* of Udah (Oda) Basha/Bashi (1084 AH/1673–1674 CE)[Index no. 591](fig. 68).[102] Besides this, the same tile is also used for the inlays of the carved stonework façade decoration of the slightly later *sabil-kuttab* of Yusuf Agha Dar al-Sa'ada (1088 AH/1677–1678 CE), and for the lunette over the *sabil* entrance of the mid-eighteenth-century *sabil-kuttab* of Sultan Mustafa III (1172–1173 AH/1758–1760 CE). This suggests that these tiles probably have the same origin, but do not belong to the delivery, which was used to decorate the Aqsunqur Mosque Complex and a number of other buildings.

The *sabil-kuttab* of Yusuf Agha Dar al-Sa'ada (1088 AH/1677–1678 CE)[Index no. 230] has tiled lunettes and carved stonework decoration with tile inlays on its façade (fig. 69). Originally, the walls of the *sabil* interior were also faced with Blue İznik tiles; however, today, only a few tiles remain.[103] Three different types of Blue İznik tiles have been used for the tile inlays of the carved stonework decoration above one of the *sabil* windows (fig. 70). One of these three tiles is also used in the Aqsunqur Mosque Complex. The lunettes over the second *sabil* window and the entrance, however, are filled with border tiles (figs. 71–72). The *sabil-kuttab* of 'Abbas Agha[104] ('Ali Katkhuda 'Azaban)(1088 AH/1677–1678 CE)[Index no. 335] has tiled lunettes over the two *sabil* windows (fig. 73).[105] Most of the tilework is gone, but the lunettes probably were originally lined with one type of tile with a vegetative-floral décor painted in blue, turquoise, green, and black over a white ground (fig. 74). One of the lunettes has at the right tip pieces of another type of tile (which is also used in the Aqsunqur Mosque Complex) (fig. 75). These pieces were most likely added during a later restoration. The mosque of Dhu al-Fiqar Bey (1091 AH/1680–1681 CE)[Index no. 415] has a tiled lunette over the entrance and tile inlays in the carved stone strapwork surrounding the inscription above the entrance (fig. 76).[106] The tilework is incomplete, but some of the remaining pieces suggest that part of the tiles was identical to the tiles used in the Aqsunqur Mosque Complex. In the interior, the carved stone strapwork of the mihrab has inlays of blue-and-white Kütahya tiles from the second half of the eighteenth century. These inlays are most likely the result of a renovation in the late eighteenth or early nineteenth century.

[100] Al-Husaynī, *al-Asbila al-'Uthmāniyya*, 168; Bayhan, "Çini kullanımı," 108, mentions tiled lunettes and tile decoration on the mihrab. He thinks the tiles were brought over from Anatolia. However, the recently renovated mihrab no longer has tile decoration; Warner, *Monuments*, 123, and Williams, *Islamic Monuments*, 143, do not mention tiles.

[101] Al-Husaynī, *al-Asbila al-'Uthmāniyya*, 169–70; Bayhan, "Çini kullanımı," 110, includes this *sabil-kuttab* in a list of buildings with tiles but does not give a description; Warner, *Monuments*, 90, mentions "a tiled lunette over the sabil window"; Williams, *Islamic Monuments*, 213, mentions "panels of blue-and-green Turkish tiles."

[102] Al-Husaynī, *al-Asbila al-'Uthmāniyya*, 171–72; Bayhan, "Çini kullanımı," 110, includes this *sabil* in a list of buildings with tiles but does not give a description; Warner, *Monuments*, 169, mentions "a tiled lunette above the window opening"; Williams, *Islamic Monuments*, 210, mentions "lunettes of Turkish tiles."

[103] Prost, *Les revêtements céramiques*, 27 and 29–30; al-Husaynī, *al-Asbila al-'Uthmāniyya*, 180–86; Bayhan, "Çini kullanımı," 111, mentions "Anatolian tiles in the interior"; Warner, *Monuments*, 131, mentions "tiled lunettes" and blue-and-white tiles that once lined the interior, "many of which have gone missing"; Williams, *Islamic Monuments*, 98, mentions "a lunette of tiles" and "panels of blue-and-white tiles."

[104] For 'Abbas Agha, who was responsible for the renovation of the *sabil-kuttab* originally built by 'Ali Agha 'Azaban, see Jane Hathaway, "The Wealth and Influence of an Exiled Ottoman Eunuch in Egypt: The Waqf Inventory of 'Abbas Agha," *JESHO* 37 (1994), 293–317.

[105] Al-Husaynī, *al-Asbila al-'Uthmāniyya*, 177; Warner, *Monuments*, 145, and Williams, *Islamic Monuments*, 58, do not mention tiles.

[106] Abdülhafiz, *Mimari etkileşimler*, 141–43, mentions "blue-white-green tiles of which most are missing"; according to Bayhan, "Çini kullanımı," 108, the tiles resemble those of the Altı Barmaq Mosque; Williams, *Islamic Monuments*, 153, does not mention tiles.

The *sabil-kuttab* of Hasan Agha Koklian (Göñüllüyan)(1106 AH/1694–1695 CE)[Index no. 243] has incomplete tiled lunettes over the two *sabil* windows (fig. 77).[107] The lunettes are lined with a Blue İznik tile with a décor of swirling stylized vegetative and floral motifs, which is also used in the Aqsunqur Mosque Complex (figs. 78–79). The *sabil-kuttab* of Hasan Katkhuda (Hasan Efendi Katib 'Azaban)(1113 AH/1701–1702 CE)[Index no. 405] also has a tiled lunette over the *sabil* window.[108] The tilework is incomplete; the remaining tiles belong to a type that is also used in the Aqsunqur Mosque Complex. The décor consists of a vase filled with cornflowers flanked by cypresses. The construction period of this last *sabil-kuttab* (c. 1700 CE) coincides with the construction period of the first building from the group of buildings decorated with Red İznik tiles at the end of the seventeenth and in the early eighteenth centuries (the mosque of Mustafa Shurbaji Mirza in Bulaq). This suggests that after the second half of the seventeenth century, when mainly Blue İznik tiles were used to decorate buildings, a shortage of Blue İznik tiles forced Cairene patrons and craftsmen to start reusing both Red İznik and Blue İznik tiles in combination with each other. However, aesthetic preferences may also have played a role in this development.

On the basis of this survey of Red and Blue İznik, it is now possible to make a preliminary chronology of the use of İznik tiles as a form of decoration in seventeenth–early eighteenth-century Cairene architecture:

1. Red İznik tiles (including tiles with a blue-white-turquoise color scheme) from the end of the sixteenth and the first half of the seventeenth centuries are used to decorate contemporary buildings (mainly from the first half of the seventeenth century);

2. Blue İznik tiles from the mid-seventeenth century are used in large numbers in the 1650s and 1660s to decorate contemporary buildings. Buildings from the period c. 1670 to c. 1700 CE are usually decorated with small numbers of reused Blue İznik tiles. The exception to this pattern is the tilework of the mosque of Mustafa Shurbaji Mirza in Bulaq, which still has a considerable number of Blue İznik tiles. These tiles were, however, most likely not contemporary but cannibalized from an earlier building;

3. From c. 1700 until c. 1720 CE both Red İznik and Blue İznik tiles are reused to decorate buildings—usually on a small scale and often in combination with each other;

4. In a number of cases, later tiles (from the eighteenth century) are used to repair incomplete tilework. This indicates that in the eighteenth and nineteenth centuries existing (but damaged) tilework was still considered important enough to be maintained and renovated.

Tekfur Sarayı

The demise of İznik as the main center for the production of tiles in the Ottoman Empire in the beginning of the eighteenth century led to a stagnation in the supply of tiles for royal building projects in the capital İstanbul. Initially, the court tried to obtain tiles from Kütahya, another Anatolian production center for ceramics. However, a dwindling supply and the low quality of the products forced the court in the late 1710s to set up an alternative production center in İstanbul, which had to satisfy the growing demand for tiles as a result of the construction boom in the capital. The new workshops were located in a former Byzantine palace called in Ottoman-Turkish Tekfur Sarayı (Emperor's Palace). Among the tilemakers of the new royal workshops were potters originally from İznik.[109] The manufacture of tiles must have started in the early 1720s and most likely

[107] Prost, *Les revêtements céramiques*, 30; al-Husaynī, *al-Asbila al-'Uthmāniyya*, 192–93; Bayhan, "Çini kullanımı," 111, includes this *sabil-kuttab* in a list of buildings with tiles but does not give a description; Warner, *Monuments*, 133, mentions "tiled lunettes over the bronze window grilles at ground level"; Williams, *Islamic Monuments*, 94, mentions a "nice lunette of blue-and-white tiles."

[108] Al-Husaynī, *al-Asbila al-'Uthmāniyya*, 197–98; Warner, *Monuments*, 152, and Williams, *Islamic Monuments*, 118, do not mention tiles.

[109] Ahmet Refik, "İznik çinileri," *Darülfünun Edebiyat Fakültesi mecmuası* 8/4 (1932), 36–53, esp. 47–51; Robert Anhegger, "Quellen zur osmanischen Keramik," (= Chapter XII) in Katharina Otto-Dorn, *Das islamische Iznik* (Berlin, 1941), 165–95, esp. 194–95; Ahmed Refik, *Onikinci asr-ı hicrî'de İstanbul hayatı (1689–1785)*(İstanbul, 1988), 65 and 71; Zeki Sönmez, "Türk çiniciliğinde Tekfur Sarayı imalatı çiniler," *Antika. The Turkish Journal of Collectable Art* 27 (Haziran, 1987), 29–35; Filiz Yenişehirlioğlu, "Tekfur Sarayı çinileri ve Eyüp çömlekçiliği," in Gönül Öney and Zehra Çobanlı, eds., *Anadolu'da Türk devri çini ve seramik sanatı* (İstanbul, 2007), 349–61; Atasoy and Raby, *İznik*, 287–88; Hans Theunissen, "Tekfur Sarayı: Een korte maar fascinerende periode in de Turkse tegelgeschiedenis," *Tegel* 38 (2010), 12–18.

continued until the early 1750s.[110] Initially, the Tekfur Sarayı workshops produced tiles in an İznik revivalist style (fig. 80), but in the late 1720s new motifs began to appear. These motifs were intrinsically linked to stylistic developments in the decorative arts of that period (fig. 81). In the second half of the 1730s and first half of the 1740s, tile production seems to have been at a low level. However, in the second half of the 1740s until the demise of the Tekfur Sarayı workshops in the early 1750s, production rebounded. The products of that period also reflect new stylistic developments such as the introduction of Baroque-Rococo motifs in the Ottoman decorative canon (fig. 82). The Tekfur Sarayı workshops used a rich color palette that included cobalt blue, turquoise, green, black, red, and yellow (fig. 83). Yellow was not used in İznik tiles from the Red and Blue periods and this suggests that technical expertise from Kütahya, whose potters did use yellow at the beginning of the eighteenth century, also reached İstanbul, possibly because ceramicists from Kütahya were brought to the capital in order to work in the new workshops of Tekfur Sarayı.[111]

The first building in Cairo decorated with Tekfur Sarayı tiles is the mosque of 'Uthman Katkhuda (1147 AH/1734–1735 CE)[Index no. 264], which has a tiled lunette and carved stone strapwork with tile inlays over the entrance to the mosque and tiled lunettes over two of the four lower windows in the street façade.[112] All Tekfur Sarayı tiles are identical and belong to the İznik revivalist type. The *sabil-kuttab* of Sitt Saliha (1154 AH/1741–1742 CE)[Index no. 313](fig. 84) has a (partially) tiled lunette over the *sabil* window and the carved stonework decoration of the wall between the entrance and the *sabil* window has tile inlays (fig. 85–86).[113] These tiles have a décor consisting

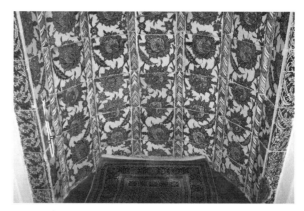

Fig. 80. İznik revivalist Tekfur Sarayı tiles in the mihrab of the Cezeri Kasım Paşa Mosque in Eyüp/İstanbul (1725–1726) (photograph by H. Theunissen).

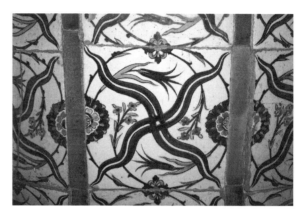

Fig. 81. Tekfur Sarayı tiles with a décor of çintamani tiger stripes and needle tulips in the Hekimoğlu Ali Paşa Mosque in İstanbul (1732–1735) (photograph by H. Theunissen).

Fig. 82. Tekfur Sarayı tiles with Baroque-Rococo motifs on a wall in the court of the Valide Sultan (Queen Mother) in Topkapı Palace (late 1740s) (photograph by H. Theunissen).

[110] Sönmez, "Tekfur Sarayı," 31, thinks production continued until 1735. However, Filiz Yenişehirlioğlu, "Tekfur Sarayı çini fırınları kazısı 1995–2001," *24. Kazı sonuçları toplantısı* (Ankara, 2003), 329–44, 331 and 336, suggests that production continued until c. 1750. The chronological reconstruction of Tekfur Sarayı tile production in Theunissen, "Tekfur Sarayı," 12–18, corroborates Yenişehirlioğlu's statement and suggests that production must have continued until the early 1750s.

[111] Theunissen, "Tekfur Sarayı," 13–18.

[112] Prost, *Les revêtements céramiques*, 26; Abdülhafiz, *Mimari etkileşimler*, 149–51, mentions the "Turkish-style tile" lunette over the entrance; Bayhan, "Çini kullanımı," 109, attributes the tiles to Tekfur Sarayı; Williams, *Islamic Monuments*, 213, does not mention tiles.

[113] Al-Husaynī, *al-Asbila al-'Uthmāniyya*, 215–19; Bayhan, "Çini kullanımı," 111, includes this *sabil-kuttab* in a list of buildings with tiles but does not give a description; Williams, *Islamic Monuments*, 154, mentions "tile panels."

of the çintamani motif (a combination of two tiger stripes and three leopard spots) in combination with Chinese cloud bands. This décor is identical to that of the çintamani tiles used to decorate the fountain of Sultan Ahmed III, near the entrance gate of Topkapı Palace (built in 1141 AH/1728–1729 CE)(fig. 87). The second window of the *sabil* in the side street also has a lunette with identical Tekfur Sarayı tiles at both ends of the lunette. In between are two identical Red İznik tiles and three different types of Blue İznik tiles. Two of these Blue İznik tiles are the same as tiles used in the Aqsunqur Mosque Complex; the third has a décor that is also used on Blue İznik tiles on the façade of the Sünnet Odası (Circumcision Room) in Topkapı Palace, which was renovated in the early 1640s. It seems that these tiles were later added to repair tile loss. Originally, the lunette may have been tiled with only Tekfur Sarayı tiles with the çintamani décor.

The *sabil-kuttab* of 'Abd al-Rahman Katkhuda (1157 AH/1744–1745 CE)[Index no. 21][114] is by far the most famous of all Cairene *sabil-kuttab*s (fig. 88).[115] The interior of the *sabil* has tiled walls from the marble floor molding up to the ceiling (fig. 89). The walls are lined with Tekfur Sarayı tiles, both repeating modular and border tiles. The Tekfur Sarayı tilework also includes a partially preserved inscription panel with the text of a supplication (fig. 90), a tile panel with a depiction of Mecca (fig. 91),[116] and a partially preserved tile

Fig. 91. Tekfur Sarayı tile panel with a depiction of Mecca in the sabil of 'Abd al-Rahman Katkhuda (late 1740s) (photograph by H. Theunissen).

[114] Prost, *Les revêtements céramiques*, 30–31, correctly remarks that an originally Moroccan ceramicist (working in Cairo) was responsible for part of the tilework, but does not suggest an origin for the other tiles; al-Husaynī, *al-Asbila al-'Uthmāniyya*, 220–27; Bates, "Tile Revetments," 43, "cannot attribute the tiles to a specific center of production," but mentions that the "picture panel illustrating Mecca is very close to those produced in the Tekfur Sarayi kilns in İstanbul in early 18th century in its rendition"; Bayhan, "Çini kullanımı," 111, repeats the information given by Bates; Warner, *Monuments*, 90–91: "The interior of the sabil is lined with pseudo-Iznik blue-and-white tiles and, unusually, includes a tiled mihrab"; Williams, *Islamic Monuments*, 195: "The interior of the sabil is faced with tiles imported from Syria, among which the representation of the Ka'ba at Mecca in the northwest corner is interesting."

[115] For 'Abd al-Rahman Katkhuda and his works, see André Raymond, "Les constructions de l'émir 'Abd al-Rahman Katkhuda au Caire," *Annales islamologiques* 11 (1972), 235–51; Doris Behrens-Abouseif, "The 'Abd al-Rahman Katkhuda Style in 18th Century Cairo," *Annales islamologiques* 26 (1992), 117–26.

[116] For Mecca tile panels see Kurt Erdmann, "Ka'bah-Fliesen," *Ars Orientalis* 3 (1959), 192–97; S. Erken, "Türk çiniciliğinde Kâbe tasvirleri," *Vakıflar Dergisi* 9 (1971), 297–320; Zübeyde Cihan Özsayıner, "Eyüp Cezeri Kasım Paşa Camisindeki Kabe Tasvirli Çini Pano Bağlamında Kabe Tasvirleri," *Tarihi, Kültürü ve Sanatıyla VIII. Eyüp Sultan Sempozyumu, Tebliğler (7–9 Mayıs 2004)*(Istanbul, 2004), 84–89; Zeki Sönmez, "Eyüp'te Cezerî Kasım Paşa Camii ve Çinileri," in Oktay Belli, Yüvel Dağlı and M. Sinan Genim, eds., *İzzet Gündağ Kayaoğlu Hatıra Kitabı-Makaleler* (İstanbul, 2005), 408–17; Theunissen, "Tekfur Sarayı," 13–16; Charlotte Maury, "Depictions of the Haramayn on Ottoman Tiles," in Venetia Porter and Liana Saif, eds., *The Hajj: Collected Essays* (London, 2013), 143–59.

The Museum of Islamic Art in Cairo has five tile panels/tiles with depictions of the Holy Cities of Islam: 1. An İznik tile with a depiction of Mecca dated 1074 AH/1663–1664 CE; 2. A large İznik tile panel dated 1087 AH/1676–1677 with a depiction of Mecca; 3. A large mid-seventeenth-century İznik tile panel with a depiction of a mihrab and Mecca; 4. A Tekfur Sarayı tile with a depiction of Mecca dated 1139 AH/1726–1727 CE and signed by Muhammad al-Shami (Mehmed el-Şami); 5. A Tekfur Sarayı tile with a depiction of Medina dated 1141 AH/1728–1729 CE. For these tiles, see Herz, *A Descriptive Catalogue*, 227, 239; Mostafa, *The Museum of Islamic Art*, 68, 71 and fig. 60; O'Kane, *The Illustrated Guide to the Museum of Islamic Art in Cairo*, 14–15 and 263–64. O'Kane (mistakenly) suggests that all these tiles and tile panels were made in Damascus.

Fig. 102. The tiled interior of the sabil of Sultan Mahmud I (1750–1751) (photograph by H. Theunissen).

panel with the standard Ottoman-Turkish mihrab verse[117] and a depiction of a mihrab with a hanging lamp—a reference to the Qur'anic Light Verse (fig. 92).[118] Locally produced blue-white-turquoise tiles imitating the décor of the Tekfur Sarayı tiles complement the imported tiles (fig. 93). The same local copies of Tekfur Sarayı tiles are also used to line the lunette over the entrance of the (earlier) *zawiyya* of ʿAbd al-Rahman Katkhuda (1142 AH/1729 CE)[Index no. 214].[119] These tiles were most likely later added to the lunette. The use of locally produced tiles in the *sabil-kuttab* of ʿAbd al-Rahman Katkhuda suggests that there were not enough Tekfur Sarayı tiles in order to completely line all walls. More locally produced tiles in the same color scheme are used over the windows and mimic the carved stonework decoration with vegetative and floral motifs on the façade of the building (fig. 94). Some of the motifs of this carved stone decoration were inspired by motifs on earlier Red and Blue İznik tiles used in other buildings in Cairo. Motifs on imported İznik tiles thus inspired carved stonework façade decoration, which, in its turn, influenced locally produced tiles. During the Egyptian-German restoration of the *sabil-kuttab* in the early 1980s, modern Kütahya copies of the Tekfur Sarayı tiles were used to repair tile loss on the lower walls (fig. 95).[120] Some of these "lost" tiles may actually have been taken from the *sabil* in the first half of the nineteenth century because identical tiles (both Tekfur Sarayı and locally produced repeating modular and border tiles) are used together on the façade of the tomb of Ibrahim al-Kulshani (fig. 96). ʿAbd al-Rahman Katkhuda also built the mosque and *sabil-kuttab* of Shaykh Mutahhar in 1157 AH/1744–1745 CE [Index no. 40]. The lunette over the entrance of this complex is lined with seventeenth-century Blue İznik tiles (fig. 97).[121] The décor consists of Chinese clouds and stylized vegetative and floral motifs, among which serrated leaves filled

[117] Q 3: 37: "Whenever Zachariah went in to her in the Sanctuary."

[118] Q 24: 35: "God is the Light of the heavens and the earth; the likeness of His Light is as a niche wherein is a lamp (the lamp in a glass, the glass as it were a glittering star) kindled from a Blessed Tree, an olive that is neither of the East nor of the West whose oil wellnigh would shine, even if no fire touched it; Light upon Light; (God guides to His Light whom He will.) (And God strikes similitudes for men, and God has knowledge of everything)."

[119] Bayhan, "Çini kullanımı," 110, states that the tiles are a local product; Warner, *Monuments*, 127, and Williams, *Islamic Monuments*, 109, do not mention tiles.

[120] Philipp Speiser, "The Egyptian-German Restoration of the Darb al-Qirmiz, Cairo," in Jere Bacharach, ed., *The Restoration and Conservation of Islamic Monuments in Egypt* (Cairo 1995), 22–45, 30.

[121] Al-Husaynī, *al-Asbila al-ʾUthmāniyya*, 228–29; Bayhan, "Çini kullanımı," 111, includes this *sabil-kuttab* in a list of buildings with tiles but does not give a description; Warner, *Monuments*, 96, does not mention tiles; Williams, *Islamic Monuments*, 181, also does not mention tiles (but she did in the 1993 [fourth] edition of the book, p. 177: "lunette of tiles over the door").

*Fig. 107. Mid-eigh-
teenth-century Dutch
purple-and-white tiles
in the sabil of Sultan
Mahmud I (photograph
by H. Theunissen).*

with flowers. Similar leaves are also used as motifs on the carved stonework over the entrance. The tiles seems to have been a direct source of inspiration for the carved stonework, which resembles that of the contemporary *sabil-kuttab* of ʿAbd al-Rahman Katkhuda (fig. 98).

The madrasa and *sabil-kuttab* of Sultan Mahmud I (1164 AH/1750–1751 CE)[Index no. 308](figs. 99–100) is decorated with tiles both on the façades of the building (fig. 101) and in the interior of the *sabil* (fig. 102). The lower walls of the *sabil* are lined with marble panels. A carved painted and gilded wooden border in Ottoman Baroque-Rococo style separates the marble panels from the tiled upper walls (fig. 103). The tilework on the upper walls is a true collection of tiles ranging from the sixteenth century to the eighteenth century: Red İznik tiles including two (incomplete) high-quality tile panels from the last quarter of the sixteenth century (fig. 104), seventeenth-century Blue İznik tiles (fig. 105), eighteenth-century Tekfur Sarayı tiles (fig. 106), mid-eighteenth-century locally produced tiles, and mid-eighteenth-century Dutch purple-and-white tiles (figs. 107–108).[122] Tile loss on the lower part of the walls was (in the nineteenth and/or twentieth centuries) repaired with a variety of tiles that do not belong to the original layout of the tilework. Among these tiles are Red İznik tiles, Blue İznik tiles, Tekfur Sarayı tiles, locally produced eighteenth-century tiles, eighteenth-century blue-and-white Kütahya tiles, and tiles resembling eighteenth-century Syrian (Damascus) tiles (fig. 109). The exterior of the building has tiled lunettes over entrances, tile inlays in carved stonework decoration, and tiled architraves over columns (fig. 110). The tiles used are Red İznik tiles, Blue İznik tiles, Tekfur Sarayı tiles, and locally produced eighteenth-century tiles.[123] The main part of the original tilework (including the Dutch tiles) was brought over from İstanbul

[122] For the Dutch tiles, see Theunissen, "Sabil-kuttab van Sultan Mahmud I in Caïro," 27–31.

[123] Prost, *Les revêtements céramiques*, 32–33, attributes the tiles to İznik, Kütahya, Syria and Europe; al-Husaynī, *al-Asbila al-'Uthmāniyya*, 232–47; Bates, "Tile Revetments," 44, only mentions the tiles on the façade of the building ("tiles [sic] pieces are used sparingly"); Abdülhafız, *Mimari etkileşimler*, 95–106, mentions tiled lunettes, tiles on the façade of the building, and Ottoman and Dutch tiles in the interior; Bayhan, "Çini kullanımı," 110, mentions "classical" tiles from the sixteenth and seventeenth centuries; Warner, *Monuments*, 141–42, mentions "tiled inlay panels" and "the sabil's interior with blue-and-white Iznik-style tiles"; Williams, *Islamic Monuments*, 150, mentions "İznik tiles"; Behrens-Abouseif, "Mahmud I," 198: "The walls are paneled with Ottoman tiles of various styles. Two tile panels centered by oval medallions of high-quality İznik ceramic of the late sixteenth century form the major attraction of the sabil's decoration. Placed in the upper part of the northern wall, they are illuminated by the three large windows facing them. The panels were probably not in pristine condition when they arrived in Cairo; both lack their original lower border, which has been replaced by tiles with repetitive motifs. The space between the two panels is also filled with repetitive seventeenth-century tiles in shades of blue. There are also some tiles of the Tekfur Saray production established in İstanbul by Sultan Ahmed III, while others may be of European origin. [...] However, with their wide range of colors, the two high-

Fig. 112. Tekfur Sarayı tiles with Baroque-Rococo motifs in the sabil of Sultan Mahmud I (late 1740s) (photograph by H. Theunissen).

for this project and includes tiles depicting needle tulips, which are characteristic of the second phase of Tekfur Sarayı tile production (1730s)(fig. 111), and tiles with Baroque-Rococo motifs characteristic of the last phase of Tekfur Sarayı tile production (second half of the 1740s–early 1750s)(fig. 112). Among the Tekfur Sarayı tiles used for the restoration of the original tilework are also tiles from these last two phases.[124]

Another royal project from the middle of the eighteenth century is the *sabil-kuttab* of Sultan Mustafa III (1172–1773 AH/1758–1760 CE)[Index no. 314], which has a lunette over the entrance to the *sabil* lined with Blue İznik tiles (fig. 113) and an interior completely decorated with blue-and-white Dutch tiles with various décors (fig. 114).[125] Identical Dutch tiles were also used to decorate various rooms of Topkapı Palace. Like the tiles for the complex of Sultan Mahmud I,

these tiles were brought over from İstanbul especially for this prestigious royal project. At some places, the original tilework is repaired with blue-white-turquoise İznik tiles, Tekfur Sarayı tiles, blue-green-yellow-purple tiles with Baroque-Rococo motifs, and other tiles (fig. 115).[126] Especially the tiles with the blue-green-yellow-purple color palette and black contour lines are intriguing. Some of these tiles seem to originally have been part of a large panel (fig. 116). Among the tiles is also a fragment of a large tile with a depiction of a medaillon with a palace along a waterway (fig. 117). This is reminiscent of images of the Sa'd-abad Palace in Kağıthane (İstanbul) or palaces along the Bosporus. Another tile copies a Dutch tile with "Dubbele stricken" (Double bows) décor, which was produced from c. 1775 CE onwards and is also used to decorate the façade of the *Sünnet Odası* (Circumcission Pavilion) in Topkapı Palace (fig. 118).[127] The mixture of traditional and Baroque-Rococo elements and the large format of the tiles suggest an Ottoman origin. The Dutch influence, the color scheme, and the loose way of painting point at the last quarter of the eighteenth century (1780s–1790s) and possibly Kütahya as the period and place of manufacture.

In the middle of the eighteenth century, the production of the Tekfur Sarayı workshops came to an end. At the same moment, the Ottomans began to import tiles from Europe (Italy, Spain, and the Netherlands).[128] The *sabil-kuttab*s of Sultan Mahmud I and Mustafa III illustrate this development. Whereas in the first building we find purple-and-white Dutch tiles alongside Ottoman tiles, including Tekfur Sarayı tiles produced in the late 1740s, in the second building we only find blue-and-white Dutch tiles (apart from several later additions). In the second half of the eighteenth century, Dutch tiles in particular played an important role in the decoration of Ottoman interiors, mainly in İstanbul and Ottoman Syria (fig. 119).[129] In Cairo, however, no more Dutch tiles ar-

quality Iznik panels within the sabīl of Sultan Mahmud may have been unparalleled in Cairo and could not have passed unnoticed. They may have been made for some princely monument in İstanbul in the sixteenth century and then transferred to Cairo when they became redundant in the course of some renovation or "baroquification" of this monument, as often happened in eighteenth-century İstanbul."

[124] Theunissen, "Tekfur Sarayı," 17–18.

[125] Prost, *Les revêtements céramiques*, 47, mentions Turkish and Dutch tiles; al-Husaynī, *al-Asbila al-'Uthmāniyya*, 255–57; Abdülhafiz, *Mimari etkileşimler*, 109–14, refers to sources that assume the blue-and-white tiles are of German origin; Bayhan, "Çini kullanımı," 111, only mentions the eighteenth-century Dutch tiles in the interior; Williams, *Islamic Monuments*, 155, mentions "blue-and-white Delft tiles."

[126] Theunissen, "Nederlandse tegels in de sabil-kuttab van Sultan Mustafa III in Caïro," 26–32; Theunissen, "Sabil-Kuttab of Sultan Mustafa III in Cairo," 1–283; Jongstra and Theunissen, "Caïro revisited," 12–17; Jaap Jongstra, "Nederlandse tegels in Caïro," *Vormen uit vuur* 215/216 (2011/4–2012/1), 50–59.

[127] Hans Theunissen, "Dutch Tiles in 18th-Century Ottoman Baroque-Rococo Interiors: *Hünkâr Sofası* and *Hünkâr Hamamı*," *Sanat Tarihi Dergisi* 18/2 (October 2009), 71–135, 116.

[128] Hatice Adıgüzel, "Topkapı Sarayı'ndaki Avrupa çinilerinin üretim merkezleri ışığında değerlendirilmesi," Phd diss., İstanbul Üniversitesi, 2014.

[129] Hans Theunissen, "Nederlandse tegels in het Midden-Oosten," *Tegel* 44 (2016), 25–36.

Fig. 114. Dutch blue-and-white tiles in the interior of the sabil of Sultan Mustafa III (1758–1760). The photograph was taken before the restoration of 2008 (photograph by H. Theunissen).

rived after 1760 CE. This can be explained by the fact that the Dutch tiles that did reach Cairo were always sent by the Ottoman sultans from İstanbul. Dutch tiles were never directly imported from the Netherlands. With no new royal building projects in Cairo in the second half of the eighteenth century, the supply of Dutch tiles also faltered. Moreover, the demise of the Tekfur Sarayı workshops in the middle of the eighteenth century forced Cairene elites once again to look for other sources of tiles.

Cannibalization, Local Production, and Kütahya

Cannibalization was one of the solutions for a lack of new tiles. The lunette over the entrance to the mosque of Hasan al-Sha'rawi Katkhuda/Madrasa al-Kamiliyya (622 AH/1125–1126 CE and 1166 AH/1752–1753 CE) [Index no. 428] is filled with what seem to be fifteenth-century blue-and-white tiles decorated with motifs belonging to the Mamluk version of the international Timurid repertoire (fig. 120).[130] One tile is decorated with a ewer and vegetative motifs, another with a two-armed vase with the same vegetative motifs. Other tiles are mainly decorated with often stylized vegetative and floral motifs and Chinese clouds. Mamluk-period tiles were thus re-used in the mid-eighteenth century, possibly in order to overcome a shortage of newly produced (Ottoman) tiles.

The faltering import of Ottoman tiles also led to the emergence of a local tile industry. Although it is not exactly known when this tile industry began its production, a lamp with the name of an originally Moroccan potter suggests that the first migrant ceramicist from the Maghrib arrived in Cairo in the early 1740s. Tiles from the same Moroccan potter have the (later) date 1171 AH/1757–1758 CE.[131] It is not known where in Cairo these tiles were produced, but it is not unlikely that this Moroccan potter had his workshop in the Fustat area, where the Cairene ceramic industry was situated from the Middle Ages until fairly recently.[132] Among the buildings with

[130] Prost, *Les revêtements céramiques*, 47, thinks the tiles are (eighteenth-century?) reproductions of sixteenth-century local products. Warner, *Monuments*, 154, and Williams, *Islamic Monuments*, 194, do not mention tiles.

[131] Prost, *Les revêtements céramiques*, 39–40, gives the dates 1155 AH/1742–1743 CE for the lamp and 1171 AH/1758–1759 CE for the tiles; Herz, *A Descriptive Catalogue*, 218–19 and 224. See also Bayhan, "Çini kullanımı," 109, for "Moroccan" tiles in Alexandria.

[132] George Scanlon, "The Fustat Mounds: A Shard Count 1968," *Archaeology* 24/3 (June 1971), 220–33; idem, "Mamluk Pottery: More Evidence from Fustat," *Muqarnas* 2 (The Art of the Mamluks)(1984), 115–26; Marilyn Jenkins, "Mamluk Underglaze-Painted Pottery: Foundations for Future Study," *Muqarnas* 2 (The Art of the Mamluks)(1984), 95–114; Marcus Milwright, "Pottery in the Written Sources of the Ayyubid-Mamluk Period (c. 567–923/1171–1517)," *Bulletin of the School of Oriental and African Studies, University of London* 62/3 (1999),

tiles most likely produced by the Moroccan potter in Cairo are the earlier mentioned mausoleum of Ibrahim al-Kulshani, the *zawiyya* of ʿAbd al-Rahman Katkhuda, and the *sabil-kuttab* of ʿAbd al-Rahman Katkhuda. Other buildings with locally produced tiles are: the *sabil-kuttab* of Ibrahim Katkhuda Mustahfizan; the mosque of ʿAbd al-Rahman Katkhuda (Shawazliyya Mosque); the *sabil-kuttab* of Ruqayya Dudu; the mosque and *sabil-kuttab* of Amir Yusuf Shurbaji; the *sabil-kuttab* of the complex of Timraz al-Ahmadi; and the mosque of Ahmad al-Dardir.[133]

Apart from the specially made tiles of the *sabil-kuttab* of ʿAbd al-Rahman Katkhuda (fig. 121), which were also used for the lunette of the *zawiyya* of ʿAbd al-Rahman Katkhuda, all other tiles have three different standard décors. The few remaining tiles on the façade of the *sabil-kuttab* of Ibrahim Katkhuda Mustahfizan (1167 AH/1753–1754 CE)[Index no. 331],[134] the tiles of the lunettes over the entrance doors of the mosque of ʿAbd al-Rahman Katkhuda (Shawazliyya Mosque)(1168 AH/1754–1755 CE)[Index no. 450],[135] the tile inlays of the carved stonework decoration on the façade of the *sabil-kuttab* of Ruqayya Dudu (1174 AH/1760–1761 CE)[Index no. 337](fig. 122),[136] and the tiles of the lunette of the complex of Timraz al-Ahmadi (876 AH/1471–1472 CE, but renovated in 1180 AH/1766–1767 CE)[Index no. 216],[137] all belong to the same type of tile with a décor that (partially) copies the motifs of a Tekfur Sarayı tile, which was imported in Cairo in the 1730s–1740s. The same locally produced tile was most likely also used for two (now empty) lunettes over the *sabil* window and the entrance door of the *sabil-kuttab* of ʿAli Bey al-Dumyati and is also still found in Bayt al-Suhaymi (fig. 123). The décor consists of a central pointed cartouche filled with tulips surrounded by small leaves with flowers and stylized vegetative and floral motifs painted in cobalt blue and green (with black contour lines) over a white ground (fig. 124). The Tekfur Sarayı tile, which was the source of inspiration for this décor (fig. 116), lines the lunette over the entrance of the mosque of Muhammad Bey Abu al-Dhahab (fig. 125) and a lunette over an entrance gate of the mosque of Hasan Pasha Tahir (1224 AH/1809–1810 CE)[Index no. 210].[138] The tiled lunette of the complex of Timraz al-Ahmadi also has fragments of Red İznik tiles at both ends of the lunette, which, in combination with the locally produced tiles, create the desired contrast pattern, which was in vogue in Cairo since the first half of the seventeenth century (fig. 126).

The second type of tile is used to line a number of lunettes of the mosque of Amir Yusuf Shurbaji (1177 AH/1763–1764 CE)[Index no. 259]. However, the lunette over the *sabil* window of the *sabil-kuttab* of Amir Yusuf Shurbaji, which is part of the same complex, is filled with fragments of various tiles among which Blue İznik tiles.[139] The décor of the second type of locally produced tile consists of a pattern of interconnected cartouches filled with stylized flowers, linked to each other by diamond-shaped forms painted in cobalt blue and green or turquoise with black contour lines over a white ground. The same tile is also used in Bayt al-Suhaymi and the

504–18; Oliver Watson, *Ceramics from Islamic Lands: Kuwait National Museum, The Al-Sabah Collection* (London, 2004), 395–425; Abraham van As, Kim Duistermaat, Niels Groot, Loe Jacobs, Judith Schoester, Nico Staring, and Rania Zin El Deen, "The Potters of Fustat (Cairo) in 2008: A Preliminary Report," *Leiden Journal of Pottery Studies* 25 (2009), 5–30; Valentina Vezzoli, "The Fustat Ceramic Collection in the Royal Museums of Art and History in Brussels: The Mamluk Assemblage," *BMRAH* 82 (2011), 119–68.

[133] According to Williams, *Islamic Monuments*, 137, the façade of the *sabil* of the complex of Radwan Bey al-Razzaz from 1168 AH/1754–1755 CE [Index no. 387] also has some "traces of tile," which may belong to this group.

[134] Prost, *Les revêtements céramiques*, 41, attributes the tiles to a Moroccan ceramicist working in Cairo; al-Husaynī, *al-Asbila al-ʾUthmāniyya*, 248–51 (with the incorrect name Ibrahim Bey al-Kabir); Abdülhafiz, *Mimari etkileşimler*, 109–10, mentions "a few remaining tiles"; Bayhan, "Çini kullanımı," 111, includes this *sabil-kuttab* in a list of buildings with tiles (under the incorrect name Ibrahim Bey al-Kabir) but does not give a description; Warner, *Monuments*, 147, does not mention tiles; Williams, *Islamic Monuments*, 147: "The kuttab has gone and the sabil is derelict, but the rounded form accented with a few tiles is a memorial to a man who, as a Qazdughli and as a *katkhuda* of the Janissary corps, exercised de facto control of Egypt from 1748 to 1754."

[135] Prost, *Les revêtements céramiques*, 27; Bayhan, "Çini kullanımı," 109, states that the tiles are a local product in Anatolian style.

[136] Prost, *Les revêtements céramiques*, 41, mentions that the tiles are the same as those of the the *sabil-kuttab* of Ibrahim Katkhuda Mustahfizan; al-Husaynī, *al-Asbila al-ʾUthmāniyya*, 258–61; Abdülhafiz, *Mimari etkileşimler*, 115–18, mentions "Ottoman-style tiles;" Bayhan, *Çini kullanımı*, 111, includes this *sabil-kuttab* in a list of buildings with tiles but does not give a description; Warner, *Monuments*, 145: "The façade is also embellished with inset panels of blue-and-white tiles"; Williams, *Islamic Monuments*, 93, mentions the "collection of tiles in the spandrels."

[137] Williams, *Islamic Monuments*, 154, does not mention tiles.

[138] Warner, *Monuments*, 126–27, and Williams, *Islamic Monuments*, 57, do not mention tiles.

[139] Al-Husaynī, *al-Asbila al-ʾUthmāniyya*, 264–65; Bayhan, *Çini kullanımı*, 109, writes that the tiles are a local product from the middle of the eighteenth century.

Fig. 124. Tile inlay of the carved stone strapwork decoration on the façade of the sabil-kuttab of Ruqayya Dudu (1760–1761). The tiles are locally produced copies of a Tekfur Sarayı tile (1750s–1760s) (photograph by H. Theunissen).

sabil of Mahmud I (fig. 127). Other tiles in Bayt al-Suhaymi with a similar color scheme (but smaller format) and related motifs probably belong to the same group of locally produced tiles from the second half of the eighteenth century (fig. 128). Another tile, which possibly also belongs to this group, has a décor consisting of white and green circles filled with rosettes over a cobalt blue ground decorated with small flowers. This tile is used to repair tile loss in the *sabil* of Mahmud I (fig. 129); fragments of the same tile also line both ends of the lunette over the entrance of the mosque of Ahmad al-Dardir (c. 1200 AH/1785–1786 CE)[Warner index no. U29](fig. 130).[140] The other tiles of this lunette are two different (but familiar) types of reused seventeenth-century Blue İznik tiles.

Other types of small-format tiles with vegetative-floral décors, also from the second half of the eighteenth century,[141] are used on the walls in Bayt al-Suhaymi (fig. 131), in a tiled lunette in the Azhar Mosque,[142] and in the mosque complex of Muhammad Bey Abu al-Dhahab (fig. 132). These tiles have a color scheme consisting of cobalt blue, green, purple, and yellow and were most likely made by originally Tunisian potters who had settled in coastal cities such as Alexandria (al-Iskandariyya), Damietta (Dumyat), and Rosetta (Rashid),[143] or were imported from Tunisia.[144] The mosque of Muhammad Bey Abu al-Dhahab (1188 AH/1774–1775 CE)[Index no. 98](fig. 133), like Bayt al-Suhaymi and the mausoleum of Ibrahim al-Kulshani, hosts a wide range of different tiles from various periods and centers of production. The lunette over the entrance to the mosque is lined with Tekfur Sarayı tiles; the lunettes over the windows are filled with Red and Blue İznik tiles (fig. 134), and locally produced or imported tiles. These tiles were apparently important enough to be mentioned in the *waqfiyya* (religious endowment deed) of the complex.[145] The tilework in the interior of the library of the complex, however, is not mentioned in the *waqfiyya* and this suggests that it was added later, possibly after the death of Muhammad

[140] Prost, *Les revêtements céramiques*, 26–27; Warner, *Monuments*, 176, mentions a "trilobed portal with inlaid tiles."

[141] According to Prost, *Les revêtements céramiques*, 43–44, local manufacture continued throughout the eighteenth century because in 1798 there were still tilemakers active in Cairo.

[142] For other tiles in the Azhar Mosque see Prost, *Les revêtements céramiques*, 25; and Herz, *A Descriptive Catalogue*, 228.

[143] http://www.discoverislamicart.org/database_item.php?id=object;ISL;eg;Mus01;32;en.

[144] For Tunisian tiles, see Dalu Jones, *Qallaline Tile Panels: Tile Pictures in North Africa, 16th to 20th Century* (= Art and Archeology Research Papers)(London, 1978); Alain and Dalila Loviconi, *Faïences de Tunisie. Qallaline and Nabeul* (Aix-en-Provence, 1994), 113–37.

[145] Daniel Crecelius, "The Waqfiyah of Muhammad Bey Abū al-Dhahab [I]," *JARCE* 15 (1978), 83–105, esp. 90: "Above it, between the iron, is a glazed tile and above that is a slab of marble on which is an inscription in gold"; and 92: "Above the slab, between the iron [supports] are panels of glazed tile." See also Daniel Crecelius, "The Waqfiyah of Muhammad Bey Abū al-Dhahab, II," *JARCE* 16 (1979), 125–46.

Bey Abu al-Dhahab in 1775 CE, when the library area was partitioned and part of it used to situate the graves of the founder and his sister Zulaykha. Another possibility is that this refurbishment happened later, at the end of the eighteenth or even at the beginning of the nineteenth century, because the tilework is a true patchwork of different tiles characteristic of this period.[146] The tiles used to line the walls in this area of the complex include Red and Blue İznik tiles, imported Tunisian tiles, imported south European tiles, locally produced (Maghribian-style) tiles, cuerda seca tiles made by court potters in İstanbul in the first half of the sixteenth century, and, last but not least, blue-and-white Kütahya tiles.[147] The patchwork of different tiles from various periods and production centers indicates that cannibalization must have been one of the most important ways of collecting tiles for the decoration of the interior of the building. However, the blue-and-white Kütahya tiles date from the second half of the eighteenth century and are thus most likely contemporary imports. Among the Kütahya tiles are tiles with décors that are also used in Topkapı Palace in İstanbul (fig. 135), in both Muslim and Christian religious buildings (mosques, tombs, churches) in İstanbul (figs. 136–137), and Anatolia, and in Armenian churches in Jerusalem. Scholarly literature attributes these blue-and-white tiles to the first quarter of the eighteenth century.[148] However, the buildings in which these tiles were used were often built or renovated in the second half of the eighteenth century (more specifically from the 1750s to the 1790s, with a peak in the 1780s). This strongly suggests that these blue-and-white Kütahya tiles are a characteristic product of the later eighteenth century and not of the early eighteenth century. The Kütahya tiles in Cairene buildings support this hypothesis, because they are generally used in typical late eighteenth- or even nineteenth-century settings, characterized by a diversity of tiles such as the interior of the *sabil-kuttab* of Sultan Mahmud I (replacing lost tiles; fig. 138), the mosque of Muhammad Bey Abu al-Dhahab (part of the patchwork of tiles in the library-tomb), the mausoleum of Ibrahim al-Kulshani (part of the assemblage of tiles on the façade)(fig. 139), and the mosque of Hasan Pasha Tahir (1224 AH/1809–1810 CE)[Index no. 210].[149] In this last mosque, the carved stone strapwork spandrels above the mihrab are lined with locally produced eighteenth-century tiles, seventeenth-century Blue İznik tiles, and blue-and-white Kütahya tiles, whereas the lunettes over the entrances of the mosque and the carved stone strapwork façade decoration of the building have inlays of seventeenth-century Red and Blue İznik tiles and eighteenth-century Tekfur Sarayı tiles (figs. 140–141). The mihrab of the mosque of Dhu al-Fiqar Bey (1091 AH/1680–1681 CE)[Index no. 415] has similar carved stone strapwork spandrels above the mihrab with inlays of blue-and-white Kütahya tiles, and a lunette over the entrance of the Mosque of al-Kurdi (1145 AH/1732–1733 CE)[Index no. 610] is also lined with blue-and-white Kütahya tiles.[150] In both cases, the tiles must have been added during late eighteenth- or

[146] Daniel Crecelius, "The Waqf of Muhammad Bey Abu al-Dhahab in Historical Perspective," *International Journal of Middle East Studies* 23 (1991), 57–81, esp. 69.

[147] Prost, *Les revêtements céramiques*, 33 and 42–43, mentions locally produced tiles, imported Tunisian and south European tiles; al-Husaynī, *al-Asbila al-ʿUthmāniyya*, 267–68; Bates, "Tile Revetments," 44: "The back wall is lined with tiles but these are from Tunisia" and "Not only in this mosque but in some other structures we find European tiles as well"; Abdülhafiz, *Mimari etkileşimler*, 71–81, mentions tiled lunettes and Turkish and Moroccan tiles in the library-tomb; Bayhan, "Çini kullanımı," 109–110, mentions locally produced tiles and Tunisian imports; Bayhan, "Çini kullanımı," 111, also includes the *sabil-kuttab* of the complex in a list of buildings with tiles but does not give a description; Warner, *Monuments*, 104, does not mention tiles; Williams, *Islamic Monuments*, 176: "The tomb area is protected by bronze grilles and decorated with a revetment of tiles, many of which were brought from Tunisia. There are other instances of Tunisian tiles used in Cairo, but in this mausoleum whole panels (as for example the niche forms with the representations of the mosque at Mecca in the hood) were imported. The tomb was finished during the Russo-Turkish (1768–1774) war, and with the Russian fleet cruising the eastern Mediterranean, it was probably easier and safer to import from Tunisia than from Syria."

[148] Oktay Aslanapa, *Osmanlılar Devrinde Kütahya Çinileri* (İstanbul, 1949), 41–78; John Carswell and Charles Dowsett, *Kütahya Tiles and Pottery from the Armenian Cathedral of St. James, Jerusalem*, vol. 2 (London, 1972), 17–58; John Carswell, "Kütahya çini ve seramikleri," *Sadberk Hanım Müzesi. Türk çini ve seramikleri* (İstanbul, 1991), 49–57; Rifat Çini, *Kütahya in Turkish Tilemaking* (İstanbul, 1991), 18; Şebnem Akalın and Hülya Yılmaz Bilgi, *Delights of Kütahya. Kütahya Tiles and Pottery in the Suna and İnan Kıraç Collection* (İstanbul, 1997), 58; Rifat Çini, *Ateşin yarattığı sanat. Kütahya çiniciliği* (İstanbul, 2002); Zeynep Tişkaya, "Galata Surp Krikor Lusavoriç Kilisesi Çinileri," MA Thesis, Hacettepe Üniversitesi, 2004, 42–52; Hülya Bilgi, *Suna ve İnan Kıraç Vakfı Koleksiyonu. Kütahya çini ve seramikleri. Katalog* (İstanbul, 2005), 66–67; Garo Kürkman, *Toprak, ateş, sır. Tarihsel gelişimi, atölyeleri ve ustalarıyla Kütahya çini ve seramikleri* (İstanbul, 2005), 79–115, and 244; Hans Theunissen and Zeynep Tişkaya, "The Dutch Tiles of Surp Krikor Lusavoriç Church in İstanbul," *Electronic Journal of Oriental Studies* 8/11 (2005), 1–41; Hans Theunissen, "700 jaar tegels uit *Kütahya*," *Tegel* 35 (2007), 21–27.

[149] Bayhan, "Çini kullanımı," 110, thinks the tiles over the entrance door are a local product; Warner, *Monuments*, 126–27, and Williams, *Islamic Monuments*, 57, do not mention tiles.

[150] Bayhan, "Çini kullanımı," 109.

nineteenth-century renovations. More blue-and-white Kütahya tiles can be found in the depot of the Egyptian Supreme Council of Antiquities in the madrasa of Sultan Mahmud I (fig. 142). These tiles suggest that, once, other buildings were also decorated with blue-and-white Kütahya tiles. The import of blue-and-white Kütahya tiles must have been limited, because there are no Cairene buildings left with large numbers of these tiles. However, the Kütahya tiles did form a welcome addition to the existing (limited) stocks of tiles from different periods and production centers that, in the late eighteenth and nineteenth centuries, were used in combination with each other in order to decorate buildings. One of the last buildings with such a similarly eclectic tile decoration is the mosque and *sabil-kuttab* of Janbalat (1212 AH/1797–1798 CE)[Index no. 381]. The lunette over the entrance to the mosque and the façade of the *sabil-kuttab* are mainly lined with (locally produced, reused) green tiles and Red and Blue İznik tiles. The hood of the mihrab of the mosque and the surrounding qibla wall are tiled with local green tiles, Red and Blue İznik tiles, and imported North African or European tiles.[151] This patchwork of different tiles connects the mosque and *sabil-kuttab* of Janbalat to Bayt al-Suhaymi, the mosque of Muhammad Bey Abu al-Dhahab, the mosque of Hasan Pasha Tahir, and the mausoleum of Ibrahim al-Kulshani, which were all either built or renovated in the last quarter of the eighteenth or the first half of the nineteenth century.

On the basis of this overview of the eighteenth century, it is now possible to complete the preliminary chronology of the use of tiles as a form of decoration in Cairene architecture:

1. The demise of İznik at the beginning of the eighteenth century leads to cannibalization and reuse of Red and Blue İznik tiles in the period c. 1700–1720s;

2. In the late 1720s–early 1730s, Tekfur Sarayı tiles for the first time reach Cairo. A second wave of Tekfur Sarayı tiles arrives in the late 1740s–early 1750s. However, the amount of Tekfur Sarayı tiles that reaches Cairo is limited;

3. This is possibly one of the reasons that a Moroccan ceramicist settles in Cairo in the 1740s. This leads to local tile production in the 1740s–1760s that is often inspired by the décors of Tekfur Sarayı tiles. However, later local products from the second half of the eighteenth century no longer follow Ottoman examples, but develop an own style;

4. In the second half of the eighteenth century, imports from Tunisia and tiles produced by Tunisian ceramicists living and working in Egyptian cities add a new, distinctly Maghribian flavor to Cairene tile culture;

5. From the 1770s onwards, limited numbers of blue-and-white tiles from Kütahya reach Cairo;

6. Throughout the eighteenth century, older Red and Blue İznik tiles are used, often in combination with other tiles, for the decoration of buildings. Moreover, tiles are constantly used to repair incomplete tilework. This indicates that in the eighteenth and nineteenth centuries existing (but damaged) tilework was still considered important enough to be maintained and renovated;

7. Buildings from the late eighteenth and nineteenth centuries are characterized by patchwork decoration. On the one hand, this is caused by a lack of new tiles leading to cannibalization and constant reuse of older tiles; on the other hand, this is in line with Cairene preferences from the first half of the seventeenth century onwards, which "dictate" the use of contrasting tiles (in both colors and motifs) for the decoration of buildings leading to lively and colorful decorative accents in stone architecture.

On the basis of this survey, some general conclusions may be drawn. Imported tiles from İznik and other Ottoman production centers usually reached Cairo in periods when production peaked and export was possible. Thus, certain developments in the manufacture of tiles in İznik in the late sixteenth and early seventeenth centuries (high volume commercial production for others than the court, decline of court commissions) facilitated exports to Cairo. Similarly, the substantial production of Blue İznik from the 1630s onwards also led to a peak in the export of tiles from İznik to Cairo. Drops in the manufacture of tiles in general led to a decline in exports to Cairo. In times of shortages of new tiles, Cairene patrons were forced to secure tiles by way of can-

[151] Al-Husaynī, *al-Asbila al-'Uthmāniyya*, 283–85; Abdülhafız, *Mimari etkileşimler*, 123–25, mentions the tiles of the *sabil*; Bayhan, "Çini kullanımı," 110, thinks the tiles of the mosque are a local product or from the Tekfur Sarayı workshops. Bayhan, "Çini kullanımı," 111, includes the *sabil-kuttab* in a list of buildings with tiles but does not give a description.

nibalization and reuse of already locally available tiles. In the late 1720s–early 1730s, the first Tekfur Sarayı tiles reached Cairo after almost a decade of production for mainly royal and elite commissions in İstanbul. However, the number of Tekfur Sarayı tiles that arrived in Cairo was limited. Faltering supply from traditional Ottoman production centers—in the second half of the eighteenth century only Kütahya survives as a producer—and continuous demand in Cairo probably also led (apart from cannibalization) to the immigration of Maghribian (Moroccan and Tunesian) ceramicists to Egypt in the mid-eighteenth century and imports from other tile production centers such as Tunisia and Italy.

Tiles play an important role in Cairene architectural decoration. Only in periods when large amounts of Ottoman tiles were available were complete buildings decorated with tiles (such as the Aqsunqur Mosque). In times of limited supply, tiles were often more sparingly used for architectural decoration (such as lunettes of *sabil-kuttab*s). In general, the application of tiles as a form of architectural decoration followed well-established local preferences. One such preference was the use of tiles with different décors and colors for the creation of contrast patterns. This application was most likely directly inspired by Mamluk-style polychrome marble inlay panelling. In mosques, tiles were mainly used to decorate the mihrab (in particular the hood) and the surrounding qibla wall and sometimes (depending on the availability of sufficient tiles) also other walls, mainly upper walls over marble inlay dadoes on the lower walls. Tile decoration of façades of buildings was usually restricted to inlays of carved stone strapwork and lunettes. In the late eighteenth and the first half of the nineteenth centuries, a limited supply of new tiles led to large-scale cannibalization and reuse of tiles resulting in "patchwork tile decoration" on the façades of buildings (such as the mausoleum of al-Kulshani), in the interior of mosques (such as the mosque of Muhammad Bey Abu al-Dhahab), and in private residences (such as Bayt al-Suhaymi). The continuous reuse of existing stocks of tiles suggests that tiles throughout this period remained a prestigious form of architectural decoration in Cairo. This probably also explains why, at the beginning of the twentieth century, a number of Cairene royal palaces such as the Manial Palace, the Palace of Prince ʿAmr Ibrahim (today the Museum of Islamic Ceramics), and the Tahra Palace were extensively decorated with contemporary tilework, among which tiles made in Kütahya.

The Ottoman Tiles of the Fakahani Mosque: A Close View

The second part of this article will focus on the tilework of the Fakahani Complex. I will give a description of the tilework and try to reconstruct its history. In addition, a comparison will be made between the tiles of the Fakahani Complex and similar tiles in other buildings, both in and outside Cairo, in order to find out when and where the tiles were produced and how the Fakahani tilework fits in the chronological survey of Ottoman tiles and the development of the use of these tiles in the architecture of Cairo.

The tilework of the Fakahani Complex is found on the façade of the mosque and the *sabil-kuttab*, and in the interior of the mosque. The tiles on the façades line the lunette over the main entrance on the north-west (west) wall of the mosque in al-Muʿizz li-Din Allah Street (fig. 143), the lunette over the side entrance of the mosque on the north-east (north) wall in Khush Qadam Street (figs. 144–145), and the lunette over the main grilled window (on the west wall) of the *sabil-kuttab* on the north-west corner of the complex (fig. 146). The second lunette over the smaller window (on the north wall) of the *sabil-kuttab* does not have or no longer has any tilework. The tilework in the interior is found in the mihrab and on the surrounding qibla wall (fig. 147). The hood of the mihrab is tiled; the lower part of the mihrab, however, is decorated with Mamluk-style marble inlay panelling. The spandrels of the carved stone strapwork decoration of the qibla wall above the mihrab have tile inlays. In the carved stone strapwork border of the mihrab is a single tile and above that is the tiled surround of the small bullseye window within a rectangular carved stone strapwork border.

A photograph of the tilework of the mihrab in Prost's study corroborates that the extant tilework was already present at the beginning of the twentieth century (fig. 148). A careful comparison of the tilework on the photograph and the present tilework shows that there are no significant differences. Two small pieces of tile around the window are missing (as is the wooden latticework of the window) and more tiles around the window are broken. This suggests that at some time in the twentieth century loose tiles must have fallen off the wall. Subsequently,

the broken pieces were reset. In addition, some small pieces of tile to the left of the single tile are no longer present. In the left spandrel there are more bits of tile missing and the right spandrel has more damaged tiles than before. The left inner border of the mihrab hood has similar damage to a number of tiles. In general, however, the tilework is the same, albeit slightly more damaged and with more small pieces of tile missing. This points at a slow degeneration of the tilework as a consequence of damage and a lack of regular maintenance.

A painting by the French artist Jean-Léon Gérôme (b. 1824, d. 1904) entitled *Prière dans la mosquée* (*Prayer in the Mosque*) also shows the interior of the Fakahani Mosque with its tilework (fig. 149). The painting is a later work by Gérôme, but based on drawings or photographs of the artist made during one of his travels to Egypt in the years 1857, 1862, 1868, 1869, 1871, 1874, and 1880.[152] In this painting, the tilework is vibrant blue and contrasts with the qibla wall and the sand-colored marble inlay panelling of the mihrab. In reality, the impression made by the tilework from a distance is not as blue as in the painting (fig. 150). Although the décors of the tiles are not discernible on the painting, there can hardly be any doubt that the painting does indeed depict the Fakahani Mosque with its tilework. This strengthens the idea that the tilework must have been part of the decoration of the mosque already in the second half of the nineteenth century. This, then, narrows down the period in which the tilework was added to the years between the reconstruction of the mosque in 1735–1736 CE and the second half of the nineteenth century.

In the last hundred years, the mosque was restored several times. The Fatimid wooden doors were restored by the *Comité* in 1919.[153] According to Warner, the mosque itself was restored in the late 1990s.[154] "Unprofessional conservation attempts in the early 2000s"[155] led to serious problems with the roof of the mosque and necessitated an emergency intervention to

Fig. 143. Tiled lunette over the main (west) entrance of the Fakahani Mosque (photograph by H. Theunissen).

Fig. 145. Tiled lunette over the side entrance of the Fakahani Mosque (photograph by H. Theunissen).

Fig. 146. Tiled lunette over the main window of the Fakahani sabil (photograph by H. Theunissen).

[152] Gerald Ackerman, *The Life and Works of Jean-Léon Gérôme with a Catalogue Raisonne* (London-New York, 1986), 45–46 and 294–95 (no. 511 and 512).

[153] *Ministère des Waqfs, Comité de conservation des monuments de l'art Arabe, Comptes rendus des exercices 1915–1919* (Cairo, 1922), 38 (http://www.islamic-art.org/Comitte/BArchViewPage.asp?BookID=729andPO=1).

[154] Warner, *Monuments*, 105.

[155] Most likely, the same restoration as that of Warner (late 1990s). See http://www.archinos.com/#!al-fakahani-mosque-cairo-emergency-int/cvpk; and http://princeclausfund.org/files/docs/Emergency%20stabilisation%20of%20the%20Al-Fakahani%20Mosque,%20Cairo,%20Egypt.pdf.

Fig. 148. Early twentieth-century photograph of the tiled mihrab of the Fakahani Mosque. After Claude Prost, Les revêtements céramiques dans les monuments musulmans de l'Égypte (Cairo, 1916), pl. VII, 2.

Fig. 147. Tiled mihrab of the Fakahani Mosque (photograph by H. Theunissen).

save the roof from collapsing. This latest restoration was completed in 2013. However, all these restorations do not seem to have had a significant impact on the tilework.

Scholarly literature suggests different production centers and periods for the tilework. As we have seen previously, Bloom thinks the tiles are from İznik (and hence from the sixteenth or seventeenth century). Bayhan does not mention the mosque in his list of Cairene buildings with Ottoman-period tilework.[156] Warner, however, mentions "a tiled surround to the upper level of the mihrab," but does not give a date and an origin for the tiles.[157] Williams does not mention the tiles at all.[158] Prost, however, deals extensively with the tilework. He not only gives an elaborate description of the tilework, but also mentions the single tile with the painted inscription "Ma sha'a Allah sene 1141" ("What God has willed, the year 1141")(AH/1728–1729 CE). Subsequently, he attributes the tilework (of the façades and of the qibla wall over the mihrab) to Anatolia (without specification) and (that of the mihrab itself) to Maghribian ceramicists working in Cairo at that time (without specification).[159] This would mean that the "Anatolian" tiles (including the dated tile) should have been produced in Kütahya, because İznik

[156] Bayhan, "Çini kullanımı;" Prisse d'Avennes, L'art arabe, vol. 4, 99, writes that the building has nothing interesting to offer; al-Husaynī, al-Asbila al-'Uthmāniyya, 214, mentions tiles but does not discuss the tilework of the sabil-kuttab; Abdülhafız, Mimari etkileşimler, does not discuss the building. Bates, "Tile Revetments," also does not deal with the building.

[157] Warner, Monuments, 105.

[158] Williams, Islamic Monuments, 164.

[159] Prost, Les revêtements céramiques, 25: "Les carreaux de faïence des tympans, des écoinçons et de l'entourage de la fenêtre, au-dessus du

Fig. 150. Tiled mih-rab of the Fakahani Mosque (photograph by H. Theunissen).

had ceased to be an Anatolian center for the production of ceramics at the beginning of the eighteenth century. The locally produced tiles, however, could only have been produced from the 1740s onwards (because products of the Moroccan ceramicist working in Cairo are only attested for the period from the 1740s onwards). Hence, according to Prost's analysis, part of the tilework was produced shortly before the reconstruction of the Fakahani Mosque in Anatolia, whereas another part was produced after the reconstruction in Cairo. Only one other author deals with the Fakahani tilework. Meinecke-Berg attributes all tiles of the Fakahani Complex to the Tekfur Sarayı workshops in İstanbul on the basis of the painted date (1141 AH/1728–1729 CE) on the single tile in the carved stone strapwork border over the mihrab.[160] Hence, the tiles are attributed to four different production centers (İznik, Kütahya, Cairo, and Tekfur Sarayı/İstanbul) and three different periods (sixteenth-seventeenth century, late 1720s/after 1740s, and late 1720s). This situation adequately illustrates the confusion surrounding Ottoman-period tilework in Cairo.

In order to come to more accurate attributions (of both period and place of manufacture) all tiles will now be described and compared with tiles in other buildings both in and outside Cairo. The lunette over the main entrance to the mosque is lined with two differerent tiles (fig. 143). The two ends of the lunette are lined with two pieces of cut-to-size çintamani tiles. At the left tip, however, there is a small piece of the same tile that is used to line the main part of the lunette between the çintamani tiles. The çintamani tile has a décor of tiger stripes painted in blue, leopard spots painted in blue, red, and green, and Chinese clouds in green and red. The contour lines are painted in black. Sometimes, the red has faded (and turned a bleak red) during the firing process. The space between the çintamani tiles is lined with tiles with a décor of a large stylized flower painted in cobalt blue and turquoise surrounded by small leaves. The leaves are filled with small flowers on foliate stems in white and red. This central element is connected through curved foliate stems to other (halved) stylized floral motifs painted in cobalt blue and red—two at each edge of the tile. Here, too, the red is sometimes faded. The contour lines are painted in black.

The lunette over the *sabil* window is lined with exactly the same tiles, but in another contrasting pattern (fig. 146). This time, the çintamani tiles are in the middle and the second type of tile is used to line the ends of the lunette. At the left tip this tile is no longer extant. At the right side two pieces of this tile still line the end of the

mihrâb, sont, comme ceux de la fontaine Ahmed III, importés d'Asie Mineure. Quant aux plaques de la niche de prière, copies évidentes des autres modèles, elles sont l'œuvre des céramistes moghrabins installés au Caire à cette époque."

[160] Meinecke-Berg, "Die osmanische Fliesendekoration," 60.

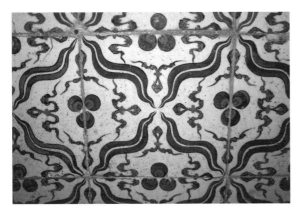

Fig. 151. Tekfur Sarayı çintamani tiles in the Hekimoğlu 'Ali Paşa Mosque in İstanbul (1732–1735) (photograph by H. Theunissen).

lunette. The tip of the lunette, however, is lined with a small piece of a çintamani tile. One of the çintamani tiles in the middle has a slightly different color scheme. The Chinese clouds are not painted in green and red, but in turquoise and red and the leopard spots in cobalt blue, red, and turquoise (instead of cobalt blue, red, and green). On this tile green has been replaced by turquoise; the décor, however, is identical.

The third tiled lunette is over the entrance to the mosque in the side street (fig. 145). This lunette is also lined with the same çintamani tiles in the middle and small pieces of the second type of tile at both ends. Once again, the right tip of the lunette is lined with a small piece of çintamani tile. This lunette has a similar layout to the one over the *sabil* window. The layout of these two lunettes is based on a contrast pattern, which is exactly the opposite of that of the lunette over the main entrance. Whereas the lunette over the main entrance has çintamani tiles at both sides, in the two other lunettes the çintamani tiles are in the middle. However, all three lunettes have a layout based on contrast patterns. As such, they are completely in line with many other tiled lunettes in Cairo, which, from the first half of the seventeenth century onwards, were often lined with different tiles in similar contrast patterns. Because all three lunettes are lined with exactly the same two types of tile, it is likely that all three lunettes were tiled at the same time.

The same çintamani tile is also used to line the lunettes and spandrels of the slightly later *sabil-kuttab* of Sitt Saliha (1154 AH/1741–1742 CE)(figs. 85–86). This strengthens the idea that the tilework of the lunettes of the Fakahani Complex may indeed be contemporary to the reconstruction period of the mosque (1735–1736 CE). More proof for this hypothesis can be found in İstanbul. The çintamani tile is identical to those used to decorate the fountain of Sultan Ahmed III near the entrance gate of Topkapı Palace, which was built in 1141 AH/1728–1729 CE (fig. 87). More identical çintamani tiles line the walls of the Hekimoğlu 'Ali Paşa Mosque built in 1732–1735 CE (fig. 151) and the Ayasofya Library built in 1739–1741 CE.[161] Tiles with the same motifs are also used for a ceramic fireplace originally made for the villa of Fu'ad Paşa in İstanbul, currently on display in the Victoria & Albert Museum in London (figs. 152–153).[162] This fireplace is dated 1143 AH/1730–1731 CE. The documented production period of this type of tile falls in the late 1720s–1730s and thus coincides with the reconstruction of the Fakahani Mosque in the years 1735–1736 CE.

The second tile used for the lunettes can also be found in Bayt al-Suhaymi (in two variations: one with turquoise and one with green)(fig. 154) and (with a different color scheme including yellow) on the façade of the mausoleum of Ibrahim al-Kulshani (fig. 155). In İstanbul, this same tile lines several walls of the Mahmud I Library in the Aya Sofya (1739–1741 CE)(fig. 156). A panel of the same tiles also lines the façade of the mausoleum of Eyüp Sultan in İstanbul. However, these tiles were added during the renovation of 2012–2015 (fig 157). The origins of these tiles is unfortunately not known, but they were not part of the tilework on the façade before the restoration. Once again, the production of this type of tile can be attributed to the 1730s. Hence, both tile types originate in the same period. This strongly suggests that these tiles were actually new when they were used to line the lunettes of the mosque and *sabil-kuttab* during the reconstruction of the Fakahani Complex.

The tilework in the interior of the mosque consists of four different types of tile. The first tile has a décor of two large split-leaf palmettes that frame a stylized flower (fig. 158). The palmettes are connected to (halved) rosettes along the edges of the tile. From the central flower emanate swirling foliate stems with stylized flowers. Two of these stems end in (halved) flowers (similar to the central flower) along the edges of the tile. The motifs

[161] Theunissen, "Tekfur Sarayı," 15; idem, "Dutch Tiles in 18th-Century Ottoman Baroque-Rococo Interiors: *Hünkâr Sofası* and *Hünkâr Hamamı*," 122–24. Prost, *Les revêtements céramiques*, 24, mentions the fountain of Ahmed III and the Ayasofya Library. Meinecke-Berg, "Die osmanische Fliesendekoration," 60, mentions the fountain of Ahmed III and the Hekimoğlu 'Ali Paşa Mosque.

[162] For this fireplace see http://collections.vam.ac.uk/item/O106607/fireplace-unknown/.

are painted in cobalt blue, turquoise, and red over a bright white ground. Sometimes, the turquoise is almost green and the contour lines are black. This tile is used for the surround of the bullseye window in the wall over the mihrab and in the spandrels (figs. 159).

The single rectangular tile in the carved stone strapwork border of the mihrab is decorated with the text of the apotropaic religious formula "Ma sha'a Allah" ("What God has willed")(fig. 160). Above this text in a smaller handwriting is a date: "sene 1141" ("the year 1141"). The text is in white with black contour lines over a dark cobalt blue ground. The only other decoration consists of scrolling acanthus leaves and a rope border motif along the edge of the tile in white, black, and an almost green turquoise.

The spandrels are decorated with (pieces of) split-leaf palmette tiles and border tiles (figs. 161–162). The border tile has a décor consisting of stylized flowers, (halved) rosettes, and serrated (*saz*) leaves in white, cobalt blue, turquoise, and red over a cobalt blue ground. Not all tiles are of the same quality. On some tiles the red is bleak and the cobalt blue and turquoise have sometimes run. One border tile has a slightly different décor. Instead of rosettes, this tile has only stylized flowers. Otherwise, the motifs and the used colors are similar. In the right spandrel is one small piece of a çintamani tile, which, however, has a different décor than the çintamani tiles used for the lunettes of the façade of the complex.

The hood of the mihrab is almost completely lined with cut-to-size pieces of this second type of çintamani tile (fig. 163). Only in the middle of the hood are two border tiles. More (upright-standing) border tiles with the same décor as those in the spandrels are used to separate the hood from the lower part of the mihrab, which is lined with marble inlay panelling. From the chronological survey it is clear that such tiled mihrabs are not uncommon in Cairo. In some mosques only the hood is tiled; in other mosques the complete mihrab is tiled, but then the hood is usually lined with other tiles than the lower part of the mihrab. Tile inlays of carved stone strapwork on qibla walls are also common in Cairo. As such, the tilework of the mihrab and qibla wall of the Fakahani Mosque is completely in line with other Ottoman-period tiled mihrabs and qibla walls in Cairo. The çintamani tile in the hood of the mihrab has two cobalt blue tiger stripes running

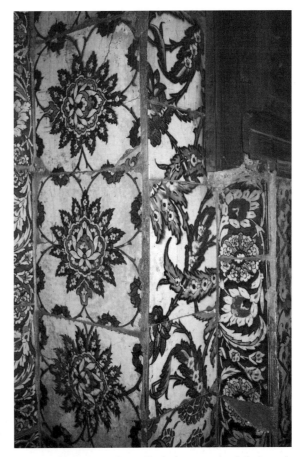

Fig. 154. Tekfur Sarayı flower tiles in the great qa'a of the harem in Bayt al-Suhaymi (1730s) (photograph by H. Theunissen).

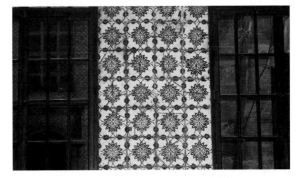

Fig. 156. Tekfur Sarayı flower tiles in the Mahmud I Library in the Aya Sofya Mosque/Hagia Sophia Museum (1739–1741) (photograph by H. Theunissen).

diagonally from corner to corner (fig. 164). The two sets of stripes (running from the upper left corner to the lower right corner and the upper right corner to the lower left corner) cross each other in the middle of the tile. Along the right and left edge of the tile are two (halved) rosettes. From these rosettes emanate swirling foliate

Fig. 158. Tekfur Sarayı split-leaf palmette tiles surrounding the bullseye window over the mihrab in the qibla wall of the Fakahani Mosque (1730s) (photograph by H. Theunissen).

Fig. 159. Tekfur Sarayı split-leaf palmette tiles in the spandrels of the carved stone strapwork decoration of the mihrab in the Fakahani Mosque (1730s) (photograph by H. Theunissen).

stems. At the end of these stems are blue needle tulips and small red flowers. The motifs are painted in cobalt blue, (a sometimes greenish) turquoise, and red over a white ground. The contour lines are in black. The décor of the tile is lively and full of movement.

The tiles in the Fakahani Mosque can also be found in other buildings both in and outside Cairo. The split-leaf palmette tile is used for the lunettes and the inlays of the carved stone strapwork on the façade of the mosque of 'Uthman Katkhuda, which was constructed in 1147 AH/1734–1735 CE, just one year before the reconstruction of the Fakahani Mosque.[163] This strengthens the idea that the tilework is indeed contemporary with the construction of the complexes and not added at a later date. The split-leaf palmette tile is also abundantly used in Bayt al-Suhaymi (fig. 161). Once again, an indication that the origin of part of the tiles in Bayt al-Suhaymi may be linked to the source for part of the Fakahani tiles. The same tile could—until the recent renovation—also be found in the tomb complex of Eyüp Sultan in İstanbul. The tiles were used to line the cupboard in which a Footprint of the Prophet Muhammad is kept (figs. 165–166). This Footprint was transferred from the

[163] Prost, *Les revêtements céramiques*, 26; Abdülhafiz, *Mimari etkileşimler*, 149–51, mentions the "Turkish-style tile" lunette over the entrance; Bayhan, "Çini kullanımı," 109, attributes the tiles to Tekfur Sarayı; Williams, *Islamic Monuments*, 213, does not mention the tiles.

Fig. 160. The Tekfur Sarayı inscription tile with the text "Ma sha'a Allah" ("What God has willed") and the date: "sene 1141" ("the year 1141") in the Fakahani Mosque (1728– 1729) (photograph by H. Theunissen).

Fig. 161. The left spandrel of the mihrab in the Fakahani Mosque with Tekfur Sarayı split-leaf palmette and border tiles in the Fakahani Mosque (1730s) (photograph by H. Theunissen).

Fig. 162. The right spandrel of the mihrab in the Fakahani Mosque with Tekfur Sarayı split-leaf palmette and border tiles (1730s) (photograph by H. Theunissen).

Fig. 163. The tiled hood of the mihrab in the Fakahani Mosque (photograph by H. Theunissen).

palace treasury to the tomb of Eyüp Sultan by Sultan Mahmud I in 1144 AH/1731–1732 CE.[164] It is likely that the tiles were applied during the construction of the cupboard in that year. Moreover, tiles with a similar décor but sometimes with a slightly different color scheme are used to line walls of the Çeşmeli Sofa, the Court of the Black Eunuchs, and various other places in Topkapı Palace (fig. 167). The walls of the Çeşmeli Sofa are also lined with the çintamani tile used for the lunettes of the Fakahani Complex (fig. 164). The present tilework of the Çeşmeli Sofa is most likely the result of a renovation of the palace in the early 1780s, which brought together tiles from different production periods and centers on the walls of the hall.[165]

Fig. 164. Tekfur Sarayı çintamani tiles in the hood of the mihrab in the Fakahani Mosque (1730s) (photograph by H. Theunissen).

The border tile that is used to line the spandrels and the hood of the mihrab of the Fakahani Mosque is also used in Bayt al-Suhaymi. Interestingly, the split-leaf palmette tile and this border tile are used in combination with each other on the walls of Bayt al-Suhaymi, as if their original application was copied when the tiles were reused on the walls of Bayt al-Suhaymi (fig. 169). The second type of border tile, of which there is only one example in the right spandrel over the mihrab, is also used in the later *sabil-kuttab* of Sultan Mahmud I (1750–1751 CE)(fig. 170). This suggests that this single tile may have been used to repair tile loss and possibly does not belong to the original tilework of the Fakahani Mosque. However, both these border tiles are abundantly used in the Hekimoğlu ʿAli Paşa Mosque (1732–1735 CE) in İstanbul (figs. 171–172). This indicates that both types were indeed produced in the first half of the 1730s. The second type of çintamani tile, which is used for the hood of the mihrab, is also used in the Hekimoğlu ʿAli Paşa Mosque (fig. 173). More tiles of this type are used in the Çeşmeli Sofa in Topkapı Palace (fig. 174). The presence of this type of tile in the Hekimoğlu ʿAli Paşa Mosque further strengthens the idea that both types of border tiles and both types of çintamani tiles were produced in the same period in the first half of the 1730s.

[164] Münir Aktepe, Şem'dâni-zâde Fındıklı Süleyman Efendi Târihi Mür'i't-tevârih (Istanbul, 1976–1981), vol. 1, 26; Mesut Aydıner, ed., *Vak'anüvis Subhî Mehmed Efendi, Subhî Tarihi, Sâmî ve Şâkir tarihleri ile birlikte (inceleme ve karşılaştırmalı metin)*(Istanbul, 2007), 135–38. The Ottoman-Turkish inscription over the cupboard also mentions the date 1144 AH.

[165] Theunissen, "Dutch Tiles in 18th-Century Ottoman Baroque-Rococo Interiors: *Hünkâr Sofası* and *Hünkâr Hamamı*," 103–4 and 129–30.

Fig. 165. Cupboard of the Footprint of the Prophet Muhammad (kadem-i şerif) in the Mausoleum Complex of Eyüp Sultan in Eyüp/ İstanbul before the renovation of 2011–2015 (1731–1732) (photograph by H. Theunissen).

 The single, dated tile with the calligraphic composition of a religious formula belongs to a group of tiles produced between c. 1725 and c. 1730 CE. All these tiles are decorated with calligraphic compositions of religious texts (Qur'anic quotations, hadith quotations, revered names, and religious formula's), which were possibly all calligraphies of Sultan Ahmed III (r. 1703–1730 CE). The tiles on which these calligraphic compositions were applied were used to decorate royal buildings and projects of Ahmed III's Grand Vizier and son-in-law Damad İbrahim Paşa. One of these—a tile panel in the mosque of the harem in Topkapı Palace—has the same religious formula as the Fakahani tile. The calligraphic composition of the Fakahani tile also resembles the one on the tile panel in the harem mosque, but is not identical.[166] Nevertheless, it is not unlikely that the calligraphic composition on the Fakahani tile is also the work of Ahmed III. This, then, raises interesting questions about the history of the Fakahani tile, which is clearly not used in a project of the sultan himself or his Grand Vizier. It is possible that this tile was originally intended for another royal project, but that for some reason it was never used. The Halil Patrona uprising against Ahmed III and his Grand Vizier Damad İbrahim Paşa in 1730 CE may have played a role in this. Subsequently, this single tile was added to a consignment of tiles intended for Cairo. Interestingly, all other tiles belonging to this batch were tiles that were used in İstanbul in projects either of Ahmed III's successor Mahmud I or of his Grand Vizier Hekimoğlu ʿAli Paşa (first grand vizierate: 1732–1735 CE). This suggests that the Fakahani tiles were probably not bought directly from the Tekfur Sarayı tilemakers, but that they were obtained via court circles. The production periods of the tiles support this hypothesis. The Fakahani tile has the date 1141 AH/1728–1729 CE. Other dated tiles from this group of tiles decorated with calligraphy bear the years 1139 AH/1726–1737 CE, 1141 AH/1728–1729 CE, and 1143 AH/1730–1731 CE. Most likely, all these tiles were produced before the Halil Patrona uprising in 1730 CE. The Fakahani tile thus fits perfectly in the sequence of this group of tiles decorated with religious calligraphy. However, the most likely production dates of the other tiles in the Fakahani Complex are slightly later; that is to say, the first half of the 1730s

[166] Emine Naza-Dönmez, "Nevşehir Müzesi'nde bulunan Medine Camii tasvirli bir çini levha," in Yıldız Demiriz, ed., *Prof. Dr. Şerare Yetkin Anısına Çini Yazıları* (Istanbul, 1996), 109–14; Tarkan Okçuoğlu, "Manzara resimli bir Kütahya çinisi üzerine değerlendirme," *Sanat Tarihi Yıllığı* 16 (2003), 1–8; Philippe Keskiner, "Sultan Ahmed III (r. 1703–1730) as a Calligrapher and Patron of Calligraphy," Phd diss., University of London, 2012, 178–90; Philippe Keskiner, "Sultan Ahmed III's Calligraphy on Tekfur Sarayı Tiles," in Frédéric Hitzel, ed., *14th International Congress of Turkish Art. Proceedings* (Paris, 2013), 431–37. The two dated tile panels in the Museum of Islamic Art in Cairo depicting Mecca and Medina also bear the dates 1139 AH and 1141 AH: a tile with a depiction of Mecca is dated 1139 AH/1726–1727 CE and signed by Muhammad al-Shami (Mehmed el-Şami) and a tile with a depiction of Medina is dated 1141 AH/1728–1729 CE. See n. 116.

(c. 1731–1734 CE). This, then, suggests that the dated tile was later added to a consignment of tiles produced in the years 1731–1734 CE. Tiles from this batch were first used in Cairo to decorate the mosque of 'Uthman Katkhuda al-Qazdaghli in 1734–1735 CE before they were used to embellish the Fakahani Complex, which was reconstructed in 1735–1736 CE by Ahmad Katkhuda Mustahfizan al-Kharbutli.

Conclusion

All tiles of the Fakahani Complex were produced in the period c. 1728–1734 CE. Examples of the same tiles are found in other buildings in Cairo but also in buildings in İstanbul. The production period and the locations where these tiles were used form important clues to the identification of the place of manufacture. All Fakahani tiles must have been made by the Tekfur Sarayı workshops in İstanbul—the main Ottoman production center for tiles in that specific period. Tekfur Sarayı tiles were predominantly used in İstanbul, but were also "exported" to other cities in the Ottoman Empire, albeit on a limited scale.

Moreover, the tiles in Cairo and İstanbul share numerous stylistic and technical characteristics, which also clearly point at the Tekfur Sarayı workshops as the place of manufacture. The color scheme of the tiles is similar. The color red is sometimes thin and bleak, turquoise sometimes turns green, and the greens and cobalt blues have sometimes run. The painting style of the tiles also similar: the motifs are often painted in a loose way and with less detail. Moreover, the décors of the tiles are characteristic of the products of the Tekfur Sarayı workshops, which initially produced tiles in an İznik revivalist style, but from the late 1720s started to use new motifs that were intrinsically linked to stylistic developments in the decorative arts of that period. The çintamani tiles with needle tulips are a characteristic product of this development. The quality of the tiles is variable and sometimes poor. This highlights problems with the raw materials used for the production of the tiles and points at technical complications during the firing process. Not only the production period, but also these stylistic and technical characteristics clearly suggest that the tiles were made by the Tekfur Sarayı workshops in İstanbul.

When we look at the chronological overview of Ottoman tiles in Cairene buildings, it becomes clear that the Fakahani tiles belong to the period of the late 1720s–early 1730s, when Tekfur Sarayı tiles for the first time reached Cairo. It is likely that the Fakahani tiles formed part of one of the first batches of Tekfur Sarayı tiles that reached Cairo. The Fakahani tiles probably belonged to the same batch as the tiles used to decorate the mosque of 'Uthman Katkhuda, which was constructed in 1147 AH/1734–1735 CE,[167] just one year before the reconstruction of the Fakahani Mosque. Another part of this same batch was probably later reused in Bayt al-Suhaymi, but may originally have been used in another residence, for instance of 'Uthman Katkhuda or Ahmad Katkhuda. 'Uthman Katkhuda al-Qazdaghli and Ahmad Katkhuda al-Kharbutli knew each other well and were friends. These good personal relations probably explain why the same tiles were used in the buildings constructed by these two military commanders in the years 1734–1736 CE. Shortly after the completion of their building projects, both men were killed in the same incident in November 1736 CE.[168] The fact that tiles from the same batch were used in two different buildings of two befriended amirs also suggests that tiles were more than just architectural decoration for members of the Egyptian military households. It is not unlikely that, especially for members of this group, the use of tiles played an important role in their quest for political legitimacy and social status. Nelly Hanna describes the correlation between households, power, and culture in eighteenth century Egypt as follows:

> One trend that is very apparent in the eighteenth century was the development of various forms of
> cultural activities around individual households. In other words, the focal points for culture had moved
> from the courts of the rulers to a series of households of prominent amirs. These households became
> private political centers, around which amirs gathered their soldiers and their followers, and where they

[167] Crecelius and Bakr, *Al-Damurdashi's Chronicle of Egypt 1688–1755*, 307–8; Philipp and Perlmann, *'Abd al-Rahman al-Jabarti's History of Egypt*, 275.

[168] Crecelius and Bakr, *Al-Damurdashi's Chronicle of Egypt 1688–1755*, 307–15; Philipp and Perlmann, *'Abd al-Rahman al-Jabarti's History of Egypt*, 274–77.

had their councils to discuss matters of state. They decided in their own houses such vital state matters as the removal of a governor, or the current price of the currency. The real center of power was, in other words, transferred from the pasha's headquarters in the Citadel to the private residences of the rival contenders for political power, that is the major clans of the Fiqariyya, the Qasimiyya, and later the Qazdagliyya.

The residences of the ruling amirs eventually became the buildings with which their power was associated; they were the buildings that, as the stature of the amirs increased, were embellished with numerous amenities and commodities, and new functions introduced to emphasize the stature of the owner. In their residences start to emerge functions associated with power, such as rooms called *diwan*s, a word derived from the *diwan* or council the pasha held in the citadel; the *mahkama* such as that which 'Uthman Bey al-Qazdagli held in his house and which he presided over personally; and the prisons where the owner of the palace could throw his enemies. This important change left its mark on culture. Households became centers for the amirs' cultural activities to support and enhance their social positions vis-à-vis the 'ulama' who legitimized their rule and, to a lesser extent, the populations they ruled.[169]

By building mosques, 'Uthman Katkhuda al-Qazdaghli, one of the dominant amirs in the years 1724–1736 CE, and his friend Ahmad Katkhuda al-Kharbutli, profiled themselves as patrons of religious architecture and thus legitimized their power and enhanced their social status. Moreover, it is likely that the Tekfur Sarayı tiles played a special role in this process of constructing political legitimacy and social status. There can be no doubt that only the very powerful and rich had the financial means to buy tiles. At the same time, it is likely that money alone was not enough. In the early eighteenth century, Cairene elites were forced to cannibalize existing local tilework and reuse extant older tiles. Although in the 1720s the Tekfur Sarayı workshops in İstanbul began to produce new tiles, access to these tiles was restricted. The Tekfur Sarayı ateliers were royal workshops and its tilemakers mainly produced tiles for royal and elite commissions in the capital of the Ottoman Empire. Hence, only the sultan himself and his direct entourage could acquire these tiles. For a Cairene amir to be able to obtain Tekfur Sarayı tiles would probably have meant that he had good connections with influential persons in court circles in İstanbul. 'Uthman Katkhuda al-Qazdaghli and Ahmad Katkhuda al-Kharbutli may very well have been such men. They may indeed have had the necessary friendly contacts with high ranking Ottoman officials such as Darü 's-Saade Ağası Hacı Beşir Ağa, head eunuch of Ahmed III and Mahmud I from 1717 to 1746 CE, and his ally Grand Vizier Hekimoğlu 'Ali Paşa, who both had direct access to Tekfur Sarayı tiles.[170] It is likely that only such good contacts could have resulted in the shipment of a batch of Tekfur Sarayı products that consisted of tiles that in İstanbul were exclusively used in royal and elite projects. This batch comprised split-leaf palmette tiles, which were also used to decorate various rooms of Topkapı Palace and Sultan Mahmud I's cupboard of the Footprint of the Prophet Muhammad in the mausoleum of Eyüp Sultan (built 1731–1732 CE), çintamani and border tiles that also line the walls of the Hekimoğlu 'Ali Paşa Mosque (built 1732–1735 CE), and the dated tile with the calligraphic composition from the reign of Ahmed III. By using new tiles from the royal workshops of Tekfur Sarayı instead of cannibalized, old tiles from Cairo 'Uthman Katkhuda al-Qazdughli and Ahmad Katkhuda al-Kharbutli could distinguish themselves from other (competing) amirs and patrons of (religious) architecture in Cairo. These Tekfur Sarayı tiles, which came from the capital of the Empire, most likely as the result of good contacts with the highest Ottoman state functionaries, thus added an extra dimension to their political legitimacy and social status in Cairo, and may even have been interpreted as a seal of approval from the center of power in İstanbul. Although there cannot be any doubt that "creatively reusing and preserving vestiges of the old mosque"[171] was an important aspect of the reconstruction project of Ahmad Katkhuda al-Kharbutli, I would argue that the new Tekfur Sarayı tiles gave extra cachet to the renewed building and further enhanced the prestige of its patron. The conscious use of selected decorative elements that were part of the "venerable

[169] Nelly Hanna, "Culture in Ottoman Egypt," in Martin Daly, ed., *The Cambridge History of Egypt Volume 2: Modern Egypt, from 1517 to the End of the Twentieth Century* (Cambridge, 1998), 87–112, esp. 92–93.

[170] For this alliance, see Hathaway, *Beshir Agha*, 72–74; Henning Sievert, *Zwischen arabischer Provinz und Hoher Pforte. Beziehungen, Bildung, und Politik des osmanischen Bürokraten Rāġıb Meḥmed Paşa (st.1763)*(Würzburg, 2008), 84–89.

[171] Bloom, "Fatimid Doors," 241.

history of the mosque"[172] in combination with new tiles from the prestigious royal workshops in the capital of the Empire must have been a particularly effective way to give expression to the power, wealth, and social standing of an Egyptian amir in mid-eighteenth-century Ottoman Cairo.

Leiden University

[172] Bloom, "Fatimid Doors," 241.

Book Reviews

Leo Roeten. *Chronological Developments in the Old Kingdom Tombs in the Necropoleis of Giza, Saqqara and Abusir: Toward an Economic Decline during the Early Dynastic Period and the Old Kingdom*. Archaeopress Egyptology 15 (Oxford: Archaeopress, 2016). ISBN (paperback) 9781784914608. Pp. xiv + 144.

As stated in the title of this work, Leo Roeten sets out to establish a relationship between mastaba development and economic decline over the course of Dynasties 1–6. Though the title does not make it clear, Giza provides his primary dataset; the necropoleis of Saqqara and Abusir are used as secondary lines of argumentation due to limitations within the published data (Saqqara) or the sample size (Abusir). Limited data on Abu Rowash are also considered.

The text is divided into four parts: I: Various chronological developments of dimensional aspects of the tombs in the necropolis of Giza (chapters 1–7); II: The necropoleis of Abusir and Saqqara. A verification of the chronological tendencies of Giza (chapters 8–10); III: Additional methods for controlling the proposed dating of a tomb (chapters 11–12); IV: Catalogues and tables (tables 01–04.2, X.1).

Roeten begins by laying out some basic considerations in Chapter one, including a short history of the development of the mastaba during the Old Kingdom and a presentation of the chronological groupings that he will employ. Also in this chapter is a brief overview of climate change in the third millennium BC that presents the period as being dominated by a drying trend (15–17). Most of the research for this short section dates to the 1990s and before; it is taken for granted that increased aridity directly equated to decreased economic power without any consideration of population size, distribution, or land use, treating the Egyptians as passive actors who could not adapt their society to a slowly changing environment (for the opposite approach, see N. Moeller, "The First Intermediate Period: A Time of Famine and Climate Change?" *Ägypten und Levante* 15 [2005]: 153–67). These three pages form the basis for the 'economic decline' portion of the title and essentialize the narrative of the Old Kingdom to one of a state weakened by the single variable of ongoing desertification. He ignores any possible cultural and socio-political factors for the weakening state; such reductionism and monocausality is characteristic of the volume and one of its central flaws.

Part one, chapter two introduces the Giza necropolis; the overview is swift and light on data, not discussing elements, like tomb distribution within the cemeteries, that will become necessary to his later analyses. Chapter three introduces chronological change in the number of false doors (1 or 2) found in a Giza tomb chapel, finding that during the reign of Khufu the number of false doors was restricted, with the use of two false doors becoming more common at the end of his reign only to decrease again starting in the late fifth dynasty, perhaps due to a "deterioration of the financial situation" of the officials (38). Chapter six reprises this analysis, looking at false door presence in "richer" and "poorer" tombs (see below). The data are presented through line graphs and scatter charts; he discusses not only number of false doors, but the relationship of false door placement to the surface of the tomb. Other elements of the false door outside of number—for example, inscription, form, or decoration—are not discussed here, presumably appearing in Roeten's earlier monograph, *The Decoration of the Cult Chapel Walls of the Old Kingdom Tombs at Giza. A New Approach to their Interaction* (Leiden, 2014).

Chapters four and five present diachronic change in the dimensions of Giza tombs. These two chapters lay out the fundamental approach of the study: to measure and chart "the surface of the tomb and the chapel, the length of the western wall, the width of the chapel and the values derived thereof…" (40). He does not work through his methodology in any great detail, so it is unclear how his figures are derived or why one should link these variables. Through the use of scatter plots (problematically called "cloud diagrams" throughout the text), Roeten strives to demonstrate the presence of two, if not three, categories of tomb, ranging from "richer" to "poorer." In chapter five he charts the differences between tomb surface and chapel surface in his "richer" and "poorer" categories, noting at the end of the chapter that there is no relationship between them (61). Chapter six relates the diachronic change in number of false doors to the sample as a whole, as well as the "richer" and "poorer" categories, finding that there is no relationship with the surface of the chapel and the number of false doors found in a tomb, but that two false doors becomes generally less

Journal of the American Research Center in Egypt 53 (2017), 331–351
doi: http://dx.doi.org/10.5913/jarce.53.2017.r016

common after the early Fifth Dynasty (64). Chapter seven concludes the Giza section, working through size differences in "richer" and "poorer" tombs and the development of the Giza necropolis; the relationship of chronological change to climate change; and "the designation of chapels with a ground-plan that leads to a divergent ratio surface/tomb surface chapel and/or a divergent ratio width chapel/length of western wall." This chapter includes an assertion that the number of false doors was perhaps "not and never had been particularly important" (72, though see contradiction on 75, 122). He links smaller tomb sizes to a declining economy that, due to climate change, resulted in a generally decreased standard of living (69). However, he also links them to a decrease of available space at Giza (71), and the movement of the royal necropolis from Giza to Saqqara (76). A plan of Giza featuring the chronological distribution of individual mastabas would have supported this point and aided the reader.

Part II generally employs the methodology laid out in Part I, using new data sets as a check or comparison against the Giza information. Less time and detail is spent on these new samples and the analyses and presentation are not very different; therefore, Part II can read as repetitive or exhausting to readers who are not interested in the specifics of individual tomb sizes in Saqqara or Abusir (but potentially very useful for those who are interested in mining the specifics of dimensions). Often, the data from the newly introduced cemeteries was included on Giza charts appearing in previous pages, lending confusion to the charts especially while reading the Giza sections.

The volume's conclusion (122–27), tucked into Part III (dating methods), asserts that there was a three-part division in social strata, a distinction not solely based on economic power, apparent through tomb size and decreasing over time (123–24); that Khufu enacted a standard tomb size across all (studied) Memphite necropoleis, from which standard tomb size would decrease over time at all three necropoleis (125); that the declining size in tombs from Dynasty 1 to Dynasty 6 was the result of an economic decline due to climate change (127).

Throughout the volume, the data is presented through charts highlighting trend lines and clustering of the variables listed above: area of tomb, area of chapel, length of western wall, width of chapel. The variables themselves, however, are not well defined and the mathematical terminology often incorrect. For example, the present reviewer was puzzled by the phrase "the surface of the tomb." It was only in Table 03 in Part IV, where the dimensions of Early Dynastic mastabas at Saqqara are presented, that it became clear that "surface of the tomb" was meant to mean the *(surface) area* of the mastaba. Incorrect and/or awkward phrasing such as this obfuscates Roeten's meaning throughout, clouding if not obliterating his points and reducing confidence in his handling of numeric data. Analysis of

the data sets are notably missing standard deviation data, sample size information (within the text and charts, not simply if one counts the tombs listed in his Part IV tables), or discussions of statistical significance which would have leant more authority and complexity to his argument. The absence of statistics despite his constant employment of numbers undermines his analyses. Further, one of his central findings, that there is a constant bipartite, even tripartite, division in tomb size that is indicative of socio-economic groups, is based on the inexact method of clustering. Determining clustering requires that one use one of several algorithms and define the variables which will themselves determine the clusters (my thanks to Dr. David Taylor, Roanoke College Math Department, for discussion regarding this concept). This method is not employed. Instead, the author seems to be judging his clusters based on personal perspective; to the current reviewer, clustering was not evident in many of the charts.

Roeten's charts presenting visualizations of tomb size by period do have the potential to be useful to dating, which he works through explicitly in Part III, Chapter 11. Readers will undoubtedly be drawn to this text for the potential to use his size ranges as one more dating criterion to help refine a tomb or cemetery's chronology. A new text on Old Kingdom dating always has a use. However, the text falls far short of working with climate change and offers no real social analysis, giving it limited utility.

For readers who approach this text due to interest in issues of economic decline, the author falls short of establishing an argument linking tomb sizes to economy and, indeed, spends a very small number of pages and very little research on the complexities behind climate change or economy, instead treating them as simple categories easily reified. Work by Mark Lehner on basin irrigation and Juan Carlos Morena García on economy would have enhanced the text. The terms "richer" and "poorer" lend an economic feel to his discussion but without correlation to titles, decoration, and tomb goods these terms are never problematized or socially defined (though see 124). The relationship of climate change to a declining (state) economy is only asserted, never argued or truly substantiated, by Roeten; it is the *deux ex machina* which he employs to explain all changing size variables. He does not create complex correlations to wall decorations, titles, or personal choice; ultimately, his sample and his data are too small to support huge conclusions about economy or climate.

A final note: the Archaeopress Egyptology series does not seem to have provided the editing or copyediting that would have helped make this a more successful, or at least more accessible, volume. Editing can provide clarity, especially when the author is not a native speaker of the language in which they publish; the editors should have worked more with this text. As is, the prose can be difficult and confusing. Copyediting appears to have been haphazard, with

names appearing multiple ways (Bárta, Bàrta), captions located within the text rather than under the image (30); font size fluctuating (32); mismanaged headers (70); poor image quality (75, 81). There is no differentiation between charts and images in his captions or lists (both are labeled 'figure'), making specific curves and graphs harder for the reader to locate. On the whole, the volume promises much but leaves much wanting.

Leslie Anne Warden
Roanoke College

Hans-Werner Fischer-Elfert and Richard B. Parkinson, eds., *Studies on the Middle Kingdom: In Memory of Detlef Franke*, Philippika: Marburger altertumskundliche Abhandlungen 41 (Wiesbaden: Harrassowitz, 2013). ISBN 9783447063968. Pp. 268 + 8 plates.

Die vorliegende Publikation hält die Erinnerung an Detlef Franke wach, der 2007 im Alter von nur 54 Jahren verstorben ist. Die Beiträge gehen in der Hauptsache auf verschiedene Aspekte zum ägyptischen Mittleren Reich ein. Der Inhalt fächert sich wie folgt auf: H. Altenmüller widmet sich der Identität des Horus-Schen in den "Osirismysterien" des Mittleren Reiches und versucht die Bedeutung dessen Beiwortes *šniw* zu lösen. Der Schlaf des Horus-Schen wird in die Nähe des Schlafes des Sem-Priesters im Mundöffnungsritual/Szene 9–10 gerückt (11). Die Bekleidung des Sem-Priesters durch ein horizontal gestreiftes Gewand wird mit Mumienbinden oder Kleinkindwicklungen assoziiert (14). Der Sem-Priester wird als Verkörperung des Horus nach dessen Vereinigung mit dem in Binden gehüllten Osiris begriffen (14). Der Schlaf des Sem-Priesters im MÖR zielt auf die Belebung der mit Osiris gleichgesetzten Statue ab (15). Die Aufgabe des Schlafes des Horus-Schen wird in der Vereinigung mit dem getöteten Osiris erkannt (15). Die Repräsentation des Horus-Schen durch einen in Binden gehüllten Priester wird deutlich gemacht (15). Die alte Erklärung von *Ḥr-šniw* als "streitbarer Horus" wird zugunsten von "umwickelter Horus" aufgegeben (15). Der Name des *ḥꜣkr*-Festes wird nicht ganz unrealistisch durch die Rufe der Träger der Prozessionsbarke erklärt, mit denen der auferstandene Gott zum Einstieg in das Gefährt eingeladen wird (19).

E. Blumenthal setzt sich mit dem Nachleben verstorbener Könige im kulturellen Gedächtnis der Einwohner der Arbeitersiedlung von Deir el-Medineh auseinander. Die Verzeichnisse sparen Hatschepsut und die Amarnakönige konsequent aus (39). Die Bedeutung Haremhabs in den Denkmälern wird wohl zu recht auf dessen Rolle als Totengräber der Amarnazeit und Gründungsheros des ramessidischen Königtums zurückgeführt (39). Die Zusammenstellungen der Könige werden von keinen historischen, sondern religiösen Interessen dominiert (40–41).

J. Darnell/C. Manassa legen vier beschriftete Objekte vom "Stelae Ridge" im Steinbruch in Gebel el-Asr vor, die der Siegler Sabastet im Jahr 4/6 von Amenemhet III. hinterlassen hat. Die Hauptgötter des Steinbruchs stellen "Hathor, Herrin des *ḥnm.t*-Steines" und der König als Teilmanifestation des Horus dar (57). Das Material des *ḥnm.t*-Steines wird als Karneol, Jaspis oder andere Kalzedonart bestimmt (60–61). Die Stele JE 59499 macht besondere Angaben zur Dauer der Minenexpedition von 3–4 Monaten, was ansonsten eher selten ist (85). Die Texte weisen in Grammatik und Syntax Parallelen zu anderen Mineninschriften auf, was sich u. a. am Anruf an die Lebenden zeigt (86). Der narrative Infinitiv wird als Kennzeichen für Tagebuchstil gedeutet (86). Im Falle eines Expeditionsmitgliedes kommt der ansonsten nicht belegte Titel *sḥꜣw wꜥr.t Nḥn* "Schreiber des Bezirks von *Nḥn*" vor (88). Die Sakralarchitektur von Gebel el-Asr besteht aus pyramidalen Schreinen, als deren ägyptischer Name das Wort *iḥꜣii* postuliert wird (90–91).

A. Demidchik zeichnet historische Gesichtspunkte der Königsdomäne der Herakleopolitenzeit nach. Die Existenz administrativer Strukturen der Bezirke nördlich von Hebenu im Alten Reich muss im Dunkeln bleiben (97). Die Einrichtung des königlichen Grundbesitzes unter den Herakleopoliten fiel mit dem Verschwinden des Vezirats zusammen (97).

H.-W. Fischer-Elfert präsentiert ein hieratisches Ostrakon mit einem Ausschnitt aus der "Lehre des Amenemhet," das bei Arbeiten von Steindorff im Totentempel des Chephren geborgen wurde. Die ramessidische Handschrift füllt der Beginn der 9. Strophe aus (108).

W. Guglielmi beleuchtet künstlerische und religiöse Aspekte zur Feldgöttin *śḥ.t* im Zusammenhang mit Assiut. Die Göttin wird im neu entdeckten Grab N13.1 erstmals einem nichtköniglichen Grabherrn gegenüber in gleicher Kopfhöhe gezeigt (118). Die Gegend von Assiut hat die bislang einzige Rundplastik der Göttin in Gestalt einer Holzstatuette erbracht, welche den Typ der Gabenbringer/Diener aufgreift (120). Die Stadt hatte sich offenbar zu einem Zentrum für die Verehrung der Feldgöttin entwickelt (121). Im Grab des Djefaihapi aus Assiut ist ein möglicher Vorläufer für den Stab/Stabstrauß der *śḥ.t* zu finden (123).

S. 124: das Wort *ẖn* ist vielleicht besser durch "fette (Gänse)" wiederzugeben, vgl. zuletzt H. Kockelmann-E. Winter, *Philae III, Die Zweite Ostkolonnade des Tempels der Isis in Philae (CO II und CO II K), Mit einem Beitrag von Shafia Bedier* (Vienna, 2016), 313.

S. Kubisch und D. Franke machen das Stelenfragment Berlin ÄS 32/66 (=31228) publik. Der Textinhalt wartet durch den Bericht über einen Speicherbau mit einem besonderen Highlight auf (150). Die Stele teilt Informationen zu den Verbindungen des Titels *imi-rꜣ gś pr* mit Magazinen und Getreideversorgung mit (157). Die Datierung wird

mangels exakter Hinweise grob in die 13. oder frühe 17. Dynastie vorgenommen (157). Die Phraseologie des privaten Stelenbesitzers greift die königliche Terminologie in Bezug auf die enge Nähe zu Göttern auf (159).

E.-S. Mahfouz veröffentlicht zehn Stelen des Mittleren Reiches aus Assiut, die heute in der Tiggart Bibliothek der El-Salaam Schule der Stadt aufbewahrt werden. Die Diktion, Grammatik und Orthographie der Objekte legen einen Ansatz in die späte 12–frühe 13. Dynastie nahe. Die Denkmäler halten mehrere Beispiele für den Gebrauch von Männernamen bei Frauen bereit.

S. Seidlmayer betrachtet die Felsinschrift des Vorstehers von Unterägypten Dedusobek aus Assuan, die in die Frontfläche des mittleren Blocks der zentralen Gesteinsformation im Ferjâl-Garten eingemeißelt ist. Das *didi*-Mineral wird mit dem Hämatit aus dem Wadi Abu Aggag gleichgesetzt (206). Die Bezeichnung *ȝbw* wird auf das ganze Gebiet um Elephantine inklusive der Steinbrüche auf dem Ostufer ausgeweitet (206). Die Verbindung *rdi mȝꜥ* "rechte Fahrt geben" wird auf den diesseitigen Steintransport per Schiff bezogen (208–209).

L. Störk steuert chinesische und byzantinische Entsprechungen für die ägyptische Vergabe von Schandnamen (211–13) sowie neuzeitliche Parallelen für ägyptische Reisedaten in Nubien (215–16) bei.

P. Usick informiert kurz über das Detlef Franke Archiv im British Museum, das ab 1970 verfasste Schriften des Autors zu Mittlerem Reich und Erster/Zweiter Zwischenzeit umfasst (219–20).

U. Verhoeven handelt Reliefs des ehemaligen Eingangsbereiches des Felsgrab M10. 1 in Assiut ab. Die Inschrift Nr. 1 fällt durch die Schreibung des Wortes *nḥḥ* "Ewigkeit" durch das Nilpferd auf, die durchaus stichhaltig unter Hinweis auf das Wort *nḥḥ* "*nḥḥ*-Nilpferd" erklärt wird. Die Textkolumnen haben direkte Parallelen in den Biographien der Gräber Siut III/IV, die als Indiz für eine eigene siutische Lokaltradition gewertet werden (228). Die Datierung von M10.1 wird in die 11. oder frühe 12. Dynastie gewählt (228). S. 224: zur Verbindung aus *nḥḥ* "Ewigkeit" und Nilpferden vgl. Sethe, *Übers. II*, um 1934, 402. S. 226: zu *ȝṯii.t* "Beamte sind Amme" vgl. ähnlich B. Ockinga and Y. al-Masri, *Two Ramesside Tombs at El Mashayikh, Part 1, The Tomb of Anhurmose—the Outer Room* (Sydney, 1988), 38.

S. 226: zu *nḳm.t* "Plage" vgl. A. Allon, "Seth is Baal—Evidence from the Egyptian Script," *Ä&L* 17 (2007), 16; S. Donnat: "Le rite comme seul rétérent dans les lettres aux morts, Nouvelle interprétation du début du Cairo Text on Linen," *BIFAO* 109 (2009), 87; H.-W. Fischer-Elfert: *Magika Hieratika in Berlin, Hannover, Heidelberg und München, Mit einem Beitrag von Myriam Krutsch* (Berlin, 2015), 238; J. Borghouts, *The Magical Texts of Papyrus Leiden I 348* (Leiden, 1971), 100.

S. 226: zu *pgȝ ḏr.t* "freigiebig o. ä." vgl. J. Heise, *Erinnern und Gedenken, Aspekte der biographischen Inschriften der ägyptischen Spätzeit* (Fribourg-Göttingen, 2007), 183, 250; W. Spiegel-

berg, "Das Grab eines Großen und seines Zwerges aus der Zeit des Nektanebês," *ZÄS* 64 (1929), 80.

P. Vernus arbeitet zwei bildliche Ausdrucksweisen heraus. Im ersten Fall wird eine Verbindung zwischen den "Klagen des Ipuwer" und der ramessidischen Biographie des Anhurmose hinsichtlich der Redensart *msnḥ nhp* "Töpferscheibe dreht sich" gezogen. Die bei "Ipuwer" negativ für das Chaos gebrauchte Metapher wird bei Anhurmose positiv hinsichtlich seiner mannigfachen Aktivitäten verwendet (234). Das gemeinsame Textstück wird nicht im Sinne eines Zitates, sondern einer Adaption interpretiert (234). Im zweiten Fall steht eine Kapelleninschrift aus dem Mutbezirk von Karnak im Zentrum, die vom Ende 25./ Anfang 26. Dynastie stammt und eine jener bekannten *historiolae* um Isis und Horus überliefert. Der verbesserte Lesungsvorschlag der Präposition *ḥr* statt *ẖ.t* "Leib" hilft sonst notwendige Emendationen zu vermeiden. Die Spitze des metaphorischen Vergleiches der Brüste der Isis mit einem überquellenden (*ttf*) Brunnen (*ḥnm.t*) kommt dadurch besser zum Tragen (238). Die Reminiszenzen an die medizinische Fachsprache werden hervorgehoben (238–240). S. 239: zu *npȝpȝ* "palpiter" vgl. W. Ward, "Observations on the Egyptian Biconsonantal Root *pȝ*," in: H. Hoffner, ed., *Orient and Occident, Essays presented to Cyrus H. Gordon on the Occasion of his Sixty-fifth Birthday* (Kevelaer, 1973), 212.

H. Willems wertet den sozialen Hintergrund der Verfügung des *N.y-kȝ-ꜥnḫ* in dessen Grab bei Ṭihna al-Gabal aus. Die Reihenfolge der Grabherren in der dortigen Nekropole wird folgendermaßen rekonstruiert: 1. *Mr.y* (Fraser Tomb 11 ?), 2. *Ḥnw-kȝ=i* (Fraser Tomb 14), 3. *Kȝ-ḥp* (Fraser Tomb 12), 4. *N.y-Kȝ-ꜥnḫ* ("Grab II" und Fraser Tomb 13 [= "Grab I"]) (244). Die Anfänge des Begräbnisplatzes werden bis zur Mitte der 4. Dynastie zurückdatiert (249). Die Gräber werden zu den frühesten auf Basis eines festen Kanons dekorierten Provinzgräbern gerechnet (249). Die Kernthemen der Verfügung zum Grabkult in "Grab II" des *N.y-kȝ-ꜥnḫ* werden in den Rechten und Pflichten der Kinder einerseits und dem Verhältnis zwischen den Totenpriester und dem ältesten Sohn andererseits identifiziert (252). Die Ersetzung der herkömmlichen Bedeutung "Erbe" von *iwꜥw* durch "Nachfolger" (252) könnte den Anschein der Hyperkorrektheit erwecken. In "Grab I" kommt dem ältesten Sohn *Ḥm-ḥw.t-ḥr* gegenüber den anderen Kindern offenbar ein Exklusivrecht zu (256). Das "Umlaufopfer" wird als Zuwendung schon dargebotener Opfer an zweite Kultempfänger, in der Regel Verstorbene, charakterisiert (260). Die Einbindung der Vorfahren in den Kult wird zur Sprache gebracht (260). Die Diffusität der Grenze zwischen Privatbesitz und Tempelbesitz wird zu Protokoll gegeben (262).

Das abschließende Urteil des Rez. stellt sich positiv dar. Die vorgetragenen Interpretationen lassen sich gut begründbar vertreten. Die einzelnen Details werden dem Leser anschaulich näher gebracht. Die z. T. etwas blumige

Sprache hängt wohl vom persönlichen Geschmack ab. Die Lektüre hat sich durchaus rentiert.

Stefan Bojowald
Bonn

Jacquelyn Williamson. *Nefertiti's Sun Temple: A New Cult Complex at Tell El-Amarna*. 2 Volumes. Harvard Egyptological Studies 2 (Leiden-Boston: Brill, 2016). ISBN 9789004325524 (E-ISBN 9789004325555). Pp. v.1 x + 224; v.2 vi + 212.

For well over a century, the site of Tell el-Amarna has been subject to archaeological investigation, and numerous books, articles, and museum exhibitions around the world have focused on the Amarna Period. While popularizing books about the ancient city's founder the "heretic king Akhenaten" may give the impression to the uninitiated that there certainly remains something to be said about the Amarna Period, the specialist is well aware that considerable excavated material still awaits publication—thousands of *talatat* blocks from Karnak and finds from the Deutsche Orient-Gesellschaft excavations at Tell el-Amarna, now in Cairo and Berlin, to mention only two important groups. Over the past few decades several volumes have been published with the results of excavations resumed at Amarna, starting in 1977, under Barry J. Kemp's direction (initially under the auspices of the Egypt Exploration Society, London; now sponsored by the Amarna Trust, established in 2005, and The Amarna Research Foundation: http://amarnaanniversary.worldpress.com). The book by Jacquelyn Williamson under review adds significantly to the corpus of Amarna material brought to light by this fieldwork; specialists have eagerly awaited its appearance ever since she made a preliminary account of her work available nearly 10 years ago (*Egyptian Archaeology* 33 [2008], 5–7).

Williamson deals primarily with relief fragments excavated at Kom el-Nana in two volumes, the first for the text, *per se*, and the second comprising a catalogue of the material. The four chapters of volume 1 provide an introduction to Kom el-Nana and Sunshades of Ra at Tell el-Amarna, followed by a second chapter with the author's reconstructions, both of reliefs and architecture; chapter 3 deals with the hieroglyphic inscriptions and suggests the implications for Nefertiti's role, and the final chapter presents conclusions that can be drawn from the study. A bibliography and a comprehensive index complete volume 1. Volume 2 is an extensive, detailed catalogue of the relief fragments found at the site of Kom el-Nana, arranged according to the grid squares where they were unearthed. A color image (with scale), excavation number, measurements, and information on material are provided for every fragment. Williamson's

reconstructions of the reliefs account for twenty-one pages of volume 2, one page for each. Finally, ten plates show additional images of selected fragments.

In the introductory chapter, Williamson provides readers with orientation to the site of Kom el-Nana and its relationship to the Sunshade of Ra temples at Amarna, especially those features shared with the Maru-Aten complex, the only other excavated sunshade at the site (which since its clearance by the EES team in the early 1920s has been completely obliterated). Both sites have some architectural features in common—in particular, the presence of two large courtyards within separate enclosures (but cf. B. Kemp, *City of Akhenaten and Nefertiti: Amarna and its People* [2013], 120; see also the note below on artificial gardens). Support for the idea that these complexes are Sunshades is forthcoming from inscriptions found at both sites. While the Maru-Aten initially belonged to Kiya, Akhenaten's "greatly beloved wife," and was later usurped in favor of the king's eldest daughter Meritaten, the situation at Kom el-Nana is less clear.

Fragment s-2570, found in square Y39 at the North Shrine of Kom el-Nana, preserves parts of two columns of a vertical inscription above the minimally preserved head of a figure, with uraeus, facing left (274). Williamson convincingly reconstructs the text in the second column to read "… sunshade of Ra in …" thus identifying the complex at Kom el-Nana as a Sunshade of Ra (12–14, fig. 1.6).

However, her identification of the royal head as Queen Nefertiti is not entirely convincing, casting some doubt on the attribution of the site to Akhenaten's Great Royal Wife. The detailing of the wig on the very small portion of the head remaining on the fragment suggests the so-called Nubian wig, closely associated with Kiya. But the presence of a single uraeus—which is original, not added—at the forehead of the figure eliminates her, as well as a princess, from consideration. Nefertiti is certainly possible, but so is the king who may also wear this wig.

Furthermore the inscription directly above the head is oriented rightwards, unlike the figure, suggesting that the epithets and titles refer rather to the Aten, which must have been depicted to the left of the royal figure, as the single preserved sunbeam radiating towards it from the disc indicates. (In general, inscriptions identifying royal figures at Amarna are oriented in the same direction as the figure they accompany.)

In Williamson's reconstruction number 2, the figure of Nefertiti is depicted at some distance from the radiant disk, behind a larger figure of Akhenaten (407). But inscriptions belonging to the Aten are placed close to the disk; in my view, fragment s-2570 should originally have been not too far away from the disk, giving the names and epithets of the Aten. The head of the human figure is directly below the inscription; this person should be the largest in the scene, leaving no space for another larger individual in front of

it. If the figure were Nefertiti, she would have been shown without the king as the sole officiant, a motif attested to date with certainty only at Karnak in the reliefs on the so called "Nefertiti pillars." For the reviewer, the fragment therefore more plausibly depicts Akhenaten as the main figure, the sunbeam behind his head ending either in a hand that touches his neck or extending towards a smaller figure of Nefertiti behind him. Probably the fragment belonged to an offering scene with the Aten disc right above the offering table.

In chapter two, Williamson presents her reconstructions, discussing in detail the methodology she employed and its application. She assumes that the fragments of relief were found not far from their original location. For the scale of the figures, Williamson uses the grid system and canon of proportions as established for the Amarna Period by Gay Robins. The body cartouches of Akhenaten and Nefertiti are given their due, since they provide information on the orientation of a royal figure and are sometimes indicative of a specific gesture as well. Williamson's painstaking approach to reconstruction is comparable to Fran Weatherhead's work on painted plaster fragments from the palaces at Amarna (F. Weatherhead, *Amarna Palace Paintings* [2007]), and, like it, demonstrates the importance of meticulous examination of any and every iconographic, stylistic, and technical detail.

Only a few of the twenty-one reconstructions proposed have not totally convinced the reviewer. (The problem posed by reconstruction 2 [407–8], which includes block s-2570 has been discussed above.) Reconstruction 1 proposes an antithetical scene showing the royal couple with three of their daughters below the Aten disc. Antithetical scenes are attested in Amarna on stelae and architraves, but to date, not in large-scale wall decoration (Williamson's reconstruction would measure 6.5 m wide and 4.5 m tall). Of course, it cannot be categorically excluded that this motif existed in the (potential) corpus of wall decoration in temples at Amarna (cf. the speculative reconstruction of antithetical wall scenes by R. Hanke, *Amarna-Reliefs aus Hermopolis* [1978], 244–45, figs. 32–33), especially since Amarna in many cases proves the exception to the rule and frequently surprises with highly unusual compositions on temple walls, even including large-scale figures of non-royal individuals (see 140 with fig. 2.108 of a bowing figure). However, reconstruction 1 seems unlikely to the reviewer.

Another problematic reconstruction is Williamson's number 3 (409) showing the King and Queen offering to the Aten. Initially, at Karnak, a strict rule is observable for the position of the Aten in offering scenes; the sun disc is always placed directly above the altar or offering table. In other contexts, the disc is placed above the king or, much less frequently, above the queen. The course of the sunbeams on block s-4047 suggests that the disc stood directly above the

king; thus, the block should not belong to an offering scene as suggested by Williamson's reconstruction.

In reconstruction number 14 with a chariot, Williamson supposes that fragment s-77 belongs to the depiction of charioteers grasping folded reins with arms held close to their chins (104, fig. 2.80A). For the reviewer, what Williamson would identify on the photograph as folded reins resembles rather a lotus blossom. Whether block s-X37B depicts a pair of hands holding reins is dubious, even if the reviewer cannot propose a convincing alternative explanation. No other fragments from excavation square X37 bear discernable traces of horses or a chariot, despite s-17 and s-18, which might belong to reins running above a horse's back (329, s-18, to be rotated 90° counter clockwise). Williamson's other reconstructions are sometimes very tentative, but in general quite plausible, showing courtiers (reconstruction numbers 4 and 15), architecture (reconstruction numbers 5, 6, and 7), and offering scenes (reconstruction numberss 13, 15, 16 and 17; reconstruction number 19 shows an offering scene in a figural panel on a column).

Limestone is not the material of each and every fragment of relief from Kom el-Nana; some are sandstone. Williamson convincingly incorporates these latter fragments into the reconstruction of a gateway approximately 3 m in depth. The gateway reliefs at the reveals probably showed the royal couple offering to the Aten (employing fragment s-3307 [92, fig. 2.69]; see reconstruction number 8 [413] on each reveal, once on a large scale and twice in a double register scene). Additional elements of the gateway are monumental cartouches of the Aten, as shown in reconstruction number 12.

At the end of chapter 2, Williamson discusses architectural and archaeological evidence on which to base a reconstruction of the building program at Kom el-Nana. Although many details continue to be unclear, the site certainly included artificial gardens with ponds, monumental gateways, and larger structures with columns (cf. Kemp's characterization of Kom el Nana [*The City of Akhenaten and Nefertiti*, 2012, 120] as differing from Maru-Aten since the former had "…much open space but so far [i.e., before 2012?] the evidence for garden cultivation covers only a very small part of it"). Whether an antithetical scene of the royal couple below the Aten disk was the focal point of the North Shrine is uncertain.

Chapter 3 deals with the hieroglyphic inscriptions, identifying the site of Kom el-Nana as "the Sunshade of Ra in the *rwd ꜥnḫw itn*" (156). The precise meaning of *rwd ꜥnḫw itn* continues to defy clarification; possibly the term describes the northern and southern enclosures (cf. Williamson, in *JARCE* 49 [2013], 143–52), while the term "Sunshade of Ra" which is documented only in the northern enclosure might have been restricted to this building complex. Using additional textual evidence from Amarna, Williamson discusses the roles of Akhenaten and Nefertiti in the sunshade

and the *rwd ꜥnḫw itn*, concluding that the entire site of Kom el-Nana may have been ultimately dedicated to the proper maintenance of Maat by the royal couple (173).

The role of Queen Nefertiti in this connection is further elaborated in chapter 4. Williamson considers it plausible that the construction of Kom el-Nana began early, after the founding of Tell el-Amarna (the Sunshade of the queen is mentioned in the text of the boundary stelae), and continued until around year 11 when the name of the Aten was changed. To account for variations in style and quality observable in the reliefs, Williamson proposes that different workshops or crews were involved in the work, just as Donald Redford explained the same phenomenon among the Karnak talatat (in R. Smith and D. Redford, eds., *The Akhenaten Temple Project*, vol. 1. *Initial Discoveries* [1976], 76: "… as many as six master draftsmen, if not substantially more"). Most scenes depict the royal couple offering to the Aten—indeed, variations on this theme are the most common subjects in the art of Akhenaten's reign. The other prevalent motifs at Amarna are scenes of the royal family's "daily life" which were also represented at Kom el-Nana as documented by fragments of relief depicting courtiers, a palace with a pool and gardens, and other elements of daily life. Most relief reconstructions at Kom el-Nana are paralleled in the decoration of non-royal tombs at Amarna. For Williamson, this congruence may have resulted from the function of the temples as the source of funerary offerings for the dead at Amarna (190), their spirits coming daily to the temples for sustenance (this was the subject of a paper Williamson presented at the International Congress of Egyptologists in Florence, on 29 August, 2015). Based on the idea put forward by some Egyptologists that Akhenaten and Nefertiti embody the creator gods Shu and Tefnut, and were thus a source of renewal and rejuvenation at Amarna, Williamson proposes that the reliefs of the North Shrine at Kom el-Nana emphasized the royal family as the primary, semi-divine participants in the Aten cult.

In her final interpretation of Nefertiti's role at Kom el-Nana, Williamson must deal with the puzzling circumstance that no evidence is forthcoming yet for Nefertiti as the sole officiant in the cult of the Aten at Amarna (as on the 'Nefertiti pillars' at Karnak), and that she is normally depicted on a much smaller scale than her husband. Williamson argues that if Nefertiti had been shown worshipping the Aten alone at her sunshade, her status vis-á-vis the Aten would have been undermined, not elevated; by standing with the king and being taller than all others except him, her status was emphasized and her participation in the cult stressed (199). But this is true, in general, for *all* representations of the royal couple throughout Egypt and not specific to Kom el-Nana. If Kom el-Nana indeed was the sunshade of Nefertiti, the reconstruction of the decoration Williamson proposes surprisingly conforms to preserved reliefs from other temples and tombs at Amarna. Of course, it must be borne in mind that most reliefs are not preserved and the reconstructions were made only with tiny fragments.

Williamson's publication demonstrates the potential of painstaking examination of even the tiniest relief fragments while providing a thorough study of Amarna motifs, iconography, style, and technique. The high quality of the images in the book and the thorough documentation of the reliefs found at the North Shrine of Kom el-Nana make Williamson's work a lasting contribution to the field of Amarna studies that points the way for further studies.

Christian J. Bayer
Roemer- und Pelizaeus-Museum, Hildesheim

Konstantin C. Lakomy. „*Der Löwe auf dem Schlachtfeld.*" *Das Grab KV 36 und die Bestattung des Maiherperi im Tal der Könige* (Wiesbaden: Dr. Ludwig Reichert Verlag, 2016). ISBN 9783954901104. Pp. 528.

This monograph by Konstantin C. Lakomy is certainly the most thorough and contextual treatment of Maiherperi that Egyptology has yet seen, and it has been a long time coming. Lakomy starts with the unusual and special location of Maiherperi's semi-intact tomb. In Chapter I, Lakomy contextualizes Maiherperi's Valley of the King's shaft tomb, comparing it to every other King's Valley tomb from the early Thutmoside period, thus allowing a more precise dating of the KV 36 architecture into the reigns of Hatshepsut and Thutmose III. In Chapter II, Lakomy provides a precise description of the architecture of KV 36, including location, the discovery by Victor Loret, and the excavation history. This section is an archival triumph; Lakomy has tracked down the excavation notes of Victor Loret in an attempt to correct Daressy's problematic publication and to add even more context to a tomb that Egyptology has neglected.

Lakomy even discusses what was *not* found at Maiherperi's tomb, including magical bricks, foundation depositions, and superstructure, examining comperanda from the proper time periods, and socioeconomic levels to determine if we might be missing or misidentifying anything. Then Lakomy moves to the tomb plan, tomb contents, and the layout of those contents. Lakomy even creates a chart of hypothetical prices for the coffins in Maiherperi's tomb, based on Janssen's *Commodity Prices* and Cooney's *Cost of Death*, with a total for the coffins, mask, canopic shrine and jars at an astounding ca. 1,108 copper *dbn*. Lakomy concludes that the tomb of Maiherperi was one of the least disturbed of those graves given to a loyal official in the Valley of the Kings and filled with objects from the royal workshops.

Chapter III focuses on the person of Maiherperi himself, including his possible place of origin, the variants and

meaning of his name, his titles and offices, and his comparison to other officials with similar titles, the latter used mostly as a (re-)dating tool rather than as a means of social analysis. Maiherperi's obvious dark skin on his mummy and in his Book of the Dead depictions have brought up a number of questions about race, status, and Egyptianization amongst Egyptologists. Lakomy questions all the previously raised hypotheses about Maiherperi's identity, including the notion that he could have been the offspring of Thutmose III with a Nubian harem consort or another idea that Maiherperi was brought to Egypt after invading forces forced defeated Nubian elites to send their sons with the Egyptian overlords. Lakomy finds more evidence for the latter hypothesis, preferring to see Maiherperi as the product of Egyptian imperialism in Nubia in some fashion, using circumstantial evidence like his young age at death and the lack of Nubian material culture in his grave, to suggest that Maiherperi was not only acculturated, but at a young age, strongly suggesting that he was indeed taken by Egyptian forces to be raised at court, maybe even with the hope of sending him back to his homeland later as an ally. The alternative that Maiherperi's family came to Egypt willingly as Medjay mercenaries is also entertained, and the short, curly wig, bow and arrow, and throw sticks fit this option well. This latter possibility that Maiherperi is descended from people of Medjay profession and ethnicity is by no means mutually exclusive with Maiherperi having been taken as a child after an Egyptian invasion of Nubia.

Maiherperi's name is then probed; it is unique, occurring only one time, as far as we know. The meaning of "Lion on the Battlefield" is not only highlighted in the title of Lakomy's book, but in his analysis of Maiherperi as a person, as this unusual name could very well find its origins in Medjay East deserts and Lower Nubia. The title Child of the Kap is also examined, the real meaning of which remains vague for Lakomy but indicates close association with the court and the king for non-royal children. Maiherperi also bore the title of Fan Bearer on the King's Right, of course, his second most common title, and Lakomy concludes that he was one of at least three fanbearers who served in the reign of Thutmose III, all of whom probably served on the battlefield with their lord in addition to serving as bodyguard off the battlefield. Lakomy identifies just such a fanbearer in a scene from TT131 of Vizier Useramen who served years 22 to 28 of Thutmose III, and while said fanbearer is not labeled, or that label is destroyed, Lakomy hints that the depiction is uncannily similar to the way Maiherperi depicts himself in his own Book of the Dead, down to his sleeveless shirt and short, curled wig. Maiherperi's other titles are also discussed. Most useful for further social analysis is Lakomy's list of more than 120 men, documented from Theban Tombs or inscribed objects with similar status, titles, and time period. One of Lakomy's goals in this endeavor is to prove that the titles Fanbearer on the Right and Child

of the Kap were not unique to Maiherperi and do indeed occur earlier than previously thought by many Egyptologists, but his list of similar men is also a huge contribution to Egyptological social studies in enabling a categorization of a growing group of powerful and court-connected men of similar military-bodyguard specialization.

Lakomy relentlessly queries all assumptions about Maiherperi including the notion that an undecorated tomb in the Valley of the Kings would have been a great honor for the recipient, as every such recipient would have had to give up a decorated tomb chapel. Lakomy questions whether the holy location of the tomb in the King's Valley would have been enough to make up for active cult activity, and the answer is decidedly no. Lakomy thus ends this chapter with the open query of where the cult chapel of Maiherperi, and people like him, could have been located, since friends and family obviously could not have visited the secret and inaccessible Valley of the Kings to offer to his spirit. Lakomy suggests some unproven alternatives for the cult of the deceased, including a hypothetical Meretseger cult place near the Gurn, or before statues or stela placed at Abydos or some other temple location, or perhaps even a statue cult located in the Temple of Millions of Years of the associated king.

Chapter IV is the object catalogue, a treasure trove of information about objects of all kinds, including 200 plus objects groups from the tomb, a massive undertaking because each entry includes contextualization and numerous comperanda from museum collections and archaeological site reports. Lakomy scoured the Egyptian Museum in Cairo for every Maiherperi object that he could find plus every item of available comperanda. Lakomy insists on a full contextual study of each object type, and so he stretches himself to examine all the different categories contextually, including tomb architecture, coffins, the polychrome Book of the Dead papyrus, linens, masks, canopics, scarabs, shabtis, jewelry, wooden boxes, senet games, pottery, even analyzing contexts like pistacia resin, all the while, reevaluating everything—date, purpose, identify, name, social place. Every object is contextualized, described, drawn, including detail drawings, photographed, with all associated texts transliterated and translated. Lakomy is fearless and quite thorough, turning up every stone that he can. This does not mean he had full access to each and every object. Indeed, it is clear in the publication when he was stymied by museum rules and restrictions, having found a comparison piece that he was not allowed to photograph outside of the case, and yet what he did achieve is nonetheless extraordinary. The object catalogue alone makes this a wonderful research volume.

The (re-)dating of Maiherperi's tomb—from the oft accepted date in the reign of Amenhotep III to an earlier date in the joint reign of Hatshepsut and Thutmose III—haunts the entire volume, and this redating is absolutely convincing. There is even a smoking gun for those who might still be

unconvinced—a linen bandage with the cartouche is Maat-kare herself. This is also a book full of useful excurses as Lakomy delves into a variety of side interests that are the life's work for many of us—including coffin studies (this was indeed the first time the coffins were carefully examined, photographed and analyzed), ceramic studies (especially of the base ring ware from the Levant), glass studies (imported glass vessels from Mesopotamia), Book of the Dead studies (this was the first time the 11 m long Book of the Dead has been described, transcribed, translated, and analyzed), and even identity studies. There is something for everyone in this excellent volume.

Kathlyn Cooney
University of California Los Angeles

François Neveu. *The Language of Ramesses: Late Egyptian Grammar*. Translated from the French by Maria Canna-ta. (Oxford-Philadelphia: Oxbow Books, 2015). ISBN 978782978688. Pp. xx + 268.

The Language of Ramesses is the first English language edition of François Neveu's grammar of Late Egyptian, *La langue des Ramsès* (1996). The book was "designed for people with a good knowledge of Middle Egyptian who wish to read texts written in Late Egyptian, the language in use during the New Kingdom" (xv). As such, the author assumes a working familiarity with the Egyptological conventions of translit-eration, grammatical terminology, and reading knowledge of the Hieroglyphic script. Of course, Neveu does provide explanations for each point of the grammar but these are generally quite concise and focused on the practical infor-mation needed to make sense of the example sentences in each section, with no additional essays or lengthy discus-sions of theory, diachronics, etc. The volume is organized and presented as a reference grammar, with a detailed system of numbered sections and sub-sections, suitable for quick citation, and including only translated example sentences, while excluding untranslated, practice exercises. Neveu presents the material in three broad sections: "Mor-phology" (1–30, §§1–11), which introduces the parts of speech; "Syntax" (31–214, §§12–42), concerning initiality, the various verbal and non-verbal predicate constructions, and clause types; and two "Appendices," dealing with in-terrogative constructions (218–36, §43) and syllabic writing (240–42, §44). Following the main text, the book includes an index of grammatical terms in English (245–47), an index of Late Egyptian words and constructions in transliteration (248–50), a brief index of Coptic words (250), an index of texts cited (252–66), and a list of figures (267). The figures interspersed throughout the volume include facsimiles of

a few of the Hieratic ostraca and papyri, from which the Hieroglyphic transcriptions for select exercises derive. The final, un-numbered and un-indexed page of the volume includes a facsimile scene from Abu Simbel depicting the caning of Hittite scouts, with a brief Hieroglyphic caption, transliteration, and translation.

As Neveu notes, a comprehensive grammar of Late Egyptian has yet to to be written, while *The Language of Ra-messes* aims only to be a pedagogical tool, permitting "its readers to study and understand 90–95% of texts" (xv). Of course, numerous scholars have published specialized monographs on specific features of Late Egyptian (verbs of motion, non-verbal sentences, the verbal system, negations, et al.). However, very few general references in English have appeared thus far. These include, above all, the compendi-ous *Late Egyptian Grammar* of J. Černý and S. Groll (1993, 4th ed.), which focuses exclusively on non-literary texts; and the more pedagogically oriented, teaching grammar of F. Junge (*Late Egyptian Grammar*, 2005, 2nd ed., translated from the German by David Warburton), which includes both literary and non-literary sources. The English-language publication of Neveu's *Language of Ramesses* constitutes a very welcome addition to this small group. The volume's greatest strength lies in its inclusion of both non-literary and literary con-structions and examples, in contrast to the reference gram-mar of Černý and Groll. Given that early literary texts, like the "Doomed Prince," constitute a logical point of depar-ture, due to their admixture of Middle and Late Egyptian constructions, students beginning with such "transitional" material will certainly appreciate its inclusion in an easily searchable, reference format. Of course, one cannot learn Late Egyptian without actually translating Late Egyptian texts, so Neveu's grammar cannot serve as a stand-alone introduction—students must retain access to hieroglyphic reading books, such as A. Gardiner's *Late Egyptian Stories* (1932) and *Late Egyptian Miscellanies* (1937) or, if possible, Hieratic facsimiles, e.g., G. Möller, *Hieratische Lesestücke*, vols. 2–3 (1910). For students interested in a single-volume teach-ing grammar, including practice exercises, Junge's *Late Egyp-tian Grammar* remains the preferred choice, particularly for self-study (i.e., outside a formal classroom setting).

The Language of Ramesses mostly employs terminology "traditionally used in grammars of Egyptian," which is to say, aligning relatively closely to Černý and Groll and the so-called "Standard Theory" of Polotsky, including terms derived from Coptic studies (Second Tenses; First Present; Third Future; etc.). Issues of grammatical theory do not constitute a significant focus of the text, which is almost purely descriptive. However, the author does allude occa-sionally to theoretical issues, which the reader might inves-tigate further or ignore, at their discretion (thus, e.g., 33, n. 62, concerning the role of the interlocutor in the speech act). In some cases, the citations appear rather too sparing to do justice to a thorny theoretical issue. Thus, for example,

in his discussion of the so-called "Second Tenses," Neveu mentions Polotsky's syntactic analysis of the emphatic verb as nominal subject to a following adverbial predicate, with the note that "Nowadays there is a tendency to reject the 'nominalization' [of the Standard Theory]" (92). However, the citation for this latter point (n. 189) refers only to a comparable phenomenon in French, with no reference to any post-Standard Theory, Egyptological studies. Of course, given the stated aims of the volume as a pedagogical tool aimed at acquiring practical reading knowledge, any such omissions constitute a largely academic quibble.

With regard to the English translation itself, Cannata has done an admirable job of navigating the fine line between the spirit and letter of Neveu's original French. The English adheres closely to the economy of words in the original text, which results generally in a very concise and understandable English prose. However, as the translator notes, in some cases, a preference for more literal rendering of the French has come at the expense of "good English style" (xvii). Such peculiarities are infrequent and do not materially affect the understanding of the text; genuine errors in the translation are uncommon (e.g., 91: "prosthetic yod," rather than "prothetic yod"; cf. *Langue des Ramsès*, 111: "yod prothétique"). Readers familiar already with the French edition of Neveu's work should know that the new, English translation follows the organization and content of the original volume very closely, including virtually identical chapters, sections, and sub-sections, all numbering systems, appendices, figures, and example sentences. Only three additions and/or changes from the French may be cited: the addition of a translator's note (vii); a reversal of §33.2.1.3 and §33.2.1.4, including a revision of the former sub-heading from a simple "Remarque" to "The protasis incorporates a Third Future (very rare examples)" (143); finally, one entirely new section has been added to the grammar itself (§33.2.3, "The protasis incorporates the ambiguous syntagma *iw.f* (?) *sḏm*"). Other purely cosmetic, but very welcome, alterations include the new volume's more compact size and the switch to a darker—and therefore much more legible—hieroglyphic font.

Within the traditional setting of the graduate-level seminar—where most students are likely to begin serious engagement with Late Egyptian—Neveu's grammar will surely take its place as one of the standard English-language resources for teaching and reference. As such, *The Language of Ramesses* belongs on the bookshelf of anyone offering instruction in or learning Late Egyptian.

Joshua A. Roberson
University of Memphis

Stephen Quirke. *Exploring Religion in Ancient Egypt* (Chechester, West Sussex: Wiley-Blackwell, 2015). ISBN 9781444332001. Pp. viii + 271.

Exploring Religion in Ancient Egypt represents Stephen Quirke's third introductory survey of Egyptian religion, following *The Cult of Ra* (2001) and *Ancient Egyptian Religion* (1992). In terms of the author's philosophy and approach to the subject generally, the present volume aligns closely with its predecessors through its careful delineation of modern preconceptions from ancient evidence. With regard to specific content, *Exploring Religion in Ancient Egypt* attempts to break new ground through the application of non-Egyptological methodologies and theoretical frameworks, primacy given to evidence from non-royal and non-elite spheres, occasional ethnographic parallels, and a de-emphasis on traditional introductory topics. As a result, *Exploring Religion in Ancient Egypt* is rather less "introductory" than its predecessors and might best be viewed as a theory- and interpretation-focused sequel to Quirke's *Ancient Egyptian Religion*, rather than a starting point for the neophyte.

A preface (vi–viii) establishes the author's theoretical agenda, above all, through recognition of the "weight of the baggage we bring from the Twenty-First century" (vii). Chapter 1, "Belief without a Book" (1–37), opens with caveats on the use of the term "religion," followed by a lengthy critique of Egyptology itself, which the author chides for "separation of disciplines" and non-holistic methodologies (3–4), Eurocentrism (4–5), overemphasis on writing (5–7), and the "unreflective use of generalized concepts and categories such as society, economy, and religion" (7–8). The author then considers Jan Assmann's definition of Egyptian religion and concludes that it is hampered by a separation of ethics and cult, as well as over emphasis on the royal sphere. In addition, he suggests that the "European" focus on mono- vs polytheism should be abandoned by shifting focus from the word "god(s)" to "cult practice." A section on landscape (12–16) introduces the familiar binary oppositions "Red" vs. "Black" land, etc., and suggests that Egyptian religion should be understood in more diverse terms of eight, somewhat arbitrarily defined (16), "ecological units," as factors shaping a heterogeneous, as opposed to monolithic, Egyptian religion. Following several sections of background material (divisions of Egyptian history, mortuary versus settlement sites, etc.), Quirke discusses "modern prejudice in distinguishing elite and popular religion" and the need to suspend assumptions with regard to these and other categories (25–27). After these preliminary discussions, the chapter segues into a discussion of iconography as an expression of the inexpressible—the nature of divinity—through "visual form as a metaphor to decode" (33). Quirke then takes up the problematic existence (or lack thereof) of Egyptian narrative mythology (35–36), before closing the chapter with a short list of common English terms like

"king" and "temple," which he brackets as containing significant modern baggage, to be viewed with caution in relation to ancient Egypt.

Chapter 2, "Finding the Sacred in Space and Time" (38–79), begins with a discussion of the sacred and its variability in different cultures; the remainder of the chapter unfolds thematically from internal experience of the sacred (e.g., self vs. other) to external, as expressed in town, temple, and shrine. Quirke introduces the anthropological/philosophical theories of Viveros de Castro as a framework for approaching Egypt's view of self and other, especially with regard to human vs. animal (40–45, including an interesting discussion of pets, at 42–44). He includes a summary of the three ontological classes of beings, namely gods, kings, and humans, noting that the last group radiates outward in concentric circles of proximity from the king, as "sunfolk," "elite," and "commoners." Quirke observes also that animals and plants are absent from this (text-based) scheme, although their prominence in the iconography of deities "warns us against assuming the separation of human from animal" (43). A longer section follows, concerning the sacred vis-à-vis the body (44–60). Of particular interest here is a discussion of bodily integrity and the desire to preserve it after death, as a whole (44–47). Quirke considers individuals with degenerative ailments like polio or leprosy—attested only rarely in the archaeological record—who might have been excluded from priestly service, driven to exile, or even excluded from mortuary rituals and therefore the afterlife. As an exceptional instance from the royal sphere, he considers Ramesses V, whose mummy exhibits characteristic lesions associated with smallpox. The author concludes that the king's status as a "different species" (47) might have provided sufficient motivation to overcome the taboo against such afflictions. Other topics include idealized depictions of the human (48–49); body alteration (49–51); the beginning and end of life (51–54); personhood and naming practices (54–57); and rites of passage, including puberty rituals for girls and boys (57–61). The remainder of the chapter is devoted to religious landscapes and "sacredness around the human" (61), illustrated through case studies from Badari (62–65), Elephantine (65–70), and Lahun, with select comparison to Akhetaten (70–79).

Chapter 3, "Creating Sacred Space and Time: Temple Architecture and Festival" (80–109) opens with a warning that the well-preserved monumental temples and royal tombs provide an incomplete picture of Egyptian religious architecture. Quirke illustrates the diversity of evidence through eight architectural types, which he defines as: 1) mounds as platforms; 2) rounded mounds with enclosing chambers; 3) squared mounds enclosing chambers; 4) freestanding rectangular or square structures with principle chambers at the rear; 5) rectilinear buildings with extended axes; 6) rock cut structures; 7) terraced structures; and 8) structures with a crescent lake. The author then provides

an overview of the daily offering rituals and the rotating "watches" of temple staff, followed by the role of the king and his priestly surrogates (91–96). He considers the role of the "bearer of the festival book" (i.e., the lector priest) as standing "at the center of of the history of sacred knowledge," and the related function of the House of Life (96–97). The second half of the chapter examines evidence for festivals and other sacred events (97–109), including, for example, kingship rituals from Lahun, festival calendars, and the reversion of offerings as a mechanism for the establishment of new sanctuaries.

Chapter 4, "Chaos and Life: Forces of Creation and Destruction" (110–49), examines "the way in which people across Egypt . . . expressed contending forces at play in their lives" (110). The discussion begins by revisiting the author's warning against philological bias and the problematic nature of Egyptian mythology. After a brief survey of different Egyptological approaches to myth (Assmann, Zeidler, Goebs), Quirke suggests that myths might have been learned through non-linguistic "information blocks," rooted in image and performance, which were only translated into words "when some gain offset the effort . . . [of transforming] fuzzy prototype concepts into rigorous concepts with checklists of features" (116). A longer section follows, concerning mythological "constellations outside writing" (116–35), with particular focus on non-royal iconography. Other elements of visual culture include images of Min and Amun (122–25); Seth (130–31); jackals (131–32); and images of "child – god – king" (133–34). Having established his "broader archaeological record" (116), Quirke devotes the remainder of the chapter to "Speaking and narrating the Divine" (135–49), including discussions of the return of the solar eye as the offering motif *par excellence*, "in stark contrast to the elusive narrative myth" (136); the so-called "Memphite theology" (141–42); and the literary tales of the "Contendings of Horus and Seth" and the "Tale of Two Brothers" (145–48).

Chapter 5, "Being Good" (150–176), concerns the Egyptian concept of Ma'at and ethical behavior. Quirke notes that our prioritization of sources depends on whether we are interested in how people actually treat one another versus "how they say they should" (152). In addition to the expected textual evidence (legal documents, instruction literature, etc.), the author includes also an interesting discussion of human remains as non-textual data for inequality in Egyptian society, as revealed through violence, trauma, or other physical suffering (malnutrition, disease, etc.) (153–55).

In Chapter 6, "Being Well," (177–200), Quirke begins with a discussion of "rural and urban health" (178–79), noting a general dearth of archaeological evidence; followed by "medicinal matter and the questions of shamanism" (179–80), including case studies of a possible "wise woman" from Deir el-Medina and a late Old Kingdom burial assemblage from Badari, which seems connected also to healing

practices. The author cautions that any interpretation of specialized objects, such as healing implements, should consider whether the tomb owner was a specialist, who utilized the objects as tools of the trade, or a patient and beneficiary of the practice itself. The remainder of the chapter discusses the function of amulets and their change over time (183–90), noting the often arbitrary distinction in modern publications between "amulets" and "jewelry"; other sorts of healing and protective objects, such as Horus stelae and clay cobras (190–91); titles associated with healing practice, noting in particular the problematic separation of titles with divine names (e.g., "Controller of Selqet") from supposedly "scientific" titles, like "doctor" (Egy. *swnw*) (191–94); medical papyri, and questions of their ownership (194–95); and finally, the consultation of oracles and other forms of divination and contact with the divine, including sleep and dreams (196–200).

The book concludes with Chapter 7, "Attaining Eternal Life: Sustenance and Transformation" (201–37). It opens with a recapitulation of the author's caveats on the types and limitations of source material, noting two overwhelming concerns that emerge from the ancient texts: sustenance of the body as a "physical anchor for human life" and transformation "into an eternal being, becoming *netjer*-like in immortality" (201). As a methodological counter to this text-based framework, Quirke suggests four guidelines to the interpretation of burial/tomb sites: 1) "burial demography," which is to say, the number, status, and timing of individuals buried together; 2) body position; 3) above- vs. below-ground mortuary structures as links between the living and dead; and 4) material goods placed with the dead (204–5). The author next offers a chronological summary of burial practices for non-royal individuals, from 3100–525 BCE (205–28). Following this impressively robust, if not exhaustive overview, Quirke includes a very brief summary of royal burial practices over the same time span (228–30). A concise discussion of mortuary literature and tomb decoration follows (230–34), consisting primarily of numbered lists highlighting major themes, including scenes of burial, the opening of the mouth ritual, a selection of four themes from the Pyramid Texts, four themes from the Coffin Texts, seven themes from the Book of the Dead, and a succinct enumeration of the twelve hours of the night, as attested in the Amduat and Book of Gates. The chapter concludes with discussion of the *akh* concept (235), further caveats on the perception of Egyptian religion as a monolith (235–36), and suggested avenues for further research (236–37). After the main text, the book concludes with a bibliography of sources cited by chapter (235–55) and a general index (256–71).

Exploring Religion in Ancient Egypt functions primarily as a vehicle for its author's interpretations of primary and, in some cases, secondary literature. As such, the critical reader may agree with some of Quirke's views and disagree with

others. Such differences of opinion and interpretation, if and when they arise, are the business of the individual and should not be dictated from the pulpit of the reviewer. In fact, it is precisely the challenges offered to traditional interpretations and theoretical frameworks that constitute one of the volume's great strengths. However, there are other issues that seem to muddy the waters that the author seeks ostensibly to clear, and which therefore merit further discussion. For example, the author's preference for pseudo-phonetic, faux Egyptian toponyms over their better known Greek or Arabic counterparts (e.g., "Waset" for Thebes; "Khemenu" for Ashmunein) holds potential for confusion (vii), in particular with regard to the index, which is sorted only by the former terminology. Above all, however, the reader confronts numerous dismissals and omissions of both individual scholars and broad swaths of scholarship, beginning with essentially *all* current university training in Egyptology, with the statement that "in university departments, Egyptologists generally train to read Egyptian writing, not to undertake archaeological fieldwork or study the visual arts, or even comparative or historical linguistics" (4). This bold indictment shows either a lack of awareness of, or lack of interest in, the breadth and variety of modern Egyptological programs, particularly in the United States, where interdisciplinary training is increasingly the norm, rather than the exception. Other curious dismissals may be cited. For instance, when discussing 525 BCE as the upper chronological limit of his study, Quirke concludes that, "as a unitary and integral social field, *ancient Egyptian religion* ends" with the Persian conquest and the introduction of a new administrative language (11, italics original). The implication that late Pharaonic religion was somehow un-Egyptian—or, perhaps, a diluted version of Egyptian—appears profoundly outdated in an otherwise "progressive" treatment of the subject. As Janet Johnson noted some twenty-five years ago, "One serious problem in the study of Egypt [after the Persian conquest] is that the Egyptian element in this multi-cultural society has been undervalued" (J. Johnson, "Preface," in J. Johnson, ed., *Life in a Multi-Cultural Society* [Chicago, 1992], xxiii). In sum, while it is perfectly reasonable to establish limits to a popular study for reasons of space, Quirke does a disservice to the beliefs of the ancient people with his suggestions that 525 BCE represents the end of ancient Egyptian religion, "unitary and integral" or otherwise (for continuity of Pharaonic religion into the Persian era and later, see, e.g., C. Manassa, *Late Egyptian Underworld* (Wiesbaden, 2007); D. Klotz, *Caesar in the City of Amun* (Turnhout, 2012); more generally, see K. Myśliwiec, *The Twilight of Ancient Egypt* (Ithaca-London, 2000); and D. Frankfurter, *Religion in Roman Egypt* (Princeton, 1999). With regard to the core subjects and time periods treated in the text, other elements also appear conspicuously abbreviated and/or outdated. Thus, when Quirke suggests that "the prominence of kingship can also be read as a study of

reception, with the gradual adoption across the society of certain models first developed for kingship" (116) or, later, "[Osirification] seem[s] to creep outward from the center, to achieve hegemonic or normative status across a wider part of society" (201), he places himself squarely within the early Twentieth Century view of the "democratization" of religion. This concept has been questioned by numerous scholars, whose contributions pass without mention in the present volume (for discussion and additional references, see M. Smith, "Democratization of the Afterlife," in J. Dieleman and W. Wendrich, eds., *UCLA Encyclopedia of Egyptology*, 2009, https://escholarship.org/uc/item/70g428wj; and H. Hays, "The death of the Democratization of the Afterlife," in N. Strudwick and H. Strudwick, eds., *Old Kingdom, New Perspectives* [Oxford, 2011], 115–30). Other eyebrow-raising statements include Quirke's surmise that the (uniquely!) well preserved "burial of Tutankhamun indicates how kingship followed regular practice of the day" (229) and his casual dismissal of the entire history of Egyptian cosmology after Akhenaten with a single laconic statement that "new compositions proliferate in the tombs of the kings at [Thebes]," mentioning only the Book of Gates (232) (for detailed discussions and additional references, see J. Darnell, *Enigmatic Netherworld Books* [Fribourg-Göttingen, 2004]; C. Manassa, *Late Egyptian Underworld* [Wiesbaden, 2007]; A. von Lieven, *Grundriss des Laufes der Sterne* [Copenhagen, 2007]; M. Müller-Roth, *Das Buch vom Tage* [Fribourg-Göttingen, 2008]; D. Werning, *Das Höhlenbuch* [Wiesbaden, 2011]; J. Roberson, *Ancient Egyptian Books of the Earth* [Atlanta, 2012]; and J. Roberson, *Awakening of Osiris* [Fribourg-Göttingen, 2013]). Finally, Quirke states that "In Egyptology, the House of Life has come to be seen as a knowledge center equivalent to a European-style university. . . at the risk of misreading [its] specific cultural and social context" (96). This condemnation—made without citation or reference—appears rather striking, insofar as Sir Alan Gardiner had reached the same conclusion in his seminal study of the House of the Life nearly eighty years prior, stating unequivocally that "One of the main results of the present article will be to show that the conception of the [House of Life] as a training college, and still more the conception of it. . . as a University, is a grave mistake" (A. Gardiner, "The House of Life," *JEA* 24/2 [1938], 159).

The criticisms offered here underscore the importance of a cautious approach to this or any work concerned primarily with issues of theory and interpretation. However, such criticisms do not negate the book's real value as a fresh, even confrontational, presentation of the complexities of ancient Egyptian religion. Overall, the wide range of material is impressive, including textual, iconographic, and archaeological evidence, which paints an admirable portrait of Egyptian religion as a complex series of processes, rather than a monolith unchanged through the ages. The task of writing a new, general book on Egyptian religion is formi-

dable. *Exploring Religion in Ancient Egypt* deserves all due credit for its attempt to approach the topic in a way that is novel, interesting, and challenging to both scholars and lay readers. Quirke accomplishes this goal by treating "standard" topics in ways that question our assumptions about what constitutes "standard" in the first place, why that standard has been applied previously, and how we might view gods, temples, the afterlife, etc., from a perspective that is more inclusive of the majority of Egyptian experience, which is to say non-royal and non-elite. Inevitably, allowing for new perspectives results in new connections and new interpretations, which might not have been apparent from a more traditional, top-down view of society. In this regard, Quirke's volume falls in line with recent trends in scholarship regarding social history, local economies, and other, less visible aspects of Pharaonic culture (see, e.g., J. Moreno Garcia, ed., *Ancient Egyptian Administration* [Leiden, 2013]; L. Warden, *Pottery and Economy in Old Kingdom Egypt* [Leiden, 2014]). Scholars working in the field of Egyptian religion will benefit from consideration of the challenges that Quirke poses throughout the volume and the new questions that might arise in their own work, as a result. Likewise, lay readers will certainly find a great deal of fascinating material within the pages of *Exploring Religion in Ancient Egypt* that has rarely, if ever, been featured in popular treatments of the subject.

Joshua A. Roberson
University of Memphis

Barbara Lüscher. *Auf den Spuren von Edouard Naville. Beiträge und Materialien zur Wissenschaftsgeschichte des Totenbuches.* Totenbuchtexte Supplementa 1 (Basel: Orientverlag, 2014). ISBN 9783905719253. Pp. xvi + 134, 151 plates.

One of the global centers of research on the Book of the Dead (BoD) is at the University of Basel where Barbara Lüscher and Günther Lapp initiated the project of a comprehensive new edition of the BoD corpus in 2004. To facilitate the project, a publication venue was created (Orientverlag) with three series (*Totenbuchtexte, Totenbuchtexte Supplementa,* and *Beiträge zum Alten Ägypten*) in which so far sixteen volumes on the BoD have appeared. The one presented here is the first of the supplement series and pursues two main goals (described previously in B. Lüscher: "In the footsteps of Edouard Naville (1844–1926)," *BMSAES* 15 [2010], 103–21; http://www.britishmuseum.org/pdf/Luescher.pdf):

(1) to reconstruct and reassess the early history of research on the BoD, with Édouard Naville's pioneer edition of 1886 as its culmination, on the basis of archival research (in particular the papers left by Naville himself); and

(2) to publish nineteenth-century hand copies of BoD

manuscripts for such Books of the Dead that have either not or not satisfactorily been published or that are today lost (as in the case of a fragment of the former "Kestner collection," which belongs to pFlorence 3660A).

Part 1 provides a detailed and beautifully illustrated history of the BoD research in the "time of the pioneers" (from the earliest known facsimile of a BoD in 1653 to Richard Lepsius, 3–35) and then focuses on Naville's edition (37–68, flagged as noteworthy is the significant contribution that Naville's wife Marguerite made), supplemented by remarks on the history of reproduction techniques and the typography of BoD editions (69–84, from woodcuts and engravings to the hieroglyphic text processor developed for the Basel project).

For the documents presented in part 2, Lüscher undertook the painstaking task of comparing the nineteenth-century hand copies with each other (where different copies are available, e.g., from Lepsius, Lepsius's draughtsmen Ernst and Max Weidenbach, Naville himself, and Ernesto Schiaparelli) and with photographs of the actual papyri; she provides on pp. 85–121 a succinct commentary of all observed copying mistakes. The hand copies are from the following source documents: Pap. Nakhtamun = pBerlin 3002 (pls. 1–77), Pap. Berlin 5509 (pls. 78–80), Pap. Nespaheran = pBerlin 3006 (pls. 81–86), Pap. Ramses-Siptah = pFlorence 3660B (pls. 87–89), Pap. Senemnetjer = pFlorence 3660A (pls. 90–93), Pap. Kestner (pls. 94–95), pFlorence 3661 (pls. 96–103), Pap. Ptahmose = pBusca, Milano (pls. 104–43), Pap. Pashed = pMilano 1025 (pls. 144–45), Ostracon Louvre E22394 (pl. 146), Ostracon Louvre N684 (pl. 147), Ostracon Louvre AF496 (pl. 148), Tomb KV2 (Ramses IV) (pl. 149), Tomb KV9 (Ramses VI) (pl. 150–51).

In a disciplinary perspective, one of the most important aspects (briefly alluded to on 55–57) is the position of Naville and his project among different national Egyptologies. Naville himself was a loyal student of Lepsius (as the present book reaffirms), and the Book of the Dead edition was financially supported by the Berlin Academy and the Prussian State. Lepsius accorded to the edition of the Book of the Dead, until the discovery of the Pyramid Texts in 1881 the largest religious text corpus of ancient Egypt, a paramount role in the study of the Egyptian language. After Lepsius died in 1884 and Naville was disregarded as successor to the Berlin chair, Naville turned his back on the new "École de Berlin" (a term coined by Naville, initially in a derogatory sense) under Adolf Erman and its dictionary project and turned to French and British Egyptology (see in detail: T. Gertzen, *École de Berlin und "Goldenes Zeitalter" (1882–1914) der Ägyptologie als Wissenschaft* [Berlin, 2013], 19–21; 32f., 91; 135f.; 161f.; 256; 360–78; and his fig. 2 on p. 21 with the academic relationships; H. Virenque, "A Swiss Egyptologist on Her Majesty's Service: Edouard Naville (1844–1926) in the Delta," in N. Cooke and V. Daubney, eds., *Every Traveller Needs a Compass* [Berlin, 2015], 189–96).

At the same time, the newly available Book of the Dead influenced intellectual and religious debates in the 1880s and 1890s. As David Grange writes in regard to English translations of the BoD: "New knowledge of Egyptian religion shaped the extent to which British thinkers were able to develop reflexive approaches to their own cosmology"; and by harmonizing the BoD with Biblical and Christological ideas, "the positive revaluation of Egypt amongst orthodox writers actually began to alter orthodox categories" (D. Gange, *Dialogues with the Dead: Egyptology in British Culture and Religion, 1822–1922* [Oxford, 2013], 209f.).

In summary, this is an excellent monograph precisely because, by tracing Édouard Naville's work, it points to the importance to integrate different areas of research: the study of the BoD itself through their nineteenth-century manuscripts, and the study of the study of the BoD within the historical context of individuals, institutions, and intellectual traditions at a transformative moment of Egyptology.

Thomas Schneider
University of British Columbia

Frank Förster. *Der Abu Ballas-Weg. Eine pharaonische Karawannroute durch die Libysche Wüste.* Africa Praehistorica 28 (Cologne: Heinrich Barth Institute, 2015). ISBN 9783927688421. Pp. 620 + 376 color and b&w illustrations, 23 tables.

Egypt's Western Desert was little explored archaeologically until the late 1930s, when Ahmed Fakhry started his investigations into the desert and, most particularly, the oases. Thereafter, limited work was carried out in these regions until the 1970s, when activity picked up in Dakhla and Kharga, and subsequently in Siwa, Baharia, and more recently, in Farafra. However, the desert hinterland was largely the purview of desert explorers and geologists (and occasionally the military) until the initiative (ACACIA) headed by Rudolph Küper and his team in the 21ˢᵗ century. In addition to locating several sites, the team tracked desert routes that connected Egypt to the rest of Africa to the south and west, demonstrating a far wider network than had been previously assumed. Förster, a member of this team, played a key role in investigating the Abu Ballas trail, one of the main tracks that left Dakhla, going west. Förster's work is the culmination of almost a decade's worth of exploration of the Western Desert. It is an invaluable and detailed record of the trail and the sites along it. The book is divided into four main sections, followed by thorough summaries in German, English, French and Arabic.

The book starts with an introduction to the project, the history of research on the elusive (legendary?) oasis of Zarzura and the identification of the Abu Ballas (Father

of Ballas Jars) trail, eponymously named for a large depot of jars found semi-buried around a rocky outcrop in 1918. It continues with a summary of work carried out to trace the route associated with the deposit, and concludes with an overview of the discoveries made by the desert explorer Carlo Bergmann and the ACACIA team.

The second portion of the book provides an extremely detailed description of the sites found along the trail and its offshoots. Figural engravings, inscriptions, ceramics (organized chronologically), archaezoological and archaeobotanical finds, carbon dates associated with some of these, as well as a careful record of other artefacts (including a discussion on desert glass) discovered along the way are described and illustrated. The texts are of particular interest as they not only record trips made by the Egyptians over the millennia, but also mention encounters with oasis dwellers and fugitives (e.g., the inscription of Kay).

The book's third section deals with the organization and practical use of the route as it changed over time (third millennium BC through the Islamic period, with the emphasis being on the pre-Third Intermediate Period). It begins with an overview of the changing climate and what that involved in adjustments for travellers, particularly with regard to water supply. Förster makes full use of ethnography to elucidate the acquisition, transport, and storage of water over long distances in an arid environment, integrating it with textual and pictorial evidence from ancient Egypt, as well as a careful study of the jars and their capacities. The highlight of this section is the thorough and detailed study of the capabilities and role of donkeys as beasts of burden in ancient Egypt. Biology, ethnography, texts, and images are all used to explain the crucial role that these extraordinary animals played in long-distance travel, allowing the Egyptians to roam several hundreds of miles long before the advent of the camel (the date remains in dispute—possibly from the 7th century BC or slightly earlier), which made desert travel comparatively easy and economical.

The work then continues with an overview of the route at different periods, and a discussion about issues concerning the route's historical life. Förster addresses questions such as, what was the role of the route; did it change over time; why were so many resources devoted to its establishment; and how long was it used? Although no firm answer is available, Förster provides an overview of many possibilities, including the traditional ones, such as offering an alternative to the Nile, non-policed and non-taxed routes (as many desert routes are used today, most recently for human trafficking), and emphasizes the point that the Egyptians might have taken advantage of a route that already was in use by populations inhabiting the margins/deserts.

Förster is to be congratulated on masterfully presenting the hitherto unknown history of this part of Egypt, and for setting a standard for documenting desert routes. This work will long be a crucial source of information on trans-Saharan movement over time, and the history of the ancient Egyptians' interaction with the desert and lands far to the west and south.

Salima Ikram
American University in Cairo

Hélène Fragaki and Anne-Marie Guimier-Sorbets. *Un édifice inachevé du quartier royal à Alexandrie. Étude suivie de un fragment de corniche peinte hellénistique à Alexandrie.* Études Alexandrines 31 (Alexandria: Centre d' Études Alexandrines, 2013). ISBN 9782111298514. Pp. 149, 131 color and b&w figures.

This slender, yet information-packed volume, is divided into two parts, the larger devoted to a study of the so-called unfinished building within the Royal Quarter of Alexandria by H. Fragaki. She collaborates on the second, smaller study of a painted architectural cornice with A.-M. Guimier-Sorbets, who has often dealt with questions about Alexandrian painting (Guimier-Sorbets, Pelle, and Seif el-Din, eds., *Renaître avec Osiris et Perséphone* [2015], reviewed in *BiOr* 73 [2016], 111–17); and Guimier-Sorbets, "L'architecture et le décor peint des tombes d'Anfouchi à Alexandrie: nouvelles perspectives," in P. Ballet, ed., Grecs et Romains en Égypte [2012], 171–86).

H. Fragaki's objective is to make sense of forty-seven monumental worked blocks, some in the Doric order, others in the Ionic. These blocks were discovered over a period of time in different loci, but those loci are all within the confines of that area of Alexandria which is universally regarded as the site of the royal quarter. Most of those worked blocks were found in isolation without any quantifiable archaeological context. Some have not been previously published; others, now lost, are only known from earlier publications. Proceeding from a consensus that their general findspots, style, and dimensions suggest that they all belonged to the same architectural ensemble, H. Fragaki first presents each in her prefatory catalogue.

Those conversant with the methodology of Hellenistic architectural exegesis can well appreciate her command of the material as she effortlessly, but convincingly, finds parallels for the details of her corpus of orders within the architectural repertoire of the Hellenistic period which she dates to the end of the third century BC. Having established their date, she reviews earlier identifications of the structure to which these worked blocks are suggested to have belonged. One of the stumbling blocks for such an identification is that no member of her corpus exhibits any detail suggesting that it was actually built into a structure, as she emphatically emphasizes: "ces blocs *ébauchés* n'ont jamais *été* mis en place, comme le montre l'absence de toute trace de moyens

d'assemblage" (9). Later she observes "le quartier royal, expression tangible de la continuité dynastique garantie par les Lagides, *était* donc en perpétuelle construction" (48). Accordingly, should one now understand the designation of Alexandria as Racotis, the city which is continually in a state of construction (S. Caneva, *From Alexander to the Theoi Adelphoi* [2016], 210), in a new light? And is it not, then, somewhat ironic that to date there is no comparable corpus of monumental worked blocks from a *completed* structure which have been identified? This begs the question regarding the appearance of Hellenistic Alexandria. Did it habitually appear like a modern airport, the construction of which is proverbially never completed? That observation forces one to ask why these apparently never-used worked blocks, found in such abundance, were ignored and left lying around for centuries while those from the seemingly myriad number of finished structures have long since disappeared. The issue is further compounded by the apparent pristine state of all the members of her corpus, as they exhibit no signs of any later alterations which one would expect to find if these were repurposed at a later time as spolia. In grappling with that irony, H. Fragaki dismisses the attempt to identify her corpus with the Arsinoeion and argues against identifying it with the Posideion.

What follows is her careful analysis, based on both the literary testimonia and comparable, contemporary architectural complexes, from which she concludes that those worked blocks are to be associated with ἐνδοτέρω βασίλεια *(palais internes)* (37–53). Her discussion is thought-provoking because it places into sharper focus discussions about the spatial divisions of "royal palaces" with their segregation of publicly-accessible areas from those restricted to royals and their intimates, balancing "la tension entre le microcosme du palais et la macrocosme de la polis" (39). That spatial segregation relied, in part, upon a series of courts, peristyles, and colonnades which, she argues, are represented by her corpus. That argument enables one to better visualize the descriptions of the venue described by Polybius's (XV,24, 3–7) account of Agathocles and his appearance with the mortal remains of Ptolemy IV, and Theocritus's (*Idyll* 5, 173–175) portrayal of the celebration of Adonis witnessed by Praxinoa and Gorgo. These are the contexts in broad strokes in which the architectural ensemble to which her corpus of worked blocks belonged has to be understood (Fragaki, "L'architecture alexandrine du IIIᵉ s. a.C.: caractéristiques et tendances," in J. des Courtils, ed., *L'architecture monumentale grecque au IIIᵉ siècle a.C.* [2015], 283–304).

Although these unfinished worked blocks were never erected into a structure, some bear masons' marks which find parallels elsewhere in contemporary Hellenistic structures. Their interpretation is open to discussion, but some appear to refer to owners of slaves or perhaps to slaves themselves, while multiple marks on one and the same worked block may suggest the presence of three different entities involved

in successive phases of life of that particular block, from its extraction in the quarry, to its transport to the construction site, to its working.

Some of H. Fragaki's conclusions have wide-ranging implications. Consider for example her comments on metrology. Some of the measurements of the worked blocks in marble appear to be based on the Ptolemaic foot, itself derived from the Egyptian cubit, whereas the measurements of those in nummulitic limestone appear to employ the Attic foot. Is this difference to be explained by the privileging of marble, possibly a more "royal" material, over local limestone? And since she describes the appearance of that stone as "marbre gris aux veines blanches" (11), are we to assume it was imported from Asia Minor, given the preponderance of correspondences of the members of her corpus with monuments in that region, because in general those correspondences "se rattachent donc à la tradition créé par les grands chantiers classiques tardifs et hellénistiques des côtes micrasiatiques" (63)?

Despite the use of two different metrological systems, the details of the Doric and Ionic elements in both types of stone conform to a *koine* (63; see R. Étienne, "Architecture palatiale ptolémaïque au IIIᵉ siècle," in des Courtils, *L'architecture monumentale grecque*, 21–34; and see L. Coulon, "Quand Amon parle à Platon (la statue Caire JE 38033)," *RdÉ* 52 [2001], 85–125, who argues against regional styles for pharaonic sculpture during the Ptolemaic Period), suggesting adherence to an international architectural style. But adherence to that style tends to disappear shortly thereafter, suggesting that, during the Hellenistic Period, the broader spectrum of creations from architecture to the minor arts appears to exhibit a parallel periodicity from introduction to eclipse (R. Bianchi, "De rogato artium elegantiorum Alexandrinarum," *BSAA* 45 [1993], 35–44; C. Andrews, *Ancient Egyptian jewellery* [1990], 199; and M. Coenen, "On the demise of the *Book of the Dead* in Ptolemaic Thebes," *RdÉ* 52 [2001], 69–84).

Within the development of Alexandrian architecture, one should note that the earliest structures, identified on Nelson Island, are in the Doric order (P. Gallo, "Une colonie de la première période ptolémaïque près de Canope," in Ballet, *Grecs et Romains en Égypte*, 47–64). That order then shares in the architectural *koine* exhibited by this corpus of worked blocks, before it adheres to an increasing degree of rigidity (Fragaki, "L'architecture alexandrine du IIIᵉ s. a.C."). The evolution of that Alexandria Doric order is in stark contrast to the development of the Alexandrian Ionic and Corinthian orders, which seem to develop a predilection for an exuberant, freer interpretation resulting in a preference for hybrid forms (Fragaki, "L'architecture alexandrine du IIIᵉ s. a.C.").

The collaborative, shorter essay discusses a painted, worked block in limestone, discovered in 1996, which formed part of a Doric cornice. The authors suggest the

block should be dated to the period between the middle of the third to the beginning of the second century BC, but, without a more secure archaeological provenance, do not hazard a guess about the building to which it belonged. The remainder of the discussion is given over to an assessment about Alexandrian painting as exhibited by this colorful fragment (Fragaki, "L'architecture alexandrine du IIIᵉ s. a.C., 296).

Robert Steven Bianchi
Fondation Gandur pour l'Att, Genève

Yahia el-Masry, Hartwig Altenmüller, and Heinz–Josef Thissen. *Das Synodaldekret von Alexandria aus dem Jahre 243 v. Chr.* SAK Beiheft 11 (Hamburg: Helmut Buske Verlag 2012). ISBN 9783875486223. Pp. viii + 269, 10 plates.

Das hier zu besprechende Buch stellt die monographische Abhandlung zu der Kalksteinstele mit dem Synodaldekret aus 243 v. Chr. dar, das im fünften Regierungsjahr von Ptolemaios III. Euergetes erlassen worden ist. Das Objekt ist 1999/2000 bei Grabungsaktivitäten des Supreme Council of Antiquities (SCA) in einem Provinztempel aus dem mittelägyptischen El-Khazindariya ans Tageslicht befördert worden. Der Inhalt der Publikation kann wie folgt wiedergegeben werden.

Im ersten Hauptkapitel (nach interner Zählung Kapitel 2!) führt der Ausgräber in das Thema ein. Die schriftliche Erwähnung des Ortes bei neuzeitlichen Ägyptenreisenden (3), dessen geographische Lage (4–5) und archäologische Relikte (5–13) werden geschildert. Das Fundmaterial hat einen Zeitraum vom Alten Reich bis ins islamische Mittelalter umspannt. Die Entdeckungsgeschichte der Stele wird in geraffter Form rekapituliert (10–12). Das Denkmal ist im heutigen Zustand in 11 Fragmente zerbrochen (12). Die letzten Seiten des Kapitels nimmt die Vorab-Präsentation des hieroglyphischen und transkribierten Teils der Stele sowie dessen Übersetzung ein (13–25).

In Kapitel 3 wird zu ausgewählten Aspekten der Stele Stellung genommen. Das neue Dekret aus El–Khazindariya kann mit dem im Kanopus-Dekret erwähnten πρότερον γραφεν ψηφισμα identifiziert werden (29). Der Umstand gestattet die Zuordnung schon länger bekannter Fragmente mit hieroglyphischem, demotischem und griechischem Text, die aus Elephantine, Assuan und Tod stammen und jetzt in Paris (Louvre), Uppsala (Victoria Museum) und Durham (Oriental Museum) aufbewahrt werden (29–30). Die äußeren Maße der Stele werden bekannt gegeben, deren Höhe 220 cm, Breite 120 cm und Dicke 21 cm beträgt (31). Das Bildfeld der Stele wird beschrieben (32–34), in dem oben eine geflügelte Sonnenscheibe schwebt, aus deren Zentrum zwei bekrönte Uräen herabhängen. Der un-

tere Bereich zeigt eine Prozession aus vier Göttern (Osiris/Isis/Horus/Min) und den königlichen Ahnen (Eltern: Ptolemäus II. Philadelphos/Arsinoe II; Großeltern: Ptolemaios I/Berenike I, beide wohl zu ergänzen), die von rechts nach links auf eine einzeln stehende, nur in Vorzeichnung markierte Figur zustrebt. Die erkennbaren Spuren deuten vielleicht auf Thot als Schreibergott und Seschat (?) hin, die eventuell von Ptolemäus III. (und Berenike II.[?]) begleitet werden.

In Kapitel 4 wird dem Leser der hieroglyphische (35–49) und demotische (50–65) Abschnitt der Stele in Original und Transkription an die Hand gegeben. Die Zeilen werden dazu in kleinere Texteinheiten zerteilt, wobei auch die Parallelen notiert werden.

Im 5. Kapitel wird eine Synopse der hieroglyphischen, demotischen und – ergänzten – griechischen Fassung erstellt. Das Textvolumen baut sich aus 21 hieroglyphischen Zeilen und 18 demotischen Zeilen auf (67). Der Text ist durch die Autoren in 25 Sinnabschnitte gegliedert worden (67). Die Rekonstruktion der griechischen Version ist Fr. Kayser zu verdanken, der sich im Rahmen seiner Tätigkeit auf Fragmente aus Elephantine und die hiesige Stele stützen konnte (67). Die Textedition bezieht auch die hieroglyphischen/demotischen Parallelen (s. o.) mit ein. Die einzelnen Paragraphen werden mit einem Kommentar zu philologischen und anderen Fragen versehen.

In Kapitel 6 werden Fakten zu Ursachen, Verlauf und Folgen des 3. Syrischen Krieges unter Ptolemäus III. gesammelt (151ff). In 6.1.2 werden die historischen Nachrichten zu diesem militärischen Ereignis gesichtet. Das Synodaldekret von Alexandria wird dafür als erste Quelle genannt (153). Das Monumentum Adulitanum (OGIS 54) wird als zweite Quelle erwähnt (153–55). Die Babylonische Chronik (BCHP 11) auf der Keilschrifttafel BM 34428 wird als dritte Quelle besprochen (155–59). Das Kanopus-Dekret wird als vierte Quelle zitiert (159). Die Überlieferung bei griechischen/lateinischen Autoren (Appian von Alexandria/ Polyainos/Catull/Porphyrios von Tyros/Justin) wird ebenso gewürdigt. In 6.1.5 werden die Ländernamen des Alexandriadekrets einer näheren Betrachtung unterzogen (161–163). Die Bezeichnung *ḥrk* ist hier offenbar zum ersten Mal belegt (161), die im Text davor überzeugend für "Kilikien" in Anspruch genommen worden war. Die Namen sind in der hieroglyphischen und demotischen Fassung unterschiedlich angeordnet, was bei der Abschrift auf die Verwendung einer alten Liste als Vorlage hindeuten könnte (162). In 6. 2 wird die Schilderung von der Rückführung der nach Persien verschleppten Götterbilder auf ihren Wahrheitsgehalt hin überprüft (164–67). Der Report wird als historisch durchaus verlässlich eingestuft (167).

In Kapitel 7 werden die wichtigsten Ergebnisse noch einmal zusammengefasst. Der König hat von der Priesterschaft die nötige Legitimation empfangen, der er im Gegenzug Autorität und Unabhängigkeit gewährt hat (170). Das

Dekret von Alexandria gehört zur Kategorie der ψηφισμα, das durch Zusätze wie die fünfteilige Königstitulatur ägyptisiert worden ist (172). Das Epitheton *iwꜤw* "Erbe" (der Vorgänger) taucht ab Ptolemaios III. Euergetes regelmäßig in der Königstitulatur auf (173). In der Formel *mrii n* X "geliebt von" des *sꜣ RꜤ* – Namens wird Amun immer öfter durch Ptah ersetzt, was vermutlich die wachsende Bedeutung der memphitischen Priesterschaft wiederspiegelt (173). Die Anlässe für die Einberufung der Synoden werden ergründet, die stets im Königshaus zu suchen sind und vom Geburtstag des Herrschers über dessen Krönung bis hin zu siegreichen Schlachten gereicht haben (174). Die materiellen Wohltaten gegenüber Tempeln und Bevölkerung haben sich für den König in entsprechenden Ehrungen ausgezahlt (175). Die Mechanismen beim Statuenprogramm werden kurz skizziert (180). Die Motive für die Einrichtung von Festtagen in den Dekreten werden beleuchtet, die u. a. religiös erklärt und mit dem Herrscherkult in Verbindung gebracht werden (180–181).

Das 8. Kapitel setzt sich dezidiert mit den Sprachen des Dekretes auseinander (185–91). Die Autoren kommen zu dem Ergebnis, dass die ägyptischen Priester als Verfasser aller vorhandener Versionen zu gelten haben (185). Der hieroglyphische Text weist nicht selten eine altertümliche Sprachgestalt auf (185). Das Vokabular ist nach Möglichkeit gegenüber der demotischen Fassung variiert worden. Die betreffenden Unterschiede werden an repräsentativen Beispielen herausgearbeitet (187–89). Der Vergleich der Verbalformen bildet den Abschluss, wobei der Schwerpunkt u. a. auf das Verhältnis zwischen hieroglyphischem *śḏm.n=f* und demotischem *śḏm=f* / Umstandssatz gelegt wird (189ff).

Das 9. Kapitel widmet dem äußeren Aufbau der bisher bekannten Dekrete eine kurze Besprechung, der sich bei allen Exemplaren ungefähr ähnlich darstellt (193–97). Die Probe aufs Exempel erfolgt anhand der Dekrete von Alexandria (243 v. Chr.) und Memphis (Rosettana, 196 v. Chr./ Philensis I, 185 v. Chr.), deren inhaltliche Parallelen optisch hervorgehoben werden.

In Kapitel 10 wird die zusammenhängende Übersetzung der hieroglyphischen und demotischen Fassung des Dekrets bereitgestellt (199–215). Die Übersetzung der rekonstruierten griechischen Fassung schließt das Kapitel ab (216–19).

Im hinteren Teil des Buches sind Glossare (hieroglyphisch: 221–30; demotisch: 230–43), Literaturverzeichnis (244–61) und Verzeichnis der Quellentexte (263–66) zu finden.

Die folgenden Anmerkungen könnten einen gewissen Nutzen versprechen:

13: lies *ḥrw* "Horus" statt *r*!

17: lies *ḫꜣꜥj.t* "Aufruhr o. ä." statt *ḫꜣj.t*!

22: lies *ḫꜣ.w-nb.w* "Nordländer o. ä." statt *ꜣw-nb.w*!

35: 3 lies *ḥr* statt *hr*, 5 lies *ꜣḥ.w* statt *ꜣh.w*!

37: lies *ḥtp.w* statt *htp.w* (ähnlich 86).

46: 89 lies *iw=ś* statt *w=ś*!

80: zu Sonderbedeutung *ḥmśi* "zur Beratung sitzen" vgl. H.-W. Fischer-Elfert, *Die Satirische Streitschrift des Papyrus Anastasi I, Textzusammenstellung*, 2., erweiterte Auflage (Wiesbaden, 1992), 62 (mit Zusatz *wꜣwꜣ* "planen"); zu *ḥmśi* "im Tempel tagen" vgl. W. Erichsen, *Die Satzungen einer ägyptischen Kultgenossenschaft aus der Ptolemäerzeit, Nach einem demotischen Papyrus in Prag* (Copenhagen, 1959), 23.

85: zu kausativem *mnḫ* vgl. auch R. Jasnow: "The Greek Alexander Romance and Demotic Egyptian Literature," *JNES* 56 (1997), 100, n. 38; zu *mnḫ* "vortrefflich" vgl. W. Schenkel, *Zur Rekonstruktion der deverbalen Nominalbildung des Ägyptischen* (Wiesbaden, 1983), 94; V. Orel and O. Stolbova, *Hamito-Semitic Etymological Dictionary* (Leiden, 1995), 392.

90: Die Verbindung der Schreibung Gardiner Sign-list Aa1 + D 43 mit *ḫꜣꜥ* "freilassen" dürfte wenig Plausibilität besitzen. Das Schriftbild sieht eher nach einer Schreibung für *ḥwi* "befreien" aus, zu dieser Bedeutung vgl. L. Borchardt, "Ein Königserlass aus Dahschur," *ZÄS* 42 (1905), 5.

9.2: zur Schreibung von *ḥꜣḳ* mit dem *ḥḳꜣ*-Szepter vgl. U. Verhoeven, *Das Totenbuch des Monthpriesters Nespasefy aus der Zeit Psammetichs I.* (Wiesbaden, 1999), 14m.

93: Das Wort *wtb* "deportieren" steht vielleicht mit *wtb* "ändern, sich verschieben o. ä." in Zusammenhang, zu diesem Wort vgl. W. Erichsen, *Die Satzungen einer ägyptischen Kultgenossenschaft aus der Ptolemäerzeit*, 29. Der kleinste gemeinsame Nenner ist dann im Ortswechsel von A nach B zu erwarten.

96: zum *kbn.t*-Schiff vgl. D. Jones, *A Glossary of Ancient Egyptian Nautical Titles and Terms* (London, 1988), 148–49; N. Dürring, *Materialien zum Schiffbau im Alten Ägypten* (Berlin, 1995), 144.

100: Die Schreibung *śḫ* für *śḫm* geht wohl auf den bekannten Ausfall von *m* zurück, vgl. dazu Westendorf, *Med. Gramm.*, 25–26.

102: zu *gmꜥ* "schädigen" vgl. J. Osing, *Hieratische Papyri aus Tebtunis I, Text* (Copenhagen, 1998), 74e; die Schreibung von *ḫꜣw.t* "Altar" ohne *t* schon bei Wb. III, 226, Belegschreibungen!

117: zur Schreibung *mꜣw* für *mꜣt* vgl. R. Jasnow and K.-Th. Zauzich, *The Ancient Egyptian Book of Thoth, A Demotic Discourse on Knowledge and Pendant to the Classical Hermetica*, Volume 1. Text (Wiesbaden, 2005), 378.

122: zum transitiven *ḏśr* "kultisch verehren o.ä." vgl. K. Jansen-Winkeln, *Ägyptische Biographien der 22. und 23. Dynastie, Teil 1: Übersetzung und Kommentar* (Wiesbaden, 1985), 176 (9).

125: vor *gꜣi.t* "(tragbarer) Naos, Schrein" könnte auch *mśi* "bilden, herstellen" zu ergänzen sein.

136: zur Schreibung *nf* für *nfr* "gut" vgl. KRI IV, 235, 14; K. Jansen-Winkeln, *Biographische und religiöse Inschriften der Spätzeit aus dem Ägyptischen Museum Kairo, Teil 1, Übersetzungen und Kommentare* (Wiesbaden, 2001), 178, 196, und 206.

178: zum Umgang mit heiligen Tieren vgl. S. Lippert, *Ein demotisches juristisches Lehrbuch* (Wiesbaden, 2004), 47.

203: in (33) ist *ḫn(r)* statt *ḫnr(w)* zu umschreiben!

Das Ergebnis kann wie folgt formuliert werden. Das Buch hat auf ganzer Linie überzeugt. Die Fakten werden in gut lesbarer Form präzise dargestellt. Der Rezensent hat aus der Lektüre persönlichen Gewinn davongetragen.

Stefan Bojowald
Bonn

Michael Cooperson, ed. and trans. *Ibn al-Jawzī: Virtues of the Imam Aḥmad ibn Ḥanbal, Vol. 2* (New York: New York University Press, 2015). ISBN 9780814738948. Pp. viii + 584.

The first volume of Michael Cooperson's translation of Ibn al-Jawzī's *The Virtues of the Imam Aḥmad ibn Ḥanbal* (2013) won praise from reviewers for its excellent translation, and this, the second volume of the same work, does not disappoint. Cooperson has a gift for translation which he modestly deflects in the introduction to the first volume: "Leaving aside the matter of length, this book was not particularly difficult to translate" (xvii). Translation is a tricky business, but Cooperson captures not only the meaning but also the panegyric tone of the Arabic prose in his colorful, readable, and engaging English. As with all publications of the Library of Arabic Literature, the volume is beautifully bound, with the original Arabic on the left page and the accompanying English translation on the right.

The compiler of the original work, Ibn al-Jawzī (1126–1200), was a native of Baghdad, and, patronized by the Abbasid Caliph, came to be one of the most important jurisprudential thinkers of the Ḥanbalī *madhhab*, or school of law (although it should be noted that he is remembered as something of an expert in everything, from theology to history, and was famously prolific). His collection *Manāqib Abī 'Abd Allāh Aḥmad ibn Muḥammad ibn Ḥanbal*, of which this volume is a translation, is a collection of *akhbār* (self-contained stories) about Aḥmad ibn Ḥanbal, the *madhhab*'s eponymous founder. He shared with Ibn Ḥanbal a strong distaste for what he considered "innovation" in the religion, and fought therefore against the dangers of rationalism, which he saw as eclipsed by revelation when the two were in conflict.

The *akhbār* are organized into thematic chapters, such as "His Love of Poverty and His Affection for the Poor," "His Accepting Invitations and His Withdrawal Upon Seeing Things He Disapproved Of," and "His Fear of God." The three chapters covering Ibn Ḥanbal's experience during the *miḥna*, or "the inquisition" (during which theological opponents of the Caliphs were put to questioning under threat of imprisonment or torture) are of particular interest,

as they offer a very personal insight into the most extraordinary experience of Ibn Ḥanbal's life. While not unique to those specific chapters, the quality of Cooperson's writing is on display as he renders in evocative English the exigency of the discussion that is clear in Arabic. Anyone who has been engrossed by a novel will find the ordeal of Ibn Ḥanbal's imprisonment grim, or his spirited defense of his theological positions during his long debate with the Caliph al-Muʿtaṣim stirring. The value of this volume lies not just in the way it gives an English-speaking readership access to one of one of Islam's most important juridical figures (as presented by one of Islam's most prolific scholars), but also in its gripping prose.

The volume also has a useful glossary of names and terms. If the volume falls short anywhere, it is that there is no introduction by the author to this second volume—a nitpick if ever there was one, since the first volume has an introduction that covers both. *The Virtues of the Imam Aḥmad ibn Ḥanbal*, therefore, is highly recommended to anyone with an interest in *ḥadīth*, history, theology, and law, and to anyone who appreciates a good read.

Aaron M. Hagler
Troy University

Michèle Casanova. *Le lapis-lazuli dans l'Orient ancien. Production et circulation du Néolithique au IIᵉ millénaire av. J.-C.* (Paris: Éditions du Comité des travaux historiques et scientifiques, 2013). ISBN 9782735507313. Pp. 281, 104 figures, 23 tables.

A dedicated monograph on the importance of the precious stone lapis-lazuli has been overdue since the completion of Georgina Herrmann's Ph.D. dissertation in the 1960s. Michèle Casanova's addition is a welcome expansion on her own doctoral research completed in 1998 at the Université de Paris—Sorbonne, entitled *Le lapis-lazuli dans l'Orient ancien: Gisements, production, circulations, des origines au début du second millénaire*. Aside from the early appearance of lapis-lazuli in the Near East at the site of Mehrgarh in Central Asia dating to the beginning of the seventh millennium BC (25), Casanova's book focuses on its development from the early Chalcolithic (ca. 5100 BC) down to the mid-second millennium BC (ca. 1600 BC) and elucidates the important role lapis-lazuli played within Mesopotamian society. While lapis-lazuli finds become abundant only within the later Early Dynastic period toward the end of the third millennium BC within Syria and Iraq, the author has documented in total ca. 40,142 objects from the periods under examination (table 7). The Royal Cemetery of Ur alone accounts for 30,874 (or 76.9% of the total number) finds from the Early Dynastic III (2600–2350 BC) alone (table 10), a fact similarly

noted by David Warburton ("The Theoretical Implications of Ancient Egyptian Color Vocabulary for Anthropological and Cognitive Theory," *LingAeg* 16 [2008], 213–59, n. 141). Overall, Casanova is not only concerned with a geographical distribution of the finds (her part I), but her work also explores methods of fabrication through an ethnological lens (part II) and considers both the commercial and symbolic value of the stone within Mesopotamian society (part III). Preceding each part is a brief discussion of her approaches. She includes more than 100 figures and illustrations and her photographs of many lapis-lazuli objects (especially in her typology chapter) are in color, so the reader can appreciate the wide variety of hues of the stone and its various degrees of quality.

The first part, "Sites de découverte du lapis-lazuli de l'orient ancien," is organized chronologically and for each site discussed the author presents a brief excavation history along with find spots of lapis-lazuli at the site (along with a list of other precious materials, when available). Sites are generally listed with their exact number of finds, though in some cases only a general grouping of objects for a site is known (e.g., fragments, chips). Contextual information for each find is not given in a catalog format, but instead, if information is available, the find is briefly described (mostly chronologically). In some cases, such as Ur or Susa, where larger concentrations of lapis-lazuli finds have been noted, more context (e.g., details on exact provenance) is considered.

With an overview of the available lapis-lazuli finds now as the basis, the second part, "Les objets en lapis-lazuli. Fabrication et typologie" surveys first the available evidence within sites for methods of production and manufacture. While, for example, a workshop with lapis-lazuli production has not yet been identified for the site of Ur, despite Ur's large quantity of lapis-lazuli finds (97–98), Casanova nevertheless sees the potential here for such a discovery. In looking at the two major sites of Tepe Hissar and Shahr i-Soktha in northern and eastern Iran respectively, the author discusses the larger number of production areas for lapis-lazuli objects at Tepe Hissar (109), while Shahr i-Soktha exhibits more standardized modes of production possibly indicating that it was regulated by a centralized authority (117). Her second chapter attempts to reconstruct the processes of production and here Casanova cursorily mentions Egyptian tomb scenes featuring bead workshops (e.g., tomb of Rekhmire (TT100) from the Eighteenth Dynasty) due to the dearth of textual sources on the subject from Mesopotamia and Syria (143). Nevertheless, her reconstruction of the processes follows the latest trends in experimental archaeology and she employs a thorough methodology as well as plenty of detailed illustrations to reconstruct these processes in a convincing manner. The final section of part II concerns a typology of the diverse types of lapis-lazuli objects, where 32,396 of the total 40,142 objects are beads (173; her

percentage calculation appears as 74.2%, though it should read instead 80.7%). In distinguishing the many different types of beads, where simple shapes dominate, she follows the nomenclature established by Horace Beck ("Classification and Nomenclature of Beads and Pendants," *Archaeologia (2nd Series)* 51 [1928], 1–76). In comparing this situation to the Egyptian evidence, more than 75% of all lapis-lazuli finds known from the Predynastic Period are made-up of beads (see L. Bavay, "Matière première et commerce à long distance: le lapis-lazuli et l'Égypte prédynastique," *Archéo-Nil* 7 [1997], 79–100, especially 82—a reference curiously absent in her bibliography).

It is in the third part, "Échanges, valeur marchande et valeur symbolique du lapis-lazuli de l'orient ancien," where Casanova finally tackles the important question of the commercial value and symbolism of the stone. In the first chapter, the question of the geological sources of the stone is addressed and she puts forth the plausible conclusion that the major mountain range in Central Asia, which comprises the mines in the Chagai Hills in Pakistan, the Badakhshan region in northeastern Afghanistan, and the Pamir range in Tajikistan, should be regarded as the likeliest source (212). A particular highlight regards the Chagai Hills, where she acknowledges that this source is vehemently denied by geologists based on the lack of the required geological conditions for lapis-lazuli to form in this area (209). Nevertheless, she states that she personally examined lapis-lazuli samples labeled *Chagai*, which were given to her by M. Tosi and J.-F. Jarrige, and she found them to be lapis-lazuli! In her consequent discussion on the various trade routes between the sources and Mesopotamia and Syria, she concludes that "les tracés des cheminements du lapis-lazuli ne peuvent être localisés avec certitude" (217). The second chapter, in turn, investigates the market value of lapis-lazuli and looks at the manners of exchange between the city-states of the third millennium BC. Her final chapter deals with the symbolism that was ascribed to the stone in the Mesopotamian world and here Casanova draws from several well-known texts. The particular use of ornaments (Fr. *parures*) as being intimately associated with the supernatural and divine led Casanova to consider that every object has a meaning, which may go beyond perceptible content (235). Ornaments of lapis-lazuli are mentioned in the context of the story of "the descent of Isthar into the underworld," where Ishtar becomes vulnerable in the presence of her sister without her protective ornaments—pieces of lapis-lazuli are included here (244). Casanova notes the assimilation of Isthar with lapis-lazuli in the text and then draws from Egyptian sources, which associate the stone with the primeval ocean—a cosmic association. Next, these underlying notions of the divine as embodied in the material are also reflected in the color "blue." The blue color of the hair, eye brow, and beard of the god is, in fact, due to lapis-lazuli and emphasizes the object as possessing the divine life force.

Her list of references in her bibliography is extensive
and the reader is referred to the many other articles pub-
lished by Casanova on the significance of lapis-lazuli in the
Near East. Minor quibbles include the lack of page num-
bers in her citations, especially when the author quotes di-
rectly from a work. Sometimes a page number is provided
(236), though in other instances not so (206). Minor spell-
ing mistakes seem to have been overlooked, such as on 203,
when *Herrman* appears, followed a few lines later by the cor-
rect spelling *Herrmann*. In sum, Casanova's monograph is
a welcome treatise on the lapis-lazuli material known from
Mesopotamia and Syria and provides a starting point for
further discussion, especially as far as other precious stones
are concerned (e.g., carnelian).

Thomas H. Greiner
University of Toronto